D1243087

JACKSON SCHOOL PUBLICATIONS
IN INTERNATIONAL STUDIES

JACKSON SCHOOL PUBLICATIONS
IN INTERNATIONAL STUDIES

Senator Henry M. Jackson was convinced that the study of the history, cultures, political systems, and languages of the world's major regions was an essential prerequisite for wise decision-making in international relations. In recognition of his deep commitment to higher education and advanced scholarship, this series of publications has been established through the generous support of the Henry M. Jackson Foundation, in cooperation with the Henry M. Jackson School of International Studies and the University of Washington Press.

The Crisis of Leninism and the Decline of the Left:
The Revolutions of 1989,
edited by Daniel Chirot

Sino-Soviet Normalization and Its International Implications,
1945–1990,
by Lowell Dittmer

Contradictions: Artistic Life, the Socialist State,
and the Chinese Painter Li Huasheng,
by Jerome Silbergeld with Gong Jisui

The Found Generation: Chinese Communists in Europe
During the Twenties,
by Marilyn Levine

Maodun (Contradictions): calligraphy by Mao Zedong
in letter to Li Da, 1952

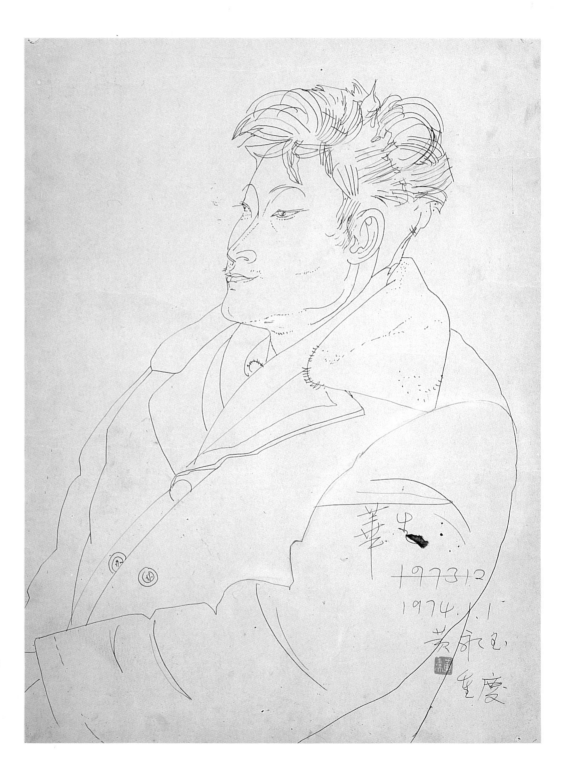

Portrait of Li Huasheng. Huang Yongyu. December 31, 1973– January 1, 1974. Ink on heavy paper. 54.5 × 39.6 cm. Collection of Li Huasheng, Chengdu.

Contradictions

Artistic Life, the Socialist State, and the Chinese Painter Li Huasheng

JEROME SILBERGELD *with* Gong Jisui

University of Washington Press

Seattle and London

This book is published with the assistance of grants from the National Endowment for the Humanities; Hanart TZ Gallery, Hong Kong; and Dr. Clyde Wu, Dearborn, Michigan

Library of Congress cataloging-in-publication data
Silbergeld, Jerome.
 Contradictions : artistic life, the Socialist State and the
 Chinese painter Li Huasheng / Jerome Silbergeld with Gong Jisui.
 p. cm.—(Jackson School publications in international
 studies)
 Includes bibliographical references and index.
 ISBN 0-295-97155-X
 1. Li, Hua-sheng, 1944– 2. Painters—China—Biography
3. Socialism and art—China. 4. Art and state—China. I. Gong,
Jisui. II. Title. III. Series.
ND1049.L4765S56 1993
759.5—dc20
[B] 92-25169
 CIP

Photo credits: Stanley Shockey, Seattle, frontispiece, figures 33, 36, 41, 46, 53, 54, 58, 62, 63, 71, 77, 78, 79, 81, 92, 103, 108, 110, 113, 114, 115, 117; moonphoto, Seattle, 38, 39, 42, 43, 45, 49, 50, 51, 52, 116; Thomas Feist, New York, 112; Jerome Silbergeld, 2, 3, 4, 5, 6, 19, 23, 26, 27, 28, 30, 31, 32, 34, 74, 80, 83, 85, 86, 89, 91, 94, 96, 99, 100, 102

Contents

Preface *xi*

1. Contradictions: Artistic Personality and the Socialist State *3*

2. "China-Born"—Early Years, First Teachers, 1944–65 *26*

3. Revolution by Day, Tradition by Lamplight, 1962–76 *35*

4. Master Teacher, Master Pupil—Chen Zizhuang and Li Huasheng, 1973–76 *55*

5. Socialist China's "Second Revolution" and the Rise of a "Younger-Generation Artist," 1976–83 *85*

6. "Spiritual Pollution" and the Fall of a "Shooting Star," 1983–86 *136*

7. Laurels Restored, the Artist Academized, 1985–89 *168*

 Notes *215*

 Selected Bibliography *233*

 Index *235*

List of Illustrations

Measurements, when available, accompany the illustrations. Figure for height precedes width. Note that the dates given are usually those of the artists' inscriptions, which are sometimes added well after completion of the painting.

Chronological table of Chinese political periods. *xiv*

Map of China: Sichuan province. *xv*

Huang Yongyu. *Portrait of Li Huasheng.* 1973–74. *xvi*

1. Li Huasheng on stage in Sichuan-style opera. *11*

2. Li Huasheng. *12*

3. Li Huasheng pantomiming Sichuan-style opera. *12*

4. Yu Jiwu. *30*

5. Yu Jiwu. *Seascape.* Undated. *31*

6. Li Huasheng. *The Jialing River at Chongqing.* Undated, ca. 1965. *38*

7. Liu Chunhua. *Chairman Mao Goes to Anyuan.* 1967. *44*

8. Wu Youchang, Li Huasheng, and Lei Zuhua. *Mao Inspects the Rivers of Sichuan.* 1972. *46*

9. Li Huasheng and Wang Jindong. *Red Lantern in the Waves.* Undated, ca. 1975. *47*

10. Li Huasheng. *Ten Thousand Mile Voyage.* 1975. *49*

11. Li Huasheng. *Dock Worker.* 1975. *49*

12. Du Yongqiao. *Edge of the Stream.* 1957. *50*

13. Li Keran. *Spring Rain in the Sichuan Mountains.* 1973. *52*

14. Chen Zizhuang at his small painting table. *56*

15. Zhu Peijun. *Swans.* 1984. *63*

16. Li Shaoyan. *64*

17. Li Shaoyan and Niu Wen. *At the Time When the Good News of the Peaceful Liberation of Tibet Was Brought to the Xikang-Tibet Plateau Region.* 1953. *65*

18. Chen Zizhuang. *Autumn Red.* 1966. *68*

19. Chen Zizhuang. *Bamboo.* 1963. *69*

20. Chen Zizhuang. *Approaching Nightfall.* Undated. *71*

21. Chen Zizhuang. *Two Boats.* Undated. *72*

22. Qi Baishi. *Trees and Cottages.* Undated. *73*

23. Chen Zizhuang. *Mountain Crossing.* 1974. *73*

24. Huang Binhong. *Landscape in the Yunjian School Style.* 1954. *73*

25. Chen Zizhuang. *The Eight Eccentric Painters of Yangzhou.* Undated. *74*

26. Li Huasheng. *Grapes and Lichees.* 1975. *75*

27. Li Huasheng. *Returning Herdboy.* Undated, ca. 1976. *76*

28. Li Huasheng. *Herdboy and Water Buffalo.* Undated, ca. 1976. *77*

29. Chen Zizhuang. *Sketch for My Son Mei [Chen Shoumei] to Keep.* 1972. *77*

30. Li Huasheng. *Yangzi River Landscape.* 1975. *78*

31. Li Huasheng. *Yangzi River Landscape.* Early 1980s. *79*

32. Li Huasheng. *Yangzi River Landscape.* 1976. *79*

33. Li Huasheng. *River Torrent.* Ca. 1976. *80*

34. Chen Zizhuang. *Sketch Done at the Age of Sixty.* 1973. *81*

35. Luo Zhongli. *Father.* 1980. *87*

36. Li Huasheng. *Landscape after Xuege [Bada Shanren].* 1979. *88*

37. Bada Shanren. *Untitled Landscape.* 1694. *89*

38. Li Huasheng. *Print-picture.* 1979. *90*

39. Li Huasheng. *Print-picture.* 1979. *90*

40. Li Huasheng. *Memory Sketch after a Painting of Tree Bark.* 1987. *91*

41. Li Huasheng. *Fisherman's Song at the Wu Gorge.* 1979. *93*

42. Li Huasheng. *Untitled Sketch.* 1979–80. *95*

43. Li Huasheng. *The Qing and Bai Rivers.* 1979–80. *95*

44. Li Huasheng. *All Night, New Rain.* 1981. *96*

45. Li Huasheng. *Scene at Yibin.* 1979–80. *97*

46. Li Huasheng. *Scene at Yibin.* Ca. 1982. *97*

47. At the Golden Ox Hotel, Chengdu, July 1980. *99*

48. Deng Lin, Huang Yongyu, Tan Changrong, and Li Huasheng.
 Landscape with Bird and Insect. 1980. *100*

49. Li Huasheng. *Scenery of Mt. Huang.* 1980. *101*

50. Li Huasheng. *Scenery of Mt. Huang.* 1980. *102*

51. Li Huasheng. *Scenery of Mt. Huang.* 1980. *102*

52. Li Huasheng. *Scenery of Mt. Huang.* 1980. *103*

53. Li Huasheng. *Mt. Huang.* 1980. *105*

54. Li Huasheng. *The Mountains of Sichuan.* 1980. *107*

55. Li Huasheng. *Untitled Landscape.* 1980. *108*

56. Li Huasheng. *Wintry Field.* 1980. *109*

57. Lin Fengmian. *Untitled Landscape.* 1937. *110*

58. Li Huasheng. *Tiller in the Field.* Ca. 1980. *111*

59. Li Huasheng. *Mountain Dwelling.* 1980. *112*

60. Members of the Ten-Artist Exhibition, National Gallery, Beijing, 1981. *114*

61. Li Huasheng and Li Keran, Beijing. 1981. *115*

62. Li Huasheng. *Untitled Landscape.* 1982. *116*

63. Li Huasheng. *Rustic Scene.* 1982. *117*

64. Li Huasheng. *Mt. Wu.* 1982. *119*

65. Li Huasheng. *Painting after Lu You's Poem.* 1982. *120*

66. Li Huasheng. *Painting after Lu You's Poem.* 1981. *121*

67. Li Huasheng. *Ferry Crossing at Wuxi.* 1982. *124*

68. Li Huasheng. *At the Fork of the Road.* 1982. *126*

69. Li Huasheng. *At the Fork of the Road.* 1982. *127*

70. Li Huasheng. *Night Rain in the Mountains of Sichuan.* 1982. *128*

71. Li Huasheng. *Night Rain in the Mountains of Sichuan.* 1982. *129*

72. Li Huasheng. *Ten Thousand Acres of Lotus.* 1982. *130*

73. Li Huasheng. *Landscape after Wang Anshi's Poetic Concept.* 1982. *131*

74. Niu Wen. *133*

75. Niu Wen. *New March in the Grasslands.* 1979. *134*

76. Chen Zizhuang. *The Min River at Wuyang.* Undated. *146*

77. Li Huasheng. *Late Autumn in the Mountains of Sichuan.* 1983. *146*

78. Li Huasheng. *Autumn Evening.* 1983. *147*

79. Li Huasheng. *Scenery of Mt. Longquan.* 1984. *159*

80. Li Huasheng. *Return from Fishing.* 1984. *161*

81. Li Huasheng. *Springtime: Fishing in the Stream.* 1984. *161*

82. Shi Yingshao. *Li Huasheng Incarcerated.* 1985. *163*

83. Li Huasheng with Ai Weiren. *165*

84. Li Huasheng. *Torches among the People Illuminate the Local Customs on the River.* Undated. *169*

85. Lü Lin with his window sign, "No visitors for longer than ten minutes." *172*

86. Lü Lin. *Qin Gui is Dead.* Undated. *172*

87. Wu Fan. *173*

88. Wu Fan. *Dandelion*. 1959. *173*

89. Li Huasheng with Yang Chao. *174*

90. Yang Chao. Calligraphy. 1984. *175*

91. Guo Ruyu. *Wild Ducks* (detail). Undated. *175*

92. Peng Xiancheng. *The Lute Song*. 1987. *176*

93. Peng Xiancheng. *Song of the Beautiful Women: Prime Minister Yang Guozhong
 and the Yang Sisters*. 1987. *177*

94. Dai Wei. *Portrait of Bada Shanren*. Undated. *178*

95. Liu Pu. *Quiet River, Distant Ferry*. Undated. *179*

96. Qin Tianzhu. *Bird*. 1988. *179*

97. Zhang Shiying. *Tiger*. 1984. *180*

98. Zhou Ming'an. *Tiger*. 1984. *180*

99. Yuan Shengzhong. *Figure Painting* (detail of work in progress). 1988. *181*

100. Tan Tianren. *Qingcheng Mountain, Zhaoyang Cave* (detail). Undated. *181*

101. Tan Changrong. *Chickens*. 1984. *182*

102. Bai Desong. *Return From Fishing*. 1988. *185*

103. Li Huasheng. *Mountain Village, the Pleasure of Fishing*. 1985. *193*

104. Chen Zizhuang. *Mountain Village, the Pleasure of Fishing*. 1974. *194*

105. Li Huasheng. *The Mountains of Sichuan*. 1981. *195*

106. Li Huasheng. *Sketch of Opera Figure*. 1987. *195*

107. Li Huasheng. *Mountain Dwelling*. 1985. *196*

108. Li Huasheng. *Mountain Dwelling*. 1986. *197*

109. Li Huasheng. *Mountain Dwelling*. 1986. *198*

110. Li Huasheng. *Night Rain in the Mountains of Sichuan*. 1985. *199*

111. Li Huasheng. *Scenery at Wutong Bridge.* 1985. 200

112. Daoji. *Man in a Hut, from Album for Daoist Yu.* Ca. 1695. 200

113. Li Huasheng. *Watching Clouds.* 1986. 201

114. Li Huasheng. *Traveling Through the Gorges.* 1986. 202

115. Li Huasheng. *Deserted Waters.* 1987. 203

116. Li Huasheng. *Scene at Gubai.* 1979–80. 204

117. Li Huasheng. *Small Album: The Bamboo Sea at Changlin.* 1987. 206

118. Chen Zizhuang. *The Pure Pleasure of a Mountain Village.* 1973. 207

119. Zeng Youshi and Li Huasheng. Selected seals (a–j). 213

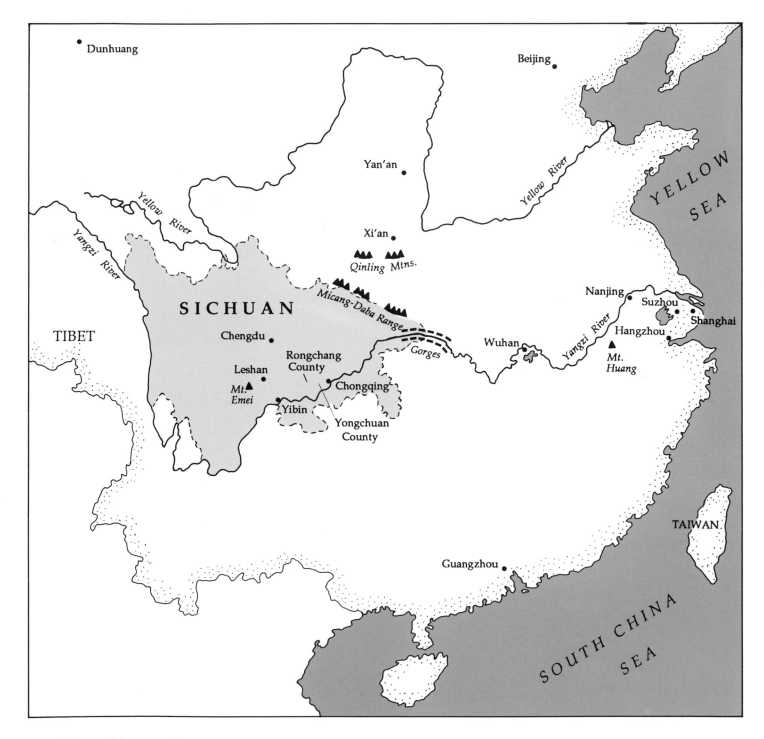

Map of China: Sichuan province.

CHRONOLOGICAL TABLE
OF CHINESE POLITICAL PERIODS

Shang	ca. 16th century B.C.–ca. 1050 B.C.
Zhou	ca. 1050 B.C.–221 B.C.
Qin	221 B.C.–206 B.C.
Han	206 B.C.–A.D. 221
Three Kingdoms, Jin, Northern and Southern Dynasties	A.D. 221–581
Sui	581–618
Tang	618–906
Five Dynasties	906–960
Song	960–1279
Northern Song	960–1127
Southern Song	1127–1279
Yuan	1279–1368
Ming	1368–1644
Qing	1644–1911
Republic	1911–
People's Republic	1949–

實事求是

Shi shi qiu shi (Seek truth from facts): inscription by
Deng Xiaoping, c. 1980

Preface

Seek truth from facts (shi shi qiu shi).

—Ban Gu (A.D. 32–92), Han shu (History of the Han

dynasty), "Biography of Liu De," expression first

popularized by Mao Zedong and later by Deng Xiaoping

THIS BOOK IS FOR THOSE WHO LIKE CHINESE ART BUT imagine that art is made in Heaven, and for those who think otherwise but have no way of knowing what it is really like to be a painter in the modern Chinese realm.

There is a remarkable lack of information about the real lives of artists in socialist China. Not only are there few books and articles on the arts under socialism, but most that do exist deal only with artistic styles and ideals and not with the realities of artistic life. Among the exceptions are a few articles by Michael Sullivan and Julia Andrews, a study by Arnold Chang on "the politics of style," and two more recent books, by Joan Cohen and by Ellen Johnston Laing, which together provide something of an overview of the postrevolutionary period.[1] Still, many important institutional features of the socialization of Chinese art and culture, as well as their impact on individual lives, have yet to be explored in depth. For example, no Western literature has dealt with postrevolutionary China's Halls of Culture and History (Wenshiguan), a national network of organizations established to maintain the prerevolutionary intellectuals (many of them painters and calligraphers, like Li Huasheng's teacher Chen Zizhuang) in a condition of ideological pacification and intellectual service to the new socialist state. Beyond such institutional matters, the fundamental artistic question of individualism and its place in the socialist state cannot be studied except in the detail of individual lives. That task has hardly begun.

Through four full decades of life under socialism, the daily realities of China's artistic politics have remained well concealed. The Chinese art world is intensely private and artists prefer to speak exclusively through their works. But behind—and therefore part of—even the most genteel of these works, the contemporary Chinese art world is intensely political, often fierce, and occasionally deadly. Mao Zedong saw art as a medium of class struggle and nationalistic regeneration. Zhou Enlai, however, beginning in the

early 1970s, recognized and exploited art's potential to help the Chinese establish more friendly international political and economic relations. In the 1980s, under Deng Xiaoping, Zhou's approach has dominated Chinese artistic policy to the point that the government no longer wants to be seen abroad as politically controlling Chinese art and artists, even though their continuing (if somewhat reduced) control is indisputable. Institutional art records remain tightly classified, as if state security were truly held in the balance. And, ironically, Chinese artists are more free in the production of their art than they are in speaking about the mechanics of on-going government control. As a result, Western scholars and laymen alike must depend on government-approved publications and occasional hearsay. Little other information exists on which to build a true understanding of the Chinese artistic realm.

The preservation of an aesthetic veneer over this social reality has resulted not only from Chinese policies and practices but also from the artistic mystique that many Western writers cast over their subject. To choose one example from an otherwise fine piece of literature, Catherine Woo's recent biography of the famous painter Qi Baishi conveys his lofty reputation among the socialists in the first years after "Liberation." But she makes no reference to the vilification of Qi ten years after his death by left-wing radicals under Jiang Qing as part of their assault on traditionalism (the "four old ways"). Qi was accused of being a "rice-valley landlord," a feudalistic gold-digger who hid money bags under his bed and who wanted to be buried with bars of gold strapped around his waist.[2]

For Qi Baishi (1863–1957; fig. 22), Huang Binhong (1864–1955; fig. 24), and a generation of artists who matured long before 1949, their few years lived in "New China" are really not the most crucial. But for a young painter like Li Huasheng and the first generation of artists raised and trained under the socialist regime, it would be impossible to convey the true nature of their artistic personae, of their painting and painterly intent, without first opening the curtains wider on the daily realities of the Chinese art world.

Li Huasheng is a rare personality on the Chinese art stage, as this book will illustrate. He is, by nature rather than by design, an *enfant terrible*, a type more readily appreciated in the West than in China. He is an uncompromising individualist in a society where compromise, as a basic part of the social and political compact that holds the massive population together, is a virtual necessity for survival. He is intently focused on his art and is far removed from engagement in pure politics (or what would be regarded in the West as political activity). Yet Li is profoundly concerned about the realities of Chinese life beyond the idealized realm of Chinese landscape painting. He is almost as intent about the quality of Chinese artistic lifestyle as he is about the quality of art itself. A pragmatist rather than an ideologue, Li—like Deng Xiaoping—frequently quotes Mao Zedong's famous instruction, "Seek truth from facts." He wishes that people would (or could) take this instruction more seriously.

An inescapable problem in this presentation is the fact that Li Huasheng is still a "youth artist" or "younger-generation artist," as the Chinese refer to a painter in his mid-forties. He has gained a major name for himself regionally, and has something of a national and even international reputation. But he is well aware of the long road that lies ahead, separating him from lasting historical stature. Various Chinese, somewhat perplexed and sometimes not a little jealous, have already inquired about why such scholarly energy as this research represents is being directed toward a young, less than universally famous, and distinctly atypical artist. Why is such a book being undertaken at this stage of Li's career when none of China's older artists have ever been explored with this degree of thoroughness? The answer to this is twofold. One is my own critical belief that Li's painting, while still in the midst of its development, already merits such attention in terms of artistic quality. Second, and more important, is Li's brave and unusual willingness to discuss thoroughly his art and his artistic life, as no older, more famous, or more typical painter has yet been willing to do. The fact that Li's art and personality are scarcely typical in no way dims the light that he sheds on Chinese cultural politics, illuminating the lives today of most Chinese artists, major and minor alike. Very little art history, after all, is about "typical" men. I hope this account of Li's life will serve to exemplify the life stories of many other Chinese artists.

The attempt to bring together the two components of this work—art and artistic life—has predictably been quite difficult. As Mark Twain notes in his *Autobiography*, "Biographies are but the clothes and buttons of the man—the biography of the man himself cannot be written." That is to say, historical circumstances can hardly account for the subtleties of individual creativity. Historians of politics and culture alike discuss this matter endlessly, and more conservative art historians doubt seriously the impact of daily life on artistic style. But there is something to be said for an interest in clothes and buttons, particularly when the otherwise unexplored cultural drapery of an entire nation is involved. And so, another well-known Twain aphorism is equally compelling: "Clothes make the man. Naked people have little or no influence in our society." Chinese painters,

in other words, do not paint in a cultural vacuum. They do not paint European paintings (not even when they try to!), for their work comes clothed in Chinese values and preconceptions. In China, one does not have to argue these matters. The Chinese have long believed that when you see the painting, you see the man—a belief predicated, of course, on their own first-hand understanding of Chinese life, Chinese art, and how the Chinese artist works.

But Twain's concern remains valid: submission to the biographer (autobiographer, as well, one must suppose) incurs a frightening potential for error and misinterpretation. While an artist's biography surely *can* be written, a good one nevertheless remains profoundly difficult to achieve. Oscar Wilde put it succinctly: "Biography lends a new terror to death." Henry Adams concurred, writing to Henry James that the difference between biography and autobiography is the difference between murder and suicide.[3] Adams, of course, wrote only figuratively of biography's relationship to death, yet in China, biographical disclosure carries genuine risks.

Actual dangers aside, however, the biographical hazards that caused Twain, Wilde, and Adams to shudder have not been wholly avoided here. The ensuing personal history is, primarily, an oral history, based on intensive interviews with the artist in Seattle in the spring of 1987 and more extensive ones with Li Huasheng and others in Sichuan (primarily Chengdu and Chongqing) in the summer of 1988. In many regards, it partakes more of anthropological fieldwork than of the traditional historical method. All uncited quotations in the text come from these interviews. These interviews have been supplemented by voluminous correspondence with Li and various other contributors, uninterrupted until the time of this writing but not without obvious constraints. Traditional research into extant publications has played a significant but distinctly secondary role.

Despite all efforts to ensure accuracy, errors undoubtedly remain. For one thing, the corroborating Chinese documentation for most oral statments is still classified, in institutional documents and dossiers, and is unavailable to the biographer. For another, Li himself readily admits to having a poor memory. (At one point in his career, in Beijing, he did not apply for membership in the Chinese Artists Association because he could not remember his birthdate.) But I made every effort to corroborate all information given with available written records and, orally, with as many informants as possible. Fortunately, many of Li's friends could reconstruct conversations, virtually word for word, many years after they had taken place, a remarkable consequence of their traditional literary training, further stimulated by the enhanced role of oral transmission in a society where

printed news is neither generally available nor regarded as reliable.[4]

Western-style interviewing greatly perplexes the inherently private Chinese. Most Chinese are totally unaccustomed to, and so are mistrustful of, direct questioning. Their responses, at least initially, tend strongly toward indirection or complete avoidance. Even among friends, questions are seldom put directly, for such questions are construed as prying. In politically difficult periods, knowledge of one's friends is dangerous for both parties, so there is really little incentive for Chinese to pry. Li Huasheng says that only the security police have ever approached him in the manner used here, and he characterizes the Security Bureau's skills as amateurish by comparison. Still, this potentially alienating process also had its allure. In 1987–88 (surely one of the most open moments in modern Chinese history), many people were not only ready to tell their side of things but were positively intrigued by a process so direct, so exemplary of "getting the truth from facts."

The author is responsible for any errors and shortcomings as well as for the interpretive "attitude" of this book. The artist played no role whatsoever in the final shaping of this document and will probably find the end result as strangely Western in its selection and conclusions as he found the interviews. Biographically, it might be ideal to claim no attitude at all, to let the facts speak their own truth. And to a degree, of necessity, this approach was followed. But, ultimately, such a posture is disingenuous. History is the recounting of selected facts. Here, the selection of figures to interview, the questions posed, and the answers recounted were all determined by the author, not the artist. It may immediately be clear to readers that this "story" is seen primarily from the point of view of Li Huasheng and his colleagues, for it is they who provided the bulk of the information. Were Li's competitors the focus of this work, a contrary view of many facts, events, and characters might well prevail. Seen from either point of view, however, the general nature of artistic life in China and its structural mechanisms would probably not differ much from what is presented here.

Socialist China's persistent cultural factionalism and periodic outbreaks of cultural warfare, exceeding anything known in America, are fully evident in the life of Li Huasheng and need no artificial dramatization. Yet, at least until mid-1989, the American public misperceived socialist China's internal culture-warfare as being over and done, as a relic abandoned at the end of the Cultural Revolution. In 1987 and 1988, American intellectuals were buying and reading *Life and Death in Shanghai*, Nien Cheng's impressive per-

sonal account of the Cultural Revolution. But most readers were not aware that rectification campaigns had occurred repeatedly since then, including the crushing of the Democracy Wall Movement of 1979–80, followed by the Campaign Against Spiritual Pollution of 1983–84 (which nearly destroyed Li Huasheng personally and professionally) and the suppression of the student movement of 1987. The events of the spring of 1989, which surprised so many in China and throughout the world, are consistent with this record, albeit its most extreme expression so far. Ironically, the events of 1989 make the sometimes grim realities in this book more credible and comprehensible to the ordinary Western reader.

Finally, as an art historian specializing in the Chinese traditional period, I feel obliged to account for a flirtation with contemporary matters, where makeshift methodology and a distinct lack of historical perspective compound the risks involved in historical biography. My justification lies in a concern for many aspects of Chinese artistic life which, in traditional times, the Chinese sense of privacy has kept out of reach of historical documentation and forever obscured from our view. This includes many matters relating to artistic patronage and artistic training. Past artists are beyond questioning about these mundane details of artistic life, but living artists could tell us about such things, if only they would. Even if they restricted their responses to modern, personal experience, many of their answers would suggest important continuities between today's practices and those of the past and would illuminate past matters in ways that the written record cannot.

There is much to be learned from today's artist which, if correctly applied, can provide unique insight into the past. While much of Chinese institutional and private behavior has changed significantly since 1949, much of it (despite government intentions to the contrary) has come as an addition to, and not as a substitution for, older sociocultural patterns and dynamics. Beneath the surface of the impersonal, highly regulated socialist economy—and especially since the reforms begun in 1979—there endures an intensely competitive exchange of personal favors and mutual obligations, and a network of patronage and protection, such as was common throughout earlier centuries. While Chinese traditional-style artists are no longer aristocratic statesmen painting as spare-tire amateurs (like Wang Wei of the eighth century, Su Shi of the eleventh, and Dong Qichang of the seventeenth, to name a famous trio), Chinese art is still mixed with politics. Many Communist politicians still affect a calligraphic practice that requires a knowledge of the old literary culture (Mao, of course, was

the chief exemplar of this, and many still admire his style). And a collection of painting and calligraphy helps to legitimize the authority of a politician-owner—maintaining the questionable Confucian notion that a well-cultured ruler will also be a benign one—so that choice paintings are now as much sought after by Marxist cadres as they once were by Confucian mandarins. For the Chinese artist, who has now been turned into an art specialist, a developing artistic reputation provides ever more powerful patrons and access to otherwise closed political circles. And, paradoxically as ever, as the patronage ladder is ascended, the artist's need for political sponsors to protect him from ever more competitive rivals rises accordingly.

Practitioners of traditional-style Chinese painting, once mostly amateurs, are now all thoroughly professionalized. But in today's society, a chronic shortage of commodities plays the role that restrictions on capital once did in dynastic China. Today as in the past, the artist produces his own currency, and while he is often without much money, he is never without a basis of exchange for such varied needs as political protection or charcoal for the kitchen stove. China's patrons of the spirit, its Daoist and Buddhist temples, have also survived after an uncertain hiatus as institutional patrons of the arts, and in the traditional fashion, today's artists still reciprocate by serving as the temple's financial patrons.

Issues like these are woven into the texture of Li's career and appear throughout this book, justifying its interest to the traditional-minded. When Li Huasheng is asked how he compares the social roles of Chinese art, past and present, before and after the advent of socialism and its many reforms and revisions, he replies (cynically, perhaps, but more seriously than not): "Then they painted by candlelight; now we have electric lights." A fuller assessment of historical continuities and discontinuities remains to be undertaken elsewhere. Yet clearly, in this and other ways, contemporary and traditional Chinese artistic studies are not separate areas of research. They are parts of a continuum; each helps us better to understand the whole.

In this book, the selection, organization, and interpretation of materials and the writing were my own responsibility. The interviews and many aspects of the research, however, were conducted jointly with my graduate student, Mr. Gong Jisui, who is on long-term leave as lecturer in aesthetics at the National Conservatory of Music in Beijing. This book would scarcely have been possible without him and his personal familiarity with the contemporary

artistic scene in China. Ours has been a thoroughly enjoyable case of mutual education, Chinese and Western.

Li Huasheng's personal contribution to this project is made clear in the Preface and cannot be adequately credited. In addition to Li, many others in China have contributed time and energy. In Chengdu, contributors include Li Shaoyan, chairman of the Sichuan Provincial Artists Association, and Qian Laizhong, director of the Sichuan Provincial Cultural Bureau. From Li's current unit, the Sichuan Provincial Academy of Poetry, Calligraphy, and Painting in Chengdu (afterwards called the Academy, or the Sichuan Painting Academy), director Yang Chao has given this project the benefit of his wisdom and his strong support. So, too, have printmaker, carver, painter, vice-chairman of the Sichuan Provincial Artists Association, and Academy vice-director Lü Lin; printmaker, painter, vice-chairman of the Sichuan Provincial Artists Association advisor Wu Fan; the Academy's secretary-general and Party secretary Liao Jiamin; office director and painting member Guo Ruyu; and painting members of the Academy, Dai Wei, Liu Pu, Peng Xiancheng, Qin Tianzhu, Yuan Shengzhong, Zhang Shiying, and Zhou Ming'an. Other contributing Chengdu painters include Tan Changrong, member of the Chengdu Sichuan-Style Opera Company and honorary painting instructor of the Chengdu Painting Academy; Tan Tianren, director of the Painting Gallery of the Du Fu Thatched Hall and honorary painting instructor of the Chengdu Painting Academy; and He Jidu, vice-director of the Chengdu Painting Academy. Additional contributors from the Chengdu area include Ai Weiren, deputy political commissar for the Chengdu Military Region; Fu Zhitian, abbot of the Shangqing Daoist Temple on Mt. Qingcheng near Chengdu, and vice-chairman of the Chinese Daoist Association; Deng Zhongcheng, director of the Chengdu Hall of Culture and History (Wenshiguan); Zheng Yongkang, general-secretary of the Wenshiguan; Chen Zihan, division vice-director of the Wenshiguan; Feng Duanyou, chief of the Architectural Planning Office in Damian Village, near Chengdu; Yan Zhengguo, manager of the Sichuan Provincial Antique Store; and Chen Gang, manager of the Chengdu Hotel Art Shop.

In Chongqing, contributors include: Li's father, Li Weixin, and his younger brother, Li Jiawei, a journalist; printmaker Niu Wen, chairman of the Chongqing Artists Association and vice-chairman of the Sichuan Provincial Artists Association; Bai Desong, chairman of the Chinese Painting Department at the Sichuan Academy of Fine Arts and honorary member of the Sichuan Painting Academy; Lü Chaoxi, chief of the administrative office of the Sichuan Mu-

nicipal Federation of Literary and Art Circles; former art teachers of Li Huasheng, Yu Jiwu and Guo Manchu (both retired instructors of the Chongqing Arts Hall, Yu Jiwu still serving as an administrative officer), and Du Yongqiao (in 1991 a painting instructor at the Sichuan Academy of Fine Arts); painters in Li's "small-circle" of long-time friends, Zhang Fangqiang (now a set designer for the Chongqing Beijing-Style Opera Company), Zeng Weihua (now a salesman and no longer a professional artist), An Weinian (now an advertising designer for a fruit and nut company), and Wang Guangrong (now an art designer for the Chongqing television station); Chen Chonggeng, a Chongqing calligrapher; former classmates of Li's at the Yangzi River Shipping School, Guo Shihui and Jiang Fanggui (both now Shipping School staff members); Yuan Guanghou, a Chongqing-based journalist for the New China News Agency; and Mme. Xiao Banghui. Several painting associates of Li Huasheng's teacher, the late Chen Zizhuang, have also contributed greatly with sincere generosity, including Professors Zhang Zhengheng and Liu Han of the Central Academy of Minority Studies in Beijing, and Professor Chen Zhidong of Sichuan Normal University in Chengdu.

In America, among those who were kind enough to read all or part of this text with care and to suggest corrections and improvements, or who otherwise offered much-needed information and timely assistance, are Professor Michael Sullivan, St. Catherine's College, Oxford University; Professor Julia Andrews, Ohio State University; Professor James Cahill, University of California at Berkeley; Professor Jason Kuo, University of Maryland; Dr. Lucy Lim, Chinese Culture Foundation of San Francisco; artists C. C. Wang (Wang Jiqian) and Gu Wenda of New York City and Walter Hahn of Pleasantville, N.Y.; Dr. Clyde Wu, Dearborn, Michigan; Professor Kenneth DeWoskin, University of Michigan; David Shrensel, University of Washington art history graduate student; Jo Nilsson, director of visual services, University of Washington School of Art; Yeen Mei Wu, assistant librarian, East Asia Library, University of Washington; and master photographer Johsel Namkung of Seattle.

I would like to thank all those who graciously granted permission for their works to be illustrated here or who have provided photographic materials, among them the C. C. Wang family in New York City, Murray Smith of Los Angeles, Elton B. Stephens of Birmingham, and the Chinese Culture Center of San Francisco, together with those who preferred to remain unnamed.

Support for research and materials was generously provided by the University of Washington Graduate School Re-

search Fund, and by the Chester Fritz Fellowship and the China Program of the University of Washington's Jackson School of International Studies. Generous publications support has come from the Henry M. Jackson Foundation, in cooperation with the Jackson School of International Studies, from the National Endowment for the Humanities, from the Hanart TZ Gallery of Hong Kong, and from Dr. Clyde Wu of Dearborn, Michigan.

Finally, I would like to express my deepest gratitude to those at the University of Washington Press who helped make this book possible and provided its final form; especially to Donald Ellegood, director, and Naomi Pascal, editor-in-chief, for their enthusiasm and staunch support; to Veronica Seyd, production manager, for the tasteful design and for her gentle toleration of an author's meddling; and to Gretchen Van Meter for a truly wonderful job of editing.

The Pinyin system of transliterating Chinese characters has been used for this text. In order to achieve internal consistency, most quoted materials that originally used Wade-Giles or other systems have been converted here into Pinyin. Excluded from conversion in this fashion are the titles of published books and articles, as well as the names of Chinese individuals living outside of China who have chosen to spell them otherwise.

JEROME SILBERGELD
Seattle 1992

Contradictions

Our People's Government is one that genuinely represents the

people's interests; it is a government that serves the people.

Nevertheless, there are still certain contradictions between the

government and the people. These include contradictions among

the interests of the state, the interests of the collective and the

interests of the individual; between democracy and centralism;

between the leadership and the led; and the contradiction arising

from the bureaucratic style of work of certain government

workers in their relations with the masses. All these are also

contradictions among the people.

—Mao Zedong, *"On the Correct Handling of Contradictions*

Among the People"[1]

Contradictions

Artistic Personality and the Socialist State

Individuality of expression is the beginning and end of all art.

—Goethe, *Sprüche in Prosa* [*Maxims*]

A revolution is not a dinner party, or writing an essay, or

painting a picture, or doing embroidery; it cannot be so refined,

so leisurely and gentle, so temperate, kind, courteous,

restrained, and magnanimous. A revolution is an insurrection,

an act of violence by which one class overthrows another.

—Mao Zedong, *"Report on an Investigation of the Peasant*

Movement in Hunan," March 1927[1]

BORN IN 1944 AND BEGINNING TO PAINT IN 1949 OR 1950, Li Huasheng represents the first generation of artists bred and trained according to Mao Zedong's vision of politics and art. Not only in the years leading up to the Communist revolution in 1949 but throughout all of Mao's years in power, China was directed by the notions of revolution and "continuous revolution," by a relentless class struggle to achieve the Communist Party's salvationist political mission.[2] The years since Mao's death have seen a relaxation of struggle and even a theoretical renunciation of it,[3] yet the 1980s have been punctuated by repeated "rectification" movements organized by the Party. In the latter half of 1989, class struggle was called for once again. Throughout the life of Li Huasheng, the Party has defined the role of art, and this definition has been couched largely in political terms. It was Mao Zedong who personally provided the Party's general guidelines for the arts, and while his strict definition has been relaxed, Mao's view of art continues to hover over every practicing artist in socialist China today.

Li Huasheng, however, has never been a typical Chinese artist. In the early 1960s, when the Cultural Revolution was still just brewing and Maoism had not quite moved into its most radical phase, Li painted realism, not "socialist realism" (fig. 6). When the Cultural Revolution exploded, Li Huasheng began painting in secret, practicing styles and subjects from the prerevolutionary past which were based on unacceptable models rather than an officially promulgated standards (figs. 36, 37). While also publicly producing propaganda works according to the government line (figs. 8, 9, 10, 11), Li was never personally interested in revolutionary art. His foremost interest has been in traditional Chinese painting, "literati" painting. To China's revolutionary politicians, literati painting was steeped in and forever identified with the prerevolutionary feudalistic aristocracy, with their philosophical elitism and their Confucian notions of individualism.

This traditional art form that Li has chosen to practice was

for long periods of time considered "contradictory" to the norms of the Chinese socialist revolution. That is to say, it represented literati ideals that were held to be mutually exclusive with socialist conditions, ideas, and practices. These two sets of values were opposed like the familiar "theses" and "antitheses" of Hegel's dialectic, the dynamic force of which drives history ever forward, necessitating a final resolution. The dialectical opposition of such theses and antitheses is vividly rendered in Maoist terminology by the phrase "*maodun*"—translated literally as the opposition of a "spear-and-shield," or less graphically as "contradiction."[4]

The traditional literati mode of Chinese painting has passed through alternating periods of limited acceptability and total disfavor since the Communist revolution in 1949. Just *how* contradictory traditional painting was held to be depended on the cultural politics of the moment and on the changing nature of its practice. Before the Hundred Flowers Movement of 1956–57, it was tolerated but discouraged nevertheless by a variety of means in China's newly reformed art academies. In the Hundred Flowers period, designed to win China's intellectuals to the socialist cause by nonforceful means, Mao Zedong promulgated his famous notion of two different forms of contradiction. As Mao (and his official editors) wrote, "We are confronted by two types of social contradictions—those between ourselves and the enemy, and those among the people themselves. The two are totally different in their nature."[5] Contradictions between the people and the enemy, Mao claimed, were "antagonistic" or counterrevolutionary and could only be resolved through revolutionary hostility. Contradictions among the people, however, were said to be "nonantagonistic," meaning correctable through criticism and "struggle,"[6] and these included "contradictions among the interests of the state, the interests of the collective and the interests of the individual; between democracy and centralism; between the leadership and the led."[7] Practically speaking, this abstruse notion softened the standards of cultural toleration. Writers and teachers wre urged to try things out; if they were wrong, they would be gently corrected.:

> We cannot compel people to give up idealism, any more than we can force them to believe in Marxism. The only way to settle questions of an ideological nature or controversial issues among the people is by the democratic method, the method of discussion, of criticism, of persuasion and education, and not by the method of coercion or repression.[8]

As a result of this attitude, literati painting became somewhat more tolerable and less readily assailable than before. At the time the speech was originally delivered to a private, official audience, in February 1957, "contradictions between the leadership and the led" implied that mistakes could be made by government officials. By the time this speech was finally published (and heavily edited), four months later, the Hundred Flowers Movement had turned into the Antirightist Rectification Campaign, the onus was transferred to the people, and the reading of "contradictions among the people" was that good socialists had to become wary of "newly emergent cleavages in socialist society,"[9] a sobering notion not previously acknowledged by Chinese socialists.[10] Even as broader justification was being provided for the teaching of literati painting in China's leading academies, numerous literati painters were being sent off to the countryside for labor reform.[11]

During much of Li's painting career, the practice of traditional Chinese painting was regarded as evidence of a contradictory ideological stance, of putting individual interests ahead of the collective interest and resisting the centralist leadership of the Communist Party. Since the same art was considered acceptable in one period and not acceptable in another, most artists changed their styles as rapidly as they were able to perceive the changes in the Party's official line. If they remained true to the Party line, then over time they contradicted themselves and their art; if true to themselves, they contradicted the Party. Contradictions are traps: only a relatively small number of artists have ever determined to remain true to their own art, to spare it the continual change of Party-line directives, as Li Huasheng has tried to do. Fewer artists still have succeeded at this, at snaring the bait of self-determination without being trapped by the contradictions.

The lives of Li Huasheng and of thousands of Chinese artists are steeped in contradictions, of both the Hegelian-Marxist-Maoist vintage and the nonideological garden variety. Like artists everywhere, they are regarded as men of unusual talent. It is often said that socialist governments like China's value their artists far more greatly than do capitalist governments, because they realize the propaganda potential of art. While the capitalist artist is viewed as a decorator, as a generator of consumer goods that are prized for their "surplus value," the socialist artist is recognized as a political voice and a moral force. And yet, for just these same reasons, artists and art in socialist China are forever suspect and painstakingly controlled. Artistic individuality is limited or denied. The artist's voice cannot simply be his own. The moral standards by which his life is judged are not his to fix nor even to stabilize.

Before 1949 in China, only a small number of China's artists—those working in the imperial atelier—were *ever* as

bureaucratized as *all* artists are today is the socialist state. Imperial Chinese governments, despite a long history of censoring literature, seem never to have engaged significantly in the censorship of visual arts. There were, to be sure, isolated incidents of painters getting into trouble for works made at the royal court, but all seem to have been cases where particular works were used as vehicles for carrying out some personal vendetta. The works themselves did not directly cause difficulties; even those artists known to have painted antigovernment subject matter, as in the early years of Mongol and Manchu rule, seem never to have gotten into trouble for so doing. If a Chinese painter found the constraints at court distasteful, he was always free to leave, to parlay his reputation there into financial success back home, and to paint in private whatever pleased him or his patrons. The earliest major examples of government repression in the visual arts are modern, beginning with warlord Sun Quanfang's attempt in 1926 to thwart the introduction of Western-style nude models, and including Jiang Kaishek's brutal suppression of socialist printmakers in the 1930s. But such fascist violence was crude and sporadic compared with the subtle and pervasive system of control devised by China's communist rulers.

The socialist system of cultural control in China bears little relationship to the popular image of hard-fisted censors, of bureaucrats who know only politics and little of art and who are readily identifiable by artists as outsiders or as enemy intruders. In fact, art censorship as the suppression of completed works of art has scarcely existed in socialist China and has been limited to certain radicalizing moments in time. Rather, the entire system has been conceived of as benign and has been couched in terms of education, helping artists to understand what is expected of them so that they might avoid anything which could cause trouble. The goal has been to create compliance and thereby to prevent forcible intervention. The government has held a virtual monopoly on the regulation of public arts, channeling all the activities of artists through state-run agencies; until recently at least, there has been no "private" realm of the arts, and the Chinese socialist artist has been a government servant or else not an artist at all. Yet much of the task of artistic control has been placed in the hands of the artists themselves, in a kind of "do-it-yourself" system.

The regulation of public art in socialist China has been conducted largely by the national, regional, and local artists associations, which encourage and monitor artistic activities, production, and exhibition. In theory, the associations are organized "from the bottom up," by the members themselves. They are designated as "organizations of the masses," that is, voluntary. And, indeed, no one is compelled to volunteer. But the prescribed rules come clearly "from the top down."[12] Down below, members play an active role in carrying out the careful screening and selecting of new members, and of helping to apply to the arts those views promulgated from above. In each unit, works are subjected to mandatory critical reviews by all members, and artists are expected to attend weekly, twice-weekly, or daily self-criticism sessions. Above each unit lie layer upon layer of other bureaucratic units that also carry out constant reviews of the art and artists. Each work of art accepted by the unit or approved by some higher unit for a broader public function (for exhibition, publication, or study) may be thought of as a group work—designed by committee. Only association members can exhibit and participate in association-sponsored activities in China. Membership in associations at all levels is tightly limited and carefully considered, both in terms of candidates' artistic potential and their political attitudes and behavior.

The creation—and appreciation—of art in socialist China differs considerably from the commercialized patterns familiar to Americans and western Europeans. The modern apotheosis of individual artistic creativity in the West (exemplified by Goethe's statement: "Individuality of expression is the beginning and end of all art"), is as far removed from the Communist Party's theory of aesthetics as Mao's proverbial dinner party and his "painting of a picture" are from a revolution.[13] Chinese socialists, instead, view artists mechanically, as "cogs and wheels." The correct guidelines for defining artistic standards have been taken to be Mao Zedong's instructions in 1942 at the Yan'an Forum on Literature and Art, a seminal moment in modern Chinese cultural history.[14]

In May 1942 at Yan'an, in order to rectify the outlook of the Chinese Communist Party's writers and artists and to forge a new unity of viewpoint, over two hundred writers and artists were called to participate in a Party forum on literature and art. Mao's ideological mission there was to transform any left-leaning liberalism and lingering individualism into the collective service of revolutionary political ends. His practical imperative was to deliver control of literature and art, once in the hands of the writers and artists themselves, into the centralized management of the Party. It was Mao himself who devised the Party's aesthetic ideology. His seizure of control over literature and the arts marked his final consolidation of personal authority within the Communist Party. While the conference was promoted as "an exchange

of views," only the words of Mao Zedong have been recorded for history: "Mao's voice, which rose above and silenced the debate, had perhaps never [before] carried so much authority."[15]

The logic of Mao's pronouncements on literature and the arts is so clearly revealed that his argument seems almost self-evident. He states at the outset just where he is headed:

> The purpose of our meeting today is precisely to ensure that literature and art fit well into the whole revolutionary machine as a component part, that they operate as powerful weapons for uniting and educating the people and for attacking and destroying the enemy, and that they help the people fight the enemy with one heart and one mind. What are the problems that must be solved to achieve this objective? I think they are the problems of the class stand of the writers and artists, their attitude, their audience, their work and their study.[16]

Mao gave precedence to the redefinition of artistic function, transforming petty-bourgeois "art for art's sake"[17] into a tool for mass reeducation. He paid special attention to identifying the proper audience: once understood in the literati tradition as the artists' fellow intellectuals, the audience for art was now redefined as the masses. Above all, Mao Zedong left no doubt about the subservience of art to politics: "Revolutionary literature and art are part of the whole revolutionary cause; they are cogs and wheels in it."[18]

The value of art in modern capitalist societies is said by socialists (as well as iconoclastic Western critics) to lie in its impracticality and inherent uselessness, from its surplus or luxury value.[19] But in Mao's realm, its value derived from revolutionary necessity. From this notion came a heightened esteem and concern for artists—although only for those who could hew to the new specifications prescribed for their work:

> Writers who cling to an individualist, petty-bourgeois stand cannot truly serve the masses. . . . No revolutionary writer or artist can do any meaningful work unless he is closely linked with the masses, gives expression to *their* thoughts and feelings and serves them as a loyal spokesman.[20]

While the re-identification of audience is central to Mao's aesthetic thought, effectively steering socialist art toward its new function, it is not simply up to the artists to determine what the new mass audience wants or needs to see. Rather, artists are regarded as creative agents of the Party in its process of mass political education, and the Party itself must define these matters for the artists. The function of artists must be regularized and their art "engineered" rather than

spontaneously created. Later on, Mao would regularly refer to his artists as "engineers of human souls," a term he borrowed from "Comrade Stalin," whose coldly manipulative imagery has a chilling effect on most Western readers.[21]

Once the matter of proper audience was settled at this forum, most other issues were pursued with an inexorable logic. Prescribing appropriate subject matter became a simple issue:

> The life of the people is always a mine of the raw materials for literature and art, materials in their natural form, materials that are crude, but most vital, rich and fundamental; they make all literature and art seem pallid by comparison; they provide literature and art with an inexhaustible source, their only source.[22]

In the practical realization of this philosophic doctrine, the modern Western world's notions of art—particularly abstract art (lacking reference to the life of the people, with no subject matter other than its own formal style) and nude painting (unrealistic, since most people do not go about naked, and immoral, since they should not)—with which many Chinese artists had flirted in the 1930s and 1940s, were treated as solipsistic exercises and were precluded from the socialist idiom. Figure painting, instead, would once again be brought to the forefront of Chinese painting. This emphasis reversed the preference of the last thousand years of Chinese art for idealized landscape settings, to which Confucian bureaucrats had fled in their minds from the distasteful realities of court politics. Ironically, it restored things to the way they had been when the imperial courts last dominated the production of Chinese art.

But for most traditional Chinese artists, style more than content has been the crux of art. For Mao (who knew and cared greatly about China's traditional poetry, but not so much for its painting),[23] this subtle matter posed greater difficulty. He defined the issue of style dialectically, in terms of comprehensibility to the masses: "popularization" (*puji*), which admits of being a lowering of standards, versus the "raising of standards" (*tigao*).[24] Mao's aesthetic, avoiding Hegelian exclusion, defended the need for both but held out a clear priority for popularization:

> We must popularize only what is needed and can readily be accepted by the workers, peasants and soldiers themselves. . . . Only by starting from the workers, peasants and soldiers can we have a correct understanding of popularization and of the raising of standards and find the proper relationship between the two.[25]

What "popularization" meant to Mao was this:

Although man's social life is the only source of literature and art and is incomparably livelier and richer in content, the people are not satisfied with life alone and demand literature and art as well. Why? Because, while both are beautiful, life as reflected in works of literature and art can and ought to be on a higher plane, more intense, more concentrated, more typical, nearer the ideal, and therefore more universal than actual everyday life.[26]

This incomparable richness of life "on a higher plane," this more-typical-than-typical, is Mao's anticipation of "revolutionary romanticism," the smiling counterpart of "socialist realism."[27] It signifies that the "realism" of "socialist realism" should not be understood in terms of *actual* reality (which Mao referred to derisively, in socialist parlance, as "naturalism"). It instead means an "intensified" realism—in other words, idealism and not realism at all. "Popularization" makes the heroes more heroic, the villains more villainous, the contrasts more extreme. "Popular art" is unambiguous, comprehensible to the audience, designed "to awaken the masses, [to] fire them with enthusiasm and impel them to unite and struggle."[28] To better understand the life of the masses, artists would later be sent out regularly for "realistic sketching," the "scientific" thing for a Marxian "scientific materialist" artist to do. But in the process of producing paintings from sketches, observable reality had to be transformed into a vision of future reality, and pure science had to be superseded by political theory.

Of all issues dealt with in his Yan'an Forum talks, the one given the most extensive consideration by Mao was this matter of stylistic popularization. Its opposite was the raising of standards. Both of these artistic directions had their time and place, and socialist art in China historically has seemed to rock back and forth between the two. But art could also go in a third direction—an improper direction. Such art, said Mao, was "unpopular" in that it was "hard for the masses to understand." Whatever the masses could not understand, or whatever would be "unpopular" with the masses, artists should not portray. It was clear in Mao's mind in 1942 that one of the things the masses could not comprehend was internal criticism, any criticism directed against the Party itself rather than outward at the enemy. The masses' "incomprehension" was a censorial shield with which the Party could defend itself. A critical reading of Mao's *Talks at the Yan'an Forum* suggests that a considerable quantity of such inwardly directed criticism was then being produced by the Party's liberal writers. Mao attacked such writing, framing it dialectically in terms of "bright" and "dark":

"Literary and artistic works have always laid equal stress on the bright and the dark, half and half." This statement contains many muddled ideas. . . . Living under the rule of the dark forces and deprived of freedom of speech, Lu Xun used burning satire and freezing irony, cast in the form of essays, to do battle; and he was entirely right. We, too, must hold up to sharp ridicule the fascists, the Chinese reactionaries and everything that harms the people; but [here], where democracy and freedom are granted in full to the revolutionary writers and artists and withheld only from the counter-revolutionaries, the style of the essay should not simply be like Lu Xun's. Here we can shout at the top of our voices and have no need for veiled and roundabout expressions, which are hard for the people to understand.[29]

Mao's peculiar logic holds that where there is freedom, there is no particular need for its practice. Subjecting the Party to the subtle exercise of unlimited free speech would not be understood by the people. "We are not opposed to satire in general," Mao told the Yan'an Forum participants. "What we must abolish is the abuse of satire."[30] Lu Xun, was extolled by Mao as the model socialist writer (and by the Party to this day, although he never joined the Communist Party and stood unswervingly for artistic individuality). But now the model Lu could scarcely be followed, for he dealt in artistic darkness and spared no one his critical barbs.

Satire is associated with elevation, not with popularization. Socialist realist art included the "bright" and "abolished the "dark." The fundamental threat of "satire" (to use the term loosely, as Mao did) is discussed in the context of its bright alternative, socialist realism, by the dissident Hungarian critic Miklós Haraszti, in his dark-humored account of state-directed socialist art in Eastern Europe, *The Velvet Prison:*

As Marx put it in a famous exhortation to philosophers: the task is not just to understand the world but to change it. So too with artists. "Socialist realism" is more than mere faithfulness to reality: it contributes to reality; it creates reality. . . . There is, in fact, only one taboo: the recognition of a *variety* of realities is forbidden, including any separate reality of one's own. "Realism" operates this way not because it does not wish to know about reality. You do not need much theoretical training to realize that there can be no "real" reality when there are many realities.[31]

Two final issues were dealt with by Mao at the Yan'an Forum in 1942. The first of these, in the realm of painting, grew out of a conundrum: the basic stylistic alternatives which history made available to artists at that time were those of traditional Chinese art and Western-style art. Each

of these was tainted ideologically, the former with its feudal-istic origins, the latter with European bourgeois associa-tions. Yet art cannot be born out of nothing, and Mao had no option but once again to avoid exclusion and to accept cau-tiously the possibility of influence from both sources:

> We must take over all the fine things in our literary and artistic heritage, critically assimilate whatever is beneficial, and use them as examples when we create works out of the literary and artistic raw materials in the life of the people of our own time and place. . . . We must on no account reject the legacies of the an-cients and the foreigners or refuse to learn from them, even though they are the works of the feudal or bourgeois classes.[32]

Other sources also existed as potential models for develop-ment, including European and Soviet socialist arts, print-making and sculpture as well as painting. These were not ideologically contaminated, but the very fact that they were foreign would from time to time be detrimental to their influence. Finally, there were the traditional Chinese folk arts, however limited they might have been in their own historical development. Much of the time, Mao seemed to favor those theories and programs intended to cultivate in-digenous "national forms," although there were those who argued that all such forms, whether elite or popular, were similarly feudalistic and that traditional folk art provided no class consciousness upon which to build.[33] Still, those too much disposed toward a program of cultural modernization along internationalist lines found themselves imperiled. But for the greater part, Mao only defined the terms of battle, leaving unspecified the details of how to undertake this selective borrowing. The question of how to establish an ideologically correct art on the basis of these various alterna-tives became a vexing, ultimately unresolvable problem in socialist arts administration. How this struggle was played out historically will be dealt with at the end of this introduc-tory chapter and throughout the remainder of this book.

The last of Mao's topics was the distinction between con-tent and style, on the one hand, and artistic quality, on the other; for Mao not only recognized the difference—wrong content or wrong style did not make for bad quality—but he was also well aware of the dangerous political potential of high-quality art that promoted incorrect content or style.[34] A remarkable, and perhaps un-Marxian, admission was there-fore offered that "politics cannot be equated with art, nor can a general world outlook be equated with a method of artistic creation and criticism."[35] On this issue, Mao again chose to close his line of reasoning with an inclusive balance rather than an exclusive decision:

> What we demand is the unity of politics and art, the unity of content and form, the unity of revolutionary political content and the highest possible perfection of artistic form. Works of art which lack artistic quality have no force, however progressive they are politically. Therefore, we oppose both works of art with a wrong political viewpoint and the tendency towards the "poster and slogan style," which is correct in political viewpoint but lacking in artistic power. On questions of literature and art we must carry on a struggle on two fronts.[36]

Thus were the literary and artistic aesthetics of the social-ist state prescribed. After the Yan'an Forum in 1942, socialist aesthetics were no longer the individual artist's to deter-mine. The Party determined, and the artist simply fulfilled. Artists were not called upon to vent their own feelings. That was a role left to Western capitalist artists, whose visual manifestations of *angst*, generated by poverty and loneli-ness in their lifetime, become such a valued commodity among the wealthy and socially prominent after their deaths. Socialist artists were meant instead to express the thoughts and feelings of the masses, as interpreted for them by their ultimate supervisory agency, the Communist Party Propaganda Departments.

Beginning in 1949, the Communist Party established a centralized network of agencies—artists associations—at the national, provincial, and municipal levels for the regula-tion of artists work, to help bring about Mao's calls for unity of art and politics, for unity of revolutionary form and high quality. For much of the time between 1949 and the present, artists associations have managed most exhibitions of con-temporary Chinese art. The associations have also been the government's main conduit for stimulating the arts, provid-ing financial and organizational aid for a range of activities, bringing artists together for exhibitions' symposia, thematic study sessions, and various such events.[37]

Art sales, until the mid-1980s, were exclusively managed by local antique stores under the control of the Bureau of Cultural Relics, itself a direct subordinate of the State Coun-cil (Guowuyuan). But before 1979, sales were limited to antiques. Contemporary artists were not expected, or al-lowed, to sell their work. By government design, they had no market whatsoever for their art, so that their work could be done in the service of politics rather than in pursuit of capital.[38]

The national-level Chinese Artists Association is super-vised from above by the Chinese Federation of Literary and Art Circles (*Zhongguo Wenxue Yishu Jie Lienhehui*; Cultural Federation or *Wenlian* for short), where the association of visual artists is joined by parallel associations of writers,

dramatists, musicians, and dancers.[39] This umbrella association, in turn, is controlled by the Communist Party Propaganda Department, a unit of the Party Central Committee.[40] Before the functional demise of the Cultural Federation (and with it, the artists associations) in the early Cultural Revolution period and after its reorganization in 1977, this control was facilitated by placing Propaganda Department personnel in the association bureaucracy.[41] The Ministry of Culture was also assured a voice in administering the associations before the Cultural Revolution through similar overlapping placements of its officials, but in the reorganization of the late 1970s, Ministry of Culture representation was reduced, purportedly to reduce bureaucratic interference in the work of artists and other cultural workers.

Over the decades, China's ideologically directed artists associations and its more pragmatic art academies, as well, have effectively discouraged independent artists and independent artwork. It is quite as Miklós Haraszti put it, sardonically, in the case of Hungary:

> Artists are educated to be unable to create anything unpublishable. . . . Open resistance to the state is seen as professional cowardice. . . . When the state is charitable, artists will try hard not to give offense. Generosity from on high will be matched by docility from below. . . . The state need not enforce obedience when everyone has learned to police himself. . . . The figure of the independent artist is now to be found only in the waxworks museum, alongside that of the organized worker. Independent art is impossible because there is no independent audience. . . . The choice available to me is not between honest and lying art, not even between good and bad art, but between art and non-art. . . . There are only writers and nonwriters, not a variety of writers. . . . I must grow into my role. . . . If the expression of my artistic consciousness is made public, this will have happened only because I have employed a coauthor: the state. My audience knows that I am a permitted author with a permitted message. . . . All my creations are based upon a set of axioms; my aesthetic explorations are variations of acknowledged truths.[42]

None of the features of Chinese socialist aesthetics provides much support for the development of personal artistic expression as (in Goethe's words) "the beginning and end of all art." And what the socialist aesthetic fails to proscribe in theory, its practical application has even further suppressed. Perhaps the strongest disincentive in practice to the development and expression of individual personality has been the simple lack of ideological consistency, the constant change of the Party's political "lines" and its alternate "tightening" and "loosening up" of the degree of political control. Historically, there has been an endless succession of shifting phases and phases-within-phases. The more radical periods have been dominated by Mao (from 1942 to 1959) and Mao in concert with his wife Jiang Qing (1966–76), balanced by moderate periods under the auspices of Liu Shaoqi (1956–66, or especially 1961–63) and Deng Xiaoping (1978 to the present). Microphases have included Mao's wavering between "letting a hundred flowers bloom" (in 1956–57) and his massive anti-rightist purge (beginning in June of his so-called Second Liberation, persisting from 1978 until the spring of 1989) and "cold" (a succession of intellectual rectification movements, including the suppression of the democracy movement in 1979, followed by a campaign against "bourgeois liberalism" in literature and the arts in 1980–81, the anti-Western "Campaign Against Spiritual Pollution" of 1983–84, in which Li Huasheng became a negative model and major target in his home province of Sichuan, and the campaigns following suppression of student democracy movements in 1985–86 and 1989).

This inconsistency alone has caused most artists not to venture forth, for yesterday's acceptable art might become a basis for today's recriminations.[43] Entrance into a government-established artists association is extremely competitive, but once achieved, the artist's tenure there is relatively secure. (Socialist policies divorcing job security from productivity have produced what the Chinese refer to as the unbreakable "iron rice bowl.") Tenure is risked only by one's doing something out of the ordinary, something that will attract criticism, something individualistic; it is threatened only by the sheer irrationality of uncontrollable external events. Since "politics cannot be equated with art" (Mao), and since recognition requires some purely artistic achievement, at least initially, artists have typically ventured forth just enough to establish a reputation and to secure for themselves government patronage, but then they have taken no artistic risks, turned no artistic corners, and gone no farther for fear of going too far. A lasting reputation is usually secured by popularizing one's art rather than by elevating it, with the usual result of its becoming sweet in a way that is cloying to educated tastes, whether Chinese or Western.

Artists who risk the security of their current reputation in pursuit of enduring artistic accomplishment, who resist the sweetness of popular taste for the self-expressive ruggedness and understatement traditionally valued in Chinese literati art, who submit to new artistic challenges in order to turn a series of stylistic corners (a must for major historical acclaim), or who dare to explore a variety of subjects or media: such artists are rarely found in China today. Today, first-rate mainland Chinese artists are so rare that a number

of Western experts view the tradition as being best served by "expatriate" Chinese, living outside of the People's Republic and free of its ideological distress.[44] These artists are exemplified by Yu Chengyao (b. 1903), Chen Qikuan (b. 1921), He Huaishuo (b. 1941), and Liu Guosong (b. 1932) in Taiwan; Fang Zhaolin (b. 1914) in Hong Kong and London; Zao Wou-ki (Zhao Wuji, b. 1920) in Paris; Zhang Daqian (Chang Dai-ch'ien, 1899–1983) in Taiwan and North and South America; C. C. Wang (Wang Jiqian, b. 1907) in New York; and Tseng Yu-ho (Professor Betty Ecke, b. 1925) in Honolulu. C. C. Wang has said:

> There are very many good painters in China. They're skillful, and they have the talent. They *could* be great, but they aren't. I don't think they can achieve greatness because they have such a limited environment. Too much is demanded by the public, whose standard is very low. Everybody wants to be popular. I haven't seen any mainland Chinese artist who still has the eremitic idea of the past, who doesn't care about popularity, who lives in the mountains and paints for himself.[45]

The lives of those artists gone to the West, or at least gone Western, represent the other side of the mirror of Chinese painting in the second half of the twentieth century.[46] Yet the suppression of artistic personality found in the Maoist aesthetic, when posed against the alternative of artistic individualism, is by no means simply an East-West dichotomy. It demands a chronological perspective as well. Miklós Haraszti reminds his readers of a time when art in the West was not much different:

> Socialist art . . . gravitates not toward [artistic] autonomy but toward the message. Because it is the social influence of such art that [socialist] aesthetics considers quintessentially artistic, the artist needs "outside" direction. Critics condemn this need as antiartistic. But they are wrong. For the first time since the Christian Middle Ages, the public spirit of art is released by this need. . . . Only in [a] planned society, a society owned by the state, will art achieve such an exalted stature.[47]

But then, neither is this suppression simply a dichotomy of old versus new, for in traditional times, China fielded two different painting systems simultaneously: court and street professionals were doing whatever was expected of them by their aristocratic and scholar-class patrons, while the scholar class itself was practicing a highly individualistic form of painting, as amateurs.

Today's Chinese artists are somewhat comparable institutionally to the imperial court painters. With court status came a degree of refined subservience in art. Those who managed to develop and get away with expressing some degree of individuality in art had little (or possibly even less) to show for it in their artistic lives. In the extreme case, the mid-eighth–century Tang emperor Xuanzong (Minghuang) formally decreed that his favorite painter, the individualistic Wu Daozi, could paint for no patron other than himself, illustrating the degree to which the government, if it chose, could control an artist.[48] But this case was exceptional, and in modern China, under the name of "democratic centralism," it is the past exception that has become something of a norm: all public painters are bound to work exclusively through government agencies, which exercise enormous influence in all artistic work assignments.

Miklós Haraszti brings up another comparison, that of commercial design in the West, where artists are assigned specific tasks and are often expected to work collectively, subjecting their designs repeatedly to external supervision until they have satisfied some project administrator. Haraszti asks, "How is this state of affairs different from socialism?" He answers, "Only to the extent that, under capitalism, the artist is free to resign and go to another company."[49]

Li Huasheng represents by temperament and choice a different kind of artistic personality from that prescribed by Chairman Mao. Li's sense of artistic individuality is in fact much closer to Goethe's than to Mao's. The sources of artistic personality are perhaps too complex to trace fully, but one can begin by noting the artist's social personality and situation, the outlook and character of the artist's local or regional domain, and the heritage of the artist's chosen models. In Li Huasheng's case, these three factors all point strongly in the same direction, piling one layer of individualism upon another.

Li's social personality, from early childhood on, has been nearly as dramatic, as intense as one ever encounters in China. It is more forceful even than his artistic personality, which in a sense is still young and in training. Li's native Sichuan adds a distinctive regional layer. The Sichuanese regional personality, consistent with Li's own, is as dramatic as the physical environment itself, as independent-minded as its geographic isolation and long history of functional semiautonomy in China might suggest. In terms of a selected painting course, Li has chosen to follow the most individualistic path, that of traditional literati-style painting, and within that, the most individualistic masters of the past tradition. In his personal choice of contemporary masters, too, Li has sought instruction from a heightened individualist, Chen Zizhuang. As a self-conscious individualist,

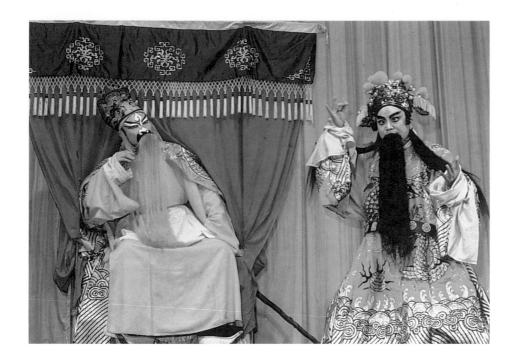

1. Li Huasheng on stage in Sichuan-style opera (seated at left).

Li Huasheng is especially aware of the pressures in modern Chinese society to conform and the consequences of not doing so:

> In socialist China, we emphasize common characteristics [*gongxing,* rather than *gexing,* individuality]. If you have a strong personality, it is terrible. You have to be consistent with central Party committee policy. So individuality is not possible. Not permitted. Not good. Being an artist, sure, it is very important to keep your personality and individuality, but this is an ambiguous matter. To stay even a little bit real isn't easy. You have to take care of both your ideas and your actual practice. In your practice, you have to maintain some idealism. But I cannot speak out about all of what I think in my mind. I cannot do all of what I want to do. Of course, it is not necessary to say that I am just a hypocrite, which is the kind of personality I most hate. But I still have to do things I don't want to do. If I really acted according to my own ideas, I would have been dead a long time ago. At least, I wouldn't be able to be a painter any more.

But Li has not conformed. His social personality, as revealed in the chapters that follow, might best be referred to as "theatrical." Far from hiding in the wings, and showing none of the reticence that has typified the Chinese public personality seemingly throughout historic times, Li Huasheng is overtly individualistic and ever ready to seize center stage. Not surprisingly, he has indulged in a lifelong love of his native province's Sichuan-style opera (*chuanju*), which is unrestrained, rowdy and hilarious by the standards of Beijing-style opera (*jingju*) or the *kunqu* opera style of the Wu region south of the lower Yangzi delta.

Li Huasheng's life ambition was to become a theater performer, and only his parents' refusal to let him sink so "low" led to the pursuit of painting as a substitute. Even as a youth, he led his neighborhood friends in a daily staging of operatic performances that gave vent both to his extroversion and to his visual imagination. Among his earliest paintings, from the age of five or so, were portraits based on his visits to Chongqing's opera theaters, and soon after came masks and puppets made for his backyard theater. Li's youthful urge to perform, his flair, and his ability to convince helped to shape a striking theatrical personality, which changed little in later years.

Perhaps I can best convey Li's persona by comparing him with someone else. In his delightful personal account of teaching and study in China, *Iron and Silk,* Mark Salzman describes his first encounter with China's former national champion martial artist, the charismatic Pan Qingfu:

> Pan looked fearsome, but what most distinguished him was that, when he talked, his face moved and changed expression. I had been in China for eight months, but thought this was the

2. Li Huasheng.

3. Li Huasheng pantomiming Sichuan-style opera.

first time I had seen a Chinese person whose face moved. Sometimes his eyes opened wide with surprise, then narrowed with anger, or his mouth trembled with fear and everyone laughed, then he ground his teeth and looked ready to avenge a murder. His eyebrows, especially, were so mobile that I wondered if they had been knocked loose in one of his brawls. He commanded such presence that, for the duration of his address, no one seemed to breathe.[50]

Li Huasheng's face moves like this (figs. 2, 3). He dominates the scene. Moreover, like Pan, he is martial and possesses *gong fu*, the "skill that transcends mere surface beauty."[51] In China, one does not put on such facial airs unless one has the talent to back it up. Pan's *gong fu* is expressed in martial arts, Li's in the art of painting; yet Li's painting is nothing if not an athletic exercise, a physical display of explosive social personality and firm cultural resolve.

Li's untrammeled personality, while not congruent with typical Chinese behavior, is nevertheless well supported by cultural tradition. For however demanding the Chinese have been about conformity, in past or present times, a certain toleration has always been granted to eccentrics. Indeed, slipping into madness, whether feigned or real, has long been an accepted mode of self-protection for the politically threatened Chinese bureaucrat. And in an artistic tradition where spontaneous or wild artistic execution was valued as the mark of natural creativity, unusually free and spontaneous behavior became the mark—or even the affectation—of many creative artists. That is not to say that a price was not exacted from those who adopted this behavior, but for those who found the constraints of social conformity too great to bear, the resulting social exclusion was a price worth paying. While a few eccentric artists in traditional times were truly mad, such as Xu Wei (1521–93), most were socially motivated in their deliberate cultivation of the "crazy" artist image, such as Wu Wei, Tang Yin, and Chen Hongshou of the Ming, and Bada Shanren (1625–after 1705).[52] It is fair to say that, in granting himself license to behave as he does, Li Huasheng is not only indulging his naturally nonconformist temperament but is also adopting a well-recognized and marginally acceptable guise, one calculated to enhance his standing with those sympathetic to artistic individuality even when offending others less tolerant of social deviation. And, of course, Li is no more alone in taking this risk today than he would have been one hundred or five hundred years ago; such recent or contemporary artists as Shi Lu (1919–82, who suffered true psychosis) and younger-generation artists like Yuan Yun-

sheng (b. 1937) and Gu Wenda (b. 1955) are his companions in this regard. Yet they are all exceptions.

In an authoritarian society, the adult Li Huasheng has scarcely been cowed by authority. In the few years of moderation during the early 1960s, "socialist realism" was obliged to share the stage with more traditional works, from both the Chinese watercolor and Western oil painting traditions. But most of these, even when attempting to slip the bonds of ideology, subtly embraced Chinese nationalist values and optimistic goals or risked criticism. Li was among those who chose to run that risk, painting just plain "realism" (fig. 6), employing subjects and styles that could readily be taken to imply that socialism wasn't working. And during much of the radical Cultural Revolution decade, after producing propaganda works on command in the daytime, he spent nights hidden behind a locked door, painting in forbidden, prerevolutionary styles (figs. 36, 37). In the mid-1970s, when all China was reeling from the unbridled repression and recriminations of the Cultural Revolution and retreating into a shell of sullen silence, Li sought out a painting teacher, Chen Zizhuang (fig. 21, among others), who was as outspoken as Li himself. Li was not at all deterred by the fact that Chen's relationship with the Nationalist Government before 1949 had made him a political pariah with whom it was politically risky to associate. In the late 1970s, as a propaganda artist for the Yangzi River Shipping Administration, when Li Huasheng's bosses made what he felt were condescending demands for his work or insisted on what he felt was more than their due, Li simply refused them, heedless of the inevitable consequences. In 1982, as a "youth artist" of rapidly rising stature, when Li was elevated to high office in his municipal artists association and vaulted over the heads of all his senior colleagues, he immediately went to battle against them, pitting his youthful vision against their entrenched conservatism. And when he was attacked on grounds of moral corruption in the national press during the Campaign Against Spiritual Pollution of 1983–84 and was put at the very risk of his life, he counterattacked and eventually launched a successful legal suit against one of the offending media (an approach rarely pursued in China). In 1984, as a result of these disputes, when Li was excluded from initial membership in Sichuan's newly established Provincial Academy of Poetry, Calligraphy, and Painting, even disinvited from its opening ceremonies and barred from participation in its inaugural exhibition, he arranged for a cross-town exhibition of his painting to be held at the same time, competing openly with the system. Waving the banner of his own work in public, he demanded that

the critics publicly compare his work with that of the Academy's new members, and with this he began boldly to win his way back from oblivion in the realm of Sichuan's artistic politics.

Chronologically speaking, Li was often "ahead of the curve" or at least on the "cutting edge" for his generation. In trouble with authorities as a student in 1963 and again in early 1966, Li had learned how to avoid trouble when the worst of it came, later in 1966. In 1982, when rejuvenation was the national theme and youth was everywhere being touted, Li was immediately projected from near anonymity to the forefront of authority in his local art circle, elevated above all but one of his superiors in the highly age- and stage-conscious artists association of his own municipality. By 1983, Li was a ready target for the anti-Western Campaign Against Spiritual Pollution. When travel to the West became possible again in the 1980s for a fortunate few—mostly students, which excluded Li—he was anxious to go examine art and artistic life abroad, finally visiting the United States in 1987. By the time he returned from America to a newly thriving and optimistic China, he had acquired a broadened social perspective that left him deeply depressed—as China itself would become two years later.

Li Huasheng's painting, like his behavior and personality, can hardly be seen as a fulfillment of Mao's aesthetic demands. Only in the 1980s have the bureaucratic strictures been relaxed enough to facilitate even official recognition of artists like Li. Most of Li's art has had no conscious political intent. But in China nothing is "independent of politics," and seeking to escape political consciousness is regarded as dangerous "liberalism." Li's art, therefore, has been subjected to constant political scrutiny both for what it does and does not do. In oil paintings, in the early 1960s, Li painted his hometown of Chongqing, the rugged Yangzi River port city, in natural terms (fig. 6). Although not meant to demean but rather to explore "another visual reality" with the appreciative eye of the artist, these unscrubbed works showed Chongqing perpetually dingy, still not cleaned up by socialism. Those who wanted to criticize the artist, and there were always some, could readily interpret such images as antisocialist. They could hardly be placed along side of the less politicized yet basically positive images tolerated briefly in the early 1960s. Instead they constituted, in Marxist eyes, the landscape equivalent of nudity, revealing parts not meant to be seen.

These paintings were but one aspect of the counterculture that Li and his individualistic "small-circle" of friends shared in the early 1960s. It already had them all in trouble

with Chinese authorities by 1963, a period of relative calm before the Cultural Revolution made trouble universal in China. During much of the 1960s and the early-to-mid 1970s, when radical artistic views were enforced with draconian rigor, and when pure landscape painting without figures was regarded as antisocialist, Li Huasheng became increasingly devoted to painting the pure landscapes of Sichuan (figs. 30, 32, 33). In the rural landscape, Li found emotional relief from the misery of regimented and dirty urban life. Li was not interested in the socialization of peasants or the modernization of the countryside, and he saw daily life going on much as it always had despite the Communist government's having removed and replaced the landlords. He painted peasants, but not smiling peasants (fig. 27), and he showed them working alone (figs. 28, 56) or in pairs (fig. 103), but only rarely in work brigades (fig. 44). His landscapes were naturally rustic, artistically plain, and not all powdered up or dammed-and-hydroelectrified like so many socialist realist–revolutionary romantic landscapes (fig. 32).

Although few of Li Huasheng's paintings were consciously political, some represented his private responses to particular social conditions. The fierce blackness of his *Night Rain in the Mountains of Sichuan* (figs. 70, 71) betrayed his resentment about ever deepening poverty in 1982, long after the first and even the second "Liberation" had promised to enrich all the people and their lives. In painting the seemingly unpeopled landscape of *Mt. Huang* (1980, fig. 52), to judge from the inscription (see p. 104, below) Li's mind was on inequality in socialist society (on what others have called China's "new elite" class) and on corruption in high places. This painting was exhibited prominently in Nanjing, and Li intended to hold it up to the critics in Beijing. But it was declared "inappropriate" for the occasion and withdrawn; there is no way to say whether some local art bureaucrat's unsolicited advice to withdraw it may have spared Li a great deal of unwanted trouble.

That his landscapes of city and rural countryside alike were shown unchanged by the socialist political presence displayed a bad ideological attitude. That his paintings were relatively abstract, as well, did not help matters. All these works ran counter to fundamental Party directions to some degree or another, and they threatened the well-being of their creator. In 1979, Li Huasheng produced a set of semiabstract "print-picutres" (figs. 38, 39)—landscapes perhaps, but without a single specific detail or politically redeeming trace of social life. He carried them to an artist's meeting in Beijing, but he finally restrained himself from sharing them

with anyone. Ironically, in 1983, when Li was finally subjected to a massive personal attack, the fact that his painted houses all leaned "this way and that" (figs. 63, 65), unlike the "upright" architecture of socialism, became a major issue. Yet none of these particulars, just mentioned, or others like them were noticed.

Li Huasheng's social personality is, in significant ways, paralleled by the regional personality of his home province, Sichuan, which provides the dramatic and lovely landscapes that are central to Li Huasheng's art. Chinese regionalism is often contrasted in terms of north (the martial stoicism of the people of the Yellow River valley and the dusty central plain) and south (the urbane elegance of those dwelling in the luxuriant lower Yangzi region). Yet Sichuan is another region altogether. While including something like a blend of the northern earthiness and southeastern elegance, the Sichuanese tend in yet another direction. They are—like Li Huasheng, if not always as extreme—outspoken and argumentative, brash and sassy, with a ready sense of humor and an independent turn of mind.[53]

The contemporary Chinese American artist C. C. Wang, who received the finest conservative training available in the Suzhou-Shanghai sphere in the 1930s and 1940s, says he finds Li's style (figs. 71, 108) too dynamic, too strong in gesture, too unreserved in its expression, and not subtle enough in brushline. But Wang admits to admiring Li's talent and suggests that his reservations reflect a difference in taste between his native Wu district and Li's Sichuan. Li, for his part, while looking up to C. C. Wang as an individual artist, finds Wang's genre to be too old-fashioned and tame. Each artist, therefore, must be measured against a specific regional personality, among other factors.

Sichuan's independent character and distinctive personality is predicated on its physical isolation from northern and eastern China and its highly localized economy.[54] Its tenuous connection to eastern China is grounded in Chongqing (Li's home from youth until 1986), which stands at the headwaters of the Yangzi River gorges, the only regular channel of contact with China's eastern provinces. Sichuan's economic autonomy is centered upon Chengdu (Li's present home), which rests in a corner of one of the world's richest agricultural plains. The fertility of this district is assured by a riverine system of man-made design that dates back to the Qin dynasty (221–206 B.C.). Surrounding Chongqing, Chengdu and the provincial core of Sichuan are practically insurmountable geographic barriers.

In western Sichuan, the mountains rise to awesome heights and lead into ever greater isolation as one approaches the great Tibetan-Qinghai ranges, the Himalayas and the Kunluns. In the south, densely folded mountains enclose deep valleys that house fifteen officially defined minority peoples, more southeast Asian than Chinese. Toward the north, the distance from Chengdu to the great ancient capital city of Chang'an (now Xi'an) is only 640 miles. But this treacherous route through the Micang-Daba and Qinling ranges by way of Jianmen Pass is infamous for its *zhandao*, or plank roads, inserted directly into the face of the cliffs for lack of adequate ground-level thoroughfare. Historically, travel this way was rare, exemplified by the desperate Tang emperor Minghuang who, in 756, was driven from Chang-an by mutinous troops. No railway was installed until 1956. The most famous lyric celebration of this passageway was by Sichuan's native son, Li Bai (or Li Bo, 701–62):

It would be easier to climb to Heaven than walk the
 Szechwan Road,
And those who hear the tale of it turn pale with fear.
Between the hill-tops and the sky there is not a cubit's space;
Withered pines hang leaning over precipitous walls.
Flying waterfalls and rolling torrents blend their din;
Pounding the cliffs and circling the rocks they thunder in a
 thousand valleys,
Alas, traveler, why did you come to so fearful a place. . . .
They say the Damask City [Jincheng, Chengdu] is a pleasant
 place;
I had rather go quietly home.
For it is easier to climb to Heaven than to walk the Szechwan
 Road.[55]

Eastward traffic by river through the spectacular gorges of the Yangzi River, while possible, is only somewhat less hazardous.[56] These "three" Yangzi gorges have long typified Sichuan's remarkable landscape, only recently rivaled by cuddly pandas lolling in Sichuan's bamboo groves.[57] Li Huasheng is proud of having traveled the gorges numerous times—more than ten times by 1976—these trips made possible by his employment with the Yangzi River Shipping Company from the late 1960s through the mid-1980s. In giving conspicuous attention to the gorges in his paintings of the late 1970s and early 1980s (figs. 30, 31, 32, 33, 41), Li has joined a chain of artists dating back to the early landscape masters. Li Chengsou (c. 1150–after 1221), in the true Song dynasty fashion, stressed that the artist must learn from nature. He is said to have roamed the length of the three major gorges from his youth on, carefully noting their details in his treatise, *Secrets of Landscape Painting*:

Multiple sandbars, agitated shallows, swirling eddies, reckless billows, whirlpools, cross-currents, heavy breakers, and rapid waves are all there. . . . Overhanging precipices and sheer walls, abrupt gorges and towering peaks, steep ranges and plunging cliffs, dark springs and luxuriant valleys, tigers' caves and dragons' pools, the dangerous and the perilous, sudden winds and wild rains; there is nothing that one will not encounter. All these are the models for today's painting.[58]

Another of Sichuan's beloved sons, Su Dongpo (Su Shi, 1036–1101), captured a poet's subjective view of this watery passage on his first journey out of the province:

From the boat, watching hills—swift horses:
A hundred herds race by in a flash.
Ragged peaks before us suddenly change shape;
Ranges behind us start and rush away.
I look up: a narrow trail angles back and forth,
A man walking it, high in the distance.
I wave from the deck, trying to call,
But the sail takes us south like a soaring bird.[59]

Perhaps the most important early Yangzi River chronicle came from Lu You (1125–1210) of the Song dynasty, who served as an official in Sichuan from 1170 to 1178 and became a follower of Sichuan's great poet Du Fu (712–770).[60] He kept a detailed diary of his 1170 journey, all the way from Shaoxing on the eastern coast of Zhejiang province through the Yangzi gorges, covering 156 days.[61] At the end of his official service, on his descent of the gorges, Lu wrote a poem that measured the journey in human terms, concluding:

When I was young I used to dream of the joys of official
 travel;
Older now, I know just how hard the going can be.[62]

Chongqing itself is built over a river gorge, carved into the sides of steep, hard embankments. At its feet, covering the floor of the limestone valley below, flows the mighty Yangzi. The deeply channeled valley at Chongqing is barely 300 yards wide, so the Yangzi River's water level rises and falls over the year by as much as seventy feet. Floods can be sudden and devastating. The main part of the city is set on a peninsula at the juncture where the Yangzi, flowing up from the southwest, meets the Jialing, which pours down from the north.[63]

Life in Chongqing is an extension of life on the river and can be just as dramatic or as hard. The city that hugs the

river teems with dock workers and sailors, and its porters and pedestrians find themselves forever climbing and descending steep stone staircases that run right down into the water in anticipation of low tides. While picturesque, Chongqing is still marked by the physical scars of bombing by the Japanese. A layer of grime seems to issue from the port itself, which Li Huasheng recorded in oil paintings of the early 1960s (fig. 6). Today, Chongqing is one of the world's largest and busiest inland ports, with an urban population of over two million and a metropolitan population of fourteen million.

Enclosed today within Sichuan's majestic isolation is the largest of China's historically integral provinces[64] and its most heavily populated—larger and far more populous than any European nation.[65] In the heart of the province, ringed by high mountains and fed by countless rivers, is the Sichuan basin (also called the Chengdu Plain and the "Red Basin," from the color of its sandstone deposits). This agrarian basin is one of China's three most fertile farm centers, and from very early times it provided the Chengdu district its enduring name of "Tianfu Zhiguo," or "the Country of Nature's Storehouse." With a temperature a few degrees warmer on average than that in the lower Yangzi delta (coastal China's "rice basket") and a year-round abundance of moisture (heavy rain in spring and summer, dense fog in much of the winter), central Sichuan's climate makes for an uninterrupted growing cycle, permitting three annual crops to be grown in rotation. "Virtually anything that grows in other parts of China can be grown economically in Szechwan, ranging from subtropical to subarctic."[66] Among these are some of China's hottest peppers, the basis of Sichuan's distinctive cuisine and, some would say, its peppery personality.

The man-made component of this abundance was an early Chinese engineering marvel (now a major tourist attraction), the huge Dujiangyan irrigation system developed in the late third century B.C., when Sichuan (then known as Shu) first came into the Chinese political fold, under the Qin dynasty. Its construction—one of many by which the Qin helped unify the new empire—was directed by Li Bing, the first Qin governor of Shu, and by his son Li Erlang. Their project split the southward-flowing Min River at Guanxian, in the elevated northwestern corner of the 200-square-mile plain, subdividing it into numerous channels. These spread into a network of irrigation canals over the entire Chengdu Plain and converged again in the south, in the Min and Tuo Rivers.[67] This "sea-on-land," still in use 2,200 years later, ultimately turned Sichuan's Red Basin into the most densely populated rural area in the world and made possible

Sichuan's degree of independence from the rest of China.

With Sichuan's complex terrain, the physical distance between Chongqing and Chengdu is more than a matter of miles (about 250 kilometers by air). No easy access between the two existed before modern times, and Sichuan sometimes constituted not one isolated political district but two or three (Shu in the west, with Chengdu at its center; Ba in the east, where modern Chongqing now stands; and Guanghan in between). No railway connected the Chongqing and Chengdu until 1952, an engineering achievement completed under Deng Xiaoping's supervision and regarded as his first administrative feat. The cultural distance is no less great. Chengdu, which Li Huasheng visited frequently after the mid-1970s, moving there in 1986, offers an elegant, urbane contrast to the rough port city of Chongqing.

In the 8th century, resident poet Du Fu coupled the city of Chengdu and the nearby western hills in this immortal phrase:

The eastern metropolis is circled within clear rivers;
The western mountains are capped with glaring snow.[68]

These famous hills, to the northwest of Chengdu, include the Qingcheng ("Green Wall") mountain range, a total of thirty-six peaks covered with centuries-old Daoist monasteries. As the Sichuanese enumerate their most famous natural monuments, Qingcheng is one of four enshrined in a popular quatrain (rhymed in the original):

Emei [Mountain], the most elegant place on earth
Qingcheng [Mountain], the most secluded place on earth
Jianmen [Pass], the most dangerous place on earth
Kuimen [Gorge], the most heroic place on earth.

The Daoist tradition there is said to date all the way back to the first century, when the founder of the Daoist church, Zhang Daoling, supposedly preached to Sichuan's locals. For generations, painters have been welcomed at the temples, which have amassed quite an art collection. In modern times, Sichuan's most famous painter, Zhang Daqian, stayed at the temples on several occasions accompanied by a whole retinue, which usually included a painting-mounter and once featured a concubine of the famous Sichuan Opera actor Zhou Qibai, sent to Zhang for his pleasure and returned by Zhang when he departed. Li Huasheng has joined this interesting train of figures, and he first left paintings for the monastery collection in 1975 (figs. 26, 30).

The rolling, terraced hills of the Longquan range to the east and the lovely Chengdu Plain complement the grandeur of Sichuan's rugged western mountains and its wild

eastern river gorges. In many of his landscape paintings in the 1980s, Li has turned to this gentle mode (figs. 56, 115, 117).

Even with such visual inspiration, it is still surprising how large a share of China's finest traditional poets were raised in Sichuan or matured as poets there. In this provincial hall of poets are Sima Xiangru and Yang Xiong of the Han; the Tang masters Li Bai, Du Fu, Bai Juyi, Chen Zi'ang, and Yuan Zhen; and Su Shi and Lu You of the Song. All these poets are distinguished by their individualistic departures from the ordinary and by a forthrightness that lies at the core of their literary inspiration. Through the centuries, they have brought countless Chinese readers into the heart of Sichuan. Yet to outsiders, even in the twentieth century, Sichuan has remained another world. Zhou Kaiqing wrote early in this century: "If you haven't been to Sichuan or if you take a narrow and unscientific approach to it, then the world of Sichuan is not only incomprehensible; it is unimaginable."[69] On the other hand, it is said that in pragmatic matters,

> more than anything else . . . Sichuan was ignored. It barely scratched the minds of most people in the eastern, southern, and northern provinces, no matter how generally well informed they might be. . . . Only an exceptionally serious crisis in Sichuan could produce continuing news reports about the province in the downriver press.[70]

Historically, Sichuan has tended to go its own way, both culturally and politically, giving rise to the popular Chinese expression: "Before the nation is in rebellion, Sichuan has rebelled first; when the nation is already back at peace, Sichuan remains to be pacified" (*Tianxia wei luan, Shu xian luan; Tianxia yi zhi, Shu hou zhi*). When the empire put together by Qin and Han collapsed, in the turbulent Three Kingdom's Period, Sichuan returned to independent status as the Shu-Han dynasty, from 221 to 265, beginning with the ruler Liu Bei and his model advisor, Zhuge Liang. The region continued to stand apart from the rest of China's fragmented realm under the name of Cheng Han, from 304 to 347. When the fall of the Tang empire left China fragmented again, in the tenth century, Sichuan went its own way once more as the Former and Later Shu dynasties, thriving economically and culturally while most of China suffered bitterly. In the troubled period of the Southern Song (1127–1279), while technically part of the realm, Sichuan developed an independent economy and even circulated its own currency. And when the Ming empire collapsed in 1644, Sichuan was turned into the "Great Western Kingdom" by the ferocious rebel Zhang Xianzhong,

who had himself enthroned in Chengdu and renamed it the "Capital of the West."

In modern times, similar secessionary conditions prevailed after the dynastic collapse of 1911. By the middle of the decade, in the struggles against the Beijing-based successors of Yuan Shikai, "guest" armies from Yunnan and Guizhou began to pour into Sichuan, occupying Chongqing and Chengdu for extended periods, leaving its politics regionalized if not independent. But after 1920, local Sichuanese joined together under the slogan "Sichuan for the Sichuanese" to drive these regional forces out, and the province ultimately fell under the control of a local warlord, Liu Xiang. By 1927, "The province was an isolated, independent militarist region with virtually no substantive ties to external political authority."[71] This separation was brought to an end in 1937 by the Japanese onslaught and the flight of Jiang Kaishek's Nanjing-based Nationalist government, just one short step ahead of the Japanese grasp, to the protective isolation of Sichuan. Local warlords naturally resisted this outside intrusion; after the initial immigration, they managed through shrewd political compromise and potent military opposition to check the further expansion of Nationalist control in the province. When Jiang Kaishek at last fled the mainland in December 1949, he did so from Chengdu, and Li Huasheng's teacher, Chen Zizhuang, apparently played an intriguing role in surrendering Jiang's last major outpost to the Communists. And still more recently, during the chaos of the early Cultural Revolution period, Sichuan again threatened the political integrity of China with independent pretensions.

Not surprisingly, with these secessionist tendencies Sichuan has long produced local rather than national Chinese leaders, at least until the ascendancy in the late 1970s of Deng Xiaoping (from Guang'an, in the hill country north of Chongqing). As a military figure, Deng helped lead the Communist assault on China's midlands and then on Sichuan in the final phases of the revolution. Soon after, as a bureaucrat in Sichuan, he guided the initial implementation of Mao's "Third Line" defensive policy, which directed much of China's heavy industry inland and away from concentrated east coast centers, away from vulnerability to offshore American forces and later from an increasingly hostile Soviet Union. Thus, building on Nationalist foundations established during the war against Japan, he helped set the stage for the modern industrialization of the province.

After 1979, the regional balance of power shifted from Mao's Hunan province to Deng's Sichuan. Deng brought to the top of China's leadership a number of Sichuanese cadres, including Zhang Aiping as Minister of Defense,

while Zhao Ziyang, former premier and recently deposed Communist Party chairman—once Deng's designated successor—first made his reputation as Sichuan's progressive Party secretary. All three of these leaders have made an appearance in the colorful early career of Li Huasheng. Like Sichuan itself, all of these figures have been mold-breakers, and their local influence has been to encourage artists like Li Huasheng to break away from the Maoist aesthetic mold.

Li Huasheng's choice of artistic models has further contributed to his artistic individualism. Although he experimented with all the media and styles available to him, including oil painting, printmaking, sculpture, pencil sketching, Western watercolors, and traditional Chinese media, he had very little tolerance for the scientific-materialist aesthetic vision espoused by Chairman Mao, or for the government's dogmatic, poster-style art. Furthermore, despite his early training in Western-style watercolors and oil painting (fig. 6) and his continuing practice of "realistic sketching" (figs. 42, 43, 45, 49–52), he has not continued to practice Western-style painting; its philosophical premises, while intriguing to him, are admittedly not well understood. Instead, it is within the native tradition of literati landscape painting and its celebration of Chinese artistic personality, that Li Huasheng has ultimately found self-fulfillment.

Literati painting refers to the traditional practice of painting as an amateur exercise by China's elite scholar class. These were the educated bureaucrats of traditional times who dominated China in every way—politically, economically, and culturally. They were the noble heroes of Confucianism, the free-thinking rustics of Daoism, and the villainous feudal landlords of the Marxist revolution. Discussions of traditional Chinese painters often contrapose traditionalism and individualism, enabling one to sort out those unchanged or partly changed features handed down from the past and to distinguish them from the artist's individual features, those creative innovations tied to a new time period. But, of course, individualism has always been a major part of the tradition. And once the socialist revolution and Maoist aesthetics turned traditional China upside-down—including literati painting practice—the practice of traditional Chinese painting became an explicitly individualistic statement. Traditionalism and individualism became all but inseparable.

In historical times, while most Chinese were denied anything more than the smallest measure of individuality in their lives, Confucianism rationalized in theory and helped bring about in fact a considerably higher degree of individuality in the lives of the scholar class. The rise of "Neo-Confucian" philosophy in the ninth century combined with the increased stature of civil service examinees in the bureaucracy (as opposed to appointive officials) to help trigger an aesthetic reorientation of Chinese painting along Neo-Confucian lines in the Song and Yuan periods. Neo-Confucianism's wariness toward the spiritual pollution of political practice and its benign attitudes toward nature and human nature set the stage for a new mode of painting that was profoundly Confucian, and profoundly individualistic, not simply in terms of subject matter and style but in its perception of the impact of painting practice and viewing on the individual psyche.[72]

While its roots may be traced farther back in time, theoretical aspects of literati painting first began to attain some critical mass in the late eleventh century under the influence of the Sichuan's artist-statesman Su Shi (Su Dongpo) and a number of Su's artistic associates. Su Shi epitomized the new trend for scholars to include painting in their repertoire of leisure activities, along with the practice of the calligraphy, poetry, and music on the *guqin*. This inclusion of painting came about once its practice was justified in terms of ethical self-cultivation and emotional contemplation, reflecting the important Buddhist and Daoist components of Song Neo-Confucian thought. The emergence of literati (or scholar-official) values in painting also required its self-conscious differentiation from the art of China's professional (hence lower-class) painters, whose talents and technique were impressive but really beside the point, and whose goals were limited to artistic fame and economic profit.

In subject matter, literati taste brought about a great change and marked a turning away from the court taste for figural narratives and the decorative paintings of birds and flowers, instituting a preference for more subtle vehicles of self-expression like bamboo, trees and rocks, and landscapes dotted with scholarly mountain retreats. In style, literati writings rejected the premium formerly placed on technical expertise and meticulous craftsmanship—the hallmarks of the hireling—and valued instead greater spontaneity of brushwork as related to the free expression of individual personality, already found in calligraphy. Unlike professional painters who painted to satisfy others and rarely inscribed their works (most, perhaps, could not), the scholar-artists painted only what and when they wanted, only for themselves and for their limited circle of close friends, and they often combined painting with calligraphic

inscriptions that described the occasion or intimated the mood or intent of the painting. In their inscriptions and their occasional writings about painting, the scholar-artists made it clear that subject matter was a secondary concern, that the work need not be comprehensible to an ordinary audience, that technical skill and accuracy in rendition counted for little, that beauty was considered but a decorative and superficial distraction, and that the artist's cultivation of personality and ethical character was all that really mattered. The ancient formula was clear and simple: "The painting is like the man" (*hua ru qi ren*).

One of this tradition's greatest purists, Ni Zan (1301–74), wrote:

> I do bamboo merely to sketch the exceptional exhilaration in my breast, that's all. Then, how can I judge whether it is like something or not, whether its leaves are luxuriant or sparse, its branches slanting or straight? Often when I have daubed and smeared a while, others seeing this take it to be hemp or rushes. Since I also cannot bring myself to argue that it is bamboo, then what of the onlookers?[73]

For this kind of artist, painting was no longer a record of nature but of the artistic personality. "What the painters now brought out was not Nature's beauty, harmony, or glory. The old motifs such as the landscape, trees, rocks, grasses, and flowers remain, but they are now used as carriers of 'expression,' expression through strange and artificial shapes or textures, distortions, unnatural movement, oppressive motionlessness, bleakness, crowdedness, and the like."[74] Such painters referred to their work only as "ink-play," although in time they did come to take this play increasingly seriously as an advertisement of their personal qualities.

As politicians by profession and painters by avocation, these artists sometimes allowed political rhetoric to intrude into their work. But more often, they applied the notion (so contrary to a good socialist attitude) that politics was an inherently dirty profession, one that sullied their emotions, and that practicing politics in an ethical manner required that their emotions somehow be regularly cleansed. Through painting, this cleansing could be accomplished, and harmony and quietude could be exercised spontaneously, unfettered by serious concern about artistic content or results. As in the handwriting of the calligrapher, the mind of the artist, his mood, his sincerity, and his ethical stature, were manifest in the final painted product. This was all that resulted of any importance: a manifestation of the artist's personality, not a manifesto of political policy, not a record of painterly expertise.

To the literati, individualism went hand in hand with subjectivism. Fundamental principles were not self-extant outside of the individual, nor was belief in them dictated by external authority. Rather they were something of which the perceiving self was an integral part, and which had to be determined through individual experience and self-examination. In what otherwise passes for a short and simple landscape poem, Su Shi crystalized this subjective view of reality, an idealistic view of man as an integral part of the structure of knowledge and truth:

> From the side, a whole range; from the end, a single peak;
> Far, near, high, low, no two parts alike.
> Why can't I tell the true shape of Mount Lu?
> Because I myself am in the mountain.[75]

Su Shi also helped invest the nascent art of literati painting with this same kind of subjectivity, so that artists came to paint according to heart and mind as much as by the eye. The "primitive" visual quality and evocative potential of Li Huasheng's paintings and those of his teacher Chen Zizhuang (e.g., figs. 18, 23, 58, 65, 115, 117, 118), so little bound by retinal experience, is a celebration of artistic freedom that dates back to artists like Su Shi. It is not surprising that Su Shi dedicated his political career to opposing the "New Laws" of his contemporary politician Wang Anshi which sought to invest the Song state with a degree of authoritarian, statutory control not seen since the Qin dynasty, and not seen again until 1949.

It would be no more fair to assert that all literati painting was individualistic than it would be to claim that Confucius was a libertarian. Indeed, when Western art historians first evaluated literati painting early in the twentieth century, they perceived nothing of its individualism. They saw only Confucian traditionalism, the slavish following of teachers, engendering in them a great distaste.[76] They saw little or nothing of literati painting's anti-authoritarian sentiment. But in fact, the arch-traditionalist of literati art was also its arch-individualist: Dong Qichang (1555–1636) revered the ancients, but he also meant them to be rivaled. In literati painting theory, the patterning of the artist on the authoritative models of his tradition was meant to engender a dialogue in which the living artist was inspired by the individuality of his model. Respect for the teacher was expressed through the student's efforts to equal him, to change him, to improve upon him. Dong Qichang wrote of four major artists of the Song and Yuan periods, all of whom modeled themselves on the mid-tenth-century artist Dong Yuan:

Juran (late 10th century) studied Beiyuan [Dong Yuan]: Yuanzhang (Mi Fu, 1051–1107) studied Beiyuan; Huang Zijiu (Huang Gongwang, 1269–1354) studied Beiyuan; Ni Yu (Ni Zan, 1301–1374) studied Beiyuan. The same Beiyuan, and yet none of them resembles the other. When other people do this, what they come up with is just the same as mere copywork, and how can stuff like that be worth handing down to posterity?[77]

If the masses of traditional China were offered little individuality, the scholars assured it for themselves in art as in life, modeling themselves on others but transforming their models into their own image. In politics, too, they placed their dedication to personal values ahead of government service; and when the two came into conflict, they departed from government, as Dong Qichang frequently did.

Among literati artists, Li Huasheng's favorites were the *most* individualistic, the *most* eccentric, those who put principles ahead of practicalities both in their art and in their personal lives, and who often paid the consequences. The eccentric strain running through much of literati behavior and art was typified by seventeenth-century artists such as Bada Shanren (fig. 37; compare Li's fig. 36 and Chen Zizhuang's fig. 18) and Bada's cousin Daoji (fig. 112; compare Li's figs. 111, 113). The anti-authoritarian Daoji defined his own artistic method as "no method":

In painting, there are the Northern and Southern Schools, and in calligraphy, the methods of the two Wangs. . . . Now if it is asked, did I learn from the Northern or the Southern School, or did they learn from me? Holding my belly laughing, I would reply: I naturally use my own method.[78]

Ordinarily, one does not affect the artistic style of such eccentrics unless one is also prepared to adopt it in one's life. Li Huasheng and his teacher Chen Zizhuang can be seen as the spiritual heirs of that traditional eccentricity.

The theory of art embodied in literati painting utterly contradicted the theories of Chairman Mao. Contrary to Marxism's dialectical offering of "scientific materialism," to its historical determinism and authoritarian control, and to its assertion that everything is essentially political, the literati humanists practiced politics as a necessary evil, the worst part of an otherwise orderly and highly subjective world. The regime of Mao Zedong could not condone literati-style art without also sanctioning its subjectivism and its skeptical and challenging attitude toward authority. And since literati painting was originally practiced only by scholar-statesmen-landlords and (in the past century) by petty-bourgeois intellectuals, what appropriate role could be found for it after 1949? Since it had been originally devel-oped and historically practiced to help fulfill upper- and upward-class aspirations, how could it be ideologically sanctioned after 1949 for artists who were neither statesmen, landlords, nor petty-bourgeoisie, but who were instead state-managed professional artists (analogous, if anything, to those imperial court artists whom literati painters spurned)? How could a socialist government, which views all art with an eye to ideological purity, sponsor painting modeled on that of the just-defeated class of feudal landlords—men like Dong Qichang, as "black-handed" a landlord as one could find? Far from resolved, and perhaps not logically resolvable, these issues have continued to plague Chinese arts administration from 1949 to the present day. The many attempted "solutions" to these problems have always been short-lived. They also have been inconsistently applied, being subject to factional disputes at the national level as well as to local political and cultural variations.

Sichuan's contribution to traditional Chinese painting, in both historical and modern times, has been modest. The one period of its major cultural contribution, the late Tang–early Song (from about 900–1050) coincided with a period of political isolation. This era was begun by painters who fled to Sichuan from the failing Tang capital in Chang'an—artists such as Sun Wei and Diao Guangyin—as well as some who came up-river from the south—such as the Chan Buddhist monk Guanxiu, who arrived in about 901 to a warm welcome by the ruling prince, Wang Jian. These émigrés and their local-born followers—Huang Quan (who studied with both Diao Guangyin and Sun Wei), Huang's sons Jucai and Jubao, and Zhao Chang—were also the first to elevate bird-and-flower painting to a lofty stature within the Chinese tradition. Their greatest accomplishment, and one of the lasting accomplishments of this golden era, was their artistic practice of "sketching from life," *xie sheng*, which helped raise Chinese painting to the pinnacle of achievement in terms of naturalistic representation and technical skill. Also forthcoming at this time—from artists such as émigré monk Guanxiu and native-born religious-figure painter Shike—were early experiments in quite a different direction, explorations of expressive distortion and "liberated" brushwork which helped lead the way toward the emergence of a "scholar's style" of painting a century or more later.[79]

But Sichuan's great era ended when the refined Shu rulers in Chengdu capitulated to the Song. Then, the tide of cultural politics that had brought a flourishing art into the

province sucked it out again, and as rapidly as their predecessors had arrived, many of Sichuan's outstanding artists went to the new Chinese court in Bianjing (now Kaifeng) in order to gain national recognition. Among them were Huang Quan and Huang Jucai, Gao Wenjin, and Shi Ke. Sichuanese painters quickly came to dominate Song court painting—by an "overwhelming majority"—until the middle of the next century.[80] But the best painting of most of these Sichuanese artists was never seen in Sichuan, and each departure that helped to glorify Sichuan's name nationally left the province itself artistically poorer, less likely to thrive.[81]

From that time until the twentieth century, it could be said of Sichuan in painting as it has been of politics, that "more than anything else, Sichuan was ignored."[82] In this century, Sichuan has produced but two leading literati masters, Zhang Daqian (1899–1983) and the great, tragic artist Shi Lu. But, being good, they left: Zhang departed Sichuan for Suzhou and Shanghai in the 1930s, returned after the Japanese invasion, and later abandoned China for Hong Kong, Taiwan, and the Americas; Shi Lu left Sichuan for the north in 1939, arrived in Yan'an in 1942, and reached his artistic maturity in Xi'an.[83] Owing to this lack of a strong artistic core, modern artistic influence has more often been national in source than local, deriving particularly from painters who visited from the outside. One of these was Huang Binhong (1864–1955), perhaps the finest Chinese landscape painter of this century, who visited the province in 1935. The impact of Huang's style on Chen Zizhuang and Li Huasheng—a style simple in its underlying structure but rich in ink and layered brushwork (figs. 23, 24, 54, 55, 67)—is said by Li to have come specifically from some of Huang's works, a series of small album leaves produced while he stayed at Mt. Qingcheng near Chengdu in 1935. Qi Baishi (1863–1957), China's best-known painter of this century, visited Sichuan in the following year, reportedly at Chen Zizhuang's suggestion. Qi's art was as simple as Huang Binhong's was complex, with something of a folk-art feel, but it also left an enduring imprint on Chen and Li (figs. 21, 22, 26, 115). Two other sources of modern influence on Li's art are Lin Fengmian (b. ca. 1901) and Li Keran (1907–89, cf. figs. 13, 61), with Lin transmitting his color and something of his semi-Western brushwork (figs. 56, 57, 73), and Li Keran offering his broad washes of ink and Western-derived sense of shading and architectural solidity (figs. 13, 44, 66, 70).

Like many others from the eastern coast, including whole academic faculties, Lin Fengmian and Li Keran fled the Japanese siege in 1937 and followed the Nanjing government to Sichuan. The next eight years became Sichuan's greatest artistic moment since the early Song as political events once again drove many of China's finest painters there, now from the eastern coast to Chongqing, the Nationalists' capital in exile. En route to the west, remnants of the Beijing National Academy of Art joined forces with the Hangzhou academy (despite their strong political differences) to form a new National Academy of Art. They finally settled at Bishan, some fifty miles to the west. Nanjing's National Central University art faculty, including the painters Xu Beihong (1895–1953), Fu Baoshi (1904–65), Zhao Shao'ang (b. 1905), and Huang Junbi (b. 1898), relocated in the Chongqing suburbs at Shapingba. Xu Beihong, under the auspices of the Academia Sinica and with the help of other artists like Zhang Daqian, Wu Zuoren (b. 1908), Zhang Anzhi (b. 1910), Li Ruinian, and Feng Fasi, also organized a new National Art Research Institute, located in the Jiangbei District (where Li Huasheng grew up a decade later).[84] Also among this artistic crowd were Guan Liang (b. 1900) and Ding Yanyong (1902–78), as well as a number of important leftist (but not necessarily Communist) printmakers, including Li Hua (b. 1907), Gu Yuan (b. 1918), and Huang Yongyu (b. 1924). Still other painters, like Wu Guanzhong (b. 1919), Zao Wou-ki, and Chen Qikuan, experienced the newly enriched artistic environment of Chongqing in the formative stage of their careers, before developing their more personal styles in later decades. Chengdu, too, was a beneficiary of the refugee influx, and the Sichuan Provincial Art College there served as a home base for such dislocated artists as Wu Zuoren, Pang Xunqin, Huang Junbi, Xiao Ding, and Yu Feng, while Zhang Daqian dwelled intermittently at the Shangqing Daoist temple of nearby Mt. Qingcheng from 1938 to 1940 and from 1943 until after the end of the war.

During the war years, through a variety of exhibitions, Chongqing and Chengdu were exposed to a range of major artistic activities that broadened the sights of Sichuan's own local artists. Still, the experience was to have a delayed impact, for the most part, and only a few local artists before the early 1980s, such as Chen Zizhuang, benefited greatly from these events. After 1945, there began another artists' evacuation of Sichuan; between then and now lay decades of conflict between literati art and Maoist aesthetic theory.

Chairman Mao instructed his listeners at the Yan'an Forum that "we should take over the rich legacy and the good traditions in literature and art that have been handed down from past ages in China and foreign countries, but the aim must still be to serve the masses of the people."[85] But how

to serve the masses was not a matter of polling the people. Ideologues had to determine what was right for the people. Mao believed deeply in the success of the Yan'an rectification campaign (1942–45), convinced even that the unexpectedly early success of the 1949 revolution resulted from high morale built by the "democratic" character of his Yan'an campaign.[86] Mao's ideological initiative at the Forum, at least in the edited version of his talks, certainly looks intellectually persuasive. Yet, in fact, the apparent early resolution of contradictions between "liberal" values and Maoist aesthetics proved to be but a temporary phantom, and the issues involved (related to audience, style, and artistic autonomy) were again in need of resolution after the Communist revolution, when theory was put into nationwide practice.[87] In the rhetoric of the day, when things were either "beneficial, harmful, or not harmful," traditional-style Chinese painting was not harmful, which meant that its fate would require struggle.

Mao's formula for the resolution of nonantagonistic problems was "unity, criticism, unity." In other words, given a desire for unity, the ensuing process of criticism or ideological "struggle" would foster a resolution of such contradictions.[88] But between contradictory values, traditional literati individualism and the Maoist submission of art and artist to the Party and masses, what real resolution could take place? Were traditional literary and visual art forms, including literati painting, a firm enough foundation on which to construct a new revolutionary edifice, or were they too worn-out to offer support for the grand new construction? Worse still, might traditionalism provide a platform for dangerous conterrevolutionary forces? In such a case, traditionalism would be better dismembered and destroyed. At Yan'an, Mao spoke with absolute self-assurance, denouncing the "Trotskyite" formula of "politics/Marxist, art/bourgeois" as being "certain to lead to dualism or pluralism."[89] But Maoist cultural attitudes fluctuated considerably when faced with practice, and so then did public policy. The desire for unity, Mao was soon to discover, included the desire of many competing bureaucrats to impose their own brands of unity on everyone else. In place of unity came a never-ending parade of cultural campaigns and countercampaigns, of ideological factions attacking and attempting to purge one another, and ever more fierce means of carrying out these campaigns.

The lesson learned from all these campaigns is that factionalism and personal motives, as much as any consistent ideology, have helped to direct events, while ideological inconsistency has led to a mass of local irregularities, especially in a regional isolate such as Sichuan. This is illustrated by the Jekyll-and-Hyde campaigns of 1956–57: the Hundred Flowers Movement (which for the first time invited non-Party members of the Chinese public to join in the rectification of Party members) and the Anti-rightist Campaign (which turned from rectification within the Party to a public scouring in June 1957, ultimately claiming an estimated 300,000–550,000 victims).

Among the Anti-rightist Campaign's prime cultural targets were Ai Qing and Ding Ling in literature and, in the visual arts, Jiang Feng, first vice-chairman of the Chinese Artists Association. All three were allied through common origins under the tutelage of Lu Xun. Jiang Feng was present at the famous printmaking workshop that Lu Xun organized in August 1931 with the help of Uchiyama Kakichi, which helped launch socialist printmaking in China, and Jiang later served as director of the Fine Arts Department of the Lu Xun Academy.[90] In the 1950s, Jiang continued to associate with Ai Qing and other Lu Xun followers—such as Hu Feng, who in 1955 became the prime target of a national ideological rectification campaign, and Feng Xuefeng, who was denounced first in 1954 and then again in 1957. Most of these figures had three things in common: they saw the writer as an autonomous figure, not merely as a Party functionary (Ai Qing and Ding Ling had openly asserted the independence of art and politics at the time of the Yan'an Forum); they felt that the revolution needed to be based on reality, not on romanticized notions of socialist "realism"; and they felt that traditional Chinese culture and art, whether high-brow literati art or folk art, offered no future potential, and that China ought to design for itself a cultural future based on international standards.[91]

Like other followers of Lu Xun, Jiang Feng was a staunch cultural reformer. While opposed to the modern "bourgeois" movements set into motion by Cezanne, Matisse, and Picasso, his personal commitment was to classical Western and Soviet-introduced socialist styles of oil painting and printmaking.[92] Like most of those in the Lu Xun group, Jiang Feng had little tolerance for China's elite heritage in the arts, especially traditional landscape painting. But unlike other Lu Xun followers in the literary areas, he also gave strong support to applying Chinese folk traditions, including New Year's prints and cartoons.[93] Also, of all the major figures in this group, Jiang Feng alone seemed truly supportive of strong, even hard-line, governmental control of culture.

Jiang pursued his chosen administrative goals with such an inflexible intensity that this later came to be used against him by an equally hard-line but a far more cunning opponent, Zhou Yang. At Hangzhou's highly prestigious

National Academy of Art, Jiang became vice-chairman and Party secretary in 1949 and directed the socialist reorganization of the Academy over the next two years. Jiang Feng apparently would not let faculty members Huang Binhong and Pan Tianshou teach. He reportedly pressured Huang, the traditional landscapist (fig. 24) and noted scholar, to do more research into the history of figure painting,[94] and he forced Pan, the bird-and-flower painter, to study figure painting from plaster casts and models, relegating him to the conservation department.[95] According to Pan, in 1950 Jiang publicly predicted the demise of traditional Chinese painting, claiming it lacked the capacity for realism or adaptability to monumental scale for mass viewing.[96] In 1949, Jiang Feng also merged Hangzhou's Department of Chinese Painting into its Department of Western Painting; the teaching of traditional landscapes and of bird-and-flower painting were virtually eliminated and figure painting was given preeminence.[97]

In 1951, Jiang departed for Beijing's Central Academy of Fine Arts, where he served as Party secretary and at first as vice-director; he then succeeded the late Xu Beihong as acting director in 1953. He also became Party secretary and first vice-chairman of the Chinese Artists Association, which made him the most influential visual arts administrator in China. Under Jiang, as under the European-trained Xu Beihong, oil painting was the Central Academy's medium of choice for painters, Soviet-derived socialist styles were obligatory, and figure painting was the predominant subject. And when, by 1954, in response to external pressures, the Central Academy's department for traditional-style painting was reestablished, Jiang was apparently responsible for changing its name from the older, more nationalistic term, Department of Chinese Painting (or "National Painting," *guohua*), to the more prosaic Department of Color-and-Ink Painting (*caimohua*).[98] Moreover, in this department, China's time-honored tradition of study by copying past masterpieces was discontinued, replaced by sketching from life. The distinctively individualistic brushwork—modulated outlines and rhythmic texture strokes—that was Chinese painting's true heritage, derived from the practice of calligraphy, was eliminated as elitist. It was supplanted in the classroom by fine, unmodulated brush outlines, filled in with flat color-wash interiors or Western-style modeling. Artists no longer painted landscape scrolls. Instead they did propaganda posters, revolutionary comic-books (*lianhuanhua*), and small propaganda paintings derived from popular New Year's prints (*nianhua*). What remained of traditional painting in its new transformation was simply the old medium, with neither the old style nor

traditional subject matter. As Jiang might have desired, the new "traditional" Chinese painting held little appeal for younger artists, and few of the more ambitious students at the Central Academy were interested in joining the Department of Color-and-Ink Painting.[99]

Surprisingly in some ways, in the Anti-rightist Rectification Campaign of 1957, Jiang Feng became the visual arts administration's big loser (labeled "the number one rightist of the art world"). The figure whose authority was most enhanced at that time was the ideological powerhouse Zhou Yang, who dominated cultural policy from his multiple positions as deputy-director of the Communist Party Propaganda Department, vice-minister of culture, and vice-chairman of the Chinese Federation of Literary and Art Circles. Zhou Yang was the prime organizer of Mao's 1942 Yan'an Forum, and in the 1940s and 1950s, he enforced Mao's dicta from the Yan'an Forum through a sequence of increasingly repressive ideological campaigns. By these campaigns, he also brought to a resolution the long and angry quarrel over the matter of Party control of the arts which had been waged between himself and Lu Xun's followers, dating all the way back to 1935.[100] In the years leading up to Anti-rightist Campaign, Zhou Yang had already managed to orchestrate showcase purges in 1954 and 1955 of Lu Xun's literary followers Feng Xuefeng and Hu Feng, forcing each into an extreme position of rejecting Party control, and then decimating them politically. In 1957, he completed the rout of his opponents by doing the same with Ai Qing, Ding Ling, and Jiang Feng.

The peculiarity of Jiang Feng's situation vis à vis Zhou Fang is that, despite his historical association with Lu Xun and his followers, most of the time Jiang was demanding the reform of art through a mix of socialist realism and folk Chinese models, much like the mix Zhou was touting for literature. And he similarly demanded the firm role of government in effecting this. But Zhou exaggerated their differences, portraying Jiang as violating the Party's increasing emphasis on "national forms." He stressed Jiang's reliance on Western models and overlooked Jiang's use of popular New Year's prints and cartoons. And Zhou demanded a greater role for the entire (though nationalistic) heritage in art than Jiang was willing to provide (greater, indeed, than Zhou demanded in literature).

In 1955, when Jiang Feng failed to implement Zhou Yang's instructions to loosen his tight restrictions on traditional-style painting, Zhou had Jiang placed under investigation. During the Hundred Flowers Movement, Zhou Yang demanded of Jiang that *guohua* be added to the middle school curriculum, and Minister of Culture Mao Dun in-

sisted that the copying of old masterpieces be reinstated in the Central Academy's curriculum.[101] But Jiang refused, and his violation of Party and government directives, however contrived and twisted their motivation may have seemed,[102] left him wide open to a frontal assault. At the Central Academy, Jiang Feng was purged and arrested, and his name was reviled throughout the Anti-rightist Campaign.[103]

Zhou Yang's attack on Jiang Feng is perhaps a classic example of factional struggles and personal associations taking primacy over ideology, or at least attaining equal status to it, in high Party politics. Zhou thereby extended his authority beyond literary arts into the visual arts area for the first time.[104] But out of the calculated illogic of Zhou Yang and Jiang Feng's personal confrontation, traditional painting gained just enough support to survive that critical period. Also, the gradual chill in Sino-Soviet relations and the rising tide of Chinese nationalism increasingly helped to justify Zhou Yang's "national forms" position and further assisted the traditional artists in their on-going struggle to endure, albeit in a radically modified form. At the Central Academy, the Department of Color-and-Ink Painting again became the Department of Chinese Painting. Still, the results were mixed at best. In May 1957, in the waning days of the Hundred Flowers Movement, a new Institute for Chinese Painting was inaugurated in Beijing (preceded by another institute of that name in Shanghai, and followed by others in Nanjing and elsewhere), in order better to maintain the senior generation of traditional painters. But in the months ahead, many of its new leaders were cast out as too conservative and, like many of China's traditional painters, were labeled as "rightists," thereby suffering greatly.[105] In 1958, those who survived were often conscripted as propagandists for the Great Leap Forward.

Although traditional Chinese painting recovered some of its classroom rights after 1957, and although Mao's retreat into semi-retirement in 1959 brought about a more relaxed period under his successor Liu Shaoqi, the accepted type of traditional-media painting (*guohua*) was by then heavily politicized—hardly the *guohua* of old. Fine lined and evenly colored, it was bereft of the calligraphically derived texture-strokes that had once conveyed the personality of literati individualists. It was, ironically, very much the kind of painting called for by the now-disgraced Jiang Feng.[106] And its hardest days still lay ahead.

In Sichuan, however, the effects of the Anti-rightist Campaign on traditional Chinese painting were not the same as in Beijing (or Shanghai, or Nanjing), and traditional-style painting suffered even more in Sichuan than in Beijing.

With the demise of Jiang Feng in Beijing came the denunciation in Chongqing of Jiang Feng's student, Lü Lin (fig. 85)—today a colleague and elder friend of Li Huasheng, and at that time the major local target of the Anti-rightist Campaign. But Lü Lin bore little resemblance to his teacher, and his was an example of guilt through personal association rather than through ideological consistency. Like Jiang Feng, he was a printmaker, but unlike Jiang, Lü Lin was also a traditional-style painter (fig. 86) and carver, and in Sichuan he was the most influential defender of artistic individualism.[107]

As soon as the Communists took Sichuan, Lü Lin became head of the Fine Arts Department at the new Sechuan Academy of Fine Arts in Chongqing, and vice-chairman of the Chongqing Municipal Artists Association. But while serving as Sichuan's chief spokesman for administrative moderation, with the establishment of the Southwest Artists Association (covering Sichuan and three other provinces) in 1953, Lü Lin was far outpaced in the competition for influence and control of that agency by a socialist-realist printmaker and hard-line advocate, Li Shaoyan (figs. 16, 17).[108] Li Shaoyan had worked with a number of traveling PLA propaganda troupes before 1949, and he had served as a propaganda artist and art editor for a number of Party newspapers and journals both before and after the revolution.[109] Similar face-offs between more moderate pragmatists, who were often academically based, and hard-line propagandists were taking place all over China, with similar, largely predictable outcomes as the nation staffed its newly established machinery of social and cultural reform. As with Jiang Feng, Lü Lin's primary power base lay in academia, administered by the Ministry of Culture, an agency of the state. Such a base was relatively weak compared with the Communist Party and its agencies like the Propaganda Department, whose subordinates included China's publications network, in which Li Shaoyan had served, and its newly established cultural associations, in which Li came next to serve.

It was all but obligatory, when the Chinese Artists Association in Beijing denounced Jiang Feng, that local art association leaders in Sichuan would do the same to his ally, Lü Lin. When they did, it is said that Li Shaoyan was in the forefront, fulfilling an ideological mission, and there could be little doubt about the outcome. It did not matter that Jiang suffered for attempting to thwart traditional Chinese painting and Lü for promoting it. Lü Lin was marched off to a labor reform prison camp as a "rightist," along with other Academy cadres like Wang Zumei and Gao Nongsheng. At

the Sichuan Academy of Fine Arts, with Lü Lin gone and the hard-line leadership more firmly entrenched than ever, the post–Hundred Flowers period brought further hardship, not relief, to the traditional-style painters.

Since 1953, the Artists Association in Sichuan—under Li Shaoyan's firm control except during the Cultural Revolution—has primarily promoted figural arts by way of content, socialist realism by way of style, and woodblock printing by way of medium. Li Shaoyan achieved his artistic vision with great success and helped to establish Sichuan as one of China's two leading printmaking centers.[110] In Sichuan—where illustrative woodblock printing was invented in the Tang dynasty as a means of spreading Buddhist propaganda, a fact well-remembered there—Li Shaoyan's success looms large. Nationally, in recognition of his enduring accomplishments, Li today is one of ten vice-chairmen of the Chinese Artists Association. Many of Sichuan's traditional-style painters have long referred derisively to the Artists Association under Li's leadership as the "Printmakers Association." But until recently, they have lacked both the weight of a strong painting tradition and the contemporary artistic vitality to effectively resist Li Shaoyan's vision. Only in the early 1980s, with the liberalization of China's ideological and artistic direction, and with the emergence in Sichuan of a generation of younger artists like Li Huasheng, did this situation begin to change.

The fate of modern Chinese painting and the direction of its theories, styles, media, and artists after 1949 cannot be understood in a contextual vacuum. Neither can the painting of any individual Chinese artist. The landscape of Chinese socialist art is fragmented and fissured. It is scarred by political tremors centered far out of sight which release their violent energies along deep-seated ideological fault lines. Much of what has been introduced here—the Marxist theories and struggles of the 1940s and 1950s, the older literati painting heritage that Marxism sought to transform or displace, and the nearly timeless personality of a region which revolutionary politics has not yet seemed to transform— describes such forces. Li Huasheng's art and artistic career occur at a point along one such fault line, where Maoist politics and artistic individualism lie across from each other and rub abrasively past. Into this turbulent artistic terrain, Li Huasheng himself now enters.

"China-Born"

Early Years, First Teachers, 1944–65

There is nothing to fear from propagandizing feudal art. . . .

Haven't we triumphed after all?

—Liu Shaoqi, *1949*[1]

LI HUASHENG WAS BORN IN THE SUBURBAN VILLAGE of Changlin, where the unusual landscape scenery is known as the Zhuhai or the Bamboo Sea of Changlin. The Bamboo Sea is one of those sites that look imaginary when rendered in painting, like the album leaf painted by Li in his "small album" of 1987 (fig. 117). This "sea" is a dramatic geological outcropping of pinnacle peaks, a spectacular karst formation. It is, brags Li, "finer than that of Shilin," the nationally known and now overrun tourist attraction in Yunnan province to the south. Changlin is a suburb of the small but distinguished city of Yibin (figs. 45, 46, 117), which over the centuries has hosted some of Sichuan's finest poets and calligraphers, including Du Fu and Cen Can of the Tang dynasty, and Su Shi, Huang Tingjian, and Fan Chengda of the Song. What brought so many important people to Yibin was its position as the starting point of navigability on the Yangzi River, about 250 miles upstream from Chongqing. At Yibin, the Yangzi pools with two other rivers, the Min from the north—one of the "four rivers" (*si chuan*) that give the province its name—and the Heng from the south, which deepen the Yangzi enough for commercial navigation. This so-called First City of the Yangzi is also the main passage to Yunnan and Guizhou provinces in the south.

The Song dynasty calligrapher Huang Tingjian built a famous pool at nearby Xingwen which still survives, after a fashion. Known as the Liubeichi, the "Pond of Where the Cups Halt," it has curved estuaries where wine cups are floated past friends trying to write poetry fast enough to avoid drinking-forfeits.[2] Fine wine was also provided at the maternal family home where Li Huasheng was born, beneath Cuiping Mountain, near the Small Drum Tower. In Li's backyard was a well, dug in the Ming dynasty by the family ancestors, with sweet water that was excellent for liquor. Over the centuries, a reputation for homemade alcohol was nourished. Li's maternal grandfather was an alcoholic—"obsessed with liquor," says Li's brother—who kept two large barrels of alcohol and drank heavily at every

meal, including breakfast, and all night long as well.[3] He died sprawled over one of these barrels, with a Ming dynasty cup in his hand. Li's younger brother, Jiawei, claims that very early, judging from Li's flamboyant personality, "people predicted Li Huasheng would take liquor as his lifestyle."[4] In fact, despite these early predictions and the later suspicion of others that Li's unusual behavior is somehow alcohol-induced, the young Li Huasheng watched his grandfather's slow death of alcoholism and was so repelled by it that, as an adult, he has rarely touched alcohol.

The well-watered home on Small Drum Tower Street was the family home of Li's mother, Jiang Kaihua (1924–73). A housewife who never had a career, Li's mother was frequently the only adult at home. Li's father, Li Weixin (b. 1904), came from Long Life Bridge in Ba Xian, a city close to Chongqing, and he moved to the maternal family home before Li's birth. But he rarely was there for long. Like so many workers in this port town, Li Weixin was drawn to a boating career on the great river, and he was frequently borne by it away from his town and family.

The life of a Yangzi boatman was not easy. The Yangzi River trip, through the three main gorges, whether upstream or down, was harrowing:

The so-called Yangzi Gorges comprise 193 kilometres of treacherous waterways in which the Yangzi breaches through the mountain ranges separating Sichuan from the lowlands of Hubei-Hunan. At irregular intervals where a sudden drop in the gradient or a constriction in the waterway occurs, the river current picks up speed. These stretches are known as *tan* or rapids. Against the current in these waters the regular means of propulsion, i.e., by sails or by rowing, availed nothing. The boatmen therefore took to "tracking." Coils of cables made of bamboo strips were unrolled with which the "trackers," straining along on shore, hauled the boat upstream. As the river bank could descend in precipitous cliff faces to the water edge, the footpaths of the trackers could be on the top of the cliffs. Should they lose their foothold or should the cables snap, they could drop to their deaths in the water chasm below. Straining against the might of the elements, the trackers moved in unison, with their movements coordinated by a drummer sitting on board the boat. Where the current was rapid, the drum beat was in short, rapid succession; where the current slackened, the drum beat also slowed down. It took eight days to go through the Gorges.[5]

Between 1911 and 1949, boating on the Yangzi was made even worse by social conditions. The fall of dynastic imperialism in 1911 led, within little more than a decade, to such fierce rivalries between warlords and with the neighboring province of Yunnan that for years no single Sichuan county was free of widespread banditry and rebellion:

The entire Yangzi River valley from Chongqing to the Hubei border was allegedly controlled by bandits, many of them in frequent contact with the army and possessing modern rifles, machine guns, and even cannon. As a result, the Sichuanese were said to make no distinction between bandits and soldiers. Attacks on river streamers were common, some villages supplementing their meager farm earnings by either ambushing or levying a transit tax on the lightly defended, slow-moving craft, even after these began flying foreign flags for protection.[6]

The internal peace that descended on China after the Liberation of 1949 brought much improvement to Li Weixin's professional life. Before 1949, he had been a crewman on a ship. Later, he was promoted to *dache*, pilot of the boat. After 1949, when a vast governmental agency, the Yangzi River Shipping Administration, took control of all commercial shipping on the river, Li was promoted again, this time to *lunjizhang* in charge of the whole crew and its operations.

Although anticipating a society without classes, in the initial decades of its rule the Communist Party propounded a theory of "revolutionary inheritance" by which children were blessed or tainted with the same social background as their parents. With Li Weixin's position, the Li family after 1949 were classified as "laborers," or *gongren*. This proletarian class background meant the family was free of the taint of intellectualism or petty-bourgeois activity, which attached to so many of China's artists and subjected them to the heaviest measure of oppression in the class struggles of the 1950s, 1960s and early 1970s. The practice of "revolutionary inheritance," especially during the Cultural Revolution, often produced greater class rigidity than was found before 1949. It would prove to be a mixed blessing for Li Huasheng. While free of the stigmatized social background of most artists in socialist society, he lacked the usual intellectual background and education of an artist. And although obtaining a literary education would require greater resourcefulness of him than it did of artists with a better intellectual background, still, he would find that in the minds of many of his fellow artists in "egalitarian" China, his lack of formal academic training forever disqualified him from legitimate membership in their ranks.

Li Huasheng was born on February 15, 1944, five years before communism grasped Sichuan. He was not the family's first born, but his elder brother Zhongsheng had already died of small pox in 1942, at the age of two. After Li

Huasheng was born and his personality became known, his father came to believe that the child was "tough" (*mingda*) and had spiritually "killed off" his older brother, making room for himself even before he was born.[7]

Perhaps if Zhongsheng had survived, Li and his siblings would all have shared the generational name Zhong; instead, polluted, it was changed to Jia. Li Huasheng was originally named Li Jiayu and his next younger brother was called Li Jiawei. Altogether, three younger brothers and two younger sisters shared the name Li Jia, followed by another syllable. Because he was born in the winter, Li was named Jiayu, meant to provide him the "heat" (*yu*) needed to survive until spring. Today, Li Huasheng's brother often calls him Li Hua, in the fashion of the Chongqing region to drop the last syllable. Earlier, however, this dropping of the last syllable made for plenty of little "Li Jia's" in the family and provided lots of confusion. Li says that people were also confused about the "yu" in his name, written with a very uncommon character. By the time Li Jiayu was six or seven years old, he decided on his own to change his name, distinguishing himself from the growing herd of Li Jia's. After 1949, the choice of personal names often reflected the movement to restore national self-esteem, and Li's choice would seem typical: Huasheng, "China-Born." But he was not particularly conscious of the meaning of the name, he explains today, nor particularly patriotic; he was just following the fashion of the time as it filtered down to the children.

The Li family lived in Yibin until about 1949. Then they moved downriver to metropolitan Chongqing: to Pingmin ("Ordinary People") Village in the North Bank district (Jiangbei Qug), across the Jialing River from Chongqing proper. As a young boy, Li Huasheng quickly developed a reputation as a troublemaker, and visitors to his family home began to predict he would become a drunkard like his grandfather. He spent much time playing in muddy ditches, making boats of sand and mud with other "tough" neighborhood boys. When a local man, a water carrier, reported this to his parents, Li found the man on one of Chongqing's long, steep flights of stairs with two large buckets of water balanced on either end of a bamboo pole. Unable to put his water down to defend himself, the victim was soon plastered with mud. Li Huasheng learned from this that he could take advantage of the other water carriers in Pingmin Village. He remembers, "When they were in the middle of the stairs, I would take a narrow strip of bamboo and tickle the soles of their feet as they went up. They could do nothing to stop me."

Beginning in 1950, Li went for six years to primary school, then six years to middle school (including the equivalents of junior and senior high school). He was not a success in school nor was he a joiner, unlike most children who readily conformed to the norms. Political and social conformity were measured by how early the children were invited into the Leninist vanguard of their peers, the red-scarf-wearing Young Pioneers:

> Young Pioneers was portrayed as a politically elite organization. In keeping with this image, when children became eligible to join, in the third grade, enrollment was restricted to the best behaved, most enthusiastic and most academically diligent children. Then successive new crops of well-behaved children were invited to join. By the end of the fourth grade, it was made embarrassing to be left out, with a scarfless collar marking a child as a naughty reject. To press home the message, in the final years of primary school the decision on entry had been placed in the hands of all the classmates who were members.[8]

In the third year of middle school, attention shifted to gaining entrance into the more exclusive Communist Youth League. Li Huasheng, from the start a nonconformist, was one of those left out of any peer group. There was no doubt about it, says Li,

> I was very mischievous. I didn't join the Young Pioneers or the Communist Youth League—not to mention ever joining the Party. All my teachers felt I was very mischievous. I was always asked by the teachers to stand up, as punishment, during classes. In early middle school, sometimes in the evening the students would be gathered together. There the teachers always picked on me. My grades were very bad. Any time I could pass a course, that was a great achievement for me, and my parents would buy me a comic book for a reward.

According to family stories, when the family moved east from Yibin to Chongqing, they took a wooden boat with all their goods loaded on board, stopping all along the way at the local villages to see amateur performances of Sichuan-style opera (*chuanju*). Li Jiawei believes that perhaps "the scenery along the river gave Li Hua a deep and unforgettable impression," influencing his lifelong love for the regional landscape. Actually, Li Huasheng has no conscious recollections of the event, but his earliest memories combine the same elements: river landscape and opera, brought together by the frequent boat trips that his family took from Pingmin Village to Chongqing to attend the opera, crossing the Jialing River, passing the beaches until they reached Chaotianmen at the tip of the urban peninsula and entered the rapids, where the Jialing pours into the Yangzi.

Li Weixin handed down his love of opera to his children. He was also the first to support his son's painting, bringing

him brushes, ink, and pigments every time he returned home from travels down the river. Teachers, however, were not provided, and Li taught himself. Li's friend from early childhood, Guo Shihui, recalls that Li Huasheng started painting at age five or six, and that his first success came as a painter of roosters. A scroll of painted roosters was submitted and accepted for exhibition in 1951 in the All-China Children's Painting Exhibition. The theme was associated with the peasantry and therefore had positive enough political implications, but Li does not remember its being significant to him or typical of his painted subject matter. The key subject for him at that time came from the Sichuan-style opera theaters; namely, the opera masks, the costumes, and the stage decoration. Before painting became important to Li, in and of itself, it was merely an adjunct to his foremost love, the theater.

Through the theater, Li first found an alternative to throwing mud and tickling feet. Watching theatrical performances of Sichuan's boisterous and earthy-humored opera took Li's boyhood imagination beyond the building and rebuilding of simple mud and sand boats. He then set himself on stage, providing an outlet for a personality not easily molded into social conformity. Li's brother Jiawei recalls:

When Li Huasheng was only four or five years old, he always went with our parents to the downtown theater in the Northbank District of Chongqing. He became the youngest of all the Sichuan opera fans. Later, he organized a group of neighborhood children and imitated the figures from those stories. He set up a temporary theater in his backyard and gave puppet show performances. First they used two bamboo poles as a structure for the stage, with a quilt across the lower part [to hide the puppeteers] and a long strip of fabric to link the two bamboo sticks above. In this way he set up a simple stage.

The puppets were made of paper, with movable faces and hands. He painted many masks and lots of clothing for the puppets. Their performance program included Sung Hou Wang [Monkey, in "Journey to the West," "Monkey King Creates an Uproar in Heaven" [Danao tiangong], "The White Serpent" [Bai she chuan, describing the love between a human being and a snake], and Chai shi jie [describing the national hero Wen Tianxiang]. The Monkey King's mask was painted with three colors: red, yellow, and green. Bai Suzhen's [heroine of "The White Surpent"] was painted flesh-colored, very gracefully. Without telling our parents, he cut up a newly purchased silk quilt-cover to make clothing for the kings and emperors, so later our family could only use an old cover for our quilt.

Li himself served as the director and star actor. For music they used wooden sticks and struck washbasins, pottery bowls, ta-

bles, and chairs. Every day they changed the performance. An audience of older men and women from around the neighborhood watched this performance with genuine pleasure and applauded in praise. After each act, he let all the performers carry several dozen puppets out and around the street, so that many people watched, and people all around came to hear about this. He also secretly went to the theater company and studied with a master there.[9]

Li Huasheng's childhood discovery of Sichuan opera, which has remained his personal passion from that day to this (fig. 3 shows him in a recent full-dress stage performance), must have convinced him that life could be lived as opera, expressive and unafraid. At an early age, he wrote his own lines and played them convincingly. Li Jiawei's account of one short "act" suggests the young Li Huasheng's grasp of the telling detail (the shift in dialect, the range of moods) as well as his self-assured vitality:

One evening, a peasant couple came from the countryside to our home, wearing ordinary long blue shirts and straw sandals. They spoke a southern Sichuanese dialect. The woman was pregnant and close to her due date, with a swollen belly. They talked about local events with a woeful appearance, but in their conversation there was a sense of humor that generated enthusiasm. They wanted to stay and borrow a room for the woman to give birth in. Just as everyone was discussing this, we heard a sound as a pillow fell onto the ground, and we were all surprised to discover that her big belly miraculously disappeared. When this pregnant woman removed her headdress, we discovered that she was Li Huasheng.[10]

During his primary school years, Li's interest in painting began to develop in earnest. In school, he remembers, "All of the spaces in my textbooks were full of the pictures I did." In 1952, the Li family had moved from Pingmin Village to #58 Xiaheng Street, still in the North Bank district, where Li Huansheng lived until setting out for vocational school in March 1963. At Xiaheng Street, Li Huasheng's family lived on the second floor. Downstairs was a traditional Chinese drug store and a grocery store, selling pottery and utensils. Li Jiawei recalls his brother's intensity of purpose:

On the flat roof above our apartment there was a small covered enclosure, about five or six meters square, with ceiling too low for anyone to live beneath, useless and full of dust, unventilated and dark, and in the summertime perhaps 100 degrees, but a good place for him to execute paintings. He confined himself there day after day, using an oil lamp by which to practice callig-

raphy and painting. The floor and walls were covered with sketches, portraits, and colored landscapes. Our family didn't know where he spent his time, and the school officials came to our home to find out where he had skipped out to.[11]

This garreted painting activity foreshadowed, sadly, the many years to come when Li would be obliged to paint in secret.

While still in his early teens, Li Huasheng began to display his paintings at amateur exhibitions in the public parks. By the age of fifteen, Li also exhibited depictions of stage characters in the waiting room of Sichuan's main opera theater. That exhibition was arranged by Li's first painting teacher, Yu Jiwu (b. 1925; fig. 4), a teacher in the Chongqing Culture Hall. The government-run Culture Halls (*Wenhuaguan*)—distinct from the Wenshiguan, for aging literati, and from the more glamorous and exclusive children's Culture Palaces (*Shaonian Wenhuagong*), organized by work units and found in a limited number of cities—were an extension of China's mass-education system. Throughout China, Culture Halls were established at the municipal level and in every nonmetropolitan district to help educate people in the factories, the mines, and the countryside, including indoctrination of the masses in Party principles and policy. The tiny faculty of the North Bank Culture Hall was responsible for a district spread over four villages with more than a hundred factories and mines, as well as several dozen primary and middle schools. Before the Cultural Revolution, their annual budget was 30,000 Chinese dollars. Yu Jiwu had studied painting in Hangzhou, and after the Communist revolution in 1949 he joined the army, which brought him to Chongqing. After being in the army for less than a year, he was transferred as a painter-tutor to the newly established Culture Hall. The Culture Hall for Chongqing's North Bank district was situated at the center of historical North Bank Park, in a small, distinguished, French-style building. The first floor was used as a fine arts activity room, fronting onto a bonsai garden surrounded by artificial mountains. Yu Jiwu calls it "an ideal place for students to study the fine arts." Yu had been with the North Bank Culture Hall for about ten years when Li Huasheng first came in looking for painting facilities and a tutor.

Yu Jiwu (b. 1900) became Li's first art teacher, teaching him Western-style life drawing using a pencil, focusing on basic methods. Yu Jiwu, in Hangzhou's prestigious National Academy of Art, was a student of one of China's premier twentieth-century artists, Lin Fengmian (fig. 57),

4. Yu Jiwu.

who had painted in Paris between 1920 and 1925 and who, along with Xu Beihong and Liu Haisu, had pioneered the Chinese study of European painting. Yu worked in a broad range of media, from oils to watercolors (fig. 5) to traditional Chinese painting. Like Lin Fengmian, Yu was also capable of a mixed style and painted with Chinese media but with Western "effects," including reflections, optical recession, and broad color areas. Guided by Yu Jiwu, Li Huasheng went beyond brush-and-ink sketches of Sichuan opera to pencil drawings of Greek busts and sculptures of Venus. He worked both from plaster casts and live models. Li was also introduced by Yu Jiwu to oil painting. But, with Yu's support, he still continued to do some figures in traditional Chinese media.

Yu says he was very selective of his students, singling out Li for extensive training. They worked together for a decade, from about 1959 to 1970, with a friendship that often brought them into each other's homes even in the midst of that period from 1967–69, when the Cultural Revolution's armed struggle phase brought the Culture Hall's functions to a halt. "I always went to Li's home for chats with him," says Yu, "talking about subjects that ranged from art to

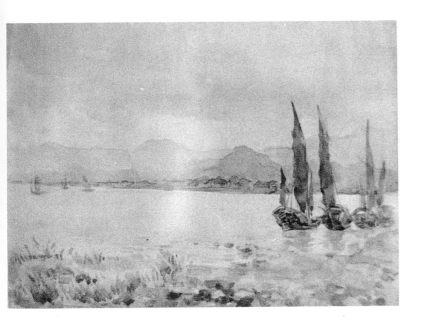

5. Yu Jiwu. *Seascape*. Ink and colors on paper. Undated. Collection of the artist.

society. There I saw his commitment to the practice of calligraphy and traditional painting."

Yu remembers Li as a hard-working student who always came to Culture Hall classes early, left late, and concentrated intently on his painting. He speaks of Li's powers of observation and comprehension and his excellent achievements in composition, three-dimensional structure, chiaroscuro, and realistic effects. Yu also remembers that Li liked to argue. For example, one student organized his own work by details, not in terms of the overall picture, so he could not grasp the likeness of his model. Li pointed out this problem to him, but the student would not accept it, and so they argued. To Yu, this meant that "Li as a student not only studied hard but also had his own understanding." "Li's accomplishments," says Yu, "came from his own serious efforts. One very unusual aspect of his art is that he seriously practiced all kinds of media."

Li first came to the North Bank Culture Hall with some ability at drawing theater figures. Yu Jiwu soon began to join Li at performances in the Jiangbei theater, where they often sat together in the front row. Afterwards, they worked on Li's opera sketches, done from memory:

We had to summarize the postures and gestures, catch the essential actions and arrange them, exaggerate the gestures and then put them on paper again. The results were very interesting,

perhaps Li Huasheng's earliest creative work. This work used to be displayed in the window of the Culture Hall and attracted quite an audience.[12]

But Li increasingly focused his attention on oil painting, which gave him the opportunity to develop his sense of color. For a while, in the early to mid-1960s, he painted townscapes—realistic scenes of local lanes and the Chongqing port (only one or two of these works still survive; fig. 6). He also began painting landscapes (none of these early pieces survives), and he became involved for the first time in traveling about the countryside to do realistic sketches. Having no painting stand or supply box, he borrowed a wooden stand from the Culture Hall and used a bamboo basket to carry his pigments and brushes. Sometimes Yu Jiwu loaned Li his "prized possession," a stand with a materials box made in Beijing "in the style of the Russians." Li also had to carry a board on which to paint. "All this was very heavy and inconvenient," says Yu, "but Li didn't care about the trouble. He once even carried this equipment to the top of Tieshanping [Iron Mountain Terrace]. This mountain was near the Tong Luo [Bronze Gong] valley of the Yangzi River, and he sketched the scenes from there all the way to Yangbei county. This exemplified Li Huasheng's obsession with his art."[13]

Li began his study with the versatile Yu Jiwu at an opportune time. The radicalism of Mao's failed Great Leap Forward had been supplanted by greater pragmatism under the leadership of Liu Shaoqi, elected in April 1959 as the second Chairman of the People's Republic. Even before 1949, Liu Shaoqi had claimed to stand for opening the doors wide and accommodating different views. After 1949, Liu deemphasized class struggle and criticized censorship—"Banning a book is like shooting a person to death."—while asserting "There is nothing to fear from propagandizing feudal art. . . . Haven't we triumphed after all?"[14] Liu made clear his basic intention regarding intellectual activities:

. . . to divorce politics from other aspects of the life and activity of the intellectuals, in order to allow more latitude in scholarly pursuits. . . . The Propaganda Department issued "Ten Articles on Art and Literature" in July (1961), which stressed literary techniques and professionalism rather than politics, classical Chinese and fine foreign art in addition to contemporary revolutionary works, and let Mao's requirement that artists participate in *xiafang* [going down to the countryside for manual labor] fall into desuetude.[15]

Especially in the early 1960s, writers and artists alike used a wider variety of styles and produced a broader range of expression than was common in earlier or later periods.[16] By the standards of the moment, there was nothing unusual about Li's simultaneous study of Western oils and Chinese media, nor of his painting theater figures, nonpoliticized landscapes, and cityscapes, except for the undisguised dinginess of his urban scenes. Of course, this was only a few years before Mao's first hand-picked successor was overthrown, charged among many other things with "raising artistic standards" at the expense of "popularization."[17]

Li continued to work with Yu Jiwu through much of the Cultural Revolution period, and he still visits Yu occasionally.[18] But Yu was just one of several teachers and artists from whom Li began to learn in the 1960s. Another such artist—"the first major painter I saw and appreciated"—was Su Baozhen (b. 1916), a 1944 graduate of the National Central University (transferred at that time from Nanjing to Chongqing), where he had studied with Xu Beihong, Wu Zuoren, and Fu Baoshi. Su became a painter of grapes and other plants.[19] When he first saw Su Baozhen's work, says Li, "I thought he was so good that I couldn't sleep all night." Li was impressed by Su's one-stroke willow branches, with long, perfectly even strokes, and he began to practice this until he learned that Su's trick was to rest a finger on the paper. "This made it easy for me to imitate," says Li, and his interest in Su's art quickly came to an end. Although they were never a major theme of his art, for at least the next decade Li occasionally painted such still-life subjects, some of which (fig. 26) certainly compare favorably with those of the specialist.[20]

In the early 1960s, when Li was still primarily interested in Sichuan opera, he practiced acting and studied opera music, particularly music for the *jinghu*, a two-stringed, bamboo-made fiddle. But Li's parents, though devout opera lovers, were equally devout in opposing his taking opera and popular music this seriously, for they considered it socially undignified. Hoping to deflect this interest, they instead had him introduced to Zeng Youshi (d. 1985), a gifted literatus, seal carver (fig. 119 a–c), calligrapher, poet, and painting collector who took on a number of private students. Zeng shared Li's love of the theater and made his income as a dramatic writer for a Beijing-style (*jingju*) opera company, the Li Family Theater begun by the old master Li Yanzhi. Li first met Zeng in about 1962, in his small office above the theater. The introduction was arranged through connections provided by Li's painter-friend Xie Dayou (who had played the "hus-band" in Li's boyhood imitation of a pregnant peasant) and with the aid of some cigarette coupons, which were then quite scarce.

Li understands that Zeng's family were very wealthy; they even owned a black car before 1949, when virtually no one had cars. In 1962, however, Zeng supplemented his meager theater income with a bit more earned from his carved seals, and he also received regular gifts from his students. But Li feels that Zeng Youshi taught simply because he was dedicated to having good students. Like the other students, Li went to Zeng's home individually, for about a half-day per week, and was instructed broadly in the arts. A friend of the famous Sichuan-born painter Zhang Daqian, Zeng passed down to Li many tales about Zhang and other personalities in the Sichuan art world. He was able to show Li paintings in his collection from the Qing dynasty, but he was not a painter himself or a painting teacher. Instead, he provided detailed instructions in calligraphy and seal carving as well as informal teaching in poetry.

Some of Zeng Youshi's seals were carved in later years for Li's use and appear occasionally on Li's paintings (e.g., fig. 119a, "Man of the River," impressed on figs. 58, 67; and fig. 119c, "Dots and lines freely done," which appears on fig. 81). These seals vary considerably in style, in part because of their varied sources of inspiration. Figure 119c, for example, is cut with a continuous horizontal movement away from the carver and combines unmodulated lines with rough, modulated, wedge-shaped lines (usually vertical). This reflects the style of Han dynasty seal script as found on bronze-cast seals and stelae titles; it is also a style often practiced by Qi Baishi. Figures 119a and 119b, on the other hand, are done with smooth, taut, unmodulated lines and carefully balanced components which reflect older (Zhou dynasty) and more formal styles. Yet all of these examples reflect Zeng's general characteristics: his strength of line (most impressive in fig. 119a); his structural control (balancing modulated and unmodulated strokes in fig. 119c, combining straight and curved lines in fig. 119b, harmonizing carved lines and empty space in fig. 119a); his freely creative sensibility (in the detached lines of fig. 119b, and the downward lines extending from one character into another in fig. 119c); and his tendency to transform characters into pictorial form (e.g., in the character for "man" on the left of fig. 119a).

Li says that under Zeng's welcome guidance, he learned to copy past masters' styles from manuscripts. He progressed rapidly, learning the style of almost any given model within two weeks. At first, Li remembers, Zeng

could not believe his speed and thought he was getting outside help. Li had to prove to him otherwise. Li began these studies with no historical knowledge of calligraphy, and he began by studying Wang Xizhi's *Orchid Pavilion Manuscript*. As he gradually began to broaden his range, he came to prefer the more dramatic, "masculine" styles of the stone-carved northern stelae to the "artificial" elegance of handwritten southern manuscripts. He studied these stelae by the double-outline or *shuanggou* method, tracing the outlines and filling them in with ink. Li's favorite period was the Northern Wei, his favorite model the *Yihe ming* attributed to Tao Hongjing, now in Zhenjiang. Other favorites, as now remembered, included the *Shimen ming* and the *Taishan jingang jing*. He was also fond of the intentionally awkward calligraphy of Huang Tingjian of the Song dynasty. He studied many styles, moving rapidly from one to the next rather than specializing in any one, but his taste at that time remained dominant in later decades (fig. 65). Since Zeng had no significant collection of calligraphy, Li worked only from book copies. The only artists to whom Zeng provided direct access were from the Ming and Qing periods and were not great calligraphers. Li never bothered to imitate these.

In studying seal carving, Li began with about twenty selected Han dynasty bronze seals and altogether worked on about sixty pieces—"not very much practice, in all." Zeng emphasized that his work must not be of artisan quality but, instead, artistic in nature, each work having some new, creative idea. Li feels that his study of seal carving, with its simple emphasis on the relation of red and white, gave him his first real knowledge of how to use empty space in his paintings—"One cannot simply leave blank spaces, but must design them" (cf. figs. 56, 113). In recent years, seal carving has increasingly become one of Li's central interests and major artistic strengths (fig. 119d–j).[21]

In studying poetry with Zeng Youshi, Li never practiced any particular artist's style. He merely tried to read broadly and to understand. His favorites were the high-Tang poets Li Bai and Du Fu "because of their great sense of self-confidence"—Li Bai because of his bold treatment of nature, and Du Fu because of his sympathetic handling of people. He was also fond of Wang Wei, Chen Zi'ang, and Han Yu. The Song poets Su Shi and Mei Yaochen seemed good to him, but not quite up to Tang standards. "I have no great achievement in poetry," Li admits today. "It is just a hobby. Painters who do poetry cannot compare themselves to poets." And it is a sad fact that the distinctive Chinese ability to produce both fine painting and poetry has nearly disappeared with Li's generation of traditional artists. On all but a few of Li's later paintings, the poems are quotations from lyricists of a past culture (his Mt. Huang poem is the outstanding exception; fig. 53, translated on page 104, below).

Li remained a friend and occasional student of Zeng Youshi until Zeng's death in February 1985. At that time, Li composed a heartfelt lament for his teacher, in traditional style, extolling Zeng's art of the seal:

In a square inch, he preserved Heaven and earth;
With an iron brush, he moved the mountain peaks.

Li Huasheng's third major instructor during this period, and the first who specialized in the traditional Chinese painting method, was Guo Manchu (b. 1919), with whom Li Huasheng studied for about five years beginning in about 1959. Guo had moved to Sichuan during the war. Like Yu Jiwu, Guo taught art at the Chongqing Culture Hall (from 1957 to 1971). But by contrast, in content and approach, Guo's instruction was extremely conservative and formal. Guo specialized in painting the "orthodox" styles of the "Four Wangs" of the late Ming–early Qing dynasty. Except for a few modern works like Qi Baishi's *Cleaning the Ear,* however, Guo did not have much of a collection, so Li studied mostly from reproductions. In the old traditional Chinese manner, Li usually studied by painting at his own home and taking his finished works to Guo's home for correction. It would have been undignified for the master to watch patiently while the student painted inferior work. The corrections, then, were based on the final product and were mostly verbal, only occasionally being supplemented with brush demonstrations by Guo Manchu. In 1965 Li suddenly quit studying with Guo, out of hostility to this conservative education and its focus on orthodox masters rather than the great individualists. Today Li retains the attitude that led to this split:

A student must have talent in his blood and cannot achieve artistic quality through learning. The old generation always emphasized the tradition as something mysterious and kept it secret, but if you are talented or clever it is very easy to comprehend the artistic heritage. In traditional Chinese painting, technique is principal, but there is nothing more to this than brush and ink. The ancients had certain standards, for example in the use of light and dark ink, which is very easy to master, for holding the brush, which is also very easy to master, for creating lines that can give a sense of being heavy or angry, or light and fast, clever, wise, silly, or foolish. Through line, one sees the mind, but all of these things are easy. And they are not art—they only serve art. Art cannot be taught by teachers. I felt

this education was boring—typical orthodox school. Guo opposed anything not based on orthodox models, and for anything else he cursed me. He trained me to become an orthodox painting production machine, which destroyed my interest in any such painting.

The relationship between Li and Guo continues cool to this day, marked by Li's disinterest in Guo's conservatism and permanently marred in 1983 by Li's public affront to Guo and his conservative art.[22] For his part, Guo Manchu writes pointedly about his former pupil, suggesting that Li was really not shackled by him but rather was unable to submit emotionally to the discipline of following the old masters:

He was very intelligent and wanted to study, so I tried hard to make everything available to him, with attention to brushwork, ink, composition, texture strokes, stones, trees, and seasonal aspects. I taught him it was necessary to read lots of books, to cultivate himself intellectually, especially with poetry. . . . Li mastered whatever he studied. . . . After a few years, I told him to paint as he wished, to gradually establish his own style and not worry, and that if he had any questions to consult with me. But one important point I said: "You must be cautious; never be arrogant or conceited or look down on others! That is a big obstacle to progress."[23]

Disappointed by his study of traditional Chinese painting with Guo Manchu, Li increasingly began to concentrate on oil painting with the help of Yu Jiwu. This was a timely decision; whether it was politically calculated or not is impossible to say. But China's cultural temper was changing, radically and rapidly. Within a year, the Cultural Revolution burst upon China's cultural scene, and propagandistic oil painting became the Chinese artist's political obligation.

Revolution by Day, Tradition by Lamplight, 1962–76

Riotous clouds are drifting swiftly past. They indicate that Chairman Mao is arriving in Anyuan at a critical point of sharp class struggle and show in contrast how tranquil, confident and firm Chairman Mao is at that moment. They also portend the new storm of class struggle that will soon begin.

—Liu Chunhua, *describing his painting, Chairman Mao Goes to Anyuan*[1]

THE MIDDLE KINGDOM, OFTEN THOUGHT OF IN THE West as "changeless China," has seen more change in the past forty years than have most other countries in the world. Perhaps this represents China's compensation for having resisted change so ardently for so long. Also to account, most certainly, is the factional nature of Chinese politics: because no mode exists for peaceful administrative transitions, factions cling desperately to their ideological "lines" as if there might be no second chance for them, only to force the most severe reversals when power shifts to those espousing alternative viewpoints. The critical first years of artistic studenthood for Li Huasheng, 1959 to 1963, under the simultaneous tutelage of Yu Jiwu, Zeng Youshi, and Guo Manchu, were for China a moment of relative calm and intellectual freedom sandwiched between periods of tighter government control.

The Anti-rightist Campaign and the economic debacle of the subsequent Great Leap Forward spent enough of the class-struggle advocates' political fuel to bring the pragmatists to the fore, under Mao's successor as chief of state Liu Shaoqi. But the intellectual calm of Liu Shaoqi's few years in power was followed by a decade fiercely dedicated to the principle of "continuous revolution." Historians date the turning point between these two eras to May 1963, when Mao (who came to believe that "the exploiting class, landlords, and rich peasants who have been overthrown [are] trying to make a comeback") initiated the Socialist Education Movement, which "he conceived . . . to be a semipermanent movement 'requiring five or ten generations.' "[2] In December 1963, Party Chairman Mao warned the Propaganda and Cultural Departments of the Party Central Committee, "Problems abound in all forms of art such as the drama, ballad, music, the fine arts, the dance, the cinema, poetry, and literature."[3] According to Liu Shaoqi's biographer, Liu's response was to blunt Mao's critique: "Within twenty days of Mao's first instruction, Liu Shaoqi personally presided over a forum on literature and art on behalf of

the Politburo, Propaganda Department Deputy Director Zhou Yang delivered a self-criticism but was on the whole optimistic about the state of the arts, and Liu generally endorsed this view."[4] Mao then began to circumvent and undermine Liu's authority, issuing a second critique in July 1964. He also appointed Beijing Mayor Peng Zhen as chairman of a Group of Five "with authority to review the entire field of art and literature, and the reform movement began to garner somewhat more momentum."[5] Any who stood in the way were eventually shunted aside, including both Peng Zhen and Liu Shaoqi.

Li Huasheng's early pursuit of his art and his choice of art teachers were carried out free of ideological involvement, during the only period between 1949 and 1976 when that was possible. By 1963, political reality had again begun to change, and Li was soon made aware of its effects.

During Li's period of study with Zeng Youshi and Guo Manchu, in 1962, he completed his public schooling— senior middle school, the equivalent of American high school. In March of the next year, he returned to school, enrolling in the technical school run by his father's employer, the Shipping Administration's Yangzi River Shipping School.[6] Li majored in benchwork (qiangong) and studied some machinery. Technically, the school was a repetition of senior middle school, and because of Li's earlier schooling, he was older than most of his classmates. But Li was not interested so much in engineering as in the opportunity the shipping profession would offer for travel through the Yangzi River gorges after his graduation. That is to say, although Li Huasheng saw no possibility of art as a profession, with the advantage of his father's career, he chose to follow him into a profession that could support his pursuit of painting as an amateur. Landscape painting had already become a passion.

Despite his proletarian background, graduation from middle school conferred upon Li a new class status: that of an intellectual.[7] Increasingly, his pursuits and his personal associations were intellectual in nature. One of these associates at about the time of his enrollment in the Shipping School was a North Bank neighbor, a painter named Zhang Fangqiang (b. 1935). Zhang was the leader of a loosely gathered cultural group whose members were mostly older than Li, known as the "Beethoven Club." By 1963, Li was spending most of his free time painting, but he sometimes joined the group in its custom of sitting about together at night on boats (not their own) moored along the Jialing riverbank, appreciating the moon and listening to recordings of Beethoven. This seemingly innocent pastime provided Li his first major encounter with socialist China's cultural politics.

This encounter was triggered by an investigation into the activities of one of the Beethoven Club's occasional participants, a painter named Du Yongqiao (b. 1934), who would later join the ranks of Li's teachers but whom he scarcely knew as yet. Du reportedly remained close-mouthed during his interrogation. His wife, however, was questioned separately and confessed the existence of this group, thinking that this token offering would convince her interrogators that Du's activities were nonpolitical. The result, however, was an investigation broadened to include Du's friends, conducted by a special unit (zhuan an zu) designated to handle the case. In an unpredictable turn, security police interrupted the group listening to Beethoven on the roof of the Heping (Peace) Movie Theater. On being questioned, one of the group members, Zeng Weihua (b. 1944), was misunderstood by the police. Rather than speaking of a "Beethoven" (in Chinese, Bei Duofen) appreciation group, he was thought to have said "Pei Duofei," Chinese for Sandor Petöfi, 1823–49, the Hungarian revolutionary poet. This error could hardly have been more critical. The Hungarian uprising of October 1956 sent shock waves through the Communist world—leading Mao to question openly the wisdom of Khrushchev's policies and to examine more deeply than ever before the loyalty of China's intellectuals—and Petöfi had become a symbol in both countries in the intellectuals' role:

> Apparently, the Hungarian uprising, particularly the role of the Petöfi Club in Hungary, had a profound impact on China's writers. The Petöfi Club was composed of old and young poets, playwrights, and novelists, who through their positions on newspapers and journals were able to publish direct criticism of the government. Its members had had a leading role in the rebellion and were responsible for fomenting student unrest. They also had had contacts with the working class. Fearing similar actions from China's writers, the leadership in the literary realm worked energetically to forestall any such eruption.[8]

In China, Petöfi meant disloyalty.[9]

In the adjudication of this affair, Du Yongqiao got off easy, being labeled a "white expert" as opposed to a "red"—in other words, not sufficiently politically conscious and certainly not a good socialist, but not so bad as to merit a criminal sentence. For the others, however, as was often done, their documentation was merely collected in their official dossiers (dang'an) and "justice" was forestalled until the next major political movement called for rectifications and victims. After the 1966 outbreak of the Cultural Revolution, Zeng Weihua and Zhang Fangqiang were labeled "anti-revolutionary" owing to charges based largely on their

1963 investigation. They were ultimately sentenced to terms at the Jiuguoqing labor reform camp near Chongqing. Zeng's internment lasted from 1967 to 1968. Zhang's term began in November 1969. Li, who remembers going to watch Zhang's bus depart, was entrusted with his book collection, which included such forbidden authors as Chekhov, Turgenev, Stendhal, and Dickens. Unfortunately, Li loaned these volumes out one by one to other young readers with a taste for such writings; by the time Zhang returned there was no collection left. Zhang remained in work detention until February 1972, his release triggered by the fall of Lin Biao and the resultant rectification movement, which like every massive fall brought a scattering of their many bureaucratic affiliates and an attempt to overturn their past actions. Zhang has never married; his friends attribute this to his experience of political persecution. He still paints landscapes, mostly using gouache. Zeng, while in labor reform, made an important artistic friendship—the prominent printmaker Lü Lin. This friendship would later provide Li Huasheng initial access to his esteemed painting teacher, Chen Zizhuang, who is the subject of the next chapter.

As for Li Huasheng, the special investigation group expressed its concern that lounging around on moored boats, appreciating the moon, and listening to Beethoven were indulgences in a "capitalist life style." But Li was simply declared "a problem individual (*you wenti de ren*). He thus came close enough to experiencing the severity of political justice in socialist China.[10] It must have reinforced any awareness in the young Li Huasheng that he was not at one with the system. Artistic endeavor had not transformed this mud-throwing, foot-tickling child into a socially conforming youth. Rather, his art provided the medium for sublimation of a nonconformist aesthetic.

The episode of the Beethoven Club was hardly sufficient to frighten Li Huasheng into conformity, into a new personality. Nor did it deter Li and his friends from their usual cultural pursuits. At the time, Li was already doing oil paintings of Chongqing cityscapes, depicting the old shabby buildings along the steep, long steps leading down to the riverbank. Li and his young artist friends were too poor then to afford wooden frames for their paintings, so they made cardboard frames with materials taken surreptitiously from their work units. "On the boats," he says, "we'd sometimes just use a knife to cut off cardboard strips that were used as door seals."

His earliest surviving painting (fig. 6), from about 1963, typified his work of that period. In style and content, it openly courted danger. His color palette made this emphatic, avoiding any use at all of the patriotic color red and instead using green, yellow, blue, and black paints. Whereas his teacher Yu Jiwu's work subtly idealized nature (fig. 5), Li selected the gloomier side of reality— "emphasizing the dark side," to use Mao Zedong's Yan'an Forum indictment of misdirected satire. Although Li says that such works were not really political and were meant only to explore a broader range of visual reality, paintings like this were poised at the edge of political neutrality; indeed, in the eyes of some, they were designed to foment political opposition. In any case, they left their creator wide open to further official criticism for bad attitude, bad life style, and bad actions.[11] The arrival of the Cultural Revolution did not put an end to this kind of painting by Li Huasheng; it only made it more dangerous.

Just before the arrival of that "revolution within a revolution," a second political encounter even more serious than the Beethoven/Petöfi Club incident took place, just at the end of Li's four years at the Shipping School. Not surprisingly, Li's painting was used by others to get him into trouble. Li should have graduated in June 1966, and students were already being assigned to new jobs at that time. But an intensification of the Socialist Education movement occurred just before that, in March, and was soon followed the outbreak of the Great Proletarian Cultural Revolution itself. At the time, everyone was obliged to engage in public debate, to manifest his or her views (silence was out of the question) by means of the "Four Greats" (*Si Da*)—speaking out freely, airing views fully, holding great debates, and writing big-character posters."[12]

With everybody's views being carefully scrutinized for ideological flaws, Li was criticized for a painting he had done on a dormitory wall, in which he depicted a pair of stones one day and added a few bamboo plants several days later. These stones and bamboo, said his accusers, represented weapons meant to be used against the Party. To bolster this accusation, Li was also faulted for having copied a Tang dynasty poem by Jia Dao: "Hoisting the Sail, I Set Out for Min [Fujian],"

To Fujian I return to my garden;
The west wind blows upon the waves . . .

Since Fujian province faced Taiwan across the straits, this made it "clear" that Li preferred the Guomindang government, perhaps even wanted to flee to Taiwan.

And that was not all. At the same time, Li had written a poem about Chairman Mao which included the phrase "the west wind violently blows." Because Li used brush and ink

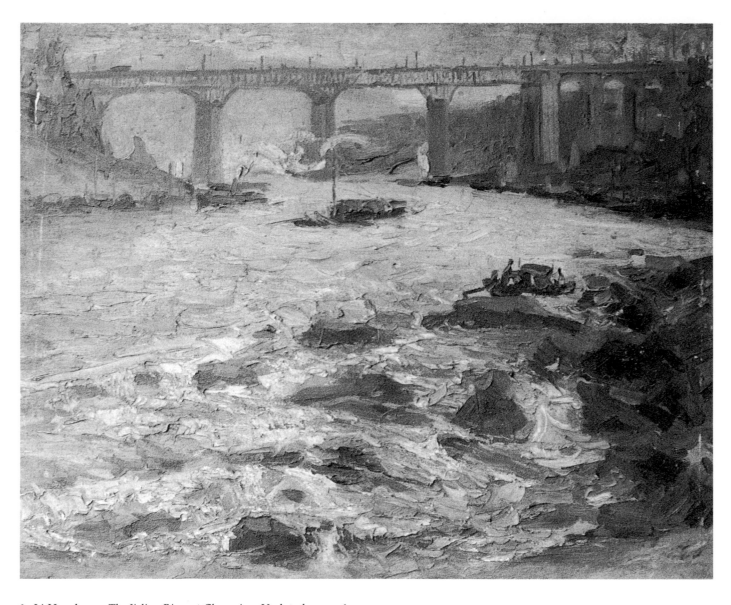

6. Li Huasheng. *The Jialing River at Chongqing*. Undated, ca. 1965.
Oil on canvas. Collection of the artist.

on paper, and because the ink had dried, the complete line could not be read; only the characters 'west wind' could be seen clearly. Since 'west wind' could be taken as a symbol of Western Power—here, directed against Chairman Mao; and the Jia Dao poem, blowing him to Fujian or Taiwan—it represented another crime, reported by a fellow student to his group leader. There was also a landscape painting of campus scenery that Li had done on paper, around which he had painted a frame with brush and ink, for lack of affordable framing materials. For that somebody attacked him, saying he had confined this socialist school in a black, capitalist frame. More generally, but most conclusively, Li was criticized as being a "white specialist" rather than a "red socialist" for selfishly working on his painting when he should have been serving the masses by concentrating on engineering.

Along with Li, two close friends were similarly accused, attacked for misstatements made during the Great Debate. One was a roommate named Guo Shihui, and the other was Ren Yongsong. The charges against all three may have been thin, to say the least, as charges at the time usually were. But as political targets, Li and his friends were typically well chosen. They were scarcely models of socialist enthusiasm, and they had scarcely any record of positive political behavior with which to defend themselves. After enduring a week of public criticism, all three decided to confess to their "crimes" rather than face the possibility of more drastic charges. At a public meeting before a large crowd, Li Huasheng was obliged to remain in a long, low bow. He was fortunate in not being beaten. He offered an oral self-criticism and afterwards also submitted a written self-criticism. It was declared of Li (as it was of Guo and Ren) that he *should* be labeled as an "enemy of the people" but that he would instead be treated more leniently, as representing a "contradiction among the people." That is to say, he was placed in the third-level category of political criminals, correctable through ideological rectification, rather than the fourth and worst class, class traitors who were subject to capital punishment.

The three offenders became known locally as the "Little Three Family Village," in reference to the trio of "anti-Maoist" intellectuals, Wu Han, Deng Tuo, and Liao Mosha, currently being turned into model targets in Beijing under the name of "The Big Three Family Village."[13] All were sentenced to do hard labor without salary in order to be reformed. The judgment was distributed by high officials to all branches of the Shipping Administration, and Li was ordered to do labor at Yichang, Hubei province, at the Xiba Shipbuilding Factory, probably on the forges there, but no specific assignment was forthcoming. While awaiting new orders, Li was assigned to the local school factory to undergo reform. With Guo Shihui and Ren Yongsong, he was moved to the factory dormitory, where they lived in a one-man room and were denied all visitors and outside contact. Li spent the daytime forging metals and scraping clean the forging tables by hand, an exhausting task that left him little energy for painting afterwards. Among the other workers, he was treated as a political outcast, obliged to work in total silence, even when subjected to harassment, and made to remain at the rear of any line to get food or to wash his dish.

In the midst of these events, Li received notification that one of his large woodblock prints was to be sent abroad for exhibition in Albania. The print was a propaganda piece about shipping, entitled *Sichuan Oil Going Through the Gorges,* done in September 1965 while Li was on a working internship at the East Wind Shipbuilding Factory. Li had submitted it for competitive consideration with the support of the Shipping School. Now, however, while Albania remained China's sole ideological ally during this period, Li tried to conceal this "success," since international involvement of any kind might be regarded as highly suspect. Anything that made him seem more of an artist and less an engineer would deepen the charge of his being "white" rather than "red," intellectual rather than proletarian. The subsequent appearance of the work inside the back cover of *Sichuan wenxue* (*Sichuan Literature*) came to him not as part of a major artistic success, but as a threat.

At night, despite his tiring work in the daytime, Li continued to paint, and now he began to work in secret. An old man, a "rightist" sentenced several years earlier to do custodial work cleaning floors in the dormitory, helped to shut him into his room and kept a watch out for others who might suspect him. Although it was very risky to express oneself artistically or politically at this time, Li spent every night painting intensively. Li's roommates remember that he had to work hard every day without any wages and that his situation was emotionally very difficult, yet whenever possible he stayed in his room producing oil paintings, Chinese ink paintings, and even some woodcut prints. His dedication moved them deeply. For models, he used his roommates or, more often, a mirror and his own image. Guo sometimes joined him in this clandestine art, doing calligraphy and seal carving. In this period, Li did a traditional Chinese painting for Guo of a blooming lotus, signifying their getting through this time of troubles while retaining their purity. The painting was burned, together with all of Li's clothing and books, when this dormitory was destroyed in battle at the peak of the Cultural Revolution.

In the summer of 1966, all of Mao's preliminary measures to reclaim his political authority in China culminated in the Cultural Revolution. Mao moved against his own government and turned it upside down. "To rebel is justified," he told the newly formed Red Guard units. "Bombard the headquarters" became their slogan. In the process, chaos descended on China and local ruling factions were frequently overthrown. At the Shipping School, this cataclysm worked to Li Huasheng's benefit and enabled the "Little Three" cases to be judged as having been "mishandled" by the pressured administration. In November 1966, the three were declared rehabilitated. They were given sympathetic consideration by their factory's Party secretary, an old revolutionary named Yan Tianshan, who issued this declaration and publicly burned all the related documents.[14] Yan also advised the three to stay on in the Shipping Administration in order to avoid the investigation that would be needed if they sought a job elsewhere, or if they attempted to join the Party, the Youth League, or the Red Guards as so many youths were doing at that moment. Yan also had Li transferred from the benchwork unit to the vehicle unit, from manual labor to machine labor, thereby enabling Li to save more energy for his painting. Li still had no diploma, for the Cultural Revolution had caused the school to be closed before June so that *nobody* had graduated. Ironically, both events that had started out so disastrously for him, as well as the Cultural Revolution that was devastating to so many others, proved beneficial to Li and his friends. Guo Shihui recounts that "because those events made us experienced, we didn't get involved in the Cultural Revolution. We just remained passive."

Early in 1967, with the advice and help of Party secretary Yan, Li went to work as an artist for the Party's propaganda unit of the Shipping Administration's offices.[15] This gave him many chances to travel through the Yangzi River gorges on Shipping Administration ships to do naturalistic sketches. He continued to live in the Shipping School's dormitory.

On May 1, 1966, at a government rally in Beijing, Premier Zhou Enlai announced the beginning of the "Great Proletarian Cultural Revolution" and called for the elimination of "bourgeois ideology in the academic, educational, and journalistic fields, in art, literature, and all other fields of culture." With that, the nature of daily life in China changed radically, and whatever had not already been politicized became so. China's government was thrown into chaos, as were the lives of the people. By the time all this was over, a decade later, countless lives had been taken and countless others shattered or scarred. The number of victims was beyond the government's ability even to estimate. It was as if the "Liberation" of 1949 had not quite occurred and suddenly the nation was at battle with itself all over again, fighting against an unseen enemy who might be a stranger, a supervisor, a friend, a parent. The watchword was prominent in the little *Red Book*, with its quotations from Chairman Mao:

> After the enemies with guns have been wiped out, there will still be enemies without guns; they are bound to struggle desperately against us, and we must never regard these enemies lightly.[16]

Everything old was a target for destruction: Mao's "Four Olds" included old culture, old habits, old customs, old ideas. China's intellectuals, as bulwarks of the old culture, became primary targets (though the peasantry, in reality, had proved even less tractable to socialist-inspired change than had the intellectuals). They were popularly denounced as the "spawn of dogs," even labeled "cow ghosts and snake spirits" by Mao Zedong himself. The theory of revolutionary inheritance was brought fully into play, and universities were closed except to children of the "five red families": workers, peasants, soldiers, revolutionary cadres, and revolutionary martyrs. Old curricula were gutted in the struggle against the "Three Separations": the separation of the university from the three realms of practice, of politics, and of manual labor.[17]

In the cultural realm, at the national level, the regular units of state control were smashed and their functions taken over by small, powerful cliques operating with support of the military. The Ministry of Culture was disbanded, to be supplanted by a Central Cultural Activity Group under Wu De which, in turn, came under the aegis of Jiang Qing's Central Cultural Revolutionary Leadership Group. At the local level, in Sichuan, there was "no one in charge" of cultural activities, according to Niu Wen, who before and after the Cultural Revolutionary decade was chairman of the Chongqing Artists Association and vice-chair of the Sichuan Artists Association. "Basically," he says, "in these ten years there was no creativity. There were no publications, no exhibitions—nothing at all," which is less a statement of fact than a denunciation of the propagandist art, publications, and exhibitions produced at that time.

The leadership of the artists associations, including provincial chairman Li Shaoyan and Niu Wen, were stripped of their authority. They were criticized and "struggled against" by others in their administrative units and were then herded

together into a "study unit," where they inculcated the new political "line" until they were ready to confess their past mistakes. While they awaited the "conclusion" of their cases, these artists were prohibited from engaging in any artistic activity. Eventually, all were sent down to the countryside for labor reform. For two years, in 1970 and 1971, at the Zhongba work farm on Little Nanhai Island in the middle of the Yangzi River near Chongqing, artists and arts administrators such as Li Shaoyan and Niu Wen worked long days, stripping the skin off the sugar cane. But there, at least, they were once again permitted to practice their art. Niu Wen says that "all local government and Party leaders, all writers and artists went through this. All of us suffered a great deal."

Throughout the land, the struggles ranged from private denunciations to pitched battles, while the destruction led from intellectual regression to economic deterioration. As a cultural revolution should, it permeated every detail of one's life. Nien Cheng later would chronicle this:

When you wished to make a telephone call, the operator would not say "hello" but "serve the people," and you would have to respond "thoroughly and perfectly." Only after this exchange would she ask what number you wanted to call. If you were unable to reply with the appropriate words, you would be told to go back and study Chairman Mao's works. . . . Before you could make a purchase, you would have to respond with the appropriate quotation. This was called "popularizing Chairman Mao's teachings and making them known to everyone."[18]

It was a crazy time—planting flowers might be considered dangerously counterrevolutionary, and serious consideration was given to changing red traffic lights to mean "go" and green lights to mean "stop." The Chairman became a deity, and the white plastic Mao was as ever-present in China as were similar Christ figures in parts of Western society. Nien Cheng recalls an episode in 1967:

The newspaper reported a new ritual observed by all Chinese people: "Ask for instructions in the morning, check your action with Chairman Mao's teachings at noon, and report everything at night." Apparently everyone went through this formality in front of an official portrait [or statue] of Mao. To ask for instructions was to read passages from the Little Redbook, to check was to read again from the same book, and to report was also to read from the same book. In short, three times a day, every day, every Chinese, except babies, had to read from Mao's book of quotations. The newspaper published articles discussing whether one should do it when one was alone at home on Sundays. The conclusion was that one should not neglect going through the ritual even when one was lying in bed sick.[19]

Li Huasheng recalls, "When I first got a portrait of Chairman Mao, it was very hard to find an appropriate place to hang it. Nothing could be placed above it, and no dent should be found on its frame."

Li Huasheng seems to have been rather inept—or at least totally disinterested—in such politics and was unwilling to memorize the passages in Mao's *Red Book*. "Once when I was trying to cross a street, a Red Guard asked me a question I couldn't answer, so the Guard would not let me cross. A passerby whispered to me, 'Serve the people.' So I repeated this." But he did use the opportunity of the "Great Link-up" policy (*da chuanlian*) dictated by Mao to permit the "exchange of revolutionary experiences." This allowed students to travel the rails for free during the heyday of Red Guard activity—provided they could fit into the train cars, for the cars typically became so crowded that there was no room on the floor to put one's feet down and no way to get to the bathrooms. In September 1966, Li and Guo Shihui went to Changsha together, then Li went on alone to Guangzhou. In Guangzhou, he saw for the first time a "black painting" exhibition featuring Guan Shanyue's works and paintings collected by him. Although Guan had toed the revolutionary line and in 1959 had produced, with Fu Baoshi, a nationally famous model of socialist landscape painting—which illustrated Mao's poem, "Snow," and was hung in Beijing's Great Hall of the People[20]—he had run afoul of the local radicals. Guan's works were now exhibited with black thread crisscrossed in an X over each, like the X deleting the name of an executed criminal. Also displayed was a photograph of Guan with a Guomindang button stuck on it. Li Huasheng, feeling lucky to have regained his freedom and to have escaped from all the trouble over his own paintings, continued traveling until January 1967.[21]

Li's teacher, Yu Jiwu, remembers his student:

When all the students started their "revolutionary travel," Li did not really join this movement. His purpose was never to promote rebellion. Out of this rebellion, he just caught this chance to go to many places, opening up his vision and drawing inspiration from natural scenery. In Suzhou and Wuxi, he painted many scenic landscapes with brush and ink. He brought back large rolls of paintings he had done in traditional media in a realistic style. And he certainly made some progress during this time.

By "progress," Yu means artistic progress, not political progress. Yu Jiwu also believes that while Li had a strong interest in traditional Chinese painting from the beginning of their contact onward, it was only after this period of free travel early in the Cultural Revolution that he began to give more personal attention to it than to other media.

But traditional painting was not the only kind that Li produced in that period. Although the view of "correct" art in this period was most specific, the Cultural Revolution produced a greatly increased demand for propaganda art and provided new opportunities for many artists willing and able to work within these paramenters. Yu Jiwu recalls it thus:

> Li was interested in all different media. He used to study oil painting and made quite an effort at that. He also made some illustrations and engravings. At the beginning of the Cultural Revolution, I painted two large oil paintings for the cultural center with Li Huasheng as my assistant. Actually, he finished one painting all by himself. This propaganda piece showed a half-length figure with some background props. Li was strongly interested in doing this painting, which was about three-meters high and more than one-meter across. He finished it in just slightly more than one day. Even during the noon period he took no rest. He learned a lot while he was doing that painting. He got some primary understanding about the techniques of oil painting and the use of color.

Increasingly, being "interested in all different media" meant maintaining a multiple artistic personality, openly producing what was politically acceptable, covertly producing what was not. Li may not have liked the propaganda, but that did not stop him from pursuing it as art.

Despite the increasingly evident risks, Li and his artist friends also continued to produce traditional (read "counter-revolutionary") works. Zhang Fangqiang was one of those who continued to travel this dangerous artistic path with Li, until he was sent off to labor reform in November 1969. He recalls of their artistic activity, "After painting works that weren't on revolutionary themes, we had to bind them up in newspapers. Li had to display a few works with revolutionary motifs in revolutionary style, and he hid the others." Throughout the decade, probably like many other artists, Li produced revolutionary works by day and works of traditional Chinese culture by lamplight.

Paintings of the lamplight variety were obviously a risky undertaking, but so too was the production of propaganda art. Not only might one make stylistic "slips"—like painting two flags instead of three, and who knows *what* was above criticism in that wild decade?—but one might also paint for the wrong patron or political faction at the wrong time. When Li Huasheng returned from his "revolutionary travel" in January 1967, he tried to remain free of the intense factionalism that had emerged both on his campus and at the Shipping Administration's offices during the Red Guard period. This factionalism divided the students, faculty, and staff (as it did the whole nation) into a "conservative" faction (*baohuang pai*, those supporting the old administration) and a "rebellion" or "revolution" faction (*zaofan pai* or *geming pai*, those supporting Mao's efforts to overthrow all). Those few, like Li, who tried to remain above the fray, were referred to jokingly as the "leisure" faction (*xiaoyao pai*), but that simply meant joining a small faction targeted by *all* the others as counterrevolutionary, and there was no hope in that. As the situation heated up, however, one faction after another splintered into smaller ones, fragmented by internal enmities. Embattled Sichuan became as minutely fragmented as any place in the whole country.

Sichuan's political situation, by the time of Li's return from travel in early 1967, has been described as an "extraordinary upheaval," even by the standards of the moment.[22] Stanley Karnow explains its uniqueness:

> Perhaps no region troubled the Beijing leaders more acutely during the first half of 1967 than did Sichuan, the immense granary lying in remote splendor beyond the gorges of the Yangzi, . . . and the self-sufficient nature of the province made its disorder crucial. For Sichuan had all the attributes of a separate state. To the Maoist leaders in Beijing, the specter of an autonomous Sichuan serving as an enemy base of operations was real and frightening. Moreover, the power of the Sichuan Party machine seemed to lend plausibility to this prospect. The Sichuan Party chief, Li Jingquan, was Marshal He Long's brother-in-law, and he was also close to Deng Xiaoping, the Party Secretary General, who had formerly served in Sichuan. The Maoists therefore made a special effort to topple Li's apparatus. But Li was a formidable foe.[23]

As a result, the struggles between Red Guards and the official establishment, including those between various student and worker groups, were especially violent. By the end of March 1967, the conservative local establishment had maintained its position well against the radical dictates of Beijing, and an estimated one hundred thousand Red Guards had been jailed throughout the province. Of these, more than twenty thousand were in Chengdu alone, confined by the army in city parks and decommissioned temples.[24]

An April 1, 1967, meeting of Zhou Enlai, Chen Boda, Jiang Qing, and others in Beijing publicly denounced Li Jingquan as a "pro-capitalist," which led to a massive Red Guard uprising against the regional political and military establishment. On May 1, "one of the rare naval encounters of the Cultural Revolution" resulted in the drowning of over two hundred youths in the Yangzi River near Chongqing.[25] More than a hundred combatants were killed in Yibin, and an ensuing battle in Chengdu included the first major use of

guns by civilians. The dismissal of Li Jingquan and placement of the province under military command merely threw matters into deeper turmoil. In Chongqing, battles were fought by youths "armed with rifles and bayonets besides such improvised weapons as clubs, crowbars, and vials of sulfuric acid," while enlistments of peasants poured into Chongqing and Chengdu to join in the fight—over a half-million of them in Chengdu alone, who "apparently welcomed this opportunity to break out of the rigors of their 'people's communes' and, in the general confusion, to loot urban shops and warehouses for merchandise that was unavailable in the rural regions."[26] In August, Red Guards marched in Beijing demanding action in Sichuan, carrying banners reading "Sichuan is swimming in blood." But even by the summer of 1968, "despite the introduction of outside troops, local conflicts reached critical proportions as rival Red Guard and Army factions fought each other with modern antiaircraft guns and artillery pieces presumably manufactured for shipment to Vietnam."[27]

In Chongqing, increasingly, gunboats and even tanks were used, and on campus the battles were waged with machine guns, cannons, and spears. Li's own dormitory was burned down in August 1967 when one of the student groups (it is not clear which one) fired a cannon at another. Despite his efforts at neutrality, Li soon found himself caught up in the factional struggle. The Shipping Administration had allied itself with the Maoists. By late 1967, Li was producing paintings of Chairman Mao on demand. At first, because they were dominant at the time, he was obliged to paint for an extremist branch of the rebellion faction—the Spear Group—so named for their chief fighting weapon, with which they had fatally impaled numerous fellow students of other groups and factions. Afterwards, Li found himself painting for another rebellion faction—the August 18 Group—named for the date when Mao first publicly received the Red Guards. Although he was not attracted ideologically to any of these groups, Li had no grounds for resistance, and the demands on him to paint for these groups at least let him practice his art. It also provided him with free painting materials and with good meals as long as he was artistically engaged. But he found himself dangerously placed in the midst of competing demands:

> When I was in school, there was an organization of students known as the Hang Feng, Shipping School Spears, well known for their violent behavior. They asked me to paint a huge portrait of Chairman Mao, which they carried to the demonstrations. This portrait was about three-meters tall, so I had to construct a frame for it to stand on. I was working on it in a collapsed room where the ceilings had fallen down, and by accident I fell down from the stands when I was painting, and when I fell my foot came down on an exposed nail on a piece of wood. I still had to continue to paint this portrait. I never attended this organization, or any others, but this organization's opposition asked them 'Who did this portrait?', and they said they would cut my hand off if I continued to paint it.

Li finished the portrait, but afterwards, as a result, he tried more earnestly than ever to cloister himself in his room. He did not, however, cease production of propaganda painting and prints.

Mao was virtually the only permissible subject, and the only standard was an accurate likeness, with no distortion or departure allowed from the standard published models. Li wanted to paint in thin layers, so that he could save paint for painting in private, but that resulted in too much of a departure from the standards. "The principal standards for painting Mao," he recalls, "were *hong, guang, liang*—red, bright, and shining. For the red flag, and for the star on Mao's cap, only the purest red pigment could be used. And one couldn't use any gray for shading."

Such standards, actually, were not so much generated by painters as they were derived from theater. In particular, they were adapted from Jiang Qing's model (*yangban*) operas and ballets, which came to represent the limits of acceptable thought and the ideological conformity imposed during the Cultural Revolution:

> Mass entertainment was essentially reduced to Jiang Qing's "ten great theatrical productions," and the songs, movies, and productions in local dialect that could be derived therefrom. The cultural and informational policy of the radicals was to pursue intellectual "monolithicity" (*yiyuanhua*), meaning that a narrowly orthodox conception of truth should prevail.[28]

In Jiang Qing's reductionist mode, her central aesthetic theory was that of the "Three Principles of Stress":

> Of all the characters, stress the positive ones. Of the positive characters, stress the heroic ones. Of the main [heroic] characters, stress the central one.[29]

The ultimate extension of "socialist realism—revolutionary romanticism," this standard eliminated all "middle characters"—anyone whom we might think of as "real" or "ordinary" people, any individuals with complex or unresolved thoughts and feelings. The rationale for this was simple: "Ambiguity was not tolerated in literature [or other arts, for] the slightest indication of sympathy toward a villain

was thought to confuse readers and lead them astray."[30] Jiang's *yangban* works (originally eight in number, gradually increased to nine, ten, or more) included four operas, two ballets, a musical composition, a sculptural ensemble (depicting the brutality of notorious Sichuan landlord, Liu Wencai of Dayi, toward his tenants, produced by members of the Sichuan Academy of Fine Arts), and one oil painting.[31] This oil painting was *Chairman Mao Goes to Anyuan* (fig. 7), and Li Huasheng had occasion to paint several copies of it, including one done together with his teacher Yu Jiwu and installed publicly in a small park on Moon Terrace Street in Chongqing.

The original painting of *Chairman Mao Goes to Anyuan*, from 1967, was designed collectively by a group of university and college students in Beijing, then was executed by Liu Chunhua, a twenty-four-year-old student at Central Institute of Arts and Crafts who was the son of poor peasants. The historical theme, set in Jiangxi province in the autumn of 1921, relates to a rural coal miners' strike, the first workers' strike organized by the Communists, and a symbol of Mao's unique policy of turning away from an urban-based revolution toward a rural worker-peasant base, which was later established in the nearby Jinggang Mountains. That Liu Shaoqi, the Maoists' prime target in the Cultural Revolution, had also played a major role in organizing the Anyuan workers underlay the importance of the theme. Earlier, Liu Shaoqi's role at Anyuan had been celebrated and Mao's ignored in two paintings by Hou Yimin, done in 1960 and 1961, but Hou paid heavily for this during the Cultural Revolution.[32] Now, the painters' intention was to reverse the situation, eliminating Liu Shaoqi from the scene in a grand rewriting of history. The designers of the 1967 *yangban* painting purported to pursue reality by actually visiting the remote spot and interviewing those who remembered the forty-seven-year-old event. There, in the words of artist Liu Chunhua, they learned to hate what had once been celebrated:

> This crime of China's Khrushchev [Liu Shaoqi, who] in order to set up monuments to himself and to help realize his aim of usurping Party and state power . . . made arrangements for the production of expensive paintings and films and fabricated reminiscences to portray him, a scab and clown, as "the hero who led the Anyuan workers in struggle."[33]

Singing the praises of Chairman Mao and "the eight revolutionary model theatrical works reflecting the thought of Mao Zedong which Comrade Jiang Qing herself carefully fostered [and which] gave us great inspiration and education," Liu Chunhua described in a journal article precisely

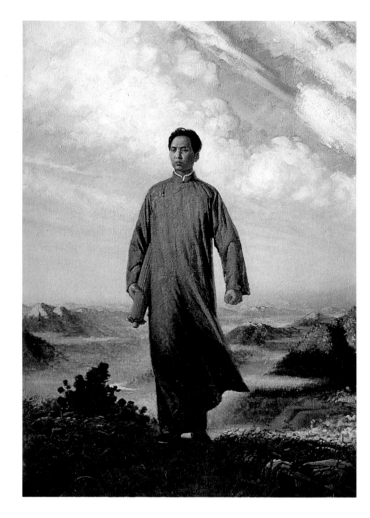

7. Liu Chunhua. *Chairman Mao Goes to Anyuan*. 1967. Oil on canvas. Unknown collection, China. (After *Chinese Painting*, September 1968.)

how, through the process of collective planning and criticism, every detail of the painting had been preconceived along ideological lines and invested with symbolic meaning:

> To put him in a focal position, we placed Chairman Mao in the forefront of the painting, advancing towards us like a rising sun bringing hope to the people. Every line of the Chairman's figure embodies the great thought of Mao Zedong and in portraying his journey we strove to give significance to every small detail. His head held high in the act of surveying the scene before him conveys his revolutionary spirit, dauntless before danger and violence and courageous in struggle and in "daring to win"; his clenched fist depicts his revolutionary will, scorning all sacrifice, his determination to surmount every difficulty to emancipate

China and mankind and it shows his confidence in victory. The old umbrella under his right arm demonstrates his hard-working style of travelling, in all weather over great distances, across mountains and rivers, for the revolutionary cause.

Striding firmly over the rugged terrain, Chairman Mao is seen blazing the trail for us, breaking through obstacles in the way of our advance and leading us forward to victory. The hair grown long in a very busy life is blown by the autumn wind. His long plain gown, fluttering in the wind, is a harbinger of the approaching revolutionary storm. The sun is rising, touching the Anyuan hills with red. With the arrival of our great leader, blue skies appear over Anyuan. The hills, sky, trees, and clouds are the means used artistically to evoke a grand image of the red sun in our hearts. Riotous clouds are drifting swiftly past. They indicate that Chairman Mao is arriving in Anyuan at a critical point of sharp class struggle and show in contrast how tranquil, confident, and firm Chairman Mao is at that moment. They also portend the new storm of class struggle that will soon begin.[34]

No painting of *Chairman Mao Goes to Anyuan* by Li Huasheng still survives. But an oil painting done collectively by Wu Youchang (then a teacher at the Sichuan Provincial Art Academy), Li Huasheng, and Lei Zuhua, entitled *Chairman Mao Inspects the Rivers of Sichuan* and illustrating the three-gorges scenery, was exhibited in 1972 in Chongqing and published on the cover of the January 1973 issue of *Sichuan Pictorial* (fig. 8).[35] The painting was designed and executed with each of the three artists producing his own draft and arriving at the final eclectic design by consensus. It manifests many of the worst aspects of *yangban* art. Although original *yangban* works have typically been criticized by Westerners for their trite, staged effects,[36] the relative success of Liu Chunhua and his fellow artists' oil painting of Mao at Anyuan is made evident by comparison with this work of Li Huasheng and his colleagues. Whereas Liu Chunhua's portrayal of Mao Zedong was based on a rigorous study of early photos and was invested with marked determination, no trace of revolutionary intensity is to be found in Li's painting of Mao inspecting the rivers of Sichuan.

"At the time," says Li, "people everywhere were doing this kind of thing, not only us. We had no ideas of our own and merely followed the social demand." All the figures in this painting share the same smile, except for Mao (done by Wang Youchang) and the one female figure, fourth from the right—two figures who seem interchangeable—and a third, minor figure to the far right. The customary clustering of figures into primary, secondary, and tertiary groups does not convey the intended revolutionary fervor. More-over, the direction of the boat's course is so uncertain in regard to the flow of the river that Chairman Mao's mission seems dangerously adrift. Li Huasheng's primary contribution was to paint two of the figures and the romantic landscape backdrop, which evokes a Maxfield Parrish fantasy as much as any revolutionary model. Heroic mountains rise well out of view: distant slopes of blue and orange on the right, unfortunately too generalized and flattened out to seem very dramatic. These contrast with a more dramatic pattern in gray and white on the left, rugged upper contours and descending wisps of clouds intended to mirror Mao's noble resolve. But whatever its aesthetic shortcomings, the appearance of this work on the cover of *Sichuan Pictorial* marked a great success for Li and his fellow artists, although public acclaim was not an admitted goal of their performance.

Also displayed at the Chongqing exhibition with this painting in 1972 was a second entry by Li Huasheng, which ultimately fared less well critically. An oil painting using gray and blue tones, entitled *People's Army in the Mountain Village*, this work was also published in the *Chongqing Daily*. It was subsequently exhibited in Chengdu, but there it was criticized by the Chengdu Military Region political commissar, Liu Guangyuan, who called it "disgusting" for its excessive use of blue—the color of the Guomindang. To Li's embarrassment, Liu's comments were published by the provincial Artists Association, and Li remembers, "This really scared me—so much! the Guomindang's colors!" Soon, however, Liu fell from power, caught up in the fall of Lin Biao and the elimination of Lin's followers. Yu Jiwu believes that this event helped turned Li away from any further interest in oil painting, although Li's final abandonment of oil painting did not come about until a few years later.

Two other propaganda works by Li, in different artistic media, were also published in this period. One of these, published in *Sichuan Pictorial*, was a comic-strip done with fellow artist Wang Jindong, entitled *Red Lantern in the Waves* (fig. 9). The story was written by a worker (Li no longer remembers who), and Li and Wang were assigned by their work unit in the Shipping Administration to depict it.

The illustrated captions tell of a fleet of ships ascending the Yangzi gorges one dark night when suddenly a great wave capsizes the signal buoy at the dangerous Coiling Dragon Shoals. A small trawler, alert to the danger, beats the ships to the spot with the intention of warning them but is unable to approach close enough to set out a lantern. With all the crew members rushing forward to the impending task, one among them, Zheng Jiang ("River" Zheng), de-

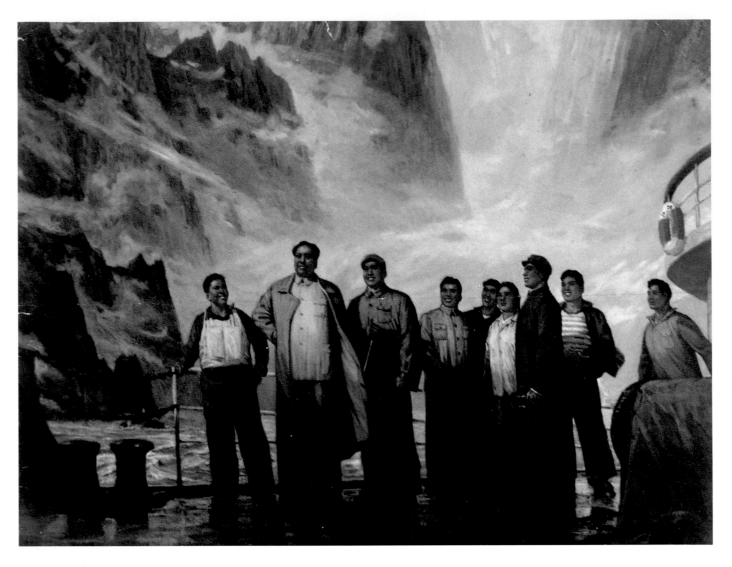

8. Wu Youchang, Li Huasheng, and Lei Zuhua. *Mao Inspects the Rivers of Sichuan.* 1972. Oil on canvas. (After *Sichuan huabao,* January 1973, front cover).

clares, "I'll go, for I'm a Communist Party member" and dives into the water "like an eagle with spreading wings flying over the waves." Grasping the buoy pilings, he holds aloft the red lantern (its chromatic symbolism obvious) which permits the fleet to steer safely past. As they go by, Zheng sees it is a fleet that Chairman Mao had once personally inspected, which "warms his heart and fills him with revolutionary spirit."

Li's contribution here is the landscape, which, though it can be dismissed as lacking in artistic subtlety, is significant for its foreshadowing of Li's depictions of the Yangzi gorges

in the later 1970s (figs. 28, 39) and his realistic sketches of the late 1970s–early 1980s (figs. 40, 41, 43). The varied brush intensity in his handling of rocky contours, the rhythmic wave patterns, the dramatic disposition of the mountains, and the striking handling of contrasts in scale and distance—most effective, perhaps, in the third frame—are an indication of artistic potential awaiting a better opportunity for free expression.

While working as a propaganda artist for the Shipping Administration, Li Huasheng kept active in all media, including not only realistic sketches of the Yangzi River gorges

① 一个盛夏的夜晚，险陡的三峡乌云滚滚，浊浪滔滔，一列满载支援建设物资的船队顶风逆浪，徐徐向盘龙滩驶来。

② 忽然，一个巨浪将盘龙滩上的浮标打翻卷走，船队就要上滩，无灯指引航线，将有触礁沉没的危险！

③ 前哨航标艇立即出动，象一支离弦的箭，射向波涛汹涌的盘龙滩。

④ 盘龙滩上水急浪险，仅有四十四匹马力的小艇把车速加到最快，也到不了标桩跟前。

⑤ 小艇离桩只有两米半，艇长说："跳过去！"同志们都要争先，郑江站立船头大声喊道："我去，我是共产党员！"

⑥ 共产党员郑江怀抱红色标灯，如雄鹰展翅飞扑过浪尖。

⑦ 小艇被急流冲下滩去，郑江在风雨激浪中一手抱住标桩，一手高举红灯，船队随即安全地驶过了盘龙滩。

⑧ 郑江目送安全驶过的船队，想到这是毛主席视察过的航道，心里发出一股股暖流，他满怀革命豪情，勇敢地坚守在岗位上。

⑨ 航道段党支部派来一艘机动船，将郑江接下标桩。支部书记拉着郑江的手，激动地说："你真是一个航道尖兵，我们的好榜样。"

9. Li Huasheng and Wang Jindong. *Red Lantern in the Waves.*
Undated, ca. 1975. Ink on paper. (After *Sichuan huabao,*
date uncertain, ca. 1975).

and paintings based on these sketches (fig. 31) but even prints and sculpture—a broad range of work, which he repeatedly entered into public competitions. He understood the need to establish a reputation, and he understood that in Sichuan's artistic culture, under the administrative leadership of Li Shaoyan, a reputation in printmaking would serve far better than any other. By the early 1970s, Li began to aim for acceptance into the provincial Artists Association. In 1972, when Li first made the acquaintance of Lü Lin—one of those who mockingly refers to the Artists Association as the "woodblock printers association" because of Li Shaoyan's attitudes—Lü advised him that to get into the association, he should produce prints in the "Li Shaoyan line." A third work of the period that can still be viewed is a woodblock print entitled *Ten Thousand Mile Voyage* (fig. 10), exhibited in 1976 in southeast Asia and published a year later.[37]

As Li remembers it, one of the leaders at a political meeting he attended happened to say, "Now women can even operate a ship," and some of the other leaders (including Lü Lin's wife) suggested that artists should create more female figures in their work. Li took the suggestion seriously. The details of the boat, on the right—signal flags, radar equipment, and passengers behind windows—are done to socialist realist standards, lending an air of reality to the work despite considerable stiffness in execution. The sky, romantically aglow, is an early example of Li's tendency to set aside space for broadly patterned, semi-abstract areas within a surrounding framework of more realistic detail (cf. figs. 31, 53, 100). Metaphorically, the "ten thousand mile voyage" of the title refers to the progressive course of Chinese socialism; the female navigator with her binoculars represents far-sighted leadership; and the radiant sun—rising, of course—indicates the bright light of Chairman Mao's ideological wisdom.

Li's technical skill in rendering the sunlit sky is impressive for an artist who had cut but a few prints before this time. The practice of seal carving, in which Li had excelled under the tutelage of Zeng Youshi, prepared him technically for woodblock cutting. Yet only in limited details, such as the hard-edged outline of the boat worker's face, is the technique here closely related to seal-carving or even reminiscent of calligraphy, and this is notably inconsistent with the rest of the work; primarily, the technique is planar, establishing smooth, soft, subtly shaded surfaces through delicate, accumulated strokes of the knife, as in pencil drawing.

The image of the woman boat-worker is based on socialist model heroines like those in *yangban* operas under Jiang Qing's guidance, which set the norm for works in the visual arts. Yet hints of subtle individualization and internal-

ization of mood distinguish it from other works with which it was published in 1977. The woman is not quite smiling and instead seems to project a sense of individual pride and dignified self-composure; while not departing from socialist-realist norms, Li chose to follow a more subdued model and to avoid the more artificial heroics so common at the time. There is even the slightest suggestion of derivation from a live model and a degree of personal feeling for the subject. The model, in fact, was Li Huasheng's wife in their first year of marriage (see below, p. 53). But Li's leaders in the Shipping Company criticized an earlier draft of the work, saying that workers, peasants, and soldiers should appear more robust, and Li was obliged to comply with their recommendation. One can see how he conformed still more closely to this criticism elsewhere, in a sculptural rendition of the same figure (fig. 11).

This sculpted figure is one of the few such works that Li Huasheng produced in the 1960s and 1970s and is the only sculpture by him that can still be viewed today. (Never exhibited or published, it now survives only in a photograph.) "I just wanted to get some experience doing sculpture," says the artist. As with the monochrome print, the work is executed with a technical skill that belies the artist's infrequent use of this medium. Entitled *Dock Worker* and executed in plaster, it again depicts a woman crew member holding binoculars. But a different mood is projected here, more sober, less glowing, less feminine. Fully frontal and lacking the graceful turn of head of the woodblock figure, this serious figure is characterized by her firmly set jaw and determined look, the squint of her eyes, and her thick, windblown hair. The proportions of the body are stockier, triangulated toward the base and projected upwards in a slightly heroic fashion. The outline is less crisp and less elegant; the clothing is more rough and bulky. The realism of the work, conveyed through such details as the cut of the lapels, and the rugged proletarianism of the figure, bring the sculpture fully into accord with the aesthetic vision of Li's superiors.

Although all of Li Huasheng's art at the time was an initial exploration and every genre offered new possibilities, propaganda art was scarcely a mode compatible with Li Huasheng's personality. He had to stretch the genre itself to work within it. In his private work, gradually, he gravitated toward landscape, both in oils and traditional media (cf. fig. 36, a slightly later example), then finally toward traditional landscapes alone. Yet his propaganda art, if not work from the heart, was a matter of practical importance. According to Lü Lin, who advised Li to get more involved in printmaking, when Li subsequently took this route, it hurt his reputation with some of the painters. But Li puts it this way:

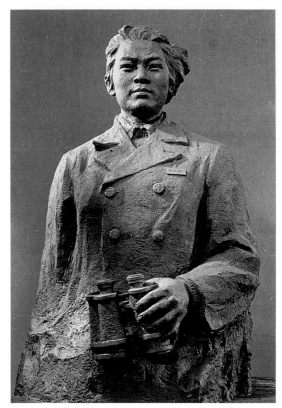

10. Li Huasheng. *Ten Thousand Mile Voyage*. 1975. Woodblock print. (After *Heibai muke ji*, II, pl. 62.)

11. Li Huasheng. *Dock Worker*. 1975. Clay sculpture. (After an unpublished photograph.)

If an artist has no reputation, there is no way for him to accomplish his ambition in practice. I think we should learn some lessons from older artists [who failed to struggle and died of attrition] and make an environment you can survive in. You must have basic subsistence, then you can create your arts. Otherwise you die from starvation. If you starve and die, you cannot carry out your artistic goals.

So the public Li Huasheng produced political arts in an age of political propaganda, but the private Li Huasheng, working at night, continued to focus on more personal art forms. He continued to work with two of his teachers, Yu Jiwu and Zeng Youshi, and in 1967 he began to study with the oil painter and printmaker Du Youngqiao, whose investigation had led to the persecution of the Beethoven Club members. Li did not really know Du very well until the summer of 1966, when their mutual friend Zhang Fangqiang, who also studied with Du, brought them together. Now an associate professor at the Sichuan Academy of Fine Arts who supplements his income by decorating new hotels and commercial buildings, Du was then a teacher at the Chongqing Academy of Fine Arts. A painter of figures in landscape settings, Du says that his work was influenced by three Russian painters, Valentin Aleksandrovich Serov (1865–1911, known as "Xie Luofu" in Chinese), Konstantin Alekseevich Korovin (1861–1939, "Ke Luowen"), and Isaac Ilych Levitan (1860–1900), "Lie Weitan"). Li remembers that "Du's paintings were always done in gray tones, following the Russian style, and because his red flags in the distance always turned to gray, they lost the bright colors, and he was criticized for that." Actually, Du had also produced socialist-realist works,[38] but even his prints were most often moody nature studies, done in sensitive tones of gray and black and reflecting British Romantic traditions (fig. 12).

Li studied "as a friend" with Du at his home, working on oil painting and watercolors, and the two frequently went

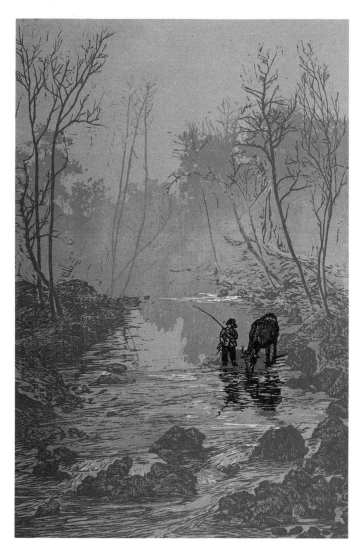

12. Du Yongqiao. *Edge of the Stream.* 1957. Woodblock print. 54.3 × 34.5 cm. Private collection, China. (After *Sichuan banhua xuan*, pl. 30.)

out into the countryside for realistic landscape sketching, often staying out for several days. Du describes this as a very hard period. There was scarcely enough money or food, so travel became a very tiring activity. He recalls once becoming so weak during their hiking in a heavy rain that Li had to carry him across a stream on his back. On their sketching hikes, Li usually carried gouache pigments, watercolors, oil paints, and pencils in a small, simple box. At that time, Du says, he was seldom able to help other artists because his own time was so limited. But he was impressed by Li's hard-working attitude and he carefully corrected Li's realistic sketches. Their first excursion together for realistic sketching was to Nanshan, and by the time of their second trip, to Dazhu (near Da Xian), Du noted the great progress in Li's oil painting: "It was equivalent already to fourth-year student work in the painting academy." "Within a very short period," Du says, "Li mastered the use of color in watercolor and oil painting, so I knew he had some 'magical ability.'" He feels that Li's current work, in its use of color, reflects this earlier training in Western-style oil painting.

At that time, traditional Chinese painting was in its period of greatest neglect, but Du remembers warning Li, about 1970, that someday traditional painting might have a real future while oil painting would be left with no outlet. So he urged Li to shift his focus: "Oil painting has no future; don't take my way." But Li remembers that his reasons for turning away from oil painting were more pragmatic: traditional painting materials were far cheaper than oil pigments, canvas, stands, and so forth. Teachers, too, were more readily available—because traditional Chinese painters were, by then, held in such low esteem and were often unemployed or only barely getting by, they actively sought out students. For whatever reason, Li slowed down his work on oil painting in the early 1970s, and Du remembers watching Li's transition from oils to traditional Chinese painting at that time. Du also arranged to loan Li several valuable volumes of reproductions of China's most famous traditional paintings in the Japanese publication *Shina nanga taisei* (*Compilation of Chinese literati painting*), borrowed from the Sichuan Academy of Fine Arts library. This became the basis of Li's secret nighttime studies—self-taught copywork after the ancient masters—for the next several years. Such literature was considered counterrevolutionary, and unless it was secured within a locked library, not only the volumes themselves but whoever might be found in possession of them were in constant threat of destruction.

In 1968 the authorities called students back to the Shipping School, restored classes, and dismissed the more violent students. The "Little Three" defendants—Li Hua-

sheng, Guo Shihui, and Ren Yongsong—although no longer students and now assigned to working units, continued living together in a school dormitory until October 1972. Then Li was transferred to housing in a different unit under the Shipping Administration, the Chongqing Sailors Club. The Club was a home away from home for Yangzi River sailors and was a recreation spot for those from Chongqing. It included apartments and a refectory for down-river sailors, game rooms, and a library where one of Li's paintings still hangs today (fig. 31).

Li's new responsibilities were slight: to produce politically edifying art, in line with the Party's current attitudes. Often this meant nothing more than reproducing the week's announcements on a blackboard, with a bit of decorative illustration done in chalk:

> Generally speaking, the major work was propaganda, writing on the bulletin board, decorating a special column on the blackboard where meetings were announced. At New Year's, I always painted lots of plum blossoms and then wrote big "Happy New Year" characters. To the big characters disseminating propaganda, in the corner, I added decorative paintings of plums, orchids, chrysanthemums, and bamboo. I always used gouache. Occasionally, I would receive a commission to do some creative art work. These commissions had to be signed by the Culture Hall and the Municipal Cultural Bureau. All my works, such as *Chairman Mao Inspects the Rivers of Sichuan* [fig. 8] and *Red Lantern in the Waves* [fig. 9] were commissioned this way. Such commissions would provide free time to accomplish something by myself. The landscape at the Sailors Club [fig. 31] was one such commissioned work. I had to compose a draft to present for my superiors' approval before I finished it. Also, these commissions were given so that the leaders could select paintings for municipal, provincial, and occasionally even national exhibitions. All the works accepted for exhibition followed the principle of "politics first, artistry second." If we workmen-painters chose the right subject matter, followed correct role models, and fit the right propaganda image promoted by the newspapers, then the Artists Association and the Culture Hall might send some expert painters to help us refine our work in terms of modeling and composition. If a work was selected by superiors, this was also an honor for our working unit.

Other propaganda or informational tasks were occasionally called for, but nothing much. Fortunately, this situation saved time and energy for Li's own art work, which he pursued in the privacy of his new living quarters.

At the Sailors Club, Li Huasheng worked by day and dwelt by night in a dilapidated single-room office-apartment. This stood right next to a patch of concrete that visiting sailors used as a skating rink, so noisy that Li often had to stuff his ears with cotton. All this sat at the foot of an undeveloped hillside where water poured down in the rain, and which Li remembers as always being very moist, full of insects, snakes, and scorpions. The roof was in such poor condition that, when rains were heavy, he sometimes felt obliged to move out. "I could never get a good rest. There was only one layer of wood that made both a ceiling and attic floor, and as the rats above scurried around they made the dust fall down and fill the air."

With China's economy approaching a state of collapse, Li was very poor and had to purchase his own painting materials. His salary was so meager that he had to supplement it through the painting and sale of bamboo hanging scrolls, a cheap decorator item for working-class apartments. Every day he brought in a small supply of oil, flour, salt, and sugar and lived during this entire period on a subsistence diet of parched flour (*chaomian*). Aside from his painting supplies and food, over several years' time he was only able to buy a few necessary clothes and one box of books. When he got married in 1974, he borrowed a ping-pong table from the unit which he used as a bed at night and a painting table by day. "Even at night, I often used half of the table to copy old painting illustrations I borrowed from others, working until the morning while my wife slept on the other half of the table." On the wall, he inscribed a two-character motto, *Jing guan* ("Silent observation"). He refused most visitors, virtually cut himself off from the world, and worked hard at his painting.

Every night, just as at the Shipping School dormitory, Li had friends lock the door of his room from the outside so it would look like no one was there; then he spent the night painting secretly. Since his daytime duties were very limited because of the Cultural Revolution, he could nap during the day when not carrying out propaganda work for the Shipping Administration. ("When others were outdoors fighting I got my chance to paint, not to 'struggle.' ") He sometimes even managed to paint privately during the daytime, after putting a note on his door which read: "Gone out for realistic sketching." All night he painted, mostly doing copywork from the *Shina nanga taisei* volumes provided by Du Yongqiao. He concentrated on the works of the eccentric "Four Monks" of the early Qing period, particularly Bada Shanren and Daoji, which gave him a new perspective on traditional painting. (Although no works of the period survive, a slightly later work in the manner of Bada, dated 1979, is still in the artist's collection; see fig. 34, 35. For Daoji and Li's later work in his manner, or at least something of that manner, see figs. 108, 109, 110.)

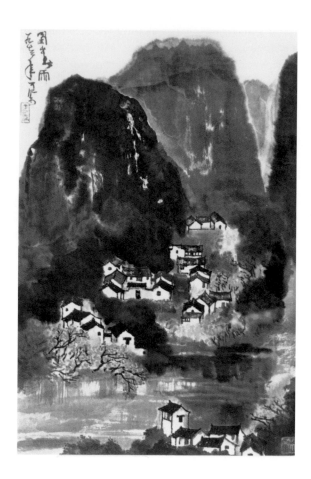

13. Li Keran. *Spring Rain in the Sichuan Mountains.*
1973. Ink and color on paper. Private collection.
(After *Chinese Literature,* October 1979.)

Du Yongqiao visited Li every few evenings at the Sailors Club in the early 1970s and remembers that, in addition to his study of early masters from *Shina nanga taisei,* Li also studied Wu Changshi (1844–1927). Once when Du was forced by a heavy rain to spend the night, Li did a large hanging scroll of wisteria in Wu's manner. At other times, when friends visited in the evening, he did small paintings ("palm-sized") of bamboo and flowers in Wu Changshi's loose *xieyi* manner, as well as working in the varied styles of both early and modern, professional and literati artists like the late Song court painters Ma Yuan and Xia Gui, Bada Shanren and the "Yangzhou eccentrics" of the early Qing, and Qi Baishi and Li Keran (fig. 13) from the present era. Li sometimes introduced "Westernized" concepts, such as dropping ink onto the painting. Du remembers Li painting prolifically, often throwing away whole piles of rejected works, and quickly getting beyond beginner's naïveté.

Li's brother Jiawei remembers that Li often skipped meals, and sometimes his food was eaten by rats. "He always forgot about the surrounding realities. Only in the artistic world could he find himself." When friends came, he would also perform opera for them. When he was happy, he would spin around, stamp his feet, roll on the ground. He could do sentimental Kunqu opera (from southeastern China) in a thin voice, as well as the more "dignified and graceful" Beijing opera. Mostly, he performed parts from the Sichuan opera, with its special attention to detail and its vivid, humorous folksy style, exaggerated yet extremely simplified. And he brought these to bear on his painting. "Every section of singing," says Li Jiawei, "every pose, he could develop and transform into some special composition in painting or some special brushstroke. You could say his painting derived from his critiques of Sichuan opera."

Li's only departure from this routine of secret nighttime painting was for boat trips down the Yangzi to do realistic sketching. His position with the Shipping Administration allowed him at least ten boat trips through the Yangzi gorges between 1965 (his first trip took place just before he was actually assigned to the Shipping Administration) and 1976. In the latter year, Li had a seal carved with the motto *Shi guo Kuimen,* or "Ten Times Through the Kuimen Gorge." In the gorges, Li traveled along ancient footpaths. While he sometimes sketched using a folding wooden board, carrying it proved difficult and even dangerous, so for convenience and safety he moved to smaller and smaller sketches. Li regards his earlier sketches as "merely realistic," his later ones as "very good." Li traveled in the gorges with a simple backpack for his painting materials and some dried food. He got water from the streams and often spent the night under

the slight protection of peasants' trellises for gourd vines. He became well aware of the peasants' poverty. He attended their harvest celebrations and paid attention to their tools, animals, and architecture. He also noted the effects on their lives of seasonal change, the feeling for which is found in many of his paintings today.

While Li kept very limited social contact at that time, in the winter of 1973–74 he had his first opportunity to meet some of China's finest traditional-style painters, including Huang Yongyu (b. 1924) and Wu Guanzhong (b. 1919), as they traveled through Chongqing. Following the thaw in international relations that began in 1971, the Ministry of Foreign Affairs began to concern itself with the interior decoration of China's hotels, restaurants, conference rooms, and the like. It is said that Zhou Enlai personally approved the production of huge quantities of traditional painting for international consumption (which he referred to as an "outer art"). Over forty artists were commissioned to produce these paintings, beginning in mid-1972 and continuing until late 1973.[39] In preparation for this, traveling around the country to see China's scenery, Huang Yongyu (professor at the Central Academy of Fine Arts, Beijing), Zhu Danian (b. 1915) and Wu Guanzhong (both professors at the Central Academy of Arts and Crafts, Beijing) all visited Li in his humble room. Li showed them his oil paintings. To Huang alone he showed his travel sketches (though a Chinese artist rarely reveals his sketches—often the basis of the artist's compositional vocabulary—to anyone). He also made a traditional painting for them showing part of the Chongqing city wall near Chaotianmen.[40] Li remembers that Huang considered his oil paintings good ("but he didn't see the concrete points"), and that Wu said to Huang that "my painting style is like a German artist's" ("Of course, Wu is quite familiar with foreign names, since he used to study in Paris, but I couldn't remember the specific name that he mentioned".)

Suffice it to say that whatever praise these outstanding artists offered was highly qualified. But Li's encounter with Huang Yongyu was the beginning of a long-term acquaintance. Huang spent a week with Li at the Sailors Club and on New Year's Eve he made a large painting of a garden-type rock for Li, a striking example of Huang's vaunted plain-line (baimiao) technique without any shading, particularly difficult to adapt to a subject of such complex three-dimensionality.[41] That same evening, Huang also painted a large portrait of Li (p. xvi).[42] Li says he claimed the portrait looked rather "cunning" (jiaohua), but Huang defended it as "looking wise."

Both Li and Du Yongqiao (whose art Li introduced to

Huang, engendering an enthusiastic response) remember this as a time when Huang was feeling deeply discouraged. It was not long since Huang and a number of others had been called back by Zhou Enlai for the welcomed task of painting for the state, after Huang had spent at least four hard years doing peasant labor in northern China together with the artists Shi Lu, Ya Ming (b. 1924), and Huang Zhou (b. 1925). Now, Mao's wife, Jiang Qing, had not only begun to criticize this "unauthorized" art, she had even taken advantage of Zhou's progressive illness to discredit the failing premier with a massive "Criticize Lin Biao, Criticize Confucius" ideological campaign, indirectly identifying Zhou as an opportunist and reactionary. Denying the distinction between "outer" and "inner art," one for foreign appreciation and one for native consumption, she had begun to denounce these paintings as "Hotel School" art.

Huang lamented that, although painters spent many decades pursuing improvement in their art, the public still criticized their work and cut them down in a minute. The garden rock he painted for Li bore an inscription suggesting his heavy-hearted feelings. Shortly after this, in the spring of 1974, with Zhou Enlai no longer to protect them, 211 of these Hotel School artists' works were collected and exhibited in a "black painting" exhibition, first at Beijing's National Gallery and later in Shanghai. Many of these artists were subjected to extreme persecution. Their art was confiscated and self-criticisms were extracted. Huang Yongyu's painting of a winking owl with only its left eye open particularly attracted Jiang Qing's ire for its suspected slander of her left-wing faction (a suspicion that was probably well placed, for Huang was already well-known for his politically satirical cartoons and poetry). Huang was sent down to do more hard labor in the countryside.[43]

In 1974, Li Huasheng was married to a primary school teacher, Zou Lin, whom he depicted in a woodblock print a year later (fig. 10). It was an arranged marriage. A son, born in 1975, was at first named Li Shi, and Li Huasheng took for himself the style-name (tzu) of Shifu, "father of Shi." Afterwards, he changed the boy's name Shi to Zhen, written with an unusual character composed of two parts, "earth" (tu) and "river" (the "chuan" of Sichuan). By that time, Li had become so poor trying to survive on his meager salary that one night he had no money for his baby's milk and worked all night in desperation to paint forty bamboo hanging scrolls (each about 1 square foot). The next morning he sold these to the Chongqing Arts and Crafts Company (Chongqing Gongyi Meishu Gongsi) for one Chinese dollar each. Although such hack work was humiliating for an artist with higher aspirations, Li depended increasingly on the

income from these plebeian works (the equivalent, one might say, of black velvet painting) which gradually took much of his time away from more serious painting:

> The procedure was pretty complex. I painted the bamboo with a white base as a background and used a napkin, because of its absorbency, to absorb the oil from the ground. Then I could paint on this ground, and the colors could fix on it. Often I did these paintings during the night and worked through until the next morning, when I would bring them to the Chongqing Arts and Crafts Company. The person in charge always came to the office around 8:00, first made a cup of tea, then criticized my paintings, always telling me my paintings were too simple and giving me some suggestions. Even in this shabby situation, there was another artisan who complained that he got paid only 80 cents for one piece though his paintings were more complex than mine. Once I was so frustrated I said I would not do this work again, and refused to accept the money. But at noontime, the company still sent me money. This is the way I made my living.

Before Li Huasheng moved to Chengdu in 1985, he had met almost every evening for more than a decade with his "small-circle" of friends, including Zhang Fangqiang, An Weinian, and Wang Guangrong. On September 9, 1976, Li, his brother Jiawei, Zhang, An, Wang, and Du Yongqiao spent the whole night painting at Wang's home, enjoying their work and not going to sleep until morning was near. It was not long before all of the public loudspeakers began loudly to broadcast the news, waking them up to the announcement of Mao Zedong's death and ordering everyone off to their work units. Li remembers that at the Sailors Club, the director made a formal announcement with an appropriate display of tears. Li himself stood in line, tired from lack of sleep and pinching his leg to produce the necessary image of grief. At one point, he accidentally made a sound like laughter, causing everyone to turn to him, and he was obliged to double over and fall down, claiming that his stomach hurt with sadness. It was the end of an era.

Late in 1976, with the end of the Cultural Revolution era, Li came out of his personal isolation and artistic secrecy, although he continued to live in this small office/room until 1981. Li Huasheng now regards himself as materially well off, but he continues to think of the many other artists who are "terribly poor." And he remembers well his own recent poverty, when his baby needed milk, when he depended on painting bamboo scrolls just to survive, and when he could not afford books. He particularly remembers falling in love with a book of original seal impressions that he could not afford to buy. He went back to the book shop several days in a row to look at, enjoy, and long for the book, until he saw one seal that read: "If you find a really good book, don't worry about the price" (hao shu dao shou bu lun qian). He remembers reading this with such embittered cynicism that he never went back to the shop again. To illustrate his own attitude toward artistic poverty, Li quotes a seal inscription composed by Zeng Mogong (who died in 1961 of starvation),[44] proudly and uncompromisingly stating: "Under the cloudy sky, I cannot bring myself to beg for a single bowl of aristocratic food."

Today, Li looks back on the entire era:

> During the Cultural Revolution, people did not respect one another. They always interfered with one another's privacy, always fought one another. This social atmosphere became pervasive throughout the entire country. As you can imagine, the Cultural Revolution surely has a close relationship with my paintings today.

Master Teacher, Master Pupil

Chen Zizhuang and Li Huasheng, 1973–76

Lord Yuan of Song wanted to have some pictures painted. The crowd of court clerks all gathered in his presence, received their drawing panels, and took their places in line, licking their brushes, mixing their inks, so many of them that there were more outside the room than inside it. There was one clerk who arrived late, sauntering in without the slightest haste. When he received his drawing panel, he did not look for a place in line, but went straight to his own quarters. The ruler sent someone to see what he was doing, and it was found that he had taken off his robes, stretched out his legs, and was sitting there naked. "Very good," said the ruler. "This is a true artist!"

—Zhuangzi, *circa fourth century B.C.*[1]

FROM MARCH 20–27, 1988, AN EXHIBITION WAS held in Beijing's prestigious National Art Gallery (Zhongguo Meishuguan) of three hundred paintings by the late Sichuan painter Chen Zizhuang (fig. 14). The crowds that flocked to the exhibition, reportedly more than 10,000 visitors every day, were declared in a Ministry of Culture publication to be a "sensation" and a "rare event since the establishment of the Gallery in 1958."[2] Among the distinguished guests at the opening were Vice-Premier Fang Yi; Zhang Aiping (from Sichuan), retired Chinese Minister of Defense; Xiao Ke, retired president of the People's Liberation Army Senior Military Academy; Qi Gong, chairman of the Chinese Calligraphy Association; Wang Zhaowen, vice-chairman of the Chinese Artists Association; Wu Guanzhong, vice-president of the Central Academy of Arts and Crafts; and Ya Ming, chairman of the Jiangsu Provincial Artists Assocation. Wu Guanzhong reportedly looked closely at each piece, praised the artists as "great" and "mighty" (*weidade*), and pointed out the difficulty of expressing nature as effectively as this artist had through such small works. Ya Ming is said to have called him the "greatest" (*zui weidade*) painter of his time.[3] Most striking was the fact that until that moment, the artist Chen Zizhuang was virtually unknown. A comparison to Vincent van Gogh, who sold but one painting in his lifetime, was widely reiterated. Far away in Shanghai, the press noted that "the National Art Gallery presenting a large-scale exhibition for a deceased unknown painter is without precedent."[4]

The exhibition was more than an artistic display. It was a boisterous political event generated in a normally serene art gallery, a spontaneous outpouring of public sentiment in a society where public demonstrations are strictly regulated. One journalist wrote, "I'm a person who is compelled to go to all the exhibitions, but I've never before witnessed such a moving scene." He passionately likened the public response to "the sound of spring thunder . . . the audience

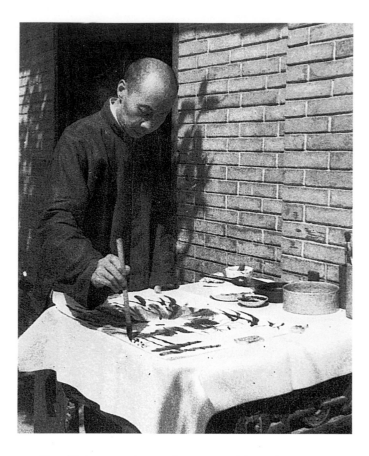

14. Chen Zizhuang at his small painting table. (After Wang Zhihai, *Shihu hua ji,* frontispiece.)

like a rushing tide . . . roomful after roomful of men and women, old and young, gathered to read the [exhibition] preface."[5] This exhibition preface, described by the same journalist as a "call for justice," was composed by the curator of the exhibition, Zhang Zhengheng, one of the late artist's closest associates, and by the exhibition's major financial patron, Yan Xiaohuai. The text described a painter whose life was spent in suffering, whose only pleasure in life was painting, and whose art had to wait until the painter was himself but a memory finally to gain public recognition. It read:

> The three hundred paintings exhibited here are surviving paintings by the modern Chinese painting master Chen Zizhuang, works that were woven together from pleasure and suffering. This "pleasure" that I speak of refers to the artist, from cloudy sunrise to the glow of sunset, submerging himself, intoxicated, in his enjoyment of natural beauty and sublimating this into an artistic self-portrait, lofty in moral character, idealistic in concept, innocent in flavor, and philosophically profound, sending the artist's soul soaring into the Heavenly realm of artistic exaltation; this "suffering" refers to his deprived circumstances, the impoverishment of his seven-member family, and his constant suffering from starvation and hardship. Because his art works are so wonderfully imbued with such a lasting quality, they could fulfill the notion; "When the man is gone, his achievement becomes apparent."
>
> . . . This intense concentration on his studies, not dedicating himself to the pursuit of empty reputation, will surely be a great inspiration, and for those enamored of a fleeting reputation, who would gain their success by chance, who would sink to the level of those "whose virtue is dispersed with their death," this is a severe admonitory blow. Art and agriculture are different. The notion that "you reap what you sow" depends not on the immediate harvesting but on the judgement of history. History will compensate you for what is yours, and history will deprive you of what is not yours, accurate to a hair's breadth. Otherwise, where is justice among men?

This is the artist who played the most important role in Li Huasheng's career, the artist who, Li believes, first inspired him to rise above descriptive realism to achieve artistic expression. Li first met Chen in 1972, only four years before his death, and their actual contacts were very limited. Chen's role is better regarded as that of an artistic model than as a teacher in the Western sense. The attraction for Li was not limited to artistic appearances, for in Chinese art, style is also strongly suggestive of the artist's social personality. In Chen Zizhuang, Li Huasheng finally found both a mature artistic style and a social personality with which he

could fully identify. He draws on a modern image to express his praise for Chen:

> Part of the nature of Chinese painting is that all of the painters of a given generation are almost of equal ability. It is just like high-jumping—it's not a matter of the lower part, which everyone can jump over, but a matter of the upper couple of inches. That's the difference between an artisan and a champion painter. In the generation of Chen Zizhuang, he's really outstanding and none of the others can compete with him.

Had he never painted, had he never been so strikingly deprived of his artistic due and received such belated historical compensation, Chen Zizhuang would still have lived a noteworthy life. In 1913 (October 10), he was born into a farmer's family in Yongxingchang, Yongchuan County, about sixty-five air-kilometers due west of Chongqing (now on the Chongqing-Chengdu rail line).[6] Not long after this, his family moved to Rongcheng (in Rongchang County), about twenty-five miles farther west.[7] His father, Chen Zenghai, although a peasant, was semiliterate and enjoyed reading novels. He became familiar with the most important of China's novels and plays, *Romance of the Three Kingdoms, Romance of the Western Chamber, Water Margin,* and *Dream of the Red Chamber.* Rongchang County at that time had become a center for the production of decorated folding fans that were frequently painted with figural narratives. Chen Zenghai learned how to paint the characters of these novels onto fans and hanging scrolls. He also decorated pottery bowls. He became so popular as a commissioned artist that his family rose to semipeasant, semiartisan status.[8]

Chen Zizhuang's original name was Chen Yue or Chen Fugui.[9] In his middle years, Chen referred to his rural origins by signing his paintings *Xiali Ba Ren,* loosely translated as "The country bumpkin from Sichuan." As a youth, Chen Zizhuang helped raise livestock as a cowherd for the Qingyun Temple. His earliest paintings were depictions of oxen. At first, around the age of twelve, he painted with mud, as ordinary colors were too expensive. Chen's pupil Chen Zhidong writes that even though these oxen were depicted in mud, "viewers were able to distinguish whether they were male or female, and the priests and country people were surprised."[10] Chen Zizhuang himself later claimed that viewers "should be able to distinguish the gender of oxen without the artist showing reproductive organs." As Chen began to use real painting materials, a student in the local civil service academy once laughed at him, saying, "You have no master to direct you, and your family has no paint-

ings by famous artists as a model for your study. If you can master this art, I'll use my hand and cook a fish on it for you to eat!" Chen said that this insult strenghened his determination to succeed at painting, and he was soon selling works on demand. By the time he was fifteen, however, the local fan-painting commerce in Rongchang County had fallen into decline, and his family's fortunes were gradually doing the same, so Chen accepted an offer to go traveling with a fan-painting dealer to Chengdu. From then on, Chen traveled as an itinerant artist, selling his paintings in the eastern, central, and southern parts of the province.

Before leaving Rongcheng, Chen had studied the Confucian classics in the Chen Family Shrine with his cousins, under the tutelage of Chen Buluan. Later, in Chengdu, under the teacher Xiao Zhonglun he studied Laozi's *Dao de jing,* the writings of Zhuangzi, and the poetic anthology *Chu Ci.* Chen's teachers and Chen himself focused on the Daoist eremitic tradition. His pupil Chen Zhidong wrote of these teachers, "The two masters Chen and Xiao were lofty men, and he [Chen Zizhuang] never took an official position. He reflected their great influence by remaining simple and sincere."[11] It is no longer certain when he changed his name from Chen Yue (or Chen Fugui) to Chen Zizhuang, a personal name reversing that of the Daoist master Zhuangzi (with appropriate irony) and "rusticating" the character "Zhuang," but this must have happened in those early years. Chen used to copy his favorite prose passages, mostly Taoist, into a separate notebook, chanting these in his spare time. As a youth, Chen Zizhuang was strong and bold and was good at martial arts (rooted in the Daoist tradition); he liked to befriend other fighters, beginning with the fighting monks at the Qingyun Temple.

Chen's family were not ordinary peasants. They were classed among those wealthier peasants who were also small-scale local landlords (*xiangshen*). And they were members of Sichuan's ubiquitous secret societies (*gelaohui,* the "society of brothers and elders," or *baogehui,* to use the local Sichuanese term). Such groups functioned as a kind of local underground government, negotiating between hostile elements as well as controlling the distribution of weapons among them, and playing a significant role in the rise and fall of regional warlords. So common were these activities that when the Nationalists, in flight from the Japanese onslaught, moved the Chinese government to Chongqing in 1937, threatening the stability and profitability of this network, the *gelaohui* were a force to reckon with:

> It was evident that the local secret society had far greater and far more pervasive influence than the Nationalist party. Not only

were Sichuan political, military, and business leaders members of the *gelaohui*, but half of the population of Chengdu was reported to be associated with it in some fashion. In fact, many *gelaohui* agents had penetrated the party's own secret police, and frequently party or government activities could be undertaken only after being approved by local *gelaohui* leaders. Such a situation lasted to the end of the war.[12]

Chen Zizhuang followed his father not only in painting but in secret society activities as well, extorting money by presenting his victims a feared warning, a "two-finger-wide strip" of paper, much like gangsters in a B-grade movie. Developing his martial-arts skills and making quite a reputation for himself when he accidently killed an opponent in formal competition (in the days before scoring from judged "points" replaced real blows), Chen Zizhuang was hired as head of a unit of bodyguards (*baobiao*) for the warlord Wang Zanxu (1885–1957). Like several other warlords, Wang had been made a general in the Nationalist government's attempt to effect an alliance with its native adversaries, including both regional rivals and the Communists, against their common enemy, the Japanese. Wang had even served as the Guomindang governor of Sichuan in 1938 and 1939, before Jiang Kaishek assumed the position himself (in order to quell internal rivalries between local warlords) and sent Wang out of the province to engage the Japanese in battle.[13]

Since Wang the warlord was also a collector of paintings and Chen the bodyguard was also a painter, Chen soon began to serve as Wang's private secretary and art curator. The Bada Shanren and Daoji paintings in Wang's collection became Chen's to study. Chen taught both martial arts and painting to Wang's son. Different versions exist, however, of Chen's relationship to Wang Zanxu and the early artistic activities that flowed from this. According to Chen himself, as the story has passed down through many of his followers, it was at his suggestion that Wang Zanxu once brought Qi Baishi (and Qi's Sichuan-born wife) to Chengdu in 1936. Qi Baishi (fig. 22) painted about ten landscapes while staying in Wang's house; after the Communist victory of 1949, Wang donated these to the Chongqing Museum, which published them in a small catalog.[14] It is also believed by some that when Huang Binhong (fig. 24) came to Sichuan in 1935, Chen accompanied him around.[15] But according to Chen's pupil Chen Zhidong, Chen first met Wang Zanxu at the end of the Japanese War in 1945, when Wang was stuck in Yunnan province after fighting the Japanese there and was vainly awaiting a Guomindang invitation to rejoin the Nationalist government in Sichuan. Deciding to call upon the Chengdu secret societies in his attempt to recover power,

Wang first made contact at that time with Chen Zizhuang, who by then controlled a "family" of several hundred members. Chen Zhidong believes that Chen's "boasts" (about having helped host Qi Baishi in Sichuan and about having begun his study of painting in the 1930s with Qi and Huang) were first made in the later 1960s and early 1970s, after most of the witnesses to the contrary were already deceased and when he desperately needed to build up the reputation of his painting in Chengdu.[16] Wu Fan, among others, rejects this view.[17]

In 1938 Chen joined an anti-Japanese resistance brigade but was quickly captured by military police at Wanxian, in eastern Sichuan, and spent three years in prison in Chongqing's Tuqiao Prison.[18] On his release, he caught the eye of secret society leader Shi Xiaoxian, with whom he became a sworn brother and who had him appointed as transport director in Rongchang County of the Congqing Food Relief Association—the kind of benevolent organization that carried out the secret societies' semiofficial functions in Sichuan society. In Rongcheng, Chen opened a "Golden Valley Tea Garden" and chaired a "Rongchang Discussion Society," both of which served as hangouts for all the local toughs. He also managed an orchard (his "Orchid Garden") where he offered instructions in literature and the arts, ranging from Confucius to Bada Shanren. It was a strange mixture of business, corruption, and lofty purpose. Pure politics was yet another ingredient. Since 1946, when Wang Zanxu became commander of the Chongqing military garrison for the nationalists, Chen managed the Rongchang military superintendent's office. But it is said that "since that time, he increasingly came under the influence of the Communist Party in Rongchang, and as the political situation became increasingly clear, by 1949, he began . . . to incite Wang Zanxu's troops to revolt."[19]

In October 1949, when Communist Party Chairman Mao Zedong declared the creation of a new government, the southwestern provinces of China still remained in Nationalist hands. The Second Field Army—under military commander Liu Bocheng and Sichuan-born political commissar Deng Xiaoping, whose collaboration in the surprisingly successful Huai-Hai campaign earlier that year had shortened the Communists' road to power by as much as five years, in the view of Party leaders—was given responsibility for the capture of these provinces. Not surprisingly, "relations between traditionalist elements in the southwestern provinces [that is, the warlords and secret-society elements] and the Guomindang [Nationalists] had deteriorated to such an extent in 1949 that the traditionalists defected without fighting and went over to the Communists."[20] Nationalist leader

Jiang Kaishek's December 1949 flight to the island of Taiwan from Chengdu left the city in the hands of Wang Zanxu. It is said that as Communist armed forces advanced on Chengdu and as Wang decided he wanted the city liberated peaceably, he sent Chen Zizhuang—his secretary with connections to the opposition—over to the Communist Party command unit to arrange for negotiations. On December 27, 1949, it was supposedly Chen Zizhuang who escorted the Communist army into the city, where he served as their guide.[21]

When Chen's hometown of Rongcheng fell, five-foot-tall characters were written on the city wall: "Down with the vicious tyrant Chen Zizhuang." Nevertheless, after the capitulation of Chengdu, both Wang Zanxu and Chen Zizhuang were treated leniently by the Red victors. (The Communists categorized their class enemies according to how much land they had owned, but since Chen had none—unlike most men of such power—he was later called, tongue-in-cheek, a "step-tyrant," *gan eba*.) With such a politically unsavory background, Chen was virtually unemployable. In Chongqing, in the first years of the "New Society," he first attended the Southwest Military Academy, but in 1952 he was reduced to menial labor, working first in Chongqing's Sanshan Concrete Factory, then serving as a technician at the Jianxin Petrification Factory. Although Wang claimed to be "too old" to work for the government, he was given positions as a member of the Chengdu Municipal People's Congress, consultant to the Sichuan Provincial People's Government, and Director of the Chengdu Municipal Library. From this status, Wang was able to help Chen out, as was another friendly former warlord, Liu Mengkang.

Through connections later made by Wang Zanxu in his behalf, Chen's well-being was finally assured by an important government agency (still almost unknown in the West) called the Wenshiguan, or Halls of Culture and History, the function of which was to assimilate the old literati into post-Revolutionary China. Maintaining the literati—the "evil landlords" of Marxist Chinese history—rather than crudely exterminating them, was part of the "united front" mission, which demonstrated the generosity of the state toward its vanquished foes while securing their participation in China's socialist rebuilding. Participation in the Wenshiguan required members' acquiescence in ideological reeducation. At the same time, it also permitted them to indulge in their old-fashioned activities of painting, calligraphy, music, and writing. Much of the writing was not spontaneous but was directed toward their production of memoirs. Thus, the old gentry voluntarily disclosed the details of their political lives and provided basic data for the future compilation of an official history of Nationalist China.[22]

The plan to establish these Wenshiguan had been decided upon by Mao Zedong and Zhou Enlai even before Liberation, in accordance with the principle of "honoring age and respecting literature" (*jing lao zun wen*). The first hall was established in Beijing in 1952, followed by others including those in Sichuan in the same year; all provinces were represented in the system by 1953. Eventually, all major cities in the country were provided with a unit. In Sichuan, the provincial unit was located in Chengdu, and Chongqing was provided a municipal unit. The Wenshiguan was administered by the Political Consultative Conference (*Zhengzhi Xieshang Huiyi*) and was funded by the Ministry of Culture; applicants were reviewed and accepted if they measured up to standards for literary background (*wen*) and sufficient age (*lao*); in the 1960s, an additional criterion was added: poverty (*pin*). By then, if not sooner, most of China's "bad elements" *had* become impoverished, because few were willing to hire them. Most of those accepted into the Wenshiguan were provided with two kinds of income, including salary (the Wenshiguan became their "work unit") and transportation fees (*chemafei*; in practice, a kind of bonus system). Wenshiguan membership was originally limited to literati at least sixty years old. But in 1955, despite his youth, Chen moved from Chongqing to Chengdu, wrote and submitted a brief biography to the Wenshiguan, and was immediately given provisional membership. At the age of forty-three, as its youngest member, he was referred to as the Wenshiguan's "Young Pioneer."

Attendance at Wenshiguan activities was voluntary, but most of those physically able to participate did so because it offered opportunity for communication. Many even came on a daily basis. These people were otherwise ostracized from Chinese society. Providing them with a place to gather away from society helped to complete their peaceable removal from the social scene. There were weekly political education meetings at which Communist philosophy and policy were discussed. A few conferences and intellectual gatherings were also sponsored. The unit had its own library of about 30,000 volumes, collected largely by donation and sometimes by purchase, mostly of post-Liberation literature.

Xie Wuliang, a Sichuanese literatus whom Chen Zizhuang greatly appreciated as a calligrapher and whom he liked even more as an unusual personality, served as the first chairman of the national Wenshiguan. Sichuan pro-

vided the second largest group of Wenshiguan members, after the combined membership of the northeastern provinces. Reportedly, almost of all of Sichuan's prerevolutionary gentry and literary figures became members, including most of the senior Sichuan painters, and a sizable proportion of the Wenshiguan members have been painters. In the cultural climate before 1978, the audience for traditional painting and calligraphy was greatly reduced, and these arts retained little cultural or economic value. For these deprived artists, the Wenshiguan provided a room with painting tables and painting materials, and each year it purchased a large quantity of xuan painting paper from Anhui province. Over the years, the Wenshiguan units developed a large collection of traditional paintings and calligraphy, mostly done by its members but occasionally donated (as were two works by Fu Baoshi in the Chengdu collection) or acquired by exchange. Today the Chengdu branch has between 700 and 800 works, approximately half calligraphy and half paintings; only one of these is by Chen Zizhuang. Throughout China, the Wenshiguan units possess an unassayed treasury of contemporary art of which Western and Japanese art historians remain virtually unaware.

At first, since he was only a provisional member, the Wenshiguan provided Chen a monthly stipend of sixty Chinese dollars (representing fifty dollars salary and ten dollars transportation fees). Since this was scarcely enough to live on, the Sichuan Provincial Cultural Bureau (Sinchuan Sheng Wenhua Ju) added fifty dollars monthly, and the Provincial Masses Cultural Hall (Sichuan Sheng Qunzhong Yishuguan) paid him an additional thirty dollars for teaching painting. This total of 140 dollars left him fairly well off. Still, he felt the need to supplement his income by selling paintings through the Chengdu Fine Arts Company, even though they paid him a mere eighty cents for larger paintings (1.3 feet wide) and sixty cents for smaller ones (1 foot wide). In 1964, Chen was made a regular member of the Wenshiguan, which entitled him to full membership in the sustaining unit, the Political Consultative Conference, and this brought his salary up to their minimal monthly level of 183 Chinese dollars.

During the fierce Anti-rightist Campaign of 1957, Chen Zizhuang avoided any significant criticism, if only because he was already regarded as a "dead tiger"—bad, but no longer a threat. But Wang Zanxu, who helped get Chen into the Wenshiguan, determined at that time to escape the rising tide of political recrimination and secretly planned to flee to Hong Kong together with the former Guomindang head of the Chengdu Security Bureau, Lei Shaocheng. Wang used the excuse of seeing a dentist in Chongqing to depart from Chengdu and traveled under the pseudonym of "Zhang Zhengyan." Wang apparently urged Chen to accompany them, since their flight involved swimming across the border near Shenzhen and Chen was a good swimmer, but Chen declined. Chen was aware that Wang's flight would become well-known and would thereby put him under suspicion at a dangerous moment. So he volunteered the details of Wang's plan to the authorities, but only after leaving enough time for Wang to complete his escape from China. Unexpectedly, however, Wang tarried for several days longer than planned in Chongqing, idling with his concubine who was living there. By the time he arrived at Shenzhen, attempting to cross the border at night, local authorities had already been tipped off as a result of Chen's insufficiently delayed disclosure. Wang was arrested by People's Liberation Army border troops and returned to Chengdu, where he soon died "of sickness" in prison.[23] Public knowledge of Chen's role cost him support from all sides, casting him into complete political isolation. Just before Chen Zizhuang died, in 1976, he reportedly confessed that his one great regret was reporting on Wang.

Only after the Cultural Revolution began did Chen's economic and political situation become one of distress. In the later 1960s, under pressure from political radicals, the Wenshiguan was eliminated as a unit, not to be restored until 1979. Some of its functions, including income distribution, were taken over from the Ministry of Culture (also a target of leftist attack, crippled in its functions and in abeyance for several years) and preserved by the United Front Administration (Tongzhan Bu), a department under Community Party Central Committee control. But members' salaries from that point on were reduced to a mere fifty Chinese dollars per month plus ten dollars in transportation fees. After that time, Chen's participation in the Wenshiguan was considerably reduced, as he became so poor that he needed to stay home painting fans and bamboo scrolls to support his family. He received a mere one dollar for each of these. Acquaintances recall that before the Revolution, when he enjoyed the fruits of warlord patronage and secret society participation,

> his family was rather wealthy and always gave financial assistance to friends and revolutionary comrades and took part in progressive activities. After Liberation, he didn't rely on this to gain rank and wealth from the government and people, but for a long time just made paintings in peace and poverty, devoting all his energy to his artistic career.[24]

Chen's concentration on his art at the expense of social interaction gradually alienated most of his friends, and his

later life was lived increasingly in social isolation. It was also a life of increasing political oppression and ever deeper impoverishment. Although he had been unscathed by the Anti-rightist Campaign, during the Cultural Revolution the political nets were cast more broadly. Like anyone with even the slightest blemish on his or her political reputation, Chen was attacked repeatedly and subjected to almost total artistic rejection. As his poverty became more extreme during the Cultural Revolution, Chen Zizhuang had no money for painting paper. He became increasingly reliant on the Wenshiguan for its resources, even as the Wenshiguan itself became a target of the radicals and was gradually dismantled by them.

The Cultural Revolution marked a drastic reversal for Chen Zizhuang in terms of social and artistic acceptability. Before that time, opportunity still existed for him. In 1962, Chen was given his first public exhibition, a five-artist show organized by the Wenshiguan at the Provincial Museum in the Chengdu People's Park and afterwards sent on to Chongqing.[25] He was able to sell several paintings through this exhibition and also to display his new painting style, transformed from more literal description and a meticulous brush technique to the seeming naïveté, the simple and understated expression of his later years. Before the Cultural Revolution, Chen is even said to have spent time viewing Western art reproductions and to have read much Western literature in translation, especially social philosophers such as Hegel and Schopenhauer.[26] In 1963–64, the United Front Administration reassigned Chen's family to a nice apartment, four rooms plus one reception hall, though later Chen could not afford the rent and had to give it up. But after 1966, no such opportunities occurred, and Chen and his family turned from facing difficulties to dealing with disaster.

Dai Wei, one of the many Chengdu artists influenced by Chen Zizhuang, first met Chen in 1958 during the Great Leap Forward, when the two of them were assigned to produce propagandist wall paintings around Chengdu. Dai Wei remembers Chen's slide into desperate poverty after the onset of the Cultural Revolution. "Chen's home was so decrepit, you didn't want to step on the floor boards for fear they'd fly up and hit you." Chen was often without food, and when Dai Wei once brought his family two steamed buns, Chen painted a small painting in deepest gratitude but could only paint it on the cheapest paper, being unable to afford the *xuanzhi* (fine-quality painting paper) normally used by painters. Dai Wei also recalls that before reaching such desperate straits, Chen had built up a fine private art collection, especially strong in rubbings of Han period tomb

tiles (for which Sichuan is justly noted) and in the "four treasures" of the painter (that is, antique paper, ink-sticks, brushes, and ink-stones). But Chen's home was twice ransacked by Red Guards during the early period of the Cultural Revolution; he was left with no collection at all. He also lost his lifetime production of carved seals.

In that period, virtually no art market existed for traditional painting. Traditional painting had retained a bare modicum of acceptability during the first fifteen years of socialist rule. But it was so severely attacked by Mao's wife, Jiang Qing, and her followers in their exclusive promotion of "revolutionary realism-revolutionary romanticism" and their campaign against the so-called Four Olds, that it became dangerous even to keep such art. By 1970, a good Ren Bonian painting (which at auction today, outside China, might fetch as much as $20,000) cost only five Chinese dollars. Chen's situation was exacerbated by a particular lack of local support in Sichuan, dating back to the early 1950s, for traditional Chinese painting. "In Chengdu," he once wrote, "there is no artistic climate. I suppose if I can sell some paintings in Beijing and get some money for it . . . this would be a pleasure for me."[27] He once offered to paint works on paper for the Rongbaozhai studio in Beijing, known for turning the work of major artists into commercially affordable woodblock reproductions. Chen approached them with the aid of the prominent Chengdu artist Lü Lin (fig. 85), with whom he remained close despite Lü Lin's downfall in the Anti-rightist Campaign, and who was also a close friend fo the Rongbaozhai manager. This led to a plan for an album of twenty small leaves to be carved into woodblocks, but the plan was never consummated.[28] By 1974, when Zhang Zhengheng persuaded Xie Bingxin (the prominent author, and wife of one of Zhang's academic colleagues), to send some of Chen's paintings to Rongbaozhai merely for the purpose of mounting, the studio responded that they could not even mount "such a painting *at a time like this*," which apparently scared Xie too much for her to offer him any further help.[29]

In 1972 and 1973, his power enhanced after the death of Lin Biao, Premier Zhou Enlai began to reopen diplomatic channels abroad. The resulting need to refurbish China's guesthouses provided a new opportunity for China's traditional-style artists. At that time, a commission came to Chen from the prestigious Beijing Hotel. But again his hopes were blocked: an investigation to clear his political background was required for the United Front Administration to approve his work, but Chen was unable to persuade the appropriate Beijing authorities to come to Sichuan to carry this out.[30] By this time, also, Chen's physical condition

had deteriorated to the point of impeding his artistic efforts. He wrote to Zhang Zhengheng, "The Beijing Hotel wants some paintings, but I have too little energy. When I paint, I really need others to grind my ink and prepare my paper, and so forth, so I can save my energy for painting."[31]

Another attempt to aid Chen in his misery came from Guo Ruyu, who began studying casually with Chen Zizhuang in the late 1950s, when Chen was still using a meticulous brush technique (*gongbi*). After graduation in 1961, Guo worked at an embroidery factory, applying his own *gongbi* painting skills as a designer. At one point, Guo and a colleague managed to have Chen contribute *gongbi* designs, including one of a white crane, to be used for embroidered wall hangings. They were unable to get Chen compensation for his work, since the job was arranged through the Wengshiguan and the designs were not actually used until several years later. But Chen was grateful for the opportunity to have any outlet whatsoever for his art.

Also in Chen's behalf, Li Huasheng visited Hubei province and Nanjing in the summer of 1974, "looking for an opportunity to arrange an exhibition for his artworks, by which means he could have the chance to make a tour." He met in Wuhan with Zhang Zhenduo, Zhang Zhaoming, Wang Xiaozhou, and Wang Wennong, and in Nanjing with Ya Ming and Song Wenzhi (the chairman and vice-chairman of the Jiangsu Provincial Artists Association, and both associate directors of the Jiangsu Chinese Painting Academy). "All of them," says Li, "considered Chen's painting just old-fashioned, lacking any contemporary sense, so they wouldn't arrange for any exhibition." According to Dai Wei, as a result of such failures to secure any public exposure for his art, Chen rarely received any appreciation for his painting, let alone economic support for it. "He would paint all day long for anyone who brought him a bowl of noodles and admired his art."

Chen's social personality and his artistic attitudes did not add to the numbers of those who appreciated him or his art. The painter Peng Xiancheng describes Chen as a "lonely soul" who preferred to stay at home rather than enrich his personality through social contact, who studied hard and followed no teacher. Chen was always drunk and often cursing others, he says, so that young people such as Peng who admired his art were afraid to meet him. Those who knew Chen remember him as a virulent critic. Dai Wei's explanation for this is that Chen identified himself as the youngest painter of the older generation, looking down on and cursing all those in the middle generation. Chen Zhidong defends his teacher's caustic criticism, contrasting "the fashion nowadays for art critics to prefer circling around and discussing general principles" with the forthrightness of Chen Zizhuang, whose "criticisms usually named people by name."[32] Chen Zizhuang himself wrote:

> When we discuss others, we should praise their strengths and conceal their shortcomings. But in academic discussions it is a different matter, and we should strive for strictness. "Literature is a matter for the ages"; so these aren't personal matters but are related to artistic evolution. . . . Judge painting strictly, judge other people's painting strictly: that means also to treat yourself strictly. . . . There is a virtue in treating your own work so strictly; if you are too relaxed, then it is easy to deteriorate, and if you first excuse your own art works then you will excuse that of others, and in this way how can there be any artistic progress?[33]

Chen lived by the motto: "Constantly negate yourself."

Chen's criticism was usually delivered in the form of curses and personal insults, intended in the best Sichuan tradition to outwit his target and (as in the martial arts) to leave his victims no immediate comeback (although sometimes setting into motion plots of revenge). Feng Jianwu—the painter Shi Lu's more conservative and less renowned older brother, whom Chen considered an uninspired political lackey with whom he wanted little to do—once offered Chen a brush. Chen refused, saying, "I take even a brush meant for writing wall slogans and produce good paintings with it. What you don't understand is that *I'm* a painter, so the quality of *my* painting doesn't depend on my brush." Asked by another artist to evaluate his horse painting, Chen sat silent for a long while. When pressed to comment, he said he couldn't tell if the horse was a male or a female! This is not surprising if one remembers Chen's childhood mud-paintings of oxen, but Chen added a vulgar dig to his insult by using the Chinese words for "man" and "woman" rather than the appropriate gender terms for animals (i.e., *nan* and *nü*, instead of *gong* and *mu*). To an older painter who once publicly claimed for his own paintings, "I have my own method"—an assertion Chen doubted, for the expression itself was stolen from Daoji of the seventeenth century—he retorted, "You'd have your own mother!" Lü Lin remembers Chen criticizing the flower painter Su Baozhen's painted grapes as being just like glass balls, repetitive and unimaginative, and suggesting he might as well make a round seal and stamp them on the paper.

Such comments (which his partisans today love to chuckle over in private) were certainly not designed to endear. But as his friend Lü Lin comments, "One fact overlooked is that Chen Zizhuang was always terribly dissatisfied with social reality. Writers are afraid to acknowledge this today. Unlike those whom Lu Xun criticized as afraid

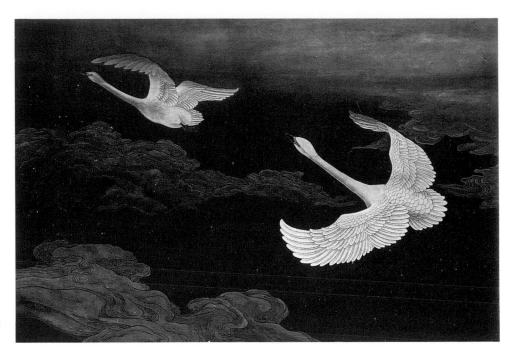

15. Zhu Peijun. *Swans*. Summer, 1984.
Color on paper. Private collection,
China. (After *Sichuan Sheng Shi Shu Hua
Yuan*, n.p.)

to stand up and fight, he was always willing to fight others." Lü Lin disagrees with the opinion, sometimes expressed, that Chen just cursed people out of anger and insists that Chen really intended constructive criticism. Similarly downplaying any destructive intent, Guo Ruyu remembers Chen as welcoming informal students, teaching them very casually by demonstration and critiquing their work without harshness. Yet Guo also feels that this positive attitude was reserved for the informal students, who came to Chen more personally. Those who studied more formally with him dissatisfied him and never amounted to much, offering too little originality of their own.[34]

Lü Lin notes matter-of-factly about Chengdu, "Here as elsewhere, artists are divided into groups and factions that strongly battle each other, or flatter, or lay traps for each other." The negative relationships bred by Chen Zizhuang's attitude often returned to hurt him professionally and even influenced Chengdu's artistic battle lines. Zhu Peijun (b. 1920) is today the director of the prestigious Chengdu Painting Academy. There she paints in a style that shows her technical facility, combining strength in naturalistic depiction with decorative boldness (fig. 15). Hers is the equivalent of a style practiced at the imperial court but associated with folk qualities through the fine craftsmanship and taste for color of the lower-class artisans who made them. It is,

therefore, a style of the people, found from royal halls to restaurants. It is said that Zhu Peijun had been relegated to framing slides in the Chengdu Fine Arts Company (which made mass-produced reproductions of old works of art) when, during the Great Leap Forward, Party leaders chose her as a model self-trained painter. They made propaganda movies of her and promoted her to an administrative position in the company. At the time, Chen Zizhuang—who knew Zhu's once-wealthy landlord father through the Wenshiguan and was not sympathetically disposed—is supposed to have baited her, saying: "Ha! Now that you're a painter, you'd better get started learning. There's still time to catch up." Chen also reported to his students that Zhu once cut the signature off a Zhang Daqian painting and attached her own, to inflate her reputation, selling it through the Artists Association where Chen himself bought it for just a few dollars. Zhu might have seemed "small potatoes" at the time. But in the 1960s she began to develop contacts with provincial officials such as Li Dazhang, who had brought Jiang Qing into the Party in 1933, and by the time of the Cultural Revolution, through them, Zhu had gained sufficient stature to prevent Chen from participating in any of Chengdu's exhibitions or artistic functions.[35]

Chen had an equally bad relationship with Li Shaoyan, who was Zhu Peijun's major patron and the leader of Sichuan's Artists Association. Li Shaoyan was born in

northern China in 1918, in Linyi County, Shihe Village, Shandong province, the son of a doctor of Chinese-style medicine. He first became involved in politics shortly after the Japanese invasion of 1937, joining the propaganda campaign just after his graduation from middle school. In 1938, in the Shaanxi-Gansu-Ningxia border region, he studied woodblock printing at the North Shaanxi Public School's spare-time art group, under the influence of the Lu Xun woodblock movement. In 1938, he joined the Communist Party and in the same year graduated from the North Shaanxi Public School. Afterwards, he joined a number of propaganda troupes, including one associated with the famed 8th Route Army, becoming chairman of the Shanxi-Suiyuan Border Region Artists Association, manager of the Northwest Shanxi Woodblock Printing Factory, and chairman of the art departments at the *Shanxi-Suiyuan Daily* and Chongqing's *New China News*. At Yan'an, he also served as personal secretary to People's Liberation Army General He Long. After 1949, in addition to his *New China News* assignment, he served as art editor and propaganda artist for the *New China Pictorial, The Masses Pictorial,* and *Chongqing Pictorial* (see fig. 16). In 1953, in opposition to Lü Lin and the ideologically more moderate artists of the Southwest Arts Academy, Li Shaoyan and the *New China News* art staff gained control of the central administrative positions in the newly created Southwest Artists Association, which incorporated the four provinces of Sichuan, Yunnan, Guizhou, and Tibet. Li Shaoyan became the Association's leader, and from the time when the Sichuan Provincial Artists Association was created out of this larger unit, in 1958, he served as its first and—to this day—only chief administrator.[36] As an artist (fig. 17) and an arts administrator, Li has promoted socialist-realist woodblock printing while withholding support from traditional landscape painting.[37]

The traditional-style painters' view of Li Shaoyan and his policies has been articulated by Li Huasheng:

> Generally speaking, the policy for the Sichuan Artists Association was that painting and art should be tools of class struggle. They predetermined the subject matter and assigned the duty of creating this to the artists. Any works counter to this policy were criticized by Li Shaoyan.

Wu Fan's folk-inspired but otherwise nonideological *Dandelion* (fig. 88, from 1959) is cited as the kind of work Li opposed. He resisted its public exhibition until its simple charms brought it widespread popularity in a time of relative ideological relaxation.

Li Shaoyan is said to have been the force behind the denunciation and imprisonment in 1957 of his moderate rival,

16. Li Shaoyan.
(After *Chengdu Hua Yuan,* n.p.)

17. Li Shaoyan and Niu Wen. *At the Time When the Good News of the Peaceful Liberation of Tibet Was Brought to the Xikang-Tibet Plateau Region.* 1953. Woodblock print. 32 x 50 cm. Private collection, China. (After *Zhongguo xinxing banhua wushi nian xuan ji,* 2, pl. 200.)

Lü Lin. He is also said to have opposed Lü Lin's friend, Chen Zizhuang, on political grounds and to have vigorously resisted Chen's painting influence. Thanks to such antagonisms, Chen was forever denied membership in the Artists Association, closing off major access to public exhibitions, public activity with other major artists, and public sales. The Chengdu flower-and-bird painter Tan Changrong recalls that, when finally asked to participate in an Artists Association meeting, Chen broke down and cried in front of everyone, out of gratitude. Yet Chen never compromised his attitudes or capitulated to those whose art and artistic views he held in disdain. To this day, Chengdu's painting is infected by the antagonism between its two major factions: the adherents of Li Shaoyan and Zhu Peijun, and the followers of Chen Zizhuang.

Given Chen's political status and public personality, it is not altogether surprising that his art won little favor among Sichuan's senior artists, and that interest in him was limited to a younger generation of more independent-minded painters. Given, also, that Sichuan's traditional painting commanded little interest outside of the province and that Chen himself never traveled with his art, there was little hope of his gaining recognition during his lifetime. Only three of China's senior painters became aware of and were impressed by Chen's work while he was still alive. One of these was Pan Tianshou, director of the Zhejiang Provincial

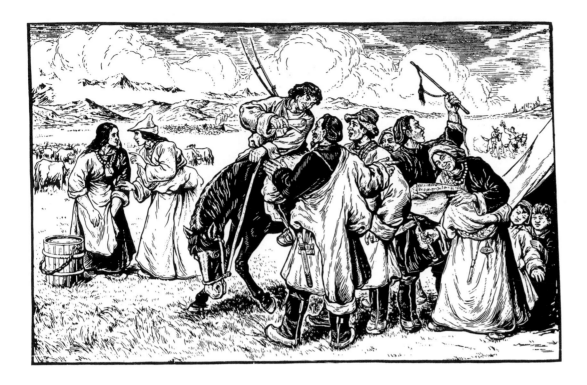

Academy of Fine Art (where he taught Chen's confidant, Zhang Zhengheng). As early as 1962 Pan had announced about Chen's paintings: "Not a trace of vulgarity. Only let him travel around."[38] Reportedly, in 1964, when Pan saw a painting of a white-headed bird that Chen had sent to Hangzhou for mounting, he commented, "If I go to Sichuan, I must visit this man."[39] Because of the Cultural Revolution, however, such a visit never came to pass. In 1974, Chen met Li Keran (figs. 13, 61), then professor at the Central Academy of Fine Arts, Beijing, who lamented, "How did I miss seeing him in my earlier travels to Sichuan!"[40] In 1973, Chen met Wu Zuoren, another Central Academy artist (now chairman of the Chinese Artists Association and vice-chairman of the Chinese Cultural and Art Workers Federation) and exchanged paintings with him. Chen wrote:

> This really expresses his [Wu's] lofty character. My paintings cannot be appreciated by common people. Only Mr. Wu does not dismiss them. This is greatly encouraging to me, very stimulating to my artistic study. Some people in Sichuan really have a low esteem for my painting—I really cannot alter this. Because their aesthetic standard is at such a level, you cannot expect any reform.[41]

Wu apparently wished to use his influence to promote Chen's work, but "because at that time the 'Gang of Four'

was in control of artistic matters, Wu's recommendations had no effect."[42]

In Sichuan today, few people are aware of Chen's life before 1949 or even during the 1950s; it is his decade of suffering during the Cultural Revolution that is best remembered. Tales about him recount that he always wore a long robe of the cheapest quality, the same robe in all seasons and for many years.[43] In 1971, Chen wrote bitterly to Zhang Zhengheng:

> My monthly income is only 60 [Chinese] dollars. Even for food, this is scarcely enough. After getting seriously ill, I still cannot recover. Yet being in debt to others affects me even worse. As for your suggestion that I sell some paintings to the export company, the people in the Chengdu branch cannot even understand my painting. How can you talk about selling anything to them? And even if I could, the income wouldn't be worth talking about. . . . The people in Beijing might be more discriminating. If I could sell them a little bit, it would be good for my creative efforts and my physical health. But the price would still be very low, so I'll just wait until I've become completely bankrupt.[44]

His pupil Chen Zhidong later wrote that the only colors he had were rattan-yellow, ochre, indigo, and a limited amount of magenta, and "even these were hard-gotten."[45] And in a letter to Zhang Zhengheng in Beijing, on whom he increasingly depended for material assistance, he urged:

Don't send rattan-yellow to me. The colors I most need are indigo, exported orpiment, and magenta. I did a painting depicting the sunrise at Jinding [the highest peak at Mt. Emei], but I couldn't finish it because I lacked decent paper and magenta. Others [of my paintings], like those of peach groves and plum groves, are all in need of red color. I don't even have any sealing paste. If I can sell some paintings, I also want to get some colors like these. (I don't even have an inkstone in my home!)[46]

Unable to afford the preferred *xuan* painting paper, Chen had to make do in better times with lesser quality Jiajiang paper,[47] but many of his paintings were done on window paper and food-wrapping paper.[48] Chen's best work was done in small scale. He never mastered large-scale painting, perhaps because he could not afford sufficient paper to practice on a larger scale. Of an estimated 1,200 known surviving works, all but one hundred are of album size.[49] Finances and household space also limited him to a small painting table, about two-feet by two-feet, which he took out of doors when the weather permitted (fig. 14).[50]

In the midst of all these troubles, in the summer of 1969 Chen's youngest son and his personal favorite, Chen Shoumei, died by drowning while swimming in the Qingyi River. This tragedy led his wife to suffer a mental breakdown from which she never recovered. Chen's wife spent the remainder of her years sitting all day in isolation cursing people, particularly Chen himself. Friends recall that he handled this tolerantly; he even wrote a poem about it:

My crazy wife curses me—let her curse;
I'm used to hearing her—like hearing a sutra recitation.

Following this, Chen was left with all of the household duties in a family of five members. Living on a monthly salary of sixty Chinese dollars provided by the Wenshiguan, he could never meet expenses. What amounted to real starvation—literally not enough rice, so that he was always running to borrow at dinner time—is described by his pupil Chen Zhidong as "the embarrassing situation of his family always waiting for some rice to drop into the pot, while he was grasping his cane and running around to borrow money."[51]

And yet, as Chen Zhidong asserts (and all his pupils agree), "These most difficult several years were the time when in his artistic thoughts he gradually matured and in his artistic style he reached his personal best."[52] Chen Zizhuang himself recognized that his social isolation and his identification with Sichuan's own geographical insularity had served to enrich his artistic vision: "Being long isolated in Sichuan has had some advantages. I have deepened and broadened myself, so that because of my spiritual perception of the Sichuan mountains and my repeated observation of them, whenever I paint them I naturally capture their marvelous qualities."[53]

It was to painting alone that Chen Zizhuang turned for solace in his last decade. "My whole life, I've been accustomed to being poor," he wrote to Zhang Zhengheng:

But all the same I'm still happy in mind. . . . I'm fascinated by the Sichuan mountains, which have a very special character. Half of my life they have intrigued me, so even when my life is bitter, I still don't regret it. I still want to stay in Sichuan to experience all its sites: Wu Stream, Youxiu, the Min River, Jialing River, Yibin, Leimaping, and even Xikang, and to paint several hundred good works. I think this is still possible.[54]

In painting alone, even more than in the actual landscape, it was possible to escape the drab misery of his daily life:

The landscapes I draw, although they are small views of rural mountain areas, I still try to depict as prosperous and fresh, everywhere shaded in green, with domestic animals scattered throughout and children in high spirits. . . . I don't like to depict things as withered and deteriorating, nor to embarrass viewers with shabbiness.[55]

Tan Changrong believes that Chen Zizhuang was very frustrated and drank a great deal of alcohol, but that concentration on his painting calmed him down. Lü Lin feels that "his paintings convey his mood. His strange-looking birds were usually painted singly, although the Chinese tradition was to paint them in pairs: people who don't understand this say that he was simply following Bada Shanren, but he really painted these to express himself. To express his pleasure, he painted peonies." Chen and Lü Lin expressed their antigovernment feelings during the Cultural Revolution by exchanging paintings on the theme of Zhong Kui, the eighth-century spirit who helped chase devils from the royal palace—conveying the idea of sweeping the "bogies" out of government, a risky theme that Chen painted despite his ailing wife's efforts to persuade him not to. Although meager finances prevented Chen from traveling as he wished,[56] he frequently asked students to accompany him to Chengdu's suburbs for realistic sketching, or he went to Jiajiang, Leshan, Mianzhu County, Hanwang County, Guangyuan County, and Jianmen, with his students pushing him along on a three-wheeled cart used to transport goods.[57]

The first time Li Huasheng saw Chen Zizhuang's art was in the five-artist exhibition in 1962, which began in Chengdu and then was shown in Chongqing, crammed into ten or eleven tiny rooms at the Confucius Pool Exhibition Hall (Fuzi Chi Hualang). "As soon as I saw his painting," Li remembers, "I thought it was excellent; I felt excited, even though I really didn't understand it." Li immediately became interested in meeting Chen, but an entire decade passed before this became possible. What he needed—as is always the case in China—was a go-between to provide an acceptable introduction. In 1967 Li went for realistic sketching to the Yangzi River gorges. There he met Su Guochao from Chengdu, a worker in the Birth Control Administration and an amateur artist who does folk-style paintings of wooden doll-like figures. Discovering that Su knew Chen's son, Li asked him for an introduction to Chen Zizhuang, but this produced no results. It was through his oil-painting friend Zeng Weihua that the contact was made. Zeng had been a member of the Beethoven Club, which led to his serving time in labor reform in 1967–68 at the Jiuguoqing camp. While in labor reform, Zeng had met Lü Lin, the Chengdu artist who had done battle with provincial Artists Association chairman Li Shaoyan in the early 1950s. Lü Lin fell into disgrace during the Anti-rightist Campaign in 1957, and then descended still further during the Cultural Revolution. By 1973, Zeng was painting theater advertisements and was also selling tickets to survive. Then, together with Zeng and Zhang Fangqiang (another Beethoven fan whose term of imprisonment at Jiuguoqing had begun in 1969), Li Huasheng went to Chengdu, met Lü Lin, and through him was introduced to Chen Zizhuang.

By this time, Chen was physically quite ill. He had posted a note on his door, by "doctor's orders" (written on a piece of toilet paper), admonishing visitors to retreat in silence. But illness did not silence Chen's critical temperament. Li did not get in the door the first day, but he returned the next day with fifty paintings in traditional style to show to Chen. Chen's assertiveness was matched by Li's contentiousness. When Chen abruptly threw Li's paintings onto the floor, pronouncing them "unacceptable," Li picked them up and asked what was unacceptable about them. Chen replied, "Certainly, I will point out where they are wrong or I would not have said this to you." He proceeded not only to ridicule them as topographical ("like relief maps. . . . When war breaks out they can be used for aid in dropping bombs") and juvenile ("no better than something out of junior high school"), but also to correct them.

In correcting Li's work, Chen emphasized he should

strive for suggestion rather than literalism. Of a bridge in one of Li's landscapes, Chen commented that there were far too many spans: one span might not be enough to identify it as a bridge, but two were too many; one and one-half spans would do. Of another work, which Li called *A Strip of Heaven*, Chen felt that Li had illustrated his title too specifically. He instructed Li to take it home and re-do it, adding, "You may have ability, but that doesn't make you an artist."

Despite the harsh treatment, or maybe because of it, Li dedicated himself to Chen. Unlike Guo Manchu, here was an artist of his own kind, unsparingly committed to quality. Personality as well as painting style established the bond. Gradually, Li says, Chen came to treat him very well. Li's manner of study with Chen was different from that with Zeng Youshi and Guo Manchu, and after their first encounter they rarely talked about Li's own paintings. Chen never actually watched Li paint, although Li watched Chen repeatedly. They preferred to critique the strength and shortcomings of others, focusing especially on the virtues of Qi Baishi and Huang Binhong, about whom they agreed. Despite Chen's influence on Li, altogether they met "fewer than ten times" during three trips by Li Huasheng to Chengdu.

Li returned in February 1975 with his close personal friend Wang Guangrong, two sculptors, and a few other friends. In May 1975, when he went again with Wang Guangrong, Chen was hospitalized, and not for the last time. Although the Chinese literati had long believed that the practice of painting could stave off illness and extend one's life span, Chen's physical deprivation began to take its toll by about 1971, leading to an aggravated heart condition. "My physical condition is very weak," he wrote. "I constantly catch cold and my heart problem becomes worse and worse. I lack adequate nutrition, having no milk, eggs, or other items."[58] Because of his lack of political stature, he found it difficult to get adequate medical care.[59] Li Huasheng visited him at that time and found Chen coughing badly and having trouble talking. "Once," Li recalls, "when I visited him around noon, a nurse asked the patients for their dinner reservations, but Chen didn't order anything. Then Chen told me he had no money at all to buy dinner, so I hurried to buy some food coupons. This is an example of the artists' situation. Chinese traditional artists were absolutely neglected."[60] Chen's emotional state only made things worse. A harsh self-critic, he had frequently thrown away paintings in earlier years because of dissatisfaction with them, but now he destroyed whole lots of them because of anger and desperation over his general situation. Li Huasheng remembers that just before he died, Chen was

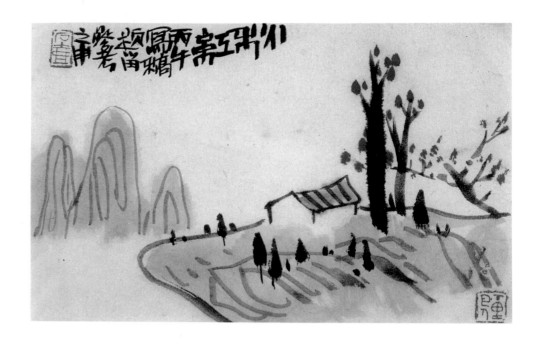

18. Chen Zizhuang. *Autumn Red.*
1966. Ink and color on paper.
Private collection, China. (After
Wang Zhihai, *Shihu hua ji,* pl. 35.)

very angry about his fate, and that he tore up many of his paintings or used them to blow his nose.[61]

Shortly before his death, Chen told Tan Changrong that his "mishandled" political case had been corrected and that he wanted to use what money he had to mount his paintings and travel around the country with them, trying to arrange for exhibitions. But soon afterwards, in late May 1976, Chen was in the hospital again, his heart enlarged to twice its normal size. According to Tan, Chen expressed "a strong will to live," asserting that if he could live to winter solstice (when the negative cosmological forces of *yin* are strongest), he would survive another year. In June, a major earthquake struck Chengdu and Li tried to bring Chen back with him to Chongqing, but Chen refused, saying that he had long lived in Chengdu and he would die there, too. Two of Chen's sons came with their wives to stay with Li. While they were with him, they received a telegram notifying them that Chen had passed away.

Chen Zizhuang died of a heart attack on July 3, 1976, at the age of sixty-three. In his will, Chen cleared up one matter of conscience, though few if any were aware of it, apologizing for "hurting China" by having sold as originals copies that he had made in earlier years of paintings by Bada Shanren and Daoji. Of his own works, in his last days he reportedly told his pupils, "I have no doubt that after my death my paintings will become illustrious."[62] How this actually came to pass will be considered in the final chapter.

In the aesthetical literature of Chinese literati painting, foremost emphasis is placed on the relationship of art and artist. Literati art, ideally, was done not for others but for one's self, and not so much to produce a finished work of art as to exercise moral self-cultivation, which happened to yield a painting as its by-product. As in early Chinese alchemy, the by-product was but the external manifestation of an internal purification process. Because the goal involved the attainment of emotional detachment, even the subject matter was, in theory, but a vehicle for this process and not something with which the artist was emotionally involved, although in practice this was occasionally not the case. In viewing the external product, only knowledgeable literati (should there happen to be any) could comprehend the "traces" of this exercise and thereby recognize the revealed character of the artist. Much attention in literati art criticism was focused on the sincerity of artistic self-expression. Despite all the ink spilled over the matter, and despite all the memorable lines, nothing better summarizes this aspect of literati theory than the clear and simple formula already mentioned: "The painting is like the man" (*hua ru qi ren*).

In socialist China, this theory was contradictory to Maoist aesthetics, which holds artists responsible not to themselves but to the state, and which holds their mission to be not one of self-expression but of selfless expression of the needs and aspirations of the masses. It is readily apparent (figs. 18–21), that the artistic life of Chen Zizhuang was

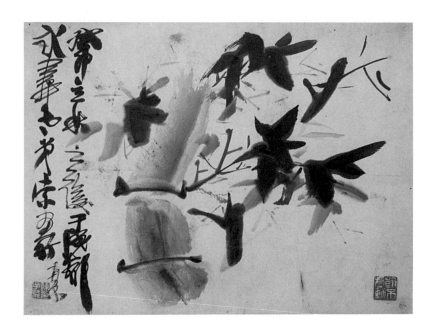

19. Chen Zizhuang. *Bamboo.* 1963. Ink and color on paper. Collection of Li Huasheng, Chengdu.

dedicated to maintaining the prerevolutionary model of artistic autonomy—how much farther could anyone's art be from the models of "revolutionary realism–revolutionary romanticism," with its stark figural contrast of heroes and villains engaged in class struggle, its rose-hued landscapes teeming with enthusiastic laborers and modernized by newly installed roads, power lines, and hydroelectric dams? Hence, the socialist need to place Chen's life and art under the protective but isolating stewardship of the Wenshiguan. How much Chen esteemed individualism is captured in an aphorism composed and inscribed for Li Huasheng: "What you can do with others is no match for what you can do alone" (*tong neng bu ru du shan*).

At first sight, it may not be clear that Chen's literati paintings achieve an identity of social and artistic personality. How can Chen himself be found in these paintings—Chen the former martial artist and secret society leader, Chen the vituperative critic, Chen the embittered social pariah but uncompromising artist. How can Chen be found in a painting style so simple, so childlike that it seems initially to have more in common with the art and personality of Grandma Moses? What aspect of Chen is to be found in his art by his new admirers, who are perhaps more sympathetic with his posthumous victory over government repression than with his art *per se*? After all, is Chen's art really good art, or is its newly won appreciation merely a social phenomenon?[63] What in Chen's primitivist style painting distinguishes it

from the truly "primitive," or from really bad art? The answers to these questions are closely related.

As is true of all literati art, Chen's painting in part represents a reaction. By the time literati theory and style attained a basic identity in the Northern Song period (11th–12th centuries), traditional Chinese painting, in the hands of professionals, had already attained high standards of technical draftsmanship and representational skill. The literati, as amateurs interested primarily in self-cultivation and self-manifestation, had little interest in depiction as such, and as members of the elite upper class they had a manifest need to distinguish their art from that of skilled professionals, who by definition were lower-class artisans. A rejection of representational skill and the substitution of amateuristic simplicity was their fundamental solution. Awkwardness (*zhou*), the bane of the professional artist, was embraced, and brush values became rooted instead in calligraphic qualities. For all of these amateur artists, as for Chen, the literati mode muddied the distinction between good art, achieved through the effective manipulation of awkwardness, and bad art, hidden behind the cover of rank amateurism. This distinction was still more blurred in the case of Chen Zizhuang, who in his maturity intentionally pushed this distinction to its very limits, drawing artistic inspiration from a historical cluster of similar artists which included the painters Chen Hongshou, Bada Shanren (fig. 37), Daoji (fig. 112), Wu Changshuo, Qi Baishi (fig. 22), Huang Binhong

(fig. 24), Lin Fengmian (fig. 57), and Li Keran (fig. 13), and in calligraphy the late Qing master Gong Qinggao.[64]

None of these literati masters resisted submitting their art, and their intentional "artlessness," to critical scrutiny. Yet they all realized that different standards were needed for their art than those applied to the art of skilled professionals, more subjective standards that constituted a near reversal of pre-literati critical values. In judging Chen's work (figs. 18, 21), it must be remembered that simplicity signifies a rejection—a rejection of ordinary values, of superficial skills that mask true identity—and that, ironically, rejection itself is not a simple but a complex phenomenon. It must also be borne in mind that such "simplicity" is not readily achieved, that it can only be achieved through a painful and disciplined process of stripping away one's knowledge, of overcoming one's acquired skill, of demanding total self-reliance and a great reserve of inner strength. A "good" painting should reveal the strength and self-reliance that lie behind that simplicity. The simplicity of Chen Zizhuang's paintings is evident. But what visual form do his strength and self-reliance take?

This can be judged from a small selection of works from Chen's maturity, representing little more than the last decade of his life, the period on which his artistic reputation now rests. (Guo Ruyu states, and all his admirers seem to agree, that Chen "really didn't excel in painting" until the early 1960s, at about the time of his five-artist exhibition, when he "suddenly" changed his style from a literally descriptive *gongbi* mode, "meticulous brushwork," to the more expressive mode known as *xieyi,* or "painting as one intends.")[65] It was at the beginning of this period, after the age of fifty, when Chen first adopted the *hao* or studio name by which he is best known today, "Shihu." The name literally means "stone vessel," but its meaning is not obvious. Zhang Zhengheng explains that it refers to the "primitive, awkward beauty of stone-age artifacts, which few people can understand."[66] This aesthetic of "primitive, awkward beauty" typifies Chen's own art.

Traditionally, bamboo was a subject with which Chinese painters and writers most directly identified; they often simply referred to it as "this gentleman" (*ci jun*). Its flexible strength, its hollow core and jointed segments, its evergreen foliage, all represented in symbolic ways the various scholarly virtues. Its slender elegance was felt to embody the literary refinement of the scholars, painters, and poets. In painting bamboo, they expressed themselves, vented their passing moods, and revealed their basic personalities. Chen Zizhuang's painted bamboo (fig. 19) shares that func-

tion, but rather than displaying literary elegance and scholarly composure, it reveals struggle, strength, and anger.[67] Shorn of its potential beauty, the three segments of this bamboo stalk are squat and bent, yet full of compressed energy. Its foliage, similarly, is made of short, broad strokes, dark over light, which appear to release the artist's negative energy. Ultimately, however, the artist's power is contained and balanced: extended calligraphy on one side of the plant, matching the subtle curvature of the stalk, balances clustered leaves on the other. Words and leaves both share the artist's conspicuously nonconformist brushwork, "ugly" but full of "character." Darkened strokes of ink down the middle of the stalk, placed beneath an ochre pigment, round out the segment and stabilize the center. The somewhat harsh configurations are all softened by the artist's wonderfully rounded brushstrokes and by his generous use of dark, moist ink. The complexity of elements are resolved into a coherent and ultimately simple image—sturdy, squat, and stable, like a martial artist poised in quiet anticipation.

The scholars' paintings of bamboo, like their calligraphy, came laden with expectations. Chen would not have painted such a distinctively homely plant without a conscious realization of the perceptions it would engender. The Yuan dynasty painter Jueyin's phrase is called to mind: "When I'm happy, I paint orchids; when angry, I paint bamboo."[68] The calligraphy, too, has an intentional imperfection, derived from the great Tang period tradition of Yan Zhenqing and Liu Gongquan. The result—as image, as brushwork—is far more memorable than the thousands of artifically elegant, look-alike examples that typify the practice of Chinese bamboo painting.

If this bamboo painting symbolizes an emotional response to the "real" world, as it impinges on the artist's life, then Chen's *Approaching Nightfall* (fig. 20) represents an alternate reality, a longed-for escape into rustic simplicity, like the poet Tao Yuanming's "Return to the Country" or Tao's "Peach-Blossom Spring." Establishing a wonderfully patterned balance between painted objects and reserved space, the near-empty barnyard and open-armed trees deliver a welcome embrace. Though "escapist" in theme, the world depicted here is unreal only to the city dweller and is routine enough to the Sichuan peasantry. Familiar to Chen from his youth but later enjoyed by him only on his retreats to practice "realistic sketching," the scene is knowledgeably observed, with readable references to Sichuan-style architecture (note, for example, the lantern-roof of the foremost barn, the *chuandou* timbers of the right-most building), carefully directed birds in flight,

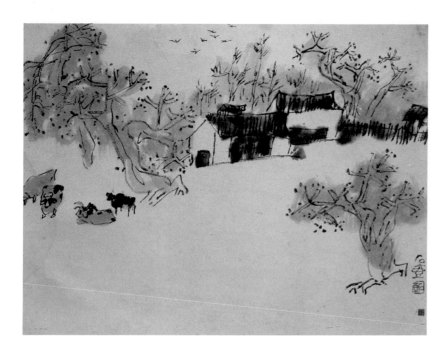

20. Chen Zizhuang. *Approaching Nightfall.* Undated. Ink and color on paper. Private collection, China. (After Wang Zhihai, *Shihu hua ji,* pl. 27.)

and well-grounded oxen (three fullgrown and one calf: is their gender evident?). This is not a fanciful escape; it is the world the artist would like to be part of, remote but approachable, crude but full of visual interest, with easily imagined smells and sounds. Style and subject, plain and simple, are well matched and offer a reminder of the philosopher Zhuangzi's rustic description of going "home":

> Call in your knowledge, unify your bearing, and the spirits will come to dwell with you. Virtue will be your beauty, the Dao will be your home, and, stupid as a newborn calf, you will not try to find out the reason why.[69]

In both theme and simplicity, the modern precedent of Qi Baishi (fig. 22) is clearly evident.

The archaic simplicity, the primal "stupidity," which Daoism has prescribed for more than two millennia as an antidote to sociopolitical oppression, is captured visibly in the brushwork of this painting—plain, unmodulated brushwork (*jianbi*) which since the birth of Chinese writing in the second millennium B.C. had represented purity in communication. Although brushwork is the most important visual element in Chinese painting, it is often packed into dense clusters or blended with rich washes of ink or color, and thus is made less evident to the probing eye of the critic. But *jianbi* painting clearly reveals the structural bones of the work and is undertaken at maximal artistic risk. Beneath the thin, stripped-down washes of this painting, the brushwork is adapted to the particular objects: the lines of the trees twist like the trees themselves, the brushwork of the barns is straight like the hand-hewn materials that barns are made of. This contrast is reinforced by the difference of wash tones, a darker ink-in-ochre wash used for the barns, a pale ink-in-indigo wash over the trees, their subtle colors adding a vital dimension to the work and helping to link the compositional sequence of solid elements that enframe and form a primal contrast with the barnyard void. Well-balanced complementary elements, interesting visual patterns, and thematic charm distinguish this painting, but its greatest strength lies in the direct appeal of its brushwork.

To this peasant pastorale may be added another essential Sichuan theme, that of life on the river (fig. 21). Here simplicity is taken to a still greater extreme and the simple strength

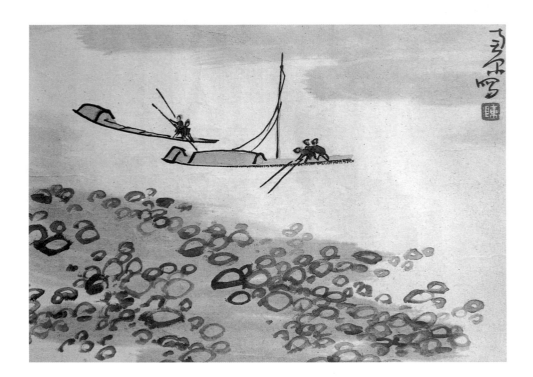

21. Chen Zizhuang. *Two Boats*.
Undated. Ink and color on paper.
Private collection, China. (After
Zhang Zhengheng, *Chen Zizhuang
hua ji*, p. 32.)

of Chen's brushwork is made even clearer, in the artist's
signature as well as in the painting itself. As in the archaic
seal script styles used in the first millennium B.C., such
brushwork looks like the easiest to accomplish but is in fact
the most difficult, requiring both great tensile strength and
what the Chinese call "roundness" or "fullness," produced
by centering the brush tip. The pure and simple style of Qi
Baishi (fig. 22) is again called to mind. The painting is so
plain as to be hard to distinguish, initially, from either the
work of children or that of boorish amateurs (the latter often
hopelessly pursuing the wonderfully "stupid" qualities of
the former). A certain astringency prevails. Yet artistic sub-
tleties like the placement of darker over lighter lines along
the ship's mast, the dry granulation of the one long stroke
defining the side of the nearby ship, the informed place-
ment of pale washes at the top and bottom of the page to
establish a boating channel, the selective use of color to
differentiate the foreground rocks and link them to the
boats, the constant variation in rendering these rocks (not
something that could be obtained by repetitive stamping),
and the sensitivity in placement of the five boating figures
are all revealed slowly, and all add flavor to the work. The
appreciation of such paintings is (to borrow the famous char-
acterization of Mei Yaochen's poetry) "like eating olives . . .

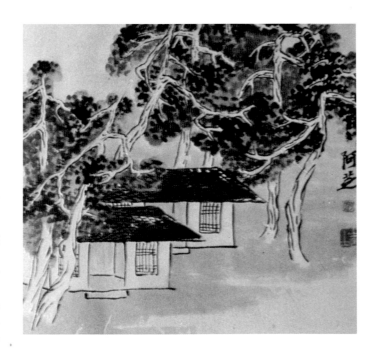

22. Qi Baishi. *Trees and Cottages*. Undated. Ink and color on
paper. Private collection. (After T. C. Lai, *Ch'i Pai Shih*, color
pl. 14.)

the longer you suck on them, the better they taste."[70]

Another landscape painting (fig. 23) represents a third basic mode in the Sichuanese landscape tradition, in addition to the peasant rusticity and river life that we have already seen. Here, Chen presents the drama of Sichuan's unsurpassed mountain grandeur.[71] Part of the remarkable nature of this painting is its attainment of such grandeur within a very small scale, little more than one square foot (fitting well within the perimeter of Chen's two-foot-square desk). Quite the opposite of the two previous works, with their transparent texture and plain linearity, this painting is created through rich textural layers. Wet bursts of mottled washes create an explosive effect, achieved by placing wet ink on top of already wet ink. Indebted to the art of Huang Binhong (fig. 24), the success of this painting depends on the artistic management of the complex brush-events taking place within it, reminiscent of Chinese bicycle cross-traffic with its scores of near misses but few actual collisions.

The result is a *tour de force*, as daring in its density as the previous two examples are in their sparseness, as active in character (*dong*) as they are serene (*jing*). As with one of his cultural heroes, Bada Shanren, Chen's works alternate between extreme frugality (indicative of the actual deprivation he was obliged to endure in his daily life) and equally extreme explosiveness (suggestive of the pent-up hostility engendered by his oppression). In this painting, however, as with his painted bamboo, the artist manages to attain a balance of the two extremes, to achieve an overall effect of stability within its dynamism, exemplified here by timeless peasant huts set so calmly within the atmospherically charged hills.

These four paintings are hardly inclusive of Chen's full range of styles and themes, and so a fifth is added to illustrate his ability to branch out into new categories: in a style close to that of the early Li Keran, a whimsical depiction of the famed "eight eccentrics of Yangzhou," who two centuries earlier suffered (if not as greatly as Chen) from social misfortune and similarly found their outlet in antisocial artistic manners (fig. 25). The subject is a record of the lofty artistic companionship Chen kept in his mind, having rejected the actual society offered by fate, and is a reminder of the long, distinguished tradition of eccentricity to which he subscribed. Other paintings could be added which, for example, illustrate his early meticulous brushwork, his paintings of birds, his depiction of flower and other plants in the manner of Qi Baishi, or his adaptation of Western color and brush techniques.

Whether Chen's art will ultimately retain its recent level

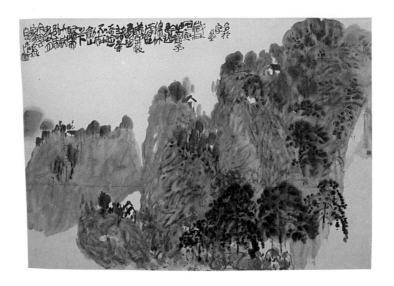

23. Chen Zizhuang. *Mountain Crossing.* 1974. Ink and color on paper. Collection of Li Huasheng, Chengdu.

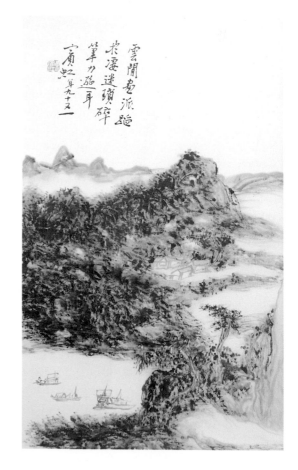

24. Huang Binhong. *Landscape in the Yunjian School Style.* 1954. Ink on paper. Collection of the Shanghai Museum.

73

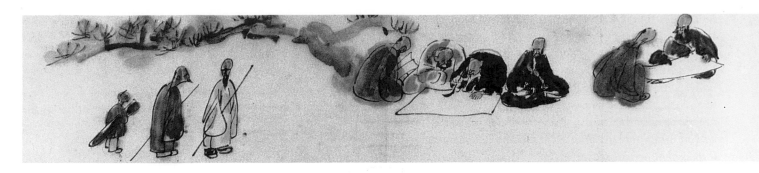

25. Chen Zizhuang. *The Eight Eccentric Painters of Yangzhou.*
Undated. Ink and color on paper. Private collection, China.
(After Wang Zhihai, *Shihu hua ji,* pl. 65.)

of acclaim, it is surely too soon to tell. In a balanced evaluation, Liu Han commented: "In the early 1950s his painting was very weak, although realistic and frank. [Even when he later matured,] his technique wasn't deep, his cultural development wasn't sufficient. His large-sized paintings aren't good and lack boldness. But he has individual talent and a hermit's mentality."[72] Li Huasheng approaches this question with less reserve: "After Qi Baishi and Huang Binhong, first place should go to Chen Zizhuang." My own opinion is that (as with many good Chinese painters) a large proportion of what survives of Chen's art is mediocre. But his best works, while small in number, are truly worthy of a lofty place in the history of twentieth-century Chinese painting.

Regardless of such critical pronouncements, in terms of artistic character, the results of Chen's artistic labors prove to be consistent with his unusual social personality. His works are something quite different, after all, from Grandma Moses's painting. Although the two have a certain awkwardness in common, the art of Chen Zizhuang is far less decorative, hard and dry by comparison—like Mei Yaochen's olives, tasting good only after long chewing—and less obviously pleasing. In a socialist society where pleasing the masses is a foremost requirement (or at least, satisfying those administrators who determine what the masses "want"), Chen's is an art of individual resistance, of inner strength reserved behind a veil of outer simplicity. He once told Dai Wei, "The true painter must have the ability to rule the country, to kill the people and burn their houses"—perhaps a confusing or offensive statement when first heard, but meaning this: Chen has understood well that to be a true artist in such times, one must be steeled against external pressures, to be a nonconformist totally at odds

with society. Grandma Moses didn't talk like that. Peng Xiancheng says of him, "Chen is too literary, too subtle, too 'mysterious' to be easily understood. But if you do understand him, you will like him very much." Stripped of all adornments, the artist becomes very much like the naked artist of his namesake, the Daoist Zhuangzi.

The earliest surviving traditional-style landscape paintings by Li Huasheng date to 1975. More than fifty works—almost all small-scale, like Chen Zizhuang's—survive from a four-year period, 1975–78, and all clearly reveal the artist's new-found relationship to Chen. Among them are themes of flowers and plants (fig. 26) very much like Chen's, and in turn very much like Qi Baishi's. Some of them, especially the landscapes, could be taken by the unsuspecting viewer for Chen Zizhuang originals, although on reflection none of them should be. It is not that *any* of these is a copy of Chen's paintings or has the intent of passing as the work of Chen's own brush, but rather that Li had pursued and successfully inculcated the essential principles of Chen's art.

In Li's *Returning Herdboy* (fig. 27), the trees are close in style to Chen's and, beyond, to those of Qi Baishi (fig. 22), with their juxtaposition of twisting linear strokes and rich, dotted foliage.[74] So, too, is the way in which this band of trees serves as a single cohesive pattern to separate the earthen elements of far and near, adding a blue wash to contrast with the orange-brown of the remainder of the painting, above and below. The rustic elements are straight out of Chen's art: the water buffalo, and the boy seen from behind, identified primarily by his straw hat composed of concentric circles. The patternization of the brushwood

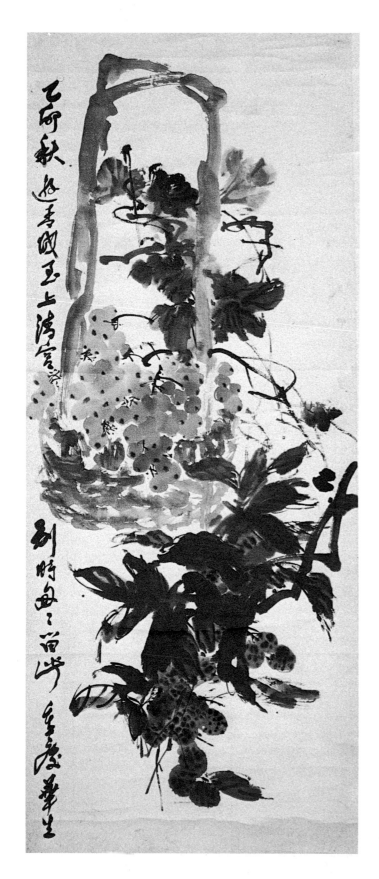

26. Li Huasheng. *Grapes and Lichees.* Autumn 1975.
Ink and color on paper. Collection of the Shangqing
Daoist Temple, Mt. Qingcheng.

27. Li Huasheng. *Returning Herdboy.*
Undated, ca. 1976. Ink and color
on paper. Collection of the artist.

fence comes from Chen, as do the row of cypress trees on the distant mountain crest and the broad, wet, internal markings on the mountainside just below. It is harder to say what differentiates it from Chen's painting. Most different is the neatness of execution and its resulting structural clarity. Chen's paintings, like those of Huang Binhong, tend to be "messier," a more suggestive fusion of loose brushwork and wet ink, closer in spirit to the earthy philosophical spirit of Zhuangzi, and more satisfying to the antiquarian tastes of the brush connoisseur. On the other hand, they require greater scrutiny on the part of reality-seeking viewers and are more of a challenge to those raised on modern decorative values. In the hand of Li Huasheng, whose training was rooted in Western-style realistic sketching, this style is crystallized into more legible objects (the L-shaped farmhouse, for example) and more readily attractive patterns.

Li Huasheng's greater decorative sense and his modern propensity for abstraction can be found in a painting of a herdboy and water buffalo in the fields (fig. 28). This is one of a number of compositional themes that Li initiated, then gradually developed over a number of years. A foreground hillock, unified by patches of brown color, bears two squat,

grotesquely angular trees. Outstretched, fingerlike branches support foliage reduced to a few globular forms, expressively personified forms clearly indebted to the art of Bada Shanren. At the edge of the foreground stands a peasant hut, crude but with such distinguishing features as a multiple-room structure, hip-and-gable thatched roof, and a low retaining fence. All these nearby objects are seen from a relatively level point of view. However simplified, this foreground is realistic in contrast with the ragingly abstract scenery beyond, with middle-ground trees further reduced to blunt stokes of the brush, while field contours spin outward to the side and upward to the top of the painting paper with no concern for gravity or depth of field. Except for one patch of green, the unpainted white background is clearly intended to heighten the contrast between the more- and less-abstract parts of the painting. The field contours themselves have all the abstraction and artistic sensibility of well-designed calligraphy or seal carving; the empty spaces are as critical to their definition as are the painted lines. Placed at the lower and upper extremes are the more pictorial elements, including a relatively well-defined ox and herdboy at the top of the page. Later versions of this theme (figs. 56, 58)

28. Li Huasheng. *Herdboy and Water Buffalo*. Undated, ca. 1976.
Ink and color on paper. Collection of the artist.

29. Chen Zizhuang. *Sketch for My Son Mei [Chen Shoumei] to Keep*.
1972. Ink and color on paper. 23 x 13 cm. Private collection,
China. (After Yang Rongzi, *Chen Zizhuang hua ji*, p. 152.)

will turn the herdboy into a plowman. They will transpose the various elements of house and fence, man and animal. But always their distinguishing feature will be the linearity of brushstrokes, describing agricultural contours yet barely descriptive at all, and the contrast between pictorial and abstract elements.

The origination of this theme in Chen Zizhuang's painting (fig. 29) shows just how different these two artists were, even when Chen's influence was most pronounced. The rustic element in Chen's version, three buffaloes drinking from a pool, also gives way to calligraphic abstraction. The buffaloes are rendered as ink puddles, more liquid than the scarcely defined water by which they stand. Plain, well-contained brush lines shaping the earth and water contrast strikingly with the irregularly scalloped edges of brown pigment, which bleed freely outward beyond the edge of the earthen forms they describe. Dominating the scene are the calligraphic trees—linear black and dotted green, more powerful and more engaging calligraphically than those of Li Huasheng. Chen's landscape, quite unlike Li's, is consistent throughout in its spatial organization, contained within a low horizon. Li's landscape, on the other hand, by displaying within itself a contrast between descriptive and nondescriptive (or barely descriptive) modes of painting, draws attention even more than Chen's to the language of painting itself and to the modern extensions of that language, beyond the representational constraints of pre-twentieth-century artistic grammar.

It is this self-conscious modernism that ultimately takes Li Huasheng beyond the training circle of Chen Zizhuang. Many such comparative examples could be illustrated which reveal both Li's lasting indebtedness to Chen and his immediate transformation of this educational model into an art form all his own. In Chen's art, one can find the precedents for any number of details that appear in Li's paintings: for his horizon-level boatmen parked at odd angles (compare figs. 34 and 67), for the distant red mountain of his *Mt. Huang* (fig. 53),[75] for his calligraphic ducks (Fig. 72),[76] for the broad-hatted figure punting his boat at an angle toward the lower edge of the painting (Fig. 80),[77] for figures on a bridge, seen from behind, gazing up in appreciation at the landscape beyond (Fig. 46),[78] and many others. Yet it is the difference between master and pupil which lies at the heart of their relationship, an artistic fellowship between two independent-minded painters, neither of whom had any tolerance for cultural or social conformity.

In the mid-1970s, Li himself could not have fully realized as yet just what alternatives would offer the most fruitful basis for future development. His painting of the Yangzi

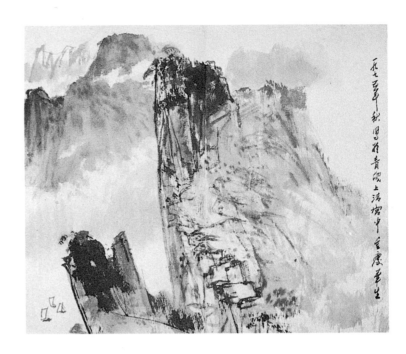

30. Li Huasheng. *Yangzi River Landscape*. Autumn 1975. Ink and color on paper. Collection of the Shangqing Daoist Temple, Mt. Qingcheng.

River gorges (fig. 30) was done in 1975 as a complimentary piece for the Shangqing Daoist temple on Mt. Qingcheng, on an excursion undertaken while visiting Chen Zizhuang in Chengdu. Its derivation from Chen's art is clear.[79] Its relationship to the landscape elements in Li's political cartoon of that period is also evident (fig. 9). More important, this work and a few others that grew out of it became the basis of Li's Yangzi gorges paintings over the next few years, in the late 1970s and early 1980s, increasingly large and dramatic works. Such paintings, like the one done for the library at the Sailor's Club (fig. 31), never failed to satisfy the popular demand for glorification of the regional scenery. They helped most to gain Li a popular reputation, but he had other, more interesting things to offer the art world.

Figure 32, done in 1976, is little different in its composition and viewpoint from figure 31, but its sense of movement is far stronger, and its contrast of plain-line drawing and wet, fused landscape is artistically much more interesting. This contrast blends two elements already seen in Chen Zizhuang's works, architecture and boats done in the simplest brushwork, enclosing areas of plain paper, derived from Qi Baishi (fig. 22), and a complex layering of stroke

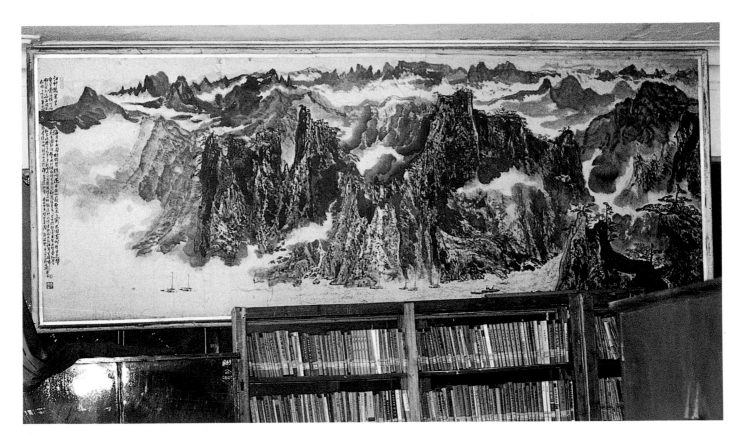

31. Li Huasheng. *Yangzi River Landscape.* Early 1980s.
Ink and color on paper. Yangzi River Shipping Company
Sailors Club, Chongqing.

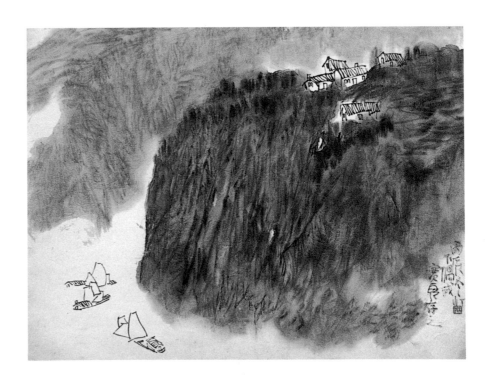

32. Li Huasheng. *Yangzi River Landscape.* 1976.
Ink and color on paper. Collection of the
artist.

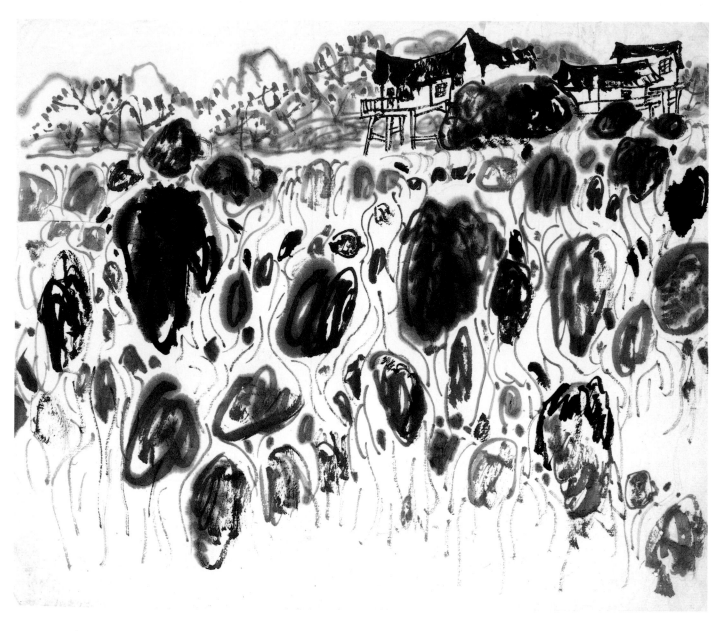

33. Li Huasheng. *River Torrent*. Ca. 1976. Ink and color on paper.
23 x 27.3 cm. Private collection, United States.

34. Chen Zizhuang. *Sketch Done at the Age of Sixty.* 1973. Ink and color on paper. Collection of Li Huasheng.

upon stroke, dark upon dark, derived from Huang Binhong (fig. 24). In Chen's work also, these two extremes exist, but nowhere are they brought together in this fashion. As usual, both elements here are treated in a cleaner, more elegant fashion than in Chen's work, less subtle and hence less profound from the connoisseurial point of view, but stronger in design and more modern in flavor.

A more original painting still is Li's *River Torrent* (fig. 33), more successful than either of these Yangzi River paintings in expressing the power of Sichuan's life-giving and equally life-threatening waterways. A small, undated work from about 1976, it contrasts the quietude of rustic life along the river banks with the turbulence of rock-strewn rapids through which no boat could safely pass. Like the painting of herdboy and buffalo (fig. 28), this work combines spatial legibility with near abstraction—clearly readable riverside huts, extending out over the water on wooden stilts, matched below by a baffling pattern of dark-ink pools dispersed within a matrix of long, unmodulated, flowing lines. With heightened contrast, the architecture is even more legible in this example than in figure 27, while the two-dimensional pattern is even less so. Although there is much in this painting to remind one of Chen Zizhuang, there is certainly no painting like it by Chen in terms of its composi-

tional dynamics. In this regard, the young painter (about thirty-two years old, and still in his artistic adolescence by traditional Chinese standards) has already gone a step beyond his teacher. In later paintings, Li Huasheng will sometimes pay conspicuous homage to his teacher (compare figs. 76, 77, and 78, or figs. 117 and 118), like Chen in formal principles and even in mood, yet in his best works generating something new, something more dynamic, something entirely modern by comparison (figs. 103, 107, 114).

Chen Zizhuang's favorite compositional device (fig. 34) is the patterned repetition of motifs, clustered together and united by means of colored wash, contrasted with other patterns and colors, and isolated by unpainted areas of paper. While Li Huasheng adopts this for his own purposes—something of that patternization can be found in the river landscape just seen (fig. 33, also figs. 54, 67)—he gives still higher priority to the compositional principle which dominates this river landscape: compressed areas of relatively realistic detail (the narrow strip of architecture at the top) juxtaposed with expansive areas that serve as an excuse for abstract design (the river rapids occupying the bulk of the painting; compare also later works in figs. 41, 56, 64, 103).

In socialist China, at least according to Maoist aesthetics, naturalism and abstraction are not equally acceptable artis-

tic alternatives but instead are the poles of an aesthetic dialectic. Abstraction is identified with bourgeois individualism. The abstract painter is fundamentally "solipsistic," working chiefly to express and please himself. Naturalism, on the other hand, while (unacceptably) lacking political significance of its own, provides the technical basis of socialist realism, of paintings that the audience "can understand." Much of Li Huasheng's basic early training was naturalistic. Yet his personal propensity is for abstraction—broad areas turned into pattern, natural and architectural elements turned into sheer gesture. In a sense, the naturalistic element in his later paintings is simply part of what he must do as an artist to survive, to make his works acceptable, as if for him naturalism is merely the frame while abstraction is the real painting, the intolerable packaged within the tolerable.

But though he is artistically most deeply engaged in the abstract expression of his art, Li is also socially engaged and is more than just competent in terms of naturalism (cf. figs. 49–52). The rustic elements of his landscapes and the life of the peasants are deeply felt in his work, and his treatment of them is much more than perfunctory. It is, then, the presence of naturalism and abstraction combined, and the tension between them, that helps assure the fundamental success of his work. Their emphatic interplay in his art—like the rhetoric of a dialectician, attempting to resolve a philosophical contradiction—represents a fundamental departure from the work of Chen Zizhuang.

Chen Zizhuang once told Li Huasheng that Qi Baishi and Huang Binhong "are like mountains; one cannot go higher; one can only go around them." Li found this notion of "going around the ancients to establish your own style" inspiring. Today, following Chen's ideas, he says:

> All of the great masters have something, but you shouldn't take more than a little bit from any one of them and should never look like them; they may all have something to offer, but you must discover your own artistic character. Others should not be able to find the historical traces in your painting. You must include them, but you should conceal them so that they are not expressed on the surface.

He applies this principle most self-consciously not to recent and contemporary masters like Qi and Huang, Lin Fengmian and Li Keran, or before them Bada Shanren and Daoji, but to Chen Zizhuang himself. Li claims:

> Chen Zizhuang is not a tree root and I am not the fruit of his tree. We are two trees. Maybe he is a greater tree and I am in his shadow. Maybe I benefit from his shade. But I am an individual, and when I call him my teacher it is only because I respect his work.

Li feels that his primary lessons from Chen were matters of artistic expression, of "spiritual influence," by which he discovered his own style. Most traditional Chinese painting masters expected students to learn by imitating their styles quite literally, and to go beyond them only after this style had been thoroughly mastered. Today, while still prescribed for youth, such devotion in middle years is seen by many as old-fashioned and slavish. Li Huasheng does not see himself as having ever copied Chen's style in this fashion. While ready to learn from Chen, his concern was how to adapt Chen's insights to his own expressive purposes. The relationship between Chen's personality and his art was subtle; the apparent (if not actual) contrast between his surly and outspoken character and the seeming gentleness of his art has required exegesis. But this is not the case with Li Huasheng. Chen's paintings expressed a sense of quietude, *jing*, which is also present in much of Li's art (figs. 115, 117). But Li's works are more frequently dominated by movement, by action, *dong*. The motifs in his paintings accentuate dynamic postures, and his brushwork makes striking gestures (figs. 63, 65, 67, 81). Li's brother Jiawei believes that this quality, while faithfully expressing Li's personality, derives also from the suggestiveness (*jiadingxing*) of Sichuan-style theater, where the props are minimal—hot tea is poured and drunk carefully without a teapot or cup, a horse is ridden without a horse, and the actor's rhythms convey all.

Li himself readily characterizes the ways in which his work differs from Chen's. He claims, "First, I tried to break away from Chen Zizhuang's composition, because composition gives the first visual impression to the audience. He painted mostly small-scale works that were limited in the range of creative concepts." Not bound by the same economic constraints, Li immediately began to convert Chen's teaching to a broader range of formats. He continues to paint album leaves but he has emphasized the larger format of hanging scrolls, and he occasionally produces oversized handscrolls. Fundamental to this development has been his desire to develop greater diversity among his paintings than Chen achieved. "Every painting," he says, "should have its own characteristics, its own purpose. This is not developed well enough in Chen's painting. His paintings didn't each have their own unique mood. His albums were excellent but were all the same in their emotional appeal. In preparing paintings, some artists create groups of works that share a common personality—this is a matter of the artist's own personality." In Li's art, the range of moods is remarkably broad, just as in his own personality, and just as in theater.

As stage performance demands exaggeration, visible to the audience from afar, so large-scale painting seems to Li to

require the use of more limited motifs drawn on a larger scale:

> Chen's approach was quite different from mine. Generally, he simplified the actual scenery, but compared with him I am even more selective. I arrange things all the way from the top to the bottom, whereas Chen centralized his composition in the middle part. In my painting, there are great contrasts between one section and the next, so the movement through my painting is quite different from Chen's. I rely more on the arrangement of dots, lines, and planes, the most fundamental elements of painting. His inscriptions could be separate from the painting, but mine could not [cf. figs. 80, 110]. The length of my inscriptions and their density cannot be separated from the painting, which further develops the organic relationship between calligraphy and painting.

Brushwork, too, is entirely different in large-scale works (compare figs. 62 and 63). "It is more difficult to control your brush and ink in large-scale paintings, but they are more suitable for displaying your ability at this. In his small-scale paintings, Chen's brush movement was uniform, quite different from my paintings. My brush movement is more dramatic than his, sometimes more like cursive writing, sometimes like seal script, sometimes more stable and dignified, sometimes more airy and mobile."

Both color and ink are also adjusted to achieve a more striking result (figs. 55, 103). "My arrangement of colors and ink also gives the audience a different sense, mine being powerful, his more subtle in spirit. His subtlety makes people perceptually penetrate into the painting; my quality is something that comes right out from the painting." Li uses mostly vegetable pigments, only rarely mineral pigments (the difference between these may be seen in fig. 115, using vegetable colors, and figs. 108, 109, using malachite and azurite). "I use mineral pigments only to wake people up," he says, "usually in a limited area, and I use them to achieve a sense of the thick and heavy. They are also easy to control in terms of shading." The one mineral pigment Li uses freely is red ochre (fig. 77), which works "just like a vegetable pigment, interacting with the *xuan* paper just like ink does, without damaging the texture of the paper or interfering with the ink" when it is ground very fine and combined with a little bit of glue.

Li often pursues complex coloristic effects derived through the risky enterprise of putting color on top of color or ink (figs. 55, 103). And he strenuously avoids any flattening out of his color into a smooth, "artisanlike" result (contrast fig. 15): "I never directly put pigments on white ground, because they will become monotonous and vulgar—first I have to paint the ground with pale red ochre or vegetation green (indigo plus moon-yellow)." Li's emphasis on yellow is unusual and striking (figs. 56, 62, 71, 115), and his juxtaposition of this with light purple (made from indigo), or with saturated green or blue (figs. 56, 108, 115), is as primitive as anything Chen Zizhuang had in mind, while at the same time it is thoroughly modern in contrast to Chen's old-fashioned sense of color. Any possible influence on Li's sense of color comes not from Chen Zizhuang but from the Western-trained, Fauvist-inspired Lin Fengmian (fig. 57), whose style Li learned through his first painting teacher, Yu Jiwu (Lin's pupil, fig. 5).[80] The richness of his ink, too, separates Li from his more conservative teacher (figs. 71, 81, 114).

Behind all these differences between master Chen and pupil Li lies an art that matured with unusual rapidity, particularly between 1980 and 1982 (figs. 54, 67). Such rapid progress is uncharacteristic in the traditional Chinese medium, where the mastery of brush technique is always slow to ripen and compositional dynamics—although easier to effect—are usually given only a secondary emphasis. True to his personality, Li made his way forward not in a walk but in a sprint. Liu Han, professor of art at the Central Academy of Minority Studies, writes of Li's artistic progress and accomplishment over this period, impressed both by Li's artistic daring and by the risk that this entailed:

> Chen Zizhuang opened the way for Li Huasheng, but by 1983–84, when Li Huasheng depicted the magnificent mountains there [in Sichuan], he had established his own character. If the best works of Li Huasheng were exhibited in the National Gallery in a one-man exhibition, he would humiliate everyone else. Even Li Keran isn't as splendid as Li Huasheng. But Li Huasheng could go astray at any time, for he hasn't control over his own rudder and anytime could go off on a tangent.[81]

This high-paced artistic development is explored in the following chapter.

Once again, it should be remembered that much of the work that Li produced under Chen's tutelage during the last years of the Cultural Revolution could scarcely be shown to others or even acknowledged except within Li's small-circle of friends. Throughout this period, the psychological pressures to conform were so great that very few artists were able to keep alive their creative impulse or to maintain any level of artistic intensity. Li, like Chen, was one of those rare individuals who managed to rise above such frighteningly destructive pressures. And like Chen, he initially earned the

disapproval of Sichuan's most powerful artistic force, Li Shaoyan.

Despite Li Huasheng's paintings in gouache and wood-block prints (the latter perhaps designed to please Li Shaoyan), Li Shaoyan criticized Li Huasheng at a meeting of the provincial Artists Association in Chengdu in 1975 as "one who neglects all subject matter and concentrates on landscape, overlooking the peasants, workers and soldiers in our creative arts and instead pursues 'pure arts', which is not beneficial in serving the peasants, workers, and soldiers." Li did not know how Li Shaoyan even knew of his traditional landscapes, but he feared repercussions and so sought help from Bai Desong, professor in the Chinese Painting Department of the Sichuan Academy of Fine Arts. Bai spoke twice to Li Shaoyan about Li Huasheng and says he made two points: first, that there should be further con-sideration of how to evaluate Li Huasheng, since he had natural talent and studied hard, and since he was a self-taught artist with a worker's family background; and second, that Li's landscapes were really not at all bad, being based on Li's wide travels and realistic sketching, and ac-complishing something through this research that is not easily achieved. Bai Desong's efforts were most helpful to Li. At least nothing awful came of the incident at that time.

Within the next few years, China would enter into a new cultural era. Political repression would by no means disappear, but China would turn away from the path of wholesale cultural self-destruction. The new cultural cli-mate would once again tolerate China's traditional art heritage and encourage individual creativity. The real mea-sure of Li Huasheng's creative artistry could at last be demonstrated.[82]

China's "Second Revolution" and the Rise of a "Younger Generation Artist," 1976–83

Writers and artists of the older generation bear an important

responsibility for discovering and training young people of

talent. Our young writers and artists are vigorous and

perceptive and in them lies the future of our literature and art.

—Deng Xiaoping, "Speech Greeting the Fourth Congress of

Chinese Writers and Artists," October 30, 1979[1]

LI HUASHENG READILY, EVEN PROUDLY, ACKNOWL-edges that "only after working with Chen Zizhuang did my style start to develop." He is equally emphatic about the ways in which his style departed from that of Chen as he pursued his own personal artistic path. Chen Zizhuang died in July 1976. Mao Zedong died in September. The death of one compelled Li Huasheng to seek an independent artistic future. The death of the other, and the subsequent fate of Maoism in the next decade, opened entirely new possibilities for artistic independence in China. Traditional Chinese painting and painters were transformed by the openness of the post-Mao years. For Li Huasheng, an artist with no formal training and no academic position, the first six years of the post-Mao era brought about significant growth in his art and a stellar rise in his artistic status unthinkable during the previous three decades of socialist rule. It was unimaginable in 1976 that, by 1980, this secretive painter-by-lamplight would be painting in public for the leader of China's so-called Second Revolution, Deng Xiaoping himself.

Certain aspects of change after Mao's death occurred with lightning speed. Huang Yongyu, whose stay with Li Huasheng in late 1973–early 1974 had been followed by deep political trouble, was now selected to help decorate the late chairman's Memorial Hall in 1977, designing the grand (and seemingly nonpolitical) landscape tapestry that hangs behind the chairman's marble statue.[2] Major political change took slightly longer, but by 1979, Deng Xiaoping had outmaneuvered not only Mao's hard-line followers, led by Jiang Qing, but also his more moderate hand-picked successor, Premier Hua Guofeng. The new decade began with the trial of Jiang Qing, the replacement of Hua Guofeng with Sichuan's reform-minded Party secretary, Zhao Ziyang (who later would add one of Li Huasheng's paintings to his personal art collection, fig. 84), the initiation of a pragmatic national program of "Four Modernizations" (first conceived under the late Premier Zhou Enlai), and the renunciation by

36. Li Huasheng. *Landscape after Xuege [Bada Shanren].* February 1979. Ink and color on paper. Collection of the artist.

Compared with art from other places, Sichuan's traditional painting is still based more on tradition, which distinguishes our art from that of Beijing, Nanjing, Guangzhou, and Shanghai. Of course, older artists always hold to conventions, but the difference here is that our younger artists also are more deeply rooted in traditionalism, whereas artists elsewhere have blindly accepted the influence of Western art. In my personal opinion, it is good for traditional Chinese painting to absorb Western elements, but those who are entirely accepting of this influence will lose their artistic advantages.

It is in the context of such provincial, conservative conditions that Li Huasheng's art would first emerge into the limelight. His work, ultimately, would be no less radical, no less individualistic, than that of Sichuan's oil painters. Yet its individuality would be rooted in Chinese, not foreign, tradition, and that traditionalism would disguise its radical elements.

Even after 1976, Li Huasheng was not directly influenced by China's opening to the West. Rather, China's opening to its own "feudalistic" past most affected his career. Since Li had been practicing this art in secret for the previous decade, the change in China's political direction did not change his artistic aims but merely facilitated and accelerated his pursuit. Although none of Li's secretly made studies of China's traditional master painters still survives, a landscape from 1979 after Bada Shanren preserves his mode of painting "in the manner" of the early masters (figs. 36, 37), particularly the most "eccentric" or "individualistic" artists of the literati tradition.

As with Chen Zizhuang's paintings, the eccentricity is not entirely obvious here. But in this study (fig. 36), two aspects are most important: the freedom and irregularity of the brushwork, every stroke spontaneous and unique; and the subjectivity with which the theme is interpreted, found,

圖作堂居雨既月閏甲
此擬敷坐望之五戌

37. Bada Shanren. Untitled landscape. 1694. Ink on paper. Shanghai Museum of Art.

for example, in the similarity of brushstrokes and outlines used for foliage and those used for the land forms, making the relationship of trees and land strangely ambiguous. Li Huasheng cannot take much credit for originality in this image, but as a "performance piece," it demonstrates a high level of artistic facility—the fruits of his decade of secret practice. Li still remembers how severely his former teacher, the conservative Guo Manchu, criticized a work of this type, about two years earlier, during Hua Guofeng's short reign: "Under the regime of Hua Guofeng, this is supposed to be the year of discipline," Guo claimed, "but your paintings are too chaotic. This looks like the year of chaos!"

Intolerable before 1978, paintings like Li's imitation of

Bada Shanren gradually became more acceptable in subsequent years. More risky and pushing the limits of the tolerable, even in Deng's new aesthetic order, was Li Huasheng's 1979 set of twenty "print-pictures" (figs. 38, 39). Done with glue-thickened ink on cardboard, impressed as well as brushed onto the painting surface, these paintings imply at least some superficial familiarity with the nontraditional, experimental painting techniques of expatriate Chinese painters like Liu Guosong (of Taiwan and Hong Kong), Chen Qikuan (from Taiwan), or Zhang Daqian and C. C. Wang (in America). All of these artists found inspiration in American "action art" of the 1940s and 1950s, in part because they also found some common ground between this Western move-

90

38, 39. Li Huasheng. *Print-picture*. 1979. Ink on cardboard. Collection of the artist.

40. Li Huasheng. *Memory Sketch after a Painting of Tree Bark*. 1987 (original painting, ca. 1979). Pencil on paper.

ment and earlier artistic experiments undertaken in China itself. Li's outreach, from Sichuan to Chinese artists abroad, may seem less than extensive, but the resulting art—nondescriptive abstraction—was still taboo in Deng's China.

To those initiated in traditional Chinese painting, these inked surfaces are so naturally read as landscapes that specific comparisons to the landscapes paintings of earlier masters readily come to mind, for example those of Bada Shanren's contemporary, Gong Xian. Yet to the political bureaucrat, such paintings could appear as pure abstraction, suggesting an art form incomprehensible to the people, in league with the worst of foreign bourgeois sources. Abstract painting was intolerable, primarily, because abstract painters were regarded as beyond political control, and its influence was scrupulously resisted. As late as 1981, the government strenuously fought against the inclusion of abstract paintings in a highly publicized exchange exhibition documenting the history of painting in United States, from Boston's Museum of Fine Arts.[10]

These print-pictures are remarkably successful for a one-time technical experiment, or indeed by any standard—rich in ink-qualities, wonderfully complex visually, and intellectually intriguing in their interplay between sheer abstraction and possible landscape form. Lacking any actual landscape details, they demonstrate the artist's thorough grasp of the basic spatial organization of his subject, both as three-dimensional depiction and as two-dimensional design. Li carried these works with him on his first journey to Beijing in the autumn of 1979 (discussed below), but finally he did not dare to share them with his fellow artists. "I never showed them to others," he says with lasting disappointment, "so I couldn't get a response from them."

Li's mixed feelings about showing these paintings—he did, after all, bring them along for that purpose—was probably well founded. Even his small-circle of closest friends had rejected another semiabstract painting by him, a view of a pine tree seen so close that the entire scroll was covered with nothing but the pattern of bark. Tall and thin, the scroll became a cluster of circular brush movements that many were unable to decipher, with a long single row of characters inscribed along the left side. Even his closest friends complained of its "formalism" and finally prevailed upon him to add some pine needles to the right. From Li's point of view, this addition ruined the painting, so he destroyed it. (See fig. 40 for the artist's memory-sketch of how this work had looked.)

Like Li's print-pictures, this pine-bark painting was by no means the purely non-representational abstraction it seemed to be, nor was it art for its own sake, lacking in

serious social significance. The evergreen pine, in Chinese painting history, has long represented rugged, enduring virtue, and its knots and gnarls (*jie*) are evocative of virtue (also *jie*), for both are written with the same character. For Li, the aged skin represented the tree as a whole, which had stood through the years as a silent witness to the political suffering of the Chinese people. "Bark," he says, "represents the age of a tree and as such has been the witness to historical and social change; its whorls are like cycles of history and rebirth. A natural object, it has dispassionately witnessed the 'true world,' unlike humans who only see with limited perspective." Such intent as this perhaps justified the view of China's harder-line bureaucrats that "abstraction" represented a threat to their goals for the visual arts and was in need of being reined in, for abstract art could mean anything the artist wanted it to mean.

Li's 1979 trip to Beijing marked a new period of travel, of fruitful communication with other artists, made possible by Deng Xiaoping's more tolerant cultural policies. It was also an important early step in Li Huasheng's establishment of an artistic reputation. By the late 1970s, says Li, he still had no *guohua* paintings published. "I had no wide reputation, and only a small reputation in Chongqing. But I started to travel after Chen's death." An earlier trip, in October 1978, took him around Sichuan province and through the Yangzi River gorges, where he painted together with three major visiting artists from the Beijing Painting Academy: Academy director Cui Zifan, the young woman artist Zhou Sicong, and Lou Shibai.[11] In the process, Li introduced them to the work of Chen Zizhuang. His strongest memory is that "only Zhou Sicong was interested in Chen Zizhuang's drawings. The other two thought that they lacked the contemporary spirit."

In 1979, after Li's painter-friend Wang Wennong came from Wuhan to Sichuan, Li again went to Wuhan (his first trip there since 1974) to "seek teachers and make friends" among the artists there. As in his earlier trip, he brought with him paintings by Chen Zizhuang, about twenty in number, for Wang to place in exhibition. Li was also able to see and study a rare Qi Baishi painting that Wang owned. On his departure, Wang presented Li with a pair of vertical calligraphic scrolls by Xie Wuliang (d. ca. 1960, the first national director of the Wenshiguan). Li's former teacher Guo Manchu had previously given these to Wang when he was visiting in Chongqing, but Wang Wennong, not liking them, now passed them on to Li. Xie's calligraphic combination of fluid movement and awkward form has influenced Li's own writing from that time on, and today these scrolls are proudly hung in Li's living room.

Li's 1979 trip to Wuhan again took Li through the Yangzi River gorges. This repeated first-hand experience of the gorges prepared Li for his monumental painting, *Fisherman's Song at the Wu Gorge* (fig. 41), painted shortly after that trip. As Li wrote in the inscription above this large hanging scroll, when studying the gorges artistically, he would disembark from the larger passenger vessels and steamers that had brought him there and would transfer to smaller craft, however dangerous, that could take him where he wanted to go:

> I used to travel through this gorge on an oared boat. Every time I arrived at Mt. Wu, I would leave the boat for the shore. Among the lofty cliffs, the thorny vines were dense and hard to pass through going sideways. It made me dizzy—frightened—numb. Looking down at the great river from above, I saw fishing boats like so many dots, and I could hear nothing but the fishermen singing in response to each other, their sound echoing back and forth in the valley of the gorges, their vitality and vigor really apparent.[12]

Structurally, this work follows the compositional notion already observed (figs. 28, 33) of placing details at the upper and/or lower extremes of the painting and filling the space between with pure brushwork, the artist's pure energy in this case conveying the powerful energies of Mt. Wu (or Witches' Mountain). The streaked brushwork that dominates the middle portion of this scroll and the red-dotted accent strokes (the latter clearly intended as tree foliage) are derived from Chen Zizhuang.[13] Linking top to bottom—a span of almost seven feet—and carving out a curve along the right edge of the painting is a precipitous waterfall that lends a dynamic, arching configuration to the rising mountain peak. The force of this unpainted cascade is suggested by the richly modulated washes that surround it, piling ink on wet ink, adding darker splashes to a broader flow beneath, and achieving an explosive visual effect.

What Li may have brought to this work from his abstract print-pictures cannot be overlooked. The powerful artistic dynamism out of which the mountain is created is most effectively suggested by contrast with the elegantly portrayed fishing village resting serenely at its base, undisturbed by all the energy above. The painting eschews the romantic coloration and exaggerated interplay of mountains and clouds that debase many of Li's other large-scale renditions of this theme (fig. 31). Still the painting is far grander and showier in brushwork than are many of Li's later accomplishments. Such grandiosity surely struck a popular chord in Sichuan, a chord that would have to be tempered for Li to avoid becoming a mere popularizer, to attain instead a stan-

41. Li Huasheng. *Fisherman's Song at the Wu Gorge.* 1979. 178.4 x 95.3 cm. Ink and color on paper. Private collection, United States.

dard respected among China's traditional painting masters.

In the later 1970s and early 1980s, traditional Chinese painting itself had a long way to go to achieve a full measure of respectability, even within Sichuan's own artistic community. It was a time, according to Bai Desong, when the provincial Artists Association "offered no support at all for traditional Chinese painting." At the Sichuan Academy of Fine Arts, Bai continued to teach traditional painting, even when challenged to demonstrate how landscape and bird-and-flower painting could help serve the people. But until 1988, figure painting remained the primary emphasis in his department, as a matter of formal policy. In 1978, Bai Desong proposed asking two landscape painters to serve there as specially invited, nonteaching faculty members. He recommended Qiu Xiaoqiu, a landscape painter and Sichuan opera playwright,[14] and Li Huasheng, "based on their artistic achievement and their moral virtue." The Academy's vice-president, Ye Yushan, also contributed support for this arrangement, but Bai failed to win faculty agreement. Bai suggests that the primary resistance came not from regular faculty members but from the honorary, nonteaching members of the Academy, older and more conservative, more concerned with status and with Li's and Qiu's lack of formal educational background. Bai and Ye would renew their efforts to add Li to their faculty, but not until much later, in 1985. While unsuccessful, Bai Desong's invitation was the first public signal of Li's emergence from obscurity.

In that same year, 1978, Ding Jingwen, principal of the middle school run by Beijing's Central Academy of Fine Arts, came to Sichuan to recruit painters for Beijing's newly organized Chinese Painting Creativity Group. The activities of this group, which later became the prestigious Chinese Painting Research Institute, reflected the widespread concern in Chinese painting circles with the problem of how to develop and renew the old tradition, which was recognized as having deteriorated badly during the Cultural Revolution. Ding first came to Chengdu, asking Li Shaoyan, "Who paints well?" He had already heard of Li Huasheng by name, and when he asked about him, Li Shaoyan reportedly answered, "He's not an appropriate person. He's too arrogant." Nevertheless, says Li Huasheng, Ding wanted good painters, not just moderate personalities. When Ding traveled on to Chongqing, he interviewed Li Huashang. A few months later, Ding sent an invitation for Li Huasheng, addressed to the Yangzi River Shipping Administration, which approved Li's traveling to Beijing for the first time.

This was in the autumn of 1979. Li brought with him the twenty abstract cards, his print-pictures, though he dared not show them to others. He remained in Beijing for almost three months. Looking back today, Li regards this conclave less as a learning experience and more as an initial chance to participate in art activities at the central level, to make himself known. He feels that Ding gave him his first significant break of this kind, and he remains deeply grateful. It is not possible to evaluate the effect of this experience on his work, but the following twelve months saw unprecedented improvements in his art.

The year 1980 was also one of significant travels, which Li recorded in his sketchbooks as realistic drawings done in pencil. Many of these realistic sketches reveal for the first time Li's propensity for architectural drawing, accurately capturing the details of southwestern China's distinctive *chuandou* type of architecture, with its use of tall, thin, ground-to-main-beam timbers and extensive, attractively arranged gable-end tie-beams (figs. 42, 43). More important, these drawings display a new level of rhythmic vitality, seen in every stroke and bringing a degree of energetic movement to every inch of the page. In earlier works, the artist's energy first appeared in larger overall patterns (figs. 28 and 33, from the mid-1970s). A comparison of the architecture in earlier works (figs. 27, 28, 32, 33) with these more recent examples demonstrates the spread of this dynamic energy from the more abstract areas of earlier works to every detail of the later ones. In figure 42, not only the architecture but also the linear banyan tree with its rippling branches and roots as well as every one of the explosive dots suggesting autumn foliage conveys a powerful rhythmic pulse. This remarkable energy, set forth with a new-found air of artistic self-confidence, grows out of the first full blossoming of Li's artistic relationship with Sichuan's rustic landscape.

After a decade of traveling and realistic sketching, Li had finally discovered in the geometric irregularity of nature the perfect outlet for his own naturally expressive impulse. He had even come to realize that

> the wealthier areas of Sichuan landscape are not suitable for painting, for their fields are located in flatter regions, lacking visual interest. Their well-constructed buildings are all geometrically regular, their once-natural pathways are straightened out as the farmers get rich, as a means of showing off their wealth. They replace their old bamboo fences, substitute tiles for their old thatched roofs, and even cut down their old, irregular trees and plant new straight ones.

After years of identifying landscape drama with the Yangzi River gorges, Li finally discovered that drama was everywhere, in every branch and roof line. As he wrote on a painting in 1981, entitled *All Night, New Rain* (fig. 44):

42. Li Huasheng. *Untitled Sketch*. 1979–80.
Pencil on paper. Collection of the artist.

43. Li Huasheng. *The Qing and Bai Rivers*. 1979–80.
Pencil on paper. Collection of the artist.

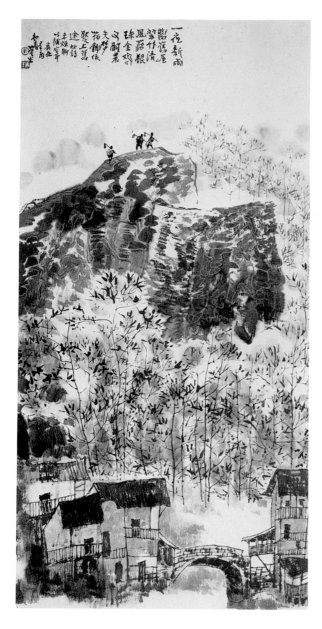

44. Li Huasheng. *All Night, New Rain.* 1981. Ink and color on paper. Collection of the National Art Gallery, Beijing. (After *He shan ru huatu*, p. 15.)

Sichuan is a land of mountains and forests, of many rivers, with forests everywhere and beautiful crops which I love to paint. But it took a long time before I realized that in making a painting, it doesn't have to be a famous mountain or a great river.

Another leaf from the same sketchbook (fig. 45) reveals the source of the *All Night, New Rain* painting on which this inscription appears—the scenery of Yibin, the town where Li was born—and it demonstrates the role that the artist's sketchbooks played. Such sketchbooks, normally regarded as an artist's most private material and rarely if ever revealed to others, provide artists with visual "ideas" that they continue to draw upon decades later. A comparison of this sketchbook (one of three done in the years 1979–80) with some of the works derived from it reveals how Li varied his treatment of an original on-site drawing in moving from sketch to painting, and from one painted rendition to the next. In this case, the original sketch loosely served for the lower, foreground portion of the painting, which was then added to, above, drawing from other sources, in order to achieve a larger hanging-scroll format (the three figures above, setting out for the fields with hoes in hand, are typical in theme and compositional setting of Cultural Revolutionary paintings). In *All Night, New Rain,* in a fashion that by then had become common for him, Li's painting combined this detailed lower section and upper border with a middle section lacking in detail, here a semiabstract pattern of bamboo and rocky bluffs.

Another painting, an album leaf painted in about 1982 (fig. 46, done on a pre-mounted, Japanese-made, cardboard-backed *shikishi*[15]), combines elements derived from the sketch and from the painted hanging scroll. From the sketch come the figures, seen from behind, seated on the bridge. Like the viewers of the album leaf itself, these figures also comprise a viewing audience for the scenery. From the painted scroll comes the particular disposition of the architecture (the lines here wonderfully merged with a soft ink wash) and the middle-ground grove, transformed here from a bamboo grove to deciduous trees in autumn. Appropriate to the small-scale album format, the high bluffs of the scroll are reduced to small, pale-brown patches suggesting distant mountains.

Many other comparisons can be made, such as Li's realistic sketch of the Qing (Black) and Bai (White) Rivers, which flow down from Mt. Emei and join at the small town of Gaomiao (fig. 43), and several paintings that derive from it (some of them even more closely related than the works just discussed), or his sketch done at Gubai Village (fig. 116), not used in painting until his *Rural Waters* scroll of 1987 (fig. 115).

45. Li Huasheng. *Scene at Yibin*. 1979–80. Pencil on paper.
Collection of the artist.

46. Li Huasheng. *Scene at Yibin*. Ca. 1982. 31.8 x 40.6 cm.
Ink and color on paper. Private collection, United States.

This sketchbook was also a visual diary. In it Li recorded his first trip all the way down the Yangzi River to Shanghai, taken in the summer of 1980. On rainy days which kept him from traveling the countryside, he went to the Shanghai Museum and sketched neolithic ceramic vessels to compare with those he was beginning to collect back home. On this journey, Li had his first and only opportunity to visit China's justly famous Yellow Mountains (Mt. Huang). But before Li's visit to the great artistic centers of south-central China, another event occurred which brought an important part of China to him.

In the summer of 1980, although he was a mere staff member at a local sailors club, Li Huasheng was invited to attend the provincial Representative Assembly of Writers and Artists, held in Chengdu. At the same time, probably to facilitate his Assembly participation, Li was nominated for membership in the Sichuan Provincial Artists Association. Association membership, strictly limited, could be arrived at either through self-application or nomination by another member. Li is not certain who nominated him, but he suspects it was Chongqing Artists Association chairman Niu Wen (fig. 74), who in time would become Li's foremost artistic mentor. Li's case was reviewed quickly, and a week before the Assembly convened, his membership was approved. At that moment, it was Li Huasheng's highest artistic distinction.

Today, Li remembers little of what was discussed at the Representative Assembly. Afterwards, Sichuan Artists Association chairman Li Shaoyan invited twelve artists to remain for several days to conduct academic research on how to restore vitality and bring needed innovations to traditional Chinese painting. Along with such senior Sichuan painters as Feng Jianwu, Sun Zhuli, and Wu Yifeng, three younger artists were included: Tan Changrong (b. 1933), a Chengdu bird-and-flower painter, an acquaintance of the late Chen Zizhuang and a friend of Li's since the late 1960s (fig. 101); Peng Xiancheng (b. 1941), another acquaintance of Chen's who would later become a professional colleague of Li's (figs. 92, 93); and Li Huasheng himself.[16] This meeting continued for more than two weeks, and the artists were hosted at Chengdu's finest hotel, the Jinniu (Golden Ox), then off-limits to ordinary Chinese.

By coincidence, a fellow guest at the hotel was Chinese Vice-premier Deng Xiaoping, returning to his home province (on an "inspection tour") for the first time since his rise to power. Accompanying Deng in Sichuan, on July 9, 10, 11, 1980, was Tan Qilong, the Sichuan provincial Communist Party secretary. Tan had been transferred in January from Qinghai province to replace Sichuan's economic reformer, Zhao Ziyang, who had been brought into the central administration late in 1979 and who, in April 1980, was made a deputy prime minister.[17] If not in art, at least in politics, Sichuan was making its mark in Beijing. On one day's notice, it was arranged for Deng Xiaoping and Tan Qilong to visit the painters' rooms (each artist had his own room) to meet the artists and view a few paintings by each. In the evening, in a large meeting room of the hotel, the artists collectively displayed their works for Deng Xiaoping and his entourage, which included Deng's wife, Zhuo Lin, and his daughters, Deng Lin and Deng Nan. Li Huasheng brought twenty of his own works, and when Deng showed his appreciation for one particular painting, Li offered it to him. When Deng demurred politely, commenting "I never studied painting"—standard etiquette for the situation—Li offered the work to Deng Lin (herself a serious artist) to give to her father, entrusting it to the hotel management on their behalf.[18]

It was at this time that the idea of a Sichuan painting academy was first introduced—a nonteaching academy, such as most provinces had already established, to support the painting activity of a very select group of Sichuan's finest and most innovative artists. The painters themselves originated the proposal, and Li Huasheng presented it on their behalf to Party Secretary Tan. Tan agreeably said there were so many painters in Sichuan that it was possible, and he authorized the artists to raise the proposal for Deng's decision. Deng, while looking at the artists' paintings, gave his approval indirectly—avoiding an inappropriately trivial decision or an intrusion on purely local affairs—by saying that provincial leaders could make the final judgment on this. Although the final decision to create and fund such an academy was not actually made at that time, the political groundwork was firmly established. Deng Xiaoping later contributed the calligraphic title of the Sichuan Painting Academy for display on its outer gates at the time of its inauguration, and he was later said by Academy director Yang Chao to have "personally directed" its establishment.[19]

The following morning, Deng Xiaoping was photographed with the artists (fig. 47)[20] and then set off to visit Mt. Emei. In his absence, three artists—Tan Changrong, Huang Yongyu (the Beijing painter, risen to great eminence since his visit with Li Huasheng in 1973–74, who just happened to be traveling through Chengdu), and Li Huasheng—got together with Vice-premier Deng's elder daughter, Deng Lin, to produce a cooperative painting (fig. 48).[21] Collective painting to commemorate social gatherings

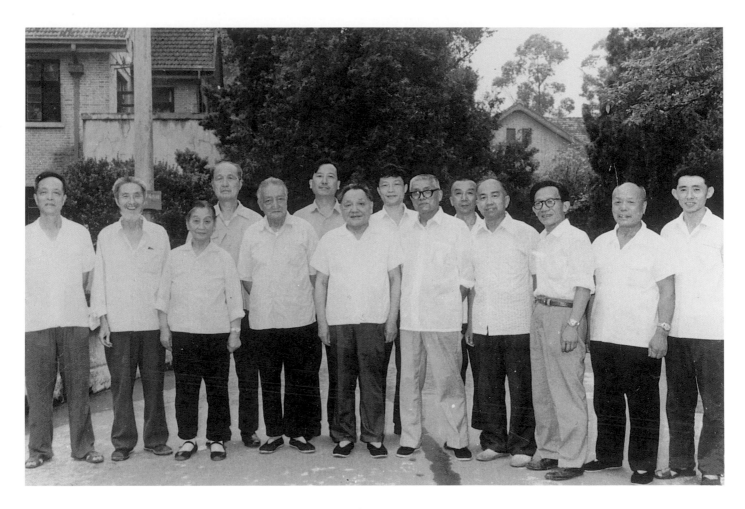

47. Vice-premier Deng Xiaoping, Li Huasheng, and members of the Academic Research Group at the Golden Ox Hotel, Chengdu, July 1980 (*front row, left to right:* Li Daoxi, Sun Zhuli, wife of the artist Nian Songfu, unidentified figure, Vice-premier Deng Xiaoping, Feng Jianwu, Yang Mingli, Qiu Xiaoqiu, Zhou Beiqi, Peng Xiancheng; *back row:* Wu Yifeng, Tan Changrong, Li Huasheng, Hu Li).

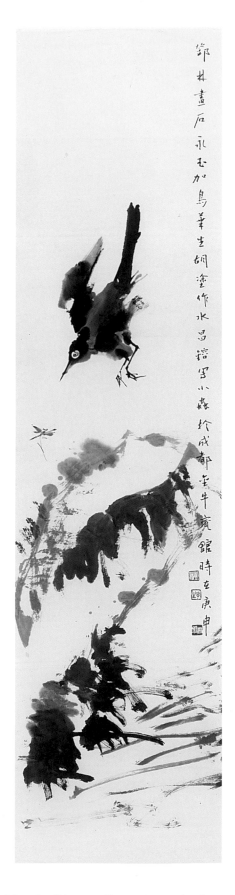

is an ancient Chinese tradition, governed by rules of propriety. Deng Lin, appropriate to her inherited social status, began the work by painting a rock. Huang, senior among the painters, added a bird, to which Tan added a flying insect that the bird was pursuing. Li, the group's junior member, says he found it difficult to add anything at all at this point, so he contributed but a few brushstrokes below, meant to resemble water, to give the painting a sense of depth. The artists seem to have outdone one another in trying to achieve some degree of literary "awkwardness," and the results were hardly distinguished. Seals were added in succession by Deng Lin, Li Huasheng, and Tan Changrong, and an inscription was added: "Deng Lin painted the stone; Yongyu added the bird; Huasheng roughly made the water; Changrong drew the small insect. At Chengdu's Jinniu Hotel, 1980." The painting was meant as a gift for the provincial Artists Association, but once it was painted, the group's attention turned elsewhere and it was never presented. The work is now in Li's collection, scarcely appreciated by him.

In his visit to Mt. Emei, Deng Xiaoping distinguished himself in the popular imagination (and in Li Huasheng's as well) by refusing his security agents' requests to close the mountain to visitors. While on Emeishan, according to the New China News Agency,

> Deng Xiaoping . . . cordially talked with tourists on the mountain. When he saw that in some places trees had been destroyed and replaced with corn, he said with a sigh: "Why has such a beautiful place been used for growing corn instead of for planting trees." He said to responsible comrades of the provincial CCP committee: "Since the peasants in mountainous areas live far apart and lead a hard life, a flexible policy should be adopted to enable them to become well-off as quickly as possible."[22]

Deng further won Li's admiration by refusing a proposed private performance of Sichuan opera scheduled solely for him and the painters groups, saying he could attend theater like anyone else. These gestures of egalitarianism, symbolizing Deng's new, more open style of leadership, helped to inspire one of Li's major paintings, done soon after, regarding tourism at Mt. Huang (south-central

48. Deng Lin, Huang Yongyu, Tan Changrong, and Li Huasheng. *Landscape with Bird and Insect*. Ink on paper. July 10, 1980. Collection of Li Huasheng.

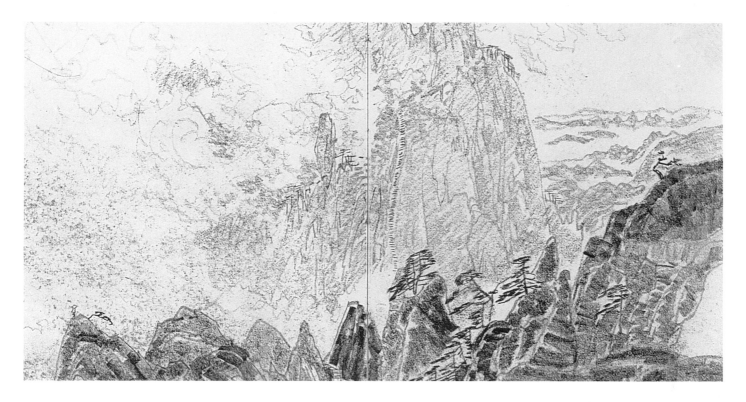

49. Li Huasheng. *Scenery of Mt. Huang.* Summer, 1980.
Pencil on paper. Collection of the artist.

China's scenic Yellow Mountains) and matters of social equity (fig. 53, discussed below).

The painting resulted from Li Huasheng's first opportunity to go climbing and sketching on Mt. Huang in the summer of 1980, soon after the Jinniu (Golden Ox) Hotel meetings, midway on the trip to Shanghai, Suzhou, and Hangzhou. This journey began with a painting expedition through the Yangzi River gorges with one of China's best-known art critics, Wang Zhaowen (a vice-chairman of the Chinese Artists Association), and printmaker Wu Fan (figs. 87, 88). Traveling on to Huangshan, Li created a sketchbook there (figs. 49–52), different in style from the other sketchbook he was producing all along the way (already looked at, figs. 42–43, 45, 116). Most of the leaves of this Huangshan sketchbook are more highly finished, more carefully shaded and textured, than those in the other book. They are a reminder that Li's earliest training was as much in Western style as Chinese, and that this training was very thorough.

More than any of Li's surviving works before or since, this sketchbook demonstrates a remarkable technical prowess that may not be obvious in his free-style Chinese painting. Throughout the album, the artist's shorthand lineation and varied shading textures re-create all the remarkable qualities of the Yellow Mountains: their extraordinary contours, their radical juxtapositions of near and far, their sky-blocking cliffs and curved horizons, the way in which their mountains and clouds seem to echo each other in shape though not in texture, the night and morningtime sea of fog that transforms distant peaks into islands adrift, pines that seem as if shaped for decades by some Oriental gardener, and the penetration of natural domain by towering ladders of hand-hewn walkways and arched bridges that mirror the curve of nearby mountains.

There is less artistic license for rhythmic exaggeration here than in the previous album and a sterner commitment to realistic observation. But Li's artistry can be seen in his selection of images as well as in his technique, manifest in his frequent reworking of initial drawings into more refined second sketches. Just as the artist's drawings show how a realistic sketch is turned into a painting (cf. figs. 44–46, 115, 116), comparison of closely related sketches also reveals

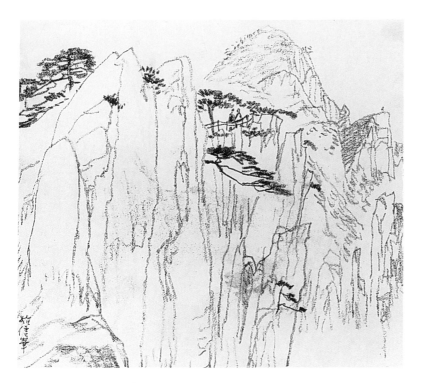

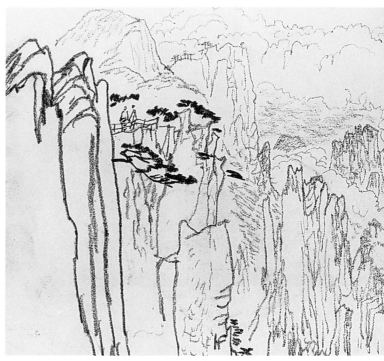

50. Li Huasheng. *Scenery of Mt. Huang.* Summer, 1980.
Pencil on paper. Collection of the artist.

51. Li Huasheng. *Scenery of Mt. Huang.* Summer, 1980.
Pencil on paper. Collection of the artist.

how the natural scene is transformed into a work of art. Figures 50 and 51, illustrating the Peak of Original Faith (Shixin Feng), reveal one such transformation. The differences between sketches seems slight, and the latter sketch at first sight appears to be nothing more than a different view done as the artist made his way along a switchback leading to the left and back to the right again, the pathway itself being not actually visible in the sketches until it arrives at a fenced-in tourist lookout, above and beyond. But it was more than felicity that led to the much-improved artistry of the second version. In the first version, there is a notable tonal contrast between dark pine trees and the generalized gray of rocky landscape, but near and far are undifferentiated. There is a slight difference between the degree of detail used for near and far, left and right, but no more than that. The main peak and the overlook below it are lined up and centered upon the page, all but monopolizing visual attention and diminishing interest in the rest of the painting, which offers no dominant movement, few contrasts, and little inner tension.

In the second version, the improvements are not so much a matter of execution as conception. The main peak and the lookout are moved to the left, and the right side of the painting opens up expansively into grand distance, so that there is something for the peak and lookout to tower over, to look down upon. There is a dynamic movement from near to far, heightened by tones that now contrast nearby and faraway features; this contrast is reinforced by a linear mountain contour that falls away from upper left to lower right, by scribbly clouds floating to the right in two parallel bands, and—most of all—by exaggerated contrasts in detail in the rendition of close and distant views. By eliminating the detail in the foreground and selectively reintroducing it in the distance, the artist draws the viewer into the painting with an opening gesture that heightens the dramatic impact of the natural scene. In the process (since maximal detail should appear close by, not far off), he reverses optical naturalism and elevates the role of artistry over representational fidelity, making a purely subjective display of line, the Chinese graphic artist's traditionally most-favored element.

In examples like this, the second draft gives the artist the chance to discover the potential of his subject, to enhance

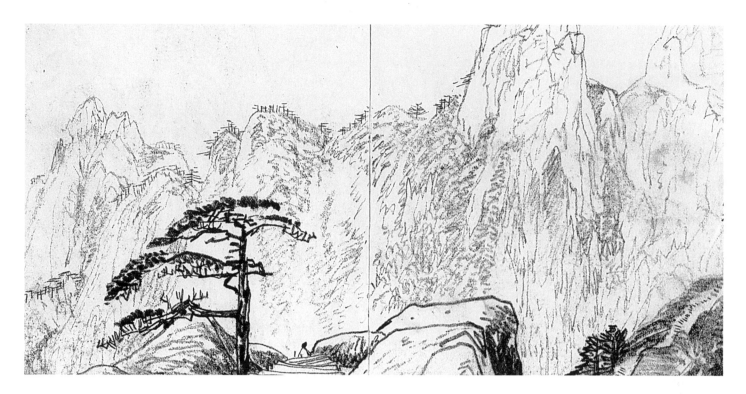

52. Li Huasheng. *Scenery of Mt. Huang*. Summer, 1980.
Pencil on paper. Collection of the artist.

his own expressive qualities. On a few leaves, such artistic insight comes forth in a highly successful first draft. In figure 52, one meets the Yellow Mountain scenery head on. In two horizontal bands, the very near contrasts with the very far, with nothing in between. A single powerful pine tree dominates the foreground with its dark silhouette; it is contrasted visually with a row of pale, delicate trees along the opposite crest. To the left and right of center, in the foreground, are rocky outcroppings; these are reflected by distant forms. These visual contrasts and parallels together help to bridge the physical separation between nearby and background forms. The other visual bridge is a set of rock-hewn stairs that points from near to far, beginning right at the viewers' feet then rapidly receding and dropping off into the unseen void straight ahead, given a sudden tilt just as it disappears, as if to add a bit of spin to the descent. Traveling this path and accentuating the drop-off is a single figure with a walking staff, the lower portion of his body already out of view behind the stairway that tilts first this way, then that, adding torque to the descending movement. The immediacy and spatial mastery of this painting invites

comparison to scenes from certain masterpieces of the past, such as Xia Gui's twelfth-century *Pure and Remote Views of Mountains and Streams* and even the Japanese painter Sesshu's famous *Long Scroll*. The reappearance of the pathway in the lower right reflects the artist's particular interest in these curving, man-made patterns that snake through Huangshan's natural realm. Occasionally selected as a major theme in his sketches, these paths play the dominant role both visually and iconographically in his *Mt. Huang* painting (fig. 53), done at the end of that year.

Li Huasheng's *Mt. Huang* painting was executed on New Year's Eve 1980. Appropriate to the occasion, it embodied a sober reflection on the events and moods of the past year, with its highpoints of Li's travel to Huangshan and Deng Xiaoping's travel to Sichuan. Visually, this abstractly designed scroll bears an even closer relationship to his print-pictures of the previous year (figs. 38, 39) than it does to his meticulously executed Huangshan sketchbook. And like these prints, with its jerky brushwork, broken structures, and broad, unpainted borders, it resembles the work of the wonderful, Sichuan-born artist Shi Lu (whose older brother,

Feng Jianwu, Li Huasheng had known since 1967).[23] The painting is as pure a study in line, wash, and tones of ink—as close to "art for art's sake"—as one could create in 1980. Little can be read as specific content other than the serpentine movement representing a mountain path, and little suggests that path other than a section of steps in its lower portion (not added until February 1981 at the suggestion of Nanjing painter Song Wenzhi, when the painting was included in Li's first national-level exhibition).[24] Barely legible as natural objects are blackened clouds draped over the mountain's shoulders and four orange vertical swatches representing distant peaks at sunset.

 This dynamic image was fueled by intense artistic energy. Much of its power, however, is lodged in the artist's poetic inscription. The most original and successful of all of Li Huasheng's poems, its effect on the image is unforgettable. Li was scarcely educated except for his informal work with Zeng Youshi, so his disclaimer to poetic accomplishment is valid by any traditional measure. Yet this unique poem stands as testimony to what a more adequate education might have yielded. The product of a New Year's Eve contemplation, its hidden references lie not only in Li's tour of Huangshan but also in Deng Xiaoping's ascent of Mt. Emei, which raised the question of how China's leaders and masses relate. The subject of this poem is none other than China's grim predicament of persistent poverty and inequality:

Layers of trees: green, dark; mountain path: white.
Draped in clouds, dappled by fog, a dancing dragon-serpent.
Splitting the sky, these gathered stones, hewn by compass
 and square,
This carved cliff of inlaid steps, of carefully measured lines.
One thousand, ten thousand blows of hammer and chisel—so
 difficult each step;
One thousand steps, ten thousand steps climbing to Heaven's
 gate.
Tourists sit around, suffering from food too rich;
In the workers' mouths: dry biscuit crumbs,
Their calloused hands painfully drawing water from the
 mountain stream,
Their dark sleeves sweat-drenched, by their own salt
 whitened.
Sunset on the vacant mountain. Laughter, talking stop.
But hammers strike, on and on. Workmen get no rest.
On the mountain face, even now, some ancient paths remain,
But no longer seen are the tears and blood of those times.
Coming and leaving, tourists compose but a few poems,
And all they compose is merely this: wind-flowers-and-snow.

The sun descends Heavenly Realm Peak, evening clouds
 darken,
And Wish-Granting Guanyin ["Goddess of Mercy" Peak],
 across the void, faces the moon.[25]

 Like his painting of pine tree bark, this work of painting and poetry considers China's predicament not merely from a personal view but with a broader concern for its causes. Its theme: that thirty years of socialism, and the drastic political measures taken in each of socialism's three decades, had done so little to eradicate the feudalistic contrast between rich and poor, between worker and tourist. It is, ultimately, a homily on social corruption. Its "tourists" may be understood as China's new ruling class, the "new elite," which has taken on all the political and economic vices of the old, although in Li's view Deng Xiaoping personally stood out at that time as an exception, offering a promise of reform. To the rulers who come and go, some with flowery rhetoric, and to the poverty that remains, the mountain itself stands as an enduring witness. Despite his middle-school and technical-school education, which categorized him as an intellectual, Li's sympathy and identification with the people of the working class into which he was born is made clear by the depth of feeling lodged in this poem.

 So pointedly political a painting as Li Huasheng's *Mt. Huang* is rare among his works. His typical paintings, instead, celebrate the timeless virtues of Sichuan's rural landscape and its inhabitants, a world he sees as little touched or changed by politics. A number of other paintings done in 1980 (figs. 54–56, 58, 59) demonstrate his increasing mastery of the rural scene, free of the glib and artificial elements of socialist modernization that typically despoiled the Cultural Revolutionary era's painted landscapes. Under the new regime of Deng Xiaoping, it became increasingly possible to produce such landscapes, which embraced the peasant environment sympathetically, neither falsifying it with revolutionary romanticism nor seeking to expose its darker aspects, as had his *Huangshan* painting. Yet such a transformation did not happen automatically, and most artists who proceeded in that direction did so cautiously. Despite policy statements from on high about an end to bureaucractic meddling in the arts, many associations and academies were still staffed by old-guard functionaries and were run according to old policies, and at the local level every step involved new risks. Especially among the younger generation, raised and trained to follow bureaucratic expectations, it was up to artists like Li Huasheng to take those risks.

 In 1980, many of Li Huasheng's paintings continued to

53. Li Huasheng. *Mt. Huang.* December 31, 1980. 139.4 x 66.7 cm. Ink and color on paper. Private collection, United States.

translate what he learned from Chen Zizhuang's small-scale works to the larger, more imposing hanging scroll. One of these landscapes (fig. 54), painted in the style of Huang Binhong (fig. 24) as transmitted through Chen Zizhuang (fig. 23), demonstrates Li's facility, if not great originality. The major elements of the work—complex black mountains (wet brushstrokes moving in all directions, covering all but irregular patches of the white paper), simple homes (plain forms composed by thin, straight lines), nearby willows (black lines and green and yellow color patches), and distant mountains (broad strokes of blue)—can all be found in Huang's work, although the willows are equally reminiscent of Lin Fengmian. But the structural formulation is more like that of Chen Zizhuang (fig. 34), bunching repetitive elements into patterned areas and unifying these by color washes, then juxtaposing these with other bunches done with contrasting patterns and colors. It is a basic mode of Chinese literati painting; but in the clarity and regularity of this organization, Chen and—even moreso—Li go a step beyond most of their predecessors. In this work, the complex brushwork lacks something of the controlled craziness of Huang Binhong's work, and the architectural drawing is more delicate. Yet Huang Binhong is not an easy model to follow (indeed, his followers have been few, and his standard can scarcely be matched in this century), and Li's 1980 work should still be measured more in terms of promise than of accomplishment. The artist's inscription is couched in terms of pursuing a challenge:

> The rules of painting can be mastered, but spirit-resonance is hard to master. The rules of painting can be understood, but spirit-resonance is hard to understand. Use your skill at what can be mastered and understood to pursue that which cannot be mastered or understood. How can that be easy? If you don't master the spirit of creativity, then even if you exhaust yourself and grind a hole in your inkstone, your painting will all be in vain. Spirit-resonance exists in the heart and isn't a matter of brush and ink. 1980, autumn. Man of Ba, Huasheng. By the east window of the Studio of the Cloudy Gorge.

The promise of this painting was soon realized in a 1980 work of both facility and originality (fig. 55). The work's indebtedness to Huang and Chen can still be recognized, but it is far more revealing of Li's personal creativity. Most of the elements are related to the previous painting, yet they have been artistically transformed. The trees can be compared to stocky-trunked willows of the former painting or, even moreso, to the long-branched trees next to the homes (scarcely visible against the thick ink of middle-ground hills), yet a different kind of vitality enlivens them. They

combine three distinct elements, each overflowing with a painterly rhythm: grotesquely exaggerated trunks, heavily pollarded over the years, dancing like aged skeletons; newly grown branches, swaying with youthful grace; and yellow leaves, radiating a vibrant color. This rhythmic vitality comes less from Li's study of the past than from his sketching of trees and architecture from life (figs. 42, 43, 45). The architectural drawing uses the same delicate lines, yet the structures are more complex—roof beams sway, buildings lean to the left or the right, chimneys and gables poke out of darkened roofs—and this architecture now takes center stage.

Yet this painting is dominated by the landscape stage itself, related technically to Huang Binhong's layering of stroke on stroke but here transformed into something totally modern, a marbleized wall of gray and ochre, with strokes of color allowed to flow together in wet puddles, their pale outer edges spontaneously etching a more complex pattern than could be produced under tight artistic control. Try as one may, such an effect relies to a high degree on chance and can only occasionally be attained to this degree of artistic satisfaction. Such a painting effort is less likely to succeed than to fail and be discarded, so no artist can afford to undertake such a challenge with frequency. Only a few times in his career would Li Huasheng achieve this kind of chance effort with greater success (for example, fig. 103, painted in 1985).[26]

At this time, Li also reintroduced his mid-1970s theme of the herdboy in the fields (fig. 28), successively varying it in a number of new versions. In one of the most innovative of these (fig. 56), Li took a counterintuitive approach to the transition from small album to hanging scroll: despite the far larger surface in this work, he reduced rather than expanded upon the details. He consciously designed his scroll to be seen from afar, emphasizing design values.[27] Ten trees in the earlier works are reduced to four (mulberry trees, like those in fig. 55, only much simplified and more graceful.) From the earlier, smaller work, fifteen brushlines in the untoned area alone are reduced to a total of five. In the later work, the lines are broader, wetter, more visible. Colors are brightened: dull green and muddy brown are replaced by saturated yellow, blue, green, and brown. Most of the scroll is left unpainted, shining white, fresh and modern. The detailed farmhouse of the earlier work is pushed to the rear and rendered in a few linear strokes plus wash. The plowman and ox are eliminated. Touches of delicacy come in the form of a curving brushwood gate, below, and young bamboo, above. The calligraphy—unlike in earlier paintings, and a harbinger of works to come (e.g., fig. 71)—has be-

54. Li Huasheng. *The Mountains of Sichuan.*
Late autumn, 1980. Ink and color on paper.
136.5 x 67.3 cm. Private collection,
United States.

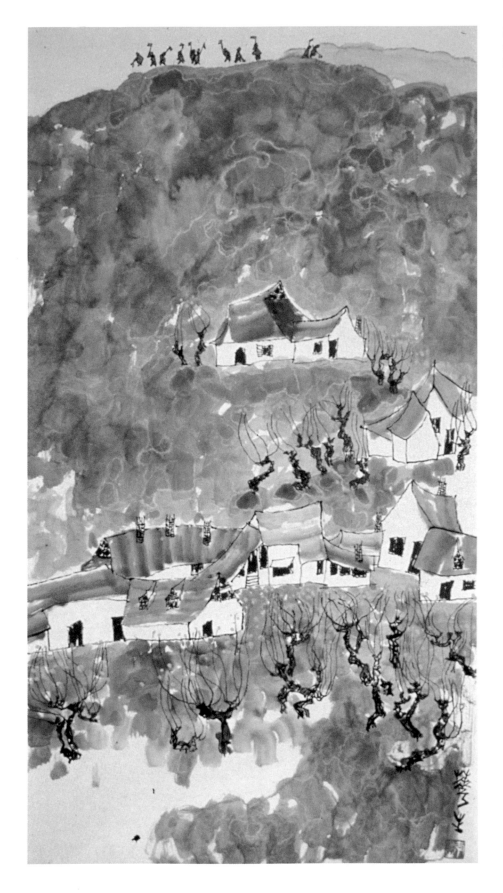

55. Li Huasheng. *Untitled Landscape.*
1980. Ink and color on paper.
Private collection, United States.

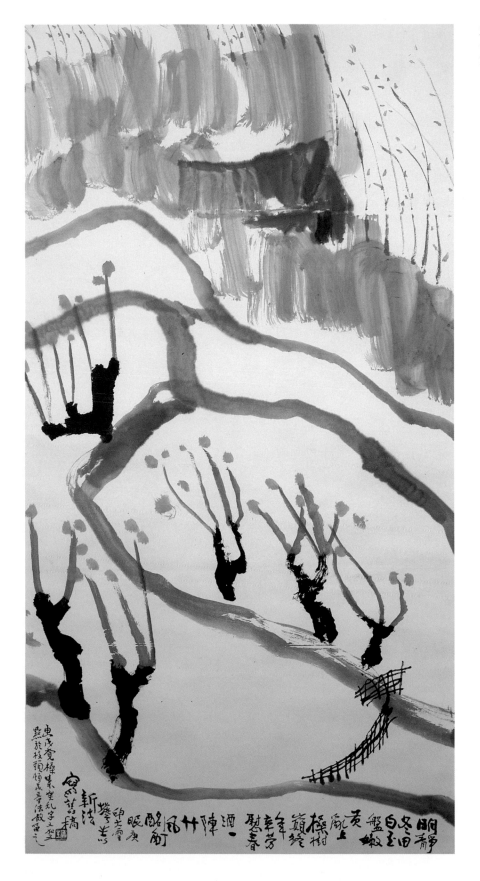

56. Li Huasheng. *Wintry Field.* Mid-December, 1980. Ink and color on paper. 133.4 x 67.3 cm. Private collection, United States.

come a design element, following the contour of nearby fields. The poetic inscription "explains" the brighter, whiter effect, although it concludes on a somber social note, darker than anything conveyed by the painting:

> Bright, cleared wintry field: a white jade dish.
> Pale yellow splattered on the tips of mulberry trees.
> A whole year's bitter labor soothed by spring wine,
> A puff of bamboo wind; a drunken slumber.

The poem now transforms the painting. Natural white paper is turned into snow. Thought of as snow, it seems purer still. Like wine, it purifies the bitterness of unrelenting labor. This is not a socialist message.

The inscription on this scroll concludes with a short note: "Using a new method to paint an old sketch." This "new method" is probably the unusual non-Chinese blue coloration that gives the painting much of its freshness, an opaque pigment applied in a distinctively non-Chinese fashion in broad, parallel strokes clearly derived from oil painting technique. This modern coloration, including the uncommon interplay of blue and yellow, and the opaque, parallel brushwork can be traced back to the painting of Lin Fengmian (fig. 57), brought back from his study in Berlin of northern European expressionists and transmitted by him into Chinese media. The intermediary for this would have been Lin's pupil and Li's first teacher, Yu Jiwu (figs. 4, 5). The sensitive juxtaposition of the gray field-contour with the black brushwork fence as well as the character of their brushwork also seem related to Lin Fengmian.

In yet another rendition of this theme (fig. 58), the details are still further reduced: nine mulberry trees (each nothing more than a dark clump of a trunk root and two or three pollarded branches with yellow tips), about as many strokes for the fields, and in greater detail a tiller on a paddleboard pulled by a water buffalo. This is Li's ultimate modernism, looking like so many notes on a musical page, a painting to be sung, a peasant's tune. It could be argued that it would look better, or more musical, by not actually showing the peasant.

The last of these scrolls from 1980, painted in midsummer, introduces for the first time what would become in the 1980s one of Li Huasheng's most frequently painted and visually most successful themes, *Mountain Dwelling* (*Shan ju tu*, fig. 59). It relates to the *Wintry Field* painting (fig. 56) in terms of its broad, rather dry contour lines, relatively unmodulated except for occasional nodes at the turning of a corner, altogether simple in feeling. Like his paintings of fields and plowmen, it is composed of abstract looping

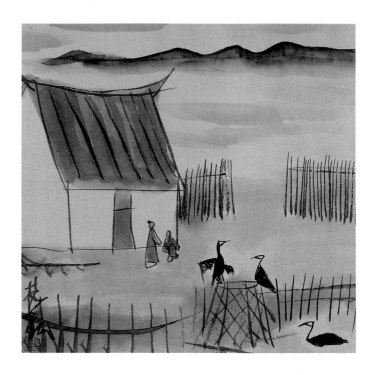

57. Lin Fengmian. *Untitled Landscape.* 1937. Ink and color on paper. 39.2 x 40 cm. Private collection. (After *Guohua* [*Sinorama*], XIV, December 1989, pp. 32–33.)

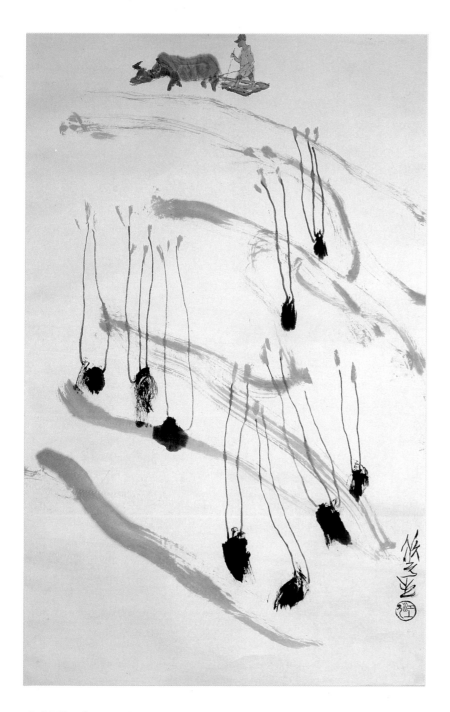

58. Li Huasheng. *Tiller in the Field.* Ca. 1980. 95.3 x 70.4 cm.
Ink and color on paper. Private collection, United States.

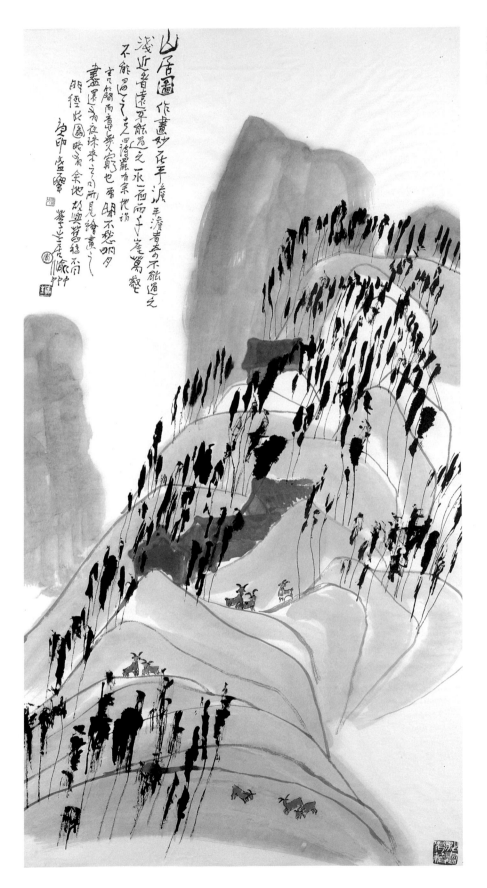

59. Li Huasheng. *Mountain Dwelling.*
Mid-summer, 1980. Ink and color
on paper. Private collection, United
States.

curves, which are stacked up playfully here and occasionally threaten to spill out the side of the painting. Playful too, are the mountain goats that cluster in twos and threes upon these ridges and in the meadows. Rhythmic punctuation is provided by a screen of cypress trees—dark, irregular pools of ink, usually done with a scratchy movement of the brush, set up on threadlike trunks, hardly any one of which is upright or straight. Nestled behind the hillside curves are four farm buildings, their rich brown sides complementing the pastel green of the hills—again reminiscent of Lin Fengmian in form and color. Rising in the distance from an unseen horizon is the upper portion of three distant hills, blue color patches that complete the three-color pallet. Indeed, this seemingly natural—ultimately Western—choice of colors is a startlingly modern reminder that in traditional Chinese paintings, green fields were not usually painted green, and wooden farmhouses were not brown.

So simple and childlike is this painting, its lines so free in form, its color washes so thin and transparent, naturally tinted by the white paper, that only the traveler to Sichuan will know how realistic it is. Accessible only by the great river and a few modern roadways are countless hills and valleys stretching hundreds of miles in all directions, piled up in just this fashion, leaning this way and that, their horizontal pitch broken by lines of sticklike cypresses whose lower branches are pruned and gathered by peasants (who use them for smoking pork). Such scenery is among China's most deeply satisfying, truly a world apart, where peasant homes and peasant life seems a part of the earth itself. This painting is another reminder of Li's turn away from the more popular drama of the Yangzi River gorges and his discovery of the remarkable marriage of natural grandeur and simple, earthy serenity in Sichuan's rural scene.[28] His inscription, in the upper left, reinforces this notion:

> In painting, the marvelous lies in the plain and simple; the unusual cannot surpass this plain and simple. Vastness cannot surpass the simple and intimate. A thousand peaks and myriad ravines cannot surpass one rock and one stone. The ancient masters said, when the poem is finished, the [feeling still] goes on; they said, if the expression is simple, the idea will be inexhaustible. . . . This painting has a [feeling that] lasts, which differentiates it from my older sketches.

The attainment of such simplicity in painting is no easy feat, particularly in a larger format. The indebtedness of this work to Chen Zizhuang is apparent in its underlying spirit and in many of its particulars (cf. fig. 118).[29] But the adaptation and realization of these remain distinctive, as do the composition and the scale of execution. More successful

renditions of this composition were yet to come (figs. 107, 108, 109). More than any earlier work by Li Huasheng, this painting conveys a clear vision of his future direction and signals the professional success that lay not far ahead. Two years later, writing in China's internationally distributed photo journal, *China Reconstructs,* the nationally prominent calligrapher and senior art critic Huang Miaozi would say that Li, steeped in the sensibility of Chongqing, paints landscapes that "reflect the calm elegance of the mountains and forests of Sichuan. The simplicity of his work reveals a great talent."[30]

As much as 1980 was a year of accomplishment, 1981 was a year of recognition. With China's new emphasis on youth and reform, a February exhibition of the works of ten younger artists was arranged in Nanjing by the Jiangsu Provincial Artists Association and was held at the Jiangsu Provincial Fine Arts Museum. This was a study exhibition for the benefit of Association members. Li Huasheng, as one of the ten invited participants, went to Nanjing in mid-February for the exhibition and accompanying discussions.[31] Jiangsu Artists Association vice-chairman Song Wenzhi (whom Li had first met in the summer of 1974, and who had responded cooly at that time to the art of Chen Zizhuang which Li showed him) suggested that Li alter the base of the mountain pathway: he recommended a degree of detail that Li had preferred to avoid, the literal addition to the "carved cliff of inlaid steps, of carefully measured lines." Li's *Huangshan* painting was not improved by the addition, but perhaps Song only meant to spare Li more serious troubles with other critics or to help open the way for a painting that was on the verge of unacceptability. By comparison, another of Li's paintings in the Nanjing exhibition attracted favorable attention, his *All Night, New Rain.* This version never left Nanjing: it was kept for the Jiangsu Provincial Museum's permanent collection. Another version was made to take its place (fig. 44, which ended up in the National Gallery collection in Beijing and in turn became the model for a third-stage replacement).[32]

While Li Huasheng was still in Nanjing, in February, Song Wenzhi gave him a landscape painting.[33] Inscribing the gift, Song wrote:

> It's a decade [*sic,* actually seven years] that you've been away, Huasheng. Now I've had the good fortune of looking repeatedly at the great improvement in your artistry. Your mastery of rusticity and awkwardness are something I've always been deficient in. Boldness of spirit is something I should study from you.

By May 1981, Li Huasheng's reputation had spread to the capital, and Li was issued an invitation collectively by the Beijing Hotel, the Beijing Airport, and the Tourist Bureau to go to Beijing to paint. He went at their expense, stayed briefly, painted, and returned to Chongqing on June 3. In July, Li earned his greatest local distinction. He was awarded the Sichuan Province Outstanding Artwork Award for a painting entitled *Summer Cooling*. Before Li could photograph it, the painting had already been delivered to provincial art authorities for inclusion in Li's first international display, a group exhibition in Singapore entitled "Exhibition of Contemporary Chinese Calligraphy and Painting." There the painting was sold.

In October and November 1981, Li's work was also included in a huge exhibition held in Guangdong Provincial Fine Arts Gallery, Guangzhou, organized by the Chinese Painting Research Institute for artists from all regions. Entitled "Exhibition of Famous Traditional Painters," it included 160 works by 120 painters, among them the senior artists Wu Zuoren, Liu Haisu, Li Keran, Li Kuchan, Qian Songyan, Ye Qianyu, Guan Shanyue, Li Xiongcai, Huang Zhou, Huang Yongyu, and a smaller group of younger artists.

As this exhibition was occurring, Li was brought back to Beijing for an even more prestigious opportunity. The Nanjing exhibition had been deemed so successful that the Chinese Artists Association repeated it in Beijing with the same ten artists (fig. 60), while improving upon the selection of their works. For the entire month of November, the exhibition hung in the National Art Gallery. In judging the paintings for inclusion, one elderly artist called Li Huasheng's *Mt. Huang* conception "too ambitious," so it was replaced in the Beijing exhibition by another work. Li never understood whether that meant too ambitious visually or politically, or both. Li's paintings, ten in all, included a new version of his *All Night, New Rain* (fig. 44), which was subsequently acquired for the National Gallery's permanent collection (now one of three works there by Li). But critically speaking, the paintings judged worthy of inclusion were scarcely the equal of Li's best 1980 works (figs. 55, 56, 58, 59, discussed above). Accompanying the exhibition was a catalog entitled *He shan ru huatu* (*Rivers and mountains resemble paintings*), with an introduction by Huang Miaozi and a title inscribed by Li Keran.[34] Afterwards, in May 1982, the exhibition went on display in Hong Kong.

60. Li Huasheng with members of the Ten-Artist Exhibition, National Art Gallery, Beijing, 1981 (*front row, left to right:* Qin Jianming, Lu Yifei, Li Huasheng, Zhang Bu, Zhang Dengtang; *back row:* Li Xiaoke, Wang Weibao, Liu Baochun, Zhu Xiuli, Song Yulin).

61. Li Huasheng and Li Keran, Beijing, November 1981.

While in Beijing, Li attempted to meet with Huang Yongyu, with whom he had painted the previous year, but Huang had become increasingly eremitic and by the time an invitation was forthcoming, Li felt too put off to accept it. He did, however, have the opportunity along with the other participants to meet Li Keran both at the exhibition (fig. 61) and at his apartment, introduced by Li Xiaoke, Li Keran's son who was a member of the ten-artist group. After their meeting, Li Keran wrote four-characters for Li Huasheng, highly honoring his work with the expression "Heavenly horse rides the void" ("*tian ma xing kong*"). But before Li left Beijing, Li Keran said it was not well-written and asked for it back; he then gave Li another, less enthusiastic inscription, "Heaven has rewarded diligence" ("*tian dao chou qin*"). To this day, Li does not know whether he offended the senior artist or whether on reconsideration Li Keran simply felt that his initial praise was overstated.

In Beijing, Li started to apply for membership in the national Artists Association, but he says he never completed the forms because he was not sure of certain factual details, including his birthdate. That was the closest he ever came to joining. Toward the end of the exhibition, the National Gal-

lery manager invited Li to assign ownership of his paintings to them. Most artists would have relished the opportunity to have their work collected by the National Gallery or even sold by them. But Li refused, already preferring to keep his favorite works to himself. To avoid any possible bureaucratic surprises, he actually came a day before the exhibition was taken down and took his paintings right off the walls to secure them! Ultimately, his *All Night, New Rain* ended up in their collection anyhow.

In addition to recognition through exhibitions, Li first began to see his paintings published in 1981. In April, the Chongqing artist (and now arts administrator) Ling Chengwei published the first short article on Li in the *Red Cliff Cultural Studies Journal*, with one page of text and illustrations of two paintings.[35] In December, all ten of Li's paintings from the Beijing exhibition appeared in a Hong Kong publication, *Meishujia*, which had also published the exhibition catalog.[36] On his return from Beijing, Li became the invited guest in Chengdu of a number of units for whom he executed demonstration paintings. He was now hailed as a "Youth Painter."[37]

In 1982, Li's reputation grew rapidly. Not only the increas-

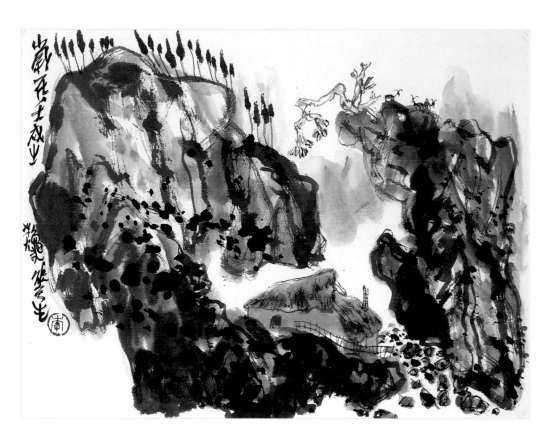

62. Li Huasheng. *Untitled Landscape*. Autumn 1982. Ink and color on paper. 31.8 x 40.6 cm. Private collection, United States.

ing number of illustrations but their appearance in publications with increasingly large circulation attest to that. This culminated in appearances both in March and May in *China Reconstructs*, the Chinese government's international pictorial magazine, published in dozens of languages around the world. In March, his *Mountains of Sichuan* (fig. 105) was reproduced in color on the inside cover. In May, Huang Miaozi reported on the Beijing exhibition of the previous autumn and illustrated three of Li's works with the phrase already quoted above: "The simplicity of his work reveals a great talent."[38]

Li's painting developed apace with his new "Youth Painter" reputation. His best paintings from 1982 (figs. 62–65, 67, 70, 71) combine the full vigor of youth with growing artistic maturity and are among the strongest works of Li Huasheng's career. Even a small album leaf (fig. 62) displays his strong sense of purpose, a coordinated, rhythmic gesture that continues unbroken throughout the painting, and jet-black ink infused with unusual power. The elements of this painting have all been seen before. The cypress trees

and mountain goats appeared in Li's lyrical *Mountain Dwelling* of 1980 (fig. 59), but here the cypress rise like spikes and the goats look downward into an abyss, knowing they had better not prance about too incautiously. The yellow-leaved mulberry is familiar, too (cf. figs. 55, 56), but here, a single tree does the work of many: scarcely bound to its place, it stretches out across space as if to communicate with the farmhouse below. The landscape does the same, rising up on the left like a dancer, then bending low at the waist to almost touch the peasant home below. The farmhouse and its brushwood fence are not new, but their gesture is: not a straight line but all rhythm and flow, as mobile as the land on which it sits. Throughout the painting, an integral artistic conception is manifest. The subtle suggestion of distant hills in the upper right is carried over to the left, filling the gap between the two upper peaks and thus completing an integral circle of earthen forms. The inscription does not line up with the edge of the paper but follows the curve of the landscape.

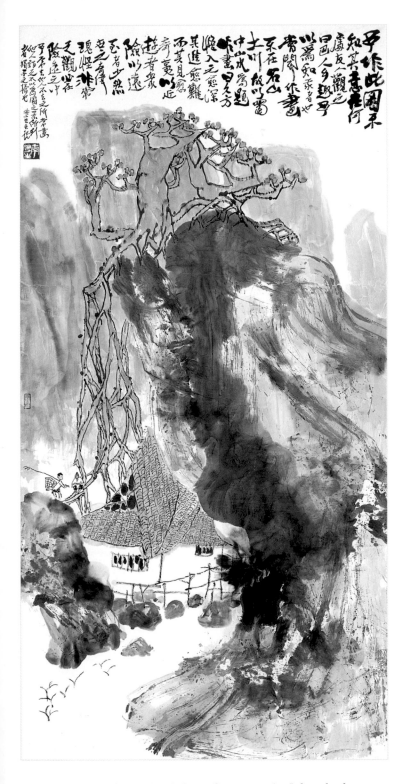

63. Li Huasheng. *Rustic Scene*. Summer 1982. Ink and color on paper. 136 x 68 cm. Private collection, United States.

The translation of this smaller leaf into a larger, narrow, more formal hanging-scroll format, *Rustic Scene* (fig. 63), is no easy task and is only partially successful. Lost in this painting is the beauty and power of jet-black ink, harder to produce in such large scale. Lacking, too, is the coherent integrity of landscape structure. The hill on the right is not as well defined as its counterpart in fig. 62: only in the smaller work is the darker ink an enhancement of, not a substitute for, structural form. The three sections of landscape are far less effective in their gesture, and far less integrated. The birds silhouetted against the water, below, are scarcely recognizable. They are thematically misplaced, and—unfortunately, like most of Li Huasheng's birds—mechanically executed. There is little to be said for the figures, particularly the standing boy, a static silhouette that adds nothing to the rhythm of the painting. Yet *Village Scene*, to this day, may be described as Li Huasheng's singular "signature piece," the first of his works to become widely known, the first in which a distinctively personal style seems to have crystallized.

If not a fully realized work—Li Huasheng now regards it as something of an embarrassment—the chief virtues of this painting still far outweigh its shortcomings and mark the emergence of the painter into artistic manhood, as important a moment as any in his career. The foreground hill, however weak its internal constitution, is effectively characterized by movement. In a single bold move, it elevates the trees to their remarkable position of dominance within the painting. The trees, generically related to the squat mulberries of earlier works (figs. 55, 56) but here transformed into banyans with impossibly extended roots, are of sheer magnificence, a mark of artistic courage. Their thickened trunks are defined by some of Li's finest brushwork, each individual stroke as taut and self-possessed as the trees themselves. Tree roots, like tiny toes, raise the trees up off the ground, while others extend downwards to the rooftop below, unifying these two elements (in a way that the landscape elements are not) and making them the major elements of the painting. The roots seem to be responsible for the extraordinary upward pull of the roof, which is reminiscent of Li's architectural renderings a few years earlier (fig. 42) but clearly surpasses them in terms of dramatic gesture. This distension unites the architecture, the banyan roots, and the foreground cliff in a dynamic, circulating rhythm. The design relationship of trees to distant mountains is well realized, the latter effectively (but not *too* accurately) framing the former and echoing their successive rise and fall. The calligraphy acts as a force from above, compressing the trunks and dwarfing the branches and sending the

banyans' energy cascading downwards. The calligraphy it-
self is newly dynamic, more varied internally than are pre-
vious examples, as intentionally awkward as the trees and
architecture.

What has brought Li Huasheng's style to fruition at this
point is not merely a development of technical skill but the
successful rendering in graphic form of his own personality
and the distinctive regional personality of Sichuan. The iden-
tification of his art with the Sichuan environment, and the
need to penetrate to the very heart of this landscape, is the
subject of Li's inscription:

> When I did this painting, I didn't know where its concept came
> from. Then a friend looked at it and said it had the flavor of
> Sichuanese rusticity, and I realized this was someone who
> really understood me. I once heard that paintings shouldn't be
> of famous mountains and great rivers, so I have taken the land-
> scapes of Sichuan as my topic. After a long time, I have found it
> strange that the deeper one enters this landscape, the more
> difficult it gets yet the more wonderful it appears. The common
> and nearby, there the travelers come in crowds. But the danger-
> ous and remote, those who get there are few. The daring, the
> extraordinary, the strange sights of this world *must* be located in
> dangerous and far-off places. I always travel where others do
> not, always paint what others don't regard as scenes for paint-
> ing, [crossing] the proverbial one-trunk bridge of the traveler.

The inscription casts attention on the sources of artistic
inspiration which have finally given rise to a personal style
in this painting. Although crediting the "dangerous and
remote," Li realized, too, that the character of a region is
universal to the one who can spot it, even in "the common
and nearby." Always alert to daily life for its visual richness,
Li today says that for the dramatic gestures like those which
enliven this painting, he needs to search no farther than the
postures of peasants in his local market place, where he
goes regularly to look with the eye of a painter for abstract
patterns and rhythms. Or he will attend the Sichuan opera,
observing minutely the actors' use of apparatus and on-
stage gestures, much exaggerated compared with those of
Beijing opera or Shanghai *kunqu*. From his lifelong study of
opera—of how one crosses the stage in double-curved lines
without a single straight movement, of subtle bodily move-
ments beneath the robes, of unusual angles for pointing
one's knees and feet—he has taken inspiration for the ever
dynamic internal movements of painting. Like the rough
and varied vocal qualities of the stage singers, he has tried to
vary his brushlines. Like the particular actors' ways of pro-
longing or concluding a musical line, he has experimented

with the starts and stops of his brushwork. He even imag-
ines that his landscape elements—rocks, trees, and
houses—are stage actors, prancing upon the stage.

Just as theater language was infused with a strong ele-
ment of Sichuanese humor, Li's paintings were increasingly
filled with a sense of visual play, exaggeration, and double-
entendre, some of it grasped only by a few in his audience.
To demonstrate that the Sichuanese humorous spirit is a
way of pointing to something of underlying seriousness, Li
recalls his favorite calligrapher, Xie Wuliang, who was fre-
quently called upon to write signs for schools and stores:
once for a painting-mounter's shop, Xie wrote four large
characters, *"Nan de hutu"*—based on the verbal idiom, "The
highest virtue is to be somewhat bewildered" (in other
words, to find social conventionality puzzling) but also read-
able here as "rare paste" (the mounter's prime ingredient).[39]
Li suggests that his most knowledgeable viewers will find
visual byplay in paintings like this one.

Aspects of Li's *Village Scene* were soon brought to bear on
other works, like his 1982 rendition of the Wuxia gorges on
the Yangzi (fig. 64). This is a direct descendent of his 1979
version of the theme (fig. 41) but distinguished by its finer
quality of staged gesture, for example, in the mountains—
drawn in at the waist, exploding upward and outward on
top—and in the yellow-leaved trees, waving rhythmically
above. Its textured ink splashing, in which the artist runs
the risk of total failure, is wonderfully varied in tone and
texture, surpassing the 1979 work, Li's *Village Scene*, and
most of his other works in this regard. As if punning visu-
ally on the ancient tradition of rendering landscapes in blue
and green with opaque azurite and malachite pigments, Li
has loosely spread a translucent patch of green about the
upper left and one of blue in the upper right; touches of red
on the boats below complete the spectrum and further en-
liven the scene.

A work more typical of Li's new spirit is his 1982 land-
scape (fig. 65) in the spirit of Lu You's poem, "Traveling to
West Mountain Village," which Lu composed in 1167,
shortly before his ascent of the Yangzi River. Lu's poem
celebrates the rustic life from the vantage point of a scholar
who stumbles across it in his travels and ends up longing
for more:

Don't laugh at this peasant family's New Year's wine, all
 cloudy;
An abundant year detains this guest of theirs, with plenty of
 chicken and tender pork.
Through many-layered mountains, crossing river after river,
 just as I suspected no road would go through,

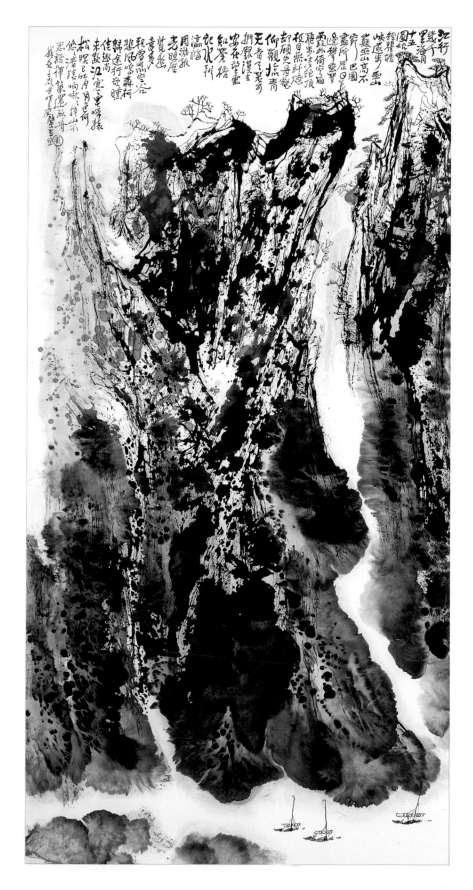

64. Li Huasheng. *Mt. Wu.* 1982.
134.4 x 68.6 cm. Ink and color on paper.
Private collection, United States.

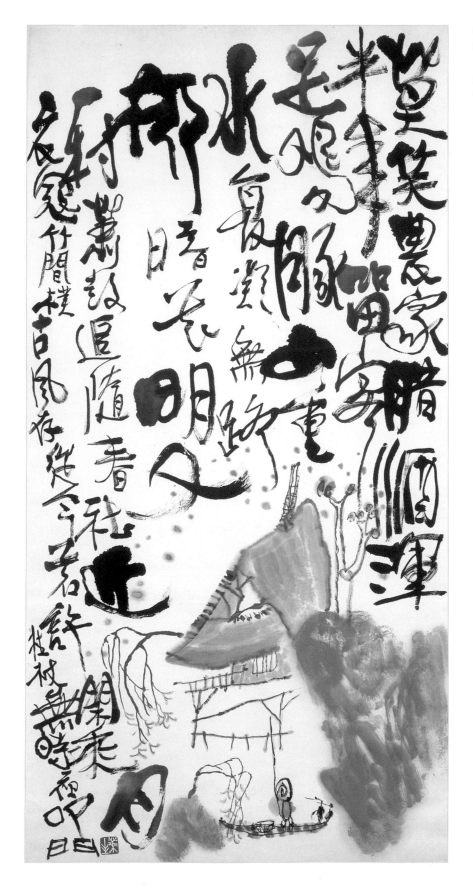

65. Li Huasheng. *Painting after Lu You's Poem.* Summer 1982. Ink and color on paper. 136 x 68.5 cm. Collection of the artist. Photograph courtesy of Chinese Culture Center of San Francisco.

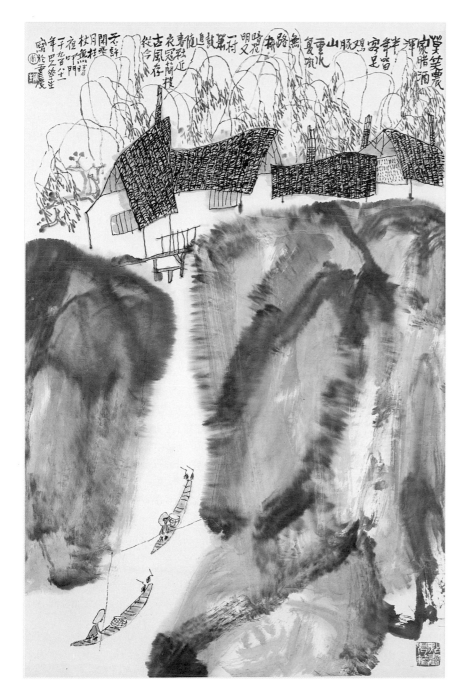

66. Li Huasheng. *Painting after Lu You's Poem.*
1981. Ink and color on paper, 103.5 x 68.6 cm.
Collection of Mr. and Mrs. Elton B. Stephens,
Birmingham, Alabama.

There—where willows shade, where blossoms brighten—
 suddenly appeared another village.
Flute and drums linger as their spring altar festival
 approaches;
Their clothes and caps, simple and rude, preserve the ancient
 customs.
From now on, if permitted the leisure to travel,
I'll take up my staff, unplanned, at night, and come knocking
 on your door.[40]

The image of obstructive mountains and rivers suddenly giving way to a welcoming rustic site is a metaphor for complexities surmounted, troubles overcome; in the early 1980s it became a literary catch-phrase for the spirit of hope brought about by Deng Xiaoping's new administration.

In painting this work, Li was not illustrating Lu You's poem for the first time. Rather, he was discarding all his earlier efforts and taking a totally new and more direct approach, as a comparison with any of his earlier efforts will tell. A year earlier, Li produced a version (fig. 66) suggesting the initial "distance" between traveler and village by forcing the peasant home to the top of the painting (a device he had already used as long ago as the mid-1970s, fig. 33), then creating an approach by means of a spatially ambiguous channel, purposely confusing "back" and "up." This composition was clearly indebted to Li Keran (fig. 13). The "willows that shade" and "blossoms that brighten" form an upper painted border and lend a tone of elegance to the entire village. The buildings arch and lean, yet their lines are thin and elegant, their tiles are placed in straight rows, and their walls seem freshly whitewashed. Their overall appearance is neat and trim, like the square-set calligraphy above. This crisply rendered village scene contrasts with the soft-edged boulders below. Yet even there, neatness and restraint prevail, and any potential messiness of large-brush ink-wash technique is carefully avoided. An attractive blue mixed with the black enhances the decorative effect. A pair of fishermen with cormorants complete the rustic setting but are otherwise a free abridgment of the poem.

Given this painting's sweet mood, it may be hard for the outsider to appreciate fully that, in 1982, no painter could feel secure as yet about China's artistic future. Indeed, a major cultural purge lay but a year ahead. As Li Huasheng knew, only six years earlier Li Keran—whose compositions and ink-wash techniques are so clearly reflected in this work—had been in deep trouble (along with "Hotel School" artists like Huang Yongyu) for painting "black" art not much different from this. The color black had been considered unforgivably "pessimistic." By 1982, Li Keran was an artist to be celebrated, at least by his fellow artists if not by the authorities, and this is clearly a work in his honor. That year Li produced his definitive treatment of Lu You's poem (fig. 65), blatantly individualistic and risk-taking. This image was drawn from Li's 1981 original (fig. 66), but most of the earlier elements were actually abandoned. The original paired embankments, soft and furry, were reduced to two small patches of ink, roughly scrubbed on with the brush. From the earlier depiction of a willow grove, only two trees remain. Of the red-blossoming trees, only a few blossoms float abstractly in the air. The village has been reduced to the left-most of the original buildings, once depicted as a spiffy bit of rustic architecture but here described as rude, held together precariously by the nervous movement of a dry brush. Elegant tile roofs have been replaced by thatch. Two fishermen are reduced to one, who halts his boat to gaze upwards, his back to the viewer, while the cormorants appear to gaze at him. He seems poised to read the poem, which has taken on an equal role with the painting. Calligraphy, now in a major way, plays that kind of foil to descriptive painting which landscape, abstractly handled, had played in numerous earlier works (e.g., figs. 28, 33, 41, 44). The colors, though still delicate, are—to say the least—peculiar. One does not see too many pink rocks in Chinese painting. The dab of green on the fisherman's back is, in a sense, the perfect touch that gives the painting focus, while the fisherman's gaze ties the calligraphy to the rest of the work.

If the painting is bizarre enough in its own right, the calligraphy is even more so, reminiscent of what the Chinese called *kuang cao* or "mad cursive" writing. No wonder Li Huasheng's critics suspected him of alcoholism, though in fact he abstained. Li's copy of the Lu You poem has five mistakes, one reason why he no longer likes the painting.[41] But he liked the crowding of characters at the end of the inscription (originally inadvertent, because he had misjudged the length) and even imitated this in some of his later versions. Li compares his multiple renditions of painted themes (which have always been typical of Chinese art), to drama: "Every time, you give a different performance, you create a different mood." In this version, Li virtually created a different opera.

With two paintings alone, *Village Scene* and the 1982 rendition of Lu You's poem (figs. 63, 65), Li Huasheng stepped into new artistic territory. In the process, he set a new standard for his work, a higher standard that pitched his career at a more challenging level and required more from a work

for it to be considered successful. His later versions of Lu You's work, for example, range from good to mediocre, but all seem more aesthetically self-conscious, thwarted by the spontaneous success of the 1982 version and unable to rival it. In new thematic areas, other excellent paintings have come forth from Li Huasheng's brush since that time, some of which surpass even these two 1982 landscapes in quality. But no other works in his career would ever mark as clearly an artistic transition as this pair. They also exemplify and validate Li's articulation of the differences between himself and Chen Zizhuang, noted earlier in chapter 4 (see p. 82).

In the autumn of 1981, as the ten-young-artists exhibition was being prepared in Beijing, the director of the Chinese Culture Foundation of San Francisco, Lucy Lim, had her first opportunity to see the work of Li Huasheng at the home of Zhang Bu, one of the ten artists, who was helping the Chinese Artists Association organize the exhibition. At that time, in cooperation with the Chinese Artists Association, Lucy Lim was beginning to plan the first extensive American exhibition of contemporary, traditional-style Chinese painting since the dawn of Maoism, over three decades earlier. She recounts that "all the paintings were landscapes, and the works of Li Huasheng caught my attention." By the summer of 1982, when the Ministry of Culture brought her back to China to select paintings for inclusion in her project, Li Huasheng's name was on her list of artists to pursue further, along with a number of other Sichuan painters. By the end of her travels, including a trip to Sichuan, and after a selection process coordinated with James Cahill of the University of California at Berkeley and Michael Sullivan of Stanford, Li was one of only two Sichuan painters among thirty-five artists selected to represent contemporary Chinese painting to America. The other was Zhu Peijun of Chengdu, Chen Zizhuang's nemesis of years past. It is much to her credit that Lucy Lim chose Li's *Village Scene* and his 1982 painting after Lu You despite seeing them unmounted. She picked the latter painting over Li's protests that he still needed to produce another version to correct the text.[42]

After visiting his home in the summer of 1982, she says, she felt him to be the outstanding representative of the "new freedom" just emerging in the Chinese art world, a "complete departure from the art of the Cultural Revolution, linked to the spontaneous art of the past." In an article preceding this exhibition, Michael Sullivan mused thoughtfully about the unknown artist: "Who is to say whether, for instance, Li Huasheng's apparent flouting of the conventions is due to a deliberate defiance of them, or merely to ignorance of them? Perhaps, except for the very strongest creative personalities, such ignorance is the best road to freedom."[43] Now, aware of Li's detailed study of the eccentric masters of the past, it is fair to conclude that his is a deliberate and knowledgeable defiance of orthodoxy, past and present—a matter of strong personal creativity rather than ignorance.

The year 1982 was perhaps the most fulfilling in Li's artistic career, and still other outstanding paintings and new visual themes emerged at that time. One of Li's most beautiful landscapes of that or any other year was inscribed in the early summer as a gift for visiting admirers of his art (fig. 67).[44] Entitled *Ferry Crossing at the Wu Stream* (after a tributary of the Yangzi near the Wu gorge), it is closely related in a number of ways to his landscape after Huang Binhong from 1980 (fig. 54). But the differences are a measure of Li's enormous growth in that short time. Both paintings include the use of patterned areas of texture and color which Li derived from Chen Zizhuang and developed into more clearly layered patterns. The sequence of foreground landscape, willows and water, houses and hillside, and distant view is the same in both paintings, with two major changes: the houses in *Ferry Crossing* are further segregated into their own pattern area, and the distant subject matter is changed from mountains to water and boats. Also similar is the brush technique—the loose piling up of layers of complex, repeated strokes that leave little to be seen of the paper beneath, but enough to intrigue one by its pattern—which derives from Huang Binhong. Yet here, too, there is a difference, indeed an enormous one, in terms of rhythm and energy. The 1981 painting, like Chen Zizhuang's, is relatively quiet (*jing*) whereas the latter is full of Li Huasheng's characteristic active movement (*dong*). This is true of the buildings, where plain outlines frame quiet, empty space in the former work, while dramatic roof pitches and a dynamic pattern of roofing tiles radically energize the 1982 painting. This contrast is also evident all through the landscape and nowhere more than in the willow trees, quieted down by flat, overlaid patches of green and yellow color in the early work, full of high-energy lineation and an exuberant dotting pattern in the later one.

Most striking of all in the comparison of these paintings is the treatment of distant space, quietly secured by soft, pale, distant mountains in the 1981 painting, but boldly irrational in the 1982 work—a watery embankment that sits on top of, as well as beyond, the farthest hills. Moored there are eight boats, vertically outstretched as if seen from directly overhead, as striking as could be both in angle and placement.

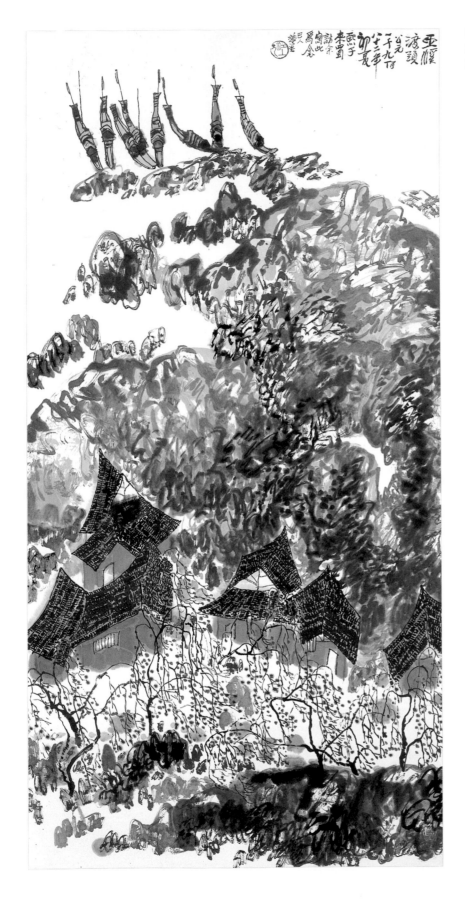

67. Li Huasheng. *Ferry Crossing at Wuxi.* Early summer, 1982. Ink and color on paper. Private collection, England.

The precedent for this may be found in Chen Zizhuang's own work (fig. 33, then as now in Li Huasheng's own collection), but the energetic execution is Li's own. The reduction of color in the painting, limited to brown for the houses and touches of green for the willow leaves, in addition to the varied shades of gray and black, helps constrain the painting's decorative tendencies. Perhaps it would never again be executed this well, but this theme would be added subsequently to Li's repertoire under the title *Returning in the Evening to the Willow Bank.*

Some of Li's artistic growth in 1982 came in rapid spurts, one of which produced another of Li's more enduring themes, *Night Rain in the Mountains of Sichuan (Ba shan ye yu)* (figs. 70, 71, and later fig. 110). The theme was based on Li Shangyin's famous ninth-century poem, "Night Rain, Sending the Guest off North," an appealingly self-reflexive poem which, presumably, a departing guest was to deliver to the author's wife in the north:

You ask when I'm returning, but no date is set.
In the Sichuan Mountains, night rain floods the autumn pool.
When, together, will we trim candles at the western window
And talk about when there were night rains in the Ba
 Mountains?[45]

The poem, however, was only a point of departure for Li Huasheng; it was loosely adapted and never inscribed on any of Li's paintings. Whereas Li Shangyin emphasized romantic longing for his wife, Li Huasheng's feeling was for the setting: the rustic isolation heightened by night and rain, and the corresponding sense of warmth and comfort in human habitation suggested by candlelight. Li Shangyin anticipated his return to the north, to China's metropolitan center. Li Huasheng, on the other hand, found identity with the peasants, whose suffering allowed him to express his own hardships and whose mountain environment he found preferable to his own urban poverty.

The image, too, was loosely appropriated from another theme that Li had painted on a number of occasions (figs. 68, 69). In an example from the autumn of 1982, a work of fairly ordinary quality but strong in rustic feeling, Li painted a scene common among his works in the early 1980s, a hillside perspective (looking down, looking up) on a country restaurant beneath trees (fig. 68). In settings throughout Sichuan's mountains, well known to Li from his travels around Mt. Qingcheng near Chengdu, stone pathways to and from distant fields and from village to village are punctuated by rustic huts, where peasant travelers can stop for food and conversation. Here one sees such a hut at the convergence of two pathways. In place of the travelers are shown a number of heavily laden baskets and bamboo carrying poles; the travelers' collective clamor, indoors, can only be imagined. A chimney belches smoke. A long piece of cloth (*zhepeng*) shading the restaurant has been stretched away from the building to let fresh air in, to let people come and go. It hangs over a bench that supports a large teapot. The painting's inscription begins with a poem, and a prose passage follows:

On the mountain peak, pines unmoving;
At the fork of the road, people shouting.

In painting the Sichuan landscape, the strange and dangerous, heroic and deep are still easily achieved. But the ordinary and bland, the shallow and near are quite difficult. . . .

In the winter of 1982, this theme of mountain crossroads appeared in another work (fig. 69) with the same poem and most of the same details as figure 68, but the solitary pine was replaced by a darkened forest. Also dated winter 1982 is a remarkably similar image—from the blackened grove right down to the unmodulated brushwork in the calligraphy, unusual for Li Huasheng—but representing Li's painting after Li Shangyin, *Night Rain in the Mountains of Sichuan* (fig. 70). In both landscapes, the darkness expands from the center of the painting to the edges, unifying it in a manner more typical of Chen Zizhuang than of Li Huasheng, whose tendency is to work by way of sequential juxtapositions and vertically layered contrasts. Yet important contrasts still prevail. The painting is given over to the painter's ink, dark layers surmounted by darker; the white outer border, beyond the edges of outward-bleeding ink, forces the eye to adjust to the darkness in the center, making the black even blacker. Within, only a few lighter passages appear: a path enters the scene; a stream emerges from it, swollen by night rain; and other random spots. The chief influence is probably Li Keran (fig. 13), but the spirit of Huang Binhong (fig. 24) is here, too. As in Huang Binhong's work, these few white spaces allow the earth to "breathe." The ink is the nighttime storm itself, flung upon the landscape, drenching it and almost taking its breath away. Tucked deep within are four buildings, one separated by a stone bridge from the other three, their details swept away by the veil of rain. On three buildings, a bit of yellow pigment is transformed by the dark, surrounding wilderness into a calm, luminous, mysterious presence. The scene is haunting, the points of light strangely memorable. Nowhere is Li Huasheng's penchant for contrast presented more poetically.

Li's poetic inscription on this work suggests sudden inspiration, emotional need, and the artist's urge to paint:

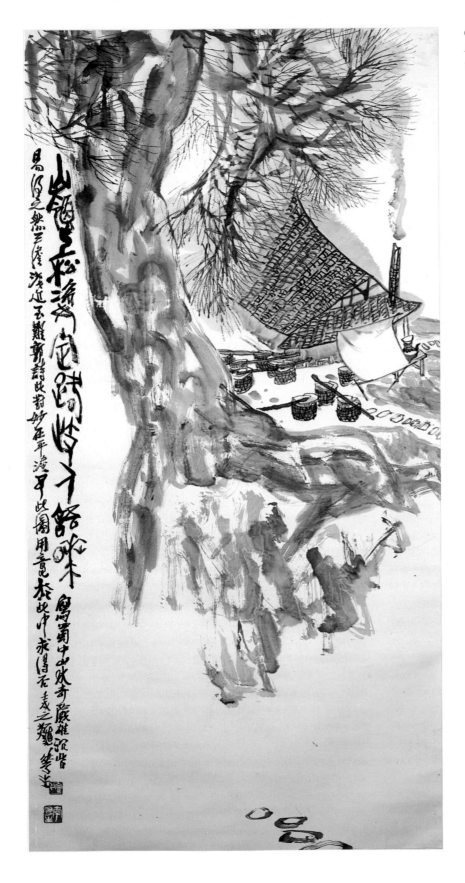

68. Li Huasheng. *At the Fork of the Road.*
Autumn 1982. Ink and color on paper.
135.9 x 67.9 cm. Private collection, England.

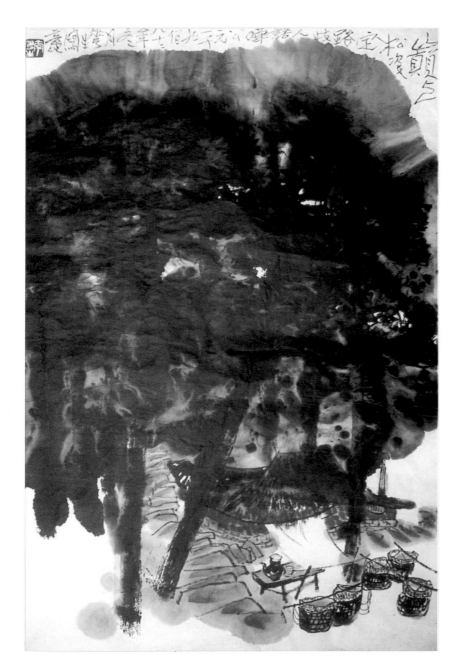

69. Li Huasheng. *At the Fork of the Road.*
Winter 1982. Ink and color on paper.
Private collection.

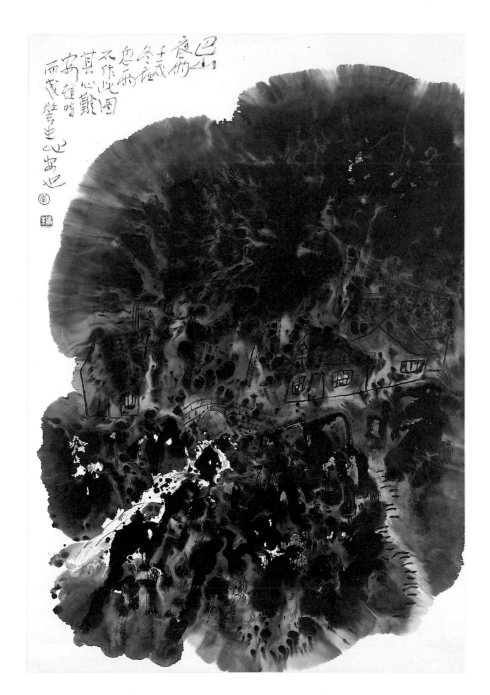

70. Li Huasheng. *Night Rain in the Mountains of Sichuan*. Winter 1982. Ink and color on paper. 97.8 x 67.3 cm. Private collection, United States.

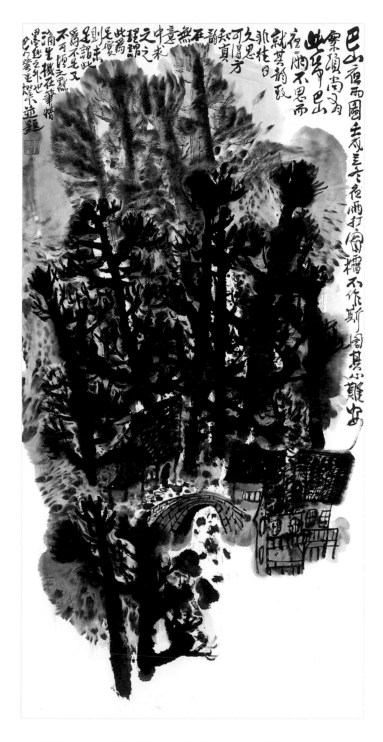

Winter evening, sudden rain. Without painting this picture, I could hardly find peace of mind. I finished it in no time. Huasheng, with mind at peace.

If there is anger, as well as peace, in this painting, it is a reminder of Li's own hardships and dilapidated quarters at the Sailor's Club where this landscape was painted. On a winter evening, Li would have been cold while he painted, working on one half of a table while his wife and child slept on the other. The sudden rain that fell on Chongqing would have brought out the snakes from the hillside and, if it became too heavy, would force his family out of their quarters in the middle of night. Only in painting, in expressing these emotions, in achieving something that made an otherwise miserable existence worth enduring, could Li Huasheng attain inner peace. In this regard, Li Huasheng was not unlike Li Shangyin, eleven centuries earlier, tormented by his absence from wife and home, achieving inner harmony through artistic imagination.

In the mid-1970s, "black" paintings cost many artists their freedom. In 1982, freedom was still a relative thing, and artistic policy was still unclear. But in this painting, restraint, respect for convention, and submission to society were thrown aside. Li Huasheng painted as an individual, as a free man. Black painting had never been so black before.

Another version of *Night Rain* is dated early winter 1982 (fig. 71). It is less centralized, less unified, less calm. In fact, if dissatisfaction led to a certain measure of calm in the earlier works, in the later example the artist's anger is scarcely repressed at all. Forest trees, individually rendered, seem blown about by the fury of the storm. Their rugged forms seem chiseled, as if by a woodcutter's knife. Half-submerged rocks appear in the stream to show its depth, their brushwork expressing its force. The inscription on this version, again painted at night to calm his feelings, admits of greater frustration, self-consciously suggesting not only the artist's emotional struggle with living conditions but the added artistic burden of trying to improve on a theme already so well realized in an earlier work:

Night Rain in the Mountains of Sichuan does not happen just by my thinking about it, with my paper sitting on the table. It's mood cannot be captured through my earlier ideas from days gone by.

In attempting to go beyond that earlier work, Li reached back to still earlier motifs, combining rocks in midstream, a middle-ground screen of trees, and architectural motifs from such works as his realistic sketch and related paintings of the bridge at his hometown, Yibin (figs. 44–46). As an

71. Li Huasheng. *Night Rain in the Mountains of Sichuan*. Early winter, 1982. Ink and color on paper. 99.7 x 67.3 cm. Private collection, United States.

expression of artistic fervor, bristling with emotion, this version certainly holds its own, if not fully equaling its predecessor. In later versions, Li usually took this work and not the earlier one as his point of departure. One such painting, suggesting the less passionate mood of a later time, remains to be discussed (fig. 110, from 1985), while still another version was presented by Li in 1986 to former Sichuan Party secretary Tan Qilong on Tan's return to his native home in Shandong.

Two final works from this extraordinarily creative year reveal an entirely different emotional side to Li and his art, more charming, more oriented toward the taste of Li's general audience and in all likelihood more popular than the boldly personal works just reviewed. In *Ten Thousand Acres of Lotus* (fig. 72), the serious intent of those other works gives way to playful decoration. The curving pathways, the hunched buildings and stunted trees, the daffy ducks and lotus flowers drawn as triangles, and the oversized dots that seem almost jokingly to cover the sides of the houses and crown the trees and top the lotus, all proclaim an artist who can reach into the Sichuanese reserve of humor for an antidote to too much personal pain. The inscribed poem does the same:

Ten thousand acres of lotus stretch toward Heaven,
A thousand silver candles illuminate the jade basin.
The mountain wind sways, in evening, the spring willows,
Ducks quack *cao cao*, but the master hasn't returned.

This is one of the finest renditions of a theme already standard in Li's repertoire in 1980, included in his 1981 National Gallery exhibition,[46] and continuing throughout the decade of the 1980s.

Another work in a similar vein, lighthearted if not exactly laughing, seems never to have been repeated (fig. 73). Entitled *Landscape after Wang Anshi's Poetic Concept*, its soft touch and fresh coloration offer easy enjoyment, as do the inscribed lines of Wang Anshi's eleventh-century poem:

Thatched eaves are always swept free of moss;
Flowers and trees encircle the paddies, planted by my own hand;
Around the fields, a moat of water, encircling their greenery;
Paired mountains push open the gate and send the spring my way.

The relationship between painting and poem is as loose as their springtime mood. Particularly notable are the blue foreground cliffs, derived from the "paired mountains" that invited the poet Wang Anshi out beyond his gate, but which the painter Li Huasheng sets no farther away than in the

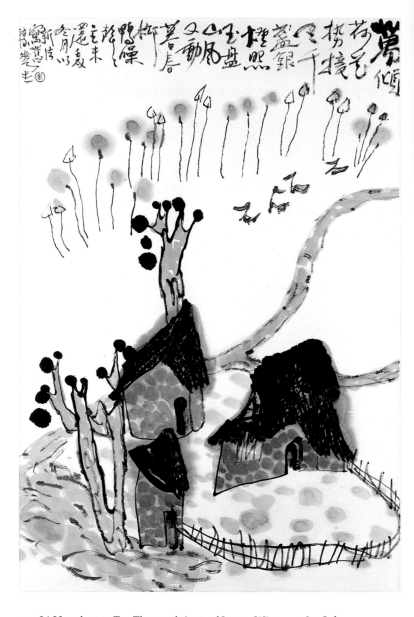

72. Li Huasheng. *Ten Thousand Acres of Lotus.* Winter 1982. Ink and color on paper. 100.3 x 67.3 cm. Collection of Murray Smith, Los Angeles.

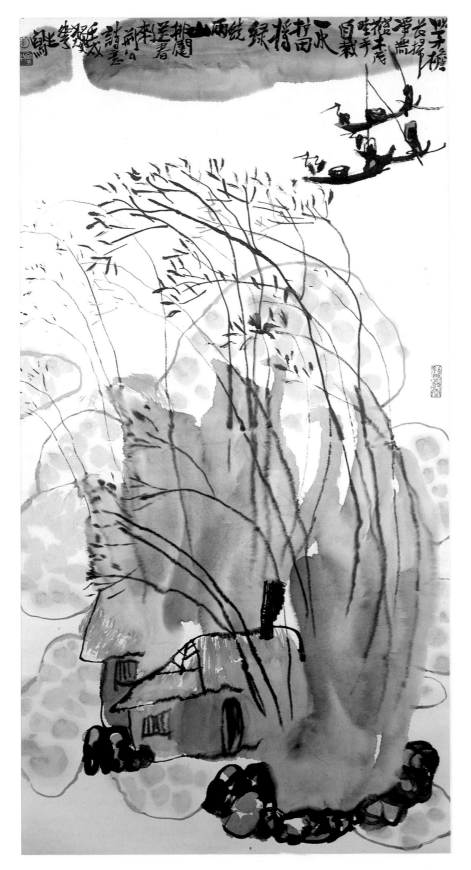

73. Li Huasheng. *Landscape after Wang Anshi's Poetic Concept*. Autumn 1982. Ink and color on paper. 133.4 x 68.6 cm. Private collection, United States.

painter's own front yard. (The technique for painting these is derived from Western oils and Lin Fengmian's conversion of this to a Chinese medium; cf. figs. 56, 57). The foreground fields are covered with curiously oversized dots of green pigment, linking this work to Li's *Acres of Lotus* (fig. 72). Both of these works are handled with deft brushwork and a masterful use of color. For all their lightness of mood, both paintings are products of an earnest technical experimentation that assures their decorative success.

Paintings in this lighter vein were hardly new among Li Huasheng's work. In fact, they were probably more typical than the others already looked at here. These paintings were intended for popular consumption and were less intensely personal. As such, they raise important questions with regard to matters of audience and acceptability in China's artistic circles. Almost all of the examples discussed preceding this pair are now in Western hands or else remain in the artist's own collection, whereas only the latter type have seemed suitable to represent Li's accomplishments in Chinese exhibitions and publications, as an extensive review clearly reveals. The autumn 1982 version of Li's hillside restaurant (fig. 68) was suitable for the Chinese public; his blackened winter version (fig. 69) was not.

The difficulty, well recognized by Li Huasheng, is that those works that advance his short-term interests are not the ones that can assure him of some measure of historical significance. And what is true for Li Huasheng is equally valid for an entire generation: if artists' most innovative and artistically sincere statements—so often dark and embittered about China's recent past—remain unpalatable to art administrators and to China's mass audience, and if only their decorative, sugar-coated works are consumed, what hope is there that this entire age of artists can earn a respectable place in Chinese painting history? By 1982, the central question for Li Huasheng was where to find a respectful audience for his more important paintings.

By the end of 1982, Li Huasheng's artistic achievements and his sudden emergence from total obscurity, without the benefit of education or social position, had become noteworthy even at the highest levels of Sichuan's art circles. Lucy Lim's selection of his works to represent China's painting to an American audience came at a time when foreign patronage of Chinese painting was beginning to outweigh the prestige of local support. If the works that foreigners found impressive were too bold, too individualistic, for most senior members of Sichuan's art circle to swallow, the locals would at least have to pay increased respect to his less challenging works done in a consciously popularizing mode. But could they be obliged to do more? In that year, success seemed to breed success for Li Huasheng, and this was not limited to his painting. In October, Li submitted a photograph, *Springtime Pleasure*, to the Sichuan Provincial Amateur Artistic Photography Exhibition. It was awarded second place. At just about the same time, Li was awarded another kind of second-place prize by Niu Wen, chairman of the Chongqing Artist Association. Over the next several years, Niu Wen would become the most important figure in Li Huasheng's career.

Niu Wen (fig. 74) was born in a farm village in the Taiyuan area in 1922. He joined the Shanxi Communist army in 1937 and, in 1940, went with his division to Yan'an. There he joined the Fine Arts Division of the Lu Xun Academy of Art and Literature and was present for Mao Zedong's classic talks at the Yan'an Forum in 1942. From 1943 until the Communist victory in 1949, he was part of a traveling arts and entertainment unit in the rugged Shaanxi-Gansu-Ningxia border region, producing propagandist woodblock prints. After 1949, he came with his division from the Communist stronghold in the north, driving down in the same truck as Li Shaoyan to Chongqing, where he worked in the arts division of the New China News Agency. In the Chongqing Municipal Artists Association, Niu Wen has wielded effective control since the time of its establishment in 1950, first as vice-chairman and then as chairman.[47] In the Southwest Artists Association, founded in 1953, and its successor, the Sichuan Artists Association, he has served as a vice-chairman and director of the Secretariat under Li Shaoyan's leadership.[48] He has continued in these positions to the present day (1992), except during the Cultural Revolution.[49] Niu Wen first went to Tibet in 1951 and afterwards spent three months there every year, often together with Li Huanmin, portraying the local people's life and helping to pioneer a theme that in the past decade has become a favorite preoccupation among China's young figure painters.[50]

Deeply sympathetic with Tibet and Tibetans, Niu Wen infused much of his work with artistic realism at a time when most Chinese artists were engaged in socialist "realism" and revolutionary romanticism. But he was not divorced from the times he lived in; he also produced works of the latter type, for example, the collaborative woodblock print done in 1953 together with Sichuan Artists Association chairman Li Shaoyan (fig. 17). Niu Wen is also said to have joined with Li Shaoyan in the public denunciation of Lü Lin during the Anti-rightist Rectification Campaign in 1957. Niu Wen has traveled internationally in the socialist world, visiting the Soviet Union, Yugoslavia, and all the Eastern Bloc

74. Niu Wen.

countries except Bulgaria in 1981 (and Hong Kong in 1985).

Increasingly independent-minded, Niu Wen has been more than ready to facilitate the post-Maoist call for added support of youthful artists. His work in the past decade, as early as 1979 (fig. 75), has cast the old-fashioned socialist-realist subject matter—a campaign to build new oil pipelines in the grasslands—in terms of chic stylishness and remarkably sophisticated artistic technique.[51] Li Huasheng describes Niu Wen as "a cadre with a good manner and good artistic taste," who in the 1980s has sought out real talent when other leaders "exclusively chose immature, younger artists" who would give them unquestioning personal support. "He is a reformer in the arts circle," says Li, "an artist who emphasizes that true artists should violate the conventions and rules." Any leader will be subject to attack, but as an innovator, Niu Wen has been all the more vulnerable. Says Li: "When people attack him, they deliberately turn this idea upside-down, asserting that he thinks they should violate social regulations, not artistic rules. Conservatives confused this on purpose. From this example, one sees how complex it is in China."

Niu Wen not only supported "youth painters," he promoted them higher than anyone could have anticipated, elevating them to positions normally reserved for senior members who had waited a long time, proving their loyalty through decades of struggle. In autumn 1982, on the recommendation of Niu Wen, as the Chongqing Artists Association was still in the process of restoring and revising its structure in the wake of the Cultural Revolution, Li Huasheng and Xu Kuang were elevated above others twice their age.[52] Being paired with Xu Kuang—who, along with Niu Wen, Wu Fan, and Li Huanmin, led the post-Maoist rediscovery of artistic freedom in Sichuanese printmaking—put Li Huasheng in extremely good company. Their appointment as vice-chairmen of the Artists Association was confirmed by a vote of the Association members. Li Huasheng, who a few years earlier could not obtain an honorary position at the Sichuan Academy of Fine Arts because of his lack of academic rank, was transformed overnight. Suddenly he was a member of the arts administration and one of the higher-ups of the inner circle. For a 38-year-old artist, such a thing was previously unheard of in China. Today, Li speaks with gratitude of Niu Wen: "He was the first one who discovered Li Huasheng, when I was just nobody." The expression is sincere. As will be seen, however, Niu Wen had also brought Li into the line of fire.

Despite his promotion, Li's work unit remaining the Shipping Administration. For a change in Li's formal assignment, both old and new units would have to agree, and a

75. Niu Wen. *New March in the Grasslands.* 1979. Woodblock print. 83 x 55.5 cm. Private collection, China. (After *Zhongguo xinxing banhua wushi nian xuan ji,* II, pl. 419.)

considerable amount of red tape and delay would be involved. So, as is often the case, a "loan" was arranged. Li's functions were shifted, and his workplace became the municipal Artists Association headquarters, located in a lovely European-style compound that was once the home of Guomindang warlord Shang Zhen. After 1949, with the bureaucratization of formerly private matters, everything in China was linked to rank and seniority, which Li, despite his youth and background, had suddenly gained. This involved everything from housing to transportation and included access to restricted stores as well as to restricted publications and movies.[53] When Li's functions were shifted out of the Shipping Administration, where he and his wife had lived for years in squalid conditions, he was assigned to a new living unit, an apartment near the Shangqing Temple controlled by the Chongqing Communist Party Committee and approved for his use by the vice-secretary of the Chongqing Party, Meng Guanghan.[54]

Li was deeply relieved to escape at last from his squalor. He was unconcerned at the time about possible repercussions, probably quite unaware of any risk. But he feels today that, given the crowded living conditions endured by nearly all Chinese, including his new artistic colleagues, many of whom were elderly, his well-appointed residence probably incurred intense jealousy on the part of some of his fellow painters. Leaping into the art world as an art official, Li Huasheng also plunged into the midst of a huge problem plaguing China, the planned inequities that transformed cadres and bureaucrats into a privileged "new ruling class" (to use Mao Zedong's own warning phrase)—inequities

that were inconsistent with Li's own egalitarian values. Increasingly in the Deng Xiaoping era, this corruption of socialist ideals would polarize Chinese society while generating numberless individual antagonisms.[55]

In moving to the Shangqing Temple district, Li gained more room to store his art, but he preferred to leave his old life behind. His move became the occasion for burning his paintings:

> The major reason for this was my dissatisfaction with my old paintings. At that time, I didn't value my painting. Also, I thought my style was not very mature. When I moved to the new house, I burned a couple of hundred paintings, not above a thousand. This does not happen every day; I'm not always burning my paintings. Otherwise I wouldn't be a painter but a fireman. But still it was a big pile.

At first, although several friends tried to dissuade him, Li tore up most of his early works with the help of two of his closest friends, Wang Guangrong and An Weinian. In the end, however, there were simply too many to shred. Li and friends concluded by burning a huge heap of them. According to his brother Li Jiawei,

> in the glow of the flames, he closed his eyes and went into thought. The next day he told others, "My paintings are nothing but reflections of others. There is nothing of my own identity in them. From now on I start anew."

"Spiritual Pollution" and the Fall of a "Shooting Star," *1983–86*

Mutual disdain among men of letters goes back to ancient times.

—Cao Pei (A.D. 186–226), Letter to Wu Zhi[1]

Socialism, contrary to all appearances, does not suppress artists' Nietzschean desires but satisfies them, offering responsibility and a constructive role to those people of quality hungry for power. . . . Today every artist is a minor politician of culture. . . . In our eyes the state represents not a monolithic body of rules but rather a live network of lobbies. We play with it, we know how to use it, and we have allies and enemies at the controls. Today "censorship" works through this calculating and accommodating spirit rather than through any sense of defenselessness.

—Miklos Haraszti, *The Velvet Prison*[2]

THE SICHUAN PROVINCIAL BRANCH OF THE CHINESE Artists Association has more than one thousand members, including printmakers, oil painters, traditional painters, sculptors, and craftsmen, mostly from Chengdu and Chongqing. The organization's basic function and its daily routines have two primary concerns: to promote artistic activity and creativity, and to facilitate public exhibitions. Before the end of the Cultural Revolution, although organizationally fractured and operating on an *ad hoc* basis, the Association was busy managing the ideological direction of the arts as well as organizing the artists to go to factories and to the countryside to experience those kinds of social life. Although sending artists "down" to the country was abandoned at the end of the Maoist era, the Association's later functions have not ceased to be political, either in the application of public (Party) policy to artistic production and display or in regulation of individual artist's careers.

Almost immediately after his appointment as vicechairman of the Chongqing Artists Association in the autumn of 1982, Li Huasheng became embroiled in controversy. Between 1980 and 1982, he had charted an innovative path in traditional landscape painting. As soon as he found himself an official with the ability to determine which artists and artistic pathways should be officially supported and which should not, his bureaucratic actions were as innovative as his painting trajectory. Li believes that he was carrying out a mandate set for the entire artistic community by municipal Association chairman Niu Wen, who "had gone beyond the old rules" and with whom—despite their difference in age—Li "shared in the new ideas." Li's determination to bring these "new ideas" into play in the Chongqing artists' circle brought a storm upon the scene. It made him a lightning rod for all the discord between two groups of artists for whom, in a moment of historical reversal, terms like "conservatives" and "liberals" or "radicals" no longer worked. One group was com-

fortable with the socialist goals and accomplishments in the 1950s, 1960s, and 1970s, either as dedicated socialist realists or as traditional artists who had come to terms with socialism's demands. The other group viewed that era as a failure; they felt that the 1980s must either throw off the politicized and popularized art of those decades and replace it with more vigorous and innovative forms, or else must face historical condemnation as an age unworthy of China's grand artistic tradition. Upon Li's arrival, the first major item on the Association's agenda was a proposed exhibition of paintings by ten senior members—outdated artists all, by Li Huasheng's standards. Li opposed it from the start.

Early in 1983, Niu Wen met with four young painters, including Li Huasheng, Yang Biwei, and Deng Chengyong. Niu Wen termed the younger generation "the hope of traditional Chinese painting." He encouraged them to try to stand out among the older painters, who so far had dominated the artistic stage on the basis of seniority and personal connections. Li reported the results of this meeting to Wang Qian, the newly appointed Party secretary of Chongqing (who had been recently downgraded from the more prestigious position of Party secretary of Shanxi province). Wang Qian had recently seen Li's paintings in Chongqing's Great Hall of the People, had liked them, and had been introduced there to Li by Niu Wen. Wang immediately made evident to Li "the very clear, sharp opinion that young and middle-aged artists should hold the center stage in the artists' group."

At that time, Li told Wang Qian, "You know only me, but there are many young painters who surpass me, while the old generation has simply degenerated." Later, Li denounced the proposed older artists' exhibition to Wang as "ridiculous." He said that the money should be distributed instead to younger painters, many of whom earned only forty to fifty Chinese dollars per month, so little they could hardly afford to buy painting brushes. He also suggested that a painting academy be set up to receive a few young and middle-aged painters every year, much like the academy that Li and other artists had proposed in 1980 to Deng Xiaoping and provincial Party secretary Tan Qilong while at Chengdu's Golden Ox Hotel, but which had yet to be established. According to Li, Wang replied: "You'd *really* better discuss this with Niu Wen. Work hard at it. I've just come to Chongqing and I don't understand the situation very well." Li, probably correctly, understood Wang to mean that he would not oppose such a proposition.

Without using Wang Qian's name, Li next brought the matter to the standing committee of the Chongqing Artists Association, directly presenting his view before all its senior members at a session convened to discuss the year's schedule. The response to Li was taken up by the Association's general-secretary, Zhu Xuanxian, who, in a long formal statement, strongly supported the proposed ten-artist exhibition. Li's rejoinder, as remembered by more than one of those present, was: "You are the typical representative of the older generation. With your obsolete and worn-out phrases, it's a good thing all you offer us is a speech! If it were a dance, you'd need a waist-drum."[3]

Li's defiant tone and youthful challenge to established authority were something not previously seen, except in the context of the Cultural Revolution. Niu Wen, caught in the middle, rebuked him sharply for his tone, saying with a certain irony, "You can think this, but you may not say it." But Niu Wen himself then discussed painters in relation to the traditional rules of painting, saying, "I support those who aren't restrained by the rules." These remarks would later be held against Niu Wen, interpreted as his urging artists to "act in violation" not of the conservative rules of painting but of the basic rules of Chinese society.

Ultimately, Li succeeded in preventing the exhibition. Among the ten older painters involved were Guo Manchu, Li's own former teacher whom he admired very little, and Yan Jiyuan, a relative and fellow townsman of Zhang Daqian and a meticulous painter of birds and flowers, whom Chen Zizhuang had regarded very highly.[4] "From now on," says one close observer of this scene, "Li offended the older generation openly. And from this point on, they clearly drew a line between themselves as older artists and the younger generation." The older artists came to be represented by Zhu Xuanxian, the Association's general-secretary whom Li had insulted publicly, and Wang Bancan, general-secretary of the Chongqing Federation of Literary and Art Circles (Cultural Federation). Zhu was reportedly very angry over Li's speech, and although he said nothing publicly, he began to speak quietly of Li as a very bad person, presenting the issue as moral and political.

There were other bold affronts by Li to men of rank and seniority, including the chairman of the Chongqing Municipal People's Representative Congress Standing Committee, Sun Xianxu. A young woman, generally regarded as Sun's "goddaughter" but regarded by Li as a "bad painter," attempted with Sun's introduction to see her paintings through the Artists Association Gallery. Li issued a refusal, in which he was joined by the gallery manager, Song Kejun, a well-known woodcut artist. At the time, perhaps unaware

of Li's primary role, Sun asked the municipal Association to prepare charges against Song for his refusal. Association chairman Niu Wen dismissed Sun's request, being once again obliged by Li Huasheng's actions to take sides against powerful old allies.

Li describes how, at about this time, he sat in a car with Niu Wen, talking about Niu Wen's humiliation during the Cultural Revolution. Niu Wen had been forced to wear a tall dunce-cap, beat a gong, and parade around in public with a sign confessing his crimes. Li remembers laughing about this, when Niu Wen suddenly said, "Don't laugh. You might be next." The elements for such a turn were indeed quickly gathering. While winning the favor of his contemporaries, Li was alienating an increasing number of senior artists, and as he did so, they began to gather reports of earlier episodes to array against him with increasingly hostile intent.

Some of these episodes had taken place not in the Artists Association but in Li Huasheng's old work unit, the Sailors Club of the Yangzi River Shipping Administration. One began in 1978–79, when Xie Limin, Party secretary of the Shipping Administration, headquartered in Wuhan, saw and admired two paintings by Li on display in one of the Administration's meeting rooms. Xie subsequently asked Li's immediate superior, Gu Zhenhai (d. ca. 1984), Party secretary of the Shipping Administration's Chongqing office, to request two paintings from Li. One of these was for Xie Limin to offer as a present on behalf of the organization in exchange for needed favors and gifts. The other was for Xie to keep, and he wanted Li to inscribe the work to him. According to Li, when Gu Zhenhai called him to his office, he asked for these paintings but offered no compensation for materials or even for the work itself, though the painting for Xie was to be done privately by Li rather than as a Shipping Administration propaganda employee. In such circumstances, Li finally could not bring himself to produce the painting expected of him. Frustrated and concerned at being unable to carry out Xie's orders, Gu soon began publicly to criticize Li as arrogant, saying, "One word and everybody else moves; many words and Li still hasn't contributed a painting."

Not long afterwards, while in Chongqing, Xie Limin had himself driven by the Sailors Club and asked a Club secretary to have Li to come down to meet him in his car. Li, through the secretary, refused, saying since Xie was making the request, he instead should come up to Li. Xie drove off, insulted. The two never met, and Li never produced the requested paintings.

Another poisoned relationship dredged up from the past involved Li Zhenyu, a former admiral in the People's Liberation Army who in the mid-1970s was Party vice-secretary of the Yangzi River Shipping Administration in Wuhan, working directly under Xie Limin. Li Zhenyu was also an amateur painter of roosters (in the manner of Xu Beihong), a calligrapher, and a collector who favored the painted grapes and flowers of Su Baozhen. The two Lis had a complex relationship, accentuated in every way by their divergent tastes in art and their contrary social values. Still, they seemed to get along well despite these differences and despite Li Huasheng's refusal to abide by the gap between them in status. Li Zhenyu gave Li painting paper for his personal use and sometimes invited him to Wuhan so that he could do realistic sketching in the Yangzi River gorges along the way. For his part, Li Huasheng once presented Li Zhenyu with a fine pair of calligraphic scrolls by Wang Wenzhi. Nevertheless, Li Zhenyu regarded Li Huasheng as "arrogant" and would not own any of his paintings. He liked almost none of the works and artists recommended by Li. To demonstrate to Li Huasheng the extent of his distaste, he once tore to pieces two calligraphic works by Lin Sanzhi and Wang Jiayou that Li Huasheng had brought before him. To Li Zhenyu's displeasure, Li Huasheng silently went about picking up the parts and piecing them back together. On one occasion, when doing calligraphy, Li Zhenyu asked Li Huasheng to wash his inkstone. Huasheng refused. Another time, at the Sailors Club in Chongqing, Li Huasheng showed Li Zhenyu a gift piece, a painting of two ducks, that Chen Zizhuang on his deathbed in the Chengdu hospital had asked his son to present to Li Huasheng. Li Zhenyu proceeded to denounce Chen as an antirevolutionary; then he struck the painting with a stick. Li Huasheng held his ground, saying that if Li Zhenyu damaged the painting he would have to pay for it.

The breaking point in this relationship came in an incident when Li Zhenyu asked Li to recommend an artist to paint a large landscape for display at the Shipping Administration's headquarters in Wuhan. Li's recommendation for the commission was Feng Jianwu (b. 1910), a professor of painting at the Sichuan Academy of Fine Arts, a painter in the conservative style who has always been characterized as the older and less successful brother of the eccentric and truly exceptional artist, the late Shi Lu.[5] Before 1949, Feng and his family had been large landlords in Renshou County. In 1960, Feng had been brought into the Sichuan Academy of Fine Arts as a regular faculty member, but in 1964, because of his "landlord" label, he was sent down to the countryside for labor reform. In 1966, at the outset of the Cultural Revolution, he was made a target for criticism

and struggle. Like most of the older-generation artists, Feng had been no friend of Chen Zizhuang. Yet long before Li Huasheng had met Chen, he had already approached and befriended Feng. In about 1967, when Feng was free but was being socially ostracized, Li Huasheng—naively ignoring public pressure and possible serious consequences—asked Feng to correct his paintings. Feng did not dare to do this, since any activity other than self-corrective political study was regarded as counterrevolutionary. Regardless, Li occasionally began to send Feng "a little bit" of food, at a time when scraps of food and bits of friendship were both deeply valued.[6]

The commission of this landscape, more than a decade later, offered no compensation, but it promised to help Feng's reputation with the Shipping Administration, which not only regulated all Yangzi River travel but also worked closely with all the hotels in the region that might have further commissions to let out. So when Li Zhenyu accepted Li Huasheng's recommendation, Feng agreed to undertake the task. After Feng had almost completed his commissioned work, the painter Yan Jiyuan became interested in the project. Undeterred by the late stage of his own arrival, he began to pursue the possibility of taking over the commission, establishing secret contacts with Li Zhenyu and persuading him to let him replace Feng Jianwu. Li Zhenyu arranged to meet at the Sailors Club in Chongqing with Li Huasheng and Feng Jianwu in order to announce his decision. At one point during their conversation, when Li Huasheng offered a cup of tea to Feng but not to Li Zhenyu, Li Zhenyu seized upon this impolitic behavior as a pretext to defend his action. He shouted out in anger, "Feng Jianwu is the landlord class. I am a revolutionary cadre. Your behavior shows your problem with class standing. This is a political problem!" He then announced his decision. Yan Jiyuan was given the commission, and although Feng actually went ahead and finished his work, it was never used.

Although Li did not appreciate the severity of the case at the time, a "political problem" in socialist China is no small matter. Political problems, unlike personal or aesthetic disagreements, are problems that involve serious ideological misunderstandings or suggest disloyalty to the system itself, problems that can lead to one's total downfall. Li Zhenyu and Yan Jiyuan (also one of the ten senior artists whose exhibition Li halted in 1982) helped spearhead the attempt in 1983 to bring Li Huasheng down.

The antagonisms engendered by Li Huasheng's professional behavior were seen by his sympathizers as a necessary part of the fresh infusion of boldness into a stagnant, perhaps even a dying system. From the point of view of his

detractors, they amounted to indiscretions born of generational disrespect and a fundamental corruption of socialist spirit. Coupled with these professional "indiscretions" were others—real or imagined—of a still more personal nature.

Issues of a sexual nature would provide the truly explosive fuel for the fires of 1983. One of these was undoubtedly more imagined than real. In May 1981, when Li was in Beijing to paint at the joint invitation of the Beijing Hotel, the Beijing Airport, and Tourist Bureau, he was introduced to a woman artist named Wu Hanlian, a Chinese American whose traditional family home was in Sichuan. As a foreigner in China, she had been studying painting with the venerable artist Liu Haisu, who many decades earlier had introduced painting academies and painting from models into China. On meeting, Li was surprised to learn that Wu Hanlian was already aware of his painting and even had two photographs of his work, and on parting she gave him a small gift to commemorate their mutual Sichuanese origins. Wu's visit with Li led to a proposal that she arrange a one-artist exhibition for him in France—just where, Li cannot remember, since at the time he didn't even know where Paris was. Shortly after Li's return to Chongqing, he received a letter from Wu Hanlian, saying she was in Dunhuang and was coming soon to Chengdu. Too busy with other matters or perhaps wary of meeting with her, Li wrote to his Chengdu painter-friend Tan Tianren, asking Tan to take care of arrangments for her.[7] Little did Li Huasheng realize at the time that his casual professional meeting with Wi Hanlian—he had even refused to follow up on it—would later lead to charges of their having engaged in an immoral—and illegal—sexual liaison.

This fabrication, however, was born of other, real offenses. In 1983, nine years after his wedding to Zou Lin, Li Huasheng's marriage disintegrated as the result of an affair with another woman which had lasted since 1980. Early in 1983, the woman's husband discovered this, reported it to Zou Lin, and then got Li Huasheng to confess. The incensed husband, a man named Chen Ji, began a campaign to humiliate Li Huasheng, and divorce proceedings instituted in midyear by Li's wife brought the matter into the public arena. There it collided with another, far larger, public event. By June 1983, with little warning, a new political rectification campaign was about to be ignited from a few chance sparks. It would be known as the Campaign Against Spiritual Pollution. And, while brief, it would change Li's life almost as much as had the decade-long Cultural Revolution. In this political context, together with his controversial artistic and administrative practices, Li says, his marital trouble became "just like a fuse."

In China, public and private life are hardly separable. Just as public political interests regularly intrude deeply into personal matters, so do personal factors regularly—and properly, from an official viewpoint—influence the conduct of public affairs. Li Zhenyu felt free to use his own discretion in offering a painting commission to Feng Jianwu and then withdrawing it, predicating this withdrawal on Feng's social background of three and more decades earlier. And this is but a solitary example of an age-old convention. Socialism did not create this sytem. In fact, socialism has done surprisingly little to alter the Confucian system of statecraft that fostered a high degree of personalized decision-making at all levels of government, just as occurs in the Chinese home. From buying coal, to renting an apartment, to securing professional advancement, personal connections (*guanxi*) are the medium of success or failure. Personal debts for favors granted are accumulated and remembered for decades, just as animosities are stored up for later repayment. Between rivals, many old scores remain to be settled until the right climate makes it possible. For Li Huasheng's rivals, late 1983 was just the right time.

Despite the economic and cultural liberalization that Deng Xiaoping's "Second Liberation" brought to China beginning in the late 1970s, including the theoretical relaxation of class struggle, periodic ideological struggle remained a principle ingredient of Chinese political life. Referred to as "cold winds," such periods occurred with regularity throughout the decade: in 1980–81, 1983–84, 1986–87, and 1989. Deng's initial ascent gave rise to a brief golden moment in Chinese cultural politics in 1977–78, somewhat reminiscent of the Hundred Flowers liberalization in 1956–57. In particular, he proposed to end the endemic discrimination against China's intellectuals:

> The Gang of Four indiscriminately labelled all intellectuals the "stinking Number Nine" and asserted that it was Chairman Mao who so named them. We should admit that at one time Comrade Mao Zedong treated the intellectuals as part of the bourgeoisie, but we should no longer do so.[8]

The Party's "arbitrary meddling" in the arts was to be curtailed, and writers and artists were to be liberated from the tyranny of "stereotypes and conventions."[9] It was under such political conditions that "wound literature" dealing with the emotional scars left by the Cultural Revolution was being written, that Sichuan's oil painters were initiating a pictorial equivalent to this literature, and that Li Huasheng's creative work of the early 1980s was exploring the limits of artistic individualism.

But by 1979, official reaction was imminent. Those in China's fledgling "democracy movement" who demanded that Deng's introduction of economic reforms and his loosening of cultural controls should lead to equivalent political reforms, went beyond what China's leadership was prepared to offer. They—and all intellectuals—were soon faced with a political reaction like 1957's Anti-rightist Campaign (which Deng himself has always defended), though far less widespread in scope.[10] Deng's first "cold wind" began to blow in March 1979.

On March 25, 1979, the most outspoken democracy-movement activist, Wei Jingsheng, posted attacks on Deng's recalcitrance. Within a few days he was arrested and was later sentenced to fifteen years in labor reform. During the year, more than fifty other leaders would be arrested. On March 30, Deng announced his "Four Cardinal Principles," reaffirming the central role of the Communist Party:

1. We must keep to the socialist road.
2. We must uphold the dictatorship of the proletariat.
3. We must uphold the leadership of the Communist Party.
4. We must uphold Marxism-Leninism and Mao Zedong Thought.[11]

In January 1980, weeks after the stern sentencing of Wei Jingsheng, Deng announced his intention to rescind the constitutional rights known as the "Four Greats" (speaking out freely; airing one's views fully; writing big-character posters; and holding great debates), which had been used to disseminate the democracy movement's aims. He blamed "the residual influence of the Gang of Four" as well as Western influences, and he pointed to China's youth as the principal culprits: "At present some people, especially young people, are skeptical about the socialist system, alleging that socialism is not as good as capitalism. Such ideas must be firmly corrected."[12]

Far from reducing or dismantling Party control, Deng soon affirmed the opposite:

> The purpose of reforming the system of Party and state leadership is precisely to maintain and further strengthen Party leadership and discipline, and not to weaken or relax them.[13]

Defending against the notion that he was taking away what he had just given, or that liberalization was only a mechanism to secure his political ascent, Deng denied the inconsistency of his policies:

> Some people may ask whether we are following a "tightening up" policy again. But since we have never pursued a "loosening

up" policy on such matters, naturally there is no question of "tightening up" now. When did we ever say that we would tolerate the activities of counter-revolutionaries and saboteurs? When did we ever say that the dictatorship of the proletariat was to be abolished?[14]

Regardless of such denials, the effect of all these events in the cultural realm was such that "in early 1979 it appeared that a fundamental change may have happened in the political control of literature [but] within a year it was clear that the relaxation had resulted from the temporary internal configuration of the system, not from its demise or its radical change."[15] Deng's speech to the Fourth Congress of Writers and Artists in October 1979 (p. 85, above) was primarily remembered for its more reassuring passages, including his charge to the older generation to bring forth and nourish the younger, but these comments were balanced by warnings about the need for self-discipline lest external controls still be required:

> Writers and artists should conscientiously study Marxism-Leninism and Mao Zedong Thought so as to enhance their own ability to understand and analyze life and to see through appearances to the essence. . . . In order to educate the people, one must first be educated himself; in order to give nourishment to the people, one must first absorb nourishment himself. And who is to educate and nourish our writers and artists? According to Marxism, the answer can only be: the people. . . . The people need art, but art needs the people even more.[16]

In June 1980, Deng's tone was echoed at the local level in Sichuan by the new provincial Party secretary, Tan Qilong, in an address to the Sichuan Writers Congress in Chengdu just a few weeks before Tan, Deng Xiaoping, and Li Huasheng would discuss the creation of a provincial painting academy:

> Emancipation in the mind and implementing the policy of "letting a hundred flowers bloom and a hundred schools of thought contend" is not the objective. The aim is to develop socialist literature and art. Only by upholding the four fundamental principles [Deng's recent Four Cardinal Principles] can we keep to the correct socialist orientation in literature and art, develop literature and art in a healthy way and really have a hundred flowers blossom.[17]

The Third Plenum of the Eleventh Party Congress, held in Beijing in December 1978, had repeatedly renounced political campaigns. But as one writer for *Liberation Daily* put it in 1981, with no humorous intent, "Not carrying out political campaigns naturally does not mean that no campaigns what-

ever should be carried out."[18] From speeches such as Deng's and Tan's, one could hardly help but wonder whether new campaigns were on the way. Yet by his own admission, Li Huasheng was naïve politically, paying little attention to events at this level.

The Marxist dialectic dictates that politics is rooted in culture. As always in the modern Chinese body politic, the illness that infects the organism is seen as psychosomatic, and the curing of bodily symptoms must be accompanied by strenuous mental hygiene. By the spring of 1981, the illness behind China's bout with the democracy movement had been identified as "bourgeois liberalism." While the political symptoms had been eliminated, the cultural cause remained. As usual, the cure was attempted with a model patient, and the chosen patient was Bai Hua, in whose movie, *Unrequited Love*, the mutual responsibilities of individual and state were examined and the state was found wanting. In this case, the treatment was not very successful nor was it ever administered very broadly—there was no treatment applied to the visual arts. The patient, instead, was quietly sent home, the symptoms gone but the cause not successfully treated. Its recurrence seemed likely.[19]

By 1983, China's ardent democrats were heard no more, having either been imprisoned or co-opted.[20] "Wound literature" had disappeared. The government's defensive maneuvers, too, were no longer a very visible part of the cultural scene. Under the premiership of Sichuan's former economic reformer, Zhao Ziyang, China was becoming more interested in profits than in ideology. Deng could complain that too many Chinese, instead of "looking to the future" (*xiang qian kan*), were "pursuing money" (also *xiang qian kan*). But as the profits poured in, he had no need to complain too loudly. The year 1983 was proclaimed a "year of reform." Party general-secretary Hu Yaobang (who once announced that the principal goal of Party was to "make people rich")[21] and Premier Zhao Ziyang

> stepped up the timetable for expanding rural agricultural and commerical reforms and experimenting with urban economic reform. In the cultural field, art troupes were encouraged to collect their own box-office receipts, foreshadowing the incursion of the market into intellectual pursuit. This venture may have been an appeal for intellectual support and part of a more general effort to cut back the state budget by limiting the dole.[22]

The "contract" or "responsibility" systems that had brought a limited degree of free marketing into the communal life of China's peasants were extended into certain artistic circles in 1983. State subsidies were reduced, and Minister of Culture Zhu Muzhi encouraged performing art troupes to make

up the difference by entering into contracts for individual compensation with the schools, factories, or other institutions before whom they performed. Zhu looked forward to the responsibility system's "developing the activism" of these art performers.[23] In the arts, economic independence meant a loosening of central control over content and style.

In theoretical matters,

Hu Yaobang in March [1983] gave a remarkably iconoclastic speech on the occasion of the 100th anniversary of Marx's death. The heart of Hu's message was to justify and strengthen a pro-intellectual policy. He stressed that intellectuals, with Marx as the premier example, have always been central to the success of revolutions, and he argued that China must adopt all "advanced" culture (socialist or not, by implication) in order to repair its backwardness.[24]

On that same occasion, Su Shaozhi, director of the Marxism-Leninism-Mao Zedong Thought Institute, offered a keynote address describing the widespread view coming to China from abroad that "Marxism has become outmoded" and that "Marxism is now in crisis." Su was not content to attribute these attitudes to the corruption of bourgeois influence in China and instead blamed Marxist dogmatism for failing to "make exploration of, and give answers to, the many new phenomena in the development of modern capitalism, the many new problems in the contemporary practice of socialism, the many new achievements in present-day natural sciences, and the many newborn disciplines of present-day social sciences."[25] At the same time, other intellectuals were speaking of Marxist humanism, humanitarianism, and socialist alienation. Humanists argued against an overemphasis on class character that led to artificial characterizations and ignored the mix of positive and negative qualities in real people. Humanitarians urged that ordinary lives be explored, portraying people's actual ideals and frustrations. Led by Zhou Yang, who between 1942 and 1966 had been the chief enforcer of Mao Zedong's Yan'an Forum policies, proponents of Marxist alienation theory suggested that socialist leaders had become objects of religious veneration, that the revolution had itself become a system of feudalistic control, that high leaders sometimes had become oppressors of the people, and that the "dictatorship of the proletariat" was but a dictatorship over the workers.[26]

By May 1983, the long-forbidden abstract art of the West—an extensive Picasso exhibition—had been shown to unprecedentedly large crowds at Beijing's National Art Gallery. In the summer, the National Gallery also held the first exhibition of works by a Chinese expatriate artist, the "landlord-class" painter from Sichuan, Zhang Daqian, sponsored by the Chinese Artists Association and the Chinese Painting Research Institute. No less striking, a large writers meeting was held in Beijing to mark the 160th anniversary of the birth of "Sandor Petöfi, The Hungarian Patriot and Poet" whose misidentification as Beethoven had sent two of Li Huasheng's friends to labor reform in the 1960s and had earned Li the official label of "problem individual."[27] The writers' meeting announced that *Selected Poems of Petöfi* had recently been published, and that other publications were soon forthcoming, *A Biography of Petöfi* and *Complete Works of Petöfi.*[28]

This liberalization, however, was not to last. Its opponents, upset over the rapid pace and scope of changes in economic policy, equated the loss of Party economic control with ideological decadence sweeping away everything the revolution had fought to attain, including the "socialist spiritual civilization" which the Party constitution was pledged to protect. Under the new "individual responsibility" system, farmers were withholding their best products for the free markets and offering only the dregs to the government distributors. The economic inequities beginning to result from the new marketing freedoms were an affront to basic Marxist tenets. Urban crime was on the rise, as was nonpayment of taxes. The dress and behavior of ordinary youth, spurred on by "Western" fashions (more often derived from Hong Kong), could hardly be distinguished from that of hooligans (*liumang*). Prostitution, pornography, and rape were becoming rampant. Free-spending foreign tourists left people wondering about China's economic backwardness. Most of all, there was a crisis of confidence in the Party and its ideology, particularly among the youth, in whom economic liberalization triggered unrealized expectations of increased social freedom. Early in 1983, female tennis star Hu Na defected to the West, and a grandson of Lu Xun piloted a plane to Taiwan. By the summer of 1983, it was time for hardliners—once seen as "leftists," now called "conservatives"—to make another stand, a more definitive stand than the one that had petered out with the attack on Bai Hua.

It had already been announced in January that foreign records, tapes, and videotapes could no longer be imported. In February, on television, Premier Zhao Ziyang announced a new movement—the "National Five Stresses [civilization, courtesy, sanitation, order, and ethics], Four Beauties [mind, language, conduct, and environment], Three Ardent Loves [of motherland, socialism, and the Party] Committee"—redolent of the ideological jargon of the Cultural Revolution. On July 1, Deng Xiaoping's *Se-*

lected Works was first published, with his most recent speeches critical of the ideological slackness prevalent in China, and with the implication that China was once again subject to "charismatic leadership" emanating from within the Party. Deng's writings, naturally, became the immediate subject of study within all units, and most readily served those who saw current economic innovations as "bourgeois" and capitalistic. Aware of their vulnerability, writers and artists groups immediately began to seek stronger Party direction, and by August the contract system for performing artists had been withdrawn in almost every province.[29] In late August, a massive anticrime campaign began. Before long an estimated 3,000 to 5,000 executions had taken place, many of them public, and all of them carried out quickly and with little opportunity for judicial appeal.[30]

> It was toward the end of the anticrime campaign that began in August and continued to October that writers and artists were more seriously taken to task. The main targets of the campaign were murderers, rapists, and thieves, and it was welcomed by large sectors of the population who had been afraid of guns and crimes. But the newspapers seemed to suggest that writers and artists were at least partially responsible for the increase in crime, by spreading doubts about socialism through their works and by confusing the "thought" of young people.[31]

On October 12, Deng Xiaoping identified "spiritual pollution" as the new ideological target:

> Spiritual Pollution can be so damaging as to bring disaster upon the country and the people. It blurs the distinction between right and wrong, leads to passivity, laxity and disunity, corrupts the mind and erodes the will. It encourages the spread of all kinds of individualism. . . . Unless we take it seriously and adopt firm measures right now to prevent its spread, many people will fall prey to it and be led astray.[32]

More than ever since Deng's rise to power, countervailing forces within the Party found themselves drawn into open conflict. On October 11, at the Second Plenary Session of the Twelfth Party Committee, reformers managed to pass a "Decision on the Consolidation of the Party," announcing a rectification of hard-core leftists intended to begin in 1984 and to continue for three years, targeting those "who rose to prominence by following the counterrevolutionary cliques of Lin Biao and Jiang Qing in 'rebellion.' " But to secure for themselves a balanced position, they also identified a second "erroneous tendency in the Party . . . some party members and cadres, who have failed to stand the test of historical setbacks and succumbed to the corrosive influence of bour-

geois ideology, doubt and negate the Four Basic Principles, deviate from the party line, principles, and basic policies adopted since the Third Plenary Session of the Eleventh Party Committee, and propagate bourgeois liberalism."[33] This second "erroneous tendency," officially recognized, provided an opening for those on the left to counterattack, to oppose the economic reforms that they felt lay behind China's most recent spiritual problems.

That this "Decision"—"such a small event that it seems to have been almost accidental"[34]—would set off a major political movement was perhaps unforeseen by many of those involved. Deng himself seems to have been caught by surprise between rival factions. But on October 23, 1983, the opposition to "spiritual pollution" was elevated to the level of a national rectification campaign. The public announcement appeared first in a People's Daily article, designed by hard-liners such as Deng Liqun of the Communist Party Propaganda Department and Hu Qiaomu of the Central Committee Political Department, and directed against liberal writers, artists, and theoreticians as well as against youth who had grown to distrust Communism. By November 5, Zhou Yang had offered a self-criticism, published in the People's Daily, confessing responsibility for the confusion that had infected theoretical writing as well as popular morals. He concluded: "To be a real Marxist, to be a thorough materialist, this is not an easy thing."[35]

Quickly, Zhou was made the subject of a massive Party attack. In addition, writers like Wang Ruoshui (closely allied with Zhou Yang), Bei Dao, Gu Cheng, Xu Jingya and Yang Lian were singled out for criticism, and Western Marxists and critics such as Sidney Hook and C. T. Hsia were taken to task. But the entire "movement" arose so unexpectedly that it lacked theoretical preparation, clear goals, and logical targets. Culture Minister Zhu Muzhi's October 31 definition, published in the People's Daily, typified the prevailing vagueness:

> There are two kinds of spiritual pollution, one in theory, that violates Marxist principles, and propagates the value of human beings, humanism, and socialist alienation . . . [and a second] within literary and art works, and in performances propagandizing sexual, depraved, terrifying, violent things, and the kind of stinking bourgeois life style that consists of looking for fun, drinking, sleeping, and being happy.[36]

Obviously, targets could be found on both the political "left" and "right," with attacks coming from both sides. Not scheduled to begin until 1984, the movement broke out prematurely and anarchically. Intended to be organized from the top down, "reactions were quicker on lower levels than at

the top, as officials in various provinces and work units rushed to avoid being left behind [with the result] that spiritual pollution was interpreted in broad and inconsistent terms"[37] In effect, officialdom was "scooped":

> The newspapers were also a central force behind the campaign against spiritual pollution. Indeed, part of the problem with the movement was that it was waged largely through papers which printed reports on the "spirit" of meetings, rather than through formal documents transmitted down the bureaucratic ranks. Had documents been used, the phrase "spiritual pollution" could not have been so generally and wildly interpreted.[38]

By the spring of 1983, Li Huasheng's career was on the verge of taking off nationally. An album of his landscapes from that time (fig. 77) shows him increasingly in control of his art, painting with sparkling imagination and a delicate touch. Cai Ruohong, a vice-chairman of both the Chinese Artists Association and the Chinese Painting Research Institute, and Huang Zhou, member of the Standing Committee of the Chinese Artists Association and a vice-chairman of the Chinese Painting Research Institute, were in the midst of organizing an invitational figure-painting exhibition to which Li had been asked to contribute a painting. The invitation, presumably, was based on his reputation in landscape painting, for not since the end of the Cultural Revolution had Li practiced figure painting. Li was assigned the theme of Li Kui visiting his mother, from the novel *Shui hu* or *The Water Margin*, which he planned to place in a landscape setting. Without Li's knowing it, his involvement in this planned exhibition drew information and attracted rumors about his marital difficulties to those at the national level.

In late April or early May in Beijing, the Chengdu figure painter Dai Wei was told by Cai Ruohong about letters received from Sichuan charging Li with sexual misbehavior and calling into question the possibility of Li's participation as planned. Cai was obliged to re-evaluate Li's qualifications, but ultimately he decided to include Li in the exhibition. Meanwhile, unknown as yet to Cai, and long before the Campaign Against Spiritual Pollution had taken form, Cai Ruohong and Huang Zhou were themselves being investigated by their units at the instigation of their opponents. Before long, both would be stripped of their authority and left with meaningless formal titles. The exhibition they had planned would never take place.

By the end of the year, Huang Zhou had fled to Wuxi. In addition, misleading rumors abounded of Cai's having been arrested. The pair had become the major victims in the Chi-

nese art circle of conservative factionalists. Such attacks were usually leveled against lesser figures prior to homing in on their higher-standing patrons, much as Hu Yaobang was thought to be the final target of the 1981 criticism of Bai Hua. At least one of Li Huasheng's knowledgeable friends speculates that had the path of this attack on Cai and Huang been followed to its end, it would have led first to their mutual political patron Gu Mu, vice-premier and member of the State Council, and through him to Zhao Ziyang.

Not until early August did Li begin to recognize the impact of his private affairs on his public career and to understand the gravity of his situation. Rumors of marital infidelity, and in particular of a liaison with a "French woman," became a topic of public conversation just when "sexual depravity" had suddenly became a national issue and cultural workers were being spotlighted as having triggered a decline in national morality. On August 9, Li Huasheng wrote from Chongqing to his Chengdu painter-friend, Tan Tianren. He was troubled but attempted to sound optimistic:

> Several days ago I had some trouble. I presume you already know the details. Now I close my door to produce paintings. My mood is still all right. When I think about my past, I know I've wasted a tremendous amount of time. . . . Now I'm already close to forty and have no accomplishments. . . . All those who are hoping to see my suffering will pass like smoke.

But by September, Li's career was in ever increasing jeopardy. The rumors were not easily dispelled, and they left him with no clear means to protect himself.

Li's deteriorating mood was reflected in his painting. In the early spring of 1983, even when he worked closely in the style of Chen Zizhuang, his work remained light and buoyant, fresh and inventive (fig. 77) as compared with the more somber mode of the older master (fig. 76). By autumn, working in that same style (fig. 78), he now came much more to resemble Chen Zizhuang in mood, more introspective and melancholy. That the trees in the autumn painting derived from those in his angry *Night Rain* landscape of the previous year (fig. 71) is an indication of where he was headed psychologically—"Gloomy" is Li's own word for this work.

Attacked in public, Li decided to counter with a public display of his well-being, touching base with prominent colleagues so that his enemies would not think him such easy prey. To do so, he flew to Beijing, ostensibly to view a painting exhibition by Liu Haisu but actually to be seen there by others. "Many of the other painters must have wondered why I came," he says today, lamenting that "as a painter, I must spend so much energy to do that kind of

thing." At the opening reception of the Liu Haisu exhibition, Li met old acquaintances Huang Yongyu and Wu Guanzhong, and he was introduced to artists such as Hua Junwu and Shi Qi. He felt that his presence there served its purpose. "I just made my appearance to the public and then went back to Sichuan."

While in Beijing, Li Huasheng was secretly provided with living quarters by Gao Yuan, a pilot and amateur painter who had studied with Li's Chengdu painter-friend, Tan Changrong. At Gao Yuan's home, Li again met Lucy Lim, who was making final preparations for her American exhibition of contemporary painting and who accompanied him to the opening of Liu Haisu's exhibit. She had already discovered that his career was in jeopardy, and administrators in the national Artists Association had informed her that the Association wanted Li excluded from her exhibition, scheduled to begin in San Francisco in November. Strongly attracted to his art, she argued that his work "certainly must be included" and tried to offer him a visible measure of "international support." She stayed by Li Huasheng throughout the Lui Haisu exhibition opening, which brought forth all the luminaries of the field, conspicuously escorting him up to prominent painters like Wu Zuoren and introducing him to Chinese Artists Association Gallery administrators whom she had met in preparation for her exhibition.

But when Li returned home after a week in Beijing, the pressures against him continued to mount. In Sichuan as elsewhere, the lack of central planning for this campaign—a skirmish being waged simultaneously by all factions of the government against one another—left much of the working out of general goals and individual targets to operatives at the local level. Particularly active was the government-controlled press—especially the New China News Agency, the *People's Daily*, and *Guangming Daily*—which functions under the watchful eye of the Party Propaganda Department and aids in its ideological guidance of such agencies as the Ministry of Culture, the Ministry of Education, the Academy of Science and Academy of Social Sciences, and their local extensions:

In each unit and commune there were propaganda groups that had special correspondents who wrote reports for high propaganda organizations or for newspapers, and these groups were available as contact points for newspaper and New China News Agency reporters. If a reporter wished to investigate any local news story, he generally went first to the local propaganda official, who became in effect his local guide and informant. Articles were often written jointly by reporters from higher levels and by

local reporters or propaganda. In this fashion, the party had a way to get information about every corner of the country.[39]

In Chongqing, two New China News Agency journalists, Yuan Guanghou and Huang Wenfu, were the first to investigate Li Huasheng and his professional and personal activities. Their investigative charges against him were first printed not for public circulation but in *Neibu cankao* (*Internal Reference, Neican* for short), the intra-Party journal written by Party members or by leading members of China's news agencies, in which sensitive and often secret reference material was made available to the highest levels of Party membership, nationally and in the provinces. Before publication, Huang Wenfu reportedly objected to Yuan Guanghou that the facts of the case had not been checked with Li Huasheng himself, and when Yuan refused to do this, Huang withdrew his name. But the article was published over both of their names in early October.[40]

The *Neibu cankao* article apparently outlined four areas of misconduct:

One: Li had supposedly said, "I, Li Huasheng, refuse to paint for the Communist Party." Such a charge could have originated with Gu Zhenhai, whose request for a painting (on behalf of Xie Limin) Li had refused, although Li himself had already given a painting to Deng Xiaoping.

Two: Li's paintings were done in defiance of socialist society. This charge apparently was not explained at the time but was soon associated with such specific concerns as the houses in his paintings leaning to some side rather than standing upright.

Three: Li Huasheng had had illicit sexual relations with a French woman. This charge stemmed from reports of Li's pending divorce. The "French woman" was presumably the Chinese-American painter, Wu Hanlian, who had met Li at the Beijing Hotel in May 1981. As the case against Li progressed, he would be accused of "seducing" ever increasing numbers of innocent women.

Four: Li had smuggled cultural relics. According to Li, in the late 1970s he noticed local peasants using early ceramic wares, like Han dynasty vessels and Song dynasty *lungquan* celadons with fish designs, which they must have found in fields. He learned that they smashed any human figurines they found, considering them to be inauspicious. Li began collecting these works by trading new, usable ceramic pieces in exchange for the old.

At the time of this publication, Li Zhenyu of the Shipping Administration (whom Li Huasheng had angered in his defense of the Feng Jianwu commission) attended a private gathering of artists at Chongqing's Eling Park. He carried

76. Chen Zizhuang. *The Min River at Wuyang.* Undated.
Ink and color on paper. Private collection, China.
(After Wang Zhihai, *Shihu hua ji,* pl. 89.)

77. Li Huasheng. *Late Autumn in the Mountains of Sichuan.*
Spring 1983. Ink and color on paper. 29.9 × 41.8 cm. Private
collection, United States.

78. Li Huasheng. *Autumn Evening*. 1983. Ink and color on paper.
94.6 × 59.4 cm. Private collection, United States.

with him a copy of the *Neican* article, which (in violation of security regulations) he showed to his driver Xie Yusheng, the head of the Shipping Administration's Chongqing transportation section. Present at the gathering were Yan Jiyuan and several other senior artists whose exhibition had been blocked a year earlier by Li Huasheng. Before their meeting was over, Li Zhenyu, Yan Jiyuan, and the others had toasted the charges printed against Li Huasheng and celebrated his imminent downfall.[41] Li Huasheng, who of course had no access to *Neican,* was first informed of it by the driver Xie Yusheng, who said that while obliged to remain silent, he could not tolerate the rumors about Li and decided to bear the risk. "Drivers," says Li Huasheng, repeating a modern adage, "are the ears of China."[42]

According to Li Huasheng, the *Neican* authors had already begun—as investigative reporters—to search for "bad models" among the artists of Chongqing when they heard about Li's marital problems. Yuan Guanghou's rationale—as told shortly afterwards to Li Huasheng and his brother Jiawei, who visited Yuan's home to voice their protest—was not surprising: "I had to pick an example of spiritual pollution to educate the masses. I had no personal animosity toward Li Huasheng. Everything we do must be based on social consciousness." Li Jiawei protested to Yuan, "But you are Party members, and so you are obliged to 'get the truth from facts.' " Despite Yuan's assertions, the publication of his article preceded by several weeks the announcement of a Campaign Against Spiritual Pollution. And today, Yuan Guanghou admits that he did not simply stumble across Li's case in search of a model; indeed, his attention was directed to it by members of Li's work unit in the Shipping Administration.[43] To judge from the charges themselves, Gu Zhenhai (whose request for a painting on behalf of Xie Limin had been refused by Li Huasheng) must have played a role in generating Yuan's investigation. But Gu's collusion with a number of others, among them Li Zhenyu, seems possible.

When the *Neican* article was published, Li's friend Wang Guangrong was in Beijing, and there he was first informed of it by the nationally prominent critic and Chinese Artists Association vice-chairman Wang Zhaowen. Wang Zhaowen reassured Wang Guangrong that Li's problem was just a matter of life style—in other words, not political or particularly dangerous—and he advised Wang that Li should simply continue to concentrate on his painting. He would, Wang Zhaowen said, "put in some good words" for Li. But Wang Zhaowen was typical of many intellectuals and politicians alike in his failure to foresee the coming storm. Not long after Wang Guangrong returned to Chongqing, Li was subjected to his first public criticism at a mass meeting, conducted by the new head of the Propaganda Department of the Chongqing Municipal Communist Party Committee, Liu Wenquan. Proclaiming the government's new policies regarding spiritual pollution and bourgeois attitudes and activities, Liu held up several negative artistic role models, putting Li Huasheng in the distinguished company of Stendhal and of Tolstoy's Anna Karenina.

From here on, Li's case took on a more formal, judicial character as opponents sought to unseat him from the Chongqing Artists Association vice-chairmanship. Given the atmosphere of the burgeoning Campaign Against Spiritual Pollution, the time was right not only to counter Li Huasheng's administrative initiatives but also, through him, to weaken (if not actually unseat) the progressive Niu Wen. Niu Wen had brought Li Huasheng to power, and if Li could be brought down, Niu Wen at the very least would be embarrassed and forced onto the defensive. "Attacking me was the same as attacking Niu Wen," says Li, "because we kept a very close relationship, and our policies and principles were the same." Li believes that Niu Wen resisted Li's opponents to the last minute. "I have no details about this, but I've heard that when somebody told him I was being criticized by central leaders, Niu Wen said that even the central leaders could make a mistake and should be corrected." But such criticism could not be deflected indefinitely.

Both Li Huasheng and Xu Kuang had been approved as vice-chairman by a vote of the Chongqing Association membership. Yet the standing committee of the Association (of which Li was also a member by virtue of his vice-chairmanship), while without the authority to select officers, was empowered to remove them and was designated to consider the matter. There was an additional party to the proceedings that took place: the Chongqing Federation of Literary and Art Circles (Cultural Federation),[44] important since the Federation was under the influence of Li Shaoyan (then empowered as national and provincial Cultural Federation member, Sichuan Provincial Party Propaganda Department vice-chairman,[45] and Sichuan Artists Association chairman), rather than that of local Artists Association chairman, Niu Wen. Both organizations had their reformers and conservatives, but the reformers were dominant in one group (the local Association), the conservatives in the other (the local Federation), and so the question of who would dominate the proceedings was paramount.

Lü Chaoxi, chief of the Administrative Office of the Chongqing Cultural Federation says today that while in theory the Federation is superior to the Artists Association

and the other cultural units, in fact the reverse is true: "The upper is void," he says, "the lower is solid." Niu Wen, however, says that the case was decided "from the top down," in other words that the outcome was determined politically by pressures brought to bear on the municipal Artists Association by the Sichuan Artists Association and the Chongqing Municipal Cultural Federation. One of Chongqing's arts administrators says of these factions, "In Chongqing, the Cultural Federation is the solid and the Artists Association is the void. The Cultural Federation employees are full-time employees, while the Artists Association's administrative work is usually carried out concurrently with other employment. So it was difficult for this Artists Association to handle this case on its own."

In November 1983, an all-day meeting in two sessions was held at the Chongqing Fine Arts Gallery to adjudicate the case of Li Huasheng. The Cultural Federation was represented by a senior member, Wang Bancan, the general-secretary who clearly opposed Li's attitude toward the elder artists. Niu Wen's 1982 statement to Li Huasheng, "I support those who aren't restrained by the rules," was being interpreted by his opponents as supporting *violation* of the rules, forcing him to defend his own position and abandon his defense of Li Huasheng. Li Huasheng was not in attendance at the morning session, where Niu Wen was finally obliged to submit his own self-criticism. Niu Wen confessed his excessive tolerance of Li Huasheng, calling himself "too soft" on the matter. Accepting this degree of responsibility weakened Niu Wen but also made him safe from further attack. The full energy of the conservatives was then turned on Li Huasheng. With Niu Wen presiding, every member was invited to contribute to a discussion of Li's mistakes. Afterwards, Niu Wen announced Li's dismissal as vice-chairman of the Association and from its standing committee. This decision was then discussed. Wang Bancan spoke first, setting the tone by strongly condemning Li's behavior but affirming Niu Wen's decision. Some called the decision "too light," while others found it "too heavy." Finally, it was agreed upon.

At the end of the session, Niu Wen informed the participants that Li would come in person in the afternoon. Yet when he went to summon Li, telling him to present a self-criticism that afternoon, Li at first refused. He refused even to attend. But when Niu reminded Li that the responsibility for him was Niu's own, that his refusal would become Niu's own personal trouble, Li agreed. In the few hours between the two sessions, Li found himself unable to write such a self-criticism. After some thought, he remembered the stalls in Chongqing's marketplace where, during the heyday of

the Cultural Revolution, such things were prepared commercially in response to a great popular demand. One of these still advertised: "I write your letters and self-criticisms. Ordinary self-criticisms, 20 cents. Really good ones, 50 cents." Unfortunately, Li could not find this well-practiced writer and turned instead to a friend who worked in Chongqing's television station.

Li Huasheng laments that "every time there's a new political movement, you must put on make-up and mount the stage." The stage setting for Li Huasheng's afternoon confessional followed well-established precedent. Everyone was already present when Li entered. With all the other members seated around a large meeting table, Li sat in a small chair about one foot high, next to the wall, his head bowed down, his body drawn in, maintaining a look of grief upon his face. Niu Wen opened the hour-long proceeding, saying, "Li Huasheng, you have made a mistake. First you will make a self-criticism, then the others will help you." But there were also some departures from the confessional norms. As usual, Li was late to the meeting. He had not even seen his self-criticism before he had to read it publicly, and he read it so haltingly that some of the others had to laugh. Li read: "Usually I don't read books; I don't read newspapers; I don't study politics. So I made this mistake. I'm very grieved about this. From now on, I will pay attention to these problems. I will accept others' help. I will devote myself to my painting." He admitted the truth of an extramarital affair with the wife of Chen Ji, but otherwise he focused only on the administrative aspects of his career. The others then began their criticism.

Wang Bancan of the Cultural Federation said, "This self-criticism is not sincere. You won't pass." Xu Kuang responded, attempting to deflect any demand for greater harshness by offering almost comically soft criticism: "Li, you have never been able to offer self-criticism. No matter *what* you say, it won't pass. So you had better read the newspapers and study politics." Li replied to this, "Yes, yes. Tomorrow I'll get myself a subscription to the *People's Daily*." He lamely admitted that his conduct of administration had not been very efficient. Su Baozhen—a vice-chairman of the Chongqing Artists Association, whose painting of grapes Chen Zizhuang had ridiculed and Li had once admired, then rejected—made a generous speech: "You have your achievements, and we're very proud of you. We regret that you have made this mistake. It wasn't worth your doing. We hope you will focus on your painting and not do this kind of thing again." Li remembers thinking that Su's comments were as round as his grapes, but he appreciated the sentiment. Qiao Bocai was an amateur painter who represented

the working class on the standing committee of the Association. He accused Li of social snobbery, of not even saying hello when they met in public but just turning his head. "Your painting is very bad," he said. "If you worked in our factory, we would kick you out of the working class!"

At last, Niu Wen announced the decision of the morning session. Wang Bancan asked Li whether he agreed with the decision, handing him a written document to sign. Li signed it at once, without looking at it. When he belatedly read it, he disagreed with some of its points—for example, Li "always fondles women," and he "always acted degenerately." He wrote his objections on a separate piece of paper, which he returned to Wang Bancan. Although only official documents—primarily negative, and not such unofficial memos as Li's objections—can be placed in an individual's security file, Wang stated, "We have no way to solve this, but we will express your opinions to the superiors. It is the business of the Propaganda Department, not ours." This remark, says Li, shows that the entire affair was directed from "higher up."

Niu Wen then closed the meeting. All the members left. Li, alone, sat on his child's-sized chair for a long time. Although Li believes that some of his fellow artists wanted him formally charged and executed—such sexual liaisons, often prosecuted as rape, carried that potential—he was only dismissed from his position as vice-chairman of the Association. Li felt "relieved" that it was over.

Niu Wen, conversely, had had to present a public self-criticism and had been unable to prevent Li's dismissal. He was embarrassed and weakened by the affair. But he continues to defend his choice of Li Huasheng, saying that he was consciously seeking to bring some younger artists into arts administration "at a time when the focus was more on the titles and reputation that administrative appointees could lend to the organization." Having selected Li "because of his talent and intelligence, and because his landscapes were quite good," Niu Wen claims to have no regrets. He asserts that "Li *really* didn't say what he was charged with saying. They just exaggerated and laid those statements on him." And he says of Li's dismissal, "It didn't hurt his personal life or his income, but it hurt his social reputation, which is most important."

Li Huasheng's case, however, did not end with his dismissal. It was far from over. Adjudication had merely been deferred because Niu Wen felt that final judgment should remain with Li's permanent working unit, the Yangzi River Shipping Administration. In transmitting the case to them, Niu Wen emphasized that their investigation should be based exclusively on facts and evidence, disregarding all rumors and speculation. But with Gu Zhenhai, one of Li's chief detractors, serving as the Administration's Party secretary and thus as head of their investigation, an impartial review seemed doubtful to many. Li, too, was soon returned to the Shipping Administration, along with his case. There, he was set to work, taking orders from men who had been students when he was first working for the Sailors Club, given daily instructions by them to paint furniture and walls. Fortunately, the assignments were light and most of his days were spent as before, doing painting and calligraphy behind locked doors. He took these home with him at the end of the day, for pending a judgment, he was still free to keep his apartment next to the Shangqing Temple as well as to walk freely about town.

Li Huasheng's political problems came while the star of his reputation was still in ascendancy. In May 1983, the National Gallery in Beijing held a Twentieth Anniversary Exhibition of Collected Works. Li's *All Night, New Rain* (fig. 44), which had been added to their collection after the 1981 ten-artist exhibition, was displayed alongside works by China's best-known artists. At about the same time, he took part in a group exhibition in Hong Kong with some of Sichuan's top painters, including Li Qiongjiu from Leshan, one of Chen Zizhuang's few preferred painters. Each participant there contributed ten works. In August, a painting on the theme of "summer lotus" was sent in a group exhibition to Tanzania. Most important of all, two of Li's paintings from the previous year, *Landscape after Lu You's Poem* and *Village Scene* (figs. 63 and 65), selected the previous summer by Lucy Lim, were finally exhibited in America's first major exhibition of its kind and published in the catalog, *Contemporary Chinese Painting: An Exhibition from the People's Republic of China.*

From November 1983 to December 1985, a full two years, the American exhibition appeared in succession at the Chinese Culture Foundation of San Francisco, the Birmingham Museum of Art, The Asia Society in New York, the Herbert F. Johnson Museum of Art at Cornell University, the Denver Art Museum, the Indianapolis Museum of Art, the Nelson-Atkins Museum of Art in Kansas City, and the University Art Museum at the University of Minnesota. The catalog, with essays by Lucy Lim and American professors James Cahill and Michael Sullivan, included this comment by Lim: "In my mind, Li Huasheng is perhaps the most original and interesting painter on the contemporary Chinese art

scene."[46] And in a separate article, she wrote that Li's "unusual, individual, spontaneous style seems emblematic of the new artistic freedom now permitted."[47] Li's *Landscape after Lu You's Poem* was chosen to illustrate both the opening-night invitation and the exhibition poster.[48] For most Americans, it was the first chance to discover socialist Chinese paintings that were not propaganda work, and Li's art played a conspicuous role in this. But when the exhibition opened in San Francisco on November 16, Li was hardly in a position to celebrate such recognition.

In December, the Beijing art journal *Zhongguo shu hua* (*Chinese calligraphy and painting*) published four of Li's paintings in color, including his 1980 *Mountain Dwelling* (fig. 59) and yet another variant on the Lu You poem.[49] Photographs of these paintings had been presented much earlier to two journal editors, Leng Yanmei and Liu Longting, who traveled to Sichuan to make their selection. "Then," says Li, "for about one or two years, they didn't publish them, but finally they published them at the time when I was in trouble. I don't know the reason. Maybe it was a gesture of their support." But such gestures—if that is what they were—did little if anything to alter the fact of Li Huasheng's professional disgrace. Just as American scholars began to become aware of Li Huasheng's talent, his Chinese colleagues began to reject him.

On November 27, 1983, the idea of a provincial nonteaching art academy came a step closer to formal approval. Such an academy, designed to promote the art of a select group of Sichuan's finest, most innovative artists, had been proposed more than two years earlier by Li Huasheng and his colleagues to Deng Xiaoping and provincial Party secretary Tan Qilong. According to press reports, China's minister of defense, Zhang Aiping of Sichuan, together with Tan Qilong and other comrades had "happily gathered with noted library and art persons, poets, and calligraphers from various cities and the province" at the Chengdu Painting Academy. Those present "spoke glowingly of the achievements made by the province in promoting literary and art creation and in building spiritual civilization." They also "studied matters concerning the construction of an academy of poems, calligraphy, and paintings in Sichuan" and recalled that "when Comrade Deng Xiaoping inspected Sichuan, he proposed that an academy of paintings should be built in Sichuan." After a "lively discussion," they decided to set up a preparatory committee for such an academy. Tan Qilong was appointed as chairman of the committee, while the vice-chairman was delegated to Yang Chao, who was retiring from the lofty Party position of chairman

of the Sichuan Provincial Political Consultative Conference.[50] The peculiar formal title of the academy, the Sichuan Academy of Poetry, Calligraphy, and Painting (Sichuan Sheng Shi Shu Hua Yuan; referred to hereafter as the Sichuan Painting Academy) was given by Zhang Aiping, who is said to have wanted a broad artistic base for such an institution. Li Huasheng had helped initiate the idea for such an academy and had vigorously promoted the younger generation of artists who might join it. Now, however, Li's own chance of becoming a member seemed remote.

From the public's point of view, the Campaign Against Spiritual Pollution was short-lived. It seemed to disappear as suddenly and surprisingly as it had begun, leaving most people uncertain about its causes and its goals. At first, conservatives had welcomed it as an opportunity to turn back the tide of "bourgeois" economic reform. But reformers as well seemed willing to use it to shore up their credibility as good socialists. In the process, it is said, the reformers ended up contributing even more than the conservatives to the view that "Deng Xiaoping and most other top-level politicians take a fairly utilitarian stance toward intellectuals, assessing their activities in the light of nonartistic, nonprofessional criteria [and that] no Chinese leader is above trading away intellectual freedoms for other goals."[51] As Li Huasheng now puts it: "The political struggles take place at the top of the bureaucracy, but it is so easy for the artists, far below, to become their victims." Before long, however, the movement got in the way of the reformers, and the conservatives could not sustain its momentum:

> The campaign against spiritual pollution did not last. This was not because reformers disagreed with conservatives that there was a need for tight ideological controls, but rather because overeager leftists [i.e., conservatives] expanded the scope of the movement beyond theoretical and literary and art circles, threatening social and economic stability. Peasants' confidence in the economic reforms was being shaken [and] some businesses were afraid to sign contracts with foreign companies and governments lest they too be accused of spiritual pollution. Intellectuals' fears that another Cultural Revolution might be beginning created a psychological climate adverse to modernization.[52]

Given this, the reformers acted quickly to end the skirmish on their own terms. In the mass media, efforts were soon made to restore public confidence, to put the brakes on this rapidly accelerating campaign. On November 17, *China Youth News* printed a commentary (subsequently reprinted in the *People's Daily*), entitled "Pollution Should Be Eliminated but Life Should Be Beautified" and urging the Party to

draw a "clear line of demarcation between the embellishments of life and spiritual pollution":

> We must not criticize the young for appreciating stylish clothes and good food and for having fun. We must not attach importance to the shape of pants, to the height of shoe heels, or to hairdos, but instead we should defend and back the legitimate aspirations of the young who want to embellish their lives.[53]

On December 24, the *People's Daily* cautioned:

> Don't take just any question and make it a matter of spiritual pollution. Don't take things which you haven't seen or dislike, and make them into spiritual pollution without analysis. Don't resemble some comrades, who think "Spiritual pollution is a basket, and anything can be packed into it."[54]

Even the conservatives helped to limit the scope of the movement. On December 9, Deng Liqun, the Party's Chief of Propaganda whom many today regard as the author of the campaign, said it should not be carried out in the countryside. On December 16, the *People's Daily* reported that the visiting Archbishop of Canterbury, Robert Runcie, was promised that the campaign would not involve religion. And on December 18, the State Council announced that the campaign should not involve science and technology.[55]

In February 1984, *Beijing Review*'s political editor, An Zhiguo, wrote a commentary entitled "Ideological Contamination Clarified": "We offer no objections to paintings and sculptures that depict the beauty of the human body, and still less do we oppose efforts to draw on the strength of outstanding Western works of art."[56] But the arts were not home free. On December 18, Hu Yaobang had said that the movement would continue in critical theory and in the literary and arts circles.[57] And a *People's Daily* article on December 21 had announced, "The work of eliminating spiritual pollution has just begun. In the theory and art and literature worlds, some people have not yet been gotten through to, some are still resisting."[58] Although economic reform might continue to expand in both the countryside and the city, intellectual liberalization would not grow apace:

> The open discussion in ideology and in literary and art theory that had been possible for part of the post-Mao period thus came to a halt. The implications, beyond the arts, for social sciences and for academic freedom in general were clear. If discussion of such questions as the emergence of a new privileged class, of the anomie of the workers, and of the deification of Mao were impossible, then there could be no intellectually honest discussion of problems facing China.[59]

It is claimed that in early 1984, the term "spiritual pollution" was officially "replaced by the more prosaic phrase 'bourgeois liberalization.' "[60] But the campaign itself, in the intellectual arena, continued until September 1984 before it was officially called off.[61] For Li Huasheng, then, the ordeal would drag on.

As the Campaign Against Spiritual Pollution entered a new phase in 1984, more narrowly focused and less visible, so too did a new phase begin for Li Huasheng—a phase, ironically, more public and virulent than the first. Early in 1984, at a confidential meeting in Chengdu at the Publication Press House, a clearing center for all the local presses, Li Shaoyan in his capacity as vice-chairman of the Sichuan Communist Party Propaganda Department read a document attacking Li Huasheng on three counts. First, he quoted Li as saying that "painters who want to gain a reputation will organize themselves and praise each other," thereby accusing Li of fostering personalized factions within the Artists Association to circumvent the traditional levels of authority in evaluating artists. Second, he claimed that Li had said, "Chinese painters who want to gain a name must depend domestically on the bureaucracy and internationally on dealers," in effect, accusing Li of using local bureaucrats and, worse still, foreign capitalist agents as pawns in his unprincipled dash toward fame. Third, he raised the charges of sexual misconduct against Li, calling him "immoral," at a time when socialist morality and spiritual pollution in the most general sense were the sole remaining elements of the continuing political campaign.

Then, on January 16, Yuan Guanghou wrote an article in the journal *Liaowang* (*Perspectives*), a Beijing weekly with a national circulation of 400,000 which was published under the auspices of the New China News Agency. With a reputation for the reporting of "inside stories," *Liaowang* delivered to the general public the basic contents of Yuan's initial attack on Li Huasheng in the restricted-circulation *Neibu cankao*. Li Huasheng was held up as a model of a "rebellious" antisocialist in a text as pedagogical as its title, "How Did a Young Artist Degenerate?":

> Not long ago, the Party Administrative Committee of the Chongqing Municipal Cultural Federation said in their report that the problem of a certain fellow Li was "an essential lesson for us in how to cultivate and bring up new generation of artists."
>
> Originally this Mr. Li was a common electrical worker [*sic*]. In his spare time he regularly went to the Chongqing Municipal Masses Cultural Hall to study painting. The leader of his unit felt

that he had a promising future, so he arranged for him to be transferred to the [Sailors] Club to do art work. Once, he accompanied a famous painter [?] to do realistic sketching in the Three Gorges. In caring for and encouraging this young man, this [famous] painter said to the leaders of the Sichuan Artists Association: "Chongqing has a certain Li who is worthy of cultivation." After that, Li received much attention from the Artists Association. Li boasted about this everywhere, trying to promote his own reputation among those fans of younger artists. It must be said that he has some talent, and his works have exhibited. Afterwards, through connections, he sold some traditional paintings in Hong Kong and received the praise of some people. So he even showed off Hong Kong publications with his paintings and boasted about his Hong Kong dollars: "I'm an artist with an international reputation." "If China wants to hold an exhibition abroad, half of the paintings must by me, Li."

At the end of 1981 [sic], this Li was promoted to position of vice-chairman of the Chongqing Artists Association. After this, he even lost sight of his proper position, by his own permission traveling out in the mountains and enjoying the rivers, painting and selling paintings, becoming an uncontrollable person. Within a few years, from being an ordinary third-grade electrical worker, he was transformed into being *nouveau riche*.

He used his material situation and his social reputation to trick several young ladies, who went to his home for dancing, and he corrupted several young women. For a long time he indulged in immoral sexual relationships, causing three families to break up. However, he said shamelessly: "This is really the unrepressed manner of a true artist. In terms of money, position, honors, love, and women, in all of these I have become greatly accomplished and fully satisfied my ambitious heart."

A young man like this who so rapidly ascended the artistic ladder, this man who in only a few years degenerated into such a corrupt soul, is a profound moral example.

In our socialist country, talented young people with proper Communist ideals have the opportunity to develop their talents. This fellow Li's "sudden emergence" is an illustration of this point. The Party secretary in his original work unit [Gu Zhenhai] consciously helped to provide him good study conditions, even personally helping him by arranging for painting brushes and paper. Without such breadth of concern and cultivation he could not have developed. But as soon as he had even a "small reputation," he raised a "rebellion," saying his Party secretary "wasn't worth a penny," even going so far as to not take Party matters at all seriously.

This Li was intoxicated by following the "freedom" path. He treated art as a economic commodity for gaining material benefits, openly advocated capitalistic cheating of others, hoarding, and the entire corpus of the "Business Sutra." He said things

like: "If you are thinking of gaining a reputation for painting, you must depend on officials internally, and internationally depend on greedy dealers." He even said to some artists: "We must unite together to cheat non-artists. Even when we just drip a few dots of ink on the paper, if we all say its wonderful, who would dare to say it's not."

Personal qualities and painting standards cannot be separated. This fellow Li's view of art is completely corrupt and counterrevolutionary. He publicly declared, "The Communist Party does not understand painting." Once, looking at a work, *Building a New House,* done by a famous printmaker and reflecting the new atmosphere of the countryside, he even uttered this nonsense: "What kind of art does this amount to? In my paintings, the buildings are all leaning this way and that. I won't sing the eulogies of the Communist Party!" This reveals the viewpoint that this fellow Li really holds.

This Li doesn't study Marxism-Leninism regularly, doesn't pay attention to moral cultivation, and this has caused his degeneration, and naturally he must take major responsibility for this. Besides this, some of our unit leaders emphasize talent, not virtue, being insensitive, and this is also a serious lesson. When Li's severe problem was revealed, several leaders of the Chongqing fine arts circle didn't take this seriously and even came to his defense. This exacerbated Li's arrogance.

Another lesson is that in our present society there is a certain midguided tendency to "praise someone to death." A youngster who has just now achieved a little success is unrealistically crowned with a wreath of laurel, so they all compete with each other, the more praise, the more bizarre. Some people are originally "top-heavy, thin at the bottom, and shallow-rooted," with the result that they are misguided and confused and take an improper, immoral path.

Now, this certain Li was dismissed from his position as vice-chairman of the municipal Artists Association. His problem is now under further investigation by relevant units and awaiting judgment. This kind of example is an exception, but from an event like this we can clearly recognize that when there are mistakes, if we don't criticize and struggle, if we take on a liberal attitude and let it go unchecked, this will be destructive.[62]

While this article concentrated primarily on Li Huasheng's misguided ways in the art community, a second article, published at the same time, focused instead on the supposed details of his "several" sexual affairs, including the assertion that Li had acquired his own legal wife by seducing her while she was married to another man. This article was presented in tabloid fashion, even though it appeared in the Shanghai monthly, *Minzhu yu fazhi* (*Democracy and legal institutions*), and spoke with all the authority of its

publisher, the Shanghai Bureau of Justice. In format, it consisted of a letter by Chen Ji, the offended husband in Li's acknowledged illicit relationship, who called for some journalist to come see the truth of the matter, followed by an "investigatory response" by Yuan Guanghou. The lurid title suggests that pressure was now being brought directly by Li's detractors against those who were about to sit in judgment upon him: "This 'Painter' with Such a Corrupt Soul and Why His Related Units Have Let Him Go Unchecked." Chen Ji's letter is quoted in full:

Comrades in the *Democracy and Legal Institutions* Editorial Bureau:

First let me thank you for your magazine's moral support of several victimized families.

Now let me set forth the situation regarding the vice-chairman of the Chongqing Municipal Artists Association, who originally was the Chongqing Sailors Club artist Li XX, a seducer who badly broke up the families of several young women:

Li XX first was a student at the Chongqing Shipping School and after graduation he got a position as an artist at the Chongqing Sailors Club. After he got a little reputation as a painter, he was praised and promoted to be vice-chairman of the Chongqing Artists Association, and from that time he used the label "young generation painter" to swindle and fool people. He boasted everywhere: "Don't be deceived by the fact that I only make a few dozen dollars salary, for whenever I happen to do a painting I get several thousand dollars."

Even when Li XX was at the Shipping School, he seduced two women classmates and afterwards abandoned them. After he became a "younger generation painter," he at first seduced a married woman XX, with the result that the family was broken up. After XX married him, she too was abandoned by him. Beginning in 1980, Li XX also seduced my wife X XX (a saleswoman), using jade rings, clothing, leather shoes and other small favors to seduce her over a period of almost three years. Beginning in October 1982, Li XX used the same means to seduce as many as four other married women with very serious results.

The victims of our several families reported this many times to the relevant officials, and a Chongqing municipal official [Wang Qian, Chongqing Party secretary] twice instructed in writing that Li XX be dealt with severely. But several people repeatedly defended Li XX, claiming that Li XX was only a "problem of lifestyle," "Li XX was an unusual talent." But until now, in opposition [to Wang Qian's orders], they still have not acted.

We ask that your magazine uphold the rightness of the victimized families, send a journalist to advance the investigation, to expose Li XX's long-term destruction of the happiness of these ordinary families, and to see that a judgment is handed down according to the law.

—From one of the victimized family members, Chen Ji

Appended to this letter were the following "Notes of the Investigation," written by Yuan Guanghou:

Already in the deep of night, the rain was falling on the plain of western Sichuan.

The sound of dripping rain; the glow of a desk lamp. In an attractive and comfortable room of the luxurious Jinniuba [Golden Ox Hotel in Chengdu], a "painter" with a goat-hair brush was writing his "love letters." It was to the woman he secretly called "Red Battle" [i.e., the wife of Chen Ji] that he expressed all the "flame of passion in his heart . . . which burned brighter and brighter." He wanted her to come at once to Chengdu.

And so, the married woman called "Red Battle" went to Chengdu. While other painters were earnestly painting, this "young-generation painter" abandoned his art work and, with his head in the clouds, brought his "Red Battle" to some of Chengdu's famous scenic spots and to several private family homes, fooling around with her as "husband and wife."

The affair was quickly exposed and word was spread all over town. Some artists angrily denounced him: "This guy is no painter; he's the scum of our group!" This "painter" named Li XX originally was a common electrical worker in some unit in Chongqing. Because he liked to paint in spare time and also because he was young, he created several art works with the help of his unit and his comrades, some of which were exhibited in a "Young Painters Exhibition." By 1981, he had been promoted to vice-chairman of the Chongqing Artists Association.

This "heavy on top, thin at the foot, and shallow at the root painter," as soon as he had a little reputation, became arrogant and was everywhere boasting about himself. Several of the mass propaganda media were undiscriminating and, following this "specialist" or that "specialist," joined in praising him. Li XX thus became increasingly arrogant and domineering. When several older comrades raised some questions about his painting, he was publicly critical, saying that "the Communist Party doesn't understand art."

Li XX used the excuse of "Artists Association" matters to casually avoid his duties, travelling around the mountains and rivers, painting and selling paintings, acting wildly and violating public standards. He originally was just a third grade worker, but through his painting and other means he quickly became *nouveau riche*. Not only did he live luxuriously in his daily life but became even more degenerate. Not a few young women were taken in by him.

This one called "Red Battle" also made Li XX's acquaintance at a dance party. One day, Li XX invited her to a meal at his home, and not long afterwards Li seized the opportunity to take advantage of her. She was afraid and cried bitterly. He seized upon her weakness, her vanity, boasting that he was well known nationally and internationally as a "master painter" and that it would be a "great glory" for her to follow him. This "Red Battle," corrupted and seduced by Li XX in so many ways, then willingly became his "woman."

After "Red Battle" was seduced, he instigated her to quarrel with her husband, pressured her husband and her to separate. Right after this, he used the same means to cheat yet another young married woman into have a sexual affair. Not only this, Li XX even openly said to his wife: "I'm only playing around with her." He even used his wife's weakness, the fact that she was previously divorced, applying hard and soft tactics, to get her not to report him.

Li XX used this kind of tactic over a long time to insult a number of young women, with the serious result that three families were broken up, two couples were divorced! But Li XX was not ashamed of this, saying, "In terms of money, position, honors, love, and women, in all of these I have become greatly accomplished."

Since the beginning of 1983, the members of these victimized families reported all of misconduct to leaders at all levels, to the judicial administration, and to *Democracy and Legal Institutions*. Most recently the relevant units have begun to take the first steps toward judging Li XX, and the Chongqing Municipal Cultural Federation has already dismissed Li XX from his position as vice-chairman of the Artists Association.[63]

On February 13, yet another article followed, in *Zhongguo fazhi bao* (*Chinese law journal*). Published in Beijing by none other than the Chinese Ministry of Justice, the article this time was written by Chen Ji himself, the enraged husband, and it bore the title "We Strongly Ask Punishment for the Rascal 'Painter' Li Huasheng." Chen Ji went so far as to discuss both Li Huasheng's wife and his own wife *by name* and to lace his story with the charge that Li had stolen "large numbers" of paintings from his teacher Chen Zizhuang. More explicitly than before, Chen Ji targeted those who have "stood up to lobby in his behalf" so that Li could "cover up and get off":

. . .Li Huasheng learned bad social habits in his youth, as early as when he studied in the Chongqing Shipping School (in the "Cultural Revolution" period), when he seduced two women classmates. After he started work, he didn't alter his immoral practices and continued to womanize. The Chongqing Second Light Industry Bureau clerk, a certain Zou [Lin], weak in char-

acter, was unhappily married in her youth. After Li Huasheng became acquainted with her, he used every means possible to seduce her, so that finally this Zou's family was broken up and she married him. After Li Huasheng married this Zou he tired of her and from 1980 he began seducing my wife, Xiao Banghui, always inviting Xiao Banghui to go to his home for dancing, listening to Hong Kong music, reading foreign magazines, dining, and giving her gifts of jewelry, clothing, and so forth. In mid-February of that year, Li Huasheng invited my wife to lunch, and after drinks, on the pretext of going to look at pictures and traditional Chinese paintings, he tricked my wife to come home with him and, half against her will, he seduced her. My wife was terrified and couldn't stop crying bitterly. But Li Huasheng, by boasting of his status, giving gifts, and other means, finally "conquered" my wife. Afterwards, Li Huasheng frequently came to my home to commit adultery, spending even more than twenty days in one month (I buy and sell products and am mostly out of town).

In March of that year, Li Huasheng instigated my wife to quarrel with me and divorce. In June, my wife left home. During an eight-month period my wife actually lived at Li's home. Li Huasheng ordered his wife and child to live upstairs while he and my wife lived downstairs, like a formal wife and a concubine dwelling in the same house. In January 1981, my wife was persuaded by others to move back home. However, Li Huasheng's wanton desires weren't done with and he used all kinds of means to seduce and bewitch her, continuing to have adultery with my wife. Every time I was gone, Li Huasheng publicly took my wife walking along the streets, to restaurants and to the movies, and several times went to Chengdu for their adultery. During this period, beginning in October 1982, Li Huasheng also seduced another married woman, a certain Yan who was a clerk in a Chongqing hardware company, finally breaking up her family. This Yan divorced her husband and became another of Li's mistresses. Besides this, Li Huasheng also seduced a certain Luo who was a nurse at the Chongqing Osteopathic Hospital and also a certain woman Fan working at the Huashan Jade Food Factory, as well as a woman apprentice Liu working at the Mountain City Hotel, and several others. In this period, Li Huasheng's being led astray by success reached an extreme, and he boasted, "In terms of money, position, honors, love, and women, in all of these I have become greatly accomplished and fully satisfied my ambitious heart." Relying upon his specialization [in art], he sought money everywhere, and with the money he sought he played around with women, saying: "Whenever I happen to do a painting I get several thousand dollars, and with so much money I need not worry about getting women, for the two are interchangeable."

In January 1983, Li Huasheng's guilty ways were revealed

(because we acquired concrete evidence for the period up to that time), several members of our victimized families brought these accusations to our relevant units. The municipal Party secretary, Comrade Wang Qian, twice instructed in writing that this should be dealt with severely. Through the investigation of the municipal Cultural Federation, Li Huasheng not only committed the criminal acts described above, but he also committed the crimes of using dancing parties at his home for fondling and seducing young women and distributing nude photographs; privately buying cultural relics to exchange for Hong Kong and Macao currency, for a color television, a refrigerator, and a high-quality camera; and all kinds of illegal activities. He also stole a large quantity of Mr. Chen Zizhuang's collected ancient paintings and Chen's own sketches, which he copied and enlarged to use as his own work, being completely corrupt in his professional morality.

In November, the municipal Propaganda Department decided to dismiss Li Huasheng from his position as vice-chairman of the Artists Association, and the Chongqing Branch of the Shipping Administration decided to record a great demerit in his personal file. But, because Li Huasheng was always boasting and flattering, hosting, gifting, and winning lots of people over, even now some people stand up to lobby in his behalf, to exonerate him, so that until now there has been no progress toward a judgment, causing the rascal Li Huasheng to become even more arrogant, to become more active in the municipal administrative units, to try to make connections everywhere in the Shipping Administration, to avoid a confession of his transgressions, to cover up and get off. We strongly ask the leaders to deal severely with and punish Li Huasheng according to the law, for his degenerate and anti-revolutionary thoughts, for his completely rotten life style, for his extremely corrupt morality, for conducting adultery with a number of women over a long period of time, and for the serious results of this.[64]

These two sections of the *Chinese Law Journal* article were followed by an "Editor's Note," written by agents of the Ministry of Justice itself, concluding—prior to any formal judgment of Li by his work unit:

> The letter by Chen Ji setting forth this situation, according to our understanding, is basically true. Being an artist, he should take up his painting brush to illustrate the most recent and beautiful pictures, to inspire people spiritually, to give people an appreciation of beauty, to encourage people to strive to build up the beautiful river and mountains of our socialist fatherland. But, under the label of "young generation painter," Li Huasheng hid his corrupt soul, carried out his despicable deeds, seized the wives of others, broke up other people's families, and freely toyed with other women. Li Huasheng's conduct has already

transgressed the laws, and he must be punished to assuage the ordinary people's righteous indignation.[65]

By this time, of course, Li Huasheng had already admitted to his illicit liaison with the wife of Chen Ji. The additional charges, he asserted, were entirely fabricated by the offended husband. Li had met Chen's wife—Xiao Banghui—by chance in 1979. The painter Feng Jianwu had asked Li to help him get his eyeglasses fixed, which usually takes a long time without some helpful personal connections. Li was able to make such a connection through Su Huajin, an elderly calligrapher who occasionally visits Li's home, and who in turn introduced Li to a young woman friend who worked at an optical shop. Xiao Banghui helped Li get Feng's request met. Later, she visited Li at his home with a girlfriend of hers. Li found her very beautiful, and his friends even called her "*yanjing* Xi Shi, the beautiful optician." Li, today, describes her as "very warmhearted, straightforward, and willing to help others." Xiao was a lover of art and literature. She helped Li buy books that were hard to obtain. While stuck in a mundane job, she shared his artistic view of the world. Through him, she felt she could contribute something of her own intellectual sensibilities. Her marriage to Chen Ji, a salesman for the Chongqing Electronic Watch Factory, was something of a mismatch. She was a model of tolerance and patience. Chen Ji, on the other hand, is described by Li's friends as "having a very short fuse."

On discovering the relationship, Chen Ji first went to Li's wife Zou Lin, and reportedly threatened her. Zou admitted that she, too, knew about the relationship but had kept it secret. Supposedly, Chen then went to Zhu Xuanxian, secretary general of the Chongqing Artists Association, and asked him for information about Li, but it is believed that Zhu refused to comply with the request. Chen next came to Li Huasheng himself, demanding that he write a note confessing the affair and promising, "I won't meet your wife again." Li would not do this at first, hesitating, then asking his friends what to do. Li's friends divided into two camps, and they jokingly referred to themselves as the "war" and "peace" factions. Li's brothers all advised him against signing anything. But Li finally gave in, and a few of his friends ended up composing a letter for him which Li signed and had delivered to Chen.

Bearing copies of Li's letter and arming himself with a general letter of introduction from his boss at the Electronic Watch Factory, Chen attempted to gain access to Li's superiors. Once he arrived at the Sailors Club, he apparently tried to pass himself off as a security-section employee of

the watch factory. But he merely impressed the guards and secretaries there as mentally troubled, and they dismissed him. Shortly afterwards, Chen photocopied Li's signed letter and mailed copies of it to every member of the Chongqing Artists Association standing committee, to all the regional artists association nationwide, to the Chinese Ministry of Culture, and to all major magazines and newspapers throughout the country. In Beijing's National Gallery, at an international exhibition of the Armand Hammer collection in 1983, he had copies freely distributed to anyone in attendance. Xiao Banghui says that Chen Ji began distributing copies of Li's letter in early 1983 and that for the whole year, "from the very beginning, he never stopped."

Xiao says that from the outset she repeatedly offered to divorce Chen, but that Chen refused, remaining emotionally attached to her despite her infidelity and lack of reciprocating affection. In the middle of 1983, she reached an agreement with Chen that she would remain married to him if he would put an end to his vendetta against Li. For a while, Chen acceded, but according to Xiao Banghui, "many in the article wanted to use this against Li Huasheng—so they persuaded him to continue." Xiao then sued Chen Ji for divorce, and this was granted in September 1983. But even after that, Chen forced her to stay on with him, unwilling to comply with the court order until, as he put it, "I clear my account with Li Huasheng." Even after Li's humiliating dismissal from the post of vice-chairman of the Chongqing Artists Association, Chen continued to hold Li Huasheng and Xiao Banghui to his account, and his success in securing the publication of articles in three nationally prominent journals provided further opportunity for Li Huasheng's enemies to join in Chen's pursuit of retribution. By the time the criminal investigation was begun against Li Huasheng in early 1984, Chen had succeeded in raising the stakes by managing to get his charges of foot-dragging against the investigators published in the national media.

Once the Shipping Administration investigators and Public Security Bureau agents began their examination of Li, they came "every day," according to Xiao Banghui, both to Li Huasheng's place and to hers. She describes these authorities as threatening, although never physically abusive. "They asked about everything, like Li's books with paintings of nudes," and ultimately they seized Li's books of Picasso and Gauguin as "pornographic" for the nude paintings reproduced in them. (To this day, these books have not been returned). They also confiscated all Li's art relics, but it was quickly concluded that he had no intent to sell these for profit, so they were returned. Xiao and a number of women with whom Li had supposedly committed adultery were reportedly pressured, repeatedly and over a long period of time, to admit that they had been the victims of rape, a capital offense in China usually punished by a speedy execution without any right of appeal. None of these women complied with the demands placed upon them by authorities. Li's wife, also investigated, repeatedly stated that, in all respects, aside from his infidelity with Xiao, Li was a good man, innocent of the charges against him.

Although willing to confess his actions to Chen Ji and helpless before the inquiry conducted by the Shipping Administration, Li Huasheng became outraged by the escalating claims published by Yuan Guanghou and Chen Ji. Together with his brother Li Jiawei, he went repeatedly to the home of Yuan Guanghou, asking why Yuan was publicly persecuting him rather than permitting him to overcome his mistakes. He demanded to know why Yuan had not allowed him to clarify the facts before publication, which is proper newspaper policy in China. Yuan's response, reportedly, was that nothing personal was involved in these publications, that it was only a matter of presenting an ideological model from which others could learn, and that he had been instructed to do so by the New China News Agency. Li's confrontation with Yuan was tame in comparison with the reactions of the husbands of the other women whose names Yuan had reported as Li's "sexual victims." One of these women was married to a public security bureau officer and one to a policeman. One of these husbands approached the journalist with knife in hand, while the other came after him with a gun! For Li Huasheng as well, his personal freedom and physical safety were increasingly uncertain, and his ability to practice art was being undermined.

On Li Huasheng's behalf, his younger brother Li Jiawei—a journalist himself, on the staff of *Zhongguo yiyao bao* (*Chinese pharmaceutical herbs journal*)—and two journalist friends from this periodical (one from Chongqing and one from Beijing) attempted to have Li Huasheng's case clarified by means of a visit to the *Chinese Law Journal* offices in Beijing. The route to justice, however, was circuitous. At the gate, they were stopped by guards. Rebuffed, they then went to the public correspondence department, a unit that had handled Chen Ji's submission in terms of a public complaint. There, they learned the article had been edited by a woman named Leng Ying, whom they attempted to telephone. The editorial department at the *Law Journal,* however, refused to connect them with her, saying this was a matter for the journal's corrections department. They approached the cor-

rections department, but were prevented from entering. Retreating, they telephoned that department but were told it was a matter for the editorial department.

After all this bureaucratic run-around, they finally managed to speak by telephone with Leng Ying, the editor, asking how the article had come to be published without any corroborating evidence. Leng Ying responded that all the materials had been obtained through and screened by the public correspondence department. Li Jiawei argued the factual details of the case with Leng, who finally acknowledged to him that the two women mentioned in the article had already telephoned *Law Journal* offices, claiming that the report was incorrect. Leng refused to admit, however, that the article was indeed incorrect. She promised them she would not report the case any further, but she offered no retraction. When Li heard this in the early spring of 1984, at the urging of his friends and no longer confident of justice, he fled from Chongqing to the Longquan Mountains near Chengdu.

Li says he followed the oldest of China's military advice, from Sunzi's fifth century B.C. *Art of War:* "Of the thirty-six strategies [for avoiding trouble], the best is flight." At Longquan, in the crossroads village of Damian, Li was sequestered by Feng Duanyou, head of the local architectural supervisory office and a well-to-do lover of art. Feng had first met Li in May 1973 in Chengdu, introduced by Tan Changrong. Toward the end of 1983, when Feng heard of Li's increasing troubles, he traveled to Chongqing to offer refuge. Li hesitated, until things turned from bad to worse. Ultimately, he stayed with Feng for about three months, with some intermittent travel to Mt. Qingcheng, Leshan, and into Chengdu for artistic activities. He spent much of his time in the Damian opera theater, as lively as it is quaint and dingy, and at the local teahouses, which line the tiny concrete road that runs the length of the town.

The poorer peasants' lives—a mirror for Li's own troubles—and the surrounding scenery of Longquan became his favorite subject at this time, imbued with what Li today calls "a sense of grieving." He quotes the Tang poet Wang Jian to sum up their lives as "every bit steeped in bitterness"—hardly a legitimate socialist attitude. Li says, "You can show the suffering of the peasants by showing beautiful landscapes cloaked in a mood of grief." In one of these landscapes (fig. 79), the local springtime green is seen by Li in somber tones of gray, the mountains are chilly, wrapped in twisting wisps of smoke that rise eerily from a peasant's hearth. Li's inscription, filled with inauspicious imagery, reads:

Traveling to Longquan [Mountain], we arrived at Daxing at evening. The evening mist touched my face, the remaining sunshine dripped down like blood, the cooking smoke curled upwards, and suddenly an ordinary mountain scene was no longer ordinary.

Li Huasheng's dejection, expressed in landscape form, was compounded by his exclusion from the new Sichuan Painting Academy; its forthcoming November opening and initial membership were announced at this time.

Just after Li's arrival at Longquan Mountain, the painter Liu Han, a professor at the Central Academy of Minority Studies in Beijing,[66] held a one-man exhibition in Chengdu at the Du Fu Thatched Hall, probably Chengdu's best-known public attraction and supposedly the site where the eighth-century poet Du Fu lived while in Sichuan.[67] After the Sichuan Painting Academy's inaugural membership was announced, it occurred to Li that he could emulate Liu Han, in part to demonstrate his well-being and his artistic independence, above the fray of politics, and in part to protest his omission from Academy membership. The general manager of the art gallery at the Du Fu Thatched Hall was the painter Tan Tianren, who had first organized the gallery in the Founders' Hall late in 1980 and who personally arranged for Liu Han's display.[68] Tan Tianren first heard of Li from the cartoon Li had published in the 1970s (fig. 9); he was afterwards introduced to Li by Tan Changrong. In the summer of 1980, Tan Tianren had arranged for Li to stay at the Du Fu Thatched Hall for one month, in a small room often occupied by visiting painters. This time Tan arranged for Li to present a one-man exhibition scheduled for November 1984, to coincide with the opening of the Sichuan Painting Academy. This opportunity to enter the competitive arena once again, to engage or even upstage his rivals, greatly buoyed Li Huasheng's spirits.

While Li was at Longquan, the last vestiges of the Campaign Against Spiritual Pollution gradually withered and disappeared. Furthermore, in the midst of the Shipping Administration's investigation, Gu Zhenhai suddenly died and was replaced as Party general secretary in Chongqing by Xu Zhigao. No longer was Li's chief inquisitor also one of his prime antagonists. By early summer, Li felt confident enough to return to Chongqing to face a new and fairer situation:

Gu Zhenhai was the person who really opposed me. Xu Zhigao was a leader who took comparatively good care of people with talent. The workers had a good impression about him. The death

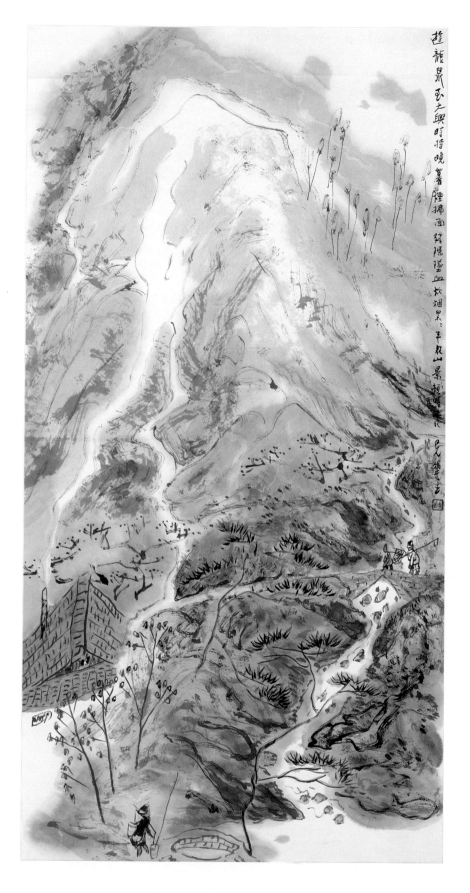

79. Li Huasheng. *Scenery of Mt. Longquan.*
Spring 1984. Ink and color on paper.
Collection of the artist.

of Gu Zhenhai coincided with the time of my troubles gradually getting solved, and after his death my situation slowly became better.

Unlike Gu, Xu went directly to Li and asked for his version of events. Li again admitted readily to the charge of sexual misconduct with Xiao and rejected all the others. Under Xu's new administration, others were also more willing than before to come forth in his behalf. While his case continued to drag on without formal resolution, Li increasingly was able to focus on the forthcoming exhibition at the Du Fu Thatched Hall, preparing the paintings with which to challenge his exclusion from the Sichuan Painting Academy.

The opening of Sichuan Painting Academy took place on November 10, 1984. The Academy chairman was Yang Chao (fig. 89), recently retired from his administrative duties in the provincial Communist Party. Yang Chao has combined administrative skills and a love of the arts of the brush—he is an enthusiastic calligrapher who practices daily (fig. 90) and a spare-time painter. Yang Chao's affirmation that "the basic idea of the Academy is to support younger artists" assured that it would serve as an alternative to the Chengdu Art Academy, which under the direction of Zhu Peijun has implemented, instead, the ideology of provincial Artists Association chairman Li Shaoyan. The new Academy has extended the modernization of Sichuan, as ordained by Deng Xiaoping, into the realm of the fine arts and has visibly shifted the balance of power in Sichuan's artistic circles.

The high level of political support behind the establishment of this institutional alternative is suggested by its membership. Honorary chairmen in attendance at the opening included Zhang Aiping, China's minister of defense; Tan Qilong, retired in 1983 as Sichuan Party secretary, now a member at the national level of the Communist Party's Central Advisory Committee and first member at the provincial level of the Party's Standing Committee; and Wei Chuantong, director of cultural affairs for the People's Liberation Army. The Academy's secretary-general and Party secretary was Liao Jiamin, secretary-general to the Sichuan Communist Party's Political Consultative Conference. Academy vice-chairman included Qin Dengkui, chief advisor to the military command unit for the Sichuan Provincial Military Region; Lü Lin, Li Shaoyan's early rival for control of the provincial arts administration; painters Feng Jianwu and Sun Zhuli; and, to assure their concurrence and harmonious participation within this new institutional balance, Li Shaoyan himself and the Chengdu Academy's Zhu Peijun. Deng Xiaoping personally provided the calligraphy displayed on the outer gates.[69] Honorary painters attending

the opening festivities included Zhu Qizhan and Tang Yun of the Shanghai Painting Academy, Wu Yifeng, and Hong Yiran. In addition to these figures, illustrious guests included Yang Rudai, Tan Qilong's successor as Sichuan Communist Party first secretary, and such artists as Qi Gong, vice-chairman of the Chinese Calligraphers Association.

At the outset, only two full-time, regular members were included: the painters Liu Pu, a landscapist who studied with Feng Jianwu, and Qin Tianzhu, a bird-and-flower painter who studied with Tan Changrong.

Invitations to the opening ceremonies had been extended to painters throughout the country. Of necessity, Li Huasheng was invited. But subsequently, he was politely told he had better plead illness because of his current reputation. Although angry and insulted, he wrote back that he was away doing painting studies. An inaugural exhibition of 275 works was displayed, about a quarter of which were calligraphic pieces.[70] Li Huasheng's works were excluded.

At the same time, however, Li Huasheng had his own opening. Adversity did not impede his creativity; indeed, an expanded visual repertory characterized his work in the spring and early summer, done in preparation for this one-man exhibition. Two new themes were introduced, both associated with the ancient Daoist ritual mode of retirement from troubles by fishing in the pure stream (figs. 80 and 81). The first of these visual themes he generally titled *Finding Coolness for Oneself in the Midst of Deep Shadows*. The title could not be more apt, with its implications of transforming dark adversity into personal satisfaction. It includes, says Li, the concept of taking satisfaction in one's own talent, so that it will not be necessary to rely on the strength or protection of others. One of the early paintings in this series bears an alternative title, *Return from Fishing* (fig. 80). The fisherman of the painting, like the artist himself, is there to enjoy the scene, the pure delight of smooth, simple, rhythmic lines and black, splashed dots. Although the artist was still in hiding at Longquan, nowhere in the flowing architectural lines or in the cool green and brown hues set on pure white paper is there a hint of Li Huasheng's deeply troubled world.

In the other work as well, *Springtime: Fishing in the Stream* (fig. 81), the only reality is artistic: a blue and purple fantasy held together by a stretch of bold, black, impossibly long lines. Painted just after his return to Chongqing, it suggests the isolated freedom of fishing. "In this painting," says Li, "with the feelings of a hermit, I tried to find some pure land." The foreground and background land masses, separated by water but visually linked by trees, clearly recall a composition made popular in the age of the Mongol con-

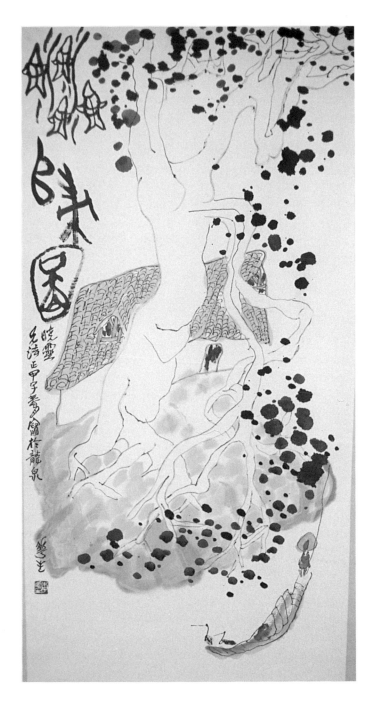

80. Li Huasheng. *Return from Fishing.*
Spring 1984. Ink and color on paper. Collection of the artist.

81. Li Huasheng. *Springtime: Fishing in the Stream.*
Early summer, 1984. Ink and color on paper. 138.7 × 69.9 cm.
Private collection, United States.

querors (late 13th–14th centuries) by several hermit-artists, including the reclusive painter Ni Zan at the end of that period. In those paintings, the separation of land masses referred to the painters' isolation from public life at that time; the trees, to the noble, stoic acceptance of that condition. But Li Huasheng is no Ni Zan. Ni was all forbearance and restraint; his paintings were as placid as the water itself, and his humble trees never quite brought near and far together. With Li, the black, angry force of his energetic tree dominates the painting, asserting a protective covering for Li's innocent fisherman and his rustic abode. Yet it was never Li's intention to submit quietly, like a fisherman, to the efforts of those who would isolate him. Like his tree, which reaches out fully to the distant shore and grasps it almost like a claw, he refused to let go of his place in Sichuan's painting circle and instead fought back with a challenge of his own.

These images should not be treated as deliberate symbols, for the artist himself was never fully aware of them as such. Rather, they are best seen as an expression of the artist's personality and inclinations, spontaneously generated when working with subjects and themes that had long served to personify such situations. While the painting's color scheme—somewhat decorative in appeal—may have been intended to attract Li's exhibition audience, its vibrant combination of purple, blue, brown, and green, and the dramatic thrust of its black tree branches was more likely viewed as bold and impulsive, even as somewhat outrageous, a vivid projection of the artist's character.

Li Huasheng's exhibition at the Du Fu Thatched Hall Exhibition Gallery in November 1984 was his first one-man exhibition. Most of the paintings shown were small pieces, still unmounted owing to his limited financial circumstances. Many of those who came to the exhibition, particularly foreign visitors from Japan, offered to buy the paintings even as they were still being laid out on the tables for hanging. But sales had not been Li's intention, and at first he refused. Afterwards, as the requests continued, he agreed to sales in order to demonstrate his popularity to the other artists and art administrators.

Sales had typically been poor at the Du Fu Thatched Hall Gallery. Liu Han, in his exhibition, had sold only one small piece (for 250 Chinese dollars) in a one-month exhibition. Indeed, sales had been so disappointing that the administrative head of the Du Fu Museum, Chen Chaoying, was not confident about holding another one-man show and had to be persuaded by Tan to do so. The gallery had room for the display of only sixty works at a time, but Li Hua-

sheng had submitted a hundred unmounted works. Now, as Li's works were sold, new ones were hung in their place. After ten days, more than half of the works were sold and, in most cases, were removed immediately by the foreign tourists who bought them. Although the exhibition was originally scheduled to last fifteen days, Li and Tan Tianren decided to close the exhibition because so few works remained, and because Li wanted to keep these for himself. Tan Tianren says Li Huasheng's sales set a gallery record. Smaller pieces were sold for 500, 600, and 800 Chinese dollars, large works for between 1,000 and 2,000 dollars. Li was given 30 percent of the sales income, an enormous amount of money for him. Two of his works were stolen.

The exhibition also attracted many of those artists who had been invited to the Sichuan Painting Academy opening. Among them was Lu Yanshao (b. 1909) of the Zhejiang Academy of Fine Arts, who had come in October with his entire family to sketch the local scenery and was visiting with Tan Tianren. According to Tan, Lu had heard of Li from the Nanjing-Beijing ten-man show in 1981. Although he had seen Li's works only in the exhibition catalog, he claimed to have found them "exciting." Before attending this exhibition, he arranged with Tan to meet Li at the Jinjiang Hotel. Li requested a painting from Lu, which was sent to him later and is still in Li's collection. Afterwards, Lu Yanshao viewed Li's exhibition and reportedly told Tan, "I still find his works exciting."

Li's Du Fu Thatched Hall exhibition was planned with the Sichuan Painting Academy in mind. His intention was not lost on those artists who attended. Shi Qi (b. 1939) of the Beijing Painting Academy, whom Li had met in the previous year in Beijing during his hasty appearance at the Liu Haisu exhibition, and who had attended the opening ceremonies of the Sichuan Painting Academy, urged Li to persist in his efforts to get into the Academy. Li says that Tan Changrong also urged him to pursue membership, claiming that it was necessary in order to strengthen the artistic reputation of the Academy. Support also came from another source, closer to the center of things: at the time of the exhibition, Li Huasheng was provided living quarters at the Sichuan Provincial Military Region Reception Hall in Chengdu under the aegis of Qin Dengkui. Closely associated with Chinese defense minister Zhang Aiping, Qin had left the military to serve as vice-president of the Chengdu Painting Academy; he then joined the army again as chief advisor to the command unit of the Sichuan Provincial Military Region. Qin had also just become one of the vice-chairmen of the new

Sichuan Painting Academy and he, too, urged Li to keep up his efforts. At the time, Qin arranged for Li to do some paintings for the military reception hall, where they are still preserved today.

By the end of 1984, the case against Li Huasheng had failed to produce confirmation of any of the charges leveled against him. But, unlike the West, such cases are often not simply closed, even when they run out of momentum. The rectification movement itself, begun in 1983, had already been formally ended. But its victims lay strewn about, entrapped and vulnerable to continuing rumors generated by opponents. Li's case had still not been adjudicated in January 1985 when, rather than improving, things took another turn for the worse. In the first days of the new year, the Nanjing youth magazine *Zhu nin chengcai* (*Wishing that you become accomplished*) revived all of the old rumors about Li Huasheng and added a few more of its own. An article entitled "The Fall of the Painting Circle's 'New Star' " (written by a student named Tang Tao, of the Jiangsu Provincial Television Correspondence School) announced that Li Huasheng—the art circle's "shooting star" turned "sex fiend"—had been imprisoned. Reporting "exactly" when Li had been apprehended, the article included a cartoon showing him in the custody of an armed guard (fig. 82).[71] This article was longer than any of those published in the prior year.

It began:

> On a morning when the air was clean, the happy news spread through the mountain city like a spring wind: the former standing committee member of the Sichuan branch of the Chinese Artists Association, vice-chairman of the Chongqing Municipal Artists Association, and artist in the Chongqing Sailors Club, Li Huasheng, due to his long-term seductions of women, his everywhere playing the shameful role of "third party," and his licentious breaking up of other people's families, has been arrested! A pair of gleaming handcuffs struck together like a funerary bell tolling for this arrogant "artist." Possessing a certain national and international influence, this younger generation painter with a promising career in the painting circles, this shooting star who appeared like a flash in the art circle only to quickly fall into the deep valley of criminality, was arrested, causing many of those who knew him to sigh with surprise.

The article continued with a long account of Li's ascent and shameful fall from grace—surpassing the earlier articles in detail as well as in errors. It told of how Li "had wanted to

82. Shi Yingshao. *Li Huasheng Incarcerated.*
(After *Zhu nin chengcai*, January 1985, p. 40.)

become an actor, had an impulse to study operatic theory," but "beginning with the study of woodblock printing" [*sic*] had gone into art instead. While crediting his "earnest study" and "great progress" during the Cultural Revolution, it accused him of being "weak in character." It blamed the social disturbances of the already discredited Cultural Revolution with having "infected him with many terrible habits, selfishness, and an extremely egotistical outlook, causing him to think that he could satisfy his own desires without regard to means." Tang Tao then reiterated the earlier tales of Li's pursuit of money and women, added charges of alcoholism, and managed to transform Li into the night stalker of Chongqing:

> This frequent success caused this beast in human clothing to become increasingly aggressive. His appetite became greater, his means became more clever, and everywhere he pursued and hunted his "targets." In less than a year, boasting and cheating, using all kinds of tricks, he seduced, fondled, and had adultery with several women workers. . . . At that moment, all over Chongqing appeared the shadow of this sex fiend.

Like the previous authors, Tang blamed the Chongqing branch of the Shipping Administration for failing to do anything more than record a demerit in Li's file (which in fact never occurred). But then Tang provided a fitting conclusion of his own:

> No matter who you are, no matter how powerful, if you violate the law, sooner or later you must be punished according to the law. This criminal rascal who went by the label of a "younger generation painter," concealing his corrupt soul and carrying out corrupt activities, seizing other people's wives and daughters and breaking up their families, was finally thrown in chains into prison. This fall of the artist circle's shooting star was just like the blossoming of a rose which in a glance turns into dust. This writer considers that the legal punishment of this criminal rascal Li Huasheng, as a warning to those who would copy him, will truly be applauded. ·

Within days, *Zhongguo bao kan* (*Chinese publications abstracts*), published a synopsis of this article.[72] And reportedly, later in the year, these charges were included in a book of collected law cases entitled *Headed Toward the Abyss*, published for a youthful audience as an example of justice meted out to those who indulged in antisocialist immorality.[73]

Li Huasheng feels that Tang Tao's *Zhu nin chengcai* article, while further endangering Li's reputation nationally, showed to many that the campaign against him had been based on nothing but rumor all along. Li Shugin, senior editor of the Hong Kong newspaper *Wenhui bao* who at-

tended Li's Du Fu Thatched Hall exhibition, had already composed an article about Li, ready for publication. Because Li was still free, Li Shugin also published a photograph to underscore this fact. Li soon wrote to Tan Tianren, "Don't worry about me. The trees want to stand upright, though the wind still blows hard." He also told Tan that he planned to sue *Zhu nin chengcai*.[74] He even enlisted a lawyer—rarely done in China—named Guo Danxia. The next day, he wrote of this intention to the journal editors. And just a few days later, on January 26, the Shipping Administration—obliged at last to succumb to such external pressures or resist—finally joined in Li's defense. They concluded in a letter directed to the publishers of the journal that Li's actual offenses were limited to one, the adultery with Xiao Banghui, and "strongly protested" that all other claims made against him by Tang Tao were false. They denied that Li had ever been arrested or that any demerit against him had ever been placed in his file. They issued a challenge:

> With regard to Tang Tao's intentionally created rumors to attack Li Huasheng and the problems of this, we believe that you know and understand the laws. . . . You publish a magazine called *Wishing That You Become Acccomplished*. Do you really wish others to become accomplished or to destroy our accomplished people? How should this be rectified? Please give us your immediate reply.[75]

The reply from Nanjing, indeed, was immediate. On January 30, the editorial board responded in writing to Li Huasheng, admitting that they had rushed this article into publication in the face of a deadline and "did not thoroughly check the details." They confessed to being "negligent in this regard." With claims of having only the best intentions and with apologetic offering ("we ourselves deeply lament your experience"), the editors noted that since "*Chinese Law Journal* is acknowledged as the authority in the area of law, we did not check the facts with the Yangzi Shipping Administration and other relevant units." They did not attempt to account for Tang Tao's detailed description of Li Huasheng's arrest. Finally, however, they agreed that the "mistakes must be corrected" and assured that "we want to carry out our responsibility to clarify the facts in our publication."[76]

As a result of ensuing arrangements made in Li's behalf by his lawyer, Guo Danxia, the following issue of *Zhu nin chengcai* (March-April 1985) publicly clarified the facts of the case. Li, however, was not satisfied that the details were complete and had Guo demand still more of the editors, persisting for another year until a final agreement was reached in April 1986. The journal thereby formally agreed to correct publicly any further details not already rectified in

83. Li Huasheng with Ai Weiren.

their second 1985 issue, such as the fabricated details of Li's arrests, with his handcuffs striking together "like a tolling bell." They acceded to Li's insistence that this retraction be published as a signed statement by Li's lawyer, thereby denying the journal any last chance to save face in the matter. The publishers also agreed in writing to "establish [internal] regulations to prevent similar errors."[77]

After its formal abandonment, the Campaign Against Spiritual Pollution soon came to be openly discredited, at least by China's intellectuals. In December 1984–January 1985, just as the *Zhu nin chengcai* article was being prepared and released, an eight-day Chinese Writers Association conference "marked the party's most liberal stance toward the arts since before Mao's 1942 *Talks at the Yan'an Forum on Literature and Art.*"[78] This meeting was highlighted by Hu Qili's opening address, which declared:

> The writer must think for himself, to have full freedom to choose subjects, themes, and methods of artistic expression, to have full freedom to express his own feelings, excitement, and thought. . . . The cadres sent by the party to the literature and art associations are good comrades, but they don't understand much about literature and art and have harmed the relationship between the party and literature and art works.[79]

Essentially, these remarks differed little from the more positive remarks found in Deng Xiaoping's "Speech Grant-

ing the Fourth Congress of Chinese Writers and Artists" of October 30, 1979,[80] except that Deng's words were directed against those in charge of the Cultural Revolution and Hu's were directed against those operating within Deng's own administration. Conspicuously absent from this important conference were Propaganda Chief Deng Liqun and Hu Qiaomu, Central Committee Political Department chief of ideology, said to have designed the Campaign Against Spiritual Pollution. As the primary targets of the campaign emerged intact, it became increasingly possible to defend those lower-level victims through whom the attack had been directed. The *Zhu nin chengcai* article had overexposed the bias of the attackers. At this stage, it was no longer feasible for Li's enemies to hold out against those who felt justice had already been done, or overdone. According to Li and his friends, the two who helped most to save him were Niu Wen—who insisted that Li's problem was strictly personal, not political, and who refused to cooperate with the journalists' investigations—and the military figure, Ai Weiren.

Ai Weiren (fig. 83), who had known and appreciated Li and his art since the summer of 1979, was then deputy political commissar for the Thirteenth Army[81] and member of the Chongqing Municipal Party Standing Committee. His authority carried great weight, and he was able to influence matters with a mere suggestion. Ai says he told the head of the Chongqing Party Propaganda Department, Liu Wenquan, "Although you have said there are problems with Li

Huasheng's painting, I can not see where there is any problem." Li Huasheng, Ai now believes, "got into trouble because there were exaggerated rumors about his behavior. But I have a head of my own on my shoulders and I could see this. I know this also from his paintings, which only show the beautiful scenery of Sichuan. At a meeting of some officials, I was able to persuade them by just telling them that there really was nothing wrong with Li." A figure like Ai Weiren can afford to suggest that the role he played was small and that he was merely speaking for the masses, the majority. "Any persuading of the officials," he says, "was simply based on facts. This was society helping him, not me."[82]

Ai Weiren's viewpoint finally had to be accepted by the Shipping Administration and by the Chongqing Cultural Federation. Today, Lü Chaoxi, chief of the Federation's administrative offices, also says that "Li Huasheng's problem was only a matter of sexual misconduct, not a matter of his art—he is a very talented painter—nor of politics." He even goes so far as to claim that Li's problem "was unrelated to the Campaign Against Spiritual Pollution."

Yet, as of this writing, there still remains Li Huasheng's official dossier (dang'an), held inaccessibly at his working unit, which has yet to be fully expunged of these erroneous materials. In some future ideological campaign, in the wrong hands, the same baseless charges can be used again.

Journalist Yuan Guanghou is a polite, frail-looking man who, according to Li's friends, was himself persecuted, labeled as a "rightist" in 1957, and subsequently "sent down" to Tibet. Today he says he hasn't heard anything or even thought about Li's case for several years. He now claims that Li's case was not related to the Campaign Against Spiritual Pollution, was not even an ideological problem; it was merely a matter of personal misconduct brought to his attention by members of Li's work unit. Yet Yuan also claims, "All the facts are basically correct. I didn't interview Li, but I based the article on the facts and checked the facts with all of the related units. China is a very moral country. If someone misbehaves, it must be reported and the masses will oppose him."

Li Huasheng's painter-friend Dai Wei believes that, among the artists in Sichuan, Li was the major public target. He notes, however, that there were other artists who received less conspicuous but even worse treatment. Some painters, for example, were imprisoned for having used nude models. Another of Li's friends who was best able to view the internal machinations of the case is convinced that Li was merely being manipulated by opportunists who would have liked to strike still higher up, at Niu Wen:

Niu Wen was one of the targets because he was number one in the Chongqing artists circle. Those who were dissatisfied with him just used this opportunity to try to catch him. Li Huasheng was a target because as a young artist he stood out, and because Niu Wen valued him and tried to promote him. Those who were jealous of him just used this as a good opportunity to turn him down.

Xiao Banghui, gentle in character but intelligent and self-determined, recollects:

From the beginning to the end, countless people put pressure on me, asking me if this love affair was of my own free will. I told them I'm over thirty; I'm not thirteen.[83] I never said one bad word about Li Huasheng. From the beginning I was very straightforward and did not try to hide anything. Naturally, in China one cannot be so straightforward. But in my whole life, Li Huasheng is the only one I have admired so much, because of his complete and total dedication to his art. Because I understand the realities of the artistic circle, which Li Huasheng's wife did not, and knew that this would affect not only us personally but Li Huasheng's entire career, I admitted that I was completely responsible for this. I told them Li Huasheng played a very passive role. Because I was truly in love, I had to protect Li Huasheng.

Xiao describes Li as "truly eccentric" and says that if Li had not recovered his career, she would have "regretted this forever."

Although the court granted her request for divorce and gave custody of one daughter each to Xiao and Chen Ji, Chen refused to let either her or the children go. But after the *Fazhibao* article was published in February 1984, she challenged him defiantly and finally walked out with both children, then ages fourteen and sixteen. Xiao's parents were both dead, and she had no means of support. For four years after her separation from Chen, she lived in a tiny room, about twelve feet by twelve feet, with both of her daughters. All three slept on the floor. Chen Ji actually left a will with his work unit stating that he hoped Xiao would commit suicide. Xiao, in fact, was often deeply depressed to the point where this was a possibility, and she remembers her younger daughter kneeling beside her, begging her never to commit suicide. Only in 1987, by which time one of her daughters was in college and the other in high school, did Xiao finally obtain better housing. Although divorced and single, she is permanently forbidden by the court's decree from seeing Li Huasheng again. Xiao is probably the one who suffered the most from this affair. She says:

Life in China is terribly bitter. Really, our love affair was so simple. If you can have just one true love affair in life, that is special enough. But now we just try to survive. It is all past, but naturally I cannot forget it. I almost died.

As for Li Huasheng, he refers to the Chinese term for jealousy, *hongyan bing* or "red-eye disease." "Jealousy and blame," he says, "are a disease that infects China. In China, if you criticize someone or say he could do better, he will store it away in his mind until he gets his revenge." Just as the journalist Tang Tao blamed the Cultural Revolution for leading to a breakdown in Li Huasheng's morality, so does Li blame that period for a breakdown in China's moral standards:

The Cultural Revolution taught the Chinese people to fight. The writers' circle couldn't get themselves an exception to this, and it was also the first thing we artists learned. So now we fight. The second thing we learned was to lie. In the Great Leap Forward, there was a photograph of a field of wheat growing so densely that everybody was able to walk on top of the wheat. Since a newspaper provided this photo, everyone actually believed it. The government should lead the people to be strong and prosperous, not trump up charges against them.

Li Huasheng expresses deep regret over his divorce and the difficulties he caused to his first wife, who has never remarried. These problems, he says, are "probably resolved politically, since they were not a problem of me personally anyway, but they are never resolved emotionally." His words are wry, laconic:

When you're attacked in China, it's not like other places. If you try to get a lawyer, even your lawyer will attack you. You become confused. It's like the sky is falling. You become completely isolated. The only way out is to commit suicide. But if I'd committed suicide, I would not have been able to fulfill my painting career.

CHAPTER 7

Laurels Restored, the Artist Academized, *1985–89*

Artists, as a group, have become part of the political elite.

They are loath to give up the attendant privileges.

—Miklós Haraszti, *The Velvet Prison*[1]

When I didn't have food to eat, you could buy even eight of my

paintings for only a dollar. But if I have a little food, I can ask

whatever price I want. Now that I already have plenty of food, I

refuse to sell any more.

—Li Huasheng

BY THE TIME HIS DU FU THATCHED HALL EXHIBITION was concluded, a resounding success, Li Huasheng had a single remaining professional goal aside from the continued improvement of his art: to gain entry into the new Sichuan Provincial Poetry, Calligraphy, and Painting Academy. Academy director Yang Chao, says Li, "set up the Painting Academy to accept only young painters, something I dreamed of being part of even before I was vice-chairman of the Chongqing Artists Association. The older generation has already been sifted through; now it's the younger generation's turn." Not just *their* turn, felt Li, but *his* turn. He had not risen this high from lower-class obscurity, largely self-educated, through any lack of ambition. By the end of this period, Li Huasheng—always a dissenter, always the purist—would find himself disenchanted with associations and academies, no more satisfied with success than he had been with artistic anonymity. Once attained, professional success would no longer matter. Artistic quality, alone, would count. And by the end of the decade, even the whole matter of artistic standards, like China's artistic future, would seem as uncertain as artistic acceptability once had.

The overreaching article published in *Zhu nin chengcai* in January 1985 and the Shipping Administration's immediate, uncompromising response seemed to break through the stigma that had hung upon Li Huasheng for well over a year. By the time the attack on Li could go no farther, the cultural rectification campaign was over and at least partially discredited. The backstage supporters of tolerance proved to have the majority on their side. Li's own fighting spirit seemed to assure that nearly everyone backstage would be willing to help "rehabilitate" him. Yang Chao invited him to contribute five paintings to a group painting exhibition jointly sponsored by the fledgling Sichuan Painting Academy and the Chengdu Painting Academy, to be held in the summer of 1985 in Shenzhen, China's gateway to Hong Kong and the outside world.

Even Li Shaoyan was prepared to be helpful. In the

words of one of Chengdu's senior artists, "As the ruler of the Sichuan art circle, Li Shaoyan can handle any situation. Since his attack on Li Huasheng failed, he reversed his position readily, turning an enemy into a friend." In July 1985, Li Shaoyan and the Sichuan Provincial Artists Association went all-out in their efforts, sponsoring a solo exhibition by Li Huasheng in Chengdu at the Sichuan Provincial Exhibition Hall.[2] Li Shaoyan himself wrote the preface to the exhibition brochure, describing Li as "self-taught and developed . . . creative in spirit . . . pursuing his own artistic language." Retired Sichuan Communist Party first-secretary Tan Qilong wrote the title displayed outdoors: "Li Huasheng Painting Exhibition. [signed] Tan Qilong." Yang Chao, director of the Sichuan Painting Academy, wrote the title displayed in the exhibition hall. Although Yang Chao was hospitalized and missed seeing Li Huasheng's exhibition, Li visited Yang's home afterwards and presented him with a pair of paintings from the exhibition.

The exhibition was reported by the Sichuan television network as a local news event. Their footage was then passed on to the national network, which aired it twice. While Li was in Chongqing, Chinese Prime Minister Zhao Ziyang, returning to Sichuan, reportedly visited the Provincial Exhibition Hall where he saw and praised two paintings by Li Huasheng. He did not ask for them, but the manager of the exhibition informed Li and obtained his agreement to present them to Zhao. One of the works presented, entitled *Many Torches among the People Illuminate the Local Customs on the River* (fig. 84), shows men with baskets catching eels, attracting them at night by the light of torches—a good example of art reflecting detailed knowledge about the life of the masses and the kind of work most likely to catch the eye of a politician.

In all, the exhibition was an extraordinary success for an artist so recently held in disgrace. The public support of Li Huasheng by Li Shaoyan, Yang Chao, Tan Qilong, and even Zhao Ziyang could hardly be resisted. Yet there were still those who regarded Li's maneuvers as brash, and several Sichuan painters wrote a letter opposing Li's entrance into the Sichuan Painting Academy. Yang Chao, on whom this decision would ultimately depend, derived his stature from lofty positions he formerly held in the Sichuan Communist Party. He stood above and somewhat apart from the arts administration and its conflicts, and he was free to reject the advice of Li's opponents. Still, it was not Yang's purpose to alienate whole factions within the artistic community but rather to build support for his new academy. He recognized the need to advance cautiously. Tan Qilong, for his part, advised Li to improve his relationship with the older artists.

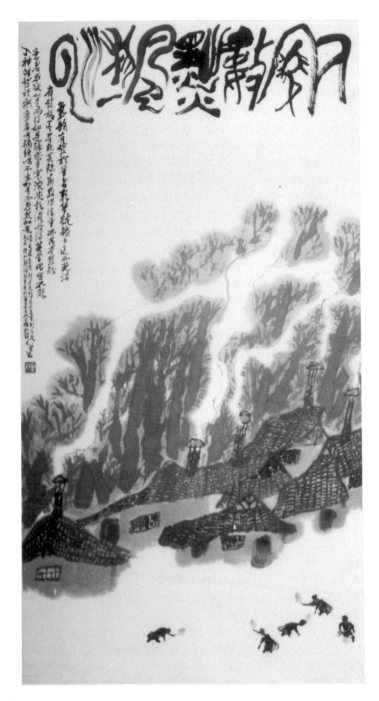

84. Li Huasheng. *Many Torches among the People Illuminate the Local Customs on the River.* Ink and color on paper. Collected by former Prime Minister Zhao Ziyang, Beijing.

Li Huasheng knew better than to discuss the matter of joining the Painting Academy with Yang Chao directly. But anticipating the fact that joining would require a change in his work assignment which would have to be agreeable both to his old and new units, Li decided to eliminate one possible obstacle. He sought in advance the support of Xu Zhigao, the recently appointed Shipping Administration Party secretary who had handled Li's case with fairness. Reportedly, Xu said politely that he did not want to part with Li but acknowledged that for Li's artistic future, it would be best if he were able to get into the Academy.

Shortly after the Chengdu exhibition, Li's name was added to the list of possible new entrants into the Painting Academy. In October 1985, it was formally agreed that the Shipping Administration would "loan" him to the Academy, as they had previously loaned him to the Chongqing Artists Association. He would join the Academy but only for the time being, on a temporary or acting basis. According to Li, the central role in arranging for his loan was played by Qin Dengkui, who had supported Li in the past and then, as vice-chairman of the Painting Academy, was in charge of daily affairs.

At the same time as this long agreement was being made, Li's second marriage—in 1984 to an administrative clerk, and described by acquaintances of Li as a difficult and argumentative relationship—quickly fell apart. Li's move in the autumn of 1985 from Chongqing to Chengdu coincided with this divorce, as well as with the loss of his collection of folk art, which his second wife retained in Chongqing.

No sooner had Li Huasheng moved to Chengdu— "moving up" in the view of many Chongqing people, to the political, cultural, and jobs capital of southwest China—than he was traveling back to Chongqing to fulfill an earlier mission and to secure an honor denied him in an earlier era. In 1978, Bai Desong of the Sichuan Academy of Fine Arts in Chongqing, with the support of Academy vice-president Ye Yushan,[3] had proposed to invite Li Huasheng and another landscapist, Qiu Xiaoqiu, as honorary, nonteaching faculty members, but their efforts were blocked. "The basis of opposition," says Bai Desong, "was the concept that he is an amateur, not academically trained—a 'country painter.' " Socialist egalitarianism was nowhere to be found in this post-Cultural Revolutionary situation. Hoping that Li might someday serve as a visiting teacher despite his lack of classroom experience, Bai and Yeh arranged for a solo exhibition in October 1985 to promote Li's reputation and to win a favorable response from faculty and students.

At the exhibition opening, on October 5, Li was given a much-delayed honorary membership at the Academy. Li remembers that (as usual) he arrived about twenty minutes late to a welcoming crowd of students who filled the spiral stairs in the main building. The Academy president presented him with an honorary certificate of award, followed by some obligatory comments and then by a public painting demonstration. After the exhibition closed, Li contributed a pair of paintings to the Academy's collection. Bai has said that the response from students was overwhelmingly positive but that the faculty remained mixed in its opinion of this "outsider." There was political as well as artistic opposition. Li's public painting demonstration was scheduled to be preceded by a demonstration on Chongqing television, but before it took place, the station managers were called by Liu Wenquan, head of the Chongqing Party Propaganda Department and the first official publicly to criticize Li in 1983. Liu Wenquan reportedly questioned why a one-man show for Li Huasheng should be held at all, why he should be made the only honorary professor in the Sichuan Academy of Fine Arts, and why he should be given such television exposure. Undaunted, the station management replied that the demonstration was an internal matter and proceeded with the scheduled program.

From Chongqing, Li traveled to Wuhan to an Invitational Exhibition of Traditional-Style Innovative Works, held from October 21–30, 1985. Organized by Zhou Shaohua, the exhibition featured a ten-day symposium on the future goals of Chinese painting.[4] The twenty-five invited symposium participants, mostly but not all younger artists, worked within a framework (in Li Huasheng's words) of being "radical but still in the tradition of not being too abstract . . . at the crossroads of conservative and new experimental styles." Among them were Zhou Sicong, Gu Wenda, Shi Hu, Liu Jimin, Li Shinan, Jia Youfu, Yang Yun, Wu Guanzhong, and the Taiwan–Hong Kong artist Liu Guosong (then teaching at the Chinese University of Hong Kong). According to Li, the audience response was spirited:

There were lots of arguments and debates at that conference. There was a book there to record audience opinions and comments, which was very interesting. I was told later by the editor that the comments and opinions were published and that most of the opinions were critical. Some of the audience wrote that the paintings were childlike and naive, done by people who didn't understand art, that they were a waste of paper and ink, and some of the writers even wanted to spit on the paper. I myself witnessed some conservative officials, guided by some conventional artists, criticizing and cursing some paintings and directing questions against the artists.

Younger artists like Li Huasheng and Gu Wenda still remember the symposium as a major moment in their artistic lives. But Li's participation was limited to the first three or four days, cut short by a still more important moment in the making. An invitation for Li to travel to the United States, as the guest of the University of Michigan's Center for Chinese Studies, had been arranged by the center's director, Professor Kenneth DeWoskin. As the symposium convened, DeWoskin arrived in Chengdu to discuss the trip with the Artists Association, which sent a telegram calling Li back immediately. Such a proposal could hardly be dealt with quickly. But, according to Li Huasheng, it could only have helped his chances of joining the Sichuan Painting Academy that his sole major obstacle, Association chairman of Li Shaoyan, saw this as an opportunity for himself, hoping he might be able to join Li in traveling to America.

In November 1985, the Sichuan Painting Academy held a first anniversary exhibition. At the time, retired provincial Party secretary and member of the Sichuan Party's standing committee, Tan Qilong, offered discreet but unmistakable support for Li's hopes of membership in the Academy: "I've gone through the whole show, and I still think Li Huasheng's paintings are best. This cannot be denied." Shortly afterwards, as a grand anticlimax, Li's full formal acceptance into the Painting Academy was finally approved. He became the Academy's fifth member after the two initial memberships, landscapist Liu Pu (fig. 95) and bird-and-flower painter Qin Tianzhu (fig. 96), and two others who followed, figure painter Yuan Shengzhong (fig. 99) and the tiger-painting specialist Zhang Shiying (fig. 97).

As a result of his prolonged efforts to penetrate the exclusive circle of Chinese academia, Li in no way underestimates the fact that, in 1990s China, success in painting and the attainment of artistic prestige is a highly competitive social affair. Like it or not, he suggests, the artist must also be a warrior:

> Life in artistic circles is just like a battle. You must engage your rivals before you can win. Without rivals, without competition, it doesn't make sense. You must rise from the county level to the provincial level and then to the national level before you can think about the international level.

Li Huasheng's formal acceptance into the Sichuan Poetry, Calligraphy, and Painting Academy, on January 25, 1986, brought him for the first time into the center of the Sichuan art circle, something even his brief months of administrative activity in Chongqing had not done. His arrival in Chengdu

brought him into regular association with a new group of colleagues. At the top of the political hierarchy was Li Shaoyan (fig. 16), whose change of attitude toward Li Huasheng in the summer of 1985, from disdainful and antagonistic to cautiously supportive, made all the difference in Li's bid for this invitation.

Li Shaoyan has, claims Li Huasheng, "the power of life and death" over Sichuan's artists.[5] This description might seem more literal than figurative to Lü Lin (fig. 85), a senior Chengdu artist (vice-chairman of the Sichuan Painting Academy, vice-chairman of the provincial Artists Association, and advisor to the Chengdu Painting Academy) who helped introduce Li Huasheng to Chen Zizhuang, and to whom Li Huasheng has drawn ever closer in recent years.[6] The early struggle between Li Shaoyan and Lü Lin for leadership in the arts administration defined the terms of debate in Sichuanese cultural politics for almost four decades: Li Shaoyan as Party propagandist, journalism-based, woodblock specialist, firm advocate of socialist realism; Lü Lin as academician, multimedia artist (traditional-style painter, printmaker, sculptor, seal and ink-stone carver, and specialist in rubbings of Sichuan's Han dynasty tile reliefs), and advocate of loose administrative control. Their battle seemed settled in 1953 by Li Shaoyan's appointment as the regional Artists Association leader, and it was permanently sealed by Lü Lin's sentence to labor reform as a "rightist" in 1957.[7] But Lü Lin's subsequent promotion of Chen Zizhuang, and his close association with Chen's admirers during the era of Maoist "continuous revolution," signaled the survival of what Li Shaoyan could only have regarded as dissident factionalism.

In the 1950s and after, Lü Lin sometimes painted figures of Zhong Kui, an eighth-century exorcist of evil spirits at the imperial palace, whose later depiction was symbolically aimed at political villains ("ghosts") in high places. On some of these, he collaborated with Chen Zizhuang, and one he later gave to Li Huasheng. After the fall of the "Gang of Four," Lü painted a similar political theme, *Qin Gui is Dead* (fig. 86), in which the style of a woodblock carver is evident. Ostensibly this work celebrates the death of the twelfth-century, imperially sponsored assassin of Yue Fei, the popular southern Song patriot who had tried to bring native government, "good government," back to northern China. But actually, with a wine cup in his hand and a dunce cap like those worn by the "Gang's" victims, this joyous figure celebrates the demise of those radical Maoists. Mostly, however, Lü Lin painted more tame subjects, particularly Sichuan's provincial mascot, the panda bear. Chen Zizhuang once wrote in praise of him:

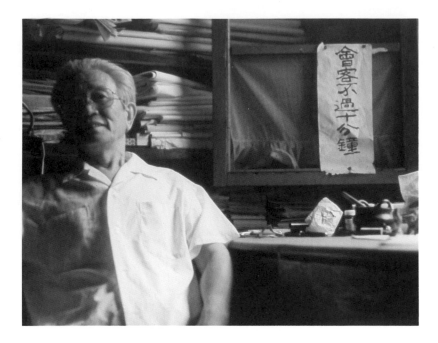

85. Lü Lin with his window sign, "No visitors for longer than ten minutes."

86. Lü Lin. *Qin Gui is Dead.* Undated. Ink and color on paper. Private collection, China.

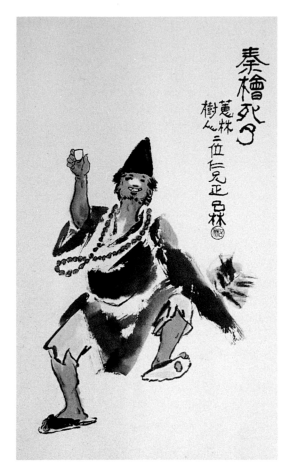

He is good in both sculpture and painting. Somebody suggested he is the best in the Sichuan Artists Association. His stone carvings imitating ancient style [i.e., Han dynasty reliefs] cannot be distinguished from the originals. His creative works are innovative and have a high artistic character. He's a real talent in his time. He treats people with extreme sincerity and especially gives me lots of support.[8]

Lü Lin is one of those who suffered the most by winding up on the "wrong" side of Sichuan's cultural politics. Today, while not exactly a recluse, Lü carefully protects his privacy, posting a sign on his window: "No visitors for longer than 10 minutes" (visible in fig. 85). But he is an animated speaker with strong convictions. Having watched Chinese artists and art administrators in action for more than five decades, he now claims, "I once didn't believe in the relationship between personality and artistic quality, but now I am strongly convinced of this." He rails against "fads" that promote artists like Zhang Daqian (Sichuan's most acclaimed modern painter, "whose taste," says Lü Lin, "is really low") and Fu Baoshi. "Sichuan art leaders," he claims, without referring by name to Li Shaoyan or other arts administrators, "don't praise the best artists. They praise the worst." Lü Lin is partial to Sichuan painting, claiming that "the worst artists today are in Beijing—they can't even compete with Sichuan artists." For Lü Lin, the best means artists like Chen Zizhuang, whose work he has held up as a standard for Sichuan's more moderate painters.[9] He is also fond of Li Huasheng's work, having collected several pieces by him and even contributed an article on Li to the *Chengdu Evening News* in 1985, in an effort to promote Li's candidacy for the Sichuan Painting Academy.[10]

Another leading artistic "moderate" with whom Li Huasheng became associated in Chengdu is printmaker and painter Wu Fan (fig. 87), who made a national reputation for himself in 1959, over Li Shaoyan's opposition, with the non-

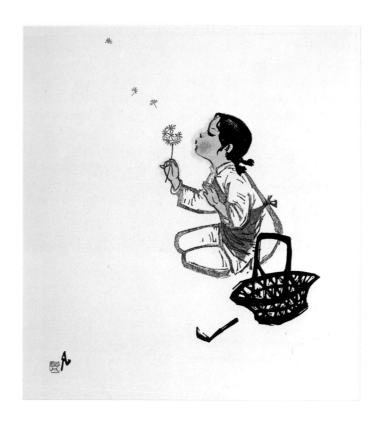

87. Wu Fan. (After *Chengdu hua yuan*, n.p.)

88. Wu Fan. *Dandelion*. 1959. Woodblock print. 55 × 34.8 cm. Unknown collection, China. (After *Sichuan banhua xuan*, pl. 39.)

ideological print *Dandelion* (fig. 88).[11] Advisor to both the Sichuan Painting Academy and the Chengdu Painting Academy, and vice-chairman of the provincial Artists Association,[12] Wu Fan complains about the dictatorial rule of the Artists Associations:

> Although theoretically meant to be organized by 'the masses' [i.e., the artists themselves], in reality they are just an officially constructed organization, with their budget provided by the government and their leadership installed from the top down— national, regional, and local.

Wu Fan was perhaps the first leader in Sichuan art circles to champion Chen Zizhuang's work, suggesting in the 1960s that two of Chen's paintings be included in an exhibition, a proposal which he says Li Shaoyan prevented. In the early 1980s, after being promoted to the vice-chairmanship of the Sichuan Provincial Artists Association, Wu began writing articles about Chen's work, which further aroused Li's opposition. Ultimately, says Wu, his support of Chen's art led Li Shaoyan to "force him out," in 1986, from his post as the Association's office vice-manager. In 1982, Wu Fan published the first book on Chen Zizhuang.[13] Lü Lin says Wu Fan's publication "could hardly be distributed. Even the

New China Bookstore [the Chinese government's nation-wide book chain] refused to order more than a few copies because they saw no readers for it and wouldn't help to send any to Hong Kong." Only 2,000 copies were printed for China's billion-plus population. But these few copies sold out almost immediately, so that Chen suddenly became noteworthy, at least locally. (Since then, remarkably, five more books have been published about Chen Zizhuang: one, a collection of his comments on art; the others, illustrative volumes with textual introductions of no more than five pages.)[14]

In contrast to Li Shaoyan, Wu Fan has great faith in the traditionalism of Chinese landscape painting. For him, the strength of Sichuan's painting lies in its traditional purity, protected geographically from too much foreign influence, and Chen Zizhuang best embodied this strength. For more than three decades in Sichuan, Lü Lin and Wu Fan kept alive the ideals of traditional Chinese painting, with its sense of artistic individuality, as a moderate alternative to socialist realism, thoroughgoing popularization, and strict artistic controls. But they were unable to provide much institutional support for their ideals. In Chongqing, in the post-Maoist era, Niu Wen (figs. 74, 75) was the first to provide

this support, favoring youth and reformation and recognizing the pivotal historical role in modern Sichuanese painting of Chen Zizhuang. And more centrally, in Chengdu, this reforming role has been thrust upon Yang Chao by reform-minded politicians less familiar with the details of Sichuan's cultural struggles but well aware of China's need for cultural renewal.

Yang Chao (figs. 89, 90) had joined the Communist Party early, in 1932, and was incarcerated for five years immediately afterwards. In 1937, he fled to Yan'an, where he studied in the Marxist-Leninist Research Institute and was subsequently appointed director of its Philosophy Instruction Department. After the end of the Japanese war, Yang Chao became Zhou Enlai's personal secretary and began a long rise to distinguished leadership positions in the Sichuan Communist Party.[15] Both well read and well published as a political philosopher,[16] Yang Chao was labeled a "right-wing Hegel" by Jiang Qing during the Cultural Revolution. Reportedly, he was criticized by the *People's Daily* because he supported scientists who studied human potential, to his sympathizers implying a recognition of human variability and individuality but representing a dangerously bourgeois notion to his enemies. Yang was as practical as he was philosophical, serving in the 1950s as Sichuan's Minister of Industry and earned a lasting reputation as China's chief pioneer in the use of methane.

Li Huasheng, never partial to officialdom, says, "You have to differentiate between officials. There are good ones and bad ones. Yang Chao is not typical. He has made a real contribution to the people." Li describes him as "a calligrapher who follows Yan Zhenqing [fig. 90], a painter who follows Chen Zizhuang,[17] an amateur philosopher who reads books, a man who has done all kinds of things." He has traveled internationally, to Germany, France, Italy, and the United States (Atlanta only). In conversation, he gives repeated and equal emphasis to art, the individual, and society. Li Huasheng describes in the most positive terms Yang Chao's hands-off administration and the trust that he places in his artists:

> All the painters in the Academy like him. He never asks what we are doing in subject matter. Usually, every one or two months, he views what all the artists have done.

There are other views. Lü Lin, for example, feels that Yang offers weak administative control because of his administrative background in the Party's loosely organized Political Consultative Conference, and he suggests that Yang has to rely too much on others' evaluation of painting quality because of his own lack of artistic expertise. Still, Lü Lin is

89. Li Huasheng with Yang Chao.

highly sympathetic to Yang's goals and asserts that such criticism is vastly different from his opposition to the central arts administration on moral grounds. Politically, Yang Chao has managed to weave an institutional organization that includes Lü Lin and Li Shaoyan, Wu Fan and Zhu Peijun, serving in largely honorary positions but all lending their authority to a younger generation of artists, most of whom regard themselves as adherents of Chen Zizhuang.

Among Chen Zizhuang's admirers in the new Academy is Guo Ruyu, director of the Academy office. Formerly an instructor at the Chengdu Painting Academy, Guo was persuaded by Li Huasheng to change positions so that the younger generation could function in the Academy's administration as well as in its painting membership. A specialist in birds and flowers who studied informally with Chen beginning in the late 1950s and who tried to lend aid to Chen in the 1960s, Guo can paint both in the meticulous manner of his early schooling (fig. 91) and in the free style of Chen Zizhuang.[18]

Another Academy artist once associated with Chen Zizhuang is a painter primarily of figures and horses, Peng Xiancheng (one of those artists who, with Li Huasheng, displayed their works for Vice-premier Deng Xiaoping in the summer of 1980; fig. 47, last figure on right).[19] Peng first met Chen Zizhuang during some of Chen's lecture-demonstrations given between 1962 and 1965 at a local

90. Yang Chao. Calligraphy. 1984. Ink and color on paper. Collection of the Sichuan Academy of Poetry, Calligraphy, and Painting, Chengdu. (After *Sichuan Sheng Shi Shu Hua Yuan,* n.p.)

91. Guo Ruyu. *Wild Ducks* (detail). Undated. Ink and color on paper. Collection of the artist.

92. Peng Xiancheng. *The Lute Song.* 1987. Ink and color on paper. 66.7 × 44.1 cm. Private collection, United States.

ings by Qi Baishi, Xu Beihong, and Zhang Daqian at an antique shop on his way to and from school, painting became his only expressive outlet. Working as a child in his family's laundry and dyeing shop, he painted all over the shop's wrapping paper, and in school he drew all over his textbooks. "No one in my family painted," he says, "but I was obsessed with painting. I just coped with classes, using my full time and energy to paint. Nowadays, I would say this was an abnormal mentality." The Cultural Revolution made a propaganda artist of him, allowing him to work in the Soviet style with bright colors. Not long afterwards, he discovered the Impressionists and Post-Impressionists, especially van Gogh and Gauguin, at Chengdu's Eastside Culture Hall, and he came under the lasting influence of their experiments with color. The cultural hall, where Peng worked in oil paints, gouache, and watercolors, also provided male models for his figural study.

Only since the mid-1970s has Peng Xiancheng practiced traditional Chinese-style painting, at first with an interest in modern Chinese artists like the "Shanghai school" painters Ren Bonian, Wu Changshuo, and Xugu, and then with a focus on more recent artists, Qi Baishi, Huang Binhong, and above all, Shi Lu. In 1980, he traveled to Dunhuang and farther west, toward Kashgar in Xinjiang province, copying more than seventy early Buddhist murals at Dunhuang. This changed the course of his art. Since then, Peng has linked his modern color sense to historically conscious improvisations on antique form, composition, and brush techniques: monumentally proportioned Tang figures, placed in sculpturesque arrangements free of background detail; pure color wash with little or no linear structure ("boneless" painting), found in many Buddhist murals and Tang dynasty tombs (figs. 92, 93). "I hide the line behind the colored surface," he says, "so that the line gives structure and sharpens the image, keeping it from seeming so flat. I like to pursue the conflict between color and ink. Color and line collide with each other and fuse, so that inside the 'boneless' there is bone." Other sources of inspiration for Peng's art range from Yunnanese bronze drums of the late Zhou period, to Tang "three-colored" funerary ceramics, to the modern minority arts and culture of southern Chinese sites such as Xishuangbanna and Liangshan.

Unlike most of his colleagues, Peng claims he does not take art as a serious professional job. He does it to relax, painting only when he is emotionally inspired. "If you are too serious," he says, "you suffer from it. I want to give viewers a sense of relaxation. I consider it important that painting should be spontaneous, that it shouldn't be done bit by bit, that it shouldn't be over-worked, because in that

cultural hall. In 1983, Peng Xiancheng organized the first one-artist exhibition for Chen's painting at Chengdu's Eastside Culture Hall, where he was then employed teaching children. Peng's sudden transition from a teacher of youth to a regionally and nationally recognized painter parallels Li's own ascent. Li Huasheng describes Peng as "a frank and honest person—I like him a lot," and he appreciates Peng's art more than that of most of his other colleagues.

Peng is entirely self-trained. Having lost his mother while an infant and being mistreated by his stepmother, Peng became so introverted that for years many thought him mute. In childhood, from the time when he began to look at paint-

93. Peng Xiancheng. *Song of the Beautiful Women: Prime Minister Yang Guozhong and the Yang Sisters.* 1987. Ink and color on paper. 33.3 × 95.9 cm. Private collection, United States.

way your energy will all be used up." But Peng's art can convey suffering, too, as in his *Lute Song* (fig. 92), after Bai Juyi's ninth-century lament in which the author (exiled, boating at night in the poem; shown grieving in the background of the painting) meets his alter ego in the form of a lonely wife, pouring her woes into heartrending music. The red-lipped beauty, cloaked in black shades of dignified sorrow; the poet, almost lost to the background; and the abstract, downward streaks of black ink intended figuratively as tears: all these convey the poetic lament. Like Chen Zizhuang's and Lü Lin's paintings of Zhong Kui and Qin Gui (fig. 86), these figures, too, serve as antique vehicles for conveying current feelings, expressing a modern air of political alienation. For his inscription, Peng reproduced a pivotal couplet from Bai Juyi's poem, proclaiming the bond between all those who suffer: "We, together, banished to the ends of the earth / Meet, and then what does it matter whether we were acquainted before?"[20]

Peng also depicted an extravagant outing by Tang emperor Minghuang's tyrannical prime minister, Yang Guozhong, and Yang's high-living cousins, the court ladies Guoguo and Qinguo, sisters of imperial concubine Yang Guifei, (fig. 93). This outlandish event, at a time of increas-

ing hardship among the people, was made infamous in 753 by Du Fu's biting poem, *Song of the Beautiful Women*. Du Fu ended his poetic masterpiece with this unforgettable description of an all-powerful official: "You can warm your *hands* on him, you can *scorch* them, so powerful is he / So beware not to come within range of this minister's angry glare!" Peng's illustration of this poem, which he inscribed in full on the scroll, points to Chinese government corruption not only long ago but also in our own time.[21] As with this poem, so too with the painting: Peng's work is partly old, an adept exercise in the formal balance of Tang-style composition and brushwork; and partly new, in its free interpretation of Tang-period fine-line brushwork, and in its bold and skillful handling of ink-and-color wash, from the wild green of a horse's ear to the subtle, almost erotic shading of hair along the female servants' neckline.[22]

A recent addition to the Sichuan Painting Academy is the artist Dai Wei. A child prodigy, Dai Wei was painting by the age of five, and soon afterwards his works were published in the Chengdu newspapers. At fifteen, in 1958, he first met Chen Zizhuang as a fellow propagandist, painting walls together during the Great Leap Forward. He first learned traditional-style painting from Chen and remains greatly

influenced by him, although in "spiritual" rather than stylistic ways. Eventually specializing in figure painting, Dai Wei served until 1989 as associate editor-in-chief and book designer for the Sichuan Juvenile Publishing House, producing covers for books by such prominent authors as Mao Dun, Ba Jin, Ai Qing, and Cao Yu. In February 1989, Dai gained national recognition with a one-artist exhibition at the National Gallery in Beijing. He was warmly praised in an exhibition brochure by Xue Yongnian, chairman of the Art History Department at the Central Academy of Fine Arts in Beijing.[23]

By virtue of his being an illustrator, Dai Wei's paintings are strongly thematic, and they are much more deeply and effectively imbued with humane, philosophical feeling than one ordinarily finds in today's figure painting. His favorite subjects are China's great writers and painters, like Zhuangzi, Du Fu, Lu You, and Bada Shanren (fig. 94), who are usually depicted as disheveled and distressed, in philosophical isolation or torment, as so many Chinese intellectuals have come to feel in modern times. His paintings often disclose subtle literary themes, such as his stiff, flat fish illustrating Ai Qing's poetic question, whether China's modern culture is anything more than a fossil. Dai Wei's best-recognized work today is a mural-sized set of hanging scrolls, entitled *Tolling Bell,* in which men and women of all races, clustered like a range of mountains and casting Bodhidharma-like stares, are awakened to the harsh reality of their modern condition. The question is, will they heed its warning?

The colleague whose work most closely resembles Li's own is Liu Pu, one of two original members of the Academy. A student of Feng Jianwu, he paints both landscapes (fig. 95) and figures. Liu Pu's reputation is one of the best established of Academy members.[24] In landscapes, his occasional stylistic similarity to Li Huasheng (compare fig. 103) is the result of influences derived by both painters from artists such as Chen Zizhuang (compare fig. 104; Chen's influence is also apparent in Liu Pu's bird-and-flower paintings) and Shi Lu. In a realm that is rife with artistic rivalry, Liu Pu and Li Huasheng have sometimes been paired off, if not by their own choice, then by critics and colleagues; one Academy member stresses the contrasts underlying their superficial similarity, saying that Liu Pu works from realistic sketches, which "he exaggerates just a bit, or rearranges just a bit," unlike Li, who "works from his own ideas and totally rearranges reality." Yet while Liu Pu's works are surely more stable and less theatrical than are Li Huasheng's, his landscapes are among the strongest of younger Sichuan artists.

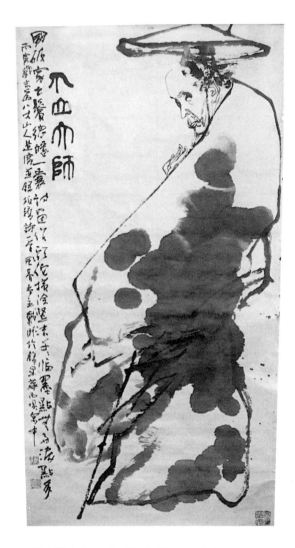

94. Dai Wei. *Portrait of Bada Shanren.* Ink on paper. Collection of the artist.

The other original Academy member is Qin Tianzhu, from a family in which a whole generation of brothers has achieved a painting reputation. Qin learned painting from an older brother, Qin Tianlin, and from Tan Changrong, both of whom are well-known faculty members at the Chengdu Painting Academy. Still, as with many of the Academy's artists, Qin's artistry was a belated discovery: at age thirty-two, he was still just an accountant in a vegetable distribution company.[25] He sometimes paints landscapes and figure paintings, but mostly he creates bird-and-flower paintings (fig. 96), stylish in their design and skillful in their handling of color, with references not only to such earlier

95. Liu Pu. *Quiet River, Distant Ferry.* Undated. Ink on paper. Collection of the National Art Gallery, Beijing.

96. Qin Tianzhu. *Bird.* 1988. Ink on paper. Collection of the artist.

modern painters as Ren Bonian, Xugu, Qi Baishi, and Pan Tianshou, but also quite clearly to Chen Zizhuang.

These artists reflect something of the quality gathered by Yang Chao into the new Sichuan Painting Academy, and suggest the belated ascendancy of Chen Zizhuang's influence in Sichuan painting circles. Li Huasheng links these painters together as being among the more independent-minded of Sichuan's younger artists. He offers his appreciation for their lofty intentions, although he remains as stern a critic of their work as he is of his own. "They're not like others who only follow popular fashion. They pursue their own ideas, although they haven't yet broken through a certain degree of conventionality." He regards his colleagues as ranging widely in quality. At his most critical, he says of one, "His lines are like chopsticks"—in other words, hard and flat—"you can eat with them."

As of the early 1990s, there are four artists in the Academy who are not indebted to Chen Zizhuang in some way or another. One of these is Zhang Shiying, head of the Academy's Creativity Unit, a specialist in tiger paintings, a theme of particular popularity in Zhang's native province of Guangzhou (fig. 97). Zhang is a practitioner of calligraphy and seal carving, and these interests can be seen in his later works, which particularly emphasize independent linear qualities.[26] Another such artist is also a tiger-painting specialist by the name of Zhou Ming'an, who often works with a striking degree of realism (fig. 98).[27] A third is the figure painter Yuan Shengzhong (fig. 99), who works in a realistic style (often still close to socialist realism), using for his figures a type of broad brushwork usually reserved for bird-and-flower painting, and for pursuing misty, atmospheric effects.[28] A recent addition to the Academy is its first calligrapher, He Yinghui, who similarly has no link to Chen Zizhuang.

One cannot simply speak of a "Chen Zizhuang group" of artists in Sichuan, or of a single entity united in values and harmonious with one another. Li Huasheng and a number of his friends agree that Chen's adherents are divided between Chen's formal pupils and his casual followers, two groups that do not get along well at all. None of those at the Sichuan Painting Academy were ever among Chen's formal students, whom Li Huasheng's group regards as "painting lackeys" and not creative enough to establish their own meaningful painting styles. "His actual pupils," says Li, "are busy producing forgeries. When I was in trouble [in 1983–84] they said I was *not* Chen's pupil. Now that I'm OK, they say that I *am* his pupil."

Conversely, not all the sympathetic relationships that Li Huasheng has cultivated in Chengdu are directly related to

179

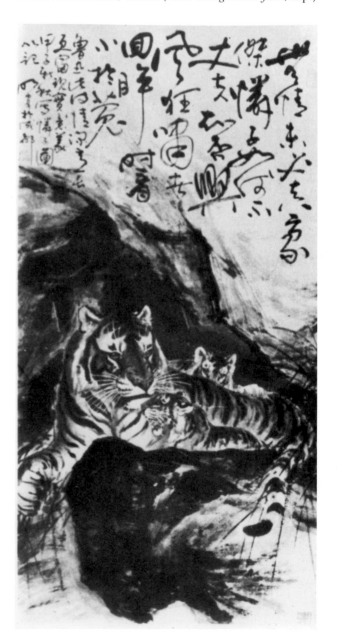

97. Zhang Shiying. *Tiger.* 1984. Ink on paper. Unknown collection, China. (After *Chengdu Hua Yuan*, n.p.)

98. Zhou Ming'an. *Tiger.* 1984. Ink and color on paper. Unknown collection, China. (After *Chengdu hua yuan*, n.p.)

the Academy or to the immediate followers of Chen Zizhuang. One such "outsider" is Tan Tianren, who arranged for Li's exhibition in the Du Fu Thatched Hall and who is a painter of meticulously executed (*gongbi*), brightly colored landscapes with distinctive Sichuanese architecture (fig. 100).[29] Tan Tianren was introduced to Li Huasheng by another close friend outside of Chen's progeny: the bird-and-flower painter Tan Changrong.[30] Tan Changrong and Li first met in 1966. In 1980, they painted together with Huang Yongyu and Deng Xiaoping's daughter, Deng Lin (fig. 48). Acquainted with Chen Zizhuang, Tan often hosted Li during his travels to visit Chen in Chengdu, and he helped to care for Li during his 1984 flight from Chongqing (still retaining a number of Li's paintings from those times).

Tan Changrong is a highly successful artist with a large coterie of artistic associates who provide a daily flow of visitors to his home. The virtually nonstop gathering of artists at his home, over which he no longer has much control, is a reminder of what the great scholar-artist-patron halls must have been like in times gone by, teeming alike with men of skill and with mere hangers-on. Li Huasheng, who cannot tolerate such a lack of privacy, believes it has interfered with Tan's artistic productivity. He says, "Now I very rarely go to Tan's house because too many people gather there every

99. Yuan Shengzhong. *Figure Painting* (detail of work in progress). 1988. Charcoal on paper. Collection of the artist.

100. Tan Tianren. *Qingcheng Mountain, Zhaoyang Cave* (detail). Undated. Ink and color on paper. Collection of the artist.

day. Even he himself has no idea how to get rid of them." Perhaps Tan's social style should be viewed as compensating for his suffering under Mao's regime. Tan remembers having painted a version of the popular theme *Chairman Mao Goes to Anyuan* (cf. fig. 7) and having his critics claim that, instead of painting Mao, he had portrayed himself. As a result, he was cruelly confined—enclosed in a "cowshed," as the Maoists put it—at the time when his eldest son was born. He named this son (now a promising teenage artist) Tan Heyi, literally meaning "How can I find any ease?" Tan Changrong now takes this concern seriously, avoiding political entanglements, enjoying and entertaining artists of all backgrounds with his gentle, relaxed personality. He claims, "My ideal is to take life easy. Society puts so much pressure on artists, so why should we put more pressure on ourselves?"

One love that Li Huasheng and Tan Changrong share in common is opera: Tan primarily supports himself as an artist by painting set designs for Chengdu's Sichuan Opera Company, the city's largest. He is also an amateur performer who sometimes plays female roles and is a member of the Chinese Dramatists Association. It is harder to find

101. Tan Changrong. *Chickens*. 1984. Ink and color on paper. Collection of the Sichuan Academy of Poetry, Calligraphy, and Painting, Chengdu. (After *Sichuan Sheng Shi Shu Hua Yuan*, n.p.)

common ground for Li and Tan in terms of painting styles: Tan Changrong primarily paints birds and flowers in a meticulous, technically high-skilled, brightly colored and boldy decorative manner (fig. 101). An honorary instructor and a member of the board of directors at the Chengdu Painting Academy, Tan's artistic attitudes are entirely different from those of Li Huasheng and Chen Zizhuang, yet he remains highly favorable toward both of these artists and toward the notion of artistic individuality.

The academization of Li Huasheng took place as part of the rising influence of Chen Zizhuang in Chengdu, in particular, and in Sichuan in general. The posthumous rise of Chen Zizhuang, in turn, was the spear point for the forward thrust of artistic reform in the province, for loosening the artistic constraints imposed by the provincial arts administration since the early 1950s. Institutionally, this reform was set in place by administrators like Niu Wen and Yang Chao. The public declaration of all this to the Chinese art world took form in the stunningly successful exhibition of Chen Zizhuang's work at China'a National Gallery in Beijing, in May 1988. Those who flocked to this exhibition were probably more interested in the artist as a symbol of cultural repression during the Maoist era than in Chen's art *per se*. It was, of course, a political display that corresponded with the increasing openness of the arts and artistic politics of the late 1980s; it could not possibly have come about earlier, and maybe not later. It was a display that Chen Zizhuang himself might have dreamt of, but never really expected. In about 1973, Chen Zizhuang confided bitterly to his friend Zhang Zhengheng:

> In Sichuan they don't like my painting too well. Those who like my painting have no power. There are quite a few under the age of fifty who admire my work, but they only ask for [free] paintings and in the last two years I haven't given a single one. So I have offended some of them, but what else can I do?[32]

What else *could* he do? Chen couldn't sell his paintings, so the best he might hope for was to preserve them for posterity, and he continued in his letter to Zhang, "What you said is right—preserve my good paintings, put them aside—and I will follow your opinion and not give them freely to others."

Following the initial publication on Chen Zizhuang by Wu Fan,[33] the business manager for a collective enterprise organized under the auspices of a railway administration, Yan Xiaohuai, became aware of Chen's art. Beginning in 1984, Yan purchased more than thirty works from Chen's

students. With the growth of his own personal interest, and with the help of Zhang Zhengheng, Yan organized the "sensational" National Art Gallery exhibition in Beijing. An example of the new concentration of corporate wealth and power that has appeared in China since Deng Xiaoping's so-called Second Liberation, Yan reportedly provided 30,000 Chinese dollars from his business unit for the exhibition. With the help of Zhang Zhengheng, he collected another 30,000 Chinese dollars from other sources, contributing toward a total exhibition cost of 80,000 Chinese dollars.[34]

Yan Xiaohuai is responsible for characterizing Chen as "the Chinese van Gogh," and certain similarities do exist. Li Huasheng says that five years ago, when Chen's paintings sold for 60 Chinese dollars per square foot (now a standard Chinese method of calculation), there were no forgeries. But soon afterwards, when prices reached 200 dollars per square foot, many forgeries began to appear. This opinion is confirmed by Wu Fan and others. Yan Zhengguo, manager of the Sichuan Provincial Antique Store in Chengdu, says that many customers come to ask for paintings by Chen Zizhuang, including many from Hong Kong; but although they were once readily available, Chen's paintings have become so popular in the past two years that they are no longer available. Forgeries have taken their place, with small-sized paintings selling for as much as 2,000 Chinese dollars. At Chengdu's local painting, mounting, and sales shops, paintings of no more than one square foot may be "ordered" for 1,500 Chinese dollars, about a year's salary for the ordinary Chinese worker.[35] At the National Art Gallery exhibition, ten smaller paintings were made available for sale by their lenders, who intended to raise funds for a memorial hall in Chengdu, with label prices ranging up to 20,000 Chinese dollars; none of these actually sold. Not long after the Beijing exhibition, the first two international exhibitions were being organized by Wu Fan and Lü Lin, but these were delayed by domestic events. The international market has yet to be fully tested.[36]

The discovery of Chen Zizhuang was not strictly an internal Chinese matter but was dependent also on a new influx of American dollars and Japanese yen. It reflected the emergence of an international market for contemporary traditional-style Chinese painting, a medium that had struggled for decades against the deterioration of native Chinese support. The "unprecedented" economics of this was frankly acknowledged by the Communist Party newspaper in Shanghai, where commerce is once again king:

> Cultural knowledge at certain times has no economic value . . . [and] the recent rise in prices [of Chinese commodities in general] still hasn't reached a realistic economic level so that prices accord with quality. Some things like the paintings of Chen Zizhuang had to wait for foreign collectors to pursue them for people to recognize their value. Then calligraphy and painting publishers gathered up his works, fine-arts museums held posthumous exhibitions, and perhaps fine-arts groups now will even want to recognize him as a member [i.e., posthumously].[37]

The need of China's most traditional arts for a foreign patron-savior is a situation Chen Zizhuang himself had understood almost two decades earlier, and had foreseen, ironically, as his only possible liberation from the Chinese rejection of traditional Chinese style:

> If you paint Chinese painting without a tradition of national style, then it really is not Chinese painting. . . . Now, the international-level painters in our country are perhaps not too many. In the future, after Japan establishes diplomatic relations with us, maybe there will be some new necessities. As our national reputation improves, so our influence will improve too. Perhaps we should be concerned with our obligations in regard to this.[38]

The sudden rise to popularity of Chen Zizhuang, in the vanguard of a new era for traditional painting in Chengdu, has by the early 1990s been felt in Chongqing as well. There, at the Sichuan Academy of Fine Arts, Bai Desong (now promoted to chairman of the Chinese Painting Department) has championed the landscape art of Chen and his followers. Bai suggests that "most of the better young traditional-style landscapists in Sichuan have shared his influence. Even in Chongqing itself, Zhang Daqian has virtually no influence compared with Chen Zizhuang." Bai's own landscape painting (fig. 102) is clearly related to that of Li Huasheng (see Li's fig. 103) although executed with meticulous brushwork in mineral colors; this similarity is owing to their common origins in the landscapes of Chen Zizhuang, a stylistic bond that extends to many other local artists as well. Administratively, under Bai Desong, the Chinese Painting Department has changed its long-time emphasis from figure painting to a new stress on landscape painting. Bai notes that this change was made possible by a much improved attitude in the Sichuan Artists Association itself, and that this attitude was based on Li Shaoyan's successful response to a new political situation. "Leadership in the artists' circles is based on politics, not art," says Bai. "Not only has the political weather changed, but Li Shaoyan's own opinions have changed." In fact, Bai even feels that the Association is now "even more responsive to these changes than the Sichuan Academy of Fine Arts it-

self." Meanwhile, much farther away in Beijing, according to the report of Zhang Zhengheng, a local journalist is now writing a fictionalized novel based on the life of Chen Zizhuang.

The transformation of Chen Zizhuang, his followers, and many others like them from unacceptable artists into ascendant masters, is the result of changes in cultural politics felt everywhere throughout China. In Sichuan, these changes have come at the expense of the long-established artistic ideology and the previously unchallenged domination of Li Shaoyan. Li Shaoyan has ultimately proved to be more flexible than many of his opponents might have imagined, and he has accommodated these changes. Yet even with the power of Li Shaoyan and other like-minded artists notably diminished, one is obliged to wonder, after the midyear of 1989, whether Chen Zizhuang's rising fortunes and those of the artists and policies associated with Chen might not take yet another turn.

Bai Desong, now an honorary painting master at the Sichuan Painting Academy, says of Li Huasheng: "Once, the basis of opposition to him was the concept that he is an amateur, not academically trained—a 'country painter.' But now, as a member of the Sichuan Painting Academy, he's a 'court artist,' so everybody recognizes him." As a member of a nonteaching academy, with none of the administrative authority available to him in his year as Chongqing Artists Association vice-chairman, Li's efforts are limited to the improvement of his art and are not aimed at affecting others. As an Academy member, he is heir to all the privileges of an elite institution, protected by Yang Chao from the usual pressures to produce institutionally approved quality, and required to create only four paintings a year for the Academy's disposal.[39] He has also acquired all the burdens of such privilege: the high expectations of others that his art be shared as a medium of social exchange, and the troubled conscience of an antiestablishment, egalitarian artist partaking in the lifestyle of socialist China's new upper class.

In Chongqing, Li Huasheng's former boss, Association chairman Niu Wen, says of the once-binding Yan'an Forum code:

Several decades have passed, so they are applied much more loosely today, and they aren't even applicable to landscapes, which are based on nature. Now, artists must guide themselves, and art serves not politics but socialism and the people.

Artists no longer have to consider making political mistakes, so they can focus on creativity, expression, and a more personal accomplishment. Subject matter and who to paint is the artist's own business.

Yang Chao's policies for the Sichuan Painting Academy have been in line with this looser attitude, prevalant throughout the arts in much of the later 1980s, leaving artists to discipline themselves. Before the summer of 1989, the political meetings required of all Chinese work units were held every Tuesday at 2:00. Li more often has come instead at 4:00 or 5:00, criticizing himself for tardiness, to the laughter of others, and has even stayed away when he knew that Yang Chao would not come. Until recently, the theoretical political discussions that were long a staple of the Chinese workplace have not been required. Little criticism of art is conducted: the artists do not care to criticize one another's work because they are all regarded as successful painters. So discussions have been limited primarily to the practical administration of the Academy and its activities, a topic of little interest to most artists.

Yang Chao's Academy, in 1989, moved into a new architectural complex along the banks of Chengdu's famous Brocade River, built with poured concrete, designed in imitation of Sichuan's finest *chuandou* tradition, executed to standards of quality rarely found except in foreign-built hotels, and costing altogether a staggering 4.5 million Chinese dollars. The complex includes individual painting studios for each regular member, administrative offices, two meeting rooms (each big enough for 20–30 people), a photographic development room, a storage tower for art works, and eight individual units with living space for visiting painters and scholars. The annual budget of 270,000 Chinese dollars provides a base salary for regular artists of 80 dollars per month, travel compensation, and bonuses.

As a Painting Academy member, Li Huasheng currently (1992) earns 165 Chinese dollars monthly, not including annual bonuses (perhaps another 100 dollars) and travel compensation. The current Chinese per capital income is about 1,500 Chinese dollars, so his income is hardly unusual. But he has a double apartment, bought by the Academy for 40,000 Chinese dollars, which he rents for about 5 dollars a month. It includes a living room, dining room, kitchen, large and small bedrooms, two baths, painting studio, and two small balconies. In the midst of China's third-world economy, he has many modern conveniences, such as a full-sized refrigerator and a small washing machine. While he owns a microwave oven, there is nothing he can cook in it;

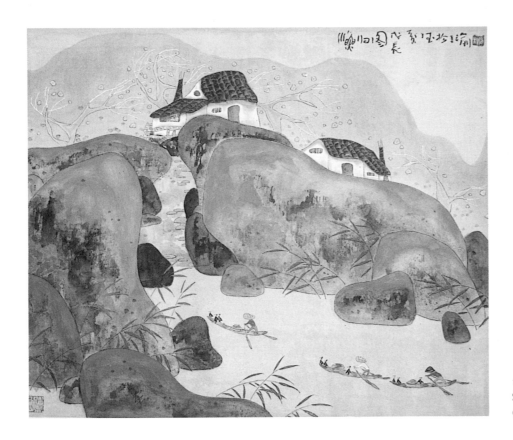

102. Bai Desong. *Return from Fishing*. Summer, 1988. Ink and color on paper. Collection of the artist.

his wife still cooks on small coal-fired stove that is slow, smelly, has to be used out on the balcony, and is often lacking for coal (rationed to three pieces per day). Li owns much of the electronic equipment one often finds in the West, mostly imported models: a stereo rack, 21-inch color television, VCR, video camera, and slide projector. For pets, he keeps a pair of noisy katydids who escape regularly from their cage and a lovely songbird, thus satisfying his taste for music while he paints.

As of this writing, Li Huasheng's lifestyle is quite relaxed, though the hours actually spent painting are still long. He begins his mornings late, with tea, spreading out paper on his painting table and preparing his painting pigments. He says he is usually unclear at first what kind of painting he will do. After an initial trial, if he finds no enjoyment in it, he turns instead to the outdoor market near his home where he looks for inspiration in such things as peasants, their postures, and the "subtle space" between them, or women's hairstyles and their bamboo baskets. "If you view figures as if they were rocks in a landscape," he says, "you can pick up some idea from them and put it in your paint-

ing." Other mornings he may go to the Du Fu Thatched Hall, to a garden courtyard behind the painting gallery which is opened specially for artists. In the evenings, pursuing the love of his youth, he goes frequently to the local Sichuan opera. Late at night, he returns to and intensifies his artistic quest, often painting into the deep hours of the night. He also frequently travels to Mt. Qingcheng for realistic sketching, in a van provided by the Painting Academy:

What I think about—only!—is how to improve my art. Continuing to achieve new variety in my art is not an easy matter. I'm so intense about painting that I even dream about it at night and scarcely get any rest.

Chainsmoking is as much Li's habit as it is China's, and he smokes especially heavily at night, stimulating himself to stay awake longer and work harder. He is aware of the risks but has dedicated his life to his art. Though impatient to succeed, he is also concerned about violating the cardinal principles of traditional literati painting: work relaxed, mature late, live long. "I think that since I've matured so early, I won't live long."

Like Chen Zizhuang, when it comes to artistic standards, Li Huasheng is uncompromising:

In my painting, I pursue my own ideas. I use every medium; I try every method. Like a man in love pursuing a lover, I am willing to try anything. If you set up some particular method, obey some limited rules, you cannot succeed. Rules are just like an arranged marriage, using a go-between to help you find some mediocre partner. If you follow conventions, you get the conventional.

Like Chen Zizhuang, he does not hesitate to criticize others, but neither does he place himself above criticism:

There are people who criticize me as arrogant, but I am a man on a mountain. There are people below me, artistically speaking, and I have the right to criticize them. There are others on peaks and ridges above me, and they have the right to criticize me.

As his own harshest critic, he is aware that the speed of his artistic development, his prodigious success, has been achieved at a high risk: "Art is like coal, which must be buried for many years to make diamonds; if it is dug up prematurely no one can use it, and it can't be buried again. Many of my paintings are still just premature things."

A successful artist, Li is also aware of the difference between success and achievement, and he is clear in his own mind about the varied pitfalls that stand in the way of true artistic progress, including popularity. These factors, which range from the social to the technical, differ significantly in China from those in the West. Effective literati painting was predicated not on skill but on successful self-expression. To be successful, it had to be spontaneous, which allowed it to represent the artist's personality—that is, it gave him no time self-consciously to misrepresent himself. But such spontaneity did not guarantee that every authentic personality statement would also be good art. Quite the contrary, the speed of production and the artistic materials purposely chosen to facilitate this speed assured that the majority of such paintings would *not* be successful. Traditional-style Chinese painting is an expendable art form, in which the successful products—rather than the failures—are accidents, and among other things, the artist needs a strong critical sense of which paintings to retain and publicly reveal, and which ones to destroy:

An artisan just copies things so that he can produce a consistent quality in his work. But an artist always tries to achieve something new, to express personal feelings in his work that can move other people emotionally. But there are so many things that can go wrong. You can pay so much attention to your composition that the brushwork is not spontaneous. Or you can pay so much attention to the brushwork that you lose control of the composition. Even the weather affects your work: if it is too wet, your ink can run all over the paper, and if it is too dry, it will not flow freely enough. People do not realize this. You cannot ask an artist to produce high quality painting every day.

Li Huasheng rejects the Maoist notion that art should be judged by its appropriateness to a mass audience or by the political attitude of the artist. He rejects the sweetness that popularization has brought to modern Chinese painting, beginning with the commercialization of art in late Qing-period Shanghai and exacerbated by modern socialist policies. But Li agrees with the concept—predicated on the literati identification of artistic quality and individual personality—that moral qualities play a large role in determining artistic standards. Individualism cannot stand apart from aspects of moral character:

It is hard to judge artists only on artistic talent and achievement. In fact, this is rarely done in China. We usually emphasize moral qualities. There is lots of conflict in the Academy over such standards. My standard is whether one can retain his spiritual integrity. I hate it when my colleagues do just what they're told to do, and do it with servile expressions and flattering behavior. This is why we have two stylistic alternatives, sweet vulgarity and bitter pungency. It is a matter of moral qualities.

Li Huasheng also laments that in modern society, no sooner does a new or individual style become successful than it is imitated, and its individuality and quality are eroded. "In the past, one could be independent, but it is impossible today to establish any degree of independence. Because of communications media, everyone knows your work immediately." However, he distinguishes individuality from innovation, recognizing that innovation alone is no guarantee of quality and arguing that quality is sufficient:

In New China, people use a standard of newness to evaluate art. But often, what is praised as being "new" is still really mediocre. So the only real standard is being good, not being new. Chen Zizhuang's art is very traditional, nothing really new. Only he managed to express things in his own way. My art also is nothing new. But whether it is good or not is yet another matter.

Li feels that artists too often are stunted by the stature of the masters they follow, unable to step out of the shadow of their masters' reputations in order to develop their own individuality. He feels grateful for the fact that Gong Qinggao, whom Chen followed, and Chen Zizhuang himself were not recognized in their own lifetimes—"didn't

stand in anyone else's way"—so that Chen and Li himself were more free to develop their individuality than if they had followed major name artists. Even among the great contributors to Chinese painting history, according to Li, quality mattered far more than innovation:

> If you look at Chinese painting history, each major painter really contributes only a little bit. Only those who really get inside Chinese painting can even recognize their contribution. If you add even a little bit that is new, this is quite an accomplishment.

It is this sense of lofty historical standards and of the role of literati individualism in shaping them, rather than anything nationalistic, that for Li Huasheng has validated traditional Chinese landscape painting as the most appropriate artistic vehicle for his pursuit of self-expression, even as more radical and shocking artistic alternatives have been opened up in the visual arts in the 1980s. He feels little kinship with the photorealistic portraiture of grizzled old hands and faces (fig. 35), needs no *tromp l'oeil* pop cans, and sees nothing to be gained in the nude oil paintings that have recently stampeded crowds and outraged public officials.[40] He may be sympathetic with the pent-up anger of those avant-garde artists who have challenged the state's definition of art and hence the definition of state authority, intentionally "abusing" art to protest governmental abuse of the arts. All of this welled up into a "New Wave" by 1985, led by young artists like Gu Wenda. The New Wave arrived at its most extreme statement in early 1989 at a National Gallery exhibition mobbed by the public, featuring printed scrolls full of unreadable pseudo-characters by Xu Bing, and even "performance art" with planned live gunfire shot into a mocked-up telephone booth which brought police to close the exhibition not once but twice. The heated expressions of this movement have lately come to make landscape painting seem increasingly quaint and politically unthreatening—an invaluable political service unintentionally rendered. But Li does not regard their work as the most significant art. And rather than the avant-garde media, traditional painting still seems to Li Huasheng to hold the greatest potential for those who would save artistic individuality from drowning in a sea of planned art. The capacity of this tradition to remain strong on the inside while maintaining a seemingly mild exterior—like Deng Xiaoping's own self-characterization as a sharp pin inside a ball of cotton—has been a necessary part of its modern durability.

In pursuit of his own individuality, and at the risk of being labeled esoteric, solipsistic, or bourgeois, Li believes in pushing his own traditional-style art to the limits. At the same time, he understands that the artist must know just where those limits lie so as not to transgress them. He compares this quest to "thinking like a mathematician about infinity while being obliged to work as a painter within the constraints of the finite":

> In using ink on paper, you are limited to the finite. If you make your ink darker and darker, infinitely dark, you might just as well turn out the lights. And if you make it lighter and lighter, infinitely light, then it becomes all water with no ink at all, and you might just as well cut a hole in the paper and hold it up to the light. I start the process of painting in a dangerous place—like the number nine, the most potent number in the *Book of Divination,* the infinite number—because if I pursue the dangerous, through what is very light or very dark, I can achieve the most. But after the number nine comes ten, which is like a reversion to zero, so pursuing the dangerous and going too far leads to nothing, to failure. Like going to the number nine without going too far and getting to ten, or zero, it is not easy to achieve something dangerous in the use of light and dark while still keeping them in harmony.

He realizes that the most individual work will not be acceptable for exhibition, but "if our current political policy continues to support artistic freedom, then artists won't be imprisoned for doing purely abstract works and won't have to worry about bureaucrats and other artists' criticism. They will just be politely refused by people saying, 'Can't you give us a different painting?' "

Li Huasheng's sense of artistic integrity is frustrated not only by the threat of external censorship but also by external praise and the obligation of the successful artist to paint for purely social purposes. Traditionally, China has largely been a non-monied economy, with goods, services, and personal favors serving as primary media of exchange. In a society where administrators are given a maximum degree of individual discretion, personal connections (*guanxi*) matter greatly in attaining almost any commercial or social goal. Although socialism offered to replace this with bureaucratic regularity, it scarcely succeeded, and the commercial liberality of the Deng Xiaoping era has seen this personal exchange system reemerge unscathed. Every individual needs something to offer, something that will provide social and commercial entrée. For the artist, the currency of exchange is art, and many works of art used thus are known as "obligation" or "courtesy" pieces (*yingchou*). Li Huasheng complains:

Without *yingchou* paintings, where would I be when I'm in trouble? Or in need? When you want a train ticket to go from Chengdu to Chongqing, you can stand three days and three nights in line. Money can't buy you tickets. None of the tickets are sold. They're all given out to people with connections who sell them for four times the price. When I got my color television, there "weren't any available."

But paintings inscribed with personal dedications will usually get the job done. Li Huasheng calls such pieces "junk pieces." "I can paint them even while I'm carrying on a conversation," he says. "They may look like they have many painted layers, but they're really very simple to produce." They also infringe on the artist's own sense of integrity. "Chinese painters are always being pestered by people trying to get free paintings."

Although he is now a state-sponsored artist in a cooperative socialist environment, Li Huasheng greatly dislikes having to part with his paintings, especially when it is obligatory. "In all my years of suffering, I had no energy to take care of others, only enough energy for my painting. Painting was my child." The artist does not like parting with his children. In earlier years, Li sold paintings out of necessity. Like most Chinese painters, he is embarrassed by his early works; only his recent works are acknowledged or offered for exhibition. "The retrospective" is in no way consistent with Chinese values. Now that Li's art has matured, the appearance of early works in galleries, circulating beyond his control, is dreaded by him and he is prone to label them as "forgeries." But courtesy paintings put the artist in an even more peculiar position than early works: either he parts with his better works, or else he distributes works of inferior quality at the expense of his image, his reputation. Here, too, there is a question of "forgeries":

> These dedicated pieces are such junk pieces that even I cannot always tell which are real and which are not. My better pieces could even be used to prove that all my dedicated pieces are forgeries! But the people who get them would like them even if they *were* fake. The range of quality in Chinese painting is enormous. It's really a crazy situation.

Like most such artists, Li Huasheng distributes inferior works, but he is not reconciled to it. His only alternative is to maintain an exaggerated independence, minimizing his social and commercial obligations and owing paintings to no one.

When I didn't have food to eat, you could buy even eight of my paintings for only a dollar. But if I have a little food, I can ask whatever price I want. Now that I already have plenty of food, I refuse to sell any more.

So Li now frequently refuses to give paintings on request: "Every time I do, it gives me pleasure, and the flavor of it lasts a long time." He prefers to burn all but a few of his best works and to keep those for himself. But in a country where socialization has merely reinforced the millennia-old tradition of putting group obligations ahead of the self, such independence is won at quite a cost.

With the obligatory paintings come the obligatory social invitations, the dinners where such products are created. Sichuan artists use the expression, *xia dan*, "to lay an egg," to paint a courtesy painting after dinner. "There are so many invitations," he says. "If you don't accept them, you offend people, and they call you arrogant. If you do accept them, you offend yourself!" He recalls a recent dinner where he produced an obligatory painting that turned out to be surprisingly good, so quickly he tore it up and produced a bad one. Such behavior, keeping things to oneself, radically contradicts Chinese social norms; demanding things from others, however, does not. The former is selfish, while the latter is a form of sharing. In 1986, Li recalls, two painters came from Shanghai to ask him for free paintings. He told them he would try to paint something for them when he got a chance. In 1988, they returned and asked his wife, "Where are those two paintings Li *owes* us?" Realistically, Li Huasheng cannot always afford to act selfishly, and *yingchou* production cannot be avoided.

The matter of trying to retain his better pieces is more difficult when the would-be recipient is an important patron, especially one with good taste, or worse still, when it is a question of presenting works for exhibition or for publication. For once seen in exhibition or in publication, an exhibition- or publication-quality work becomes vulnerable to all those would-be collectors to whom the artist is most deeply obligated. As a result, Li claims, "From the time even before my 1981 ten-artist exhibition in Beijing, I have kept a tight control over what happens to my paintings. The really good pieces are still mostly in my collection." This "tight control," of course, has necessitated his concealing much of his better work and revealing a select part of it only in the right circumstances—in a major exhibition or publication, or to a major patron. The result is that many of his best works remain unknown to the general public, while lesser-quality works have become known. This situation is not

characteristic of Li Huasheng alone, although it is exaggerated in his case. His colleagues, too, have typically seen one another's very best work only in the exhibition galleries or in book publications, if at all.

As a result of such concealment, the image and appraisal of the artists' achievements can be substantially skewed and in general tends to be lowered. So, too, one might imagine, would the audience and the market prices for their works. Yet the situation can be managed by releasing just enough good painting to make the difference. On inquiry, it seems that one of the more beneficial by-products of Li Huasheng's retention of so many of his paintings is an inflated price in the galleries, even for his works of lesser quality. One of Chengdu's dealers, at the Bo Ya Art Gallery, says, "He doesn't let anybody have his paintings anymore, so his prices are very high, even though he is still alive."

Accordingly, this careful secreting away by Li Huasheng of his better paintings and his sometimes frantic attempts to rid the world of his early works is matched by the urgency with which others have tried to acquire them. Years ago, Li Huasheng gave Wu Fan a gift painting; today, Li can no longer stand the piece. Wu recently brought it by Li's home, asking him to add a seal impression. Characteristically, Li refused. So Wu took one of the seals sitting out on Li's painting table and stamped it himself. Li says he tried to grab the painting and tear it up, but Wu prevented him, offering instead to exchange it for a new painting if Li would bring one to him. Li agreed and subsequently took Wu a new painting. But Wu Fan never relinquished the old painting, saying it was a valuable study piece and vaguely promising to tear it up "sometime" later on. Similarly, Yang Sizheng, a former actor turned businessman, once came to Li, saying he had two old pieces which he offered to destroy if given two new pieces for each old one. Li was tempted, "But he was so rude," says Li, "that finally I refused."

After the beginning of communalization in 1955, and until the expansion of Deng Xiaoping's "responsibility system" to the arts in the early 1980s, traditional Chinese painters had virtually no market for the sale of their works.[41] Since 1985, the commercial nature of Chinese painting has grown much more complicated, patronage more open, and artists more independent. Painters have freely arranged to sell their works through an expanded variety of government-licensed outlets and have even become able to sell on the streets. Li Huasheng was introduced to the murky world of China's newly commercialized art in the mid-1980s by agents like his old friend Qiao Deguang, a well-known connoisseur employed to Chengdu's state-run antiquities shop,

Wenwu Shangdian. Qiao approached Li on behalf of a licensed gallery in Heilongjiang province which was attempting to establish an art network by gathering up works throughout the country and placing them in outlets in Guangzhou and Shenzhen, close to Hong Kong's lucrative art market. Qiao said that Li could ask a good price for his paintings. Li had no real interest, but out of politeness to Qiao he offered what at the time seemed like a ridiculous figure: 500 Chinese dollars per square foot. He presumed the offer would be refused, or at least that he would not lose anything if it weren't. To Li's surprise, the Heilongjiang gallery did not back off but instead sent Qiao 4,000 dollars for whatever Li wanted to paint. They assumed that Li had just been talking wildly. Since he had not simply refused their offer, they thought he would be willing to produce a more reasonable quantity of work at a reasonable price, something more like 40 or 50 Chinese dollars per square foot. Li accepted the money from Qiao and produced two pieces, one large, one small, totaling ten square feet. This lowered the gallery's cost to 400 dollars per square foot, but left a chasm of understanding between Li and the gallery.

The gallery was at a loss for what to do over Li's stingy contribution. Contractual relations being alien to China, and reasonability serving as the sole standard of judgment in such matters, since Li had accepted the money and produced no more than he did, he was clearly the one in violation of the art world's unwritten rules. Apparently, the gallery persuaded Qiao Deguang to tell Li that the 4,000 dollars paid to him had been Qiao's own, put up by him as the middleman, and that Heilongjiang was unwilling to reimburse Qiao for such minimal painting footage. However improbable it was that Qiao could personally have put up 4,000 dollars, Li was obligated out of friendship for Qiao to return all the money. He naturally also asked Qiao to get his paintings back.

Nobody could have been happy about the undoing of this deal, but at least at this point the losses were spread about equally and there was no undue loss of face. But the gallery refused to return the paintings, presumably put out by Li's behavior and feeling that the failure of the enterprise was his to bear. So Qiao was now caught in the middle, if he had not actually been so all along, and he came personally to be in Li's debt for the loss of Li's two paintings. Unable to gain the gallery's cooperation in returning the paintings, Qiao turned to his own resources and gave Li a painting from his own collection. Done by Qi Baishi, Qi himself claimed it to be a "perfect" painting in his dedication of it to a famous seal carver. Li now felt the bargain was his and was pleased

about it, although his friend Qiao had become the clear loser. But in showing off his new prize painting to others, as Li was bound to do, the truth came out that his friend had bought the work at the time it was brought to the Chengdu Antiquities Shop. As the shop's agent, Qiao had had no right to do this.[42] The painting definitely had to be returned to the shop, and Li was obliged to bring it back in his friend's behalf. Li was now empty handed again, and Qiao's reputation was smudged. Moreover, Qiao was still indebted to Li for the two paintings that were never returned. Feeling that enough damage had been done and hoping to put the affair quietly to rest, but unable now to offer more than token compensation, Qiao one day rode his bicycle to Li's home with a group of fine seal stones. Li accepted the peace offering and subsequently distributed the stones among friends, his hard lesson learned.

Agents—or institutional agencies—ordinarily fare quite well in the sale of paintings, collecting up to 50 percent of the sales price. In addition, the government currently takes 60 percent of any monthly income over 800 Chinese dollars. So when Li Huasheng made his most expensive sale of a painting in China, for 8,000 Chinese dollars, he earned only 1,980 dollars or less than 25 percent.[43] Guo Ruyu agrees that these are not new problems. He quotes the Confucian adage: "The gentleman only worries about principle, not about poverty," to suggest that the traditional Chinese scholar has never been free of some such predicament. Yet he also emphasizes that in earlier times, pricing and patronage were not as centrally controlled as they are now. Professionalized literati artists like Zheng Xie of the seventeenth century posted their painting prices openly, matching social reprobation for such blatant commercialization with their own frankly antisocial disdain. Even imperially sponsored artists, once they had made their reputations, were normally free to use this prestige to develop their own private followings. Only after 1949, says Guo, were artists prevented from selling paintings—to do so was proclaimed as "following the capitalist road" in the Cultural Revolution. Although artists were free to sell their works again after 1985, the native audience for traditional Chinese painting had largely been destroyed. Says Guo, "Liberation eliminated businessmen. Now the art business is dominated by foreigners, buying art in galleries that the Chinese themselves can't even get into."

While this commercialization of state-run dealerships has a strictly modern air, more traditional practices also continue to play a part in Li Huasheng's career. His artistic relationship with Daoist and Buddhist temples, rooted in ancient historical practice, is more positive in nature than any of his other patronage relationships. On Mt. Qingcheng outside of Chengdu, the Shangqing Daoist Temple (Shangqing Gong) has a collection of more than a thousand paintings and calligraphic works, contributed to the temple by the artists who made them, including modern visitors to Sichuan like Xu Beihong, who spent two summers there in the 1940s, and native sons like Zhang Daqian. Since early times, most landscape artists have been clustered in urban centers, and it was the mountain temples that offered them the means to penetrate the depths of nature in pursuit of their beloved subject matter. The temples, then as now, offered housing and shelter. But even more, their priests offered an intimacy with the lore of the mountains, a knowledge of the medicines concocted from its plants, a philosophy about how to live one's life free of the city's social jungle, and a model of the individual who could rise above the common crowd. The appeal of these offerings is as alive today as ever for the artists who travel to Qingcheng in their four-wheeled vans, who seek its special beauty as a subject for their realistic sketching, who enjoy its pristine solitude for their work, and who are renewed by spiritual communion with the individuality and traditionalism cultivated by those who dwell there monastically. And, of course, to join the ranks of artists like Xu Beihong and Zhang Daqian who have previously stayed at this mountain retreat and contributed their art to the temple collection is to become part of an ancient artistic chain, both a humbling experience and a means of elevating one's prestige.

Until 1979, official socialist policy in China opposed religious practice as superstitious, contrary to the forward thrust of scientific materialism. Yet even when the 1982 constitution forbade discrimination against people on account of religious beliefs, that did not put an end to all government control, manipulation, and occasional suppression of religious aspirations.[44] Superstitious or not, Li Huasheng says that like most Chinese landscape artists of the past, he feels every element in nature has its own living spirit—not only animals and plants, but even rivers, rocks, and mountains. This is a nonsocialist view, essentially animistic and thoroughly Daoist. For Li and other frustrated traditional artists, the older generation of Daoist priests at the Shangqing Temple are exemplars of successful resistance to repression, models to be admired. Li first stayed at the Shangqing Temple in 1975, one of the gloomiest moments in the history of Chinese socialism, while visiting the mountain for realistic sketching. At that time, he contributed two paintings to the temple, a landscape that he painted in a collective album (fig. 30) and a hanging scroll with lichees and a basket of grapes (fig. 26) done in a style based on Wu

Changshi, Qi Baishi, and Chen Zizhuang. By the time he visited in August 1988, Li Huasheng had become a well-known visitor, welcomed on his arrival by the abbot, Daoist master Fu Zhitian, one of three vice-chairmen of the Chinese Daoist Association.

Today as in the past, while the temple plays the role of social and spiritual patron, in the exchange between temple and artists, it is the artist who serves as the financial patron of the temple, still playing the role of the privileged guest whose generosity sustains the temple. In return for housing, good companionship, and lofty inspiration, the temple receives offerings of paintings and cash, often with considerable ritualistic posturing. On one temple visit, made with this author, Li was charged a much-inflated 40 Chinese dollars for a lunch for four. Abbot Fu then politely offered to intercede and personally pay half of Li's bill. Li refused with equal politeness and firmness. And after paying his bill, Li donated an additional 100 Chinese dollars to the temple's coffers in recognition of the serious illness of Master Fu and the difficulties this might soon impose on the temple.

At the Shangqing Temple, Li also shed his strong aversion to "obligation paintings." When asked to leave behind a calligraphic inscription as a memento of his visit, Li offered more, producing instead two paintings, with the use of materials thoughtfully provided by the temple. One of these works, entitled *Fishing in the Clear Stream,* he dated to the autumn although it was painted in the heat of summer, "because that gave the work a more interesting character." The other painting was done collectively with his colleague Guo Ruyu, who accompanied him on this visit. In contrast to this expression of unaffected generosity, when the chief administrator of the Sichuan Religious Affairs Bureau (a political rather than a religious appointee) arrived just before Li's departure and was introduced to him, Li turned away "disinterestedly," without as much as a greeting for this bureaucrat, who in Li's mind was in no way a legitimate part of the temple or its cultural life.

Still other forms of patronage now help to shape Li Huasheng's career. Traditionally, some Chinese patrons compensated artists for their services with something other than (or in addition to) money and goods, intangibles more valuable than either. Patrons with the appropriate social standing of their own were able to offer entrée to higher levels of society, public recognition in the arts, access to other perhaps more prestigious artists, an opportunity to study past and present works of art housed in their collections, and protection against potential adversaries. In socialist China, with the institutionalization of nearly all art and artists, and with the destruction of many private collections

(although not so many as was once thought), such patrons' offerings have tended toward influence lent and protection shared. In China's often-hostile environment, there has rarely been protection enough to assure anyone's political well-being, yet the more important an artist becomes, the more of a target he becomes and the greater his need for protection. Although this situation—so well exemplified by Li Huasheng's own career—is by no means a modern condition, it has been exacerbated by the increased politicization of Chinese daily life in recent times. In recent years, one of Li Huasheng's most important patrons has been Ai Weiren (fig. 83), until recently the powerful deputy political commissar for the Chengdu Military Region (covering the four provinces of Sichuan, Tibet, Yunnan, and Guizhou).[45] As noted earlier, it was Ai Weiren, more than anyone else, whose influence finally protected Li Huasheng during the 1983–84 Campaign Against Spiritual Pollution.

In the 1980s, high-ranking cadres have become China's major internal consumers of traditional Chinese painting. Finding themselves with more money than there are available goods to purchase, they have discovered art and the age-old prestige that it sheds upon the owner, upon cadres today as on mandarins in ages past. Ai Weiren, however, offers a more personal reason for his artistic pursuits, saying that he first became interested in art during the Cultural Revolution, when under the most stressful of times he found out for himself the truth of the ancient adage: "Since early times, it's been known that soldiers don't love war." "Military figures fight," he reminds his listeners, "because they love peace, not warfare." Although Ai himself does not paint or practice calligraphy, he has discovered that even for the engaged viewer, "painting is a medium for self-cultivation." Ai began to build a small painting collection, now perhaps numbering fifty works, not all of them choice. The finest piece is a bamboo painting by the seventeenth-century Yangzhou master Zheng Xie; Li says Ai became "very well read" during that time.

Ai Weiren first heard of Li Huasheng in 1979 when he asked Wu Fan, simply, "Who paints well?" Wu Fan recommended Li Huasheng. But Li and Ai did not meet until two years later, after Li returned from the ten-artist exhibition in Beijing. Ai then invited Li to attend the founding meeting in Chongqing of the 117th Military Unit's Cultural Center, at which several artists were asked to help teach painting to his soldiers. Ai remembers that at this meeting, Li walked up to him and asked him boldly, "Are you the highest-ranking person here?" With that appealingly direct approach, they became friends, and Ai began to visit Li Huasheng with some frequency. Among the paintings in Ai

Weiren's collection is a large, romanticized depiction of the Yangzi River gorges done in 1983. In Li's opinion it is one of his best works from that period. Yet Ai has been much more interested in Li's artistic companionship than in accumulating his works, of which he owns only three.

Since Ai Weiren's work is military and is involved with highly sensitive matters, such as Tibetan security, his dialogue with Li Huasheng is restricted to art and culture. Li says:

> He is a high-ranking official. I am a commoner. So it is hard for us to be in agreement. But being friends, we never press each other, and I don't expect him to share my ideas or do anything according to my principles. He never talks about his military business either, because that is confidential.

Asked why he appreciates a "rebellious" artist like Li Huasheng, Ai asserts that "actually, there is no contradiction between Li and myself, because in military strategy you must be able to come up very quickly with new creative solutions. As Li is so good at doing this in art, I can learn from him."

Without his paintings, without their quality, Li Huasheng would still be nothing more than "a commoner" (as he puts it), an ordinary engineer or a Sailors Club staff member, not an academician and friend of generals, and not a subject for artistic biography. The quality of painting which finally earned Li Huasheng his position in the Sichuan Painting Academy may be seen in a work done in the last months before his "loan" by the Shipping Administration was arranged. Entitled *Mountain Village, the Pleasure of Fishing* (fig. 103), it is perhaps the finest example of all those paintings that have dodged the Party's aesthetic proscription against abstract art by limiting representational detail to the top and bottom of a work while filling in everything between with a broad area of free brushwork (e.g., figs. 33, 63, 67). Into a strip along the top of the work and along the right side are compressed a crude peasant home and a heavily inked, puffy-leaved banyan tree or two, with long, descending roots. Two rustics standing in a stream and fishing with woven baskets are the only other details. All else must be interpreted as landscape, an embankment and some rocks in the stream, but these are indeed nothing short of abstract painting, the kind that bureaucrats most distrust. Created by the chance interplay of ink, blue-green and brown pigments, mixed freely on a wet surface, these elements produce an effect like that of rare colored marble.

The chance of such success, Li would insist, is but one in a thousand for this, his most prized painting.

This painting is also a clear example of the student surpassing his teacher. The derivation from Chen's landscape composition can be demonstrated, originating with Chen's 1974 painting of the same title (*Mountain Village, the Pleasure of Fishing*, fig. 104) and transmitted via an intermediary landscape by Li from 1981 (fig. 105). But nothing in Chen's work fully anticipates Li's landscape gestures—the exaggerated rise of the cliff, reaching to the upper limits of the page, or the low bow of the trees, hovering protectively over the building. And there is nothing like the abstract modernity of this magically colored mountain to be found in Chen's art. This painting, published in a promotional article by Li's friend Lü Lin in August 1985, was a powerful advertisement of Li's candidacy for admission to the Painting Academy.[46]

At the same time as its derivation from Chen Zizhuang's art seems self-evident, this is but part of a more complicated situation involving multiple sources of influence. For Li himself feels that his inspiration for this work (and for related ones like his *Rustic Scene*, fig. 63) came primarily not from other art—not Chen Zizhuang's or anyone else's—but from his experience of Chinese daily life. Already (see chap. 5, above), he has expressed his interest in the pattern of human form, in the "subtle space" between figures viewed in the local market place, seen "as if they were rocks in a landscape." Such bodily rhythms, he feels, have been transported into this painting. But most influential of all in this painting, says Li, is the Sichuan theater with its all its decorative apparatus.

Li claims that it is from the actors' paraphernalia that the chief elements of this painting—its banyans and buildings, with their peculiar, distorted gestures—were derived, while their swaying rhythms derived from the actors themselves. With the benefit of simple sketches (fig. 106), he illustrates how faces painted with exaggerated eyes and noses were transformed into the windows and doors of his buildings, how an arched hairline and an actor's cap gave rise to a peaked tile roofing, how a plumed and baubled headdress (see also fig. 1) lent its form to the leaves of his banyan tree, how an artificial beard became cascading banyan roots, and how an actor's hunched shoulders were turned into the neighboring hills. Just how two such different artistic sources—Chen Zizhuang's painting and the Sichuan opera—might have joined in the painter's creative psyche to help produce such a fine work of art can hardly be described, although the possibility that they did so cannot be denied. Neither, however, can either or both sources of influ-

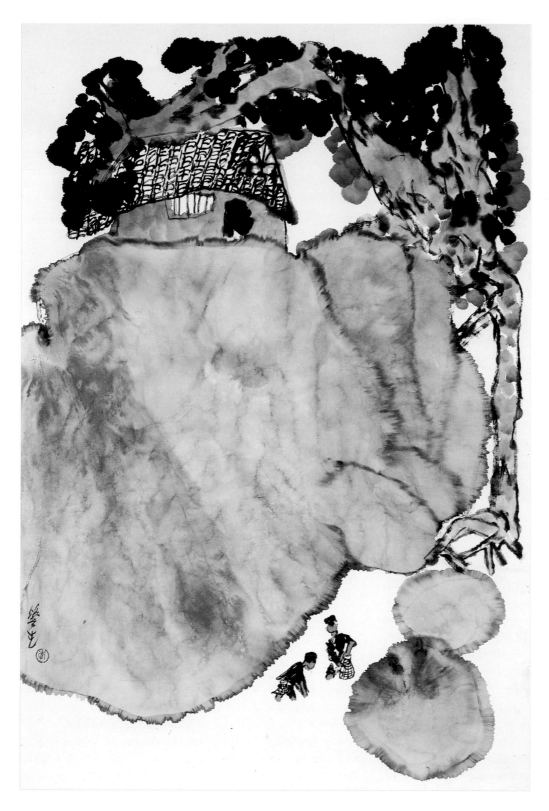

103. Li Huasheng. *Mountain Village, the Pleasure of Fishing.*
Spring summer 1985. Ink and color on paper. Collection of the artist.

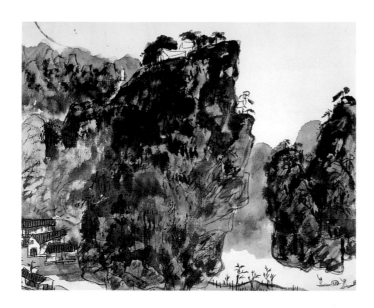

104. Chen Zizhuang. *Mountain Village, the Pleasure of Fishing.*
1974. Ink and color on paper. 52 × 64 cm. Private collection,
China. (After Yang Rongzi, *Chen Zizhuang hua ji*, pp. 40–41).

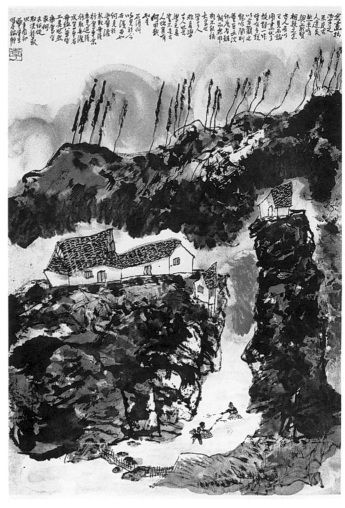

105. Li Huasheng. *The Mountains of Sichuan.*
Early autumn, 1981. Ink and color on paper. Collection unknown.
(After *China Reconstructs*, March 1982, front inside cover.)

ence explain or guarantee the actual success of Li
Huasheng's execution of the work, which depends so much
on technical skill and in which so much more is left to
chance, beyond the artist's conceptual plan.

Lü Lin's article in praise of Li Huasheng's painting empha-
sized that in addition to conveying the feeling of a "return to
rural rusticity," he effectively distinguished the local spirit
of his native province from that of China's other cultural
regions by having delved so deeply and so personally into
the cultural mentality of Sichuan's own mountain region.[47]
In all of Li Huasheng's career, perhaps no works have more
successfully captured the rhythm of Sichuan's rustic moun-
tain regions than a series begun in about 1980 entitled *Moun-
tain Dwelling (Shan ju tu)*, and none in this series has been
more effective than a painting done in the late spring–early
summer of 1985 (fig. 107). Like his *Mountain Village, the Plea-
sure of Fishing* (fig. 103), this work was published just before
Li's acceptance into the Painting Academy and probably
helped pave his way.[48] Comparison with the earliest pub-
lished work in this *Mountain Dwelling* series (fig. 59) shows
the distance Li covered within a mere half decade. It is an
aesthetic leap forward in terms of sparkling color and danc-
ing rhythms, enhancing the capacity of Li Huasheng's paint-
ings to convey feelings through creative imagination, inde-

pendent of any actual image. Yet the painting, in the end, is
truer to the emotional experience of travel through the
sweep and roll of Sichuan's mountains than any photo-
graph or purely representational painting could be.

The landscape in this painting is seen through a lens of
childlike naïveté, yet its execution affords a wonderfully
sophisticated balance of successive compositional gestures,
moving the eye upwards past one inviting contour after
another. A rhythmic counterpoint is played between major
landscape forms and minor accents: whiplike cypress trees
stretch across the contour lines like notes on a musical score;

mountain goats extend an invitation to join in play in rolling meadows; quaintly tilted houses offer the chance to linger on pleasant hillsides. Chinese Daoists and landscape artists have written for centuries of creating an "alternative universe" (*bie you tian di*). Yet too often, artists' efforts to achieve this in painting have merely degenerated into decoration and fluff, the artistic demands of creating an effective visual fantasy being more difficult than one might imagine, perhaps because such "escapist" art lacks an adequate basis in reality. Only the most successful artists have created such compelling fairylands as this one.

Two other paintings in the *Mountain Dwelling* series, both produced in 1986 (figs. 108 and 109), are richer in color and more complex structurally than the 1985 work, submerging the mountain landscape beneath a wet texture, evoking the ambience of Sichuan's natural setting. Their distant mountains, which can hardly be distinguished from storm clouds, display the increasing power of Li Huasheng's ink-wash technique. These two landscapes are not the equal, perhaps, of his 1985 rendition, having traded away its pristine simplicity, but Li personally considers one of them (fig. 108) to be his "most mature version" of this theme. Regardless, both are surely among Li's finer works, and they illustrate the high standard achieved in the first paintings done by him within the auspices of the Sichuan Painting Academy.

Li's inscription on the earliest of these three versions (fig. 107) and the largely identical inscriptions on the other two all refer theoretically to the process of achieving artistic refinement:

The *Critique of Poetry* [by Sikong Tu, 837–908], in the chapter "On Refining," says, "Like extracting gold from a mine, like extracting silver from lead, purify your heart and discard the remains." This refers to a method for refining poetry. Actually, painting should also be refined according to this method. This refinement has to do with brush and ink, not your ideas about painting. For if your concept is sufficient, how can you labor over the addition of complex brushwork?

Surely, this 1985 painting is one of Li Huasheng's purest, most wonderfully refined works. It leaves his audience to wonder how such untroubled simplicity could emerge from the brush of an artist so surrounded by troubles, who so effectively expressed his frustration in other paintings (such as his *Night Rain in the Mountains of Sichuan*, fig. 71). The answer is lodged in one of his *Night Rain* inscriptions (fig. 70) in more personal terms,[49] and is suggested more theoreti-

106. Li Huasheng. *Sketch of Opera Figure*. Spring 1987. Pencil on paper.

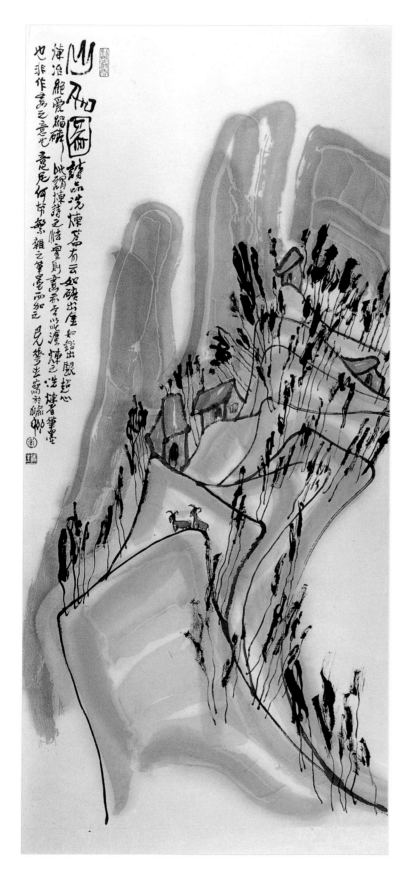

107. Li Huasheng. *Mountain Dwelling.*
Spring-summer 1985. Ink and color on paper.
Collection unknown.

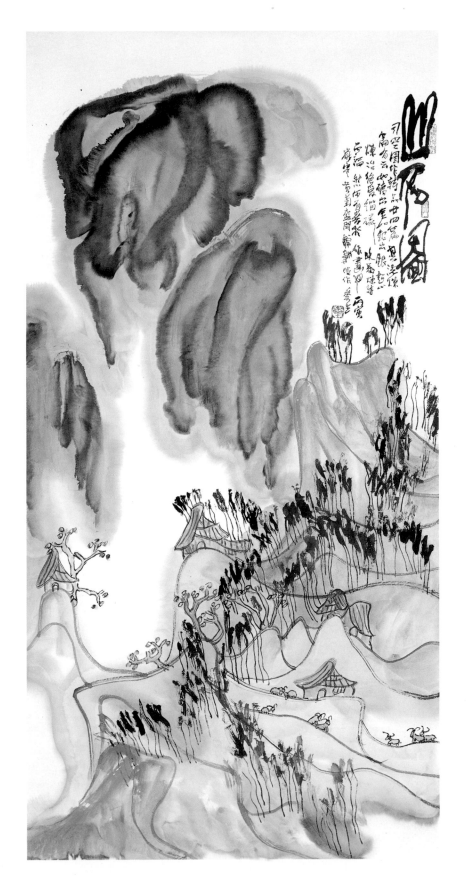

108. Li Huasheng. *Mountain Dwelling.*
Winter 1986. Ink and color on paper.
138.7 × 69.2 cm. Private collection,
United States.

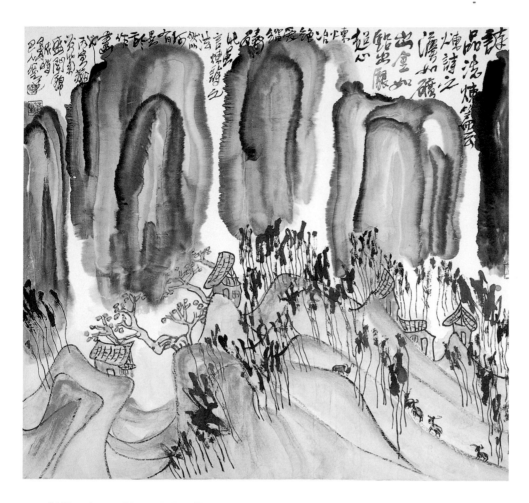

109. Li Huasheng. *Mountain Dwelling*.
1986. Ink and color on paper. Collection unknown.

cally in the inscription in figure 107: The activity of painting was itself emotionally cathartic, allowing Li Huasheng to "discard the remains" of his impurity. In the art of painted landscapes, Li Huasheng succeeded in creating an alternative universe, beholden neither to reality itself nor to "socialist reality" (that is to say, bound neither to things just as they are nor to romanticized propaganda about the society of the future), and clearing instead a private pathway into the sanity of individual imagination.

As with his *Mountain Dwelling* series, Li Huasheng continued to work on his *Night Rain* theme after joining the Sichuan Painting Academy, for example, in a painting done in late autumn 1985 (fig. 110; for earlier renditions see figs. 70, 71). In this work, as in a number of his best paintings at this time, one can see an increasing trend for Li Huasheng to push his imagery as far toward self-conscious artistry (or, as derogated by Maoist aestheticians, "art for art's sake") as might possibly be tolerated of an academized artist, paid by the state for producing such work. Edging away from description and verging on pure ideograph, the water which rushes down the stream, not actually painted, is instead suggested by partially submerged rocks which themselves are reduced to discrete strokes of the brush like those in the written character (or radical) for "water." And not bound to the stream alone, the ink (unleashed as "water") also pours down abstractly upon the trees and all down the left edge of the painting. The trees themselves are nothing more than the pure energy and directional impulse of non-descriptive brushstrokes. The bridge over the swollen stream, like the buildings, is a cut-out silhouette, an isolated form with no

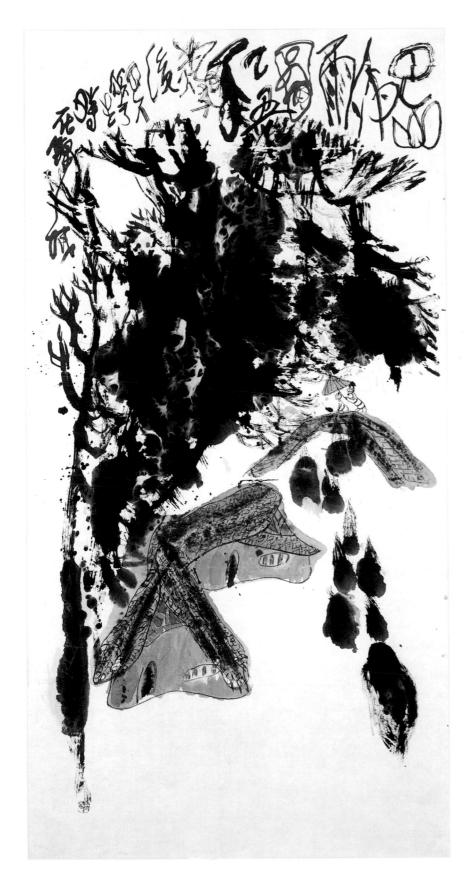

110. Li Huasheng. *Night Rain in the Mountains of Sichuan.* Late autumn, 1985. Ink and color on paper. 137.5 × 69.5 cm. Private collection, United States.

basis of physical support. And the calligraphy is now an integrated pattern, as much a part of the painting in placement as it is in brushwork, arching over the scene as if it were the cloudy source for all this water. The location of the artist's seal is highly irregular, not attached to the inscription itself but seemingly swept downward to the lower corner of the painting by the rushing "water," carrying the impulse of the inscription from the top to the bottom of the work. This is Li's favorite rendition of this theme, and the focus of his own satisfaction is the peasants coming down to shelter from the rain, with their distinctive red oil-paper umbrellas, an authentic regional type.

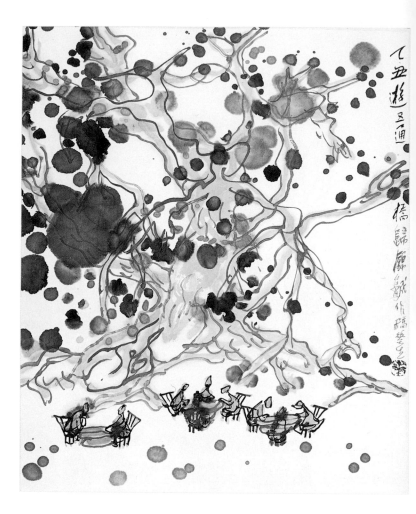

Two other works from Li's first year in the Academy also show this push toward still greater abstraction, albeit toward very different visual and emotional extremes, one explosive (fig. 111), one serene (fig. 113). In the first, abstraction is the disguise for a genre painting of tea-drinkers under a banyan tree, a scene originally viewed and accurately recorded on a sketching trip near Chengdu. In this work, the lines and dots of the tree and leaves have taken over the work, seemingly out of control but actually carefully balanced in design and skillfully managed in terms of the flow of ink. The figures keep the painting sane, somewhat at least, as they sit undisturbed by the riot of nature all around them. This natural riot, and the taming of it, is reminiscent of the art of Daoji (fig. 112), the 17th-century "eccentric" master whose work Li studied closely behind locked doors in the 1960s and who remains one of his favorite models, as he was for Chen Zizhuang. And if the painting—yet another of Li Huasheng's extreme juxtapositions of detail and abstraction—is compared to Daoji in its abstraction, it needs to be viewed beside Chen Zizhuang in its details, particularly in Chen's rendition of the Yangzhou "eccentrics," who constituted Daoji's first creative followers (fig. 25).

The second painting of this pair, *Watching Clouds* (fig. 113), is expressly done "in the brush-manner of Daoji," and again it is concerned with the relationship between the serene human observer and the untamed natural world around him. As in some of Daoji's paintings, clouds obscure anything at which the painted figure might be looking. We are forced to realize that the figure's seemingly outward gaze is actually inward and meditative, and that he is as integral a part of nature as the tree on which he rests. The linear play—shown here as hard-edged clouds—differs but little from other manifestations in Li Huasheng's earlier art, such as the earthen contours of farmers' field (figs. 28, 56). And this in turn reveals a major stylistic and spiritual source of those works, for Daoji's

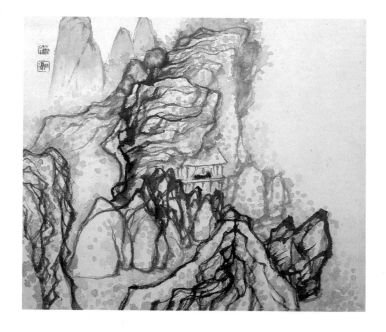

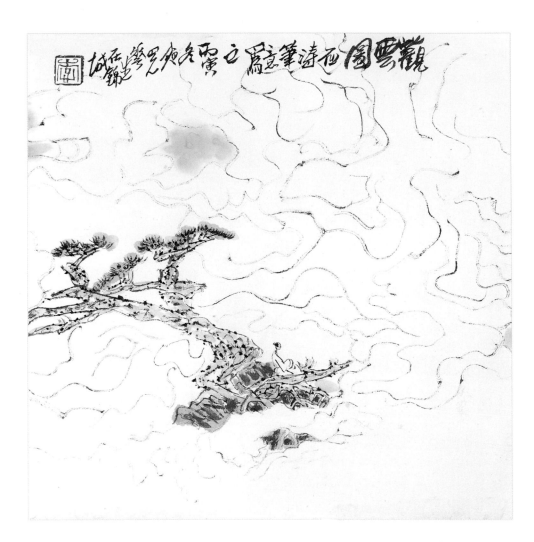

111. Li Huasheng. *Scenery at Wutong Bridge.* 1985. Ink and color on paper. Collection unknown.

113. Li Huasheng. *Watching Clouds.*
Winter 1986. Ink and color on paper. Collection of the artist.

112. Daoji. *Man in a Hut, from Album for Daoist Yu.*
Ca. 1695. Ink and color on paper. 24.1 × 27.9 cm.
C. C. Wang family collection, New York.

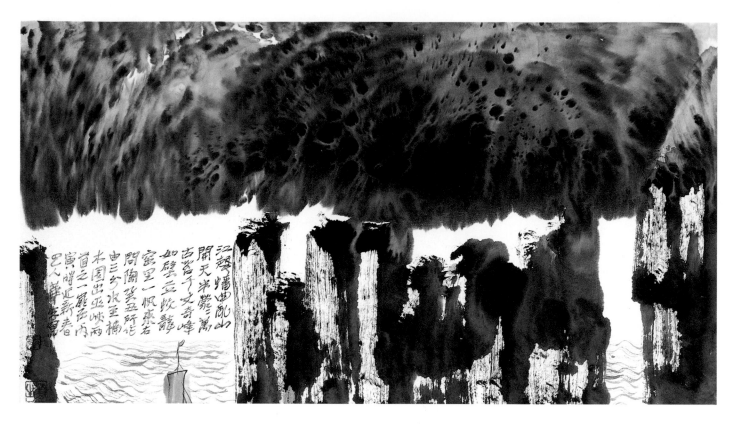

114. Li Huasheng. *Traveling Through the Gorges.* Late winter, 1986. Ink on paper. 54.3 × 98.7 cm. Private collection, United States.

presence is as visible there as it is here. Without the disturbing splash of ink dots, however, this painting remains as calm as the previous one is boisterous.

This pair of works demonstrates Li's artistic control of a broad stylistic and emotional spectrum, ranging from the dramatic to the serene. So, too, does another pair of landscapes, one monochrome (fig. 114), one in color (fig. 115), the first one daring and dangerous, the other naïvely innocent. These latter are two of Li's favorites among his own works; they confirm the high quality attained by the artist while midway in his career. In the first of this pair, from the late winter of 1986, Li makes a rare return to his once-preferred theme, *Traveling Through the Gorges.* But this is a total departure from Li's other work, old or new. Li himself says, "This painting is very strange, not even really a Li Huasheng painting." The Yangzi setting is shorn of its old romanticism and presented in starkly modern extremes, jet black and sheer white, storm clouds and jutting peaks, a horizontal band and vertical pillars.

In this remarkably new composition, heaven, earth, and water are locked in contention. As often seems the case in a Yangzi River journey, heaven is no longer remote—forced downward by the unusual horizontal format (though the painting is mounted as a hanging scroll)—as it joins with the Yangzi's turbulent water below to trap and threaten the earthen forms between. The dark and angry clouds are a *tour de force* of ink-wash technique, a combination of rare skill and perfect luck like that in the marble mountain of his *Mountain Village, the Pleasure of Fishing* (fig. 103). They seem almost as solid as the screen of perpetually wet, moss-covered peaks, which permit but a narrow opening for the passage of a solitary boat, making its way through this inhospitable realm. Only seen is the upper part of its sail, the boat itself weighted down not only by the force of weather but also by the peculiarly placed inscription, with a poem by Zhang Wentao (1764–1814):

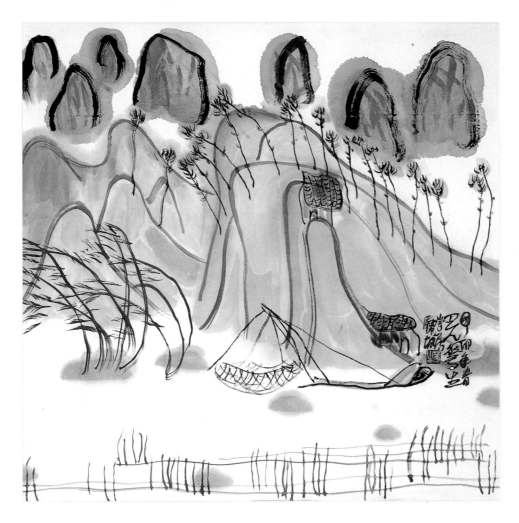

115. Li Huasheng. *Deserted Waters.* Spring 1987. Ink and color on paper. 68.6 × 68.6 cm. Private collection, United States.

River roars, coils and winds, opening through dense
 mountains;
Heaven half covered over by primeval moss
On thousand-yard-high weird peaks rising up like walls;
Through the dragon caves comes a single sail.

The inscription goes on to say that Li first copied this poem while traveling through the Wu Gorge in 1973. Given the difficult personal voyage endured by the artist between 1973 and 1986, when this work was completed, it is easy to imagine why Li Huasheng chose this solitary boat to represent himself, a rugged individual sailing against the current and weathering the storms of his time. Li says of this work that

"its 'spiritual-image' (*qixiang*) here is very much like Daoji." Stylistic inspiration, too, for the treatment of the water, the partly visible boat, and the explosive ink wash can be found in the works of Daoji, who similarly endured the political storms of a new regime.

The other half of this pair is *Deserted Waters* (fig. 115), from the spring of 1987.[50] It is as wonderfully naïve as his 1985 *Mountain Dwelling* (fig. 107), similar in color to one of his 1986 *Mountain Dwelling* paintings (fig. 109), and compositionally close to his other 1986 *Mountain Dwelling* (fig. 108). But its origins lie elsewhere, in a 1979–80 sketch of the rural village of Gubai (fig. 116), retained in this painted version with remarkably little variation. Among the few variations

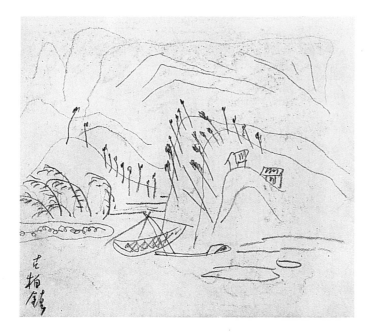

116. Li Huasheng. *Scene at Gubai.* 1979–80. Pencil on paper. Collection of the artist.

from sketch to painting are the separation of the two peasant huts to emphasize the elevated placement of one, the inclusion of reeds below (according to the artist, a last-minute addition designed to balance with its verticals, the middle-ground trees, and to give a base to the composition), and the transformation of distant mountains, above, into individual, cellular peaks.

Sichuan itself, then, is the chief composer of this work. The colors, however, and especially the yellow pigments, are derived from a different time and place, from the fifth- to eighth-century Buddhist caves at Dunhuang in northwestern China, which were painted with a strong folk-art flavor of both Chinese and Central Asian origin. The cavelike hills in the distance are a visual reference to the monastic cells of Dunhuang, lined up in rows like so many monks in meditation. And beyond the visual image, they conjure up the entire ethic of social retirement and retreat into spiritual hermitage so pronounced in the quietude of this painting.

Although this *Deserted Waters* landscape with its link to the arts of Dunhuang is dated later than Li's three *Mountain Dwelling* paintings, it is a key to understanding one of the chief sources of their style, of their simple compositional form, their expressive rhythm, and their childlike colors. Like his various *Mountain Dwelling* renditions, this landscape image is another of those "worlds apart" or "alternate universes" created by the artist for his own mental dwelling, far from the worldly turmoil that left its residue in his *Traveling Through the Gorges.* In addition to the meditational caves, above, other links to social withdrawal are the title of the painting, *Deserted Waters,* and the empty fishing boat. Both derive from an early twelfth-century stanza given by Song Emperor Huizong as an examination subject for his painters at court:

> Deserted waters, no one crossing;
> The lonely boat, all day long, lies stretched out.

Today, as in the twelfth century, the realization in painting of such poetic quietude presents a competitive challenge. A work like this, which looks so simple, so easily done, is not really a simple matter. Its success calls forth a great deal of satisfaction from the artist, who says, "This painting is like music. It is very subtle and would be very hard to do again." And Li would surely admit that, if achieving such simplicity is difficult in painting, achieving it, and retaining it, as a state of mind is even harder.

Reflecting on the dependence of Chinese artists on patrons, Li Huasheng sees later artists as caught between two unsavory historical alternatives: commercial patronage by the greedy and powerful in the presocialist era, and the ideologically oriented patronage of a collectivist state. "In China," he says,

> everything is political and artists' fate is always in the hands of others. From the middle Qing period on, painting became commercialized and painters sold their painting. Even Qi Baishi and Huang Binhon sold their paintings. But after 1949, people had so little money that they could not buy paintings, so how could artists make a living? They had to depend on their work units. And they had to obey whatever their leaders said, even if they gave instructions about painting style, because they were the ones who gave artists their bread.

Li contrasts these alternatives, in his own mind, with an overly simplified view of the "independence" of Western artists. In 1987, Li Huasheng got the opportunity, still rather rare for Chinese artists, to see the Western artists' situation for himself.

As noted earlier, in October 1985, Professor Kenneth DeWoskin proposed to the Sichuan Artists Association to invite Li Huasheng to the United States under the auspices of the University of Michigan's Center for Chinese Studies. This cultural exchange would help promote the Sichuan–

Michigan sister-state relationship and the Chengdu–Ann Arbor sister-cities friendship. At the time, Li had not yet been accepted into the Academy, so the Artists Association did not have final jurisdiction over the matter. But according to Li, it helped that Li Shaoyan thought of joining him, which pushed the concept forward. It was therefore agreed in principle that Li could go, but a whole year was taken up with arrangements for such details as deciding which party would pay for the air travel. In December 1986, by which time Li had become an Academy member, DeWoskin again visited Chengdu. Academy leaders offered their final agreement, although Li Shaoyan no longer intended to make the journey. The Sichuan Provincial Foreign Affairs Office gave its consent but then none of the various officials wanted to sign the documents, thereby taking responsibility for Li's departure, his correct behavior while abroad, and his eventual return.

The matter stalled, until at last Academy director Yang Chao said, "China has one billion people. If Li Huasheng escapes, what does it really matter!" So the others finally added their signatures to Yang Chao's. Still, says Li,

> they were worried that if I didn't return, it would be a bad influence. After Yang Chao decided to sign, the Academy secretary came to my house and asked, "Do you really intend to come back?" In fact, I never even *thought* about not coming back.

What he most hoped to do with an American visit was to hold a personal exhibition somewhere and to see the Western paintings in the Metropolitan Museum—where, says Li, "a scholar can see paintings by appointment, unlike China where we cannot trace back the origins of our tradition, since museums do not make their collections open to the public, not even to artists."

Hosted by the University of Michigan in May and June 1987, Li Huasheng also accepted invitations to visit the University of Washington, Yale University, and Harvard University. To each of these places, he brought examples of his paintings. At each, he demonstrated his painting for faculty and students. Exhibitions were held first at the University of Washington's Henry Art Gallery, and then at the Detroit Institute of Art. He toured New York's Metropolitan Museum at leisure, as well as the Freer Gallery–Sackler Museum in Washington, D.C. He visited independent Chinese painters, connoisseurs, and collectors who were living in America, such as C. C. Wang in New York, and he received their criticism of his work, sometimes accepting it and sometimes rejecting it.

Among these critics, C. C. Wang found too much animated "gesture" in Li's compositions, though he was willing to ascribe this view to his own more restrained Suzhou standards as opposed to the openness of Sichuanese expression, as well as to aesthetic differences between the older and younger generations. Li dismissed all this as simply a difference in taste. C. C. Wang also criticized Li's brushwork as lacking in subtlety, something perhaps lost to an entire generation of younger Chinese artists. Li rejected this at first, but within a year's time—a period filled with intense introspection—he came to agree with C. C. Wang and announced his intention to concentrate seriously on improving his brushwork. This typified the sometimes delayed but ultimately long-lasting effects of Li's relatively brief travel abroad.

Just before coming to America, Li Huasheng produced an exquisitely simple, jewel-like album, his so-called *Small Album* (fig. 117), which he carried on his journey and which received as much praise from viewers and critics as anything he brought with him. Done in homage to Chen Zizhuang, its stylistic indebtedness to Chen is clear (compare fig. 118), yet so, too, is its ability to stand with the best work of Li Huasheng's late master. Before his departure for America, Li Huasheng had become engaged for the third time, to a young woman named Dai Ling. In her early twenties, Dai Ling is a teacher at the Sichuan Provincial Academy of Sichuanese Opera (the kind of job the opera-loving Li Huasheng might privately desire to have for himself). Produced in a romantic mood, this *Small Album* was intended as an engagement present for Dai Ling and was given to her on Li's return to China. Though seemingly always the individual, always the loner, Li says he needs to be in love to be happy, and romantically happy to be artistically productive; that he needs to share another personality as different from his as *yin* is from *yang* in order to feel creative. Sounding more romantic than he appears, Li adds:

> If you are alone, everything in the studio seems dead. You unfold the paper on the table and can't see anything inside it. You paint only with reluctance. I don't know if others feel this, but I think if you are not in love you must search for it. Because an artist makes something out of nothing, there must be something already inside. If you feel in love, then even when you are physically alone, something will come out on the paper.

A few months after his return, on October 15, 1987, Li and Dai Ling were married.[51]

But Li Huasheng's reunion with China was no love fest. He says that as soon as he boarded the return flight in Hong Kong, on China Airlines, he was reminded by the service of two different attitudes toward human beings. Immediately on his return, he was interrogated on the details of his trip

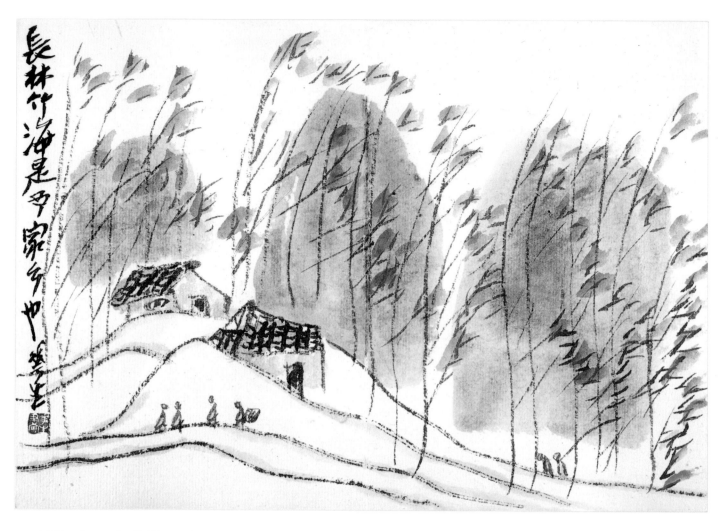

117. Li Huasheng. *Small Album: The Bamboo Sea at Changlin.*
1987. Ink and color on paper. Collection of the artist.

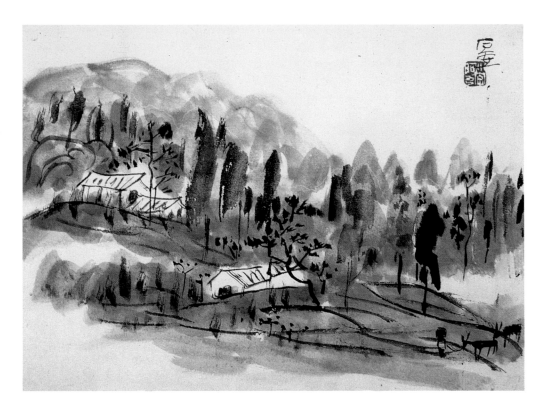

118. Chen Zizhuang. *The Pure Pleasure of a Mountain Village.*
1973. Ink and color on paper. 19.5 × 26 cm. Private collection,
China. (After Yang Rongzi, *Chen Zizhuang hua ji*, p. 14.)

by the sister-cities section of the Sichuan Provincial Foreign Affairs Office. He informed them of everyone he had met, how long they had talked, what about, and with what gifts he had returned. Afterwards, they checked on the accuracy of his report. Shortly before the end of his stay in America, the Michigan State Senate had passed a lengthy resolution to the effect that "the highest tribute be accorded Mr. Li Hua Sheng, the first Michigan-Sichuan exchange artist."[52] Li says that the cadres who interviewed him were "particularly interested in this resolution of appreciation," and that it gratified all those who had worried about the impression Li might leave behind.

Li Huasheng also reported to the head of the Sichuan Provincial Cultural Bureau, Jiang Minghua, who had signed his name in approval of Li's departure. Li Huasheng then had to give the same information to his immediate superiors. Yang Chao invited him to report on his trip to Academy members, and Li insisted in advance that he not be interrupted, saying that he would accept any criticism after-

wards. He took almost three hours for his report. After all of this reporting, some began to refer to Li Huasheng as the "America-loving partisan." This was said with reference to the figure painter Fan Zeng, who has been branded a "Japan-loving partisan" for his popularity with that audience. Li says, "No foreigner can really see the depths of Chinese suffering, with all of our political regulations."

Patronage by foreigners has come to play an important, if ironic, role in socialist China. In addition to the various forms of artistic patronage already noted—the pre-eminent role of Artists Associations, the purely monetary trade in paintings (exemplified by Li's unfortunate venture with Qiao Deguang), the exchange of obligatory (*yingchou*) paintings for scarce goods and services, the mutual patronization of artists and religious temples, and the interchange between artists and Party cadres (such as Ai Weiren)—the role of overseas patronage has become increasingly prestigious in the past half-decade. It is not only that foreigners have far more cash to pay for traditional Chinese painting

(although in a cash-hungry nation, this is not to be dismissed; in the 1980s, shops were opened in the major eastern cities to sell art exclusively to foreigners with the international currencies sought by the government). But foreign attention, once cast upon a Chinese artist, has a remarkably protective value in a state that increasingly pursues a favorable international image, that no longer wishes to be thought of as politically subjugating its artists.[53] In his 1983–84 difficulties, Li Huasheng was no doubt shielded somewhat from still greater trouble by all the attention to the traditional Chinese painting exhibition then touring the United States and the praise showered on Li in the accompanying catalog, just as he was by the interest that the Japanese began to take in his art from the time of the Du Fu Thatched Hall exhibition. His 1987 trip to America increased his visibility to a foreign audience and certainly added to his prestige, which protected him even further. Yet the results of Li's foreign travel were far more complicated than this.

Li Huasheng's journey was a cultural shock. "Before I went to America, I thought it was a frightening place, full of Mafia. Even the first night that I went to bed there, I felt threatened. But in Boston, I saw a man speaking in public, cursing the president. For anyone who lived through the Cultural Revolution, this was unbelievable." Li had always thought in terms of artistic independence, but he could not anticipate the degree of independence he would find in the West or its profound effect on him. "Art in American museums," he says, with irony, "really embodies Chairman Mao's 'Let a hundred flowers bloom.' Americans really follow Chairman Mao's idea. Maybe it was spoken *so loud* by Chairman Mao that it reached to America but deafened the Chinese people." And he reflects that "only those Chinese who have traveled abroad can understand Chinese life well enough to care profoundly for our nation's future and the powerlessness of our people." The bitter realization that his treatment during the Campaign Against Spiritual Pollution was not something to which all artists, everywhere, were vulnerable began to seethe in him as never before.

After returning from America, Li at first refused to receive visitors. There were even rumors, though untrue, that he had posted this refusal on his door. He became increasingly intent on living in accord with the statement he had made in an interview in Washington, D.C., for the Voice of America program, "Artists' World":

> During the Cultural Revolution, I kept my distance from politics and increased my artistic ability. When I got in trouble again,

later on [1983–84], I kept my distance from politics and increased my artistic abilities again. *But politics should also keep its distance from art.*

Li's journey to the West has convinced him that nothing matters to him but the quality of his art, that Chinese cultural politics can only get in his way, and that no degree of success within the system can be of help. Like Chen Zizhuang, who fiercely defended his own artistic independence with the statement "The true painter should have the ability to rule the country, to kill the people and burn their houses," Li has begun increasingly to isolate himself from his own version of what constitutes "cultural pollution." He is no longer concerned about current responses to his art and worries only about what he will leave to history. He compares himself to a singer who sings only in a sealed room, so that no one else is able to hear him. "The only way a painter can gain his independence," he says, "is if he pays no attention to officials. Otherwise, every day the Party will continue to call for national unification, and everyday there will still be conflict."

Li Huasheng opposes the fact that one can join exhibitions only through the patronage and protection of one's superiors, who in turn control the artistic contents of what is displayed. "In order to participate in a national exhibition," Li points out, "you must first make a draft of your proposed work so that Association leaders can criticize it and make suggestions on how to improve it. Now, how can you *do* that?" He says he won't tolerate such instructions any longer. He ponders with resentment Li Shaoyan's earlier insistence on Luo Zhongli's addition of a ballpoint pen beneath the head-scarf of his now-famous peasant painting, *Father* (fig. 35).[54] And because Li Huasheng today openly resents this kind of control, he says that he and Li Shaoyan are now "feuding," despite Li Shaoyan's efforts to the contrary.

For his part, Li Shaoyan has tried repeatedly to include Li's paintings in exhibitions displaying Sichuan's art beyond the province and outside of the country. After Li's return from America, Li Shaoyan called on Wang Mingyue as an intermediary to ask Li to offer a painting for a Hong Kong exhibition; the catalog had already been printed with Li Huasheng's name included. Artists are normally nothing if not compliant, so such license is frequently taken by arts administrators. But Li refused. He even invoked rarely used artists' rights to prevent Li Shaoyan and the Artists Association from using a painting already in the Sichuan Painting Academy's collection and available for sale. Since this put

the provincial Association in an embarrassing position internationally, Wang returned to bargain with Li, proposing to help organize a one-man exhibition for him in Beijing's National Gallery if he would only comply. But Li merely saw this as an empty promise. Li also turned down offers to put him in a four-artist exhibition at the National Gallery and in an exhibition of fifteen well-known middle-aged artists in Shanghai. In the end, Li told Wang they would have to excise his name by physically cutting it out of the printed catalog, which they finally had to do.

Li Shaoyan subsequently organized an eight-artist Sichuan painting exhibition in Beijing's National Art Gallery for March 1988, ostensibly meant to show the rest of the country Sichuan's great recent progress in traditional Chinese painting. But some say it was intended by Li Shaoyan to reassert his regional authority in the face of the traditional painting revival he had opposed for so long—a response to the challenge posed by Yang Chao and the new Academy, coming just at the time of a similar exhibition planned by Yang Chao. Li Huasheng, sharing the latter view, refused to participate in this exhibition as well.[55] "I just don't want my paintings mixed with those of others," he now claims although he had been happy to do just that on various other occasions. Li Huasheng resents that, during this exhibition, Li Shaoyan was publicly referred to on Beijing television as "a Bo Le among painters"—that is, as a great connoisseur, after ancient China's best-known judge of fine horses—despite Li's long-time disinterest in, or opposition to, *guohua*. He takes pleasure instead at the remark by China's leading painting critic, Wang Zhaowen, who ridiculed much of the work included in this eight-man exhibition as mere provincial stuff, writing, "The monkeys have come down from Emei Mountain and tried to pass themselves off as pandas!"[56] Li Huasheng also rejoiced that virtually all those who participated in Li Shaoyan's exhibition agreed to join Yang Chao's National Gallery group exhibition as well, to which Li himself submitted two paintings.

Li Huasheng insists that "the relationship between Li Shaoyan and myself is not personal." Nor does he see Li Shaoyan as unusual in the role he plays. "But since I came back from the United States," he declares:

> I really cannot tolerate this kind of dictatorship, this control of policy and regulation making. Correct thinking requires resisting this. All outstanding ancient figures were attacked by the bureaucracy: Sima Qian, Li Bai and Du Fu, Su Shi. Even if you cannot equal them, you can take them as your models. Don't follow bad role models. If you obey the will of others or submit to

> their orders, you will become a slave artist. It's exploitation: all the benefits go to them. It's necessary that somebody sacrifice himself. Maybe there can be some change, and maybe then Chinese art can really flourish.

Li also does not think of this conflict as primarily generational, as younger artists versus the old:

> Many young painters think only of themselves and see their leaders as the only way for them to get to Heaven. They never think about the well-known artists of ancient times who didn't take this road, artists like Yangzhou's "Eight Eccentrics," Bada Shanren, Daoji, Wu Zhen, and Xu Wei. Whether your painting is good or not is not so important. What matters is having a social conscience.

True to this view, Li has become increasingly unwilling to rely even on those authorities he most respects. Recently a book illustrating his art has been prepared by Wu Yingji, *Selected Paintings of Li Huasheng* (*Li Huasheng hua xuan*), for publication by the Sichuan Fine Arts Publishing House. A calligraphic book title (the highest form of artistic endorsement) was written by Li Keran, who until his recent death was chairman of the Chinese Painting Research Institute and was probably China's most prestigious living painter. Li had met Li Keran twice, the first time during his ten-man exhibition in Beijing in 1981 (fig. 61), the second, during his rushed visit to Liu Haisu's exhibition in 1983; he had admiringly studied photographs of Li Keran's painting (cf. fig. 13) in order to better his own work (cf. figs. 63, 64, 66). But to show his disapproval of the social custom of "the young depending on the old" and all that this implies about the loss of individuality, Li finally refused to let Li Keran's calligraphy be used for this purpose, despite possible offense to the painter whom he admired so much.

Even among those sympathetic to Li's view (such as Dai Wei, who states, "I really appreciate Li Huasheng's rebellious spirit"), some might find this refusal excessive. But as his submission of two paintings for Yang Chao's National Gallery exhibition suggests, there are also limits to Li Huasheng's noninvolvement. Among his more important "obligation pieces" are two he did for the provincial government. "At first I refused," he says, "thinking that since I came back from America I should behave in some democratic manner. But that didn't work. I just tried to refuse at first, but could not." One of these paintings was for the governor of Michigan, the other for the United States Congress, sent to them as gifts by the province of Sichuan. "I

think that the quality of the two paintings," both six feet tall, "was all right," he says, realizing that some public pieces must be done well. He also attended a banquet on the fifth anniversary of the Sichuan and Michigan sister-state relationship, the only artist invited to attend this meeting of high provincial officials. And in the summer of 1988 he painted two leaves in a collective album by Academy members to be presented with gratitude by Yang Chao to Fang Yi (China's former vice-premier, now a National Party Congress Standing Committee member and member of the State Council), who had visited the Academy in March 1986. On this occasion, Li worked seriously and patiently to produce paintings of high quality, constrained by the fact that the paintings were done in a pre-bound album already begun by others so no changes could be made.

Another aspect of bureaucratization that Li could not avoid was the universal restoration of institutional ranks. Differential ranks of all kinds, from army officers to academicians, were abolished by Lin Biao in 1963. The overturning of this extreme display of egalitarianism had long ago been promised, ever since the demise of Mao, but since it involved a vast number of individual decisions, it was not actually begun until 1988. Initially, at the Sichuan Painting Academy, all members had simply been designated as "painting masters." Now, according to the national pattern, each member had to propose his own rank, which was then held up for bureaucratic review. Li Huasheng entertained no doubts about the matter and proposed that he be promoted to first-rank painting master (*yiji huashi*), the equivalent of a full professor in a teaching academy.

After the first two meetings of the committee designated to rank all of Sichuan's academically based artists, the Sichuan Provincial Fine Arts High Ranking Titles Evaluation Committee chaired by Li Shaoyan, it was agreed that Li should be promoted to first rank on the basis of outstanding merit.[57] This conclusion was submitted to the Sichuan Provincial Cultural Bureau (*Sichuan Sheng Wenhua Ting*), where it was approved with the help of the Bureau head, Jiang Minghua. From there, the recommendation was forwarded to the Sichuan Office for Evaluating Ranks—staffed by "bureaucrats with mostly scientific background, who check schooling and diplomas but who don't review the artistic materials or know how to judge quality," according to Li, who has no diploma himself. This office set up an interview with Li which he found "humiliating," but he was told that to oppose it would be arrogant and insulting to Party policy. At this interview, despite initial suggestions by the office's committee members that he accept a second-rank appointment, Li demanded first-rank status, bolstered by the sup-port he had received from lower-level evaluations up to that time. But the review committee concluded that he did not have enough years of service and refused to approve the recommendation for first-rank status.

Although Yang Chao sent up Li's case for promotion to first-rank status several more times, it was repeatedly turned down. "Once, they said it is impossible that I would get first rank," says Li. "They discussed with me whether I would temporarily hold second rank and later be promoted to first rank. I said no. 'If it's impossible, then I won't participate in this evaluation. I don't need any rank.'" According to Li, "Yang Chao made quite an effort to steer this thing through," calling the Propaganda Department for their assistance and enlisting the aid of Jiang Minghua of the Cultural Bureau. The Painting Academy's Party secretary, Liao Jiamin, also added considerable effort. Finally, in the summer of 1989, Li Huasheng was ranked "first-grade painting master." This, says Li, "was made possible only with many people's help; otherwise, I could not have gotten it."[58]

Other forms of recognition have come to Li Huasheng since his return from America. Institutionally, Bai Desong helped to obtain for him an honorary research fellowship at the Sichuan Academy of Fine Arts (like all apppointments there, a two-year renewable appointment). Through this, Bai hopes to convince Li actually to teach a class, although so far he has failed to get Li Huasheng's commitment. Commercially, recognition can also be found in the local painting shops in the form of ballooning prices. Predictably, the rising price of Li's works no longer guarantees the unwary shopper any degree of authenticity. The manager of the Chengdu Hotel Art Shop, Chen Gang, admits that he once purchased one hundred forged works attributed to Li Huasheng.

But formal status and commercial recognition no longer satisfy Li Huasheng. After his American experience, he is not only dissatisfied with the artistic climate in China (although he remains wedded to the landscape of Sichuan), but he is also convinced that his own art must grow beyond its present stylistic limitations. "I am determined to change my style," he says. "How my work will look, even I cannot predict." He laments the tendency of many Chinese artists to establish one style, managing it throughout their whole lives, like a commercial trademark. As have an increasing number of other artists, mostly younger and less traditionally oriented than himself, Li has come to view Chinese art and Chinese cultural politics as inseparable. He thinks increasingly of how his art should express his dissatisfaction, but he is also painfully aware of how inadequate it is to change anything:

Since I came back from America, I've produced very few good paintings. My professional situation is so chaotic, and my heart isn't at peace. I think about my country's situation. Being a painter, I *must* think about this. But I have no idea how to solve it. I just behave shabbily and think about survival. Now I keep thinking I should just paint by splashing a few drops of ink about and adding a small seal, or maybe just squeezing out a little color from the tube directly onto the paper, to express how useless my painting is for the future of my country.

While Li can no longer evaluate his art happily, he alternates between sadness over this and patient forbearing:

In a marathon, some fall down at the beginning; some die part way through; some stop to get a drink and just settle down. In my generation, we're all still in the middle and the result won't be seen for a hundred years. After I got back from America, my thinking became more open. Before, I ran blindly and wanted to reach the finish line. I looked forward to see who was in front of me, whom I could pass with a final sprint, and to see whether those behind had the strength to catch me. I'm in the middle of my life span, but there's a long, long way in my career. Now I'm in a state of relaxation, recovering my energy. But my audience doesn't understand. They think I'm arrogant because they're not accustomed to seeing a runner go so slowly. The artist wants a reputation, yet like Wu Zhen [a retiring Daoist artist of the 14th century who constantly resisted his wife's pleas to go out and make a reputation for himself], he should want it not for the present but for after his death.

By 1988, Li had turned much of his artistic energy from painting to seal carving (fig. 119d–j), going back to the basics he had studied long ago from Zeng Youshi (fig. 119a–c) but now bringing to this medium all of the dynamic energy, the unusual composition sense, and the love of dramatic transformation that had gradually reached maturity in his landscape painting. The artist's transformational skill (which elsewhere turned operatic stage personae into painted landscape forms, figs. 103, 106), is seen in the treatment of his own name, Huasheng, as an actor's mask (fig. 119d) and again as dancing figures (figs. 119e, f). In one of these dancing images (fig. 119e), the lines are more typical of painting than of writing—dynamic and impatient, like the extended tree branches of some of his landscapes (fig. 81); and the characters are more pictorial than calligraphic— ghostlike figures, such as those found on lacquer fragments of the late Zhou period. In this seal, the characters fill every corner of available space, pressing up to and beyond the very edge. This seal pursues the impression of a hair brush with the hairs sometimes clumped together, as in the so-

called flying-white technique of painting. Unusual linear effects are also pursued in Li's "Leaky Hut" seal (fig. 119g, the name of his painting studio), in which Li has intentionally "cracked" or abraded the surface of the stone so that chips appear both along the edge and in the midst of the lines.

In the mate to this dancing "Huasheng" seal (fig. 119f), by contrast, the figures are compressed and carefully located (reminiscent of flower and animal compositions by Bada Shanren), sketched in turn, constrained lines; they share equal emphasis with empty space. Characteristics of both of these "Huasheng" seals are combined in Li's "Spirit soaring" (fig. 119h), done with relatively thin lines and with forms that fill the frame. Here the characters are personified as dancing and flying figures, with flashing feet, bent knees and outstretched arms and sleeves, like the shamanic figures known from Han dynasty tomb tiles. Yet another pictorial metamorphosis is found in his seal *Sun you yu*, "Eliminate whatever is unnecessary" (fig. 119i, paraphrasing the Daoist classic, *Daode jing*), with the characters for *sun* and *yu* transformed into human figures and that for *you* into a house. The buoyant rhythm of Li's "Spirit soaring" contrasts with the unresolved tension of his *Gui hua taofu*, "Charm painted by a ghost" (fig. 119j), where the characters seem almost too crowded to move, yet each shifts uncomfortably off its axis.

The success of Li Huasheng's recent seal carving clearly stems from his painting. Perhaps, in return, he can ultimately bring these carved designs to bear on the layout of solids and voids in his paintings, or to enhance the quality of his brushwork. For the time being, since his return from America, Li has sought to express his troubled mood—or, alternately, to escape it—through paintings that are characterized more than ever before by exaggerated forms and dramatic linear gestures. But he is not yet comfortable with the results, not convinced of their achievement. For two favorite works from this recent period, the best he claims is that "I felt they were not bad." But he asks, "In them, can't you hear the sound of the wind and rain in Sichuan?" It is a disquieting allusion, pointing to the troubled future which he and all of China now face.

In 1987 and 1988, socialist China's cultural policies has never been more open, and most artists celebrated that fact. Li Huasheng's American journey, on the contrary, broadened his perspective on Chinese cultural politics and gave him a gloomier outlook on its condition than that held by many Chinese intellectuals and artists. Li determined that his career should begin a new chapter, but he was not sure whether he would have the opportunity to carry it out. In

1987, he predicted, referring with dark humor to his once-persecuted older friend, "If the current reform movement does not continue, I will become like Lü Lin."

Ai Weiren once said of his earlier support for Li, "This was society helping him, not me."[59] When asked, in 1988, if the society would continue to help Li Huasheng in the future, Ai replied that Li and other artists are never free from politics, because "artists cannot live separately from society, but society will protect him. Society will protect him. You can be sure, now that ranks have been restored." In other words, now that normality had returned to post-Cultural Revolutionary Chinese society, Li was secure. But in 1989, normality was once again upset. Exposed once again was a mass of contradictions among the people and between the people and the state. With that, a period of unparalleled openness in Chinese cultural politics drew to a close, and the Chinese art world itself entered a new and unpredictable chapter.

119. Zeng Youshi and Li Huasheng. Selected seals (original scale).

Upper row, from left. a. Zeng Youshi, carved for Li Huasheng, 1979. *Jiang shang ren* ("Man of the River"). b. Zeng Youshi, 1981. *Dian hua lang ji* ("Dots and lines freely done"). c. Zeng Youshi, carved for Li Huasheng, 1979. *Dian hua lang ji* ("Dots and lines freely done"). d. Li Huasheng, undated. *Hua* (artist's name, in the form of an actor's mask).

Middle row, from left. e. Li Huasheng, 1988. *Huasheng* (artist's name). f. Li Huasheng, 1988. *Huasheng* (artist's name). g. Li Huasheng, 1988. *Xia Lu* ("Leaky Hut," name of the artist's studio).

Bottom row, from left. h. Li Huasheng, 1988. *Shen fei yang* ("Spirit soaring"). i. Li Huasheng, 1988. *Sun you yu* ("Eliminate whatever is unnecessary," paraphrasing the *Daode jing*). j. Li Huasheng, 1988. *Gui hua taofu* ("Charm painted by a ghost").

a
江上
人

b
點
畫
狼
籍

c
點
狼畫
籍

d
華

e
生華

f
生華

g
盧鑣

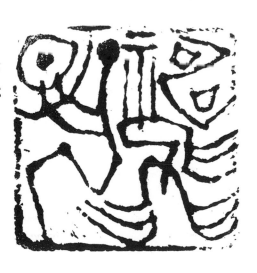

h
神
揚飛

i
損
有
餘

j
鬼
桃畫
符

Notes

1. For epigraph (page 2) see *Selected Readings from the Works of Mao Tsetung* (Beijing: Foreign Languages Press, 1971), p. 434. This is a heavily revised official version, published first in the *People's Daily* on June 18, 1957, of Mao's speech to the Eleventh Session of the Supreme State Conference, February 27, 1957. For the original "speaking notes" for this speech and other Mao speeches from 1957–58, with related articles by editors Roderick MacFarquhar, Timothy Cheek, and Eugene Wu, and by Benjamin Schwartz and Merle Goldman, see *The Secret Speeches of Chairman Mao: From the Hundred Flowers to the Great Leap Forward* (Cambridge: Harvard University Press, 1989), pp. 131–89. The revised official versions in *Selected Readings* –however unfaithful to the originals—are quoted throughout this text, unless otherwise noted, for these were the versions known to and acted upon by most Chinese people.

Preface

1. Michael Sullivan, "Values Through Art," in Ross Terrill, editor, *The China Difference: A Portrait of Life Today Inside the Country of One Billion* (New York: Harper and Row, 1979); Julia Andrews, "Traditional Painting in New China: *Guohua* and the Anti-Rightist Campaign," *Journal of Asian Studies*, 49.3 (August 1990), pp. 555–85; Arnold Chang, *Painting in the People's Republic of China: The Politics of Style* (Boulder: Westview Press, 1980); Joan Cohen, *The New Chinese Painting, 1949–1986* (New York: Abrams, 1987); Ellen J. Laing, *The Winking Owl: Art in the People's Republic of China* (Berkeley and Los Angeles: University of California Press, 1988).

2. Woo claims instead, in a section entitled "Onward to Undying Glory," that despite "some minor repercussions" among Taiwan critics over the progovernment testimonials in some of his late paintings, "both Taiwan and Beijing continued to uphold Qi Baishi's art as exemplary." Catherine Yi-yu Cho Woo, *Chinese Aesthetics and Ch'i Pai-shih* (Hong Kong: Joint Publishing Company, 1986), p. 42. Compare the less reverential and more revealing approach in Ellen Laing's *Winking Owl*, pp. 63–64, 84.

3. These statements by Wilde and Adams appear in James Breslin's paper, "Modernizing Biography: The Case of Mark Rothko," presented at the College Art Association annual meeting in 1989.

4. The Chinese term *kou bei* (literally, an "oral stele") signifies the use of memory and speech to transmit unvarying copies, as the use of stelae and rubbings once did.

1. Contradictions: Artistic Personality and the Socialist State

1. Mao Zedong, *Selected Readings*, p. 30.

2. Lowell Dittmer, in *China's Continuous Revolution: The Post-Liberation Epoch, 1949–1981* (Berkeley and Los Angeles: University of California Press, 1987), p. 1, writes, "The desire to continue the revolution after power has been seized is not altogether unique. But in no other revolution in history has this attempt been as protracted, thoroughgoing, and consequential as in the Chinese case. Indeed, our contention is that the attempt to 'continue the revolution under the dictatorship of the proletariat' has dominated Chinese politics more than any other single concern in the three decades since the founding of the People's Republic." Dittmer defines three essential characteristics of this revolution in terms of "charismatic" leadership constantly mobilizing mass support against illegitimate elements in the authority structure in pursuit of utopian goals (pp. 3–5).

3. At the Third Plenum of the Eleventh Party Congress, held in Beijing in December 1978, the organizing of mass movements was officially renounced, although in practice this has not been upheld.

4. See Mao Zedong, "On Contradiction," August 1937, a speech originally delivered at the Anti-Japanese Military and Political College in Yan'an, *Selected Readings*, pp. 432–79, and Mao Zedong, "On the Correct Handling of Contradictions Among the People," ibid., pp. 85–133, which provided the quotation on p. 2 above.

5. Mao Zedong, "Contradictions Among the People," *Selected Readings*, p. 433. See paragraph at beginning of Notes, above, with regard to the editing of Mao's original, secret speeches.

6. Ibid., pp. 433, 439. According to Mao (ibid., p. 439): "This democratic method of resolving contradictions among the people was epitomized in 1942 in the formula 'unity, criticism, unity.' To elaborate, it means starting from the desire for unity, resolving contradictions through criticism or struggle, and arriving at a new unity on a new basis."

7. Ibid., p. 434.

8. Ibid., pp. 438–39.

9. Dittmer, *China's Continuous Revolution*, p. 65.

10. In his original February presentation, Mao noted that "historically, Marx and Engels talked very little about this problem; Lenin discussed it, but briefly, saying that while antagonisms in socialist society had vanished, contradictions still exist," and that

"when Stalin was in charge, for a long time he confused these two types of contradictions." Mao Zedong, "Contradictions Among the People," in Robert MacFarquhar et al., editors, *The Secret Speeches of Chairman Mao* (Cambridge: Harvard University Press, 1989), p. 136.

11. The rapid ideological about-turns of this period, the complex reasons for them (including the need to enlist intellectuals in the forthcoming collectivization campaign; Nikita Khruschev's secret speech revealing and denouncing Stalin's excesses, and the mass revolt in Hungary which encouraged Mao to woo the intellectuals with a more open policy; and Party leaders' disappointment that this policy led to fierce criticism of the government rather than to unity with it), and the pivotal role of Mao's "Contradictions Among the People" speech (in its two divergent forms of February and June 1957) have been the subject of much study. See, for example, Roderick MacFarquhar, *The Origins of the Cultural Revolution*, vol. 1, *Contradictions Among the People 1956–1957* (New York: Columbia University Press, 1974); Merle Goldman, *Literary Dissent in Communist China* (Cambridge: Harvard University Press, 1967), chs. 8 and 9; Merle Goldman, "Mao's Obsession with the Political Role of Literature and the Intellectuals," in MacFarquhar et al., eds., *Secret Speeches*, pp. 39–58. MacFarquhar concludes that "despite the changes of tone and content [between the earlier and later versions of Mao's speech] that must have dismayed the Chinese bourgeoisie, the speech remained a document that promised a new deal [and] still emphasized persuasion, not coercion" (*Origins*, 1: 269).

12. For an overview of the organization that provided the model for Chinese cultural associations, see John and Carol Garrard, *Inside the Soviet Writers' Union* (New York: Free Press, 1990); cf. pp. 8–9 for the matter of structural voluntarism.

13. See above, p. 3.

14. For a background study of this critical event, see Tsi-an Hsia, *The Gate of Darkness: Studies on the Leftist Literary Movement in China* (Seattle: University of Washington Press, 1968). All official government versions of Mao's text published after 1953 (e.g., the *Selected Readings* version quoted here) represent a version re-edited in that year and the only version known to the public after that time. For a translation of the original version and a study of Mao as literary theorist, see Bonnie McDougall, *Mao Zedong's "Talks at the Yan'an Conference on Literature and Art": 1943 Text with Commentary* (Ann Arbor: Center for Chinese Studies, University of Michigan, 1980).

15. Hsia, *Gate of Darkness*, p. 241.

16. Mao Zedong, "Yenan Forum," *Selected Readings*, p. 251.

17. Mao, in fact, denied even the possibility of an "art for art's sake," of any art "that stands above classes, art that is detached from or independent of politics." Ibid., p. 271.

18. Ibid., pp. 271–72; the phrase "cogs and wheels" (or "screws") was borrowed from Lenin's famous 1905 article, "Party Organization and Literature," which became the cornerstone of Soviet aesthetic theory. "Down with non-partisan writers! Down with the literary supermen! Literature must become *part* of the common course of the proletariat, 'a cog and a screw' of one single great Social-Democratic mechanism . . . a component of organized, planned and integrated Social-Democratic Party work." V. I. Lenin, *Collected Works* (Moscow: Progress Publishers, 1978), 10: 45.

19. Cf. Miklós Haraszti, *The Velvet Prison: Artists Under State Socialism* (New York: New Republic/Basic Books, 1987), pp. 64–65.

20. Mao Zedong, "Yenan Forum," *Selected Readings*, pp. 260, 269; emphasis added.

21. This term is still used in early 1990s Party parlance. One conspicuous instance was in Deng Xiaoping's warm "Greeting to the Fourth Congress of Chinese Writers and Artists" in October 1979, at the outset of his administrative tenure; *Selected Works of Deng Xiaoping (1975–1982)* (Beijing: Foreign Languages Press, 1984), p. 204.

22. Mao Zedong, "Yenan Forum," *Selected Readings*, p. 265.

23. Mao's private collection of painting mostly comprises works presented to him on formal occasions, especially in celebration of National Day (October 1). It is hard to say that it represents his individual taste, or that he had strong tastes in the visual arts. See *Mao Zedong gu ju cang shuhuajia zengpin ji (Works presented to Mao Zedong, in the collection at his former residence)* (Beijing: Renmin meishu chubanshe, 1983).

24. This polarization is the particular focus of Arnold Chang's *Painting in the People's Republic of China: The Politics of Style* (Boulder: Westview Press, 1980), ch. 1.

25. Mao Zedong, "Yenan Forum," *Selected Readings*, p. 264.

26. Ibid., p. 266.

27. According to Merle Goldman, "revolutionary romanticism" derived from the terminology of Andrei Zhdanov, used by him as early as 1934, although it was put forth in China by Zhou Yang and Guo Mouro as an original concept in 1958, during the Great Leap Forward. Goldman suggests that, although it was really nothing more than "a restatement of the original Soviet concept of socialist realism," the new term was designed to "reinvigorate" the concept and to distinguish it from its corrupted usage (more realistic than socialistic) by Soviet "revisionists" of the late 1950s. *Literary Dissent in Communist China*, p. 246.

28. Mao Zedong, "Yenan Forum," *Selected Readings*, p. 266.

29. Ibid., pp. 277, 278–79.

30. Ibid., p. 279. "The people won't understand it" has become, over the decades, the most clichéed justification of the socialist bureaucrat both for exercising or *not* exercising his authority.

31. Haraszti, *The Velvet Prison*, pp. 124, 121.

32. Mao Zedong, "Yenan Forum," *Selected Readings*, p. 265.

33. The foremost proponents of the "national forms" were Qu Qiubai and Zhou Yang; their "internationalist" adversaries included Wang Shiwei, Hu Feng, and Feng Xuefeng. The historical development of this ideological clash, from the early 1930s through the 1950s, is detailed in Goldman, *Literary Dissent in Communist China*, and is reintroduced later in the present chapter.

34. "Some works which politically are downright reactionary may have a certain artistic quality. The more reactionary their content and the higher their artistic quality, the more poisonous they are to the people, and the more necessary it is to reject them." Mao Zedong, "Yenan Forum," *Selected Readings*, p. 275.

35. Mao Zedong, ibid.

36. Mao Zedong, ibid., p. 276.

37. Artists associations must be thought of as unions—ideological unions, as it were, working in close conjunction with other agencies—rather than as primary employers of artists. Only a very limited number of artists are assigned an artists association as their primary work unit. Art academies, instead, under the joint authority of the Ministry of Culture and the Ministry of Education, have provided many artists with their jobs and salaries. The academies manage their own exhibitions. As an artist's work unit, they also retain his personal dossier (*dang'an*), which is

kept inaccessible to its subject. The relationship between academies and associations has often been rivalrous, with their relative influence determined by the assymetry of their overlapping personnel: academics have had to apply to associations for membership, and not the other way around. In addition, many lesser artists have, like Li Huasheng, been employed as propaganda artists for a wide variety of production units, working under the auspices of the Communist Party staff attached to each such unit.

38. Niu Wen, chairman of the Chongqing Artists Association, claims that "before and during the Cultural Revolution it was absolutely impossible to sell any contemporary painting." Aside from the salary provided by one's unit, additional compensation came only from the occasional publication of one's art work. More recently, in the 1980s, the Bureau of Cultural Relics has become a unit of the Ministry of Culture. Since 1979, as the contemporary Chinese painting market has become a burgeoning enterprise, a wide variety of agencies including artists associations, as well as individual artists, have been permitted to join the Bureau and its antique stores (*wenwu shangdian,* the best known of which is Beijing's Rongbaozhai) in pursuing the profits of art.

39. In the 1980s the list of associations under the umbrella federation has been expanded to include such areas as calligraphy, film, photography, television, folk artists, ballad singers, and acrobatics, while the Chinese Writers Association has become so large that it has been delegated an independent status parallel to that of the federation itself.

40. The notion that the Cultural Federation is a "mass organization," generated "from the ground up," is generally recognized as a fiction. At the provincial level, it is said that the Federation operates primarily "horizontally" rather than "vertically." That is to say, it takes political guidance from the provincial Party Propaganda Department rather than from the national Cultural Federation.

41. In the early Cultural Revolution period, the Ministry of Culture itself was dismantled and its functions were taken over by Wu De's Central Cultural Activity Group, under the auspices of Jiang Qing's Central Cultural Revolutionary Leadership Group. In 1971, the Ministry was reestablished under Wu De's direction.

42. *The Velvet Prison,* pp. 133, 137, 78–79, 96, 19, 72, 78, 119.

43. Chinese art historians, too, have suffered greatly from this fear to venture forth and have failed collectively even to produce an effective or systematic Marxist interpretation of Chinese art. Typical is the story told to a graduate seminar at Berkeley in 1984 by a Central Academy of Fine Arts historian about his paper, which could never pass through the stages of internal review fast enough to avoid the latest shifts in political "lines," requiring endless rewriting until he finally decided to withdraw it entirely. So risky is the study of art in its cultural context that the chairman of the Central Academy's art history department in 1988, Xue Yongnian, safely promoted purely stylistic studies, even though that approach would seem to run the alternate risk of being labeled "formalistic" and "bourgeois."

44. See Jerome Silbergeld, *Mind Landscapes: The Paintings of C. C. Wang* (Seattle: Henry Art Gallery and University of Washington Press, 1987), pp. 10–11.

45. Ibid., p. 11 .

46. Cf. ibid.; Chu-tsing Li, *Liu Guosong: The Growth of a Modern Chinese Artist* (Taibei: National Gallery of Art and Museum of History, 1969); Nelson Wu et al., *Chen Chi Kwan Paintings, 1940–1980*

(Taibei: Art Book Company, 1981).

47. *The Velvet Prison,* p. 40.

48. For a brief bibliographic guide to modern studies on imperial management of the arts in China, see Jerome Silbergeld, "Chinese Painting Studies in the West: A State-of-the-Field Article," *Journal of Asian Studies,* 46.4 (November 1987), pp. 876–79.

49. *The Velvet Prison,* p. 67.

50. Mark Salzman, *Iron and Silk* (New York: Vintage Books, 1986), p. 65.

51. Ibid., p. 30.

52. See James Cahill's chapter, "Quickness and Spontaneity in Chinese Painting: The Ups and Downs of an Ideal," in his *Three Alternative Histories of Chinese Painting* (Lawrence: University of Kansas, Spencer Museum of Art, 1988); and Cahill, "The 'Madness' in Bada Shanren's Paintings," *Asian Cultural Studies, International Christian University Publications,* 16 (March 1989), pp. 119–43.

53. The Sichuanese have traditionally described northerners as "brave but not astute" (*you yong wu mou*), and southeasterners as "astute but not brave," while thinking of themselves as "both brave and astute."

54. On Sichuan's geography and material culture, see Ferdinand von Richthofen, *Baron von Richthofen's Letters, 1870–1872,* 2nd ed. (Shanghai: North China Herald, 1903; 1st ed., 1873), pp. 109–11, 155–91, 203–7.

55. "The Sichuan Road," translated in Arthur Waley, *The Poetry and Career of Li Po* (London: Allen and Unwin, 1950), pp. 38–40. For a modern account of the passage into Sichuan from the north, through Guangyuan, see von Richthofen's *Letters,* pp. 155–61.

56. See also, Lyman Van Slyke, *Yangtze: Nature, History, and the River* (Reading, Mass.: Addison-Wesley, 1988).

57. The Chinese usually speak of three gorges, beginning upstream with the Qutang Gorge, then the Wushan (Witch's Mountain or Shaman's Gorge), "famous in Chinese literature because of their precipitous and curiously formed cliffs, inhabited by crying gibbons, and because of many treacherous rocks and currents in the river." But there is no agreement over the identity of the third major gorge, for there are in fact many; some name it as the Yellow Cow Gorge, farthest downstream in the area of present-day Yichang, while others include the Bright Moon Gorge, a mere twenty-seven miles east of Chongqing. See William Hung, *Tu Fu, China's Greatest Poet* (Cambridge: Harvard University Press, 1952), pp. 220–21.

58. Li Chengsou, *Hua shanshui jue (Secrets of landscape painting),* translated in Susan Bush and Hsio-yen Shih, eds., *Early Chinese Texts on Painting* (Cambridge: Harvard University Press, 1985), p. 144.

59. "On the Yangtze Watching the Hills," translated in Burton Watson, *Su Tung-p'o: Selections from a Sung Dynasty Poet* (New York: Columbia University Press, 1965), p. 23.

60. Lu You's lyric celebration of rustic peasant values, "Traveling to West Mountain Village," became one of Li Huasheng's favorite themes (figs. 65, 66; translated and discussed on pp. 118, 122).

61. For a full translation of this diary, entitled *Ru Shu ji* or *A Record of Entering Sichuan,* see Chun-chu Chang and Joan Smythe, *South China in the Twelfth Century: A Translation of Lu Yu's Travel Diaries, July 3–December 6, 1170* (Hong Kong: Chinese University Press, 1981); a partial translation is included in Burton Watson, *The Old Man Who Does as He Pleases: Selections from the Poetry of Lu Yu*

(New York: Columbia University Press, 1973, pp. 69–121.

62. Watson, *The Old Man Who Does as He Pleases*, p. 6.

63. The most famous painting of the Jialing was done by the Tang painter Wu Daozi, who traveled there on imperial command then returned to paint a three-hundred mile stretch of it in a single day at the Datong Hall in Chang'an, without recourse to any sketches.

64. That is, excluding relatively recent additions to Chinese territory: Xinjiang, Xikang (from which much of Sichuan's Western uplands were appropriated), Qinghai, and Tibet.

65. Sichuan has an area of 220,000 square miles, as compared with Europe's largest nation, France, with 211,000 square miles. Its estimated population in 1984 was 104 million, up drastically from 57 million in 1949 and roughly double those of West Germany, France, or Italy. Metropolitan Chengdu's 1985 population of 2,260,000 (U.S. Bureau of the Census estimate), yields a population density of 90,400 people per square mile, as compared with Shanghai's 85,871, Calcutta's 50,057, Tokyo's 23,356, and New York's 11,458. The combination of dense urban populations and vast, nonarable mountainous regions leaves the per capita farmland at .164 acres (one-tenth the American average) and shrinking annually by an estimated 115,000 acres as industry expands.

Sichuan long had an ethnically distinctive stock, but the province was severely depopulated first by the Mongols and later at the fall of the Ming by the fearsome warlord Zhang Xianzhong, whose motto was supposedly, "Kill, kill, kill. Kill, kill, kill. Kill." Following each of these occasions, large numbers of ethnic Han settlers migrated to Sichuan, joining the fifteen major ethnic groups (which remain primarily in the south and west), and greatly altering Sichuan's ethnic character.

66. Winston Lo, *Szechwan in Sung China: A Cast Study in the Political Integration of the Chinese Empire* (Taipei: University of Chinese Culture Press, 1982), p. 11.

67. See *Baron von Richthofen's Letters*, pp. 181–85; T. R. Tregear, *A Geography of China* (Chicago: Aldine Publishing Company, 1965), pp. 76–78.

68. Du Fu, "Leaving Chengdu for the Qingcheng District, I Send This to Messrs. Tao and Wang, Two Vice-Prefects of Chengdu," translated by Hung, *Tu Fu*, p. 174.

69. Translation of Zhou included in Robert Kapp, *Szechwan and the Chinese Republic: Provincial Militarism and Central Power, 1911–1938* (New Haven: Yale University Press, 1973), pp. 69–70.

70. Ibid.

71. Ibid., pp. 14, 17–18.

72. From among the numerous studies of literati painting theory and style, see Max Loehr, "The Question of Individualism in Chinese Art," *Journal of the History of Ideas*, 22 (1961), 147–58; James Cahill, "Confucian Elements in the Theory of Painting," in Arthur Wright, editor, *The Confucian Persuasion* (Stanford: Stanford University Press, 1966), pp. 115–40; Susan Bush, *The Chinese Literati on Painting: Su Shih (1037–1101) to Tung Ch'i-ch'ang (1555–1636)* (Cambridge: Harvard University Press, 1971); James Cahill, "Style as Idea in Ming-Ch'ing Painting," in Maurice Meisner and Rhoads Murphy, editors, *The Mozartian Historian: Essays on the Works of Joseph R. Levenson* (Berkeley: University of California Press, 1978), pp. 137–56.

73. Translated in Bush, *The Chinese Literati*, p. 134.

74. Loehr, "The Question of Individualism," p. 156.

75. "Written on the Wall at West Forest Temple," composed while in political exile; based on the translation in Watson, *Su Tung-p'o*, p. 101.

76. Cf. Ernest Fenollosa, who wrote in 1912 of the Confucianists, "Their ideal is uniformity; their standard is not insight but authority [and] what they hate most is any manifestation of human freedom. . . . But what has all this to do with modern [i.e., post-13th century] art? Everything." From his *Epochs of Chinese and Japanese Art* (New York: Dover Books, 1963; reprint of 1912 ed.), pp. 142–43.

77. Dong Qichang, *Hua yan (The painter's eye)* (Taibei: Shijie shuju yinhang, 1975; *Yishu congbian* edition), p. 24.

78. Translated in Marilyn Fu and Shen Fu, *Studies in Connoisseurship* (Princeton: The Art Museum, 1973), p. 55.

79. This glorious period was the subject of Huang Xiufu's *Yizhou ming hua lu* (preface dated 1006) (*Huashi congshu* ed., vol. 3; Taibei: Wenshizhe chubanshe, 1974).

80. Wai-kam Ho, "Aspects of Chinese Painting from 1110 to 1350," in Wai-kam Ho et al., *Eight Dynasties of Chinese Painting* (Cleveland: Cleveland Art Museum, 1980), p. xxxvi.

81. No other major Sichuan artist emerged until the Ch'an priest-painter Muxi, at the end of the dynasty.

82. Kapp, *Schechwan and the Chinese Republic*, p. 70.

83. A third artist could be added to this small group: the figure painter Jiang Zhaohe (1904– ?), who created his most poignant works before 1949, when the tragic social realities of Chinese life could still be displayed in art.

84. For Xu Beihong's activities in Chongqing, as well as at Chengdu and Mt. Qingcheng, see Liao Jingwen, *Xu Beihong: Life of a Master Painter* (Beijing: Foreign Languages Press, 1987), pp. 192ff.

85. Mao Zedong, "Yenan Forum," *Selected Readings*, p. 259.

86. Mao Zedong, "Contradictions Among the People," ibid., p. 439.

87. For an in-depth survey of these campaigns in the literary realm, see Goldman, *Literary Dissent*.

88. Mao Zedong, "Contradictions Among the People," *Selected Readings*, p. 439.

89. Mao Zedong, "Yenan Forum," ibid., p. 271.

90. Jiang Feng (1910–82; originally named Zhou Jiefu, also known as Zhou Xi) was a native of Shanghai with working-class origins. In August 1931, he began producing woodblock prints in the workshop organized by Lu Xun which began the socialist arts movement in China. In 1932, he joined the Communist Party and became a member of the left-wing Spring Field Painting Society. He was imprisoned on two occasions during the "White Terror" period in Shanghai when Marxists were ruthlessly uprooted by the Nationalist forces, once arrested together with Ai Qing, in 1932, and again in 1933. The year after the Japanese incident at the Lugou Qiao (Marco Polo Bridge) in Beijing, he traveled to Yan'an to join Mao Zedong's forces, arriving in March 1938. At first, he edited the *Front Pictorial*, published by the political propaganda department, but in January 1939, he was appointed head of the Academy's Fine Arts Department. Propaganda wood-block printing remained his specialty. In 1945, he was appointed Party secretary of the North China Literary and Art Workers Troop, and in 1946, he was made chairman of the Fine Arts Department of the Federation of North China Literary and Art Academies. After the 1949 revolution, he was successively appointed as the Beijing Military Control Commission's vice-chairman for the arts and as vice-chairman and Party

secretary of the Hangzhou Academy of Fine Arts. In 1951, he returned to Beijing as vice-chairman and Party secretary of the recently designated Central Academy of Fine Arts; he became acting director in 1953.

A fuller sketch of Jiang Feng's career can be found in Yang Mingsheng, editor, *Zhongguo xiandai huajia zhuan* (*Biographies of contemporary Chinese painters*) (Zhengzhou: Henan meishu chuban she, 1989), *xia*, pp. 433–39. The comments which follow regarding Jiang Feng's attitudes and administrative role are greatly indebted to a paper by Julia Andrews, "Old Painting in New China: The Theory and Practice of Guohua," presented at the College Art Association annual meeting, San Francisco, February 1988, and published in revised form as "Traditional Painting in New China: *Guohua* and the Anti-Rightist Campaign," *Journal of Asian Studies*, 49.3 (August 1990), pp. 555–85; Prof. Andrews has also generously shared information from her current study of China's art academies and associations, provisionally titled *Painters and Politics in the People's Republic of China* (Berkeley and Los Angeles: University of California Press, forthcoming); see also the material in Ellen Laing's *Winking Owl*, pp. 28–29. For an introduction to the role of Lu Xun in the arts, see Shirley Sun, "Lu Hsün and the Chinese Woodcut Movement: 1929–1936," Ph.D. dissertation, Stanford University, 1974; Laing, *Winking Owl*, ch. 1.

91. Feng Xuefeng and Hu Feng first set forth their opposition to "national forms" beginning in the late 1930s. Largely because they lived in Guomindang-controlled areas during the 1930s and '40s (Shanghai and Chongqing), they got away with this for the time being, in contrast to Wang Shiwei in Yan'an, a Trotskyite who set forth similar views and was made a central target of the first ideological rectification campaign in 1942. Cf. Goldman, *Literary Dissent*, pp. 12–17, 87ff. As for the distinguished poet Ai Qing, whose comparison of traditional Chinese culture to a fossilized fish is well-remembered to this day, he was assigned to teach Maoist aesthetic philosophy, as spelled out in 1942 at Yan'an, at the Central Academy of Fine Arts in Beijing, but he obviously taught it his own way. In 1953, he published a lecture denouncing traditional copywork, declaring traditional painting incapable of supporting the new socialism and claiming that it was filled with lies, since it failed to reflect its times. This material was used against him in the 1957 rectification movement. Cf. Ai Qing, "Tan Zhongguohua" ("Discussing traditional Chinese painting"), *Wenyibao*, 92(1953), pp. 7–8; Andrews, "Traditional Painting," pp. 460, 464; Laing, *The Winking Owl*, p. 28.

92. In the early 1950s, Jiang published three books entitled *Italian Art in the Period of the Literary and Artistic Renaissance*, *The Appreciation of Famous Western Paintings*, and *The Art of da Vinci*, and more than fifty articles on Western art history.

93. The emphasis on this in Yang Mingsheng, editor, *Zhongguo xiandai huajia zhuan* (*Biographies*), *xia*, p. 438, presents Jiang as less exclusively Western in orientation than his enemies in the mid-1950s charged him with being.

94. Reported in Andrews, *The Reforming of Art*, unpaginated ms.

95. Andrews, "Traditional Painting," pp. 564, 566.

96. Ibid., p. 564.

97. Ibid., p. 560, citing Ding Ye, "Jiang Feng fandang jituan zai huadong meishu fenyuan ganle xie shemme," *Meishu*, 9(1957), p. 16. In merging these two departments, Jiang Feng followed the precedent already set before 1949 by director Xu Beihong at Beijing's National Academy of Art. In 1950, this National Academy became the Central Academy of Fine Arts and took over the direction of the Hangzhou Academy, which was renamed the East China campus of the Central Academy; yet Jiang Feng was more than following centralized instructions in mandating this merger of departments.

98. The term for traditional painting was presumably shortened either from *Zhongguo hua*, simply "Chinese painting," or from *guocui hua*, "painting of the national essence," the latter with somewhat elitist overtones derived from the cultural politics of the early postimperial period (see Andrews, "Traditional Painting," especially pp. 557–59, for a full discussion of these terms, and subsequent pages for their implications). The Central Academy's east coast campus in Hangzhou, in 1952, preceded the Beijing Academy in the reestablishment and renaming of its traditional painting department (Andrews, "Traditional Painting," p. 569, citing Deng Ye, p. 16).

99. Laing, *The Winking Owl*, p. 28.

100. For a summary of this, see Goldman, *Literary Dissent*, pp. 9ff.

101. Julia Andrews, personal communication.

102. Julia Andrews, in her *Reforming of Art* (unpaginated ms.), reports that "at one point he [Jiang] exclaimed in exasperation, 'My head is not a lantern, so it cannot twirl in the wind.' "

103. An enormous quantity of writing was directed against him in *Meishu* and other journals. According to Yang Mingsheng, editor, *Zhongguo xiandai huajiu zhuan* (*Biographies*), *xia*, p. 438, Jiang was sent off to Beijing's Shuangqiao labor reform camp until 1961. In the Cultural Revolution period, from 1970–72, he was "sent down" for reform through labor near Tianjin. He was rehabilitated and returned to arts administration in 1979 as director of the Central Academy of Fine Arts and chairman of the national Artists Association, still set in his attitudes but more flexible in his enforcement.

104. Goldman's *Literary Dissent* gives considerable emphasis to the effects of this feud between Zhou Yang and the Lu Xun faction. There were, of course, others who benefited by Jiang's fall and who might have helped to hasten it. Cohen, *New Chinese Painting*, p. 30, notes the role of "personal as well as ideological purposes" in the battles of the moment when discussing the opposition of Zhang Ding, chairman of the Central Academy's Department of Color-and-Ink Painting, to Jiang Feng's views. The traditional painter Cai Ruohong moved up within the Chinese Artists Association to fill Jiang's position (as noted by Julia Andrews, "Traditional Painting," p. 568). Andrews has also suggested that "the art world, although related to the literary world, had special dynamics of its own that probably operated at a level below that of Zhou Yang." Also critical to this political rupture, she suggests, though still requiring research, was the antagonism between Jiang Feng and vice-minister of cultural Qian Junrui, whose suggested improvements for the teaching of traditional painting Jiang had rejected in 1955 (personal communication).

105. Andrews, "Traditional Painting," p. 568. Among those at this institute who fell were vice-director Xu Yansun, Wang Xuetao, and Chen Banding. Among associates of Jiang Feng who fell with him were a number of staunchly socialist printmakers and painters like Yan Han and Mo Pu. Among the many others who were denounced, labeled, and "sent down" to the countryside at that time were the prominent painters Pang Xunqin (director of the Central

Academy of Arts and Crafts in Beijing), Liu Haisu, and Lin Fengmian.

106. As concluded by Andrews, "Traditional Painting,"570–72.

107. For biographical information on Lü Lin, see pp. 171–2, 230n.6.

108. For an outline of the early history of the Artists Association in Sichuan, see below, p. 223n.36.

109. For biographical data on Li Shaoyan, see pp. 63–4.

110. The other center is the army-supported production center at Beidahuang.

2. "China-Born"—Early Years, First Teachers: 1944–65

1. In Lowell Dittmer, *Liu Shao-ch'i and the Chinese Cultural Revolution: The Politics of Mass Criticism* (Berkeley and Los Angeles: University of California Press, 1974), p. 268.

2. Li Huasheng has painted this site on more than one occasion.

3. Li Jiawei, correspondence with author, September 1987.

4. Ibid.

5. Winston Lo, *Szechwan in Sung China: A Case Study in the Political Integration of the Chinese Empire* (Taipei: University of Chinese Culture Press, 1982), pp. 12–13.

6. Phil Billingsley, *Bandits in Republican China* (Stanford: Stanford University Press, 1988), p. 37.

7. Affirming his belief in the notion of *mingda*, Li Weixin relates it to the popular belief in *ke*, "overcoming," as in the destructive sequence of the "five phases" theory.

8. Anita Chan, *Children of Mao: Personality Development and Political Activism in the Red Guard Generation* (Seattle: University of Washington Press, 1985), pp. 15–16.

9. Li Jiawei, correspondence with author, July 1988.

10. Ibid.

11. Ibid.

12. Yu Jiwu, correspondence with author, undated, 1988.

13. Ibid.

14. Dittmer, *Liu Shao-ch'i*, p. 268. The latter statement was made in 1949; the former in 1952.

15. Ibid., pp. 273–74.

16. Cf. Laing, *The Winking Owl*, pp. 33–47.

17. Dittmer, *Liu Shao-ch'i*, pp. 270–71.

18. Yu Jiwu as of 1989 was an administrative officer in the Chongqing Culture Hall, now renamed the Chongqing Arts Hall (Chongqing Yishunguan) and provided with a budget of 50–60,000 Chinese dollars, double that of the period before the Cultural Revolution.

19. Su Baozhen was born in Suqian County, Jiangsu province. In 1941, he won the Outstanding Young Artist Award at the National Art Exhibition. His work was exhibited internationally before 1949 and has appeared in more than eleven countries since that time. He was in 1989 a vice-chairman of the Chongqing Artists Association, vice-director of the Chongqing Chinese Painting Academy, and an advisor at the Chengdu Painting Academy.

20. Su Baozhen in 1989 was a vice-chairman of the Chongqing Artists Association, vice-director of the Chongqing Chinese Art

Academy, and an advisor of the Chengdu Painting Academy. Cf. Su's works illustrated in *Sichuan Sheng Shi Shu Hua Yuan* (*The Sichuan Poetry, Calligraphy, and Painting Academy*) (Chengdu: Sichuan Sheng Shi Shu Hua Yuan, 1985), unpaginated, and in *Chengdu hua yuan* (*The Chengdu Painting Academy*) (Chengdu: Chengdu: Chengdu Painting Academy, 1986), unpaginated.

21. Discussed on p. 211.

22. Discussed on p. 137.

23. Guo Manchu, correspondence with author, dated October 1987.

3. Revolution by Day, Tradition by Lamplight: 1962–76

1. Liu Chunhua, "Singing the Praises of Our Great Leader Is Our Greatest Happiness," *Chinese Literature*, September 1968, pp. 36–37.

2. Lowell Dittmer, Liu Shao-ch'i and the Chinese Cultural Revolution: The Politics of Mass Criticism (Berkeley and Los Angeles: University of California Press, 1974), p. 57.

3. Ibid., p. 61.

4. Ibid.

5. Ibid.

6. The school was originally known as the Chongqing Yangzi River Shipping Engineering School (Chongqing Changjiang Hangyun Jigong Xuexiao), but it merged in August 1965 with a school of the shorter name, Yangzi River Shipping School (Changjiang Hangyun Xuexiao), and moved to the campus of that school.

7. "The term 'intellectuals' refers to all those who have had middle school or higher education and those with similar educational levels. They include university and middle school teachers and staff members, university and middle school students, primary school teachers, professionals, engineers and technicians, among whom the university and middle school students occupy an important position." *Selected Readings from the Works of Mao Tsetung* (Beijing: Foreign Languages Press, 1971), p. 228, editors' footnote.

8. Merle Goldman, *Literary Dissent in Communist China* (Cambridge: Harvard University Press, 1967), p. 190.

9. The literary group of writers associated with Ding Ling was deemed conspiratorial in the Anti-rightist Campaign. "Proof" of this included their similarities to Hungary's Petöfi Club; cf. Goldman, *Literary Dissent*, p. 228. In June 1964, warming up for the Cultural Revolution, Mao warned writers and artists that if revisionism were not avoided by their arts administrators, then China would have its own Petöfi Clubs to suppress.

10. Nowhere is the profoundly psychological basis of China's harsh reform-through-labor system, and the universal application of this deterrent psychology among the Chinese civilian population, better revealed than in the autobiography of Bao Ruowang (Jean Pasqualini), *Prisoner of Mao* (New York: Penguin Books, 1976).

11. Ellen Laing, "Zhongguo di 'yuegui' yishu yu 'fandui' yishu" ("Deviant and dissident art in China"), *Jiuzhou xuekan*, 2.2 (January 1988), pp. 137–48, documents a number of works from this period which were denounced even after widespread dissemination and a period of initial public acceptance; she attempts to distinguish be-

tween a number of such works on the basis of intention.

12. The "Four Greats" concept was formulated by Mao. Although it was later guaranteed in article 45 of the 1978 Constitution, it was discredited soon after the 1979 democracy movement by Deng Xiaoping, who claimed that the Four Greats "have never played a positive role." See Andrew Nathan, *Chinese Democracy* (Berkeley and Los Angeles: University of California Press, 1985), pp. 36 *passim*.

13. The Maoist line of attack on Wu Han, vice-mayor of Beijing, led upwards to mayor Peng Zhen, and from there to Peng's patron, Liu Shaoqi; cf. Dittmer, *China's Continuous Revolution*, pp. 68–78.

14. Generally speaking, the material, once placed in an official dossier, remains there forever. Nonetheless, a rare opportunity to have some such materials removed may occur during a rehabilitation period, when the mistakes of a prior political movement are reviewed and rectified.

15. In the Chinese institutional structure, every unit has its Communist Party committee, so that the Party in effect has a shadow structure that matches the institutional structure of the whole nation. These two parellel units, institutional and political, stand everywhere side by side.

16. Mao Zedong, from his "Report to the Second Plenary Session of the Seventh Central Committee of the Communist Party of China," March 5, 1949, in the so-called Red Book, *Quotations from Chairman Mao Tse-tung* (Beijing: Dongfanghong chubanshe, 1967), p. 31.

17. An account of the Cultural Revolution on a university campus, and arguably the best personal account of the entire period, comes from Yue Daiyun, written with Carolyn Wakeman, *To The Storm: The Odyssey of a Revolutionary Chinese Woman* (Berkeley and Los Angeles: University of California Press, 1985).

18. Nien Cheng, *Life and Death in Shanghai* (New York: Grove Press, 1987), p. 210.

19. Ibid., p. 185.

20. Entitled *So Beautiful our Mountains and Streams*, illustrated in Laing, *The Winking Owl*, pl. 38.

21. Yue Daiyun reports that the first such "black painting" she encountered had originally been published without any political taint in *China Youth* magazine, but later, in 1966, it was denounced for including only two rather than three red flags. This, she was surprised to learn, signaled the painter's opposition to the current Three Banners campaign, which touted the Great Leap Forward, the people's communes, and the general line for socialist reconstruction. See Yue Daiyun and Wakeman, *To the Storm*, p. 155.

22. Stanley Karnow, *Mao and China: From Revolution to Revolution* (New York: Viking Press, 1972), p. 307.

23. Ibid., pp. 351, 307–8.

24. Ibid., p. 309.

25. Ibid., pp. 352–53.

26. Ibid., p. 385.

27. Ibid., pp. 384, 431.

28. Dittmer, *China's Continuous Revolution*, p. 199. Dittmer also notes (p. 199) that in this era, "control over media channels was tightly centralized: in 1960, 1,330 official periodicals had been published in China; in 1966, the number was cut to about 648, and by 1973, it had been further reduced to about 50." According to Roxane Witke, "The evolving use of *yangban*, meaning 'mold' or

'model' had political significance. During the late 1950s *yangban* referred to 'demonstration fields'—model farms constructed for general emulation during the Great Leap Forward. Thus the term *yangban xi*, 'model *theater*,' extended the metaphor from the base to the superstructure. The message was that styles of public entertainment, no less than agriculture, should fit a mold but change with the demands of revolutionary leaders and their times." From her *Comrade Chiang Ch'ing* (Boston: Little, Brown, 1977), pp. 391–92.

29. Yu Huiyong, "Let Our Theatre Propagate Mao Tse-tung's Thought For Ever," *Chinese Literature*, July–August 1968, p. 111.

30. Yue Daiyun and Wakeman, *To the Storm*, p. 281.

31. The operas included *The Red Lantern, Shajiabang, Taking Tiger Mountain by Strategy,* and *Raid on White Tiger Regiment;* the ballets were *Red Detachment of Women* and *White-haired Girl;* the one musical composition was the *Yellow River Piano Concerto;* and the sculptural setting was entitled *The Rent Collection Courtyard.*

The Rent Collection Courtyard, begun in June 1965, was produced by a sculptural team headed by Ye Yushan, chairman of the Sichuan Academy of Fine Arts Sculpture Department, under the leadership of Li Shaoyan. It originally had no direct link to Jiang Qing and her associates. But it was gradually appropriated and even remodeled by them, with the original 114 figures increased by five to include a maudlin ending of revolutionary heroes uplifting a huge copy of Mao's *Little Red Book.* Cf. *Rent Collection Courtyard: Sculptures of Oppression and Revolt* (Beijing: Foreign Languages Press, 1970) and Laing, *The Winking Owl*, p. 62. Liu Wencai was the brother of Sichuan's powerful warlord Liu Wenhui.

32. Cf. Laing, *The Winking Owl*, p. 68 and pl. 39; also Tao Yongbai, editor, *Zhongguo you hua, Oil Painting in China, 1700–1985* (Shanghai: Jiangsu meishu chubanshe, 1988), p. 11 and pl. 65.

33. Liu Chunhua, "Singing the Praises," *Chinese Literature,* September 1968, p. 35.

34. Ibid., pp. 36–37.

35. The significance of this theme is unclear. It might simply have been painted as a matter of regional pride. Or, it might have been associated with Mao's three-day journey in March–April 1958 through the gorges; at the conclusion of the Chengdu conference which paved the way for his Great Leap Forward; since the failure of this movement opened the door for more moderate leadership—for Liu Shaoqi and others who were later castigated in the Cultural Revolution—the portrayal of this theme would have been appropriate to celebrate Mao's return to political dominance. Cf. Roderick MacFarquhar, *The Origins of the Cultural Revolution*, vol. 2, *The Great Leap Forward 1958–1960* (New York: Columbia University Press, 1983), pp. 35–36ff.

36. For example, Harold Schonberg's review of *The White Haired Girl*, which he saw live in Shanghai, concludes: "To Western eyes the ballet is anything but revolutionary. It is a naive, innocent propaganda fairy tale, primarily stemming from Russian ballet, saturated with the dance vocabulary of the West. Once in a while, Chinese elements are introduced—native instruments, the pentatonic scale, and even a few microtones. But . . . most Western listeners would classify the score of *The White Haired Girl* as movie music. Certainly all the clichés are there." *New York Times,* October 7, 1973, reported in Roxane Witke, *Comrade Chiang Ch'ing,* p. 432.

37. Heibai muke ji (*Collection of Monochrome Woodblock Prints*),

vol. 2 (Shanghai: Shanghai renmin meishu chubanshe, 1977), p. 62.

38. For example, Du's *Lion Reservoir Construction Site*, in *Sichuan banhua xuan* (*Selections of prints from Sichuan, 1949–1959*) (Chengdu: Sichuan renmin meishu chubanshe, 1960), pl. 6.

39. For a general discussion of the "Hotel School" phenomenon, see Laing, *The Winking Owl*, pp. 85–87.

40. This work is no longer extant.

41. This painting is still in Li Huasheng's collection.

42. Huang's painting was dated "12.1983," which he then crossed out, followed by "1.1.1984."

43. Among these artists were Lin Fengmian, Liu Haisu, Li Kuchan, Li Keran, Huang Zhou, and Cheng Shifa. Huang Yongyu eventually got his revenge: within months after the death of Mao and the fall of the so-called Gang of Four, he was called upon to design the huge tapestry that hangs in the Mao Zedong Memorial Hall overlooking Mao's marble statue, although officials never gave him public credit for the deed. Huang also began to paint his winking owls in quantity, to great commercial success; for an example done in 1978, see Laing, *The Winking Owl*, pl. 14, and the book's cover.

44. See below, p. 223n.35.

4. *Master Teacher, Master Pupil—Chen Zizhuang and Li Huasheng: 1973–76*

1. *The Complete Works of Chuang Tzu*, translated by Burton Watson (New York: Columbia University Press, 1970), p. 228.

2. Xiao Chong, "Chen Zizhuang Posthumous Works Exhibition Is Sensation in the Capital," *Zhongguo wenhua bao*, April 6, 1988, unpaginated.

3. Yu Qiao, "On Promoting the Exhibition of Painting Circle's Eccentric Talent, Chen Zizhuang," *Aomen ribao*, February 12, 1988, p. 12.

4. Li Xigen, "Zhen Zizhuang Praised as Chinese van Gogh; Three Hundred Surviving Works to Be Exhibited in Beijing," *Xin min wanbao*, March 16, 1988, unpaginated.

5. Shang Yuan, "Universal Justice, Public Criticism," *Gongren ribao*, May 5, 1988, unpaginated.

6. Yang Rongze, editor, Chen Shouyue [son of Chen Zizhuang], Preface, *Chen Zizhuang xiesheng gao* (*Chen Zizhuang's sketches from life*) (Chengdu: Sichuan meishu chubanshe, November 1986), p. 1; Zhang Zhengheng, editor, *Chen Zizhuang hua ji* (*Collection of paintings by Chen Zizhuang*) (Beijing: Rongbaozhai, 1987), p. 1; Wu Fan, "Chen Zizhuang," in Ren Yimin, editor, *Sichuan jinxiandai renwu zhuan* (Biographies of modern and contemporary Sichuanese) (Chengdu: Sichuan University Press, 1988), pp. 326–28.

7. Chen is commonly written of as born in Rongcheng. Alone among those aware of his Yongchuan County origins, Wu Fan does not place Chen in Rongcheng until after the end of the war.

8. Wu Fan, "*Chen Zizhuang*," p. 326; Chen Zhidong, editor, *Shihu lun hua yu yao* (*Essential comments from Shihu's* [*Chen Zizhuang's*] *discussions of painting*) (Chengdu: Sichuan meishu chubanshe, 1987), p. 154.

9. Depending on which source one credits; Chen Zhidong, *Shihu lun hua yu yao*, p. 154, gives Chen Yue, while Wu Fan, "*Chen Zizhuang*," p. 326, gives Chen Fugui.

10. Chen Zhidong, *Shihu lun hua yu yao*, pp. 154–55; Xiang Pu,

"Artistic Genius Being Compared to van Gogh," *China Daily*, March 24, 1988, p. 5.

11. Chen Zhidong, *Shihu lun hua yu yao*, p. 155.

12. Hsi-sheng Ch'i, *Nationalist China at War* (Ann Arbor: University of Michigan Press, 1982), p. 194; see also Jean Chesneaux et al., *China from the 1911 Revolution to Liberation* (New York: Pantheon, 1977), p. 272.

13. See Li Zhonghua, "*Chuan jun jiangling Wang Zanxu*" ("Sichuan Military Leader Wang Zanxu"), *Xichong xian Wenshi ziliao xuanji*, vol. 6 (Xichong, Sichuan: Chinese People's Consultative Congress, Xichong County Committee, n.d. [1988/89?]), pp. 36–52.

14. See Chu-tsing Li, *Trends in Modern Chinese Painting* (*The C. A. Drenowatz Collection*) (Ascona, Switzerland: Artibus Asiae, 1979), p. 86 and fig. 38, for one of the works done by Qi Baishi at that time. Still other such works may be seen today in the Shangqing Daoist Temple on Mt. Qingcheng, outside of Chengdu.

15. Xiang Pu, "Artistic Genius," p. 5.

16. Chen Zhidong, personal correspondence, dated August 30, 1989.

17. Wu Fan, "*Chen Zhizhuang*," p. 327.

18. Ibid.

19. Ibid. Toward the end of the Nationalist period, Chen also served as private secretary for another notorious Guomindang official, Kong Xiangxi, but they didn't get along and Chen "escaped" from this task; since it was later said this service was undertaken involuntarily, it was not officially held against him by the young Communist regime. Wu Fan (p. 327) asserts that Chen participated as well in activities of the Peasant and Laborers Democratic Party and of the Chinese Democratic League (befriending League leader Zhang Bojun), which is to say that he stayed free of true allegiance to any party.

20. Chesneaux et al., *China from the 1911 Revolution*, p. 272.

21. Semiofficial accounts suggest that Wang's desicion to capitulate peaceably was triggered by a persuasive letter from People's Liberation Army Commander Zhu De; see Li Zhonghua, "*Chuan jun jiangling*," p. 50. Chen Zhidong believes that two others helped Chen Zizhuang with these negotiations, Chen Zengxiang and Liu Ziheng, but he feels that of these three, Chen Zizhuang was the one who had best cultivated relations with the Communists. Still, says Chen Zhidong, "the exact function played by Chen Zizhuang remains a mystery." Chen Zhidong, personal correspondence, dated August 30, 1989.

22. In 1960, at Premier Zhou Enlai's suggestion, the compilation of members' historical experiences and observations began to be published in the journal *Wenshi ziliao* (*Reference materials on cultural history*), which was distributed only to approved government circles (*neibu*). The government even began to provide Wenshiguan writers with historical archives for this purpose.

23. Li Zhonghua, "*Chuan jun jiangling*," p. 51.

24. Pao Ji, "Chen Zizhuang's Painting," *Beijing ribao*, February 11, 1988, unpaginated.

25. Also included in this exhibition were artists Yao Shiqian, Feng Guanfu, Zhou Lunyuan, and Zhao Yunyu. In Chongqing, their works were crammed into ten or eleven tiny rooms at the Confucius Pool Exhibition Hall (Fuzi Chi Hualang).

26. According to Peng Xiacheng.

27. Chen Zizhuang, unpublished correspondence with Zhang Zhengheng, dated November 16, 1971.

28. Chen Zizhuang, unpublished correspondence with Zhang Zhengheng, July 4 [1973?].

29. Not until 1987 did Rongbaozhai finally reproduce any of Chen's works, in the book edited by Zhang Zhengheng, *Chen Zizhuang hua ji* (Collection of Chen Zizhuang paintings).

30. Chen Zizhuang, personal communication with Zhang Zhengheng, dated July 4, [1973?].

31. Chen Zizhuang, personal communication with Zhang Zhengheng, dated July 4 [1973?].

32. Chen Zhidong, *Shihu lun hua yu yao*, p. 151.

33. Ibid., p. 153.

34. The few Sichuan artists who were spared Chen's critical disdain included seal carver Zeng Mougong, a practitioner of traditional Chinese medicine who died of starvation in 1961; Li Qiongjiu from Leshan; and Yan Jiyuan, whom Chen appreciated for his draftsmanship and application of color and whom he often watched paint. These three artists are in the 1990s gaining a degree of belated recognition. Zeng Mougong (1881–1961) was a physician who introduced Chen to Zhang Zhengheng in 1955. Li Huasheng asserts that "once you see Zeng's seal carving, others seem like paper for kindling a fire." See also Zeng Yao, "*Zeng Mougong jinshi zuopinxuan*" ("Selection of Seal Carvings by Zeng Mougong"), *Sichuan Sheng Shi Shu Hua Yuan yuankan*, 1 (1986), pp. 50–53. Li Qiongjiu (b. 1909) graduated from the Sichuan Fine Arts Academy as a practitioner of traditional Chinese paintings distinguished by their heroic style; but after 1949, he also produced propaganda works, such as his *Capture of the Luding Bridge*, which hangs in the Great Hall of the People in Beijing. Li is director of the Jiazhou Painting Academy and an advisor at the Chengdu Painting Academy. For an article on Yan Jiyuan, who is now an advisory member of the Chengdu Painting Academy, see Li Luogong, "Wo suo renshi di Yan Jiyuan," *Duo yun*, 3 (September 1982), p. 126. To this list, Dai Wei would add Feng Guanfu, a member of the first Chinese air force under the Nationalist government and a Wenshiguan member, and Shi Xiaochang, who came from Hangzhou. Feng was a generation older than Chen and helped out financially by providing customers who used his large-scale calligraphy for shop signs.

35. It is said by a number of Chen's adherents that Zeng Mogong's persecution was triggered by Zhu Peijun's antagonism toward him, which reduced him to grinding pepper for sale on the streets of Chengdu, and that at the time of his death he had been granted grain coupons for only 11.5 kg. a month (two-thirds of today's typical consumption, at a time when grain had become the prime nutritional source and meat was virtually unavailable).

36. Sichuan had served as the wartime home of Jiang Kaishek's Nationalist regime, and southwestern China had provided the Nationalists their last stronghold against the Communist insurgency. Accordingly, provincial government in Sichuan, Yunnan, and Kuizhou, as well as Tibet was withheld until these areas could be politically reconstructed, and from 1949 to 1954 control was administered by a special Communist Party agency, the joint Southwest Military and Political District, housed in Chongqing. Provincial-level arts administration was conducted under the control of the Communist Party regional Propaganda Department until 1953. In that year, a regional, four-province Southwest Artists Association was established. A figurehead chairmanship was held by the calligrapher and traditional painter Ke Heng. Ke Heng, a native of Taiyuan, in Shanxi province, had opposed the leading warlord in that area, Yan Xishan, and had helped many of Yan's victims among the revolutionaries. But he was a non-Party member, an independent (*minzhu renshi*) of a type the Communist Party's United Front administration wanted to assimilate. Party member Li Shaoyan, however, was always the real authority in the organization, as vice-chairman in charge of the Standing Committee, which controlled all daily operations. (The other vice-chairman was Liu Yisi, also a non-Party member, and a professor of oil painting at the Southwest Fine Arts Academy.) In 1954, as the Southwest Military and Political District was disbanded and provincial governments were established, the regional association took the name of Chongqing Branch of the Chinese Artists Association (distinct from the Chongqing Municipal Artists Association). In 1958, this regional association was finally subdivided into four provincial organizations, and the Sichuan Artists Association's headquarters were transferred from Chongqing to Chengdu, as the political capital had been four years earlier. At about that same time, Ke Heng retired and returned to Taiyuan, leaving the position of chairman in the Sichuan Artists Association open until 1980, following the Cultural Revolution, when Li Shaoyan formally assumed the position.

37. In the 1980s, Li Shaoyan has been a vice-chairman of the Chinese Artists Association, a vice-chairman of the Chinese Printmakers Association, chairman of the Sichuan Artists Association, vice-chairman of the Chinese Cultural and Art Workers Federation, and a vice-chairman of the Sichuan Provincial Propaganda Department. He was a local representative at the third through seventh National People's Congresses. In 1988, he was accorded the status of "first-rank fine artist." His publications include *Li Shaoyan banhua xuan* (Selected woodblock prints by Li Shaoyan) and *Li Shaoyan zuopin xuanji* (Selected works of Li Shaoyan), (Beijing: Renmin meishu chubanshe, 1962). See also Li Runxin et al., editors, *Zhongguo yishujia cidian, xiandai* (Dictionary of Chinese artists, contemporary), 5 volumes (Changsha: Hunan renmin chubanshe, 1981–85), vol. 1, pp. 462–63.

38. This remark was made to Liu Han, who was Zhang Zhengheng's colleague at the Central Academy for Minority Studies, and to Zhou Zhanggu, who visited Pan at that time. In the same context, by contrast, Pan disparaged several artists who were far more prestigious than Chen—Fu Baoshi ("Japanese tradition"), Shi Lu ("I can't judge him while he's still alive"), and Huang Zhou ("Shi Lu is still on his way, but Huang Zhou isn't going anywhere"). Liu Han, personal correspondence, 1988.

39. Chen Zhidong, *Shihu lun hua yu yao*, p. 155; see also, Zhang Zhengheng, *Chen Zizhuang hua ji*, Introduction, p. 1.

40. Li had lived in Chongqing during the war years, then went on artistic travels through the Yangzi gorges and as far as Mt. Emei, beyond Chengdu, in 1954 and 1956. In 1973–74, he traveled as part of the "Hotel School." At the time of his death in 1989, Li was a vice-president of the national Artists Association. Cf. figure 61.

41. Chen Zizhuang, unpublished correspondence with Zhang Zhengheng, dated August 29 [1973?].

42. Zhang Zhengheng, *Chen Zizhuang hua ji*, Preface, p. 1.

43. Yan Xiaohuai, "Painting in Peace and Poverty, Accomplishment Appearing after the Man is Gone: Notes on the Painting of Chen Zizhuang," *Lianhe zaobao* [Singapore], March 19, 1988, unpaginated.

44. Chen Zizhuang, unpublished correspondence with Zhang Zhengheng, dated November 16, 1971.

45. Chen Zhidong, *Shihu lun hua yu yao*, p. 154.

46. Chen Zizhuang, unpublished correspondence with Zhang Zhengheng, dated November 16, 1971. In another letter, Chen wrote, "It is extremely hard to buy a good inkstick in Sichuan. If you find any, please buy one or two for me. You cannot even see a good inkstone in Sichuan. Also, the price of Duan and She stones is too high. Even for low-quality stones, they ask for several dozen dollars, and that isn't affordable. More and more, those who buy inkstones in Sichuan are from other provinces, which will get even worse in the future." Chen Zizhuang, unpublished correspondence with Zhang Zhengheng, July 4 [1973?].

47. Chen Song, "Chen Zizhuang's Works Exhibited Posthumously in Beijing," *Leshan bao*, March 24, 1988, unpaginated.

48. Li Xigen, "Zhen Zizhuang Praised," unpaginated.

49. Xiang Pu, "Artistic Genius," p. 5.

50. Chen Zhidong remembers that "in 1969, when I first got to know him, he still had no table in his home and only painted on a wooden storage box."

51. Chen Zhidong, *Shihu lun hua yu yao*, p. 153.

52. Ibid.

53. Chen Zizhuang, unpublished correspondence with Zhang Zhengheng, dated August 29 [1973?].

54. Chen Zizhuang, unpublished correspondence with Zhang Zhengheng, dated November 16, 1971.

55. Qiu Chi, "Beyond Brush and Ink," *Zhongguo meishu bao*, March 21, 1988, unpaginated, quoting from Chen's correspondence.

56. Chen Zizhuang, unpublished correspondence with Zhang Zhengheng, dated November 16, 1971: "Recently, I've wanted to go to Neijiang to paint sugar cane fields, but I have no money and cannot go."

57. Yan Xiaohuai, "A Neglected Great Painter," *Guangming ribao*, March 27, 1988, unpaginated.

58. Chen Zizhuang, unpublished correspondence with Zhang Zhengheng, dated July 4 [1973?].

59. Chen Zizhuang, unpublished correspondence with Zhang Zhengheng, dated June 15 [1973?]: "Recently my illness has gotten worse. In terms of medicine and treatment, because I have no money or social status, the doctors treat me lightly."

60. As did Tan Changrong, Li also found that Chen still wished to live to achieve his artistic goals. Li says that Chen told him, "I want to paint many paintings, but I have little time left. I never painted Mt. Emei, but I have thought a great deal about it. If I could, I would like to do a large splashed-ink painting with the ink very roughly spread about. I imagine that at first glance the audience would turn away and leave, but then they might come back to look again at the image of the tree branches, then they would leave again. At last they would find the setting sun penetrating through the trees, dazzling people's eyes. The method of ancient painters wasn't enough to depend on." Afterwards, Li tried to achieve this particular vision in one of his own works.

61. On one occasion, Li picked up a number of painting scraps from under a pillow and patched together five small Chen Zizhuang paintings which he still has today. Another such repaired painting is published in Yang Rongzi et al., editors, Wu Fan, Preface, *Chen Zizhuang hua ji* (*Collection of paintings by Chen Zizhuang*), Chengdu: Sichuan meishu chubanshe and Waiwen chubanshe, 1988), p. 169.

62. Chen Zhidong, *Shihu lun hua yu yao*, p. 154.

63. That is to say, how does it fit into the critical task of disentangling politics from the arts? One journalist at the time of Chen's exhibition complained that artistic recognition depends entirely on the political climate, their there must be others *still living* who deserve to be discovered, the "Zhang Zizhuangs" and "Wang Zizhuangs" who should be given a "current exhibition" and not have to wait for "posthumous exhibitions." Li Weizhong, "Painting Circle's Eccentric Talent, A Look at the 'Cold and Warm [Winds],' " *Sichuan Daily*, May 5, 1988, p. 3.

64. Li Huasheng remembers Chen lamenting that, already in his sixties, he had wasted too much of his life ever to equal Qi Baishi and Huang Binhong. Of Li Keran, Chen wrote, "I like Li Keran's painting very much; I'd like to get one or two small pieces of Li Keran's painting to set out in order to stimulate my practice." Chen Zizhuang, unpublished correspondence with Zhang Zhengheng, dated November 16, 1971.

65. A small number of Chen Zizhuang's early *gongbi* paintings still exist, but unfortunately reproductions of them could not be obtained for publication.

66. Zhang Zhengheng, "Hidden Goals, Surpassing the Ordinary: On Chen Zizhuang's Painting Exhibition," *Keji ribao*, March 4, 1988, unpaginated. Chen used a variety of names in his career. In his early period, he used the studio name of Lanyuan ("Orchid Garden"); in his middle period, from about 1949 to 1963, he used Nanyuan (a place name), Xiali Ba Ren ("Country Bumpkin from Sichuan"), Chen Fengzi ("Crazy Chen"), Jiu Fengzi ("Crazy Alcoholic"), and Shi'erh Shu Meihua Zhuren ("Master of the Twelve Blossoming Plum Trees Studio"). See also Yan Xiaohuai, "Devoted to Art, Unconcerned With Reputation," *Renmin tiedao*, February 28, 1988, p. 4; Chen Zhidong, *Shiha lun hua yu yao*, p. 154.

67. The inscription on this painting reads: "*Guimao* [1963], beginning of autumn. After coming to Chengdu, my old student [one character unread]-jun asked for a painting of bamboo. [Signed] Nanyuan."

68. Jueyin continued, "I say this because the orchid's leaves are graceful; in blossoming and putting forth stamens it achieves a happy spirit. Bamboo leaves are criss-crossed, put forth in disorder like spears and knives in a display of anger." From Li Rihua's *Lun hua*, in Wang Yuanqi et al., *Peiwenzhai shu hua pu* (Beijing: Beijing shi zhongguo shudian, 1984), ch. 16, 8a *xia* (2, p. 409); I am grateful to Prof. James Cahill for this citation.

69. Translated by Watson, *Complete Works of Chuang Tzu*, p. 237.

70. Ouyang Xiu, from Burton Watson's translation of Kojiro Yoshikawa, *An Introduction to Sung Poetry* (Cambridge: Harvard University Press, 1967), p. 37.

71. The inscription on this painting reads: "In the autumn of the *jia yin* year [1974], upon [*sic*] crossing through Mianzhu and Hanmang counties, on [one character unread]-zi Ridge, I gaze west over the gathered peaks, great and dangerous: they're not at all inferior to Mt. Jian [at Jianmen, the pass between northern Sichuan and Shaanxi province]. After returning, I lay ill for several months, but now I am somewhat better. I painted this for my own pleasure." Before this inscription is a brief correction saying, "One extra character 'upon.' "

72. Personal correspondence, dated 1988.

73. This is well-demonstrated by the selection of works in Yang Rongze et al., *Chen Zizhuang hua ji*.

74. Still further antedating this style is the tradition of Shen Zhou, in the late 15th century.

75. Yang Rongze et al., *Chen Zizhuang hua ji*, p. 1.

76. For example, Yang Rongze et al., *Chen Zizhuang hua ji*, p. 27.

77. Ibid., p. 62, bottom.

78. Ibid., p. 44, bottom, and p. 63, bottom.

79. See, for example, Zhang Zhengheng, *Chen Zizhuang hua ji*, pp. 21, 23. The ultimate source of this seems to come from Xia Gui of the Southern Song.

80. By early 1990, Li primarily works with colored sticks purchased from China's prime distributor, the Jiang Sixu Hall in Suzhou. He buys mineral pigments in small tubes of Suzhou's Ancient Pagoda Brand. He does not use Western pigments.

81. Personal correspondence, dated 1988.

82. As for the modern fate of the Wenshiguan, which was Chen Zizhuang's institutional patron for two decades, it was practically dismantled during the Cultural Revolution; its founding principles and unit structure were restored after the Third Party Conference in 1979. A 60-dollar bonus was added to members' salaries, for a total of 110 dollars per month. The Chengdu Wenshiguan's present annual budget is about 400,000 Chinese dollars, enough to provide tours and exhibitions with "brother" institutions, to arrange for poetry gatherings on national holidays, to provide its members with tickets to cultural events, and to sponsor nationally distributed publications (particularly the journal *Wenshi zazhi* [*Culture and history digest*] with biographies, histories, and literature on the arts and social sciences written by members. In the early 1990s, of its current 130 members, about 50 are painters, and as traditional painting has begun to flourish once again, increasing numbers of requests for paintings by living members have come from Chinese units like the army and the handicapped. Museums also have begun to make requests, offering no artist's fee, but artists occasionally are remunerated by the Wenshiguan itself with compensation ranging from mere token prices to 40 Chinese dollars per work. The Chengdu branch operates not only a unit bookstore but also a painting sales shop, where members' paintings are priced up to 3,000 Chinese dollars; business is "slow," however, and not a single painting sale took place in the June–August period of 1988.

The Wenshiguan's institutional life span is limited naturally by the diminishing population of elderly pre-Revolutionary literati. Over the years, the Chengdu branch has sponsored about 700 members; originally there were almost 300 members, and in the early 1990s the total is down to 130 members, with an average age of 77.6 (ranging up to age 95, and with only a few members younger than age 70).

5. China's "Second Revolution" and the Rise of a "Younger-Generation Artist": 1976–83

1. Deng Xiaoping, *Selected Works*, p. 205.

2. Cf. Michael Sullivan, "New Directions in Chinese Art," *Art International*, 25 (1982), p. 42; Laing, *The Winking Owl*, p. 94 n. 29. Laing, p. 95, offers a political interpretation for this landscape theme.

3. Deng Xiaoping, "Speech Greeting the Fourth Congress of Chinese Writers and Artists," *Selected Works*, p. 201.

4. Ibid.

5. Ibid., p. 206.

6. Cf. Perry Link, *Stubborn Weeds: Popular and Controversial Chinese Literature after the Cultural Revolution* (Bloomington: University of Indiana Press, 1983), pp. 19–24.

7. Deng Xiaoping, *Selected Works*, p. 205.

8. Joan Cohen, in *The New Chinese Painting, 1949–1986* (New York: Harry Abrams, 1987), pp. 104–9, discusses realism in 1980s Sichuan painting, making a valuable distinction between Luo Zhongli's photorealism (consciously drawing on the work of Chuck Close) and the more romanticized "magic realism" of artists like He Duoling (derived from Andrew Wyeth).

9. Cohen, ibid., pp. 106–7, discusses Luo Zhongli and this painting in detail; the information on Li Shaoyan comes from Li Huasheng and his colleagues. By 1985, although the movement was beginning to acquire a faithful following in New York's galleries, its social force was largely spent.

10. In late August, in a conspicuous public flare-up over the first major international exhibition from the United States, seventy paintings from the Boston Museum of Fine Arts were already hung in Beijing's National Gallery when Chinese Minister of Culture Huang Zhen previewed the exhibition and pronounced thirteen modern works unacceptable. These included paintings by Jackson Pollock, Franz Kline, Helen Frankenthaler, and Jules Olitski. Museum of Fine Arts officials remained adamant about the integrity of their exhibition, and American cultural officials insisted that either the disputed works be included or the entire cultural exchange program cancelled, a threat to which, according to sources, the Chinese yielded grudgingly at the last minute. On September 1, in a Beijing speech delivered on opening day and originally intended to further improve Sino-American relations, American Supreme Court Chief Justice Warren Burger added to his scheduled remarks a strained lecture on Western standards of censorship and freedom of expression. On September 5, a long-term U.S.–China cultural exchange pact was concluded and the cultural dam was finally broken. By 1983, exhibitions of Pablo Picasso, the expatriate artists Zhang Daqian and Zao Wu-ki (Zhao Wuji), and other abstractionists began to flood Beijing's National Gallery.

11. Cui Zifan (Cui Shangzhi, b. 1915); Zhou Sicong (b. 1939), who later became the youngest vice-chair of the Chinese Artists Association; Lou Shibai (b. 1918).

12. Following this passage, the inscription continues: "Recently when painting, I have seriously studied spirit-resonance. Spirit-resonance can derive from the brush, and when you rub about with a dry brush and your strength is penetrating, then it will be revealed. It can derive from ink, and then the ink-images [created through] outlines, clustered dots, and broad washes can attain it. It can derive from concept, when the movement of the brush and of the wrist are just what you want them to be, when sparse and dense, complex and simple, thick and thin, dry and wet are all attained just as planned. Yet even with all of this, [a painting] still may not enter the divine class [the highest aesthetic caliber]. Only through spontaneity can one achieve such superiority, when one concentrates the spirit and fixes the mind, watching the movement of the wrist, at first not thinking about what [the painting] should be and then suddenly producing it. If you say it is achieved, then really it isn't; if you say it isn't achieved, then it is impossible to add a single dot. When your concepts are based on something beyond brush-spirit and ink-quality, then the results of natural vitality will

be worth looking at Huasheng."

13. Compare, for example, Zhang Zhengheng, *Chen Zizhuang hua ji*, pl. 21.

14. Qiu later wrote a popular opera on the life of Zhang Daqian, who, like Qiu, came from Neijiang County.

15. From about 1981 to 1983, Li Huasheng produced a number of works on *shikishi*-type leaves, including figure 62.

16. Sun Zhuli (b. 1907), from Luan County, Hebei, was too poor to afford an education, but he studied figure, landscape, and bird-and-flower painting with a professional artist. He then taught elementary school, and later, joining the Northwest University staff, he acquired an education in poetry and painting from the faculty there. For a long time after the Revolution, he remained a teacher, improving his traditional-style painting and poetry. He then became an advisor at the Chengdu Painting Academy as well as director of the Jinhua Calligraphy and Painting Academy. Wu Yifeng (b. 1907), now also an advisor at the Chengdu Painting Academy, was born in Pinghu County, Zhejiang province, and graduated from the Shanghai Art Academy. He first came to Sichuan on a trip with Huang Binhong in 1932 and was so taken with the landscape that he settled down in Chengdu. He also practices calligraphy and seal carving. The other painters mentioned here are introduced elsewhere.

17. Zhao Ziyang was placed under the Prime Minister Hua Guofeng and did not actually replace him until later in 1980, but it was already announced in April that the "day-to-day" work of the government was placed in his hands.

18. Li never photographed this work and no longer recalls just what it was like.

19. *Sichuan Sheng Shi Shu Hua Yuan Yuan Kan* (*Bulletin of the Sichuan Provincial Poetry, Calligraphy, and Painting Academy*), 1 (1986), p. 4.

20. The participants (see fig. 47) include, in the first row, from the left: Li Daoxi, a bird-and-flower and figure painter from the Leshan area; Sun Zhuli, who came to Sichuan from Tangshan before the Communist revolution, who particularly likes to paint lotus, and whom Li Huasheng describes as "a good man and a good artist, whose poetry is especially good"; the widow of the artist Nian Songfu (a bird-and-flower and tiger painter), who herself does not paint; one figure unidentified; Deng Xiaoping; Feng Jianwu, older brother of Shi Lu, sometimes ridiculed by Chen Zizhuang and considered a rival by the artists associated with Li Huasheng, who says, "We must recognize that he is capable in different aspects of art, including painting, seal carving, and composing poetry, but he always has a bad relationship with young artists; Yang Mingli, who came from Taiwan and whom Li regards as an imitator of Zhang Daqian; Qiu Xiaoqiu, the painter and playwright from Neijiang who, along with Li, was denied an honorary teaching position at the provincial fine arts academy in Chongqing; Zhou Beiqi, a martial artist and painter of monkeys, whose public ridicule by Huang Yongyu as a mere local artist is well remembered by Li and his friends; Peng Xiancheng, a colleague of Li Huasheng. Painters in the second row are: Wu Yifeng, who moved to Sichuan from the Jiangsu- Zhejiang area, who was labeled a "rightist" in the 1950s, and of whom Li says, "He is very openminded, has a very clear head, and never gives young artists a hard time"; Tan Changrong; Li Huasheng; Hu Li, who studied with Zhang Daqian

but whose enemies, says Li, joke that "he was just a servant whose duty it was to feed Zhang's monkey."

21. Deng Lin (b. 1941) first studied voice at Middle School of the Beijing Conservatory in 1959 until suffering laryngeal illness, then studied painting with Li Kuchan at Central Academy of Fine Arts from 1962 until 1966. Unable to find work after graduation because of her father's political disgrace at that time, she became a Red Guard, reportedly with her parents' approval. (see also Uli Franz, *Deng Xiaoping* [New York: Harcourt Brace Jovanovich, 1988], pp. 203–4.) In 1980, Deng Lin had scarcely been noticed as an artist, but she would later become director of the Oriental Art Exchange Association in Beijing, achieving great financial success through the combination of her art and her family position.

22. Xinhuashe (Chengdu), July 11, 1980, reported in *United States Foreign Broadcast Information Service Daily Reports*, July 14, 1980, p. Q1.

23. See pp. 138–9.

24. Song Wenzhi (b. 1919) was associate director of the Jiangsu Chinese Painting Academy and vice-chairman of the Jiangsu Provincial Artists Association. For the Nanjing exhibition, see p. 113.

25. This poem is written in *xin yuefu* form.

26. Note also in this work the peasant laborers displaced to the upper edge of the painting, the same incongruous holdover from revolutionary romanticism already seen in figure 44.

27. See above, p. 83.

28. Cf. his 1981 inscription, on figure 44: ". . . it doesn't have to be a famous mountain or a great river."

29. For further examples, see Yang Rongze et al., *Chen Zizhuang hua ji*, p. 14, bottom, for a similar choice of colors; p. 93, for a somewhat analogous treatment of earthen contour lines; pp. 61 and 72, for somewhat similar trees; and pp. 76, bottom, and 81, top, for the distant hills.

30. *China Reconstructs*, May 1982, p. 40. An advocate of the newly emerging culture, Huang Miaozi (b. 1913) had been attacked—and silenced—just a few years earlier, in the Cultural Revolution, as the "secretary of the treasury for the Guomindang."

31. Other members in the group, whose selection in some cases may have involved more than just quality, included Song Yulin (b. 1947, son of Song Wenzhi), Li Xiaoke (b. 1944, son of Li Keran), Zhang Bu (b. 1934), Lu Yifei (b. 1931), Liu Boachun (b. 1932), Zhu Xiuli (b. 1938), Wang Weibao (b. 1942), Qin Jianming (b. 1942), and Zhang Dengtang (b. 1943).

32. This third version is in a private American collection.

33. In the early 1990s, Li retains this work, which shares striking stylistic similarities with Li's painting of a half-decade earlier, *River Torrent* (fig. 33), and with his *Fisherman's Song at the Wu Gorge* (fig. 41) in terms of combining small precise details set at the edge of the work with a centralized area of broad, abstract brushwork.

34. *He shan ru huatu* (Hong Kong: Meishujia chubanshe, 1981).

35. Ling Chengwei, "Lodging Deep Feelings in Painting," *Hong yan wenxue jikan*, April 1981, pp. 240–42; the paintings published were entitled *Returning to the Grove at Dusk* (dated the first day of spring, 1981), and *Song of the Fisherman* (1980).

36. Pp. 50–53, with a short introductory note by Qin Lingyun, modified from Qin's commentary in the exhibition catalog.

37. Wei Xuemei, "Putting a New Poetry of Landscape into

Painting—A Visit with the Youth Painter Li Huasheng," *Zhoumo* [Chengdu], November 28, 1982, p. 6.

38. Huang Miaozi, "Some Landscape Painters," *China Reconstructs,* May 1982, pp. 40–43.

39. This expression, with its philosophical implications, comes from the unconventional 18th-century Yangzhou "eccentric" painter Zheng Xie; the punning application to mounter's paste—turning the lofty sentiment into the lowly and humorous—was Xie Wuliang's own.

40. For the original text, see Ji Feng, editor, *Lu Fangweng shi ci xuan* (Hangzhou: Zhejiang renmin chubanshe, 1975), p. 10. Other translations have been published by David Gordon, *The Wild Old Man: Poems of Lu Yu* (San Francisco: North Point Press, 1984), p. 5, and, in prose form, Peter Chau, in *East/West,* November 23, 1983, reprinted in John Seto, *Landscape Painting in Contemporary China* (Birmingham: Birmingham Museum of Art, 1984), p. 18.

41. *Feng nian* (abundant year) is written as *ban nian* (half year); *fu* (in river *after* river) should have a double-man radical; *yi* (suspect) is miswritten *ning* (frozen); *xiao* (flute) uses the grass radical instead of bamboo; *guan* (caps) is miswritten as *kou* (invader).

42. Three Japanese-mounted album leaves (*shikishi*) by Li were also selected for the exhibition, but these were finally excluded by the Chinese Artists Association as being too many works by one young artist. Lucy Lim points out that "some of the older artists were angry that the younger painters were included at all."

43. Michael Sullivan, "Contempory Chinese Painting," *Orientations,* October 1983, p. 13.

44. Like so many Chinese paintings, this work was not originally intended for the recipient to whom it was at last dedicated. It may have been done earlier (slightly earlier, in this case) than the date ("early summer, 1982") in the inscription.

45. *Tang shi sanbai shou xiangshi* (Taibei: Zhonghua shuju, 1970), p. 318. For a different translation, see A. C. Graham, *Poems of the Late T'ang* (Baltimore: Penguin Books, 1965), p. 159.

46. *He shan ru huatu,* p. 68.

47. The Chongqing Artists Association's first chairman, Ke Heng, served in an honorary capacity only, as he did as first chairman of the regional Artists Association (see above, p. 223n.36). The two other initial appointees as vice-chairmen were Lü Lin and Wang Zumei, who was a cartoonist at the Sechuan Academy of Fine Arts.

48. From the time of its founding in 1950, until the Southwest Artists Association was first established in 1953, the municipal Artists Association in Chongqing, like those in Beijing and Shanghai, was independent of its particular region. It was accountable instead to the national association.

49. See above, p. 40–1.

50. The initial artistic plunge into Tibet was made in the 1940s by guest-artists in Sichuan, including Wu Zuoren, Xiao Ding, Guan Shanyue, and others.

51. For biographical material on Niu Wen (b. 1922), see Li Runxin et al., editors, *Zhongguo yishujia cidian, xiandai,* vol. 5, pp. 392–93; Ling Chengwei, "Caihua, xinnian, yishu—lun Niu Wen de xianshi zhuyi yishu daolu" (Talent, conviction, artistry—discussing Niu Wen's path of artistic realism), *Chongqing meishujia tongxun* (Chongqing artists newsletter), May 1988, pp. 9–13. His collected works have been twice published, in Li Wenzhao, editor, *Niu Wen zuopin xuanji* (*Selected works by Niu Wen*) (Beijing: Renmin meishu chubanshe, 1963), and in Li Qun, Preface, *Niu Wen Banhua xuan* (*The selected wood engravings of Niu Wen*) (Chengdu: Sichuan Fine Arts Publishing House, 1988). In addition to being chairman of the Chongqing Municipal Artists Association and a vice-chairman of the Sichuan Provincial Artists Association (serving as its secretary-general, in charge of daily activities, during most of the 1980s), Niu Wen is a vice-chairman of the Sichuan Cultural and Art Workers Federation, and a vice-chairman of the Chinese Printmakers Association.

52. Xu Kuang (b. 1938), from Hubei, graduated from the Central Academy of Fine Arts Middle School, then came to Sichuan to work as an editor and artist for the *Chongqing Pictorial,* published by the Chongqing Artists Association. His artistic emphasis has been the depiction of southwest China's minority peoples. His paintings have been widely published in art journals, and his prints won a first prize at the national competition in 1979. For Xu's biography, see Li Runxin et al., editors, *Zhongguo yishujia cidian, xiandai,* vol. 1, pp. 513–14.

53. Cf. Andrew Nathan, *Chinese Democracy* (Berkeley and Los Angeles: University of California Press, 1988), pp. 70ff.

54. The proposal to assign new housing to Li was raised by Niu Wen, then formally applied for by the Chongqing Artists Association, then sent up for approval by the Chongqing Federation of Literary and Art Circles. When this was completed, the application was sent to the municipal Propaganda Department, a Party unit, for consideration. When, at last, municipal Party vice-secretary Meng Guanghan approved this proposal, Li got his apartment.

55. "Officials who benefitted could easily see the injustices but feared to tamper with a system whose ropes they had mastered only after the investment of much effort and whose protection of their own narrow margin of safety and comfort required steady vigilance." Perry Link, *Stubborn Weeds* (Bloomington: University of Indiana Press, 1983), p. 7.

6. "Spiritual Pollution" and the Fall of a "Shooting Star": 1983–86

1. Bonnie McDougall, *Mao Zedong's "Talk at the Yan'an Conference on Literature and Art": 1943 Text with Commentary* (Ann Arbor: Center for Chinese Studies, University of Michigan, 1980), p. 1.

2. Miklos Haraszti, *The Velvet Prison: Artists Under State Socialism* (New York: New Republic/Basic Books, 1987), pp. 26, 78–79.

3. The waist-drum is an ancient musical instrument, introduced in the Tang period and now used mostly among the peasantry.

4. Others included Wang Kaiying, Peng Zhilin, Jiang Yousun, Cai Lan, Liu Qing, and Cheng Manman.

5. For Chen Zizhuang's attitude toward Feng, see above, p. 62. Shi Lu was originally named Feng Yaheng and derived his adult name from Shi Tao (Daoji) and Lu Xun. For a short biography, see Qi Fenggo, "Shi Lu," in Yang Mingsheng, editor, *Zhongguo xiandai huajia zhuan,* pp. 707–15.

6. In later, less troubled years, Feng was able to respond by occasionally inviting Li to specialty dinners of oxtail soup. They would continue to maintain a positive relationship, though it was sometimes threatened by their very different artistic values. Li remembers that Zhu Qizhan (b. 1891/2) of the Shanghai Painting

Academy visited Sichuan in the late 1970s, when his national reputation was in ascent, and the three artists collaborated on a painting. Zhu painted a rock in pale ink, "which was excellent." Feng made a rock, too, "which was awful." "I then used dark ink to paint orchid leaves over Feng's rock," recalls Li. "Feng told me, 'There's enough room for you, too," pointing elsewhere about the painting. I didn't listen to him until after I had covered all of his rock. Later, I really regretted this."

7. Li Huasheng, correspondence with Tan Tianren, dated June 8, 1981.

8. Deng Xiaoping, "Mao Zedong Though Must Be Correctly Understood as an Integral Whole," speech at the Third Plenary Session of the Tenth Central Committee of the Communist Party, June 21, 1977, *Selected Works*, p. 56. For the reference to intellectuals as the "stinking Number Nine," see above, p. 86.

9. Deng Xiaoping, "Speech Greeting the Fourth Congress of Chinese Writers and Artists," *Selected Works*, p. 206.

10. Deng Xiaoping, "The Present Situation and the Tasks Before Us," speech at a meeting of cadres called by the Central Committee of the Communist Party, January 16, 1980, *Selected Works*, p. 228: "The anti-Rightist struggle of 1957 was necessary and correct. . . . At that point an ideological current appeared, the essence of which was opposition to socialism and to leadership by the Communist Party. And some people were making vicious attacks. It would not have been right for us to refrain from striking back. What, then, was wrong with the anti-Rightist struggle? The problem was that, as it developed, the scope and targets of the attack were unduly broadened, and the blows were much too heavy. Large numbers of people were punished inappropriately or too severely. . . . Nevertheless, it does not follow that the anti-socialist ideological current did not exist in 1957 or that the counter-blow against it was unwarranted."

11. Deng Xiaoping, "Uphold the Four Cardinal Principles," March 30, 1979, speech at a forum on the principles for the Party's theoretical work, *Selected Works*, p. 172.

12. Deng Xiaoping, "The Present Situation and the Tasks Before Us," *Selected Works*, pp. 235, 237.

13. Deng Xiaoping, "On the Reform of the System of Party and State Leadership," speech to the Political Bureau of the Central Committee, August 31, 1980, *Selected Works*, p. 324.

14. Deng Xiaoping, "The Present Situation and the Tasks Before Us," *Selected Works*, p. 239.

15. Perry Link, *Stubborn Weeds: Popular and Controversial Chinese Literature after the Cultural Revolution* (Bloomington: University of Indiana Press, 1983), p. 4.

16. Deng Xiaoping, "Speech Greeting the Fourth Congress," *Selected Works*, p. 204.

17. Speech of June 18, 1980, reported in *United States Foreign Broadcast Information Service Daily Reports*, June 19, 1980, pp. Q1–2.

18. Shen Baoxing, "Do Not Exaggerate the Concept of 'Political Campaign,' " *Jiefang Ribao*, November 12, 1981, p. 4, quoted in Dittmer, *China's Continuous Revolution*, p. 261.

19. For more on this, see Rudolph Wagner, "The Chinese Writer in his Own Mirror: Writer, State, and Society—the Literary Evidence," in Merle Goldman, editor, *China's Intellectuals and the State: In Search of a New Relationship* (Cambridge: Harvard University Press, 1987), pp. 219ff.; Carol Lee Hamrin, "New Trends Under Deng Xiaoping and His Successors," in Merle Goldman, editor, *China's Intellectuals and the State*, pp. 290–92; Judith Shapiro and Liang Heng, *Cold Winds, Warm Winds: Intellectual Life in China Today* (Middletown: Wesleyan University Press, 1986), pp. 28–33; Andrew Nathan, *Chinese Democracy* (Berkeley and Los Angeles: University of California Press, 1985), ch. 5.

20. For this "co-option," see Nathan, *Chinese Democracy*, p. 43.

21. Harry Harding, *China's Second Revolution: Reform after Mao* (Washington, D.C.: Brookings Institution, 1987), p. 184.

22. Hamrin, "New Trends," in Goldman, ed., *China's Intellectuals and the State*, p. 293.

23. Lynn White, "Thought Workers in Deng's Time," in Goldman, ed., *China's Intellectuals and the State*, p. 261.

24. Hamrin, "New Trends," in Goldman, ed., *China's Intellectuals and the State*, p. 293.

25. Ibid., p. 294.

26. Shapiro and Liang, *Cold Winds, Warm Winds*, pp. 82–83; see also David Kelly, "The Emergence of Humanism: Wang Ruoshui and the Critique of Socialist Alienation," in Goldman, ed., *China's Intellectuals*, pp. 159–82; Hamrin, "New Trends," in Goldman, ibid., pp. 285–89.

27. See pp. 36–7, above.

28. *Chinese Literature*, July 1983, p. 128.

29. Shapiro and Liang, *Cold Winds, Warm Winds*, pp. 84–85.

30. Department of State, *Country Report on Human Rights Practices for 1983* (Washington, D.C.: U.S. Government Printing Office, 1984), p. 743, cited in Shapiro and Liang, *Cold Winds, Warm Winds*, p. 45.

31. Shapiro and Liang, p. 92.

32. Translated in Geremie Barmé and John Minford, *Seeds of Fire: Chinese Voices of Conscience* (New York: Hill and Wang, 1988), p. 345.

33. Shapiro and Liang, p. 93.

34. Ibid.

35. Ibid., pp. 114–15.

36. Translated in Shapiro and Liang, p. 95.

37. Ibid., p. 61.

38. Ibid., p. 130.

39. Ibid., p. 126.

40. This was supposedly told to Li Huasheng by Huang Wenfu in 1984, when he visited Huang's home in Chengdu, carrying out his own investigation of the charges made against him.

41. This toast was reported to Li by Yan Jiyuan's relative, Xiong Wanxian.

42. Xie Yusheng died of cancer in 1986.

43. Personal conversation with the author, August 1988. Yuan Guanghou asserted in this conversation that his article "was not related" to the Campaign Against Spiritual Pollution. Although the article might be viewed as conservative propaganda that anticipated a more formal phase of political rectification, it is uncertain whether in July, August, and September 1983, Yuan Guanghou could already have been seeking out "bad models."

44. See above, pp. 8–9, 217n.40.

45. A position Li Shaoyan had held since 1975.

46. Lucy Lim, James Cahill, and Michael Sullivan, *Contemporary Chinese Painting: An Exhibition from the People's Republic of China* (San Francisco: Chinese Culture Foundation of San Francisco, 1983), p. 17.

47. Lucy Lim, "Contemporary Chinese Painting: An Exhibition from the People's Republic of China," *Art International*, August 1984, pp. 12–13.

48. Lim also planned to use Li's *Village Scene* on the journal cover accompanying her *Art International* article; instead, through an editorial change, the journal cover was a landscape by the young woman artist Yang Yanping.

49. *Zhongguo shu hua*, 14 (December 1983), pp. 8–9.

50. *Sichuan Ribao*, November 28, 1983, reported in *United States Foreign Broadcast Information Service Daily Reports*, December 1, 1983, p. Q3.

51. Hamrin, "New Trends," in Goldman, ed., *China's Intellectuals and the State*, pp. 278–79.

52. Shapiro and Liang, *Cold Winds, Warm Winds*, p. 145.

53. Translated in Orville Schell, *To Get Rich is Glorious: China in the Eighties* (New York: Pantheon, 1984), pp. 186–87.

54. Translated in Lynn White, "Thought Workers," in Goldman, ed., *Chinese Intellectuals and the State*, p. 269.

55. Shapiro and Liang, p. 147, citing *People's Daily*, December 10, 16, and 18. It is suggested (by Harding, p. 179) that the National People's Congress—ordinarily a "rubber-stamp" institution, also played a handy role: "On several occasions, in fact, the NPC has been able to modify the text of proposed legislation . . . and on one occasion—its apparent refusal to adopt a resolution supporting the movement against 'spiritual pollution' at the end of 1983—the Standing Committee of the NPC may have expressed the equivalence of a vote of no confidence on a significant Party policy."

56. Translated in Orville Schell, *To Get Rich is Glorious*, p. 188.

57. Shapiro and Liang, *Cold Winds, Warm Winds* p. 148.

58. Ibid.

59. Ibid., p. 115.

60. "Apparently . . . Deng [Xiaoping] was informed that the term Spiritual Pollution had a somewhat unsavoury history: Adolf Hitler had used it to condemn decadent bourgeois and Bolshevik culture in his famous speech on 'Aryan art' in 1937." Geremie Barmé and John Minford, *Seeds of Fire: Chinese Voices of Conscience* (New York: Hill and Wang, 1988), p. 345.

61. "The Spiritual Pollution Campaign came to a halt in September 1984, when a meeting convened by Deng Liqun and Hu Qiaomu to rebut criticisms of this puritanism [restricting the movement to intellectuals, for practical reasons of modernization] ended on a very opposite note: Deng Xiaoping, Hu Yaobang, and others called on the conference to criticize leftists instead." Lynn White, "Thought Workers," in Goldman, ed., *China's Intellectuals and the State*, p. 271.

62. *Liaowang*, January 16, 1984, p. 41.

63. *Minzhu yu fazhi*, January 1984, p. 42.

64. *Zhongguo fazhi bao*, February 13, 1984, p. 4.

65. Ibid.

66. Liu Han (b. 1932) was born in Zhongshan, Guangdong, son of an anarchist and professional assassin who became an assistant of Sun Yatsen. He joined the PLA in 1949, fought in mopping-up actions in Sichuan in 1949–50, and first became involved in art by producing political cartoons about land redistribution. He failed in examinations taken to enter the Central Academy of Fine Arts and the Zhejiang Painting Academy, perhaps because he rejected Soviet-inspired socialist realist styles. In 1956, he switched from oil painting to Chinese traditional painting. In the 1960s and 70s, he had little choice but to produce narrative figure paintings and historical themes, and by the end of the Cultural Revolution he could no longer support himself as an artist, so he was obliged to do construction work. After the end of Maoist era, however, his paintings began to gain some recognition. In 1985, he displayed a one-man exhibition in National Gallery, and that same year two of his paintings were given as gifts by the Chinese government to Japanese Premier Nakasone. He is hopeful of establishing a Chinese watercolor painting association.

67. William Hung, *Tu Fu*, p. 162, argues that the exact location of Du Fu's original thatched hall is probably unknown. The present site was not identified until 1090, when the first scholar to produce a chronological study of Du Fu's life, Lü Dafang, built a memorial temple there. Since then, the garden there was reconstructed at least four times from Song through Qing. Modern reconstruction has been carried on since 1952, and in 1961 the buildings were placed on the register of protected cultural monuments.

68. Tan Tianren was born in Chengdu in 1945. He studied painting there with Liu Jimin, a Sichuan artist who in turn was a student in Shanghai with Wu Changshuo, Pan Tianshou, and Liu Haisu. In 1924, Liu Jimin had brought Huang Binhong to Chengdu to lecture. Tan had acquired for the gallery's collection a number of notable paintings, including Jiang Zhaohe's well-known portrait of Du Fu, and while these were usually kept in protective storage, Tan's own precise copies of these are often on display. Tan's original paintings (fig. 100) are mostly landscapes with detailed architectural renderings, done in bright mineral colors and with a realistic grasp of regional Sichuan. He is a painting instructor at the Chengdu Painting Academy and has held solo exhibitions in Chengdu, Beijing, Japan, and Singapore. See Zhang Dauan, editor, Li Shaoyan, Preface, *Tan Tianren hua ji* (*Collection of Paintings by Tan Tianren*) (Chengdu: Sichuan meishu chubanshe, 1990).

69. This calligraphy is reproduced on the cover of the commemorative volume, *Sichuan Sheng Shi Shu Hua Yuan*, published by the Academy in October 1985.

70. These are reproduced in the commemorative volume, *Sichuan Sheng Shi Shu Hua Yuan*.

71. Tang Tao, "The Fall of the Painting Circle's 'New Star,' " *Zhu nin chengcai*, January–February 1985, pp. 40–41; the cartoon was by Shi Yingshao. *Zhu nin chengcai* is a semimonthly mazagine published under auspices of the Jiangsu Provincial Science Writers Association.

72. *Zhongguo bao kan*, January 9, 1985, p. 4.

73. *Zou xiang shenyuan* (Harbin: Heilongjiang chubanshe, 1985).

74. Letter from Li Huasheng to Tan Tianren, dated January 21, 1985.

75. Yangzi River Shipping Company, Chongqing Branch Labor Union, correspondence with the Jiangsu Provincial Science Writers Association, dated January 26, 1985.

76. *Zhu nin chengcai* Editorial Board, correspondence with Li Huasheng, dated January 30 [1985].

77. Jiangsu Science and Technology Publishing House, correspondence with Li Huasheng and Guo Danxia, dated April 28, 1986.

78. Shapiro and Liang, p. 175.

79. Shapiro and Liang, pp. 175–76.

80. See above, pp. 85–6.

81. See p. 232n.45, on the nature of this position.

82. This is an example of what Perry Link terms "soft support" or "backstage support" in Chinese cultural politics: "If a supporter is powerful, weight can compensate for lack of firmness." Link, *Stubborn Weeds*, p. 11.

83. Xiao was born in 1947, three years after Li.

7. *Laurels Restored, the Artist Academized: 1985–89*

1. Miklós Haraszti, *The Velvet Prison: Artists Under State Socialism* (New York: New Republic/Basic Books, 1987), p. 19.

2. The actual organization was done by Gao Wen, head of the Sichuan Provincial Bureau of Cultural Relics office. Financial contributors to the exhibition were all the subordinate units of this bureau, such as the Du Fu Thatched Hall, the Zhu Geliang Family Shrine, the Baoguang Temple in Xindu County, the Emei Cultural Relics Administration, the Leshan Cultural Relics Administration, the Guan Xian Cultural Relics Administration, and so forth. After the exhibition, Li gave a painting to each of these units.

3. In 1990, the Academy president.

4. Zhou Shaohua (b. 1929) was vice-chairman of the Hubei Artists Association and director of the Hubei Academy of Fine Arts. The exhibition and symposium were sponsored by the Hubei Branch of the Chinese International Cultural Exchange Center, the Hubei Artists Association, the editorial section of the cultural journal *Meishu sichao*, and the Hubei Fine Arts Center.

5. See above, pp. 63–4, for biographical information on Li Shaoyan.

6. Lü Lin, born in Shanxi, was a graduate from the Marxist Lu Xun Art Academy at Yan'an, worked as an artist with an army propaganda troupe in the northwest, and served as head of the Fine Arts Department at the Northwest Art Academy. He came to Sichuan with the advancing PLA troops in 1949. Soon afterwards, he was appointed Fine Arts Department head at the Sechuan Academy of Fine Arts (a position he held from 1950–52) and was made a vice-chairman of the Chongqing Municipal Artists Association.

7. See above, pp. 24–5. In 1950, Lü Lin had been appointed one of three vice-chairman of the Chongqing Municipal Artists Association, along with Niu Wen and Wang Zumei. Adherents of Chen Zizhuang ascribe Lü Lin's fall to Li Shaoyan's personal denunciation of him during the Anti-rightist Campaign, although given the ethics of the time, Li Shaoyan was doing what was "expected" of him when Lü Lin's teacher, Jiang Feng, fell from power as a prime artistic target of the movement. Lü Lin was not formally "rehabilitated" until after the Third Party Congress, in 1979. He was appointed vice-chairman of the Sichuan Artists Association in the following year.

8. Chen Zizhuang, correspondence with Zhang Zhengheng, dated June 15 [1972?].

9. Other artists of whom he is particularly fond include Lin Fengmian, Zhu Qizhan, Yan Jiyuan, and Li Qiungjiu. Like Chen Zizhuang, he is an advocate of the calligraphic style of the late Qing artist Gong Qinggao.

10. Lü Lin, "My View of the Art of Li Huasheng's Painting," *Chengdu wan bao*, August 20, 1985, p. 4.

11. Wu Fan (b. 1924), originally named Wu Zhenglun, is a native of Chongqing. From 1944 to 1948, he was a student in the National Art Academy, first in its temporary home in Chongqing, then back in Hangzhou after the war. He first studied traditional Chinese painting under the influence of such teachers as Pan Tianshou and Li Keran; afterwards he pursued realist art through Western-style training. Upon graduating, he returned to Chongqing and taught middle school. After the Communist revolution, he worked in the art department of the municipal culture hall and then in the publications office of the Cultural Federation, doing cartoons and propaganda art. He joined the Communist Party in 1952. Much of this time, he also taught in the Southwest Art Academy. He became vice-director of the provincial Artists Association office in 1956. In 1964, *Wu Fan zuopin xuanji* (*Selections of Wu Fan's works*) was published (Beijing: Renmin meishu chubanshe), followed in 1984 by *Wu Fan banhua xuan* (*Selections of Wu Fan's prints*) (Chengdu: Sichuan meishu chubanshe). As of 1990, he was a chairman of the standing committee of the national Printmakers Association and vice-chairman of the Sichuan Artists Association. His works are described as "striving to explore the poetic character of the period through ordinary lives, sincerely expressing the pleasures and hardships of the people"; Li Junxin et al., *Zhonnguo yishujia cidian, xiandai*, vol. 1, pp. 477–78.

12. Wu Fan was first appointed to this position in 1980.

13. Wu Fan, editor, *Chen Zizhuang zuopin xuan* (*Selection of works by Chen Zizhuang*) (Chengdu: Sichuan meishu chubanshe, 1982).

14. Chen Zhidong's book of collected comments, *Shihu lun hua yu yao* (1987), has drawn a negative response from some of Chen's admirers, who question its reliability; it was even refused distribution at the Chen Zizhuang's National Art Gallery exhibition in March 1988. The other works are: Yang Rongze, editor, *Chen Zizhuang xiesheng gao* (1986); Wang Zhihai, editor; Wu Fan, preface, *Shihu hua ji* (*Collection of Paintings by Shihu* [*Chen Zizhuang*]) (Tianjin: Tianjin renmin meishu chubanshe, 1987); Zhang Zhengheng, editor, *Chen Zizhuang hua ji* (1987); and Yang Rongze, editor, *Chen Zizhuang hua ji* (1988).

15. Yang Chao (b. 1911), was born in Da Xian, Sichuan. In 1928, he studied at the Chengdu Foreign Language Professional School. In 1929, he became a member of the Communist Youth League and in May 1932, he joined the Communist Party. Only three months later, in July 1932, he was arrested by the Guomindang. As soon as he was released from prison in August 1937, Yang Chao went to Yan'an. There he attended the Marxist-Leninist Institute of the Central Party Cadre School, and afterwards he was appointed director of the Institute's Philosophy Instruction Department. In August 1945, Yang Chao returned to Sichuan, working in Chongqing as director of the Number One Office of the Central United Front Administration and serving as political secretary for Zhou Enlai during Zhou's negotiations with the Guomindang. Between 1950 and 1961, Yang Chao held such positions as provincial Minister of Industry and director of the Sichuan Provincial Economic Planning Commission. In 1959, he became a member of the Sichuan Provincial Communist Party Standing Committee. From 1961 until 1974, Yang Chao served on the secretariat of the Sichuan Provincial Community Party Standing Committee, and in 1974 he became the Standing Committee's secretary. In 1982, Yang Chao reached the peak of his career, as chairman of the Sichuan Provincial Political Consultative Conference. In 1983, on his retirement from full-time

service, he became a member of the provincial Communist Party's Advisory Committee.

16. For a selection of Yang Chao's political writings in the post-Mao era, see *Tansuo de shi nian* (*Ten Years of Study*) (Chengdu: Sichuan jiaoyu chubanshe, 1987).

17. See *Sichuan Sheng Shi Shu Hua Yuan*, calligraphy and painting section, unnumbered p. 3., for his Chen Zizhuang-like birds and flowers.

18. Guo Ruyu (b. 1941) is a native of Chengdu. His early relationship with Chen Zizhuang is recounted above, pp. 62–3. He graduated from the Chengdu Fine Arts School in 1961. Like most traditional artists and intellectuals, Guo suffered during the Cultural Revolution. Severely criticized for paintings of Tang-style women and so forth that were supposedly meant to help defeat socialism, he was classified in the lowest of the four classes (in succession, good, bad, possessing contradictions that could be rectified, and "enemy" of the people), but formal sentencing was avoided since there was no local authority structure left to carry it out. Before joining the Sichuan Painting Academy, in addition to serving as an honorary teacher at the Chengdu Painting Academy, Guo was vice-director of the standing committee of the Sichuan Industrial Arts Academy (Sichuan Gongyi Meishu Xuehui) and a director of the Sichuan Academy of Self-taught Traditional Chinese Painters. He is also a member of the Chinese Calligraphers Association. His work has been exhibited in more than ten foreign countries.

19. Peng Xiancheng (b. 1941) is a native of Chengdu. He graduated from the Chengdu Teachers Academy in 1962 in their general education program, then taught art in primary school. From 1969–73, he taught at Chengdu's Eastside Culture Hall. He then taught art at the local Children's Palace from 1973–84 before joining the Sichuan Painting Academy. His works were first exhibited internationally in Singapore in 1986 and nationally in 1988 at the National Gallery in Beijing. In 1989 his *Painting the Idea of the West Chamber* won a bronze prize in the Seventh National Painting Exhibition. His art has recently been published in *Peng Xiancheng huaji* (*Selected paintings of Peng Xiancheng*) (Chengdu: Sichuan meishu chubanshe, 1989), and in Mo Yidian, editor, with an introduction by Wu Fan, *Peng Xiancheng shuimo huaji* (*Collection of watercolor paintings by Peng Xiancheng*) (Hong Kong: Rongbaozhai, 1990).

20. For original text, see *Tang shi sanbai shou xiangshi*, pp. 96–98. For a complete translation, see Witter Bynner and Kiang Kang-hu, *The Jade Mountain* (New York: Anchor Books, 1964, pp. 100–3.

21. For original text, complete translations, and further discussion of the original poem, see William Hung, *Tu Fu*, pp. 77–78, and David Hawkes, *A Little Primer of Tu Fu* (Oxford: Oxford University Press, 1967), pp. 18–27.

22. For two early illustrations of this theme, which influenced Peng's, both entitled *Traveling in Springtime* and traditionally said to be Song copies after an eighth-century original by Zhang Xuan, see the version attributed to Song emperor Huizong in the Liaoning Provincial Museum, illustrated in Jin Weinuo, editor, *Zhongguo meishu quan ji: Huihua being, II, Sui Tang Wudai huihua* (Beijing: Renmin meishu chubanshe, 1984), Plates 41–45, and a version attributed to Li Gonglin in the National Palace Museum in Tabibei, Taiwan, in James Cahill, *Chinese Painting* (Geneva: Skira, 1960), p. 20.

23. Dai Wei was born in 1943 in Lhasa and soon moved to Chengdu. He went to the middle school attached to the Sichuan Academy of Fine Arts. But before graduation, the Four Cleanups Movement (in 1964, a phase of the Socialist Education Movement) put an end to the use of nude models and he quit his studies, volunteering to go down to the countryside to enrich his experience. But after preparing for this, he agreed instead to stay behind to help the Communist Youth League in preparing others. In 1966, he went with his wife to an impoverished Yi minority area in southwestern Sichuan, were they remained for five years, losing their first child to the extreme poverty. During that time, he painted coffins for a living. (Coffins were a major commodity, purchased by Sichuan peasants well in advance of their use and painted twice yearly by all who could afford the price.) In 1971, Dai Wei became a professional painter in a cultural bureau in Xichang. He finally returned to Chengdu in 1979 as an illustrator and book designer. Dai Wei is also an honorary instructor at the Chengdu Painting Academy.

24. Liu Pu was born in Changdu in 1945. He has won numerous awards for his art, including the Sichuan Youth Art Exhibition award, the Sichuan Province Outstanding Artwork award, first prize in the Changdu Art Festival, and the Eighteenth Japanese Modern Ink-painting Exhibition award. He has had solo exhibitions in Chengdu, Nanjing, Beijing, and Singapore.

25. Qin Tianzhu was born in Chengdu in 1952. His painting brothers include Qin Tianlin and Qin Tianlun. He has had solo exhibitions in Chengu, Beijing, Nanjing, and Singapore, and in 1987 he won an outstanding artist prize at the Eighteenth Contemporary Chinese Ink-wash Painting Exhibition in Japan.

26. Zhang Shiying (b. 1933) graduated from the Sichuan Academy of Fine Arts in 1960. Before the joining the Sichuan Painting Academy, he was deputy-general engineer at the Sichuan Industrial Arts Institute, a director of the Sichuan Industrial Arts Association, and an honorary teacher at the Chengdu Painting Academy.

27. Born in Chengdu in 1949, Zhou Ming'an has practiced art since his youth. In the 1970s, he studied calligraphy and landscape painting with a number of elder generation artists in Chengdu. He then took the painter Yan Songfu as his teacher and began to focus on the painting of animals. Before joining the Sichuan Painting Academy, Zhou was an instructor at the Chengdu Painting Aacademy. He is a director of the Sichuan Academy for Self-Taught Traditional Chinese Painters and is also a member of the Sichuan Calligraphers Association.

28. Yuan Shengzhong was born in 1947 in Dazhu, Sichuan. He studied for one year at the Sichuan Academy of Fine Arts then taught at the Eastside Culture Hall. He has won the Sichuan Provincial Outstanding Artwork award.

29. See above, p. 229n.68, for Tan Tianren's biographical background.

30. Tan Changrong (b. 1933) is a Chengdu native.

31. Tan Changrong has had individual exhibitions in Chengdu, Chongqing, Beijing, Sinapore, and the United States.

32. Chen Zizhuang, unpublished correspondence with Zhang Zhengheng, dated July 4 [1973?].

33. *Chen Zizhuang zuopin xuan* (*Selection of works by Chen Zizhuang*). (Chengdu: Sichuan meishu chubanshe, 1982).

34. See Yu Qiao, p. 12, for background on Yan's efforts in organizing this exhibition.

35. This author's personal experience. The paintings subsequently delivered were of poor quality and uncertain authenticity.

36. In 1989, Wu Fan was arranging an exhibition for Hong Kong's Oriental Art and Cultural Endowment, while Lü Lin was organizing an exhibition of Chen's art for the Chinese Painting Research Institute in Beijing that would also travel afterwards to Hong Kong.

37. Yi Zhang, "Unprecedented Painting Exhibition," *Jiefang, ribao*, March 3, 1988, n.p.

38. Chen Zizhuang, unpublished correspondence with Zhang Zhengheng, dated August 10 [1971?].

39. The artists make their own selection of works to submit. These works enter the Academy collection and are not for sale. If a national or provincial art gallery wants to select such a painting, this must be done by arrangement with both the Academy and the painter.

40. Cf. Joan Cohen, *The New Chinese Painting, 1949–1986*; also, *You hua renti yishu dazhan zuopin, Works of the Chinese Nude Oils Exhibition* (Nanning: Guangxi renmin meishu chubanshe, 1988).

41. See above, pp. 8, 217n.38.

42. On arrival at the antiquities shops, under Bureau of Cultural Relics policies, works of art are assigned to one of three grades. Third-grade works are priced and are generally available for purchase. Second-grade pieces are available only for acquisition by local museums, by officials of an appropriate level, for retention by the shop to be used for training shop employees in connoisseurship, and more recently for raising larger sums of money from foreign buyers. First-grade pieces are made available only to major museums. A first- or second-grade piece like this one would not have been available for purchase even to someone who was not a shop employee.

43. Calculation based on Li's monthly income of 165 Chinese dollars.

44. Cf. Harding, *China's Second Revolution*, p. 175; Shapiro and Liang, *Cold Winds, Warm Winds*, pp. 70–77; Richard Bohr, *Religion in the People's Republic of China: The Limits of Reform* (New York: Asia Society, China Council, 1982).

45. Since the late 1920s, Communist attempts to liberate China from the scourge of military warlords and establish the primacy of the Party in military affairs gave rise to a system of political commissars to whom military commanders were subordinated in matters of general policy. The role of military-based commissars, as Party representatives, was to assure that commanders would "be conscious of the potential political impact of their orders both on their own men and on the civilian populace with whom their men would associate. It was hoped that commissars, while the army pursued essentially conventional military tactics with conventional weap-ons, would constantly emphasize their responsibility for forging a revolutionary political instrument. . . . The commissar would be responsible for directing the loyalties of the rank and file away from their traditional focus on the commander to a broader institutional focus on the Party and the Party's principles." William Whitson, *The Chinese High Command: A History of Communist Military Politics, 1927–71* (New York: Praeger, 1973), p. 17.

46. Lü Lin, "My View of the Art of Li Huasheng's Painting," p. 4.

47 Ibid.

48. *Sichuan ribao*, August 17, 1985.

49. Translated on p. 129, above.

50. The artist confirms that his "*jia mao*" date (a non-extant combination) should be *ding mao*.

51. On April 3, 1988, a son was born to Dai Ling and Li Huasheng whom they named Li Cai.

52. Michigan State Senate Resolution 200, June 10, 1987.

53. A similar phenomenon protected Taiwanese avant-garde artists, beginning with the Fifth Moon Group, in the 1950s and 1960s.

54. See above, p. 87.

55. The exhibition was titled and catalogued as *Sichuan ba ren Zhongguo hua zhan* (*Sichuan eight-man Chinese painting exhibition*). It included Sichuan Painting Academy members Peng Xiancheng, Liu Pu, and Qin Tianzhu, Li's friends Tan Changrong and Tan Tianren, and other Chengdu painters Qiu Xiaoqiu, Li Jinyuan, and Zhang Xiuzhu.

56. Cai Ruohong, a vice-chairman of the Chinese Artists Association, published a more positive review of the exhibition, singling out Peng Xiangcheng for special praise; *Renmin ribao*, March 25, 1988, p. 8.

57. Members of this committee at its first meeting in February 1988 were Yang Chao, Bai Desong, Liao Jiamin (the Academy's secretary-general for administrative affairs), Zhang Shiying, and Du Xianqing (a retired figure painter at the Sichuan Academy of Fine Arts), while the second meeting, in March, also included Li Shaoyan, Zhu Peijun, and Zhang Fangzhen.

58. Zhang Shiying, the only painter in the Academy with a diploma, was the only other artist given first rank. The newly added calligrapher, He Yinghui, was ranked as second grade, as were Guo Ruyu, Peng Xianchen, and Liu Pu. Qin Tianzhu, Zhou Ming'an, and Yuan Shengzhong were placed in the third tier. Dai Wai was not formally graded; he had already been granted the position of associate editor, equivalent to second grade. Certificates of grade were issued on March 15, 1988.

59. See above, p. 166.

Selected Bibliography

Andrews, Julia. "Old Painting in New China: The Theory and Practice of *Guohua*." Paper presented at the College Art Association annual meeting, February 1988, unpublished.

———. "Traditional Painting in New China: *Guohua* and the Anti-Rightist Campaign." *Journal of Asian Studies*, 49.3 (August 1990), pp. 555–85.

———. *Painters and Politics in the People's Republic of China*. Berkeley and Los Angeles: University of California Press, forthcoming.

Barmé, Geremie, and John Minford. *Seeds of Fire: Chinese Voices of Conscience* New York: Hill and Wang, 1988.

Cahill, James. "Confucian Elements in the Theory of Painting." In Arthur Wright, editor, *The Confucian Persuasion*. Stanford: Stanford University Press, 1966.

Chang, Arnold. *Painting in the People's Republic of China: The Politics of Style*. Boulder: Westview Press, 1980.

Chen Zhidong, editor. *Shihu lun hua yu yao* (*Essential comments from Shihu's* [*Chen Zizhuang's*] *discussions of painting*). Chengdu: Sichuan meishu chubanshe, 1987.

Chengdu Hua Yuan (*The Chengdu Painting Academy*). Chengdu: Chengdu Painting Academy, 1986.

Cohen, Joan. *The New Chinese Painting, 1949–1986*. New York: Harry Abrams, 1987.

Deng Xiaoping. *Selected Works of Deng Xiaoping (1975–1982)*. Beijing: Foreign Languages Press, 1984.

Dittmer, Lowell. *China's Continuous Revolution: The Post-Liberation Epoch, 1949–1981*. Berkeley and Los Angeles: University of California Press, 1987.

———. *Liu Shao-ch'i and the Chinese Cultural Revolution: The Politics of Mass Criticism*. Berkeley and Los Angeles: University of California Press, 1974.

Ellsworth, Robert, Keita Itoh, Lawrence Wu et al. *Later Chinese Painting and Calligraphy, 1800–1950*. New York: Random House, 1986.

Fu, Shen, with Jan Stuart. *Challenging the Past: The Paintings of Chang Dai-chien*. Washington, D.C.: Smithsonian Institution; Seattle: University of Washington Press, 1991.

Goldman, Merle. *China's Intellectuals: Advise and Dissent*. Cambridge: Harvard University Press, 1981.

———, editor. *China's Intellectuals and the State: In Search of a New Relationship*. Cambridge: Harvard University Press, 1987.

———. *Literary Dissent in Communist China*. Cambridge: Harvard University Press, 1967.

Haraszti, Miklós. *The Velvet Prison: Artists Under State Socialism*. New York: New Republic/Basic Books, 1987.

Harding, Harry. *China's Second Revolution: Reform After Mao*. Washington, D.C.: Brookings Institution, 1987.

He shan ru huatu (*Rivers and Mountains Resemble Paintings*). Hong Kong: Meishujia chubanshe, 1981.

Kao Mayching. "China's Response to the West in Art: 1898–1937." Ph.D. dissertation, Stanford University, 1972.

———, editor. *Twentieth Century Chinese Painting*. Oxford: Oxford University Press, 1988.

Karnow, Stanley. *Mao and China: From Revolution to Revolution*. New York: Viking Press, 1972.

Kraus, Richard. *Pianos and Politics in China: Middle-class Ambitions and the Struggle Over Western Music*. New York: Oxford University Press, 1989.

———. *Brushes with Power: Modern Politics and the Chinese Art of Calligraphy*. Berkeley and Los Angeles: University of California Press, 1991.

Kuo, Jason. *Innovation Within Tradition: The Painting of Huang Pin-hung*. Williamstown, Mass.: Williams College Museum of Art and Hanart Gallery, 1989.

Laing, Ellen Johnston. *The Winking Owl: Art in the People's Republic of China*. Berkeley and Los Angeles: University of California Press, 1988.

Li, Chu-tsing. *Liu Guosong: The Growth of a Modern Chinese Artist*. Taibei: National Gallery of Art and Museum of History, 1969.

———. *Trends in Modern Chinese Painting* (*The C. A. Drenowatz Collection*). Ascona, Switzerland: Artibus Asiae, 1979.

Liao Jingwen. *Xu Beihong: Life of a Master Painter*. Beijing: Foreign Languages Press, 1987.

Lim, Lucy, James Cahill, and Michael Sullivan. *Contemporary Chinese Painting, An Exhibition from the People's Republic of China*. San Francisco: Chinese Culture Foundation of San Francisco, 1983.

Link, Perry. *Stubborn Weeds: Popular and Controversial Chinese Literature after the Cultural Revolution*. Bloomington: University of Indiana Press, 1983.

MacFarquhar, Roderick. *The Origins of the Cultural Revolution*, 2 volumes. New York: Columbia University Press, 1974, 1983.

Mao Zedong. *Selected Readings from the Works of Mao Tsetung*. Beijing: Foreign Languages Press, 1971.

McDougall, Bonnie. *Mao Zedong's "Talks at the Yan'an Conference on Literature and Art": 1943 Text with Commentary*. Ann Arbor: Center for Chinese Studies, University of Michigan, 1980.

Nathan, Andrew. *Chinese Democracy.* Berkeley and Los Angeles: University of California Press, 1985.

Shapiro, Judith, and Liang Heng. *Cold Winds, Warm Winds: Intellectual Life in China Today.* Middletown: Wesleyan University Press, 1986.

Sichuan banhua xuan (Selections of prints from Sichuan, 1949–1959). Chengdu: Sichuan renmin meishu chubanshe, 1960.

Sichuan Sheng Shi Shu Hua Yuan (The Sichuan Poetry, Calligraphy, and Painting Academy). Chengdu: Sichuan Sheng Shi Shu Hua Yuan, 1985.

Silbergeld, Jerome. *Mind Landscapes, The Paintings of C. C. Wang.* Seattle: Henry Art Gallery and University of Washington Press, 1987.

Strassberg, Richard, et al. *"I Don't Want to Play Cards with Cezanne" and Other Works: Selections from the Chinese "New Wave" and "Avant-Garde" Art of the Eighties.* Pasadena: Pacific Asia Museum, 1991.

Sullivan, Michael. *Chinese Art in the Twentieth Century.* Berkeley: University of California Press, 1959 (rev. ed. forthcoming).

———. *The Meeting of Eastern and Western Art,* 2nd edition. Berkeley and Los Angeles: University of California Press, 1989.

———. "Values Through Art," in Ross Terrill, editor, *The China Difference: A Portrait of Life Today Inside the Country of One Billion* (New York: Harper and Row, 1979).

———. "Recollections of Art and Artists in Wartime Chengdu." *Register of the Spencer Museum of Art* [*The University of Kansas*], 6.3 (1986), pp. 6–19.

Sun, Shirley. "Lu Hsün and the Chinese Woodcut Movement: 1929–1936." Ph.D. dissertation, Stanford University, 1974.

Tao Yongbai. *Zhongguo youhua, 1700–1985: Oil Painting in China.* Shanghai: Jiangsu meishu chubanshe, 1988.

Wang Zhihai, editor; Wu Fan, preface. *Shihu hua ji (Collection of paintings by Shihu [Chen Zizhuang]).* Tianjin: Tianjin renmin meishu chubanshe, 1987.

Witke, Roxane. *Comrade Chiang Ch'ing.* Boston: Little, Brown, 1977.

Woo, Catherine Yi-yu. *Chinese Aesthetics and Ch'i Pai-shih.* Hong Kong: Joint Publishing Company, 1986.

Wu Fan. "Chen Zizhuang." In Ren Yimin, editor, *Sichuan jinxiandai renwu zhuan (Biographies of modern and contemporary Sichuanese).* Chengdu: Sichuan University Press, 1988.

Wu Fan, editor. *Chen Zizhuang zuopin xuan (Selection of works by Chen Zizhuang).* Chengdu: Sichuan meishu chubanshe, 1982.

Wu, Nelson et al. *Chen Chi Kwan Paintings, 1940–1980.* Taibei: Art Book Company, 1981.

Yang Rongze, editor; Chen Shouyue, preface. *Chen Zizhuang xiesheng gao (Chen Zizhuang sketchbook).* (Chengdu: Sichuan meishu chubanshe, 1986).

Yang Rongze et al., editors; Wu Fan, preface. *Chen Zizhuang hua ji (Collection of paintings by Chen Zizhuang).* Chengdu: Sichuan meishu chubanshe and Waiwen chubanshe, 1988.

Yue Daiyun and Carolyn Wakeman. *To the Storm: The Odyssey of a Revolutionary Chinese Woman.* Berkeley and Los Angeles: University of California Press, 1985.

Zhang Keren, editor; Hua Junwu, preface. *Sichuan meishu xueyuan zuopin xuanji (Selection of works from the Sichuan Academy of Fine Arts).* Chongqing: Chongqing chubanshe, 1984.

Zhang Zhengheng, editor. *Chen Zizhuang hua ji (Collection of paintings by Chen Zizhuang).* Beijing: Rongbaozhai, 1987.

Glossary-Index

Adams, Henry: on autobiography, xix

Ai Qing 艾青 (1910-?), poet and literary critic, target of Anti-rightist Campaign, 22, 23, 178, 218n.90

Ai Weiren 艾維仁 (b. 1932), from Liaoning province, joined PLA in 1948, joined Party in 1949, deputy political commissar for the Chengdu Military Region with rank of major-general, patron of Li Huasheng, 165-6, 186, 189, 191-2, 207-12; photograph, 165 (fig. 83)

Ai Xuan 艾軒 (b. 1947), son of Ai Qing, specialist in Tibetan figure paintings, associated with Sichuan realist oil painting movement of early 1980s, 86

An Weinian 安維年, member of Li Huasheng's "small circle" of friends, 54, 135

Anti-rightist Campaign (1957), 4, 9, 22-24, 35, 60-1, 67, 132, 140, 171, 219nn.104, 105, 228n.10

Artists associations. See Chinese Artists Association; Chongqing Artists Association; Sichuan Artists Association; Southwest Artists Associaton

Bada Shanren 八大山人 (or Zhu Da 朱耷, 1625–after 1705), early Qing dynasty individualist painter, 12, 51-2, 58, 66, 68, 69, 72, 76, 82, 88-9, 91, 178, 209; painting, 89 (fig. 37)

Bai Desong 白德松, landscape painter, now Painting Department chairman at Sichuan Academy of Fine Arts: supporter of traditional-style painting, 94; sponsor of Li Huasheng for honorary faculty membership at Sichuan Academy, 94, 170, 210; on Li Shaoyan, 183; honorary member of Sichuan Painting Academy, 183; painting, 185 (fig. 102)

Bai Juyi 白居易 (or Bo Juyi, 772-846), Tang dynasty poet, author of "The Lute Song," 17, 177

Beethoven (Ch. Bei Duofen 貝多芬) Club, 36-7, 49, 67

Bureau of Cultural Relics 文物局, controls Chinese antiquities, including sale of Chinese art, 8, 217n.38, 232n.42

Burger, Warren (b. 1907), as U.S. Supreme Court Chief Justice, lectures Chinese on artistic freedom, 225n.10

Cai Ruohong 蔡若虹 (b. 1910), chair of art department at Lu Xun Academy in 1940s, Chinese Artists Association vice-chairman, in conflict with Jiang Feng in support of national forms, target of Campaign Against Spiritual Pollution, 144, 219n.104

Campaign Against Spiritual Pollution. See Spiritual Pollution

Central Academy of Fine Arts 中央美術學院, Beijing, 23-4, 219n.97

Central Cultural Revolutionary Leadership Group 中央文革領導小組, organized under Jiang Qing during Cultural Revolution, 40, 217n.41

Changlin 長林, Li Huasheng's birthplace, 26; as painting theme, 206 (fig.117). See also Yibin

Chen Fugui 陳福貴, original name of Chen Zizhuang, 57

Chen Hongshou 陳洪綬 (1599-1652), late Ming figure painter, 12, 69

Chen Ji 陳季, husband of Xiao Banghui, 139, 149, 154-7, 166

Chen Qikuan 陳其寬 (b. 1921), Taiwan painter, 10, 21, 89

Chen Shoumei 陳壽眉 (d. 1969), son of Chen Zizhuang, drowned, 66

Chen Yue 陳越, original name of Chen Zizhuang, 57

Chen Zenghai 陳增海, father of Chen Zizhuang, 57

Chen Zhidong 陳滯冬, student of Chen Zizhuang, painter at Sichuan Normal University, Chengdu, 57, 58, 62, 65, 66

Chen Zizhuang 陳子莊 (1913-76), 10, 13, 17, 19, 55-84, 92, 98, 137-9, 155-6, 171; family background, 57-8; and warlord-governor Wang Zanxu, 58-60; and Wenshiguan, 59-61, 66; during Cultural Revolution, 60-2, 65-8; as harsh critic, 62-3, 67; relationship with Li Shaoyan and Zhu Peijun, 63-4; and Li Huasheng, 67-8; 74-8, 88, 105-6, 113, 123-5, 144, 186, 191-2, 200, 205; current influence in Sichuan, 170-80, 182-4; paintings, 68 (fig. 18), 69 (fig. 19), 71 (fig. 20), 72 (fig. 21), 73 (fig. 23), 74 (fig. 25), 77 (fig. 29), 81 (fig. 34), 146 (fig. 76), 194 (fig. 104), 207 (fig. 118); photograph, 56 (fig. 14). See also Li Huasheng

Chengdu: general background, 16-17, 21, 170. See also Sichuan

Chengdu Painting Academy 成都畫院 (established 1980), 160

Chinese Artists Association 中國美術家協會, 22-4, 114, 115, 123, 142, 144; general background, 8-10, 216n.37. See also Chongqing Artists Association; Sichuan Artists Association; Southwest Artists Association

Chinese Federation of Literary and Art Circles 中國文化藝術工作者聯合會 (Cultural Federation 文聯), 23; general background, 8-9, 217nn.39, 40; Chongqing branch, 137, 148-50, 152, 155-6, 166

Chongqing: general background, 14-16; wartime role in Chinese art, 21. See also Sichuan

Chongqing Artists Association 重慶美術家協會, 24, 40, 51, 132-4, 136 passim, 148 passim, 227n.48, 230n.7

Chongqing Branch of the Chinese Artists Association 中國美術工作者協會重慶分會 (four-province regional association, 1954-58), 223n.36

Chongqing Sailors Club. *See* Li Huasheng, artist for Yangzi River Shipping Administration

Close, Chuck (b. 1940), photo-realistic painter, 86

Communist Party Propaganda Department, 23-4, 35-6; national level, 8-9, 35-6, 143, 145, 152, 165; Sichuan level, 148, 152, 210; Chongqing level, 148, 150, 156, 165, l70

Contradictions 矛盾, 2-4, 20, 22, 39, 212; defined by Mao Zedong, 2-4; and traditional Chinese painting as contradiction of Maoist aesthetic, 3-4, 18-20, 61, 68; and abstraction in Li Huasheng's painting as contradiction of Maoist aesthetic, 81-2, 89-92, 103-4, 187-8, 192, 198, 200. *See also* Mao Zedong, Yan'an Forum

Cui Zifan 崔子范 (b. 1915), director of Beijing Painting Academy, met Li Huasheng (1978), 92

Cultural Federation. *See* Chinese Federation of Literary and Art Circles

Cultural Revolution, 3, 9, 13-14, 17, 25, 27, 35-54, 133, 167, 174, 176, 180, 190-1, 217n.41; general background, 35-6, 40-1; Sichuan art administrators during, 40-1; artistic standards during, 43-5, 53, 83-4, 86-7, 190; "black painting" exhibitions and "Hotel School" art, 41, 53; military struggle in Sichuan, 42-3. *See also* Jiang Qing; Li Huasheng; Socialist Education Movement

Culture Halls (*Wenhuaguan* 文化館), 30, 51, 172-4, 190

Dai Ling 戴玲, third wife of Li Huasheng, 205

Dai Wei 戴衛 (b. 1945), figure painter and book illustrator, member of Sichuan Painting Academy, 61, 62, 74, 144, 166, 209, 232n.58; biographical sketch, 177-8, 231n.23; painting, 178 (fig. 94)

Daoji 道濟 (or Shitao 石濤,

1641-ca. 1720), Qing dynasty individualist painter, 51, 58, 62, 68, 69, 82, 200–3, 209; painting, 200 (fig. 112)

Deng Lin 鄧琳 (b. 1941), artist daughter of Deng Xiaoping, 98-100; collaborative painting (1980) with Li Huasheng et al., 100 (fig. 48)

Deng Liqun 鄧立群, Communist Party Propaganda Department chief who helped design Campaign Against Spiritual Pollution, 143, 152, 165

Deng Tuo 鄧拓 (d. 1966), Beijing Communist Party secretary (1966), victim of Cultural Revolution, 39

Deng Xiaoping 鄧小平 (b. 1904), Chinese vice-premier, xviii, 9, 42, 92, 103, 122, 135, 140-3, 151, 165, 183, 187, 189; Sichuan origins and relations, 17-18; leads Communist troops into Sichuan, 58; introduces moderate policies, 85-6; meets Li Huasheng (1980), 98–100; approves creation of Sichuan Painting Academy, 98, 160; provides calligraphy title for Sichuan Painting Academy opening ceremonies, 160; photograph, 99 (fig. 47)

DeWoskin, Kenneth, University of Michigan professor, brought Li Huasheng to America (1987), 171, 204-5

Ding Jingwen 丁井文 (b. 1914), principal of Central Academy of Fine Arts Middle School, invited Li Huasheng to Creativity Group in Beijing (1979), 94

Ding Ling 丁玲 (1909-89), novelist, repeated target of Maoists for defending literary independence from politics, 22-3, 220ch.3n.9

Ding Yanyong 丁衍庸 (1902-78), from Guangdong, painter in Western and traditional Chinese styles, 21

Dong Qichang 董其昌 (1555-1636), late Ming dynasty landscape painter and critic, xx, 19-20

Du Fu 杜甫 (712-770), Tang dynasty poet, 15–17, 26, 30, 177, 178, 209, 229n.68; Du Fu Thatched Hall 杜甫草堂, Chengdu, 158, 180, 185, 229n.67. *See also* Li Huasheng, Du Fu Thatched Hall exhibition

Du Yongqiao 杜詠樵 (b. 1934), painter at Sichuan Academy of Fine Arts, teacher of Li Huasheng in 1960s, 36, 49, 51–4; woodblock print, 50 (fig. 12)

Emei, Mount, 16, 66, 96, 209

Fan Zeng 范曾 (b. 1938), figure painter, former member of Central Academy of Arts and Crafts, Beijing, 207

Fang Yi 方毅, former Chinese vice-premier, 55, 210

Fang Zhaolin 方召麐 (b. 1914), Hong Kong–London artist, 10

Feng Duanyou 馮端友, sheltered Li Huasheng (1984), 158

Feng Jianwu 馮建吳 (b. 1910), member of Chengdu Painting Academy, brother of Shi Lu, 98, 160, 178; insulted by Chen Zizhuang, 62; befriended and recommended by Li Huasheng, 138-40, 145; photograph, 99 (fig. 47)

Feng Xuefeng 馮雪峰 (ca. 1900-?), essayist and poet, denounced (1954, 1957), 22-3, 216n.33

Fu Baoshi 傅抱石 (1904-65), Nanjing-based traditional-style landscape and figure painter combining dynamic brushwork and Japanese characteristics, 21, 30, 60; disparaged by other artists, 172, 223n.38

Fu Zhitian 傅之天, abbot of Shangqing Temple near Chengdu, vice-chairman

Chinese Daoist Association: as patron of Li Huasheng, 191

Gao Xiaohua 高曉華 (b. 1955), oil painter associated with Sichuan realist movement of 1980s, 86

Gao Yuan 高原, pilot who housed Li Huasheng in Beijing (1983), 145

Goethe, Johann Wolfgang von: on artistic individualism, 3, 5

Gong Qinggao 龔晴皋 (active late-18th century), Qing dynasty Sichuan calligrapher admired by Chen Zizhuang and Li Huasheng, 70, 186

Gong Xian 龔賢 (ca.1618-89), early Qing "individualist" landscape painter, 91

Gorges, Yangzi River. *See* Li Huasheng, through Yangzi River gorges; Yangzi River and Yangzi River gorges in Sichuan

Great Leap Forward (1958), 24, 31, 35, 61, 221n.35

Gu Mu 谷牧 (b. 1914), former vice-premier, patron of Cai Ruohong and Huang Zhou and possible target of Campaign Against Spiritual Pollution, 144

Gu Wenda 谷文達 (b. 1955), landscape painter and installation artist, former member of Zhejiang Academy of Fine Arts, now living in America, met Li Huasheng (1985), 170-1, 187

Gu Yuan 古元 (b. 1918), Guangdong woodblock artist, at Yan'an, later vice-director of Central Academy of Fine Art: in Chongqing during war, 21

Gu Zhenhai 谷振海 (d. ca. 1984), Yangzi River Shipping Administration official (Chongqing Office, Communist Party secretary), tried to procure painting from Li Huasheng for Xie

Limin, opposed Li during Campaign Against Spiritual Pollution, 138, 145, 148, 150, 153, 158-60

Guan Shanyue 關山月 (ca. 1910-86), Cantonese painter, seen by Li Huasheng in "black-arts" exhibition (1966), prominent in Cultural Revolution as socialist-realist, 41, 114

Guo Danxia 郭旦霞, lawyer hired by Li Huasheng during Campaign Against Spiritual Pollution, 164

Guohua. See Traditional Chinese painting

Guo Manchu 郭蔓鋤 (b. 1919), Chongqing painter, early teacher of Li Huasheng, 33-6, 67, 89, 92; Li Huasheng opposed exhibition by, 137

Guo Ruyu 郭汝愚 (b.1941), bird-and-flower painter, member and administrator of Sichuan Painting Academy, 62, 63, 70, 174, 232n.58; biographical sketch, 231n.18; painting, 175 (fig. 91)

Guo Shihui 郭世惠, classmate of Li Huasheng at Yangzi River Shipping School, charged during Socialist Education Movement, 29, 39-41, 51

Hall of Culture and History. See Wenshiguan

Haraszti, Miklós (b. 1945), Hungarian dissident poet, 7, 9-10, 136, 168

He Duoling 何多苓 (b. 1948), oil painter in Sichuan realist movement, 86

He Huaishuo 何懷碩 (b.1941), Taiwan painter, 10

He Long 賀龍 (1896-1969), People's Liberation Army general, one of ten marshals created in 1955, victim of Cultural Revolution (d. 1969), 42, 64

He Yinghui 何應輝, calligrapher, member of the Sichuan Painting Academy, 179

Hou Yimin 侯逸民 (b. 1930), oil-based figure painter, professor at Central Academy of Fine Arts, 44

Hu Feng 胡風 (1902-85), poet and literary theorist, denounced (1955), 22-3, 216n.33

Hu Qiaomu 胡喬木, member of Communist Party Central Committee Political Department, helped design Campaign Against Spiritual Pollution, 86, 143, 165

Hu Yaobang 胡耀邦 (1915-89), Communist Party general-secretary from 1981 to 1987, 141-2, 144, 152

Hua Guofeng 華國鋒 (b. 1921), premier and Communist Party chairman (1976), formally replaced (1981), 85, 89

Huang, Mount (Yellow Mountains, Anhui province), 98, 100-4

Huang Binhong 黃賓虹 (or Huang Zhi 黃質, 1864-1955), from Anhui province, prominent conservative-style landscape artist and art-scholar, active in Shanghai, Nanjing, and Beijing, xviii, 23, 74, 176, 204; visit to Sichuan, 21, 58; influence on Chen Zizhuang, 21, 67, 69, 72, 76; influence on Li Huasheng, 21, 67, 78–9, 106, 123, 125; painting, 73 (fig. 24)

Huang Junbi 黃君璧 (1889-?), traditional-style landscape painter, professor in Guangzhou and then at Nanjing's National Central University, moved to Taiwan (1949), 21

Huang Miaozi 黃苗子, nationally prominent calligrapher and art critic, 113

Huang Wenfu 黃文福, Chongqing journalist, coauthored article attacking Li Huasheng (1983), 145

Huang Yongyu 黃永玉 (b. 1924), ehtnic-minority artist from Hunan, painter

and satirist, formerly professor at Central Academy of Fine Arts, severely denounced during Cultural Revolution, met Li Huasheng (1973), 21, 53, 85, 98-100, 114-5, 145, 180, 222n.43; drawing of Li Huasheng, iv (frontispiece); collaborative painting with Deng Lin et al., 100 (fig. 48)

Huang Zhen 黃鎮, Minister of Culture (early 1980s), 225n.10

Huang Zhou 黃冑 (b. 1925), Beijing animal and figure painter, vice-chairman Chinese Painting Research Institute, target of Campaign Against Spiritual Pollution, 53, 114, 144, 223n.38

Hundred Flowers Movement (1956-57), 4, 22-5, 208

Jia Youfu 賈又福 (b. 1942), member of Central Academy of Fine Arts, met Li Huasheng (1985), 170

Jiang Feng 江豐 (1910-82), revolutionary printmaker, advocate of internationalism as opposed to national forms, arts administrator at Zhejiang Academy of Fine Arts and Beijing's Central Academy of Fine Arts, target of Anti-rightist Campaign, 22-4, 230n.7; biographical sketch, 218n.90

Jiang Kaihua 姜開華 (1924-73), mother of Li Huasheng, 27

Jiang Kaishek 蔣介石 (1887-1975), leader of Nationalist China, 5, 17, 58-9, 223n.36

Jiang Qing 江青 (1914-91), fourth wife of Mao Zedong, radical arts leader of Cultural Revolution, 9, 40, 42-3, 48, 53, 61, 63, 85-6, 174, 217n.41, 221n.31

Jiang Zhaohe 蔣兆和 (1904-?), Sichuan-born figure painter, teacher at Central Academy of Fine Arts, Beijing, after revolution, 218n.83, 229n.68

Jiuguoqing 九鍋菁 Labor

reform camp, 37, 67

Ke Heng 柯橫 (d. ca. 1958), calligrapher and traditional painter, first chairman of Southwest Artists Association and Chongqing Branch of Chinese Artists Association, 223n. 36

Khrushchev, Nikita (1894-1971), premier of Soviet Union, 36, 44, 216n.11

Korovin, Alekseevich (1861-1939), Russian oil painter, 49

Lenin, V. I. (1870-1924), Soviet revolutionary leader: on artists' role, 215n.10, 216n.18

Levitan, Isaac (1860-1900), Russian oil painter, 49

Li Bai 李白 (or Li Bo, 701-762), Tang dynasty poet, 15, 17, 30, 209

Li Hua 李樺 (b.1907), foremost socialist printmaker, in Chongqing during war, after 1953 chair of Woodblock Print Department at Central Academy of Fine Arts, 21

Li Huanmin 李煥民 (b. 1930), Sichuan wood-block artist, 87, 132-3

Li Huasheng 李華生 (b. 1944): personality characterized, xviii, 10-13

— artistic background: early schooling, childhood painting, 28-30; early training, 30-34, 43-53; in Yangzi River Shipping School, 36-40, 43, 50-1, 154-5; Beethoven Club, 36-7; secret study of traditional Chinese painting, 39, 50-2, 54. Early private teachers, see Du Yongqiao; Guo Manchu; Yu Jiwu; Zeng Youshi

— artistic career: effect of social background on , 27; Socialist Education Movement, denounced in, 37-40; artist for Yangzi River Shipping Association and Chongqing Sailors Club, 40, 43, 45-9, 51, 129, 133-4, 138-9, 145, 148, 150, 156-8,

164, 166, 168, 170; in Cultural Revolution, 41-54, 83-4; Sichuan Academy of Fine Arts, honorary membership in, 94, 170, 210; meets Deng Xiaoping, paints with Deng Lin (1980), 98-101; Sichuan Painting Academy, 98, 160-3, 168-71, 184-6, 209-10; vice-chairman of Chongqing Artists Association, 133-4, 136-8, 148-50; in Campaign Against Spiritual Pollution, 136-67, 191, 208; patronage in the post-Mao era, 187-92; official ranking, 210

— artistic media: calligraphy, 30-2, 48, 100, 117-8, 122, 123, 125, 200; oil painting, 30-3, 42-5, 49-51; seal carving, 30-2, 48, 211; realistic sketching, 31, 41, 49-50, 52-3, 94-6, 101-3, 185, 203-4; cartoons, prints, sculpture, 39, 45-9; propaganda works, 39, 42-9; photography award, 132. *See also* Li Huasheng, traditional painting and aesthetics

— artistic travels: through Yangzi River gorges, and gorges as painting theme, 15, 36, 40, 45, 52, 78, 81, 92, 94, 98, 101, 113, 118, 123, 192, 202; to Beijing (1979), 91-2, 94; to Huangshan [Yellow Mountains] (1980), 98, 100-4; to United States (1987), 171, 204-5, 207-8, 211

— artists, other: Li Shaoyan, 48, 84, 94, 98, 152-3, 168-9, 171-4, 205, 208-10; meetings with Chen Zizhuang, 67-8; influence of Chen Zizhuang, 74-84, 105-6, 113, 123-5, 144, 186, 191-2, 200, 201, 205. *See also artistic influence of* Bada Shanren; Daoji; Du Yongqiao; Huang Binhong; Li Keran; Lin Fengmian; Liu Chunhua; Qi Baishi; Shi Lu; Yu Jiwu; Zeng Youshi

— exhibitions: as teenager, 30; ten-artist exhibition, Nanjing and Beijing (1981), 113, 114-15; American exhibition (1983-85), 123, 150-1, 208; Du Fu Thatched Hall exhibition (1984), 158, 160, 162, 164, 168, Sichuan Provincial Exhibition Hall (1985), 169; other 1980s exhibitions, 114, 168, 170-1, 209

— traditional painting and aesthetics: comments on traditional Chinese painting, xx, 186-7; Sichuan opera, influence of, 11, 28-32, 182, 185, 192; social content in traditional-style paintings, 13-14, 37-8, 39, 91-2 (fig. 40), 103-4 (fig. 53), 118, 122 (figs. 55, 56), 125, 129-30 (figs. 70, 71), 158 (fig. 79), 160-2 (figs. 80, 81), 194-8 (figs. 107, 108), 202-3 (fig. 114); abstraction in Li's paintings, as contradiction of Maoist aesthetic, 81-2, 89-92, 103-4, 187-8, 192, 198, 200

Li Jiawei 李家偉, younger brother of Li Huasheng, 27-9, 52, 54, 82, 135, 148, 157-8

Li Jiayu 李家煜, original name of Li Huasheng, 28

Li Keran 李可染 (1907–89), student of Lin Fengmian and Qi Baishi, long a painter at Central Academy of Fine Arts, vice-chairman of Chinese Artists Association, first met Chen Zizhuang in 1974, met Li Huasheng (1981), 21, 52, 65, 70, 73, 82, 83, 114-15, 122, 125, 209; painting, 52 (fig. 13); photograph, 115 (fig. 61)

Li Qiongjiu 李瓊久 (b. 1909), Sichuan painter admired by Chen Zizhuang, director of the Jiazhou Painting Academy at Leshan, advisor at Chengdu Painting Academy, 150, 223n.34

Li Shangyin 李商隱 (813-858), Tang dynasty poet, author of "Night Rain in the Mountains of Sichuan," 125, 129

Li Shaoyan 李少言 (b. 1918), chairman of the Sichuan Artists Association, 24-5, 40-1, 48, 63-6, 67, 84, 87, 132, 148, 160, 162, 171-4, 183-4, 209-10, 221n. 31, 230n.7; and Li Huasheng, 48, 84, 94, 98, 152-3, 168-9, 171, 174, 205, 208-10; and Chen Zizhuang, 64, 173, 184; biographical sketch, 63-4; woodblock print, 65 (fig. 17)

Li Shinan 李世南 (b. 1940), figure painter with Hubei Artists Association, met Li Huasheng in 1985, 170

Li Weixin 李維新 (b. 1904), father of Li Huasheng, 27

Li Xiaoke 李小可 (b. 1944), Beijing Painting Academy artist, son of Li Keran: in exhibition with Li Huasheng (1981), 115; photograph, 114 (fig. 60)

Li Zhen 李圳 (b. 1975), originally named Li Shi 李實, eldest son of Li Huasheng, 53

Li Zhenyu 李震宇, Yangzi River Shipping Administration Communist Party vice-secretary under Xie Limin in Wuhan, amateur painter who consulted with Li Huasheng, opposed him during Campaign Against Spiritual Pollution, 138-40, 145, 148

Li Zhongsheng 李中生 (1940-42), elder brother of Li Huasheng, died in childhood, 26-7

Liao Jiamin 廖家岷, amateur calligrapher and Sichuan Painting Academy secretary-general, 160, 210

Liaowang 瞭望 (*Perspectives*), Beijing weekly published by New China News Agency, 152-3

Lim, Lucy, director of Chinese Culture Foundation of San Francisco, first brought Li Huasheng painting to America (1983), 123, 132, 145, 150-1

Lin Biao 林彪 (1907-71), head of People's Liberation Army and Mao's designated successor during first part of Cultural Revolution, 37, 45, 53, 61, 86, 210

Lin Fengmian 林風眠 (b. ca. 1901), landscape painter who combined Chinese and Western techniques, first director of Zhejiang Academy of Fine Arts, 21, 30, 70, 82, 83, 106, 110, 113, 132, 219n.105; painting, 110 (fig. 57)

Ling Chengwei 凌承偉, Chongqing artist, critic, and administrator, 115

Liu Bocheng 劉伯承, led Second Field Army with Deng Xiaoping in Huai-hai campaign and capture of Sichuan, PLA marshal, 58

Liu Chunhua 劉春華 (b.1943), propaganda painter of *Chairman Mao Goes to Anyuan*, 35, 44-5; painting, 44 (fig. 7)

Liu Guosong 劉國松 (b. 1932), Taiwan painter, met Li Huasheng (1985), 10, 89, 170

Liu Haisu 劉海粟 (b. 1896), founded first Chinese painting academy in 1912, modernist oil painter and traditional-style artist, active in Shanghai and Nanjing, 114, 139, 144-45, 221n.105

Liu Han 劉漢, art professor at Central Academy of Minority Studies, Beijing, solo exhibition at Du Fu Thatched Hall, 74, 83, 158, 162; biographical sketch, 229n.66

Liu Pu 劉樸 (b. 1945), member of Sichuan Painting Academy, 160, 171, 178, 232n.55, 232n.58; painting, 179 (fig. 95)

Liu Shaoqi 劉少奇 (1898-1969), moderate Chinese chief-of-state in early 1960s, 9, 24, 26, 31

Liu Wenquan 劉文泉, Chongqing Communist Party Propaganda Bureau

director, first to publicly criticize Li Huasheng during Campaign Against Spiritual Pollution, 148, 165, 170

Liu Yisi 劉藝斯, an original vice-chairman of Southwest Artists Association, 223n.36

Lou Shibai 婁師白, member of Beijing Painting Academy, met Li Huasheng (1978), 92

Lu Yanshao 陸儼少 (b. 1909), member of Zhejiang Academy of Fine Arts, met Li Huasheng (1984), 162

Lu You 陸游 (1125-1210), Song dynasty poet whose work was illustrated by Li Huasheng, 15, 17, 118, 122-3, 150-1, 178

Lu Xun 魯迅 (1881-1936), prominent left-wing satirist, critic, and promoter of socialist woodblock movement, 7, 22, 24, 62, 64

Luo Zhongli 羅中立 (b. 1950), oil painter in Sichuan realist movement, 86, 87, 208; painting, 87 (fig. 35)

Lü Chaoxi 呂朝璽, Administrative Office chief of Chongqing Federation of Literary and Arts Circles, 148, 166

Lü Lin 呂林 (b. 1920), Chengdu printmaker and painter, vice-chairman of Chongqing Artists Association until removed in Antirightist Campaign, honorary vice-chairman of Sichuan Painting Academy: spokesman for moderation in conflict with Li Shaoyan, 24-5, 171-4; purged in Antirightist Campaign, 24-5, 64, 132, 212, 230n.7; introduced Li Huasheng to Chen Zizhuang, 37, 67; advised Li Huasheng to make propaganda woodblock prints, 48; supported, promoted Chen Zizhuang, 61-3, 183; painted dissident subject matter with Chen Zizhuang, 66, 171, 177; and Sichuan Painting Academy, 160; on

Yang Chao, 174; on official artistic standards, Zhang Daqian, 172; article in support of Li Huasheng, 192, 194; biographical sketch, 171-2, 227n. 47, 230n.6; painting, 172 (fig. 86); photograph, 172 (fig. 85)

Mao Dun 矛盾 (1896-1982), prominent writer, Minister of Culture, in conflict with Jiang Feng, 23, 178

Mao Zedong 毛澤東 (1893-1976), chairman of Chinese Communist Party xvii, xviii, xx, 2, 3, 9, 18, 20, 35-48, 51, 53-4, 58, 59, 61, 85-7, 135, 140-2, 152, 181, 208; at Yan'an Forum, 1942, established Party aesthetic policy, 3-8, 21-2. *See also* Yan'an Forum on Literature and Art

Mei Yaochen 梅堯臣 (1002-60), Song dynasty poet, 30, 72, 74

Ministry of Culture, 9, 40, 55, 59-60, 123, 145, 157, 217n.41

Minzhu yu fazhi 民主與法制 (*Democracy and legal institutions*), Shanghai monthly published by Shanghai Bureau of Justice, 153-5

National Academy of Fine Arts 國立北平藝術專科學校, Beijing: combined with National Zhejiang Academy of Art in Chongqing during war, 21; became Central Academy of Fine Arts (1950), 219n.97

National Central University 國立中央大學, Nanjing, relocated in Chongqing during war, 21

"National forms," 8, 23-4, 216n.33

Neibu cankao 內部參攷 (*Neican, Internal Reference*), restricted-circulation Communist Party journal, 145-8, 152

Ni Zan 倪瓚 (1301-74), Yuan

dynasty landscape painter, 19, 20, 162

Nien Cheng 鄭念 (b. 1915), author of *Life and Death in Shanghai*, xix-xx, 41

Niu Wen 牛文 (b. 1924), chairman of Chongqing Artists Association and mentor of Li Huasheng, 40-1, 87, 98, 132-3, 136-8, 148-50, 165-6, 173-7, 182, 184, 217n.38, 230n.7; biographical sketch, 132-3; woodblock prints, 65 (fig. 17), 134 (fig. 75); photograph, 133 (fig.74)

Opera. *See under* Li Huasheng, traditional painting and aesthetics

Pan Qingfu, Chinese martial artist, 11-12

Pan Tianshou 潘天壽 (late 1880s-1971), bird-and-flower painter, former director of Zhejiang Provincial Painting Academy, victim of Cultural Revolution, admired Chen Zizhuang's work, 23, 64-5, 179, 223n.38

Pang Xunqin 龐熏琴 (1903-85), figure painter in mixed Chinese-Western style, director of the Central Academy of Arts and Crafts, Beijing, 220n.105

Patronage. *See* Bureau of Cultural Relics; Chinese Artists Association; *under* Li Huasheng, artistic career; *yingchou* paintings

Peng Xiancheng 彭先誠 (b. 1941), figure and horse painter, member of Sichuan Painting Academy, 62, 74, 174, 176-7, 232n.55, 232n.58; biographical sketch, 174, 176; 231n.19; paintings, 176 (fig. 92), 177 (fig. 93); photograph, 99 (fig. 47)

Petöfi, Sandor (Ch. Pei Duofei 裴多非, 1823-49), Hungarian nationalist poet, 36-7, 142

Propaganda Department. *See* Communist Party Propa-

ganda Department

Qi Baishi 齊白石 (1863-1957), traditional-style painter primarily of flowers, insects, small landscapes, xviii, 33, 52, 74, 82, 92, 176, 179, 189, 191, 204; visits Sichuan, 21, 28; influence on Chen Zizhuang, 21, 67, 69, 72, 74; influence on Li Huasheng, 21, 67, 74, 78, 191; painting, 73 (fig. 22)

Qi Gong 啓功 (b. 1912), chairman of Chinese Calligraphy Association, 55, 160

Qian Junrui 錢俊瑞, vice-minister of Culture, in conflict with Jiang Feng, 219n.104

Qiao Deguang 喬德光, connoisseur at Chengdu Antiquities Shop, 189-90

Qin Dengkui 秦登魁, officer in Sichuan Provincial Military Region and vice-chairman of Sichuan Painting Academy, 160, 162-3, 170

Qin Tianzhu 秦天柱 (b. 1952), bird-and-flower painter, member of Sichuan Painting Academy, 94, 160, 171, 178-9, 232nn.55, 58; painting, 179 (fig. 96)

Qingcheng, Mount 青城山, near Chengdu, home of Shangqing Daoist Temple, 16, 21, 78, 158, 185, 190-1

Qiu Xiaoqiu 邱笑秋 (b. 1935), Sichuan landscape painter and playwright, 94, 170, 232n.55; photograph, 99 (fig. 47)

Qu Qiubai 瞿秋白 (1899-1935), proponent of "national forms" in literature, 216n.33

Ren Bonian 任伯年 (or Ren Yi 任頤, 1840-96), painter of birds, flowers, and figures, first generation of "Shanghai school," 61, 176, 179

Ren Yongsong 任永松, classmate of Li Huasheng at Yangzi River Shipping

School, denounced during Socialist Education Movement, 39, 51

Rent Collection Courtyard, socialist-realist sculptural ensemble, 44, 221n. 31

Rongbaozhai 榮寶齋, Beijing antique shop, 61, 217n. 37

Sailor's Club. *See* Yangzi River Shipping Administration

Serov, Valentin (1865-1911), Russian oil painter, 49

Shangqing Daoist Temple 上清宮 (Shangqing Gong). *See* Qingcheng, Mount

Shi Lu 石魯 (1919-82),oil-based propaganda- and traditional-style painter, native of Renshou County, Sichuan, persecuted in Cultural Revolution, 12, 21, 53, 62, 103, 138, 176, 178, 223n.38

Shi Qi 石齊 (b. 1939), member of Beijing Painting Academy, met Li Huasheng in 1983 and 1984, 145, 162

Shipping School. *See* Yangzi River Shipping School

Sichuan (province): geography of, 14-17, 218n.65; political background, 17-18; famous poets of, 17, 26 (*see individual listings*); art historical background, 20-1; in Cultural Revolution, 42-3; oil painting in early post-Mao period, 86-7; traditional painting in early post-Mao period, 87-8. *See also* Chengdu; Chongqing

Sichuan Academy of Fine Arts 四川美術學院,Chongqing, 94, 133, 170, 183, 210, 220n.108, 221n.31

Sichuan Academy of Poetry, Calligraphy, and Painting. *See* Sichuan Painting Academy

Sichuan Artists Association 四川美術家協會, 24-5, 64, 87, 94, 98, 100, 132, 136, 169, 171-3, 183, 204-5, 208-9, 223n.36, 227n.47

Sichuan opera (Chuanju 川劇). *See under* Li Huasheng,

traditional painting and aesthetics

Sichuan Painting Academy (Sichuan Academy of Poetry, Calligraphy, and Painting 四川省詩書畫院), Chengdu: creation of, 13, 98, 137, 151, 160; opening ceremonies, 160. *See also individual members* Dai Wei; Guo Ruyu; He Yinghui; Liao Jiamin; Li Huasheng; Liu Pu; Peng Xiancheng; Qin Tianzhu; Yang Chao; Yuan Shengzhong; Zhang Shiying; Zhou Ming'an

Sichuan Provincial Art College 四川省立藝術學校, Chengdu, as wartime host to painters, 21

Sichuan Provincial Cultural Bureau (Sichuan Sheng Wenhua Ting 四川省文化廳), 207, 210

Sichuan Provincial Fine Arts High Ranking Titles Evaluation Committee 四川省美術高級職稱評審委員會, 210

Sikong Tu 司空圖 (837-908), Tang dynasty recluse, theoretician, poet, 194

Socialist Education Movement: general background, 35-7. *See also under* Li Huasheng, artistic career

Song Wenzhi 宋文治 (b. 1919), vice-director Jiangsu Chinese Painting Academy, met Li Huasheng (1974), advised him on painting (1980), 62, 104, 113

Southwest Artists Association 西南美術工作者協會, four-province regional artists association (1953-54), then renamed Chongqing Branch of the Chinese Artists Association 中國美術工作者協會重慶分會, 24-5, 132, 223n.36

Spiritual Pollution, Campaign Against (1983-84), xx, 9, 13; general background, 140-44; end of movement, 151-2, 158, 163, 165. *See also under* Li Huasheng, artistic career

Su Baozhen 蘇葆楨 (b. 1916), flower painter, vice-chairman of Chongqing Artists Association, advisor at Chengdu Painting Academy, 32, 62, 138, 149

Su Guochao 蘇國超, Chengdu figure painter, 67

Su Shi 蘇軾 (or Su Dongpo 蘇東坡, 1036-1101), Song dynasty statesman, poet, painter, and art theorist, xx, 15, 17-19, 26, 30, 209

Sun Xianyu 孫先余, Chongqing Municipal People's Representative Congress Standing Committee chairman, exhibition request refused by Li Huasheng, opposed Li during Campaign Against Spiritual Pollution, 137

Sun Zhuli 孫竹籬 (b.1907), advisor at the Sichuan Painting Academy and the Chengdu Painting Academy, with Li Huasheng in Golden Ox Hotel research group (1980), 98, 160, 226n.16; photograph, 99 (fig. 47)

Tan Changrong 譚昌熔 (b. 1933), Sichuan Opera Company artist and member of Chengdu Painting Academy, 64, 66, 68, 98, 100, 145, 158, 160, 162, 178, 180-2, 232n. 55; collaborative painting with Li Huasheng et al., 100 (fig. 48); photograph, 99 (fig. 47); painting, 182 (fig. 101)

Tan Qilong 譚啓龍, former Sichuan Communist Party first secretary and supporter of Li Huasheng, 98, 130, 137, 141, 151, 160, 169, 171

Tan Tianren 譚天仁 (b. 1945), landscape painter and manager of painting gallery at Du Fu Thatched Hall, 139, 144, 158, 162, 164, 232n.55; biographical sketch, 229n. 68; painting, 181 (fig. 100)

Tang Tao 唐濤, wrote about Li Huasheng's "arrest" during

Campaign Against Spiritual Pollution, 163-4, 167

Traditional Chinese painting, *guohua* 國畫 (also "scholar's painting," "literati painting"): contradicts Maoist art theory, 3-4, 18-20, 61, 68, 81-2, 88-92; in Antirightist Campaign, 23-5; in Cultural Revolution, 61, 83, 94, 123; in post-Cultural Revolution era, 87-91, 137, 142, 186-7. *See also* Mao Zedong, at Yan'an Forum; Li Huasheng, comments on traditional Chinese painting

Tseng Yu-ho 曾幼荷 (or Dr. Betty Ecke, b. 1923), Honolulu-based landscape painter and art historian, 10

Twain, Mark: on biography, xviii, xix

United Front Administration (Tongzhan Bu 統戰部), 60, 61

Wang Bangcan 王邦燦, general-secretary of Chongqing Federation of Literary and Art Circles, opposed Li Huasheng during Campaign Against Spiritual Pollution, 137, 149-50

Wang Guangrong 王光榮, member of Li Huasheng's "small circle" of friends, 54, 67, 135, 148

Wang Jiqian 王季遷, (or C. C. Wang, b. 1907), New York-based landscape painter and connoisseur, 10, 14, 89, 205

Wang Qian 王謙, Chongqing Communist Party secretary, at first sympathetic to Li Huasheng, later said to have demanded severe punishment during Campaign Against Spiritual Pollution, 137, 154, 156

Wang Wennong 王文農 (b. 1910), painter from Hubei province, met Li Huasheng (1974), 62, 92

Wang Xiazhou 王霞宙, painter from Hubei province, met

Li Huasheng (1974), 62

Wang Zanxu 王讚緒 (1885-1957), warlord and governor of Sichuan, patron of Chen Zizhuang, 58-60

Wang Zhaowen 王朝聞, sculptor, prominent art theorist and critic, vice-chairman of the Chinese Artists Association, supporter of Li Huasheng, 55, 101, 148, 209

Wang Zumei, cartoonist at Sichuan Academy of Fine Arts, vice-chairman of Chongqing Artists Association, denounced as "Rightist" with Lü Lin, 24, 227n. 48, 230n.7

Wenshiguan 文史館 (Hall of Culture and History), xvii, 59-63, 66, 69, 225n.82

Wilde, Oscar: on biography, xix

Wu Changshi 吳昌石 (or Wu Changshuo, 1844-1927), painter of flowers, active in Shanghai, studied by Li Huasheng in early 1970s, 52, 176, 191

Wu De 吳德, mayor of Beijing and head of the Central Cultural Activity Group during Cultural Revolution, 40, 217n.41

Wu Fan 吳凡 (b. 1924), printmaker and painter, vice-chairman of Sichuan Artists Association, advisor to Sichuan Painting Academy and Chengdu Painting Academy, 58, 64, 101, 133, 172-4, 183, 189, 191; non-political art opposed by Li Shaoyan, 64; on post-Cultural Revolution era Sichuan painting, 86, 87; as champion of Chen Zizhuang's traditionalism, 173, 182; biographical sketch, 230n.11; woodblock print, 173 (fig. 88); photograph, 173 (fig. 87)

Wu Guanzhong 吳冠中 (b. 1919), vice-president of Central Academy of Arts and Crafts, met with Li Huasheng (1973, 1983,

1985), 53, 55, 145, 170

Wu Han 吳晗, vice-mayor of Beijing (1966), early victim of Cultural Revolution, 39

Wu Hanlian 吳漢蓮, Chinese-American woman painter who befriended Li Huasheng, 139, 145

Wu Yifeng 吳一峰 (b. 1907), Sichuan landscape painter, advisor at the Chengdu Painting Academy, with Li Huasheng in Golden Ox Hotel research group (1980), 98, 160

Wu Yingqi 吳應琪, member of Sichuan Academy of Fine Arts, wrote articles about Li Huasheng's painting, wrote preface to his selected works, 209

Wu Zuoren 吳作人 (b. 1908), member of Central Academy of Fine Arts, chairman of Chinese Artists Association, met Chen Zizhuang (1973), met Li Huasheng (1984), 21, 30, 65, 114

Wyeth, Andrew (b. 1917), "magic realist" oil painter, 86

Xiao Banghui 肖邦惠 (b. 1947), affair with Li Huasheng, 155-7, 160, 164, 166-7

Xie Bingxin 謝冰心 (b. 1900), noted Beijing author from whom Chen Zizhuang asked for help, 61

Xie Dayou 謝大有, childhood friend of Li Huasheng, introduced Li to his teacher Zeng Youshi, 32

Xie Limin 解立民, Yangzi River Shipping Administration Communist Party secretary, unsuccessfully sought paintings from Li Huasheng, opposed him during Campaign Against Spiritual Pollution, 138, 145

Xie Wuliang 謝無量 (d. ca. 1960), Sichuan calligrapher admired by Chen Zizhuang and Li Huasheng, first chairman of Chinese Wenshiguan, 59, 92, 118

Xie Yusheng 謝渝生 (d. 1986), head of Yangzi River Shipping Administration's Chongqing transportation section, showed Li Huasheng charges against him during Campaign Against Spiritual Pollution, 148

Xu Beihong 徐悲鴻 (1895-1953), Western academic-style painter, with Nanjing's National Central University in Chongqing during war, organized National Art Research Institute in Chongqing (1943), became first director of Central Academy of Fine Arts (1950), 21, 133, 148, 149, 219n.97

Xu Bing 徐冰 (b. 1955), avant-garde printmaker, 187

Xu Kuang 徐匡 (b. 1938), Sichuan woodblock artist, promoted to vice-chairman of Chongqing Artists Association along with Li Huasheng, 87, 133, 148, 149, 227n. 52

Xu Zhigao 徐志高, Yangzi River Shipping Administration Chongqing Office Communist Party secretary after Gu Zhenhai, supported Li Huasheng during Campaign Against Spiritual Pollution, 158-60, 170

Xugu 虛谷 (1823-96), monk painter (family name Zhu) of flowers and fruits, associated with "Shanghai school," 176, 179

Ya Ming 亞明 (b. 1924), chairman of the Jiangsu Provincial Artists Association, 53, 55

Yan Jiyuan 晏濟元, Chongqing painter, admired by Chen Zizhuang, prevented from exhibiting by Li Huasheng (1983), opposed Li during Campaign Against Spiritual Pollution, 137, 139, 148, 223n. 34

Yan Tianshan 閻天山, Yangzi River Shipping School

official, helped Li Huasheng become Shipping Administration propaganda artist, 40

Yan Xiaohuai 楊曉懷, financial patron of Chen Zizhuang's posthumous exhibition, 56, 182-3

Yan'an Forum on Literature and Art (1942), 132, 142; Mao Zedong established Party aesthetic standards at, 3-8, 21-22; policy abandoned in 1980s, 86, 184. See also Contradictions; Cultural Revolution, artistic standards during; Traditional Chinese painting

Yang Chao 楊超 (b. 1911), director of the Sichuan Painting Academy, 151, 160, 168-70, 174, 179, 182, 184, 205, 207, 209, 210; calligraphy, 175 (fig. 90); photograph, 174 (fig. 89)

Yang Rudai 楊汝岱, Sichuan Communist Party first secretary after Tan Qilong, 160

Yangzi River and Yangzi River gorges in Sichuan, 14-16, 26-7, 217n.57. See also under Li Huasheng, artistic travels

Yangzi River Shipping Administration 長江航運局, 13, 27, 36, 40, 43, 94, 133-4, 138-9, 145, 148, See also under Li Huasheng, artistic background

Ye Yushan 葉毓山 (b. 1935), Sculpture Department chairman, then vice-president, now president of Sichuan Academy of Fine Arts: helped obtain honorary faculty position for Li Huasheng, 94, 170; headed team producing Rent Collection Courtyard, 221n. 31

Yibin 宜賓, near Li Huasheng's birthplace, 26, 28; painting theme, 96-7 (figs. 44-6), 129 (fig. 71), 206 (fig.117)

yingchou 應酬 (obligation or courtesy) paintings, 187–89, 191

Young Pioneers, 28

Yu Chengyao 余承堯 (b. 1903), Taiwanese landscape painter, 10

Yu Jiwu 余輯伍, Chongqing landscape painter, pupil of Lin Fengmian, early teacher of Li Huasheng, 30-34, 35, 49, 83, 110; painting, 31 (fig. 5); photograph, 30 (fig.4)

Yuan Guanghou 袁光厚, Chongqing journalist, attacked Li Huasheng during Campaign Against Spiritual Pollution, 145, 148, 152-4, 157, 166

Yuan Shengzhong 袁生中, figure painter, member of Sichuan Painting Academy, 171, 197, 232n. 58; painting, 181 (fig. 99)

Zao Wou-ki 趙無極 (or Zhao Wuji, b. 1920), Paris-based modernist painter, 10, 21, 225n.10

Zeng Mougong 曾默躬 (1881-1961), Sichuan seal-carver admired by Chen Zizhuang and Li Huasheng, 54, 223nn.34, 35

Zeng Weihua 曾維華, member of Li Huasheng's "small circle" of friends, 36-7, 67

Zeng Youshi 曾右石 (d. 1985), Chongqing calligrapher and seal-carver, teacher of Li Huasheng, 32-3, 35, 49, 67, 104, 211; seals, 213 (fig. 119)

Zhang Aiping 張愛萍 (b. 1910), former Chinese Minister of Defense, helped organize Sichuan Painting Academy, 17, 55, 151, 160, 162

Zhang Anzhi 張安治 (b. 1910), student of Xu Beihong, professor at Nanjing's National Central University and National Art Research Institute based in Chongqing, later at Central Academy of Fine Arts, 21

Zhang Bu 張步 (b. 1934), member of Beijing Painting Academy, 123; photograph, 114 (fig. 60)

Zhang Daqian 張大千 (Chang Dai-chien or Zhang Yuan 張爰, 1899-1983), from Neijiang, Sichuan, traditional-style landscape and figure painter, left China after 1949 and assimilated Western influence, 10, 16, 21, 63, 89, 137, 142, 172, 176, 225n.10

Zhang Ding 張汀 (b. 1917), landscape painter, at Lu Xun Academy in Yan'an in 1940s, former chairman of Central Academy of Fine Arts Chinese Painting Department, later Central Academy of Arts and Crafts vice-president, 219n.104

Zhang Fangqiang 張方強, member of Li Huasheng's "small circle" of friends 36-7, 42, 49, 54, 67

Zhang Shiying 張士瑩 (b. 1933), tiger painter, member of Sichuan Painting Academy, 171, 179, 232n.58; painting, 180 (fig.97)

Zhang Zhaoming 張肇銘 (1897-1976), painter from Hubei province, met Li Huasheng (1974), 62

Zhang Zhenduo 張振鐸 (b. 1908), painter from Hubei province, met Li Huasheng (1974), 62

Zhang Zhengheng 張正恆, member of Central Academy of Minority Studies, Beijing, student of Pan Tianshou, confidant of Chen Zizhuang, 56, 61, 65, 70, 223n.34

Zhao Ziyang 趙紫陽 (b. 1919), former premier of China and Communist Party secretary-general, 85, 93, 141-2, 144; given painting by Li Huasheng, 169 (fig. 84)

Zhejiang Academy of Fine Arts 浙江美術學院, as National Zhejiang Art Academy 國立杭州藝術專科學校 combined with Beijing's National Academy of Art near Chongqing during war, returned to Zhejiang in 1946, 21–3, 219n.97

Zheng Xie 鄭燮 (1693-1765), "eccentric" Yangzhou painter, 190, 227n.39

Zhongguo fazhi bao 中國法制報 (Chinese law journal), published in Beijing by Ministry of Justice, 155-6, 164, 166

Zhou Enlai 周恩來 (1898-1976), premier of China, xvii, 40, 42, 53, 59, 61, 85

Zhou Ming'an 周明安 (b.1949), tiger painter, member of Sichuan Painting Academy, 179, 232n.58; painting, 180 (fig. 98)

Zhou Shaohua 周韶華 (b.1929), vice-chairman of Hubei Artists Association, director Hubei Academy of Fine Arts, organized creativity symposium in 1985 attended by Li Huasheng, 170

Zhou Sicong 周思聰 (b.1939), member of Beijing Painting Academy, vice-chair of Chinese Artists Association, met Li Huasheng (1978, 1985), 92, 170

Zhou Yang 周揚 (1908-89), foremost Communist Party cultural propagandist, 22-4, 36, 142, 143, 216n.33. See also "National forms"

Zhu Danian 祝大年 (b. 1915), Zhejiang painter, faculty member of Central Academy of Arts and Crafts, Beijing, associated with "Hotel School" art: visited Li Huasheng (1973), 53

Zhu Muzhi 朱穆之, former Minister of Culture, 141, 143

Zhu nin chengcai 祝您成才 (Wishing that you become accomplished), youth magazine published in Nanjing, 163-5, 168

Zhu Peijun 朱佩君 (b. 1920), director of Chengdu Painting Academy, antagonist of Chen Zizhuang, 63-4, 123, 160, 174; painting, 63 (fig. 15)

Zhu Qizhan 朱屺瞻 (b. 1891), painter of flowers and landscapes, with Shanghai Chinese Painting Academy: attended opening of Sichuan Painting Academy, 160; painted with Li Huasheng and Feng Jianwu, 227n.6

Zhu Xuanxian 朱宣咸, Chongqing Artists Association general-secretary, opposed to Li Huasheng during the Campaign Against Spiritual Pollution, 137, 156

Zhuangzi 庄子 (ca. 4th century B.C.), early Daoist philosopher, 55, 57, 71, 74, 76, 178

Zou Lin 鄒麟, first wife of Li Huasheng, 53, 139, 155